WHISTLER

WHISTLER

A RETROSPECTIVE

Edited by Robin Spencer

WINGS BOOKS

New York

For Pamela with love

Copyright © 1989, Hugh Lauter Levin Associates, Inc., New York
Introduction and notes copyright © 1989 by Robin Spencer
All rights reserved.

This 1991 edition is published by Wings Books, distributed by
Outlet Book Company, Inc., a Random House Company, 225 Park
Avenue South, New York, New York 10003, by arrangement with
Hugh Lauter Levin Associates, Inc.

Printed and bound in Singapore

Library of Congress Cataloging-in-Publication Data

Spencer, Robin.
 Whistler: a retrospective/edited by Robin Spencer.
 p. cm.
 Includes bibliographical references and index.
 ISBN 0-517-05773-5
 1. Whistler, James McNeill, 1834–1903. 2. Artists — United States —
Biography. I. Whistler, James McNeill, 1834–1903. II. Title.
N6537.W4S6 1991
760'.092 — dc20
[B] 91-2956
 CIP

8 7 6 5 4 3 2 1

The excerpts in this book are reproduced by kind permission of the copyright owners and publishers, as follows:

E.R. and J. Pennell, *The Life of James McNeill Whistler,* Lippincott, 1908, and *The Whistler Journal,* Lippincott, 1921. By permission of Harper & Row Publishers Inc.

12 letters in the Whistler Collections, by permission of Glasgow University Library.

Daphne du Maurier (ed.), *The Young George du Maurier, a Selection of His Letters 1860–67,* 1951. By permission of William Heinemann Ltd.

Letter of Whistler to George Lucas, with acknowledgement to the Wadsworth Athenaeum, Hartford, Conn.

Letter of Whistler to James Leathart, with acknowledgement to the University of British Columbia.

2 Letters to and from Fantin-Latour, with acknowledgement to the Bibliothèque Nationale, Paris.

Cecil Y. Lang, *The Swinburne Letters,* 1959. By Permission of Yale University Press.

4 letters and the Statement of Claim from the Pennell Collection of Whistler mss. By permission of the Library of Congress, Washington, D.C.

T.R. Way, *Memories of James McNeill Whistler,* John Lane The Bodley Head, 1912. By permission of The Bodley Head Ltd.

5 excerpts from correspondence between Fantin-Latour and Scholderer, reproduced in Ruth Fine (ed.), *James McNeill Whistler, A Re-Examination: Studies in the History of Art,* 1987. With acknowledgement to the National Gallery, Washington, D.C.

Whistler, *The Gentle Art of Making Enemies,* 1892. By permission of William Heinemann Ltd.

John L. Sweeney (ed.), *The Painter's Eye, Notes and Essays on the Pictorial Arts by Henry James,* Hart-Davis, 1956. By permission of Grafton Books Ltd.

Mortimer Menpes, *Whistler as I Knew Him,* 1904. By permission of A. & C. Black (Publishers) Ltd.

W. Graham Robertson, *Time Was,* 1931. By permission of Hamish Hamilton Ltd.

William Rothenstein, *Men and Memories,* Faber, 1931. By permission of Sir John Rothenstein.

P.H. Emerson, *Naturalistic Photography for Students of the Art,* 1899. By permission of Arno Press.

Clive Bell, *Art,* Chatto & Windus, 1914. By permission of The Hogarth Press and the Executors of the Clive Bell Estate.

James Laver, *Whistler,* Faber, 1930. By permission of David Higham Associates Ltd.

Stephen Spender, "A Painter Haunted by Greatness," 1960. By permission of *The Listener.*

Full information for each excerpt is given in the Bibliographical Index, page 10.

CONTENTS

PREFACE AND ACKNOWLEDGEMENTS

The purpose behind the selection of writings by and about Whistler for this anthology has been to provide texts relevant to his professional career as an artist, and to include appropriate biographical material to illuminate it. In his autobiography *The Gentle Art of Making Enemies* Whistler clearly hoped to cast himself in an olympian mould, a task in which he was abetted by his first biographers, Elizabeth and Joseph Pennell, originally of Philadelphia. Soon bored by these posturings, posterity has been slow to acquiesce. Nonetheless it would have over-compensated to omit from a book of this sort two texts from *The Gentle Art* which have since become major art-historical documents of the modern movement. Accordingly, Whistler's own version of the proceedings he brought against John Ruskin for libel in 1878, and the text of the "Ten O Clock" lecture, first given in 1885, are included here. In the case of articles, books and unpublished mss, the reader will soon become aware that most of the texts are extracts from the original publication or other source: a bibliographical index is provided on p. 10. The symbol . . . in the present book indicates an omission from the original text; * * * represents the omission of one page or more. For reasons of design and limited space it has not been possible to print all the notes which the editor intended should accompany the texts.

I am grateful to friends at St. Andrews University and elsewhere for information, particularly Martin Hopkinson of the Hunterian Art Gallery, Glasgow University, and Nigel Thorp of Glasgow University Library. Margaret MacDonald kindly agreed to allow the chronology of Whistler's life to be adapted from the longer one she originally prepared for the *catalogue raisonné* of Whistler's oil paintings which she co-authored with me in 1980. I should also mention here the Whistler bibliography prepared by my friends and colleagues Robert H. Getscher and Paul Marks (*James McNeill Whistler and John Singer Sargent. Two Annotated Bibliographies*, Garland Publishing, Inc., New York and London, 1986) which was not only invaluable for the present task, but is also an essential tool for any future study of Whistler and his work. Translations have been made by Judith Landry, Charlotte Humphreys and the editor. I am grateful to Duncan McAlpine-Mitchell for taking time to proof-read; and to Elisabeth Ingles of Calmann and King for her great patience with a publication which took me far longer to prepare than I would ever have thought possible. Finally, Dawn Waddell of the Department of Art History, St. Andrews University, added accuracy and speed to expedite it.

ROBIN SPENCER
Department of Art History
University of St. Andrews

Bibliographical Index

The complete paintings of Whistler are discussed and illustrated in the *catalogue raisonné* by Young, MacDonald, Spencer and Miles, *The Paintings of James McNeill Whistler*, 2 vols., Yale University Press, New Haven and London, 1980 (referred to as YMSM in the notes to this book). For the etchings, see Edward G. Kennedy, *The Etched Work of Whistler*, 5 vols., Grolier Club, New York, 1910 (new edition, Alan Wofsy Fine Arts, San Francisco, 1978) (referred to as K); for the lithographs, see Thomas R. Way, *Mr Whistler's Lithographs. The Catalogue*, compiled by T.R. Way, G. Bell and Sons, London, 2nd edition, 1905 (referred to as W).

p. 35 E.R. and J. Pennell, *The Life of James McNeill Whistler*, Lippincott, Philadelphia, 1908, Vol. I, pp. 14–15, 17, 21.

p. 37 James McNeill Whistler, *Letter to his Mother*, unpublished, Whistler W.386, Glasgow University Library, 17 March 1849.

p. 38 *The Critic*, Vol. 43, no. 3, New York, September 1903, pp. 249–50.

p. 39 Pennell 1908, II (Appendix), pp. 305–9.

p. 50 *The Book Buyer*, Vol. 17, no. 2, New York, September 1898, pp. 113–14.

p. 51 *Century Magazine*, Vol. LXXV, New York, April 1908, pp. 928–32.

p. 55 L.M. Lamont (ed.), *Thomas Armstrong, C.B. A Memoir 1832–1911*, Martin Secker, London, 1912, pp. 146, 174–75, 177–79, 186–93.

p. 59 *The Times*, London, 17 May 1860, p. 11.

p. 59 Daphne du Maurier (ed.), *The Young George du Maurier, A Selection of His Letters, 1860–67*, Peter Davies, London, 1951, pp. 4, 38.

p. 60 Charles Baudelaire, *Art in Paris 1845–1862, Salons and Other Exhibitions*, trans. and ed. Jonathan Mayne, Phaidon Press, London, 1965, p. 220.

p. 61 Pennell 1908, I, pp. 79–80.

p. 62 *The Athenaeum*, London, 28 June 1862, 5 July 1862, 19 July 1862, p. 859, p. 23, p. 86.

p. 63 Pennell 1908, I, pp. 81–82.

p. 63 James McNeill Whistler, *Letter to George Lucas*, unpublished, Wadsworth Athenaeum, Hartford, Conn., 26 June 1862.

p. 71 *Gazette des Beaux-Arts*, XV, Paris, July 1863, pp. 60–61.

p. 72 Anna M. Whistler, *Letter to Mr Gamble*, Whistler W.516, Glasgow University Library, 10 February 1864, reprinted in *Atlantic Monthly*, Vol. 136, no. 3, Boston, Mass., September 1925 (ed. K.E. Abbott), pp. 319–28.

p. 73 William Bell Scott, *Letter to James Leathart*, unpublished, University of British Columbia, 25 February 1864.

p. 74 *Critiques Fantin-Latour Vol. I*, unpublished, Cabinet des Estampes, Bibliothèque Nationale, Paris, May 1864.

p. 75 *Critiques Fantin-Latour Vol. I*, unpublished, Cabinet des Estampes, Bibliothèque Nationale, Paris, Vol. I, 25 May 1864.

p. 76 Cecil Y. Lang (ed.), *The Swinburne Letters*, Yale University Press, New Haven, 1959, Vol. I, pp. 118–20, 130–31.

p. 77 *Fraser's Magazine*, Vol. LXXI, no. 426, London, June 1865, pp. 747–78.

p. 78 William Michael Rossetti, *Rossetti Papers 1862–70*, Sands, London, 1903, pp. 222, 228–29, 233–35, 245.

p. 80 *The Athenaeum*, 18 May 1867, p. 667.

p. 81 *The Saturday Review*, London, 1 June 1867, p. 691.

p. 82 James McNeill Whistler, *Letter to Fantin-Latour*, unpublished, Pennell Collection of Whistler mss., Library of Congress, Washington, D.C., 1867.

p. 84 A.C. Swinburne, *Essays and Studies*, Chatto and Windus, London, 1875, p. 360.

p. 85 James McNeill Whistler, *Draft Letter to Albert Moore*, unpublished, Whistler M.436, Glasgow University Library, 1870.

p. 86 *The Saturday Review*, 12 August 1871, pp. 223–25.

p. 101 E.J. Poynter, *Letter to Whistler*, unpublished, Whistler P.651, Glasgow University Library, 10 October 1871.

p. 101 *The Times*, 14 November 1871, p. 4.

p. 102 James McNeill Whistler, *Letter to F.R. Leyland*, unpublished, Pennell Collection of Whistler mss., Library of Congress, Washington, D.C., November 1872.

p. 103 *The Academy*, London, 15 May 1872, p. 185.

p. 103 Mrs. Anna M. Whistler and James McNeill Whistler, *Letter to Mrs. W.C. Alexander*, unpublished, British Museum, London, 26 August 1872.

p. 104 Pennell 1908, I, pp. 164–75.

p. 106 T.R. Way, *Memories of James McNeill Whistler*, John Lane The Bodley Head, London, 1912, pp. 67–68.

p. 107 *The Art Bulletin*, Vol. 49, no. 3, New York, September 1967 (ed. John A. Mahey), pp. 252–53.

p. 108 Robin Spencer, "Whistler, Manet and the Tradition of the Avant-garde," in Ruth Fine (ed.), *James McNeill Whistler, A Re-Examination: Studies in the History of Art*, National Gallery, Washington, D.C., 1987, Vol. 19, p. 63.

p. 109 *The Pictorial World*, London, 13 June 1874.

p. 119 *The Academy*, London, 30 October 1875, p. 462.

p. 119 Pennell 1908, I, p. 189.

p. 120 F.R. Leyland, *Letter to Whistler*, unpublished, Whistler L.106, Glasgow University Library, 21 October 1876.

p. 121 James McNeill Whistler, *Draft Letters to F.R. Leyland*, unpublished, Whistler L.109, 111, Glasgow University Library, 24–30 October, 31 October 1876.

p. 121 *Pall Mall Gazette*, London, 15 February 1877.

p. 123 Rev. H.R. Haweis, *A Sermon Preached at St. James's Hall*, London, H.S. King & Co., Cornhill, London, 1877, pp. 7–8.

p. 124 James McNeill Whistler, *Statement of Claim for Libel against John Ruskin*, Pennell Collection of Whistler mss., Library of Congress, Washington, D.C., 1877.

p. 125 *The British Architect*, London, 18 April 1878, p. 180.

p. 126 *The World*, London, 22 May 1878, p. 4.

p. 128 James McNeill Whistler, *The Gentle Art of Making Enemies*, William Heinemann, London, 1892, pp. 2–19.

p. 133 Henry James, "On Art-Criticism and Whistler," *The Nation*, New York, 13 February 1879, reprinted in *The Painter's Eye, Notes and Essays on the Pictorial Arts*, John L. Sweeney (ed.), Rupert Hart-Davis, London, 1956, pp. 175–77.

p. 143 *The Nineteenth Century*, VI, no. XVIII, London, August 1879, pp. 339–43.

p. 147 *Scribner's Monthly*, XVIII, no. 4, New York, August 1879, pp. 486–90, 493–94, 494–95.

p. 151 *The Academy*, 21 February 1880, pp. 148–49.

p. 153 Otto Bacher, *With Whistler in Venice*, The Century Co., New York, 1908, pp. 74–78, 90–124, 165–80.

p. 172 *The Times*, 25 December 1880, p. 4.

p. 176 *The Observer*, London, 6 February 1881.

p. 178 *Harper's Bazaar*, New York, 15 October 1881.

p. 180 *Gazette des Beaux-Arts*, XXIII, March 1881, pp. 364–69.

p. 197 James McNeill Whistler, *Letter to Théodore Duret*, unpublished, Pennell Collection of Whistler mss, Library of Congress, Washington, D.C., May 1882.

p. 198 John Rewald (ed.), *Camille Pissarro, Letters to his Son Lucien*, Kegan Paul, Trench, Trubner, London 1943, pp. 22–23.

p. 199 *Lady's Pictorial*, London, 24 February 1883.

p. 200 Whistler 1892, pp. 106–8.

p. 201 *Le Jour*, Paris, 5 May 1883.

p. 201 *The British Architect*, London, 11 July 1884.

p. 202 Mortimer Menpes, *Whistler As I Knew Him*, Macmillan Co., New York, 1904, pp. 115–24.

p. 206 *The Studio*, XXXII, no. 135, London, June 1904, pp. 7–12.

p. 211 "A Foreign Resident," *Society in London*, Chatto and Windus, London, 3rd edn., 1885, pp. 315–17.

p. 212 Whistler 1892, pp. 135–59.

p. 228 *Pall Mall Gazette*, XLI, 21 February 1885, pp. 1–2.

p. 229 R.A.M. Stevenson, *The Magazine of Art*, Vol. 8, 1885, pp. 512–14.

p. 231 Frank Stephen Granger, *Notes on the Psychological Basis of Fine Art*, James Bell, Nottingham, 1887, pp. 76–77.

p. 232 Menpes 1904, pp. 15–26, 29–30.

p. 243 Albert Ludovici, *An Artist's Life in London and Paris 1870–1925*, T.F. Unwin, London, 1926, pp. 74–79, 170–72.

p. 247 *Illustrated London News*, London, 10 December 1887.

p. 248 *St James's Gazette*, London, 16 June 1888.

p. 250 E.R. and J. Pennell, *The Whistler Journal*, Lippincott, Philadelphia, 1921, pp. 165–67.

p. 252 Whistler 1892, pp. 250–58.

p. 255 Whistler 1892, pp. 259–62.

p. 256 *The Pall Mall Gazette*, 2 February 1889.

p. 257 *Mercure de France*, Paris, 1931, pp. 209–10.

p. 257 J.K. Huysmans, *Certains*, Tresse & Stock, Paris, 1889, pp. 63–76.

p. 268 *The Pall Mall Budget*, London, 13 March 1890.

p. 271 *La Justice*, Paris, 1 July 1891.

p. 273 James McNeill Whistler, *Letter to Beatrice Whistler*, unpublished, Whistler W.584, Glasgow University Library, 11 June 1891.

p. 274 Édmond and Jules de Goncourt, *Journal. Mémoires de la Vie Littéraire*, Robert Ricatte (ed.), Éditions de l'Imprimerie Nationale de Monaco, 1956, Vol. XVIII, pp. 52–53.

p. 276 *The Fortnightly Review*, LI, London, April 1892, pp. 543–47.

p. 279 James McNeill Whistler, *Letter to D.C. Thomson*, unpublished, Pennell Collection of Whistler mss., Library of Congress, Washington, D.C., 2 May 1892.

p. 280 Richard Muther, *Letter to Whistler*, unpublished, Whistler M.497, Glasgow University Library, 5 September 1892.

p. 281 George Moore, *Modern Painting*, Walter Scott, London, 1893, pp. 11–15, 20–24.

p. 293 W. Graham Robertson, *Time Was*, Hamish Hamilton, London, 1931, pp. 187–90, 192–201.

p. 299 François Lesure (ed.), *Claude Debussy Lettres 1884–1918*, Hermann, Paris, 1980, p. 83.

p. 300 William Rothenstein, *Men and Memories*, Faber, London, 1931, pp. 110–11, 266–69.

p. 302 C.P. Barbier (ed.), *Mallarmé – Whistler Correspondance*, A.J. Nizet, Paris, 1964, p. 257.

p. 303 Stéphane Mallarmé, *Divagations*, Bibliothèque Charpentier, Paris, 1897, pp. 125–26.

p. 304 *The Studio*, VI, no. 33, December 1895, pp. 219–26.

p. 318 *The St. James's Gazette*, April 1897.

p. 319 Gustav Klimt, *Letter to Whistler*, unpublished, Whistler S.150, Glasgow University Library, 13 December 1897.

p. 320 *The Pall Mall Gazette*, 26 April 1898.

p. 322 James McNeill Whistler, *Letter to Charles Lang Freer*, unpublished, Freer Gallery, Smithsonian Institution, Washington, D.C. (copy Whistler LB 4/33, Glasgow University Library), 29 July 1899.

p. 323 P.H. Emerson, *Naturalistic Photography for Students of the Art* (1899), Arno Press, New York, 1973, pp. 98–99, 176–79.

p. 325 James McNeill Whistler, *Eden versus Whistler. The Baronet and the Butterfly*, Louis-Henry May, Paris, 1899, pp. 76–78.

p. 326 Igor Grabar', *Niva (Literary Supplement)*, Munich, January–April 1897.

p. 329 Pennell 1908, II, pp. 230–38.

p. 342 Pennell 1908, II, pp. 284–86.

p. 344 Pennell 1921, pp. 296–98.

p. 345 *The Athenaeum*, 25 July 1903, pp. 133–34.

p. 347 Arthur Symons, *The Weekly Critical Review: Devoted to Literature, Music and the Fine Arts*, Vol. 2, London, 30 July, 6 and 13 August 1903, pp. 36–37, 59–60, 81–82, reprinted in *Studies in Seven Arts*, Constable, London, 1906, pp. 121–48.

p. 351 *The Metropolitan Magazine*, Vol. 20, no. 6, New York, September 1904, pp. 728–33.

p. 364 Marcel Proust, *Correspondance*, Philip Kolb (ed.), Plon, Paris, 1979, V, pp. 41–42.

p. 365 *The Pacific Era*, Vol. I, no. 2, Detroit, November 1907, pp. 58–62.

p. 367 *The New Age*, Vol. XI, no. 26, London, 24 October 1912, pp. 611–12.

p. 368 Clive Bell, *Art*, Chatto & Windus, London, 1914, pp. 188–91.

p. 369 James Laver, *Whistler*, Faber, London, 1930, pp. 288–94.

p. 372 *The Listener*, London, 8 September 1960, p. 377.

CHRONOLOGY

1834
JULY 11. James Abbott Whistler is born in Lowell, Massachusetts, third son of Major George Washington Whistler, civil engineer, and eldest son of his second wife, Anna Matilda McNeill.

1837
Family moves to Stonington, Connecticut, where Major Whistler is in charge of the construction of a railroad.

1843
SEPTEMBER. Mrs Whistler, her two sons James and William and stepdaughter Deborah, join Major Whistler in St Petersburg where he is working on the St Petersburg–Moscow railway.

1845–46
Whistler attends drawing lessons at the Imperial Academy of Fine Arts in St Petersburg. Gains first place in his class for drawing heads from life.
Visits the Triennial Exhibition of the Academy of Fine Arts.

1847
FEBRUARY. While convalescing from rheumatic fever, he is given a volume of Hogarth's engravings.
OCTOBER. Whistler is groomsman at the wedding in Preston of his half-sister Deborah and Francis Seymour Haden, surgeon and future etcher; afterwards returns to Russia.

1848
JULY. Another attack of rheumatic fever, then visits London, Isle of Wight, and attends a school near Bristol in autumn.

1849
JANUARY. Stays with the Hadens in London.
APRIL 7. Death of Major Whistler. Mrs Whistler and William move to London.
JUNE. Family visit the Royal Academy to see Boxall's portrait of Whistler.
AUGUST. Family goes to live in Pomfret, Connecticut. Both James and William attend school at Christ Church Hall, for two years.

1851
JULY. Whistler enters West Point. He adds to his name his mother's maiden name of McNeill.

1852
Whistler's earliest published work, the title-page of the music sheet *Song of the Graduates* appears.

1854
JUNE 16. Discharged from West Point for deficiency in chemistry, though top of his class in drawing under Robert W. Weir. Works as an apprentice for a few months at Ross Winans' locomotive works in Baltimore.
NOVEMBER. Appointed to drawing division of the United States Coast and Geodetic Survey, Washington, D.C. Etches maps and topographical plans.

1855
FEBRUARY. Resigns from the Coast Survey.
APRIL. Paints his first oil portraits.
NOVEMBER. Studies at the École Impériale et Spéciale de Dessin, Paris.

1856
JUNE. Enters Charles Gleyre's studio and meets Henri Martin, Henri Oulevey, George du Maurier, Poynter and L.M. Lamont. Early patrons are the Greek family Ionides and the American art agent George Lucas. Meets artist Thomas Armstrong.

1857
FEBRUARY. Copies various paintings in the Louvre.
SEPTEMBER. Visits Art Treasures Exhibition in Manchester with Henri Martin and sees work of Velazquez.

1858
AUGUST. On an etching tour of northern France, Luxembourg and the Rhineland with Ernest Delannoy.
OCTOBER. Returns to France and begins printing the "French Set" etchings at Delâtre's in Paris. Meets Fantin-Latour, Legros, Carolus-Duran and Astruc, Bracquemond, Courbet and his followers. Formation of The "Société de Trois" – Fantin, Whistler and Legros.
NOVEMBER. To London where he begins his first important painting, *At the Piano*. The "French Set" of etchings is published in London at Haden's.

1859
APRIL–MAY. Two etchings are accepted for the Salon, but *At the Piano* is rejected and exhibited in François Bonvin's studio where it is praised by Courbet.
Moves to London, staying with the Hadens and in rooms in Wapping. Begins the "Thames Set" etchings. Two etchings are exhibited at the R.A.

1860
MAY. *At the Piano* is praised at the R.A. and bought by John Phillip, R.A. Shares studio with Du Maurier.
AUTUMN–WINTER. Paints *Wapping* which includes the figure of Joanna Hiffernan who is to become his mistress and principal model. Paints *The Thames in Ice* in three days.

1861
MAY. *La Mère Gérard [Old Mother Gérard]* and three etchings are exhibited at the R.A.
SUMMER. Ill with rheumatic fever in London. Probably meets Manet for the first time in Paris. Paints his first major seascape, *The Coast of Brittany*, whilst in Brittany.
WINTER. In Paris, painting *The White Girl*, later called *Symphony in White, No. 1: The White Girl*.

1862
JANUARY. Thames etchings exhibited at Martinet's gallery in Paris and praised by Baudelaire.
MAY. *The White Girl* rejected but *The Coast of Brittany, Thames in Ice* and one etching, *Rotherhithe*, accepted and well received at the R.A.
JULY. Writes his first letter to the press, published in the *Athenaeum*, about *The White Girl*, then on exhibition at Morgan's Gallery, Berners Street. Meets D.G. Rossetti and Swinburne.
OCTOBER. Paints seascapes at Guéthary, Basses-Pyrénées.

1863
MARCH. Moves to 7 Lindsey Row in Chelsea near Rossetti. Meets other members of the Pre-Raphaelite circle; the Greaves brothers, Chelsea boat builders who begin to work as his pupils;

and probably the architect Edward W. Godwin. Visits Paris with Swinburne and introduces him to Manet.

APRIL. *The White Girl*, rejected by the Salon, is one of the most controversial pictures at the Salon des Refusés.

MAY–JUNE. *The Last of Old Westminster* is exhibited at the R.A. Whistler's etchings exhibited at The Hague win a gold medal. Visits Amsterdam with Alphonse Legros and Haden.

In Paris to see the Salon des Refusés.

WINTER. Whistler's mother comes to London in order to live with him.

Concentrates on Oriental subject pictures incorporating his own china, fans and other accessories, including *Purple and Rose: The Lange Leizen of the Six Marks*.

1864

FEBRUARY. Working on *Variations in Flesh Colour and Green: The Balcony* at Lindsey Row. Poses with Manet, Baudelaire and others for Fantin's *Hommage à Delacroix*.

MAY. *Wapping* and *The Lange Leizen* are exhibited at the R.A.

WINTER. Mrs Whistler is sent to Torquay for her health. Jo Hiffernan sits for *The Little White Girl* and *The Golden Screen*.

1865

APRIL–MAY. His brother, Dr William Whistler, comes to live in London. In Paris, Whistler poses for Fantin's *Hommage à la Vérité: Le Toast*, exhibited at the Salon with Whistler's *Rose and Silver: The Princess from the Land of Porcelain*.

Symphony in White, No. 2: The Little White Girl and *Brown and Silver: Old Battersea Bridge* are exhibited at the R.A. with two Oriental compositions. Whistler meets Albert Moore. Later in the year Moore replaces Legros as the third member of their "Société de Trois."

OCTOBER–NOVEMBER. Joins Jo Hiffernan and Courbet at Trouville. Paints several seascapes including *Sea and Rain*.

1866

JANUARY–MARCH–SEPTEMBER. Makes a will in Jo's favour and gives her the powers to manage his affairs while he travels to South America. Paints a number of seascapes, including his first night scenes, in Valparaiso, where he witnesses the Chilean war of liberation against Spain. After his return to England, parts amicably from Jo.

1867

FEBRUARY. Moves to 2 Lindsey Row (96 Cheyne Walk).

APRIL. Whistler accuses Seymour Haden of disrespect towards his late partner, Dr Traer, and violently assaults Haden in Paris. The Whistler brothers arrange Traer's burial rites in Paris. Haden and Whistler are never to speak again and it is some time before Whistler communicates again with his half-sister Deborah.

MAY. Exhibits three paintings at the R.A. including *Symphony in White, No. 3*; two at the Salon and four at the Paris Universal Exhibition including *Crepuscule in Flesh Colour and Green: Valparaiso*.

SEPTEMBER. Writes to Fantin-Latour rejecting Courbet's realism, and wishing he could have studied under Ingres. Makes numerous studies of classically draped figures relating to the "Six Projects."

DECEMBER. Expelled from the Burlington Fine Art Club as a result of the Haden affair. D.G. and W.M. Rossetti leave with him to show their support.

1868

JULY. W.M. Rossetti sees the "Six Projects."

DECEMBER. Working on *The White Symphony: The Three Girls* in a studio in Great Russell Street.

1869

Returns to Lindsey Row. Attempts to borrow money from his half-brother George, and from Thomas Winans, to repay £400 advanced on *The Three Girls* by the Liverpool shipowner F.R. Leyland. Leyland, a patron for several years, commissions him to paint all his family. Visits Leyland's home at Speke Hall.

1870

MAY. Exhibits *The Balcony* at the R.A.

JUNE 10. Birth of Charles Whistler Hanson, child of Whistler and Louisa Hanson, a parlourmaid.

1871

SPRING. Publishes *Sixteen Etchings of Scenes on the Thames* and begins to paint a succession of Thames Nocturnes—first called "Moonlights."

SUMMER. Paints the portrait of his mother, *Arrangement in Grey and Black*.

WINTER. Begins the portrait of Mrs Leyland at Speke Hall.

Begins to exhibit work in small London dealers' exhibitions, including Durand-Ruel's gallery, the Society of French Artists, and takes great interest in the framing and presentation of his work.

1872

FEBRUARY. At Speke Hall becomes engaged, briefly, to Mrs Leyland's sister Elizabeth Dawson.

MAY. *Arrangement in Grey and Black: Portrait of the Painter's Mother* is admitted to the R.A. after Sir William Boxall threatens to resign if it is rejected. It is to be the last picture shown by Whistler at the R.A. Commissioned to paint portrait of Cicely Alexander, daughter of the banker W.C. Alexander.

NOVEMBER. In the exhibition at the Dudley Gallery in London Whistler uses the word "Nocturne" for the first time to describe his pictures.

1873

JANUARY. Exhibits his self-portrait and pictures of the Thames at Durand-Ruel's in Paris. Works on decorative schemes for W.C. Alexander at Aubrey House. Begins to give dinner parties and initiates his midday "Sunday breakfasts."

JULY. Painting the portrait of Thomas Carlyle.

WINTER. Finishes the portrait of F.R. Leyland in evening dress. Maud Franklin, who has taken Jo's place as Whistler's mistress and chief model, stands for the final drapery studies in the portrait of Mrs Leyland, *Symphony in Flesh Colour and Pink*.

1874

JUNE. Holds his first one-man exhibition, in the Flemish Gallery, Pall Mall, where, among oils, drawings, etchings and one painted screen, portraits of Carlyle, Mrs Huth, Miss Cicely Alexander and Mr and Mrs Leyland are first exhibited.

1875

AUGUST. Mrs Whistler retires to Hastings.

SEPTEMBER. Painting Nocturnes of Cremorne Gardens in Chelsea of which the most important, *Nocturne in Black and Gold: The Falling Rocket* exhibited at the Dudley Gallery in November.

1876

SEPTEMBER. Working on the decoration of the dining-room of Leyland's London house, 49 Princes Gate, in a peacock design.

1877

FEBRUARY 9. Newspaper critics visit the completed Peacock Room, which Whistler has called *Harmony in Blue and Gold*. Leyland had commissioned Whistler only to retouch some details, and annoyed by the publicity, only pays half the 2,000

guineas Whistler expects.

APRIL 17. His brother William marries Helen Ionides.

MAY. At the newly opened Grosvenor Gallery Whistler exhibits eight paintings including the most controversial of his pictures *Nocturne in Black and Gold: The Falling Rocket*.

JULY. He sues Ruskin for libel in respect of his criticism of the painting.

SEPTEMBER. Commissions E.W. Godwin to build the White House in Tite Street, to be large enough for him to open an atelier.

1878

MARCH–APRIL. Exhibits *The Coast of Brittany* at the first exhibition of the Society of American Artists in New York, and contributes regularly to their later exhibitions.

MAY–JUNE. Exhibits seven paintings at the Grosvenor Gallery including a portrait of Maud, *Arrangement in White and Black*, and *Nocturne: Grey and Gold—Chelsea Snow*. In an article in *The World* on May 22 Whistler proclaims his aesthetic theories.

An exhibition stand designed by Whistler and Godwin is shown at the Paris Universal Exhibition.

Moves to the White House.

JULY. The London printer Thomas Way teaches Whistler the principles of lithography.

Visits Disraeli at Beaconsfield but his portrait is never painted.

SEPTEMBER. Finishes portrait of Rosa Corder for C.A. Howell.

NOVEMBER. Awarded a farthing's damages without costs in his libel action against Ruskin, and finds himself in desperate financial straits.

DECEMBER. Publishes *Whistler v. Ruskin: Art and Art Critics*, dedicated to Albert Moore, the first of a series of pamphlets bound in brown paper.

1879

FEBRUARY 2. Maud has a child, Maud McNeill Whistler Franklin.

MAY. Exhibits *Arrangement in Brown and Black: Portrait of Miss Rosa Corder* and *Harmony in Yellow and Gold: The Gold Girl— Connie Gilchrist* at the Grosvenor Gallery. Meets Walter Sickert who is later to become Whistler's pupil and assistant.

MAY 7. Auction sale of Whistler's paintings, etchings, drawings, Nankin porcelain, Japanese items, and household effects held at the White House. Declared bankrupt on May 8. Bailiffs take possession of the White House.

JUNE. Creditors appoint a committee of examiners composed of Whistler's chief creditors—Leyland, Howell and Thomas Way. Whistler destroys many pictures to prevent their falling into the hands of the bailiffs. His friends, including Howell and Way, acquire paintings, some of which are later returned to Whistler.

SEPTEMBER. Leaves for Venice with Maud Franklin, and a commission from The Fine Art Society for twelve etchings. The White House is sold to the art critic Harry Quilter for £2,700.

1880

FEBRUARY. Sale of Whistler's effects at Sotheby's.

SUMMER. Meets Otto Bacher and others in Venice.

NOVEMBER–DECEMBER. Returns to London and stays with his brother until he finds lodgings. Introduced to Duret by Manet.

Exhibits the twelve "Etchings of Venice" at the Fine Art Society Gallery.

1881

JANUARY 29. Private view of fifty-three Venice pastels at The Fine Art Society.

JANUARY 31. Whistler's mother dies at Hastings. Whistler paints seascapes in Jersey and Guernsey, possibly in February.

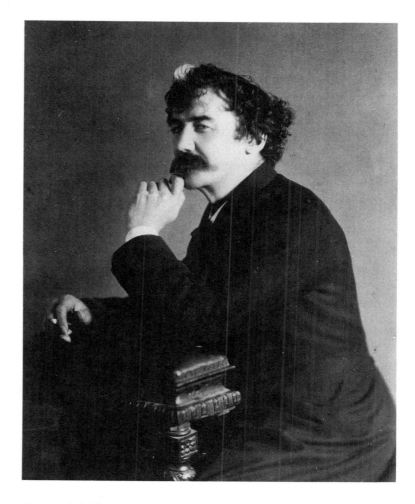

James McNeill Whistler. December 1878. Photograph by the London Stereoscopic Company. Whistler Collections, Glasgow University Library.

MARCH 22. Leases flat and studio at 13 Tite Street.

MAY. Exhibits *Harmony in Grey and Green: Miss Cicely Alexander* at the Grosvenor Gallery. A quarrel with the Society of Painter–Etchers, which had mistaken etchings of Venice by Frank Duveneck for Whistler's, results in the publication of *The Piker Papers*.

AUGUST 26. Alan Cole sees Whistler at work on three portraits of Lady Meux. Whistler becomes friendly with Oscar Wilde.

1882

Working on a number of portraits including three of Lady Archibald Campbell.

MAY. Portrait of Lady Meux and three Venice etchings are exhibited at the Salon; seven paintings are exhibited at the Grosvenor Gallery.

JUNE. Walter Sickert leaves the Slade School of Art to become Whistler's pupil and assistant.

1883

FEBRUARY 17. Private view of fifty-one etchings, mostly of Venice, at The Fine Art Society. Each catalogue entry is followed by a quotation from earlier criticisms.

MAY 7. Whistler in Paris. At the Salon the portrait of his mother is awarded a third-class medal, and enthusiastically reviewed by Théodore Duret, whose portrait Whistler also paints. Paintings exhibited at the Galerie Georges Petit include Whistler's self-portrait. He exhibits Nocturnes there and, in London, at the Grosvenor Gallery.

SUMMER. Painting oils and watercolours in Holland.

1884

JANUARY. At St Ives, Cornwall, with his pupils Mortimer Menpes and W.R. Sickert. Painting small seascapes in oil and watercolour.

JANUARY—FEBRUARY. First exhibition of the Société des XX, Brussels, includes four paintings by Whistler and Venice etchings. Whistler spends some time in Holland around Dordrecht painting and etching.

MAY. Exhibits his portraits of Cicely Alexander and Carlyle at the Salon, and a newly completed portrait of Lady Archibald Campbell a the Grosvenor Gallery.

MAY 17. Opening of one-man exhibition, "Notes"— "Harmonies"—"Nocturnes", at Dowdeswell's.

JULY 13. Meets Joseph Pennell, his future biographer.

OCTOBER 11. Leases studio at 454A Fulham Road, and works on the portraits of Duret and Beatrice Godwin.

NOVEMBER 21. Elected member of the Society of British Artists; shows regularly at its summer and winter exhibitions.

DECEMBER 1. Opening of exhibition of Dublin Sketching Club, which includes twenty-six paintings by Whistler, mostly watercolours.

1885

FEBRUARY 20. Delivers the "Ten O'Clock" lecture in Princes Hall; repeats it elsewhere on several occasions that year.

MAY. Portraits of Lady Archibald Campbell and Duret are exhibited at the Salon.

SUMMER. Sends his portrait of Sarasate and seven small seascapes of Holland and northern France to the S.B.A. Whistler and Maud Franklin are living in The Vale, Chelsea.

Goes to Belgium and Holland with the American artist William Merritt Chase, visiting Haarlem and the International Exhibition in Amsterdam.

SEPTEMBER. Painting the portrait of Lady Colin Campbell— exhibited in an unfinished state at the S.B.A. winter exhibition, and never finished.

Staying with W.R. Sickert; in December paints portraits of Mrs Sickert and later of W.R. Sickert.

1886

APRIL. Set of Twenty-Six Etchings of Venice are issued by Dowdeswells' in London.

MAY. Second one-man exhibition, "Notes"—"Harmonies"— "Nocturnes", at Dowdeswells'. Exhibits the portrait of Sarasate at the Paris Salon and in Brussels.

JUNE 1. Elected president of the S.B.A.

AUGUST 22-3. Paints portrait of George A. Lucas in France.

OCTOBER 6. Death of E.W. Godwin. Whistler ensures that suitable obituaries appear in the London papers. Continues the portrait of Godwin's widow Beatrice which is sent to the S.B.A. winter exhibition.

1887

MAY. Oils, watercolours and pastels are exhibited at the Galerie Georges Petit in Paris, including recent panels of Dieppe and a portrait of Maud Franklin—possibly Whistler's last portrait of her.

JUNE—JULY. Notes, a set of six lithographs, are published in London by Boussod, Valadon & Cie.

Whistler sends Queen Victoria an illuminated Address on behalf of the S.B.A. on the occasion of her Jubilee. A series of twelve etchings done at the Naval Review at Spithead is also presented. The Society receives a Royal Charter thus becoming the Royal Society of British Artists (R.B.A.).

AUTUMN. Visits Holland and Belgium with Dr and Mrs Whistler, stopping at Brussels, Ostend and Bruges.

1888

FEBRUARY 1. Opening of Société des XX exhibition in Brussels. Whistler exhibits oils and pastels, with recent etchings of the East End of London.

MARCH—APRIL. Starts to collect silver. Designs a lion emblem for the R.B.A.

Patents his design for a velarium for use in exhibitions. To improve the standard of the R.B.A. Whistler has the galleries redecorated and hangs exhibitions more spaciously. Many members object to his policy.

MAY. Exhibits Nocturnes, etchings and drawings at the Galerie Durand-Ruel in Paris, with The Fur Jacket.

JUNE. At the first exhibition of the New English Art Club Whistler shows an early oil and a recent etching of Brussels.

Resigns as president of the R.B.A. Menpes, Sickert, Alfred Stevens, Théodore Roussel and others also resign.

His son Charles Hanson comes bottom of his class at King's College in London; he acts as Whistler's secretary until he has completed his course in engineering. Whistler supports him and helps him to find a job.

In Paris, Monet introduces Whistler to Stéphane Mallarmé who agrees to translate the "Ten O'Clock" lecture into French.

Moves to the Tower House, Tite Street.

JULY. At the invitation of the organizing committee sends oils and a group of watercolours, pastels and etchings to the third Internationale Kunst-Ausstellung in Munich. He is awarded a second-class medal and thanks the committee for the "second-hand compliment".

AUGUST 11. Marries Beatrice Godwin, widow of E.W. Godwin.

The couple spend a working honeymoon travelling in France, to Boulogne, Paris, Chartres, down the Eure and Loire to Tours in September, and then to Loches, returning at the beginning of November.

NOVEMBER 3. Elected honorary member of the Royal Academy of Fine Arts in Munich.

1889

MARCH. Big exhibition of his oils, watercolours and pastels held at Wunderlich's in New York.

APRIL 28. Banquet for Whistler in Paris is followed by a dinner in London to celebrate the award of a first-class medal at Munich and the Cross of St Michael of Bavaria.

MAY. Retrospective exhibition in the College for Working Men and Women, London, inefficiently organized by Sickert, including recent shop-fronts and major portraits. Exhibits the portrait of Lady Archibald Campbell and The Balcony at the Paris Universal Exhibition, and is awarded a gold medal.

SEPTEMBER 4. Makes a set of ten etchings in Amsterdam and paints at least two oils. Is awarded a gold medal at the International Exhibition in Amsterdam where he exhibits the portrait of his mother, The Fur Jacket and Effie Deans. Is made a Chevalier of the Légion d'Honneur.

1890

FEBRUARY. Moves to 21 Cheyne Walk. Unauthorized selection of The Gentle Art of Making Enemies is edited by Sheridan Ford and published in Ghent.

MARCH. Meets C.L. Freer of Detroit, who forms a major collection of Whistler's work.

MAY. Exhibits two Nocturnes at the Paris Salon and several paintings at the Brussels Salon, including The Fur Jacket which Whistler hopes to sell there.

JUNE. Whistler's version of The Gentle Art appears, published by William Heinemann in London.

1891

FEBRUARY 13. Commissioned to paint portrait of Comte Robert de Montesquiou-Fezensac.

APRIL 2. The Corporation of Glasgow buys the portrait of Carlyle for 1,000 guineas. This is the first of Whistler's pictures to be bought for a public collection.

MAY 15. Sends two paintings to the first exhibition of the Société Nationale des Beaux-Arts, Champs de Mars. Whistler stops exhibiting at the Salon. Spends the summer in Paris working on lithographs—"Songs on Stone."

AUGUST. On hanging committee of autumn exhibition at Walker Art Gallery, Liverpool.

NOVEMBER 2. Whistler's portrait of his mother is bought for the Musée du Luxembourg for 4,000 francs, largely through the efforts of Mallarmé, Duret and Roger Marx.

1892

JANUARY. Is made an Officier of the Légion d'Honneur.

MARCH—MAY. Important retrospective exhibition, *Nocturnes, Marines & Chevalet Pieces*, at the Goupil Gallery in London.

Working on lithograph of Mallarmé for frontispiece of *Vers et Prose*. Exhibits six paintings at the World's Columbian Exposition in Chicago and is awarded a gold medal.

Exhibits a portrait of Lady Meux and five Nocturnes with the Société Nationale des Beaux-Arts.

JUNE. At the sixth Internationale Kunst-Ausstellung in Munich, is awarded a first-class gold medal for *The Fur Jacket*. The committee of the Munich Pinakothek tries unsuccessfully to buy *The Little White Girl* from its owner.

SEPTEMBER. Moves to a house at 110 rue du Bac, Paris.

1893

MAY—JUNE. Paints small portraits in Paris, including those of the New York dealer Edward G. Kennedy of Wunderlich's and the Edinburgh collector J.J. Cowan.

SUMMER. Prints etchings with Pennell. Meets Aubrey Beardsley.

The Whistlers visit Brittany. He does some etchings and paints two large seascapes and a panel "out in the full sea."

DECEMBER 18. Sixty-third exhibition of the Pennsylvania Academy of the Fine Arts includes *The Lady in the Yellow Buskin*. It is bought for the Wilstach Collection in 1894, the first work bought for an American public collection.

1894

JANUARY 9. Lady Eden starts to pose in Paris for a small full-length portrait.

MARCH—MAY. Instalments of George du Maurier's novel *Trilby* appear in *Harper's Magazine*.

Whistler's portrait of Sarasate is his main contribution to international exhibitions in Hamburg and Antwerp.

Paints several portraits of his sister-in-law Ethel Philip.

Exhibits recent seascapes and portraits of Mrs Sickert, Montesquiou and Lady Eden at the Société Nationale des Beaux-Arts.

NOVEMBER 23–DECEMBER. C.L. Freer buys *Harmony in Blue and Gold: The Blue Girl*, the first of a series of nude studies.

Is awarded Temple Gold Medal at sixty-fourth annual exhibition of the Pennsylvania Academy of the Fine Arts. Mrs Whistler becomes ill. Whistler works in W.R. Sickert's studio at 13 Robert Street until March 1895, and paints several portraits.

1895

MARCH. Sir William Eden brings an action against Whistler for not handing over the portrait of Lady Eden. Judgment goes against Whistler but this is reversed upon appeal.

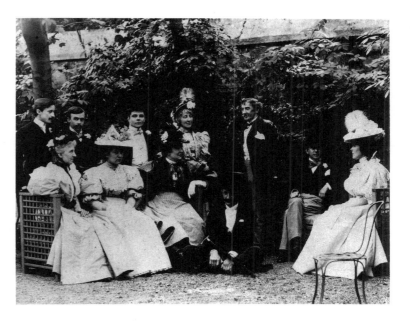

Wedding of Ethel Philip and Charles Whibley, in the garden of 110 Rue du Bac, Paris. July 1895. Whistler is centre right. Whistler Collections, Glasgow University Library.

APRIL. Wins honours at Venice Esposizione Internazionale and gold medal at Antwerp.

JUNE. Painting a self-portrait in the pose of Velazquez's *Pablo de Valladolid*, in Paris.

SEPTEMBER. Working on etchings, lithographs and paintings, including *The Little Rose of Lyme Regis* in Dorset.

DECEMBER. Exhibition of seventy-five lithographs at The Fine Art Society.

1896

Publication of first *catalogue raisonné* of Whistler's lithographs by Thomas Way.

JANUARY—MARCH. Mrs Whistler is very ill. Whistler working on lithographic portraits and views of the Thames.

J.S. Sargent lends Whistler his studio. Takes studio in Fitzroy Street. The Whistlers move to St Jude's Cottage on Hampstead Heath.

MAY 10. Death of Mrs Whistler. For a while Whistler makes his home with William Heinemann. He adopts his sister-in-law Rosalind Birnie Philip as his ward, and makes her his executrix.

JULY—SEPTEMBER. Goes with his American dealer and friend E.G. Kennedy to Honfleur. Spends two weeks painting around Dieppe and Calais.

OCTOBER. Sickert fails to apologize to Whistler for associating with Sir William Eden and they become estranged.

NOVEMBER. Opening of first annual exhibition at Carnegie Institute, Pittsburgh, including the portrait of Sarasate, which is bought by the Institute.

1897

APRIL. Negotiates the lease of 2 Hinde Street, Manchester Square as premises for The Company of the Butterfly, formed to sell Whistler's work.

Whistler supports Pennell in his successful libel action against Sickert.

MAY. Exhibits three oils at the Société Nationale des Beaux-Arts including a small panel of the late C.E. Holloway.

Paints several portraits including that of George W. Vanderbilt.

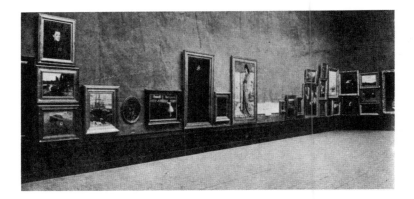

Photograph of the First International Exhibition at Knightsbridge. 1898. Centre group of works arranged by Whistler. Pennell Collection, Library of Congress, Washington, D.C.

JULY. In Dieppe with Pennell and E.G. Kennedy. He joins the Birnie Philips in Etretat, and the Pennells begin a journal about their relations with him. Returns to Paris September.

OCTOBER. Visits Valvins, and paints Mallarmé's daughter Geneviève.

DECEMBER. Vanderbilt sits for Whistler.

Whistler's appeal in the case with Sir William Eden is heard in Paris. This time the verdict goes in Whistler's favour and he is allowed to keep the portrait of Lady Eden provided it is made unrecognizable.

1898

FEBRUARY. Whistler has a "Phryne—a Danae—an Eve—an Odalisque—and a Bathsheba" in his studio in Paris. He is working on portraits of himself and Miss Birnie Philip but his health is poor.

He is unanimously elected chairman of the executive council of the International Society of Sculptors, Painters and Gravers.

APRIL. Elected president of the International Society. Attends the opening of the first exhibition which includes works by Rodin, Monet, Manet, Sisley, Toulouse-Lautrec, Bonnard, Vuillard and several German and Scottish artists. He exhibits several oils including a self-portrait and also three etchings by his wife.

SEPTEMBER. Death of Mallarmé. Whistler is ill himself in London and is very upset.

OCTOBER. He returns to Paris. Opening of Académie Carmen. Whistler undertakes to visit it with the American sculptor F. MacMonnies.

1899

JANUARY. Exhibits on Diaghilev's invitation at the first World of Art Exhibition at St Petersburg. Some of his pictures are later bought by the Russian collector Sergei Shchukin.

MARCH. Visits Italy for the marriage of William Heinemann at Porto d'Anzio, and visits galleries in Rome and Florence.

MAY. Opening of second International Exhibition or "Art Congress" in Knightsbridge. Whistler exhibits six oils including *Rose and Gold: The Little Lady Sophie of Soho* with four drawings and there is a special show of his etchings.

His account of the Eden case, *Eden versus Whistler: The Baronet and the Butterfly*, is published in Paris.

JUNE—JULY. Mrs Vanderbilt sits for her portrait in Paris.

Articles Miss Inez Bate (Mrs Clifford Addams), one of the first students at the Académie Carmen, as his legal apprentice. Suffers from recurrent illness. Convalesces at Pavillon-Madelaine, Pourville-sur-Mer near Dieppe with the Birnie Philips.

1900

FEBRUARY. Death of his brother, William. The *British Medical Journal* reproduces Whistler's lithograph *The Doctor—Portrait of my Brother* as frontispiece of his obituary.

APRIL—MAY. In Paris, where in May at the request of the American Commissioner he shows *The Little White Girl*, a self-portrait and a portrait of Ethel Whibley, *The Andalusian*, at the Universal Exhibition; is awarded a Grand Prix for his paintings and another for etchings. After the exhibition he rubs down the self-portrait and never completes it to his satisfaction.

Heinemann asks the Pennells to write the authorized life of Whistler.

AUGUST. Visits Holland and then joins the Birnie Philips near Dublin for three weeks

OCTOBER. In its third and final year the Académie Carmen is opened by Mrs Addams with a life-class for women only. Whistler is in Paris at the end of October, but he rarely visits the Académie and it is finally closed on April 6 1901.

Back in London, works on a portrait of Mrs Heinemann.

DECEMBER. He is very ill in Marseilles and then sails for Corsica. Does many sketches, several etchings and a few paintings.

1901

APRIL. Exhibits seven small paintings and pastels at the International Exhibition of Sculptors, Painters and Gravers. In Buffalo and Dresden he is awarded gold medals and in Paris is elected honorary member of the Académie des Beaux Arts.

OCTOBER. Closes the studio in Paris and sells 11 rue du Bac.

DECEMBER. Convalesces in Bath with the Birnie Philips.

1902

JANUARY—APRIL. Is awarded the Gold Medal of Honor at Pennsylvania Academy of The Fine Arts.

Meets Richard A. Canfield who buys many of his late works and sits during the next year for his portrait.

Leases 72 Cheyne Walk from the architect C.R. Ashbee and lives there with the Birnie Philips.

MAY—JUNE. Five paintings are exhibited at the Société Nationale des Beaux-Arts. C.L. Freer sits to Whistler.

Carmen Rossi, who for months had taken work from Whistler's studio and sold it in Paris and Rome, agrees to sell one portrait back to him. He refuses to prosecute her.

JULY—AUGUST. While on holiday with Freer in The Hague, Whistler becomes seriously ill. Convalescent, he writes to the *Morning Post* to congratulate them on the premature obituary they had published. Visits Scheveningen, the Mauritshuis and galleries at Haarlem.

SEPTEMBER. Returns to London, paints portraits of Rosalind Birnie Philip and his model Dorothy Seton. Vanderbilt tries to arrange sittings for his portrait but neither it nor that of Freer is completed.

1903

APRIL. Receives honorary degree of Doctor of Laws from the University of Glasgow but is too ill to attend the ceremony.

JULY 17. Death of Whistler. He is buried in Chiswick Cemetery. His pallbearers are Théodore Duret, Sir James Guthrie, John Lavery, Edwin A. Abbey, G. Vanderbilt and C.L. Freer.

1904

Memorial exhibition of his work in Boston, Copley Society.

1905

About 750 works are exhibited at the memorial exhibition, *Paintings, Drawings, Etchings and Lithographs,* by the International Society in London and about 440 in the École des Beaux-Arts, *Oeuvres de James McNeill Whistler,* in Paris.

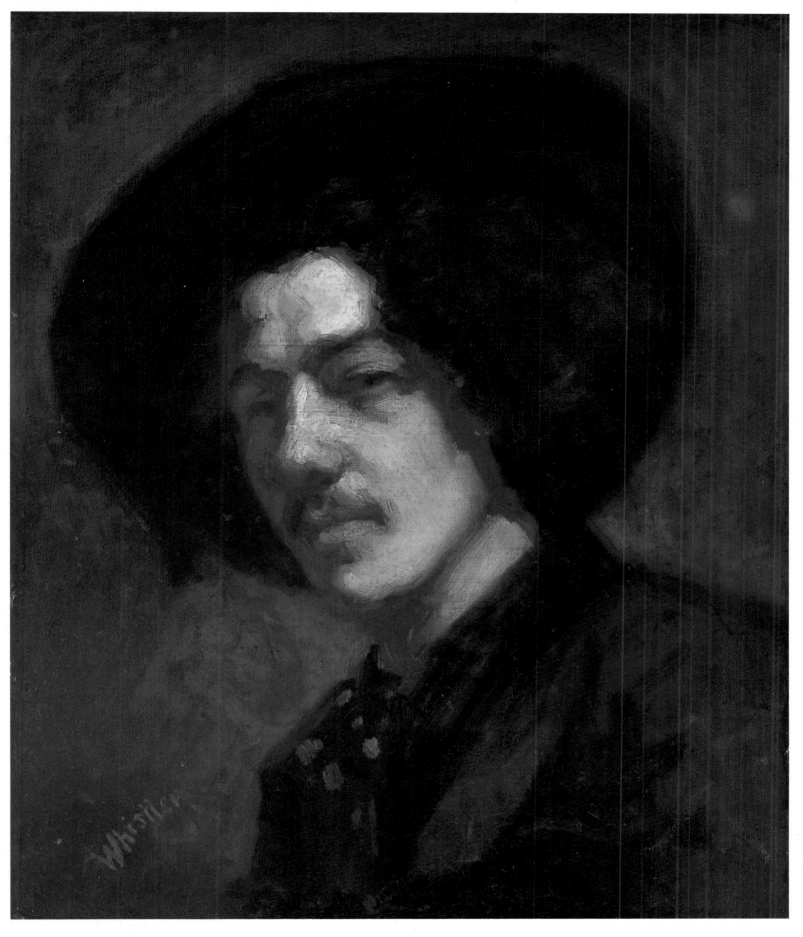

COLOURPLATE 1. *Portrait of Whistler with Hat*. 1857/58. 18¼ × 15″ (46.3 × 38.1 cm).
Freer Gallery of Art, Smithsonian Institution, Washington, D.C.

COLOURPLATE 2. *A Fire at Pomfret. c.* 1850. Watercolour on brown paper, 5⅛ × 7¾″ (12.8 × 19.6 cm). Freer Gallery of Art, Smithsonian Institution, Washington, D.C.

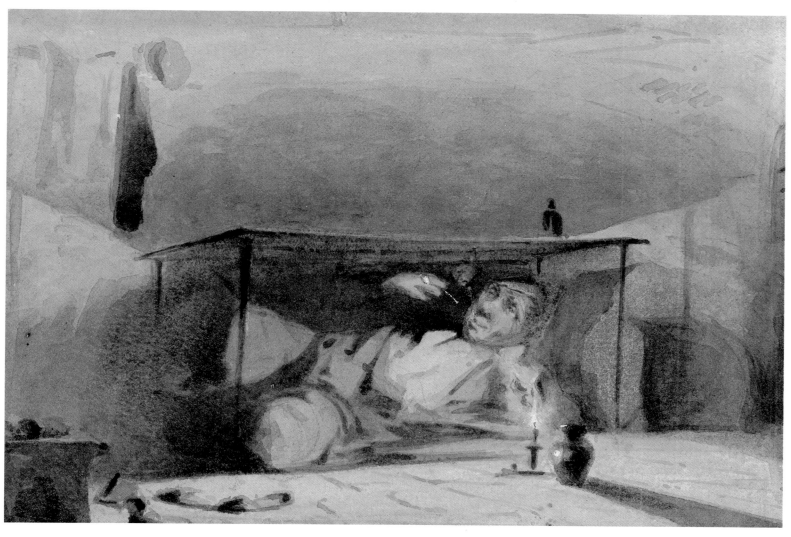

COLOURPLATE 3. *The Cobbler*. 1854-55. Watercolour, 4⅛ × 5⅞″ (10.4 × 14.9 cm).
Freer Gallery of Art, Smithsonian Institution, Washington, D.C.

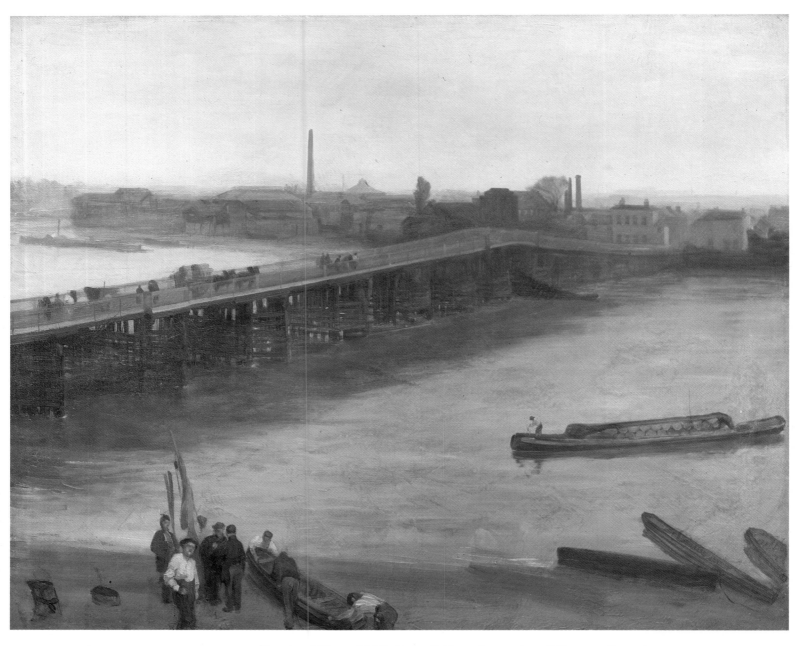

COLOURPLATE 4. *Brown and Silver: Old Battersea Bridge.* 1859. 25 × 30″ (63.5 × 76.2 cm).
Addison Gallery of American Art, Phillips Academy, Andover, Massachusetts.

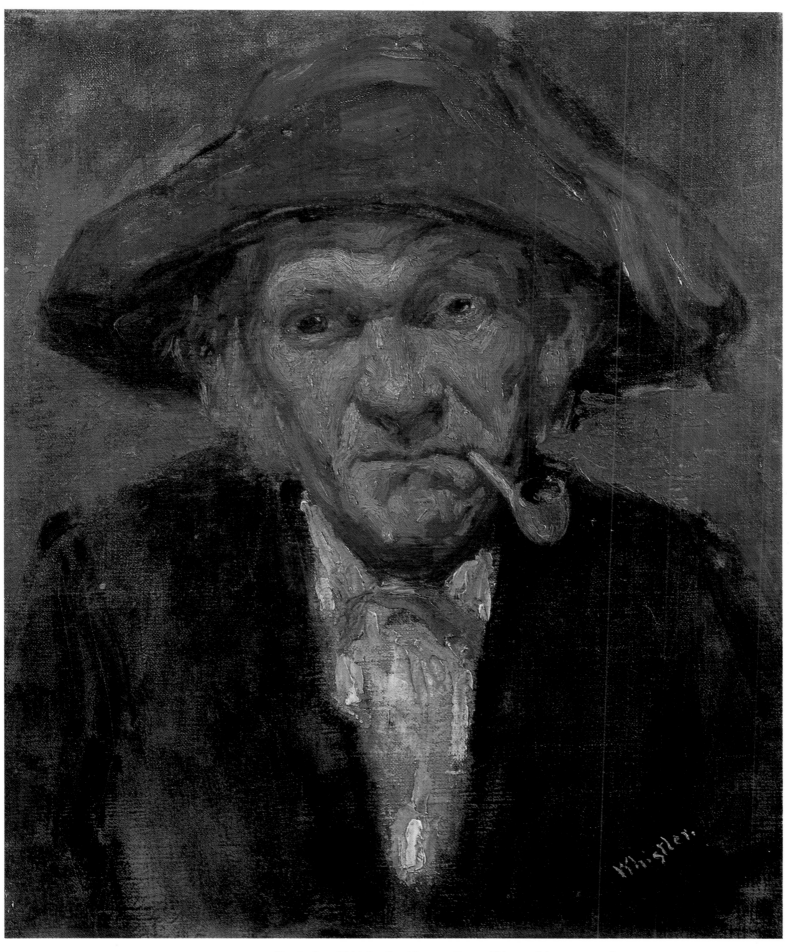

COLOURPLATE 5. *Head of an Old Man Smoking*. c. 1859. 16¼ × 13″ (41 × 33 cm).
Musée du Louvre, Paris.

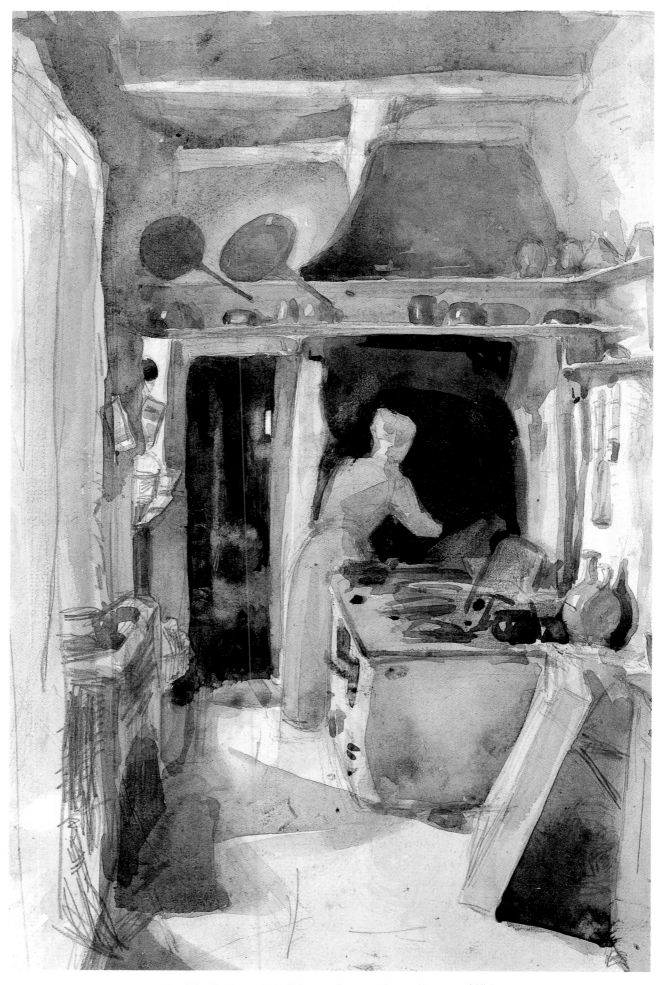

COLOURPLATE 6. *The Kitchen*. 1858. Watercolour and pencil, 12 × 7¾″ (30.4 × 19.7 cm).
Freer Gallery of Art, Smithsonian Institution, Washington, D.C.

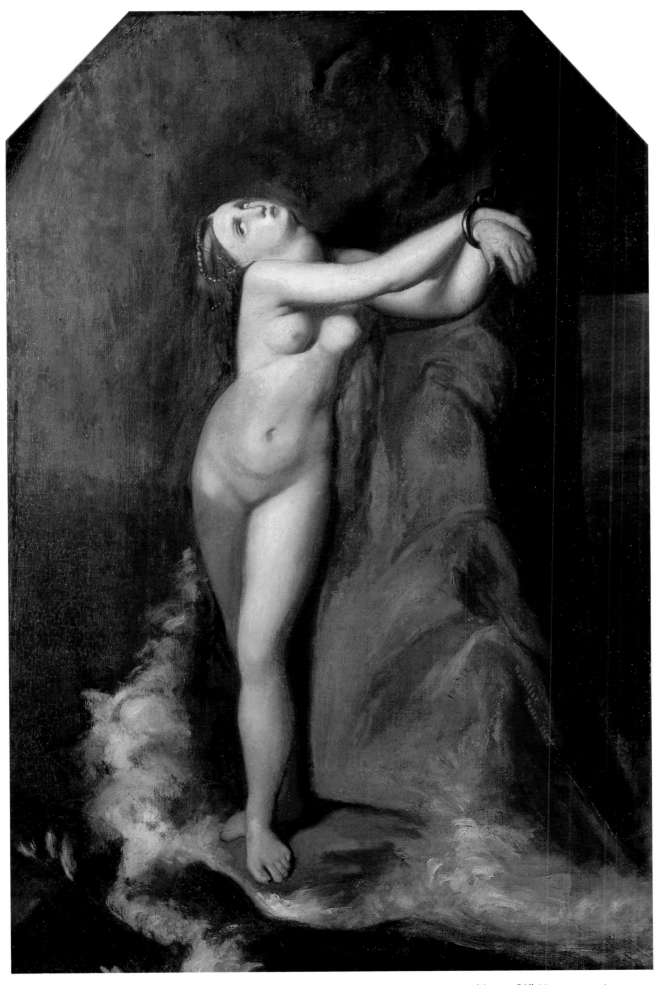

COLOURPLATE 7. Copy after Ingres's *Roger rescuing Angélique*. 1857. 32¼ × 20⅞″ (82 × 53 cm).
Hunterian Art Gallery, Glasgow University.

COLOURPLATE 8. *Old Mother Gérard* (I). 1858-59. 12 × 8⅝″ (30.5 × 22.5 cm).
Private Collection, U.S.A.

INTRODUCTION

By the end of the third week of February 1905, one and a half years after Whistler's death, 25,000 people, including King Edward VII and Queen Alexandra, had visited his Memorial Exhibition at the New Gallery, Regent Street. It had been organized by the International Society of Sculptors, Painters and Gravers, the Art Congress Whistler had founded in 1898 as London's answer to the Secessionist movements which sprang up in other European capitals in the closing years of the century. The exhibition was opened by Rodin, Whistler's successor as President of the International Society. In Paris, similar numbers were drawn to the Memorial Exhibition at the École des Beaux Arts in the same year. One year before, a watercolour by Whistler, *Waiting for the Fishing Boats*, 8½ × 5″ (21 × 13 cm), was sold at Christie's for proportionally as much as a famous watercolour by Turner (*The White Haven*) in the same sale. Several oil paintings changed hands for between five and ten times their 1877 equivalent of 200 guineas which John Ruskin had accused Whistler of asking "for flinging a pot of paint in the public's face." While the Detroit collector Charles Lang Freer was willing to pay thousands for major works, to form the largest single collection of Whistler's art in America, the paintings of a well-known Royal Academician of the Victorian ara, Frederick Goodall, were being sold, also at Christie's (in 1905), for an average of six shillings each. Among the laudatory columns of newsprint claiming Whistler as "one of the greatest artists the world has seen," "the 'coxcomb' who defeated Ruskin," "the fighter . . . who supported the fight for true art," the critic of *Art and Artists* on 28 February 1905 sounded a warning note:

> But, in this hour of triumph, there are certain things to regret, and the greatest cause for regret [is] . . . the unfortunate condition into which many of the pictures are falling. Never again in this country can such a collection of works be gathered together. But, if they were gathered together twenty-five years hence, I fear that many of them would be but ghosts and shadows and wrecks of themselves . . . unless some method can be devised for preserving some of the most beautiful of his pictures, posterity may have to take our word for it.

For well over half a century Whistler's oil paintings have been a trial for conservators, museums and art dealers. This alone makes difficult an appreciation of his painting. But it has been made doubly so by Whistler himself, who saw a very different role and purpose for art, and one quite out of step with the modernism to which we have become accustomed today. Within only a few years of his death, the *avant-garde* he represented was replaced by one entirely at odds with his updated version of the European tradition. Faced with the claims put forward by the critic Roger Fry for the radical new art of Cézanne and the Post-Impressionists (which owed not a little to Whistler's campaign against the atrophied narrative tradition of Victorian art), Walter Sickert made an explicit repudiation of his one-time master. "Whistler has filled in England for the last twenty years or so a disproportionate space in the artistic horizon," Sickert, Whistler's first pupil to become a major artist, and inheritor of the mantle of the *avant-garde* from Degas and Whistler, wrote in 1910. "I think that Whistler was hampered by an excessive dose of taste. He wished to give his pictures from the beginning the suave, smooth, exquisite surface, the patina that the great works have acquired with time."

French reaction was more conciliatory. The publication in the *Gazette des Beaux Arts* in 1905 of Whistler's correspondence with the painter Henri Fantin-Latour related him to the generation of Manet and the Impressionists, whose fame was then being established. In one letter of 1867 he wrote that he wished he had been a pupil of Ingres (page 82); this effectively

located his art in a debate about the nature of classicism current in France in the first years of the twentieth century. In extended essay tributes by the critic Camille Mauclair and the artist-writer Jacques-Émile Blanche, too long and anecdotal to edit for this book, his art was fully embraced by the Symbolist orbit in which he moved in his last fifteen years, and in which he had first been promoted by Mallarmé and Huysmans. Marcel Proust could reconcile his hero Ruskin with Whistler (page 364), whose art he idolized, claiming that he once got Whistler to say something good about his old adversary. A study by the art historian Robert de la Sizeranne showed how Whistler's art differed from that of his French contemporaries, and claimed Ruskin as an important forerunner of Impressionist colour theory. Yet it was Ruskin's words about Whistler's painting, the ubiquitous "pot of paint" uttered more than a quarter of a century before, that Mauclair used to describe the effect that canvases by Matisse and Derain had on the spectator in 1905. Nonetheless, to those brilliant colourists, and to the apologists of Fauvism, grey was the universal enemy of painting – and whose art in 1905 could ever be described as being greyer than Whistler's?

Until the First World War, Whistler's prices rose stratospherically, but by 1921, in a lament for the lack of interest shown in him by the American public, his biographers Elizabeth Robins and Joseph Pennell were assured by the editor of an art magazine that "so much has been written about Whistler, a certain weariness is making itself felt." Unlike American critics such as E. A. Gallatin and collectors like Arthur Jerome Eddy, who sat to Whistler and wrote a book about him, but was also one of the first Americans to buy paintings by Wassily Kandinsky, the Pennells were unable to make the transition from Whistler to twentieth-century modernism, lamely regretting that "Artlessness and Cubism and other Isms are the fashion, and fashion rules art here, not tradition." While Whistler's influence on American Impressionism and on individual figurative painters since has been considerable (if little studied), the twentieth-century *avant-garde* of Europe and America has found no secure place for him in its pantheon of past heroes. Nevertheless, attempts are occasionally made (which are generally unpersuasive), to claim him as a forerunner of abstraction, minimalism, and so on. The Pennells, over-eager to present Whistler as the first artist of the New World to conquer the Old, and blind to the innovations of the new century, could not accept that his art had run its course. Nor were they willing to acknowledge Sickert's dictum that a painter's reputation is generally made neither by critics nor by the public, but by other painters. They had witnessed, at first hand, the last twenty years of Whistler's professional career, which they saw as a heroic struggle between their subject and the rest of the world, or rather the English art world, with the hero emerging victorious, when even Whistler complained that they were trying "to make an Old Master of him before his time." In the belief that everything he told them must be true, the Pennells assumed that the first half of Whistler's career was passed in the same way that they had witnessed the second.

For all intents, not least for the purpose of this book, Whistler's professional career can be divided into two parts: *before* and *after* Ruskin. By 1877 he had written only two letters to the press; his autobiography, *The Gentle Art of Making Enemies*, first published in 1890, contains the rest. Before suing Ruskin, he was obliged freely to submit his art to the critics, among whom he moved, counting as friends, not Philip Hamerton and Frederick Wedmore who always had reservations about him, but Victorian journalists such as George Augustus Sala, Tom Taylor and William Michael Rossetti, the brother of the first Pre-Raphaelite, Dante Gabriel. Acceptance by the inner Pre-Raphaelite circle gave Whistler access to their patrons, Leathart of Newcastle, Graham of Glasgow, and the man he called the "Liverpool Medici," F. R. Leyland, as well as the literary circle

James McNeill Whistler. *c.* 1864. Photograph by Étienne Carjat, Paris. Whistler Collections, Glasgow University Library.

around Swinburne. Still as much at home in Paris as he was in London, a friend of Manet's and a follower of Baudelaire and of Poe, as familiar with the works of Balzac as he was with those of Dickens, Whistler quickly modified the dominating influence of Courbet's painting and ideas, which had so impressed him in France, to suit the English taste for poetic realism in the 1860s. When Courbet saw *The White Girl* in Paris in 1863, with its soulful stare and symbolic flowers, he understandably expressed surprise that his young follower, the author of the realist French and "Thames Set" etchings, should have produced "une apparition du spiritisme" [a ghost of spiritualism]. So swiftly assimilated was Whistler's art by the literary *avant-garde* in London that as early as 1864 *The Little White Girl* inspired verses from Swinburne (page 76). With Swinburne's encouragement, as much as Baudelaire's example, Whistler suggested the synaesthetic expression of music through the medium of painting, beginning with *Symphony in White No. 3* in 1867. Well before the end of the century, the relationship between his art and its literary context was reversed. Whistler's drawings of dancing girls were used as illustrations to Symbolist verse, while the nocturnes specifically influenced Oscar Wilde's choice of subjects for poetry, and stimulated the aural imagination of Claude Debussy for music. Meanwhile, he continued to adapt his art: to the fashion for things Japanese; and to the classicizing tendencies exemplified in English art by Albert Moore. Above all, Whistler was in open competition with the decorative art of Burne-Jones, and with William

Morris's arts and crafts firm, for lucrative commissions for domestic decoration with which he hoped to attract Leyland. First was a series of Graeco-Japanese-inspired paintings in the 1860s that never materialized beyond the breathtakingly beautiful oil sketches known as the *Six Projects*; it was followed in the 1870s by *Harmony in Blue and Gold: The Peacock Room*, which he pressed on his reluctant patron. Although this was the beginning of the end of his relationship with Leyland, it was cited in a sermon by the Aesthetic Movement's preacher Reginald Haweis (page 123) (of which even Ruskin could have approved) and soon became one of the most written-about schemes of modern decorative art in Europe.

Given limited resources Whistler did everything that was socially expected of the Victorian artist. Living in unfashionable Chelsea, just beyond the modern amenities of the new Embankment, but unable to invite patrons on Sundays as did his more successful Royal Academy contemporaries with spacious homes and studios in Kensington, he instead improvised American-style breakfasts which soon had a fashionable following. In 1874 he leased a gallery in the West End of London, decorating it in the style then current with blue and white china, turkey matting and pastel-coloured walls. He thought that he could afford to build his own house, and had one designed in the modern Japanese style by Edward Godwin, on a newly developed site in Tite Street, close to the Embankment. It was funded by the putative £1,000 in damages which he fully expected to recover from Ruskin for libelling him, in addition to the £2,000 which he expected from Leyland for *The Peacock Room*; but neither sum materialized, and the miscalculation cost Whistler his last chance of ever becoming a conventional Victorian artist.

The Victorians generally saw little or no conflict between art and profit. Ruskin, with his follower William Morris, thanks to whom we still have difficulties in balancing this equation, was the venerated and vociferous, but controversial exception. For Ruskin, capital amassed by the exploitation of unfulfilled human labour was not wealth but "ilth." The estimate of a picture's moral value, as opposed to its worth, he calculated by reference to its subject, the time expended making it, and the price asked for it: measures Ruskin applied to his criticism of Whistler's *Nocturne in Black and Gold: The Falling Rocket*, exhibited in the Grosvenor Gallery in 1877 and offered for sale at 200 guineas. Whistler's case rested on what he believed to be the material yet no less traditional rights of the artist to paint what and how he liked and, in a *laissez-faire* society, to set his own price on it, in contrast to commissioned piece-work from a craftsman or designer. In this connection it is significant that attempts were made by Ruskin's witnesses at the trial to claim Whistler's painting to be little more than "delicately tinted wallpaper," which, in spite of Morris's campaign to raise the status of what he called "the Lesser Arts," was then still a critical stigma to attach to easel painting.

Lindsey Houses, 95–101 Cheyne Walk, Chelsea. *c.* 1870. Photograph by James Hedderly. Kensington and Chelsea Public Libraries, London. Whistler lived at nos. 101 and 96 between 1863 and 1878. The garden of the artist W. B. Scott can be seen on the right, and the Greaves boatyard to the left.

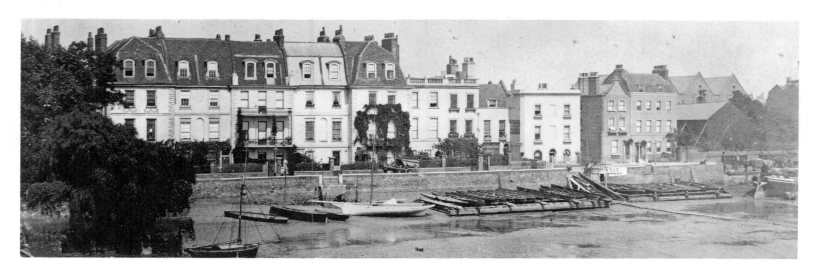

Because critical opinion soon afterwards swung in Whistler's favour at the expense of Ruskin's (and for the benefit of the art world has more or less continued to do so), it is often assumed that in 1877 Whistler, rather than Ruskin, was the more radical figure. Paradoxically, while Whistler's invitation to the spectator to react in a subjective manner to his nocturnes sounds like a recipe for what we today call "freedom of artistic expression" (and is often cited by the twentieth-century *avant-garde* in its search for historical self-justification), it was in fact a case made for just the opposite. Whistler's claim was that his livelihood as an artist had been curtailed by the growing capital power exercised in the art world through an influential medium of mechanical reproduction – newsprint – in the person of the art critic who was not a professional artist. Rather than asking for the artist to be placed beyond the reach of society, which we generally consider today's modernists to be, his request was for recognition of the professional role of the artist within it. Had this much not been recognized by the jury in 1878, Whistler would have lost not only the damages he claimed from Ruskin, but the verdict in the case as well.

Whistler's quarrel with art criticism was an argument that he set out with a passionate but deliberately calculated disregard for logic in his pamphlet *Art and Art Critics: Whistler versus Ruskin* (page 128). It served Whistler as a manifesto for the campaign he conducted in London in the 1880s. The managers of the Fine Art Society had shrewdly calculated that commissioning him to make twelve etchings of Venice, a city associated with Ruskin in the public mind, would produce something extraordinary. They were not disappointed. After returning from Venice in 1880 he devised a method of marketing his art, with the participation of dealers, particularly Ernest Brown of the Fine Art Society and Walter Dowdeswell, which short-circuited the entrenched monopoly of the art critic. The brilliant simplicity of Whistler's method consisted of hijacking the offending medium, newsprint, and subverting it to his own ends. This thereby enabled him to attract a compliant aristocratic and high-bourgeois audience which enjoyed reading about itself in the liberal gossip papers such as *The Pall Mall Gazette, Truth* and *The World* that flourished in the 1880s, when "Art," Whistler wrote in the "Ten O'Clock" lecture, was "upon the Town!" The practical mechanics of Whistler's strategy centred on the Private View, and also on the design of the exhibitions. These became progressively more elaborate, from the comparative simplicity of the shows of Venice etchings and pastels at the Fine Art Society in 1881, to the richer colour harmonies, in yellow, red and grey, for the 1883 Venice exhibition and the Dowdeswell one-man shows of 1884 and 1886 respectively, in which every detail, including the gallery attendant's uniform, was designed by him. By issuing his own catalogues in 1883 and 1892, containing adverse opinion of his art taken out of context and often deliberately misquoted, as in the case of Frederick Wedmore (page 200), Whistler forced the words of his critics back down their throats and thus made the press work for rather than against him. But it was with the art itself, shown in these exhibitions, that he succeeded in making the economic forces controlling the art world meet him on his own terms. Previously he had painted portraits, landscapes and figure subjects on canvas and panel, in more or less traditional sizes. In the 1880s he invariably worked on a scale of 5 × 8″ (13 × 20 cm) or less, and exhibited oils, watercolours and pastels in elaborate deep frames, thus focusing on, and reasserting control over, the very issue that Ruskin had abrogated from the artist in 1877: subject, time/treatment and price. Whistler well knew that to a dealer, as to the public, a picture's worth, as opposed to any moral value it might have for Ruskin, was not unreasonably determined by its subject-matter, execution and size. Whistler subverted all three by forcing critical attention to engage an insignificant detail of nature, be it a wave, a shopfront or a pretty girl, loosely painted in a matter of half an

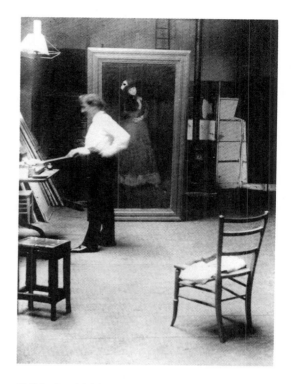

Whistler in his Fulham Road studio. 1884/8. Whistler Collections, Glasgow University Library.

hour on a tiny scale. "Now this pastel," Whistler told a journalist, "it's very slight – isn't it? If you were only to touch it with your finger, the colour would come off." No matter how clever the reporter might be, recalled the artist Mortimer Menpes, "he never got a word in edgeways."

Meanwhile, Whistler expanded his horizons by exhibiting abroad, in Brussels, Munich, New York and Paris. Théodore Duret's *Critique d'avant-garde* of 1885, which he dedicated to Manet (who had died in 1883), and which includes his essay on Whistler first published in the *Gazette des Beaux-Arts* in 1881 (reprinted here, pages 180–197), marked Whistler's re-emergence as a major figure on the French art scene. In Paris the sensation caused by the dreamy sensuality of *The White Girl* was still remembered more than a decade and a half later. It appealed to the Symbolist generation of French writers who, in following Stéphane Mallarmé, the translator of Whistler's "Ten O'Clock," required of painting that it should poetically suggest and evoke associations with nature rather than scientifically describe it. Whistler's subdued night had always been the absolute antithesis of the harsh light of noonday French Impressionism. In a century when scientific advances were measured by the increasingly accurate recording of empirical observation, Whistler substituted darkness and ambiguity for brilliance and clarity, and indeterminate description for specific topography. Whistler's art spoke a different language in Paris from that in London; or rather, it was the language of Mallarmé, Huysmans and Geffroy, derived from the same source that he had drawn on, namely the syntax of Baudelaire. Vainly had Whistler sprinkled his prose with the slang of the Bohemian *quartier* and berated his English critics for literary associations limited by Dickens' "Trotty Veck." *Before* Ruskin, Whistler's nocturnes confused an Anglo-Saxon audience more familiar with Wordsworth's city "bright and glittering in the smokeless air." To read his critics *after* Ruskin is to look at the work of a different artist, the creation of a post-industrial modernist, whose city's past is as obscure as its future, its existence defying conventional perception, and capable of being described only "with poetry, as with a veil," the poetry of Baudelaire's oriental harmony of night where "les sons et les parfums tournent dans l'air du soir" [sounds and perfumes revolve in the evening air].

"The object of the new art criticism," wrote George Moore, "is to give free trade to art." The purpose of the new art critics was as much to attack the restraint placed on independent art by the all-powerful Royal Academy as it was to defend Impressionism. By the time Whistler, as its president, obtained a Royal Charter for the Society of British Artists in 1887, the new art critics were already writing brilliantly about his art. It was the achievement of the "new critics" such as George Moore and R. A. M. Stevenson to take up the challenge which Whistler had issued to the *littérateur*. Among them was Walter Sickert, whose profession equipped him with the one qualification Whistler regarded as essential for art criticism. By dispensing with what Whistler termed "the accepted vocabulary of poetic symbolism," and discussing painting by analysing its form and colours, the new art critics, in whose circle Roger Fry was schooled, breathed fresh life into writing about art in England. By 1890, Ruskin's ideas and influence on the development of English painting were ousted forever.

While Whistler had good reason to be suspicious of art criticism, his quarrel with Swinburne, like Degas's occasional thrusts at Zola, was part of a wider argument about the primacy of the two art forms. That Whistler learned his craft as a creative dialectician at the feet of his friend Swinburne – he had witnessed at first hand the battle fought in public in the 1870s by Swinburne against Robert Buchanan's critical onslaught on Rossetti's poetry – adds further poignancy to his duel with the poet when he reviewed the "Ten O'Clock" lecture in 1888. Whistler believed that his

lecture had firmly and forever established an absolutist case for painting which could make a breach in the supreme citadel of literature. Swinburne disagreed and demonstrated the primacy of his craft with a devastating dissection of Whistlerian logic. As a painter Whistler had been influenced by Swinburne; what he gave as an artist-critic to Oscar Wilde he ultimately disallowed as influence and charged as plagiarism. Wilde disputed the painter's presumption (pages 228–229), and in *The Decay of Lying* made the case for literature, not painting, as the appropriate medium for the representation of deception as artistic truth.

Whistler's evanescent art began to appreciate in the early 1890s, when the market for Barbizon painting in England started to decline, and the merits of Impressionism slowly began to be acknowledged. Without recognition from the Royal Academy, the imprimatur of material success came to Whistler from further afield; in the form of awards and honours from the European Secession associations where he exhibited regularly in the last years of the century; from the Corporation of Glasgow which purchased his *Carlyle*; and above all, from the French government, which acquired *Arrangement in Grey and Black: Portrait of the Painter's Mother* for the Luxembourg Museum, and awarded Whistler the *Légion d'Honneur*. Thus fortified, and with the creation of his own Art Congress in London, the International Society of Sculptors, Painters and Gravers (which was especially intended to raise consciousness in the graphic arts), he mercilessly pilloried the narrow parochialism of the English art establishment for the benefit of his future biographers, the Pennells. His art was much in demand from the new American rich: Richard Canfield, Mrs Jack Gardner, George Vanderbilt, but above all, Charles Lang Freer of Detroit. The latter's Whistler collections, and those of the ancient arts of China and Japan in the Freer Gallery of Art of the Smithsonian Institution, embody for the American people an unchanging statement of cultural history dedicated to Whistler's vision of a renewal of the European tradition through the marriage of East and West. Whistler's art, and his perception of the past, stressed the continuity of the European tradition, something he found lacking in his friend Manet, of whose late conversion to *plein-airisme* he disapproved. In the century of scientific relativism exemplified by Hippolyte Taine's theories of social determinism, Whistler offered a reductive theory of art history which uncompromisingly related the art of classical Greece to Hokusai and Velazquez, as being the only peaks of civilization worthy of the modern artist's aspiration. The rhetoric of his "Why drag in Velazquez?" was more than a claim for the superiority of his own art; by refuting equality he implied that no great modern art was possible without such a comparison.

The identification with the European tradition that Whistler sought occurred towards the end of his life, just as his encounter with the paintings of Frans Hals, in the Haarlem Museum, occurs at the end of this book. Such statements concerning artistic tradition should be viewed against the social disruption of the 1890s, particularly in Paris, where the bombs of the anarchists Whistler so deplored provided a backdrop to new artistic visions with which he was not always in sympathy. But in relating his art to that of the past Whistler was doing more than laying a claim to posterity. Throughout his career his art maintained a constant dialogue with the classical tradition. In an interview published in the *Pall Mall Gazette* on 3 February 1905, Rodin recognized that Whistler "went to that ancient source of beauty and grace, Greek sculpture, which approaches so closely to nature . . . In other days, in the days of Raphael, the painter loved the rounded bust; today we adore the flat bust – the bas relief." By interpreting the classical heritage in this way, and by fusing it with Japan, Whistler breathed fresh life into Western art. It provided him with a theme susceptible to endless variation, from the decorative schemes of the

1860s and 1870s, to the figurative paintings and pastels of dancing girls of the 1880s and 1890s.

For many nineteenth-century artists in Britain and France, classicism proved too intractable a language to represent modern life with any conviction; conversely, modern life, with its lack of innate pictorial decorum, defeated those whose photographic vision was blind to the lessons of past art. Like Degas, whose art provided an uncompromising answer to this dilemma, Whistler demonstrated that disciplined draughtsmanship need not preclude originality. His portrait of Mallarmé was not only thought by Mallarmé's friends to be a likeness of penetrating originality, but as with so many of his lithographs, it is also a piece of brilliant graphic invention. Its deceptive appearance of spontaneous improvisation was achieved only after agonizing hours of posing by Mallarmé, and after many versions had been destroyed by Whistler, a veritable illustration of the maxim that "Industry in art is a necessity – not a virtue – and any evidence of the same, in the production, is a blemish, not a quality; a proof, not of achievement, but of absolutely insufficient work, for work alone will efface the footsteps of work." The "secret of drawing" which Whistler enigmatically told his pupils he had discovered in Venice, consisted as much in knowing when to stop drawing as it did with making the marks on the paper or copperplate with which he began. The most enduring testimony to this unique artistic gift is to be found in some of the etchings and lithographs of his later years, in which even the most casual line or breath of chalk takes on an intense and profound meaning, which the medium had neither achieved before, nor has ever been capable of realizing since.

Study No. 1, Portrait of Thomas Way, W.108. 1896. Lithograph, 14¼ × 8¾" (36.3 × 22.6 cm). Hunterian Art Gallery, Glasgow University (Birnie Philip Bequest).

The artistic strengths we recognize in Whistler today are the very characteristics which brought him disapproval then. Whistler's art was one of constant invention, between one medium and the next: from etching to painting, and watercolour to lithography, always building on the achievement of one medium further to maximize its effect in another. Such qualities are the very opposite of the kind of dry repetition in a debased formula which brought academic accolades over a century ago, when Wedmore criticized Whistler, who was then 45, because "for his fame Mr. Whistler has etched too much." He gained only the grudging acknowledgement of conventional critics, who ranked him as an etcher next to Rembrandt, but were unable to forgive him his wayward vision in painting, his ever-darkening canvases, and his constant quarrelling.

Art history, that most conservative of cultural determinants which always favours the consensus of whatever artistic style or ideology is in the ascendency, has, therefore, tended to give Whistler the verdict that his "importance" was greater than his art. The great art illusion of the twentieth century, performed by capitalism's sleight-of-hand, has been to foster belief in an art for the masses, a utopia first put about by William Morris, much to Whistler's disgust, based on an idea of Ruskin's. Whistler exposed this as hokum, with truths as unfashionably unpalatable in today's unequal society as they were when he preached them to a liberal bourgeois audience a hundred years ago. Instead, in his "Ten O'Clock" lecture, Whistler offered an autonomous future for art, unencumbered by Ruskinian morality, at a time when it was much needed.

> Art happens – no hovel is safe from it, no Prince may depend upon it, the vastest intelligence cannot bring it about, and puny efforts to make it universal end in quaint comedy, and coarse farce.
>
> This is as it should be – and all attempts to make it otherwise are due to the eloquence of the ignorant, the zeal of the conceited. . . .

> False again, the fabled link between the grandeur of Art and the glories and virtues of the State, for Art feeds not upon nations, and peoples may be wiped from the face of the earth, but Art *is*.

WHISTLER

ANNA M. WHISTLER

The Russian Journal

1844-47

In 1831 Anna Matilda McNeill (1804–81)
married Major George Washington Whistler
(1800–49) who in 1842 was invited by Tsar
Nicholas I to become chief engineer for the
construction of the railroad from St
Petersburg to Moscow. Anna, her two sons
and stepdaughter Deborah (daughter of
Major Whistler's first wife), joined their
father in St Petersburg in September 1843.
The MS of the journal is in New York Public
Library.

William Miller, a Scottish suitor to Deborah.
Sir William Allan (1782–1850), Scottish
artist, history painter and President of the
Royal Scottish Academy (1838) had been
commissioned by the Tsar to paint scenes from
the life of Peter the Great in the Winter
Palace. He first visited Russia in 1805 and
thereafter spent several years in the Ukraine.
[Colonel T] Colonel Charles Stewart Todd
from Kentucky was the American Minister in
St Petersburg.
The MS of the copied poem referred to [10
July] is now in the Whistler Collections of
Glasgow University Library.

1 July (1844) – ". . . Just as we were seated at tea, a carriage drove up, and Mr Miller entered, introducing Sir William Allan, the great Scotch artist, of whom we have heard lately, who has come to St Petersburg to revive on canvas some of the most striking events from the life of Peter the Great. They had been to the Monastery to listen to the chanting at Vespers in the Greek chapel. Mr Miller congratulated his companion on being in the nick of time for our excellent home-made bread and fresh butter, and, above all, the refreshment of a good cup of tea. His chat then turned upon the subject of Sir William Allan's painting of Peter the Great teaching the mujiks to make ships. This made Jemmie's eyes express so much interest that his love for the art was discovered, and Sir William must needs see his attempts. When my boys had said good-night, the great artist remarked to me, "Your little boy has uncommon genius, but do not urge him beyond his inclination." I told him his gift had only been cultivated as an amusement, and that I was obliged to interfere, or his application would confine him more than we approved."

* * *

4 July (1844) – "I have given my boys holiday to celebrate the Independence of their country. . . . This morning Jemmie began relating anecdotes from the life of Charles XII of Sweden, and rather upbraided me that I could not let him do as that monarch had done at seven years old – manage a horse! I should have been at a loss how to afford my boys a holiday, with a military parade today, but there was an encampment of cadets, about two estates off, and they went with Colonel T.'s sons to see them."

10 July (1844) – "A poem selected by my darling Jamie and put under my plate at the breakfast-table, as a surprise on his tenth birthday. I shall copy it, that he may be reminded of his happy childhood, when perhaps his grateful mother is not with him."

20 August (1844) – ". . . Jemmie is writing a note to his Swedish tutor on his birthday. Jemmie loves him sincerely and gratefully. I suppose his partiality to this Swede makes him espouse his country's cause and admire the qualities of Charles XII so greatly to the prejudice of Peter the Great. He has been quite enthusiastic while reading the life of this king of Sweden this summer, and too willing to excuse his errors."

* * *

[On 14 May (1845) there was a review of troops in St Petersburg, and a window in the Prince of Oldenburg's palace overlooking the Champ de Mars was reserved for the Whistlers]

"Jemmie's eagerness to attain all his desires for information and his fearlessness often makes him offend, and it makes him appear less amiable than he really is. The officers, however, seemed to find amusement in his remarks in French or English as they accosted him. They were soon informed of his military ardour and that he hoped to serve his country. England? No, indeed! Russia, then? No, no, America, of course!"

"On 18 September 1845, the new tutor, M Lamartine, was installed, and the freedom with which the boys chatted with him soon made me comfortable, for Jemmie and he are both such talkers. Great has been the

Photograph of Whistler as a boy.
c. 1844. Whistler Collections,
Glasgow University Library.

demand for patience on his part, until they were broken of their wild pranks in the school and street, for the Russian lads are drilled from infancy to politeness and submission."

* * *

23 January (1847) – ". . . Jamie was taken ill with a rheumatic attack soon after this, and I have had my hands full, for he has suffered much with pain and weariness, but he is gradually convalescing, and today, 30 January, he was able to walk across the floor; he has been allowed to amuse himself with his pencil, while I read to him; he has not taken a dose of medicine during the attack, but great care was necessary in his diet."

27 February (1847) – "Never shall I cease to record with deep gratitude dear Jamie's unmurmuring submission these last six weeks. He still cannot wear jacket or trousers, as the blistering still continues on his chest. What a blessing is such a contented temper as his, so grateful for every kindness, and rarely complains. He is now enjoying a huge volume of Hogarth's engravings, so famous in the Gallery of Artists. We put the immense book on the bed, and draw the great easy-chair close up, so that he can feast upon it without fatigue. He said, while so engaged yesterday, 'Oh, how I wish I were well, I want so to show these engravings to my drawing-master, it is not every one who has a chance of seeing Hogarth's own engravings of his originals,' and then added, in his own happy way, 'and if I had not been ill, mother, perhaps no one would have thought of showing them to me.'"

BELOW Page of Studies. 1847/48. Pencil, 6⅝ × 8⅛" (14.3 × 20.3 cm). St Petersburg Sketchbook, Hunterian Art Gallery, University of Glasgow.

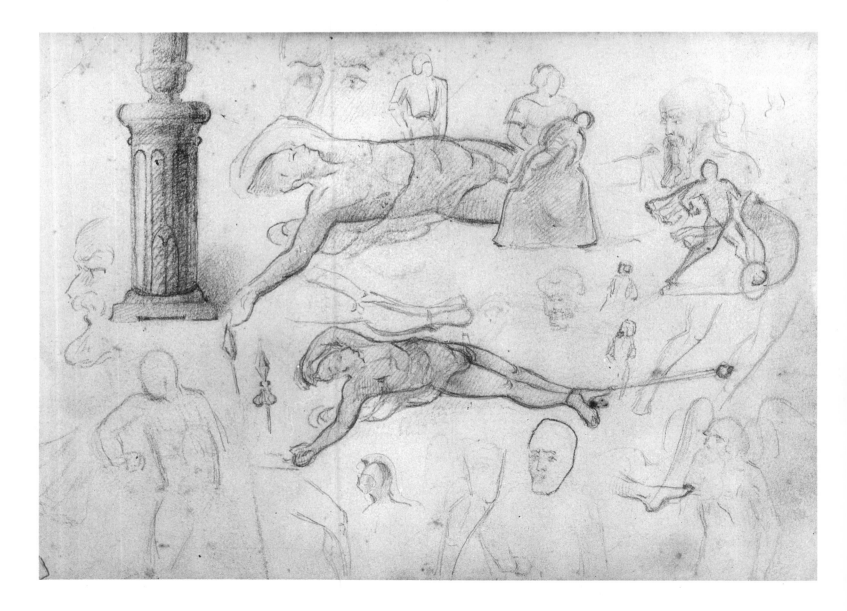

JAMES MCNEILL WHISTLER

Letter to his Mother

17 March 1849

62 SLOANE ST, 17 MARCH 1849

My dear Mother

I send you a little sketch of a Young Sweep – one who cleans the crossings in the Streets: we were preparing some sketches for a Scrap Book and this is one of them, but as I can easily make another copy, and thinking you might perhaps like to have one, I enclose this. Thank Willie for his nice letter to me, and tell him I shall answer it after Father's. You know I have lately attended some lectures on Painting by Mr Leslie at the Royal Academy, well I like them very much and hope to go next Thursday again to hear the last one. One evening he gave a kind of history of British Art; he spoke of Reynolds, of Hogarth, of Stothard and of Bewick's Wood cuts. In speaking of Hogarth, he described the Marriage piece in *The Rake's Progress* (you can see the picture in Father's *Works of Hogarth*) the scene is in a little old church, and, as Mr Leslie said, any common Genius might make cracks and cobwebs about the walls, but *Hogarth* made a crack through the *Commandments* and a cobweb over the hole of the *Charity box*!!

Mr Leslie showed us the first sketch of West's *Death on the Pale horse*, it is perhaps a fine thing but of Death himself, I think Mr L – said, West might have made something more sublime, and I think so too. – Do you know that Seymour has given me such a nice present: a 10s Print from one of Fuseli's works called *The Lazar House*, it is taken from Milton and is really a very fine thing tho' much exaggerated. – How you would like to see the Babie, dear Mother, her hair has grown and is going to be of a pretty flaxen colour and Sis intends it to be curly, so that she is to be the pretty Miss Haden. I began a sketch of her which Seymour finished and made really very like her; when I have done a nice likeness all by myself, I shall send it to St Petersburg, that you may form some faint idea of little

Whistler was at this time living at the home of his brother-in-law, the surgeon and etcher, Francis Seymour Haden (1818–1910) and his wife Deborah, Whistler's half-sister. In a previous letter to his father Whistler had already expressed a wish to become a painter.

Willie: Whistler's younger brother William Gibbs McNeill Whistler (1836–1900). Charles Robert Leslie RA (1794–1859), grew up in Philadelphia and taught drawing at West Point Military Academy before becoming Professor of Painting at the Royal Academy (1847–52). William Hogarth (1697–1764), the English artist Whistler always admired unreservedly. The fifth of Hogarth's series of engravings The Rake's Progress (1734–35) shows Tom Rakewell marrying an old woman for her money in the church at Marylebone. Sir Benjamin West RA (1738–1820), the Pennsylvanian-born history painter. In Henry Fuseli's (1741–1825) The Vision of the Lazar House based on Milton's Paradise Lost, XI, 477–490, the Lazar house is one of the images of death that the Archangel Michael shows to Adam. Whistler's niece Anne Harriet Haden had been born on 14 December 1848. A pencil drawing of her by Whistler is in the Hunterian Art Gallery, Glasgow, as is the oil portrait (YMSM 1) which also dates from 1849 (see page 61).

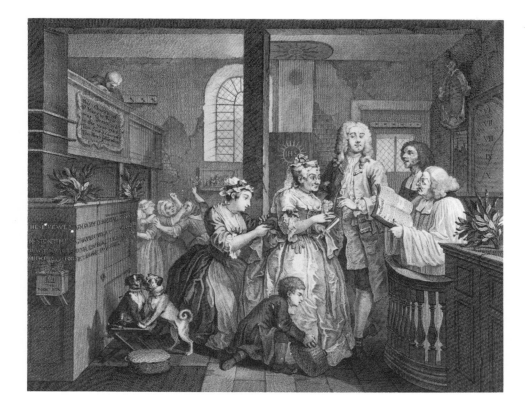

LEFT William Hogarth, *The Rake's Progress*, Plate V. 1735. Etching and engraving, 12 × 15″ (30.5 × 38 cm). British Museum, Department of Prints and Drawings.

BELOW Sir William Boxall, *Portrait of James McNeill Whistler as a boy* (detail). 1848. Hunterian Art Gallery, Glasgow University (Birnie Philip Gift).

Annie before you see her, for I hope that you and Willie, at least, if not dear Father, may be able to come over to England next Summer. And so Father has another appointment: one at Cronstadt! well I wonder what they will do without him, when we all go home to America? – –

Monday 19th. – Mr Eastwick dined with us yesterday – he is going to leave on Friday and will take my sketches I have ready to send by him, to St Petersburg; I also hope to send a letter by him to Edward. I may perhaps go with Mr Eastwick on Wednesday next to Mr Boxall's that he may report my likeness at *Home* and I am sure he *must* think it very good. – We have just finished dinner dear Mother, and while Seymour is reading his paper, and Mr Lloyd his book, Sis is enjoying "The Babie". You should just hear Annie talk; sometimes she comes out with such a Ghaie . . . Since I have been writing this she began a short conversation, but I cannot write her language, but I can assure you it is very poetical – musical at least – By the by does Willy continue his music lessons with the German Lady? – I am reading Tyhlers *Universal History* and will soon have finished Mrs Jameson *History of The Early Italian Painters*, a small work in two volumes and being one of the Series of Knight Weekly Volume. It is a present from Mr Boxall and is very interesting.

Tuesday 20th. My letter must now go dear Mother so I have only time to say Goodbye. Give my love to dear Father and Willie and remember me to all friends. Sis thinks I had better keep the sketch and send all together by Mr Eastwick. I must tell you before I let this go of another beautiful present from Seymour, two beautiful pair of pantaloon! But I must now go to my reading with Sis.

I shall soon write again.

Your affectionate Son
(sg). Jemie

The naval dockyards at Cronstadt. Already severely weakened by cholera, he was to die on 7 April 1849; he probably never saw this letter.
Andrew Eastwick of the Baltimore locomotive works Eastwick & Harrison provided part of the rolling-stock for the St Petersburg – Moscow railroad.
The portrait painter Sir William Boxall RA (1800–79) became Director of the National Gallery in 1865. This portrait of Whistler was exhibited at the Royal Academy in 1849 (see page 37).

Anna Brownell Jameson, Memoirs of the Early Italian Painters and the Progress of Painting in Italy, *Charles Knight, London, 1845.*

A. J. BLOOR

THE CRITIC

"Whistler's Boyhood"

September 1903

"James at this time [1850] was tall and slight, with a pensive, delicate face, shaded by soft brown curls, one lock of which, even then, fell over his forehead. In later years he was very proud of this lock, which turned grey while he was yet young (a peculiarity shared in some degree by others of his family), and this gave him rather a striking appearance. It was also said to be a sort of barometer of his various moods. When he was in good health and spirits, it would be very conspicuous, when not, it would be hidden away. On the family's re-arrival in Stonington after so long a sojourn in that then almost unknown and far-off land, he had a somewhat foreign appearance and manner, which, aided by his natural abilities, made him very charming, even at that age.

"His mother, after looking around for a school where she might take her two boys, finally decided on Pomfret in this State, where there was at that time a large and flourishing school, (the place is still an educational centre), presided over by Rev Dr Roswell Park, a West Point man, highly recommended to her as a teacher and disciplinarian. And there they remained until he was old enough to go to West Point. James, or Jim, as

The Whistlers had lived in Stonington between 1837 and 1840; Whistler's father was buried in the graveyard of Stonington's Episcopal Church.

After the death of Major Whistler in 1849 the family returned to America and settled at Pomfret, Connecticut, where James was sent to Christ Church Hall, a private school. This description of the young Whistler is quoted from a paper, Short Sketch of James Abbott McNeill Whistler's Early Life *which was given by Emma Palmer, a friend of Whistler's mother, to the Archaeological and Genealogical Society of Stonington, where A. J. Bloor recorded it.*

he was always called, was a great favourite with all the school, for his spirits were perennial, and he charmed alike old and young. No-one could withstand the fascination of his manner, even at this early age, or resist the contagion of his mirth, inconsequent and thoughtless as he often was. He was so amiable under the reproofs of his elders, so willing to make amends, that it was impossible to be provoked with him long. He was continually getting into scrapes, but was such a favourite that the boys would always try to help him out. One instance will suffice: One day, in school hours, he was drawing a caricature of Dr Park, who was rather peculiar in his looks, being very tall and thin, with a long neck and a collar so high and stiff that he couldn't turn his head. He was also very prim and precise, and a rigid disciplinarian. He noticed that the boys were convulsed over something, and going softly behind them, he surprised Jim as he was putting the finishing touches to his picture. When he saw it, he could hardly help laughing, even if it was of himself, it was so true to life, although of course exaggerated; but he told Jim to present himself to be feruled, as such a breach of discipline could not be tolerated. But in an instant two or three boys jumped up and said they would take Jim's punishment for him, or he could ferule them all. So it was compromised, and Jim got off with a few strokes.

Aunt Alicia. 1844. Pencil, 4 × 3″ (10.2 × 7.6 cm). Cooper-Hewitt Museum, Smithsonian Institution, Washington, D.C. (Photo Art Resource, New York).

GENERAL LOOMIS L. LANGDON
Whistler at West Point
1908

"I entered West Point in June 1850, and in June 1851 passed my examination and entered the 'Third Class.' Whistler reported 3 June 1851, passed the examination for admission and was, of course, assigned to the 'Fourth Class.' He was, therefore, in the class just below mine.

"Whistler evidently had the experience of some good schooling. He had considerable knowledge of French and algebra and a marked proficiency in English grammar, and he had read much of the best English literature, so his first year was an easy task, but his second and third years were miserable failures.

"His conversational powers were soon recognized, as were his various accomplishments and good breeding, while his witty remarks and original views and sayings, often verging on the sarcastic, could not fail to attract attention. But his intercourse with the other cadets was, with few exceptions, confined to his own class. The distinctions between the different classes were very sharply drawn. Whistler was a Fourth Classman or a 'Pleb' during his first year, and nothing in his antecedents, family, character or mental equipment would lift him into anything but the most formal intercourse with the youths of the classes above him. 'Plebs' were mere 'things,' sometimes playfully spoken of as 'animals,' and often the subjects of practical jokes and cowardly and disgraceful 'hazing.' Such was the case in those days. Since then a better discipline and the amenities as well as necessities of the popular football game have, I suppose, broken down some of the barriers between the classes.

"There were those who divined in Whistler the dawning of an unmistakable genius. But the aristocracy of the sword, that shapes the destinies of nations, has no use for a genius other than the Napoleonic. And life at the Academy is so fully filled with professional work that there is no time for the cadets to sympathize with a genius if they would, or to wander aside from the hard, beaten path of routine duties into the fields of the fanciful and the artistic. Unflagging industry, self-denial,

General Loomis Lyman Langdon (1830–1910), was born in Buffalo and graduated from West Point Military Academy in 1854. He was also an occasional newspaper correspondent, and studied art in London in 1903–4. He may have been the Colonel from Buffalo who commissioned a portrait of his son from Whistler in Venice in 1880 (YMSM 211).

Whistler's Engagement of Service and Oath of Allegiance, West Point. 7 February 1852. United States Military Academy, West Point, New York.

concentration to duty, implicit obedience to orders and regulations, and proficiency in studies are the requirement for success at West Point, where no favouritism is shown to the incompetent through family or political influence. The standard of excellence adhered to may be estimated by the fact that, in those days at least, hardly more than a third of those who were admitted to the Military Academy ever graduated.

"That was evidently no place for a genius. And many a man who rose to distinction in afterlife has had to regret that he was 'found deficient' at West Point. A remarkable instance of this is found in the case of Edgar Allan Poe, the critic and poet, who, after having been appointed a cadet by the President himself, served as a cadet only eight months and five days when he was dismissed, 6 March 1831, by sentence of a general court-martial for 'gross neglect of duty' and 'disobedience of orders.'

"As an illustration of the lack of appreciation of the genius in Whistler, I may mention the following: As a matter of curiosity, I asked a general officer, whose reputation as an able writer and man of science is world-wide, and who knew Whistler well, 'How was Whistler looked upon by the older cadets?' His answer, which reinforces what is said above, was: 'Well, he was tolerated.' Which, I imagine, was his way of saying the older cadets held Whistler in higher esteem than they held others of his – the lower – class.

"Whistler, bound to get out of life all that was to be had in the way of enjoyment, was never unemployed. Like his father before him, he was addicted to pranks, not malicious, but harmless to every one except himself. . . .

"Whistler lived in the barracks near me. As I took great delight in pictures, not so common as they are now, and I stood at the head of my class in drawing and painting and he at the head of his class in the same branches, we had a common interest; the distinction of classes was never thought of between us. He was often in my room and there made sketches in Indian ink, while he rattled on, now with some droll story, and now with sarcastic remarks about the administration of affairs by the academic authorities, meant only for my ears. It was always a treat for me whenever he came to my room. Indeed, we painted a large picture together; he the figures and I the landscape part. . . .

"The battalion of cadets was divided into four companies; A B C and D. Whistler and I were in 'C' company, and when the company was 'sized,' or the men arranged from right to left according to their height, Whistler was generally near me, and often right behind me, in the rear rank. The little rascal took advantage of this to try and get me laughing in ranks; forgetting if I were caught at it, I would get 'skinned,' i.e., reported and incur demerit marks. Thackeray was one of our favourite authors, and we two had been reading Pendennis at the same time, and not seldom discussed the characters that figure in it. There is one scene, near the end of the book, that he keenly appreciated and to which he often referred. It is where 'Alias' (or Altamont) escapes from the police by scrambling hastily out of a back window of 'Captain' Strong's room, in which also dwelt, on sufferance, his Irish friend, an ex-army officer, Captain Costigan the father of 'the Fotheringay,' and sliding, hand over hand, down the broken, ramshackle gutter-pipe. Whistler liked to rehearse old Costigan's comments on the means of escape he had suggested to 'Alias,' and he took particular delight, occasionally, in whispering them to me when we were in ranks and required to be as silent as the tomb. At many a 'dress parade' when we were all standing at 'parade rest,' as motionless and gravely dignified as the statues in the halls of the Vatican, when to raise a hand to brush aside a fiercely persistent mosquito assailing the helpless cadet's nose was an unpardonable offence, I would be day-dreaming of home and the blue waters of old Erie, as the band marched slowly past our front to the strains of delicious, soul-inspiring music, when a muffled whisper from right behind me, in the rear rank, would shatter my reverie and then I

Edgar Allan Poe (1809–49) remained a life-long inspiration; later Whistler came to identify himself with the American writer (see page 302).

Whistler's father graduated from West Point in 1819.

Present whereabouts not known (YMSM 2).

Song of the Graduates, Design for a Music Cover. 1852. Lithograph, 13⅜ × 10¼″ (34 × 26 cm). Glasgow University Library.

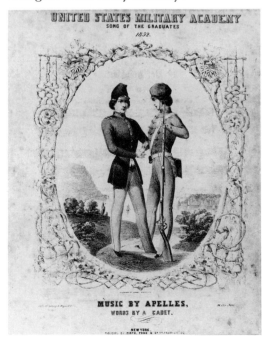

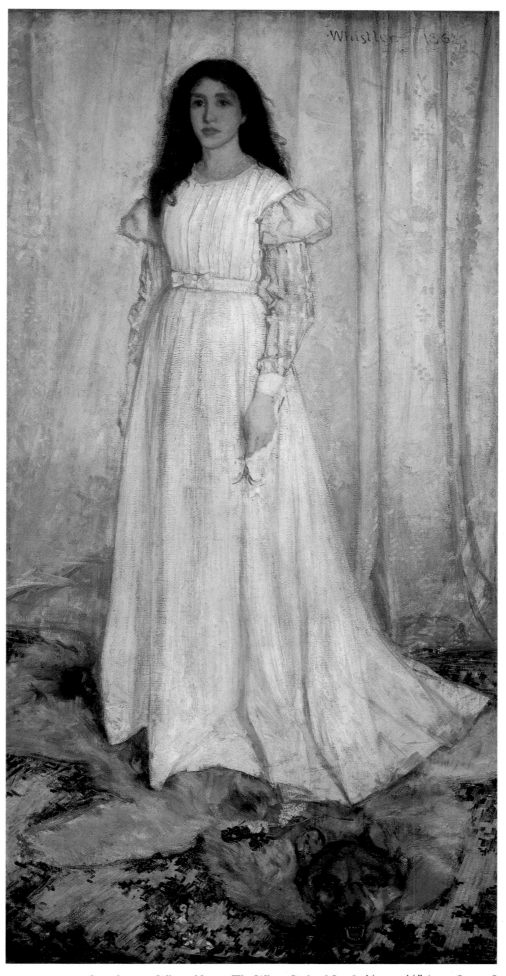

COLOURPLATE 9. *Symphony in White, No. 1: The White Girl.* 1862. 84½ × 42½″ (214.6 × 108 cm).
National Gallery of Art, Washington, D.C. (Harris Whittemore Collection).

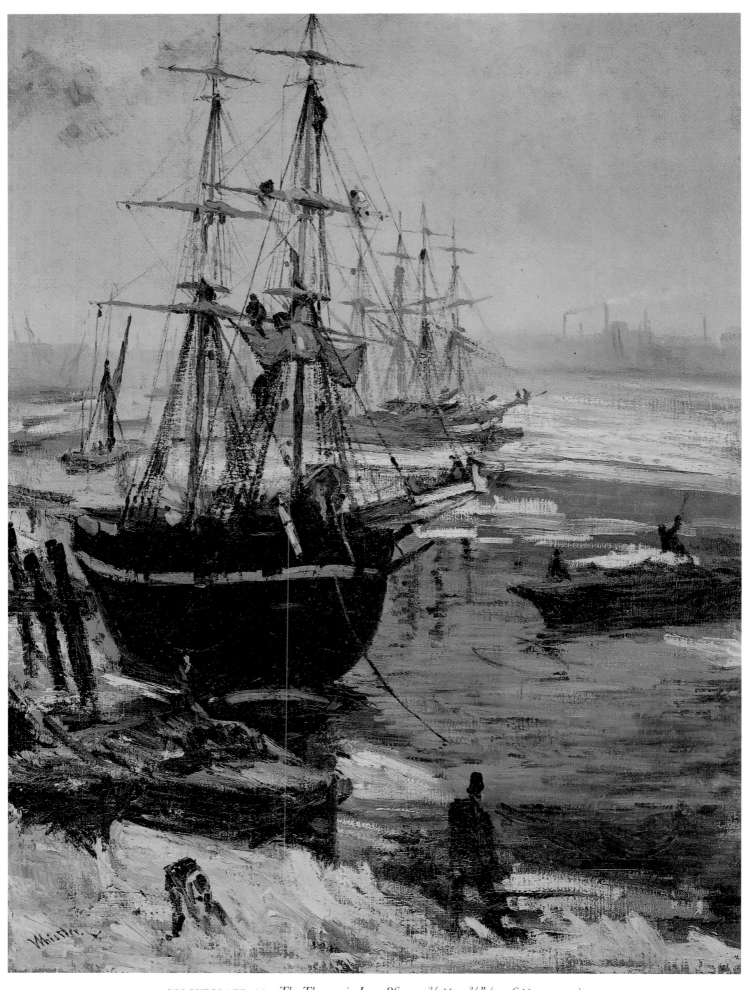

COLOURPLATE 10. *The Thames in Ice*. 1860. 29⅜ × 21¾″ (74.6 × 55.3 cm).
Freer Gallery of Art, Smithsonian Institution, Washington, D.C.

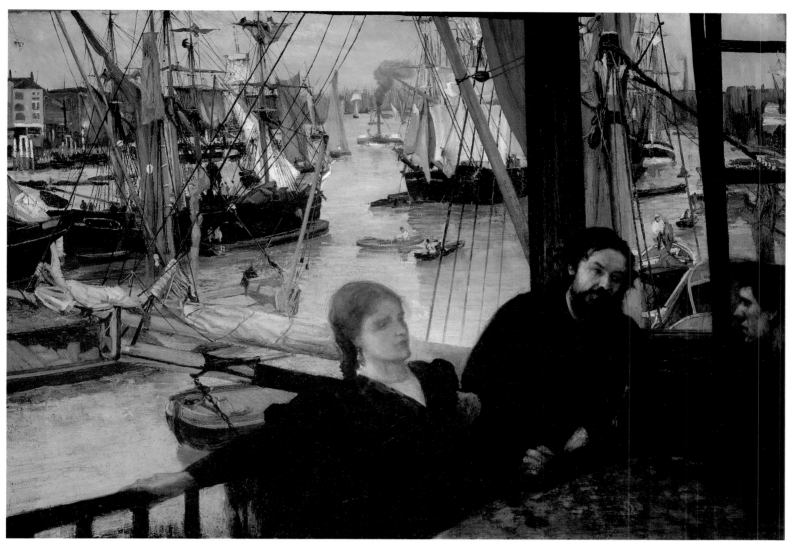

COLOURPLATE 11. *Wapping on Thames*. 1860-61. 28 × 40″ (71.1 × 101.6 cm).
National Gallery of Art, Washington, D.C. (John Hay Whitney Collection).

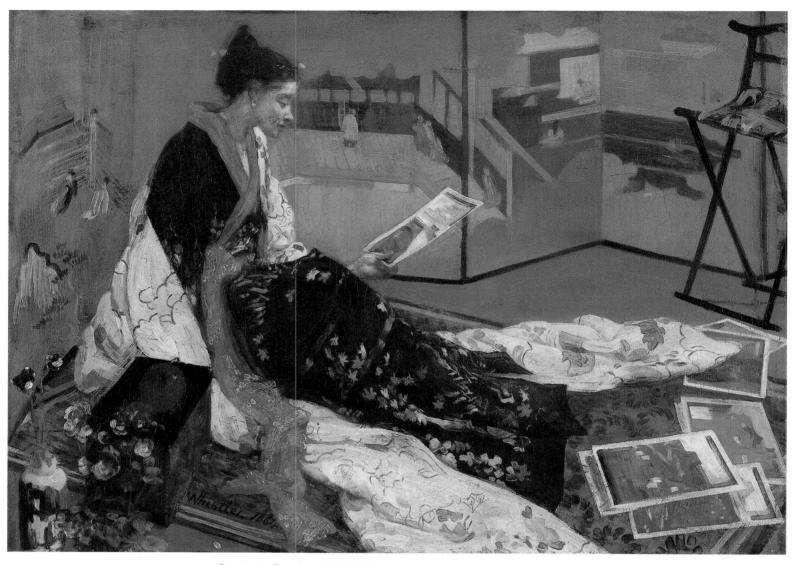

COLOURPLATE 12. *Caprice in Purple and Gold No. 2: The Golden Screen.* 1864. 19¾ × 27″ (50.2 × 68.7 cm).
Freer Gallery of Art, Smithsonian Institution, Washington, D.C.

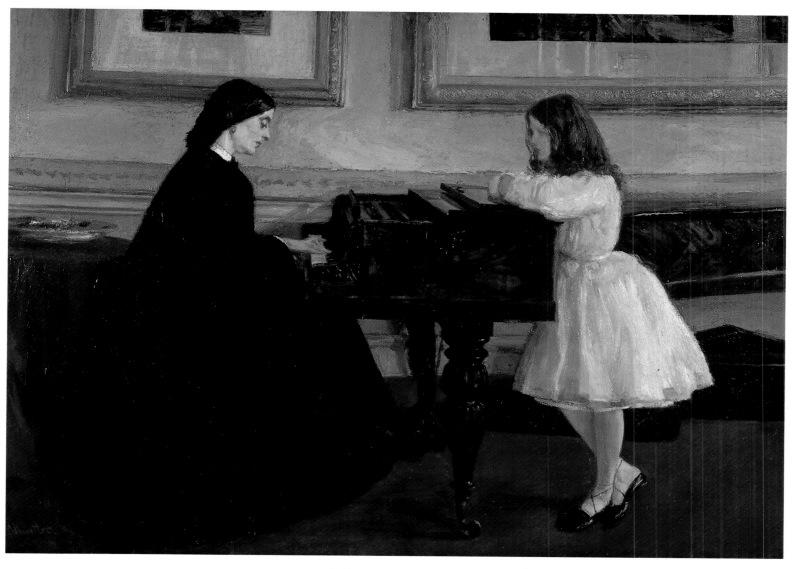

COLOURPLATE 13. *At the Piano.* 1858-59. 26⅜ × 35⅝″ (67 × 90.5 cm).
Taft Museum, Cincinnati, Ohio (Bequest of Mrs Louise Taft Semple).

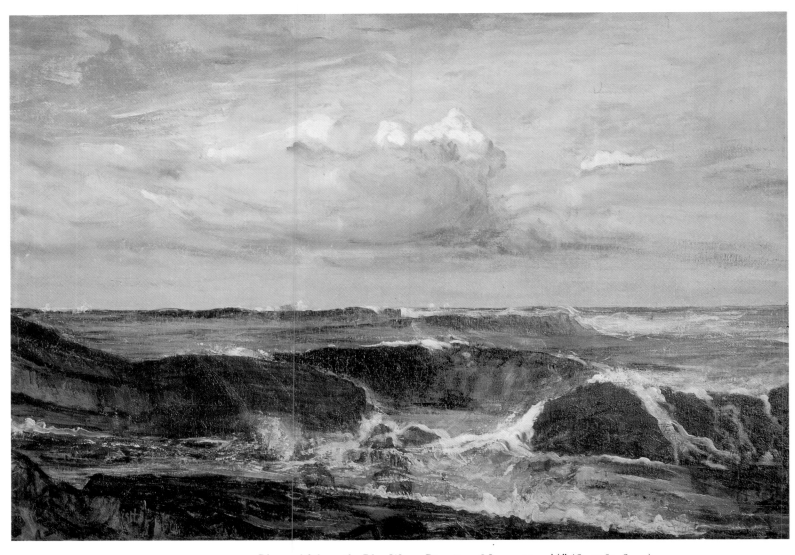

COLOURPLATE 14. *Blue and Silver: the Blue Wave, Biarritz.* 1862. 24 × 34½″ (61 × 87.6 cm).
Hill-Stead Museum, Farmington, Connecticut.

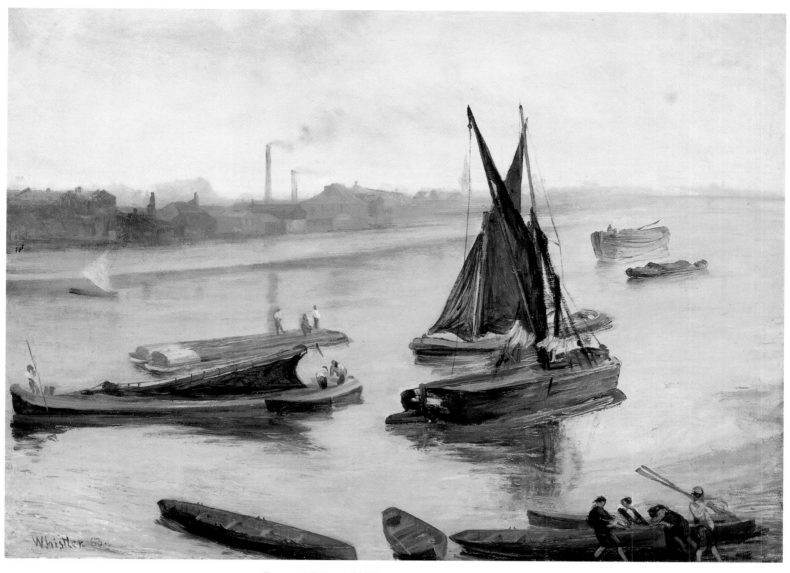

COLOURPLATE 15. *Grey and Silver: Old Battersea Reach.* 1863. 20 × 27″ (49.5 × 67.9 cm).
© 1988 Art Institute of Chicago, All Rights Reserved (Potter Palmer Collection).

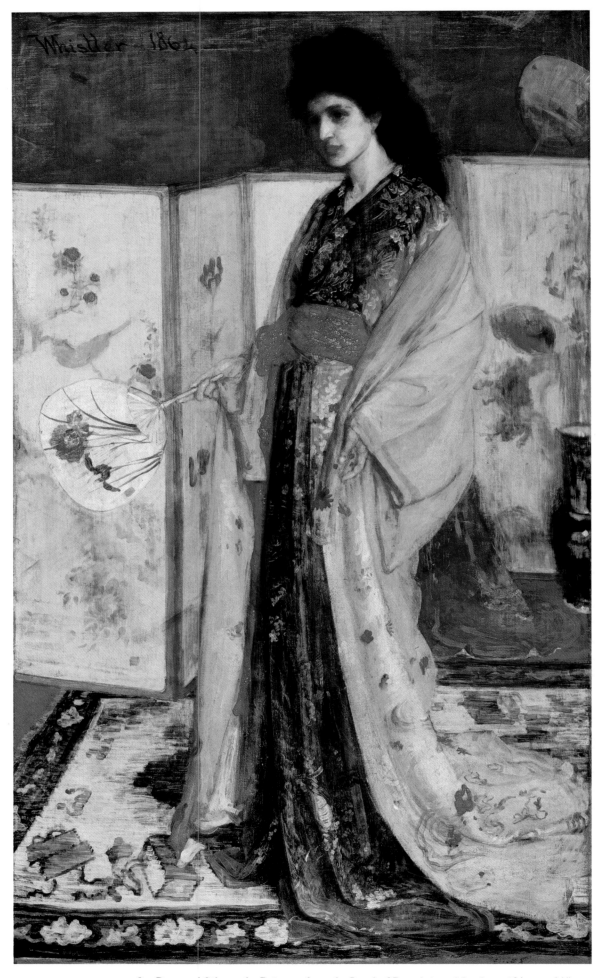

COLOURPLATE 16. *Rose and Silver: the Princess from the Land of Porcelain.* 1863-64. 78¾ × 45¾″
(199.9 × 116 cm).
Freer Gallery of Art, Smithsonian Institution, Washington, D.C.

could hear that little imp, Whistler, quoting, in a rich Irish brogue, Captain Costigan, for my special benefit: 'I was reminded of that little *sthrategem* by remembering me dorling Emelee, Lady Mirabel, when she acted the puart of Cora in the plaie and by the bridge in Pizarro, bedad!'

"The incongruity of such remarks, though not by any means novel, in a scene so impressive, where all else was so solemnly in earnest, always excited my risibles, and the effort to restrain my laughter always drew from Whistler a chuckle of satisfaction. . . .

"A large part of Whistler's leisure time, during 'release from quarters,' was spent in the rooms of his class-mates and friends, who were in my class. When thus visiting he was never idle, but while chatting in his witty and inimitable way, was busy making for his hosts sketches in pencil or Indian ink of figures, single or in groups, peculiar to cadet life, or imagined scenes from Dumas' and Hugo's novels. *The Three Guardsmen*, then very popular, was a favourite with him, and with his class-mate, Cadet Vinton, who stood well in drawing and often sketched the same subjects with Whistler, and then the two compared their work for the entertainment of their common friends. . . .

"I graduated from the Academy early in June 1854, really before Whistler's class came up for examination, nor did I know his fate for a long time, and then, much to my deep regret, I learned he had been 'found,' *i.e.*, failed, to pass the examination. In the official records it is stated he was 'discharged 15 June 1854, for deficiency in conduct and chemistry.'

"'Deficiency in conduct' sounds badly, but really it does not imply the commission of any very serious offences. Demerit marks were given for the slightest deviation from the strictest rule of conduct, from a spot of rust on a musket-barrel down to having the nightmare during the Sunday morning services in the chapel. A 'late' falling into ranks was one demerit; underclothes not properly piled on shelves, with folded edges out, two demerits; smoking, six demerits. The offensive cigarette and its accompanying disgusting trick of exhaling the smoke through the nostrils were not known in those days at West Point. One hundred demerits during the second year deprived the cadet of his much-coveted furlough, and two hundred in a year caused discharge from the Academy. The more serious offences were reserved for a general court martial which might cause a dishonourable dismissal from the service.

"Colonel Wheeler, Professor of Engineering at West Point some years ago, and member of the Academic Board, told me the story of Whistler's failure to pass the examination in chemistry. Silica constitutes about seven-eighths of the earth's surface, and, at the examination of his class before the Academic Board and the Board of Visitors, Whistler was told to discuss the subject of silica, one of the simplest subjects in the whole course. Whistler began his recitation by the astounding announcement: 'Silica is a saponifiable gas!' That finished him. It is inconceivable that Whistler did not know better. But it is easily believed that, knowing from the weekly exhibit of the bad marks for his daily recitations, he was sure to be found deficient, he promptly and purposely made an answer so magnificently absurd that it would be crystallized into a tradition of Whistler.

RIGHT *On Post in Camp.* TOP TO BOTTOM "First Half Hour"; "Second half hour"; "Third half hour"; "Last half hour!". *c.* 1852. 25⅜ × 28¾" (64.4 × 73 cm). United States Military Academy, West Point, New York.

THOMAS WILSON

THE BOOK BUYER

"Whistler at West Point"

2 September 1898

Thomas Wilson (c. 1832–1901), graduated from West Point Military Academy in 1853, became a Union Officer and served as Chief of Commissariat for the Richmond campaign of 1863–65. He retired in 1896 as Colonel Assistant Commissary General of Subsistence.

The instructor in drawing and painting at the Military Academy, during Whistler's stay, was Professor Robert Weir, who executed the panel-picture in the rotunda of the Capitol building at Washington, known as *The Departure of the Pilgrims*, for which the Government paid him 10,000 dollars.

The models which cadets are required to copy when they first enter the drawing-class at West Point are what are known as "topographical conventional signs." They illustrate the mode of depicting, with pen and ink, the various topographical features of a country, such as water, hills, trees, cultivated ground, etc. In a much shorter time than seemed possible, Whistler had finished the copy of the model given to him, and his work was most exquisite, far surpassing the model itself in accuracy and beauty of execution. Professor Weir then brought from the picture gallery a large painting, containing many figures, and directed Whistler to prepare a board with drawing paper, and copy this picture upon it with pen and ink.

Whistler was very near-sighted, and in making drawings he would first fix his eyes near a portion of the model, and then proceed to copy it upon his drawing board. He never drew any outline of the work he was copying. He seemed to work at random, and in this instance he displayed one of his favourite tricks, which was to draw first, say a face, from the model, then a foot, then the body, skipping from one part of the picture to another, apparently without keeping any relation of the parts. But when the picture was completed, all the parts seemed to fit together like a mosaic. And it was a complicated piece of work. This remarkable copy by Whistler was placed in the picture gallery at West Point.

Professor Weir's assistant in the drawing class, one Lieutenant S——, was apparently jealous of Whistler's talent, and of the value the professor appeared to place upon his work. On one occasion Whistler was painting in water-colours from a picture representing the interior of a cathedral, with monks and nuns scattered about. Behind the tonsured head of one of the monk's Whistler had painted a shadow; Lieutenant S——, in making his rounds of examination of the work of the students, paused at Whistler's seat, and said, very audibly:

"Your work, sir, is faulty in principle. What is the meaning of that shadow? There is none in the model, and you should know better, for by no principle of light and shade could any shadow be there. Why, there is nothing to cast it." Without saying a word, Whistler filled his brush, and with one sweep of it he threw a cowl over the head of the monk. He had painted the *shadow* first. Lieutenant S—— walked quietly away, without a word.

Professor Robert Walter Weir (1803–89) first taught drawing at West Point Military Academy in 1834 and remained there for more than forty years. (See Irene Weir, Robert W. Weir, Doubleday, New York 1947.)

Neither this nor the watercolour copy described in the next paragraph seems to have survived.

JOHN ROSS KEY

CENTURY MAGAZINE

"Recollections of Whistler while in the Office of the United States Coast Survey"

April 1908

John Ross Key worked as a draughtsman for the Coast Survey in Washington, which was founded in 1807 and became the United States Coast and Geodetic Survey in 1878. Although Whistler was there for only three months – between November 1854 and February 1855 – the experience was crucial because it was there that he learned to etch.

Years ago the offices of the United States Coast Survey were located in three or four old houses two or three squares south of the Capitol. Captain Benham, afterward General Benham, U.S.A., was in charge. During the winter of 1853-54, the drawing department, which was in charge of Captain Gibson, was moved to a new building, which was one of three newly erected a few doors south of the main office.

A short time after the removal to the new quarters, the corps of draughtsmen was increased by a new member, who was introduced as Mr James Whistler. He was a slender young man of medium height, with dark, curly hair and a small moustache. A Scotch cap was set well forward over his eyes, and he wore a shawl of dark blue and green plaid thrown over his shoulders, as was the fashion of the day. He was assigned to a room on the third floor, adjoining the one where I was employed as a draughtsman, and we soon became good friends.

Captain Henry Washington Benham (1813–84), Union General, graduate of West Point Military Academy (1837), became Chief Engineer, Department of the Ohio, in 1861.

It was reported about the office that Whistler had been at West Point, and that his disinclination to obey rules, chief of which had been his lack of promptness, had led to his retirement. His artistic ability, which had been recognized at West Point, induced Captain Benham, who was a friend of Whistler's father, to give the young man a position in the drawing department of the Coast Survey. I also remember hearing it stated at that time that Professor Weir, the artist who painted the picture of the *Embarkation of the Pilgrims* for the rotunda of the Capitol at Washington, and instructor of drawing at West Point, had declared that "Whistler with only the most ordinary industry would make a name as an artist."

It was not long before it was seen that Whistler's mind was wandering from his work. He did not appear to be interested or to have any definite idea of what was to be done, and his experiments in map-drawing were not successful.

His artistic feeling, however, found expression in any number of clever, droll or humorous sketches, made without effort on the margins of his map failures, or on bits of paper, which he kept on his table. His keen sense of humour frequently led him to attempt to illustrate some character in song or story.

A droll figure of lugubrious expression, hat in hand, illustrating a line from an English song, "All around me 'at I wears a green willow," was one of the drawings which he gave to me when I had watched him complete it.

A little water-colour which he did at this time, and which I much coveted, was claimed from his hands by Mr Martin, an elderly gentleman employed as a draughtsman, and a friend of Captain Benham and Whistler's father. It illustrated the Cobbler, in *Pickwick Papers*, who had been imprisoned for debt. His friends, visiting him, found him lying on a blanket under a table. Replying to their inquiries as to his unusual position, the prisoner explained that he had always been accustomed to a four-poster, and could not sleep without one. It was a charming bit of colour, subdued and soft in tone, appropriate to the subject. Many years afterward I met Mr Martin at the home of General Benham in Boston, and he told me with much satisfaction that he still had the little picture in his possession. It impressed me as being the only drawing that I ever saw Whistler make at that time which could be called a picture.

1837 by Charles Dickens (1812–70). See Colourplate 3.

So strong was his proclivity to sketch what was in his mind that a bare white wall offered temptation not to be resisted, and the wall along the stairs leading down to the superintendent's room was soon covered by Whistler with pencil-sketches of soldiers fencing, soldiers on parade, at rest, or in action, and various little heads. He frequently stopped on his way up or down to correct or add to these drawings. During this time I never knew him to attempt to portray the features of those about him, until one day he took up one of my crayons and began to draw me as I sat at my student's sketch-board. He was not pleased with his effort, and finally threw the half-completed sketch upon the floor; but when I asked him to finish the drawing, he picked it up, and rubbed and erased it several times, something I had never seen him do before. Mr Martin, who always showed the liveliest interest in Whistler's sketches, looked on for a moment, and said reprovingly to me, "You have worried Whistler so much that he can't draw." Much displeased with his effort, Whistler again threw the sketch upon the floor, and I picked it up and put it away. It is here reproduced for the first time, with the permission of the painter's executor, his sister-in-law, Miss Birnie-Philipps [sic].

It seemed that it was only the creations of his own brain or his own ideas that formed so freely under his pen or pencil. The accuracy required in the making of maps and surveys, where mathematical calculations are the foundation of projections upon which are drawn the topographical or hydrographical conventional signs, was not to Whistler's liking, and the laborious application involved was beyond his nature, or inconsistent with

Rosalind Birnie Philip (1873–1958), daughter of the English sculptor John Birnie Philip, was twenty–two when her elder sister Beatrice, Whistler's wife, died in 1896; whereupon Whistler made her his ward and executrix. She bequeathed her Whistler collections to Glasgow University.

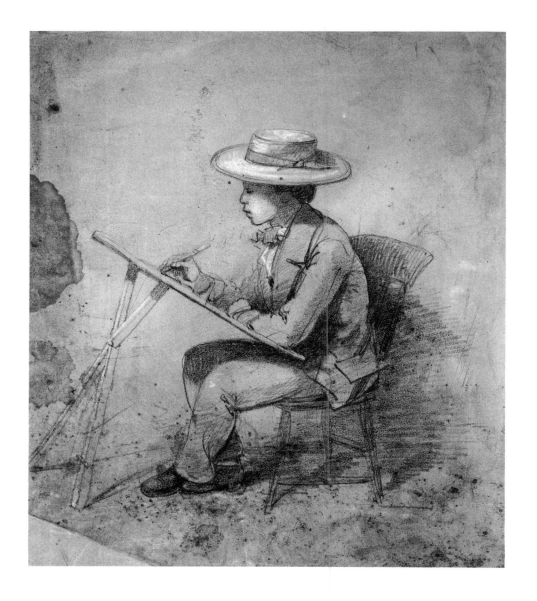

Portrait of John Ross Key. 1854. Crayon, white chalk on brown paper, 20¼ × 12½″ (51.5 × 31 cm). Freer Gallery of Art, Smithsonian Institution, Washington, D.C.

it. He was preoccupied in those days with producing the soldiers and heads of his fancy, and when he had completed a bit that pleased him, he signed it with the intials J. W. I cannot remember hearing him laugh, and he seldom smiled. Neither can I remember ever seeing him ill-natured or in a bad temper.

When, after many trials, it was plain that he would not take to map-drawing, it was suggested that he might etch the little views of entrances to harbours that were then engraved upon the lower part of coast-maps.

As I had been in the office some time and had made friends with the engravers, I went with Whistler to introduce him to the men in that department. Mr McCoy, one of the best engravers in the office, a kindly, genial Irishman, always ready to aid or advise the younger men, listened while I explained our mission. He then went over the whole process with us – how to prepare the copper plate, how to put on the ground, and how to smoke dark, so that the lines made by the point could be plainly seen.

For the first time since his entrance into the office Whistler was intensely interested. Always sedate, he was also singularly indifferent, but on this occasion he seemed to realize that a new medium for the expression of his artistic sense was being put within his grasp. He listened attentively to McCoy's somewhat wordy explanations, asked a few questions, and squinted inquisitively through his half-closed eyes at the samples of work placed before him. Having been provided with a copper plate, such as was kept for the use of beginners, and an etching-point, he started off to make his first experiment as an etcher. I watched him with unabated interest from the moment he began his work until he completed it, which took a day or two. At intervals, while doing the topographical view, he paused to sketch on the upper part of the plate, the vignette of *Mrs Partington* and *Ike*, a soldier's head, a suggestion of a portrait of himself as a Spanish hidalgo, and other bits, which are the charm of the work.

The Coast Survey Plate,
K. (Kennedy) 1. 1855–6.
Etching, 5¼ × 9¾″
(14.5 × 25.9 cm). Freer Gallery of
Art, Smithsonian Institution,
Washington, D.C.

The benevolent village gossip Mrs Partington and her mischievous nephew Ike appear in the Life and Sayings of Mrs Partington *(1854) by the American humorist B. P. Shillaber.*

After he had finished etching, I watched him put the wax preparation around the plate, making a sort of reservoir to hold the acid, as McCoy had instructed. Then he poured the acid on the plate, and together we watched it bite and bubble about the line, as with a brush he carefully wiped the line to prevent the refuse accumulating and biting unequally. When it was decided that the plate was bitten sufficiently, and the acid was poured off, and the wax removed, we went again to McCoy to ask him how to get the ground off. I do not now recall McCoy's instructions, but I believe we were told to heat the plate. Finally we went to the basement, where the printer washed the plate, and an impression was then taken of Whistler's first etching. While we were engaged in examining the proof, Captain Gibson came along, and inquired of me if I did not think that Whistler could do his work without suggestions from me. I was therefore forced to return to my tedious task of map-making.

The result of Whistler's experiment sank deep into my mind, and I resolved to attempt this line of work myself at the first opportunity. One day when I returned from my vacation, I found that Whistler was no longer connected with the office. I have heard it stated that he lost his position because of the drawings on this plate, but there is no foundation for this report. As I have explained, this plate was merely an experiment, intended as such. Had it been actual work, it would have been etched upon the lower part of one of the large plates upon which the maps were engraved, as is shown on a coast view which Whistler did later, and which was published by the Coast Survey office, a copy of which is now in the Lenox Library. With the intention of taking up etching myself, I one day went into that department, where small pieces of copper were given out to beginners. Among the scraps of copper I found Whistler's first plate. "Yes, you can take that, and have it cleaned off," the man in charge told me. When I had explained that I preferred to keep the plate as it was, I paid the small amount charged for the copper, and carried home my prize. I kept it as one of my treasures for over forty years. When I went abroad, I took it with me, intending to return it to Whistler; but unfortunately he was away from London every time I called to see him.

The hours of the Coast Survey offices were from nine until three; but Whistler invariably came late to work. He lived on Thirteenth Street, near Pennsylvania Avenue; but as he would not get up in time in the morning, he frequently missed his breakfast, and soon got into the way of going to a restaurant for his meals. An excellent restaurant and confectionery store was then kept in the vicinity by Mr and Mrs Gautier. They had taken a fancy to Whistler, and always made an effort to get him whatever he desired. He seemed to have charmed them into bestowing upon him and his friends extra attentions, and I was frequently invited to join him and share his good fare.

We often played billiards in the evening at a room on the corner of Thirteenth Street and Pennsylvania Avenue, where we met other youths and young men, who gathered there to play the game. I could play more than ordinarily well, but Whistler was so painfully near-sighted that he played badly, and I remember that when he lost a game, he would pitch down his quarter of a dollar, the price of the game, exclaiming, "Here goes my breakfast – " this I fancy, from a sense of humour over the shortness of his purse, rather than from any real need, as he was then boarding with the Gautiers. I do not recall his making any intimate friendships with those whom he met either at the billiard-room or in the office, and he was not interested in young ladies. He rarely drew pictures of women except of the Mrs Partington type – characters in books he had read. He had no bad habits, and did not smoke. His manners were quiet and sedate, and his attractive personality interested every-one with whom he came in contact, and I never knew any one to say an unkind word of him. If he had any pecuniary troubles at that time, he kept them to himself.

The Standard Bearer. 1855.
Lithograph, 8 × 5⅝"
(20 × 14.2 cm). Library of
Congress (Division of Prints and
Photographs), Washington, D.C.

An Artist in his Studio. c. 1856. Ink, pencil, diameter 9¼″ (23.4 cm). Freer Gallery of Art, Smithsonian Institution, Washington, D.C.

THOMAS ARMSTRONG

A MEMOIR

Whistler in Paris

1912

The English artist Thomas Armstrong, CB (1832–1911), studied in Paris under Ary Scheffer and probably first met Whistler, who had arrived in Paris in November 1855, the following summer. He later developed a decorative style of figure painting not unlike that of Whistler and Albert Moore (see page 85).

Whistler took up etching in Paris in 1857, a process with which he was already familiar from some practice he had had while engaged on a government survey in the United States, but I don't think he told us this. He was very keen about it, and suggested that we should all get plates and try our hands. It was decided that each should choose his own subject, and that prints from the plates should be sent to some literary person in England and he should build up from them a story for publication to be called *Plawd*, a word composed of the first letters of our names – Poynter, Lamont, Armstrong, Whistler and du Maurier. We were very vague about the prospective writer of the text, who was spoken of as the "literary bloke."

Three of them were executed, Whistler's represented an interior. I don't remember it well, but I think it was, in composition, something like Tassaert's well-known picture in the Luxembourg, a garret with female figures. Poynter's was in the style of the illustrations to Balzac's *Contes Drolatiques* [Ribald Tales] by Doré, his best work, with which we were all much impressed at that time. It represented a French castle with many turrets dark against the sky, and from the upper part of it a beam or gallows projected with a skeleton dangling from it.

Sir Edward John Poynter R.A. (1836–1919), painter of history subjects in the neo-classical French style; Thomas Reynolds Lamont (1826–98?) Scottish genre and watercolour painter; George Du Maurier (1834–96), graphic artist and Punch *illustrator (see page 59).*
Octave Tassaert (1800–74); his An Unfortunate Family *or* The Suicide *(1850–51) drew particular attention because its subject reflected current social concerns.*
Gustave Doré (1832–83); Contes drôlatiques *("Ribald Tales"), 1855.*

* * *

I have a most vivid recollection of my first sight of Whistler, as vivid almost as that of my first meeting with du Maurier, and no wonder, for his appearance, at all times remarkable, was on that occasion most startling, "mirabolant," as one used to say. I remember the exact spot at the corner of the Odéon Theatre where I first caught sight of him, and his image rises before me as I think of it. It was in the warm weather of August or September, and he was clothed entirely in white duck (quite clean too!), and on his head he wore a straw hat of an American shape not yet well known in Europe, very low in the crown and stiff in the brim, bound with a black ribbon with long ends hanging down behind. At that time, and long afterwards, the ringlets of his black curly hair were much longer than he wore them when he became well known in London, and the white hairs were not carefully gathered into one lock.

* * *

For a time Poynter and Whistler shared rooms, and afterwards when Poynter went to the Rue Jacob, where he lived for a considerable time, Whistler took up with a very nice little fellow called Aubert, who was employed in the Crédit Mobilier. His services there brought him a very exiguous salary, but he was always neatly dressed and looked very clean, and we all liked him.

When this partnership had been running a little while, the eyes of both were opened to the fact that the monthly allowance each of them had dwindled away to nothing long before the next pay-day came round; so they laid their heads together to evolve some economic system by which their finances should be put upon a better footing. And this is what they did. Pillboxes of various sizes were procured from the druggist; there were a few large ones for the month's rent, for the crêmerie where they took their morning coffee, and for the pension where they had lunch and dinner. Perhaps there may have been another for the washerwoman, but there were thirty little ones, each containing the small sum set aside for daily incidental expenses, "menus plaisirs," such as drinks and tobacco. This system seemed very delicately contrived and balanced, Aubert being, you see, a bank clerk; and you will probably be surprised to hear that at the end of the first fortnight our friends found all the thirty little pillboxes quite empty, and there was, moreover, nothing in the bigger ones. I don't think there is anything quite like that in Murger's book.

During the time I was working in the Luxembourg Gallery Whistler made copies of portions of two pictures, the nude figure of Angelica chained to the rock in Ingres's picture and a group in Couture's *Décadence des Romains* [Decadence of the Romans]. The painting of the former was not a bit like that of Ingres, for it was done in a thin, transparent manner, with no impasto and hardly enough paint to cover the canvas, also the colour of it was warmer and richer than that of the original. When we reproached Jimmy with not putting more paint on, he replied that the price he was to be paid would not run to much more than good linseed oil, for he was to have only one hundred francs apiece for the copies. The order was given him by a whaling captain whose acquaintance he had picked up somehow. There were to be four pictures, and I believe the other two were chosen by his patron from the Louvre collection. I mention these copies because I never saw any other specimens of Whistler's painting while I was in Paris, and I do not know of any coming between them and *La Mère Gérard* [Mother Gérard], which was done after I had returned to England.

He had a strange habit of picking up acquaintances in cafés and other places. I cannot remember how he met the whaling captain who ordered the four copies, but I have a distinct recollection of his foregathering with an extraordinary Irishman at the well-known brasserie on the eastern side of the École de Médecine, at that time much frequented by Champfleury, Courbet, and disciples of the Realist school. It was a dark, dingy place with wooden tables, but had a great renown for its excellent Strasbourg beer.

At the Sixth, K.3. 1857. Etching, 4¼ × 3″ (10.8 × 7.7 cm). Hunterian Art Gallery, Glasgow University (J. W. Revillon Bequest).

[Crédit Mobilier] *a personal finance house or bank; Whistler's biographers, the Pennells (see page 104), described Aubert as "the first man he knew in Paris, a clerk in the Crédit Foncier" (real estate).*

YMSM 11. Ingres' Roger rescuing Angélique *of 1819 entered the Luxembourg Museum in 1824 and was transferred to the Louvre in 1874 (see Colourplate 7); YMSM 18. Thomas Couture's* Decadence of the Romans *(Louvre, Paris) was bought from the Salon of 1847 and exhibited at the Luxembourg Museum from 1851.*
Three further copies by Whistler after works by Mignard, Greuze and Velazquez, all of which are in the Louvre, have been recorded. (YMSM 12, 14 and 19.)

COLOURPLATE 8 (YMSM 26).

Champfleury – the pen name of the Realist writer and critic Jules Francois Félix Husson (1821–89); Gustave Courbet (1819–77), the French artist and leader of the Realist school of painting foregathered with his followers at the Café Andler.

I have always thought that Whistler learnt much from Courbet, who was a very skilful painter, and, I should think, a very good teacher. The first important recognition of Whistler's talent I ever heard of came from him when, after criticizing the studies from living models that were being done at Bonvin's, he exclaimed, pointing to Whistler's little picture called *La Mère Gérard* [Mother Gérard], "Mais que voulez-vous que je vous dise? ça y est – quoi!" [What can I say? That's it!].

Many people have heard the story, I expect, of how Whistler, after being away from Paris for some time, was walking with friends up the Rue de Vaugirard towards the place where the Mère Gérard used to sit selling violets under the grille of the Luxembourg Gardens. It was proposed that one of them should go on in front and tell her that he (Whistler) was dead. Jimmy was to go to the other side of the railing to hear what she would say. The listener did not hear any good of himself. The old woman could not easily be made to understand what they were telling her, so they explained that it was about the artist who had done her portrait. "Eh bien, quoi?" "Eh bien, il est mort." "Voila une fameuse canaille de moins," [Really? Oh well, so he's dead. That's one good-for-nothing less!] was her only remark. I have always felt grateful to Whistler for telling us this funny story against himself.

<p align="center">* * *</p>

The Art Treasures Exhibition held in Manchester in 1857 was a memorable event, and a visit Whistler made to it had no little influence on him. . . .

It was in the summer of 1857 that Whistler, who had heard of the fine pictures lent to the Exhibition, turned up at our studio one morning to tell us he much wanted to go to Manchester with "le petit Martin," a fellow student at Gleyre's and a son of Henri Martin, the well-known historian, who was setting off in a few days. There was a little difficulty, however, as to ways and means, and he wanted to know if, in our opinion, it would be expedient for him to ask for a loan from M Bergeron, a sort of connection of his, who was, I think, engineer of the Northern of France railway [sic], and who had before acted as a Providence to him. . . .

It was that visit to Manchester, when he saw very fine specimens of the work of Velazquez, which began to bring about the appreciation of the Spanish painter, whom he afterwards, so to speak, took into partnership. Before that time I think we had all learnt to admire his *Infanta Margaret* in the Louvre, but Velazquez was not much talked about in those days. According to the public taste, *The Immaculate Conception*, by Murillo, bought about 1857 from Marshal Soult's collection for the Louvre at the price of £23,000, was the most precious picture in the world.

<p align="center">* * *</p>

I never knew Ernest, one of Whistler's most intimate friends, with whom he made the tour in Germany. Their money ran short through the miscarriage of a letter, so they had to go on foot, and they did pencil portraits of the inhabitants of villages they passed through to pay their expenses, at first charging a thaler each for them, and at last in dire necessity having to do them for a groschen. The bellman was generally sent round to announce the arrival of two distinguished artists from Paris; I think some of the etchings in the first set of twelve were done during this walking tour. The journey was made memorable to many of us by the inimitable way in which Whistler related their adventures. There never was such a raconteur, I verily believe. As for his story-telling at that time, you may say of it what Courbet said of the painting of *La Mère Gérard* [Mother Gérard]. He gave one the most vivid impression of their wanderings. The account of his lying ill in the hospital in Paris was equally vivid, and for the most part this was very funny, but there were pathetic passages.

In May 1859 Whistler and Henri Fantin-Latour exhibited their paintings, originally refused at the Salon, in the studio of the Realist painter, François Bonvin, at 189 rue St Jacques.
There are two undated etchings by Whistler of Mother Gérard *(K. 11 and 12) and a second oil painting recorded (YMSM 27).*

The Manchester exhibition consisted of over 1,000 pictures by Old Masters (including Rembrandt and Velazquez) and over 700 works by living British painters.

The French historian Henri Martin (1810–83); Charles Gleyre (1808–74), French history painter and academician whose studio Whistler entered in June 1856.
Charles Bergeron married Francis Seymour Haden's elder sister Emma, who according to Whistler's mother was "as a sister to him."
Ernest Delannoy, a French artist, and close friend of Fantin-Latour as well as of Whistler, was, according to the Register of Copyists in the Louvre, born in either 1831 or 1832; the Rhine journey Whistler made with Delannoy resulted in his first independent etchings, Twelve Etchings after Nature, *commonly known as "The French Set."*

Street at Saverne, K.19(iv). 1858.
Etching, 8⅛ × 6³⁄₁₆″
(20.8 × 15.7 cm). Hunterian Art Gallery, Glasgow University (J. W. Revillon Bequest).

La Mère Gérard [Mother Gérard] was the earliest exhibited picture by
Whistler, and I think it was also the earliest original work in oil. He was
supposed to be a student at Gleyre's atelier at this time, but he did not
work much there or elsewhere. I have been told lately that a letter to
Fantin is in existence in which Whistler expresses regret at not having
been a pupil of Ingres. Perhaps he might have been more regular for a
while in attendance at the atelier with the influence and prestige of
Monsieur Ingres to bear on him, but I don't think he would.

* * *

*The letter referred to was written in 1867 (see
pages 82–84).*

Among the early etchings by Whistler, in the set of twelve, if I am not
mistaken, there is one of a seated figure of a girl, with long hair hanging
loose about her shoulders and with a basket in her lap. This was done from
Héloïse, a girl-model well known in the Quartier. She was a remarkable
person, not pretty in feature, and sallow in complexion, but with good eyes
and a sympathetic sort of face. As this was long before the fashion came in
for women and children to wear their hair hanging loose, and not in plaits
down their backs, Héloïse attracted the notice of passers-by almost as
much as Whistler did when he was wearing "more Americano," his
summer suit of white duck, with the jaunty little flat-crowned Yankee hat.
She used to go about bareheaded and carrying a little basket containing
the crochet work she was in the habit of doing, and a volume of Alfred de
Musset's poems. This little pose added to the interest excited by her
flowing locks and her large eyes. She was a chatterbox, and at times
regaled us with songs, rather spoken than sung, for she had not much
voice or power of musical expression.

Known as Fumette, *above.*

*Alfred de Musset (1810–57), French
Romantic poet, novelist and dramatist.*

* * *

In this Héloïse were some slight suggestions for the character of Trilby,
but only in the basket of work and in the book, and I know of no other
female inhabitant of the Quartier Latin who had any of the characteristics
of du Maurier's heroine. I am very sorry and feel like an imposter, but
really this Héloïse is as near as I can get to the original of Trilby.

Trilby was the heroine of Du Maurier's novel
Trilby *(1894), based on his experiences in
Paris (see page 59).*

TOM TAYLOR (?)

THE TIMES

"Exhibition of the Royal Academy"

17 May 1860

The name of Mr Whistler is quite new to us. It is attached to a large sketch, rather than a picture, called *At the Piano*. This work is of the broadest and simplest character. A lady in black is playing at the piano, while a girl in white listens attentively. In colour and handling this picture reminds one irresistibly of Velazquez. There is the same powerful effect obtained by the simplest and sombrest colours – nothing but the dark wood of the piano, the black and white dresses, and under the instrument a green violin and violoncello case, relieved against a greenish wall, ornamented with two prints in plain frames. Simpler materials could not well be taken in hand; but the painter has known what to do with them. With these means he has produced what we are inclined to think, on the whole, the most vigorous piece of colouring in this year's exhibition. The execution is as broad and sketchy as the elements of effect are simple; but if this work be the fair result of Mr Whistler's own labour from nature, and not a transcript or reminiscence of some Spanish picture, this gentleman has a future of his own before him, and his next performance should be curiously watched.

Tom Taylor (1817–80), dramatist and editor of Punch, *was for many years art critic for* The Times *and the* Graphic.

At the Piano (Colourplate 13, YMSM 24) is set in the music room of Whistler's brother-in-law Haden's house, 62 Sloane Street, and shows his wife, Whistler's half-sister Deborah, and her daughter Annie. It was bought for £30 from the Royal Academy exhibition of 1860 by John Phillip RA, the artist known as "Spanish Phillip" because of his propensity for Spanish genre subjects.

GEORGE DU MAURIER

Letters to his Mother

May 1860–April 1861

Jemmy is going to introduce me to Keene who is a friend of his, and he says a very nice fellow, with more work on his hands than he can do. Mr W. also going to introduce me to publishers, ce qu'il en connait [he knows of]. . . . You've no idea of the kind welcome from O'Connor and Whistler; the others I've not yet seen. I must now tell you about Jemmy since there is not much more to say at present about your unappreciated Kycke. I have seen his picture, out and out the finest thing in the Academy. I have seen his etchings, which are the finest I *ever* saw. The other day at a party where there were swells of all sorts he was introduced to Millais, who said: "What! Mr Whistler! I am very happy to know – I never flatter, but I will say that your picture is the finest piece of colour that has been on the walls of the Royal Academy for years." What do you think of that old lady? And Sir Charles Eastlake took the Duchess of Sutherland up to it and said "There Ma'am, that's the finest piece of painting in the Royal Academy."

But to hear Jemmy tell all about it beats anything I ever heard. A more enchanting vagabond cannot be conceived. He will introduce me to his brother-in-law etc. and I shall not lack nice houses to go to.

* * *

George Louis Palmella Busson Du Maurier (1834–96), graphic artist and illustrator, designer of wood engravings for numerous publications, including satires on bourgeois and aesthetic society for Punch. *His hugely successful novel* Trilby, *first serialized in* Harpers Monthly Magazine *in 1894 and based on memories of his days in Paris, caused deep offence to Whistler who threatened to sue Du Maurier for representing him as "Joe Sibley," the "Idle Apprentice," a character Du Maurier was obliged to drop from the published novel.*
Charles Samuel Keene (1823–91), English graphic artist and Punch *illustrator, whose work Whistler very much admired.*
Probably William Henry O'Connor who studied with Whistler in Gleyre's studio in Paris, and who exhibited literary and biblical subjects at the Royal Academy between 1859 and 1865.
[Kycke] Du Maurier's family nickname.
COLOURPLATE 13 (YMSM 24).

Sir John Everett Millais, Bt. (1829–96); Sir Charles Lock Eastlake (1793–1865).

The Music-Room, K.33. 1858.
Etching, $5^{11}/_{16} \times 8^{5}/_{16}''$
(14.4×21.7 cm). Hunterian Art
Gallery, Glasgow University.

. . . If I had barely an existence I should etch, as I feel sure my etchings would be wonders like Jimmy's. Fancy Jimmy's first set of etchings, a dozen (the whole set sold for two guineas), brought him in 200£ and he has just sold the twelve plates for another 100£, that makes each etching twenty-five guineas, and I for a drawing on wood, more elaborate, only get three. And he doing anything he likes, while my subjects are cut out for me. If I could only work at etchings for three summer months I may perhaps be able to combine the two. Jimmy's later etchings, those of the Thames, which are most *magnificent*, have not sold so well, but because he asks most exorbitant prices for them, one and two guineas a proof – but however, all will turn out well in the end I suppose.

"The French Set" was printed in Paris by Auguste Delâtre (see pages 57 and 167), and dedicated to Whistler's brother-in-law Haden who published them at Christmas 1858. Whistler sold the plates to the London print dealer Serjeant Thomas who exhibited the "Thames Set" etchings at his gallery, 39 Bond Street, in 1861.

CHARLES BAUDELAIRE

LE BOULEVARD

"Painters and Etchers"

14 September 1862

We should like to believe that, thanks to the efforts of artists as intelligent as MM Seymour Haden, Manet, Legros, Bracquemond, Jongkind, Meryon, Millet, Daubigny, Saint-Marcel, Jacquemart and others whose names for the moment escape me, etching will regain its old vitality; whatever may be said, however, let us not hope that it win as great a popularity as it did in London, in the heyday of the Etching Club, when even fair "ladies" prided themselves on their ability to run an inexperienced needle over the varnished plate. A typically British craze, a passing mania, which would bode ill for us.

Just the other day a young American artist, M Whistler, was showing at the Galerie Martinet a set of etchings, as subtle and lively as improvisation and inspiration, representing the banks of the Thames; wonderful tangles of rigging, yardarms and rope; farragos of fog, furnaces and corkscrews of smoke; the profound and intricate poetry of a vast capital.

Charles Baudelaire (1821–67), the poet of Les Fleurs du mal *(1857), also wrote Salon reviews and championed Romantic painting, particularly that of Delacroix. This, the only mention of Whistler in Baudelaire's published writings, concerns a group of the "Thames Set" etchings which were exhibited in Paris early in 1862. Significantly, the article was first published with the title* L'eau forte est à la mode *(Etching is in Fashion).*

Édouard Manet (1832–83); Alphonse Legros (1837–1911); Félix Bracquemond (1833–1914); Jean-Barthold Jongkind (1819–91); Charles Méryon (1821–68); Jean François Millet (1814–75); Charles François Daubigny (1817–78); Charles Edmé Saint-Marcel-Cabin (1819–90); Jules-Ferdinand Jacquemart (1837–80). The Etching Club was founded in London in 1838. Haden became a member in 1860. In 1859 Whistler was elected a member of the Junior Etching Club which was dissolved in 1864.

ARTHUR SEVERN

Recollections

1908

"My first recollection of Whistler was at his brother-in-law's, Seymour Haden (he and Du Maurier were looking over some *Liber Studiorum* engravings), and then at Arthur Lewis' parties on Campden Hill, charming gatherings of talented men of all kinds, with plenty of listeners and sympathizers to applaud. It was at these parties the Moray Minstrels used to sing, conducted by John Foster, and when they were resting any-one who could do anything was put up. Du Maurier with Harold Sower used to sing a duet, *Les Deux Aveugles* [The Two Blindmen]; Grossmith half-killed us with laughter (it was at these parties he first came out). Stacy Marks, too, was always a great attraction, but towards the end of the evening, when we were all thoroughly in accord about everything, there used to be drowning yells and shouts for Whistler, the eccentric Whistler! He used to be seized and stood up on a high stool, where he

The English painter Arthur Palliser Severn (1842–1931) is best remembered for his long association with John Ruskin (to whom he rendered practical assistance with the libel suit Whistler brought against him in 1878, see page 128), and for a series of recollections he later wrote concerning the great critic.

The series of landscape engravings the painter J. M. W. Turner published after his own work. Arthur J. Lewis, amateur artist, partner in the drapery firm of Lewis and Allenby in Regent Street; celebrated for the musical soirées centred on his choir The Moray Minstrels, named after Moray Lodge, Kensington, to which he moved in 1863. He later married the actress Kate Terry. John Foster, alto singer in the Choir of Westminster Abbey. Weedon Grossmith (1852–1919), humorist, writer, illustrator of his brother George's The Diary of a Nobody *published in* Punch *in 1852. Henry Stacy Marks RA (1829–98), genre painter.*

LEFT *Rotherhithe*, K.66(ii). 1860. Etching, 10¾ × 7¾" (27.5 × 19.9 cm). Hunterian Art Gallery, Glasgow University (J. A. McCallum Collection).

BELOW *Annie Haden*, K.62(iii). 1860. Drypoint, 13¾ × 8⅜" (34.8 × 21.4 cm). Hunterian Art Gallery, Glasgow University.

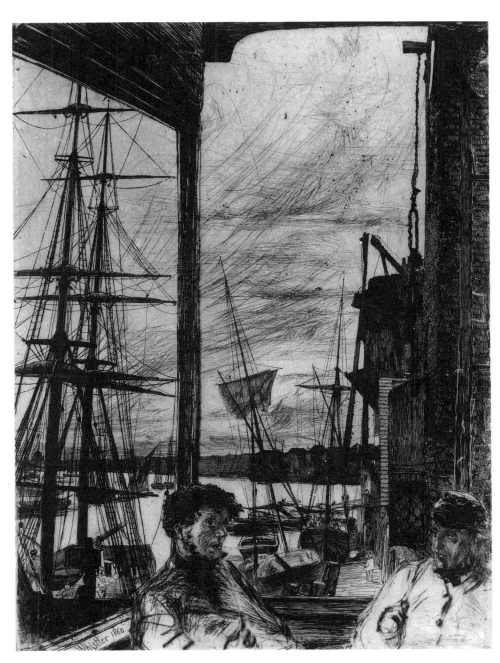

assumed the most irresistibly comic look, put his glass in his eye, and surveyed the multitude, who only screamed and yelled the more. When silence reigned he would begin to sing in the most curious way, suiting the action to the words with his small, thin, sensitive hands. His songs were in *argot* French, imitations of what he had heard in low *cabarets* on the Seine when he was at work there. What Whistler and Marks did was so entirely themselves and nobody else, so original or quaint, that they were certainly the favourites."

F. G. STEPHENS (?)

THE ATHENAEUM
"Fine-Art Gossip"
June-July 1862

Frederic George Stephens (1828–1907), an original member of the Pre-Raphaelite Brotherhood, produced few paintings; he subsequently turned to art criticism, particularly for The Athenaeum.

A new exhibition of pictures has been opened in Berners Street, with the avowed purpose of placing before the public the works of young artists who may not have access to the ordinary galleries. Although containing some amazingly ugly pictures, by untrained clever men, and a few very foolish ones, it must be admitted that the ability shown in the first consoles us for the pain of seeing the second class. The most prominent is a striking but incomplete picture, by Mr J. Whistler, *The Woman in White*, which, the Catalogue states, was rejected at the Royal Academy. Able as this bizarre production shows Mr Whistler to be, we are certain that in a very few years he will recognize the reasonableness of its rejection. It is one of the most incomplete paintings we ever met with. A woman, in a quaint morning dress of white, with her hair about her shoulders, stands alone, in a background of nothing in particular. But for the rich vigour of the textures, one might conceive this to be some old portrait by Zucchero, or a pupil of his practising in a provincial town. The face is well done, but it is not that of Mr Wilkie Collins's *Woman in White*. Those who remember the promise of this artist's *Lady at the Piano*, seen at the Academy, will gladly see it again here.

Whistler submitted The White Girl *(Colourplate 9) unsuccessfully to the Royal Academy in 1862, and then sent it to a mixed exhibition held at* The Picture Gallery, *14 Berners Street, between 1 June and 2 August 1862.*

A reference to the Zuccari brothers Taddeo and Federico, who towards the end of the sixteenth century represented the tail-end of the Mannerist tradition in Rome.
Wilkie Collins's novel The Woman in White *was remarkable for pioneering a new genre of "sensation" fiction, and enjoyed a colossal success when first published in 1859–60.*

* * *

We insert this explanation as desired:—

"62 Sloane Street, 1 July 1862

"May I beg to correct an erroneous impression likely to be confirmed by a paragraph in your last number? The Proprietors of the Berners Street Gallery have, without my sanction, called my picture *The Woman in White*. I had no intention whatsoever of illustrating Mr Wilkie Collins's novel; it so happens, indeed, that I have never read it. My painting simply represents a girl dressed in white standing in front of a white curtain. I am, &c.,

JAMES WHISTLER"

Whistler reprinted this, his first letter to the press, in The Gentle Art of Making Enemies *(1892).*

* * *

Mr Buckstone, of the Picture Gallery in Berners Street, writes to say, in reply to Mr Whistler's letter, that Mr Whistler was well aware of his picture being advertised as *The Woman in White*, and was pleased with the name. "There was no intention," Mr Buckstone adds, "to mislead the public by the supposition that it referred to the heroine of Mr Wilkie Collins's novel; but being the figure of a female attired in white, with a white background, with which no-colour the artist has produced some original effects, the picture was called *The Woman in White*, simply because it could not be called *The Woman in Black*, or any other colour."

From his letter to George Lucas (see page 63) it is evident that Whistler also appreciated the publicity which the notoriety of his picture brought.

JAMES MCNEILL WHISTLER

The Royal Academy Subject

14 October 1900

"Well, you know, it was this way. When I came to London I was received graciously by the painters. Then there was coldness, and I could not understand. Artists locked themselves up in their studios – opened the doors only on the chain; if they met each other in the street they barely spoke. Models went round silent, with an air of mystery. When I asked one where she had been posing, she said, 'To Frith and Watts and Tadema.' 'Golly! what a crew!' I said. 'And that's just what they says when I told 'em I was a'posing to you!' Then I found out the mystery: it was the moment of painting the Royal Academy picture. Each man was afraid his subject might be stolen. It was the great era of the subject. And, at last, on Varnishing Day, there was the subject in all its glory – wonderful! The British subject! Like a flash the inspiration came – the Inventor! – and in the Academy there you saw him: the familiar model – the soldier or the Italian – and there he sat, hands on knees, head bent, brows knit, eyes staring; in a corner, angels and cogwheels and things; close to him his wife, cold, ragged, the baby in her arms – he had failed! The story was told – it was clear as day – amazing! – the British subject! – What."

This anecdote of Whistler's was recorded by Elizabeth Pennell (see page 104) after a dinner party on 14 October 1900 at which were also present the Scots painter John Lavery, Miss Birnie Philip and Mr Harper, Professor of Assyrian at Chicago University. William Powell Frith RA (1819–1909), the creator of modern-life genre pictures, particularly Derby Day *and* Paddington Station, *whom Whistler held in particular contempt, especially after he gave evidence for Ruskin in the libel suit Whistler brought in 1878 (see page 128). George Frederic Watts OM, RA (1817–1904), painter of portraits and allegory. Sir Lawrence Alma-Tadema OM, RA (1836–1912), Anglo-Dutch painter renowned for his portrayal of lavish scenes from Roman life.*

JAMES MCNEILL WHISTLER

Letter to George Lucas

26 June 1862

I dare say you have given us both up and voted us both ungrateful and selfish long ago. I do not think we are either of us viciously so, and over and over again I have intended to write and thank you for the trouble you took with the easel which arrived safely. Enfin! It is the old story and I am a deuced bad correspondent, as George would tell you – but my friendship does not rust as readily as my pen, and I should like jolly well to see you again, old fellow, and indeed this autumn we shall probably return to Paris. In the meantime you ought certainly to come accross [sic] the Channel and let me lead you through the pictures in this great exhibition: – not, by the way that there are many there that worth the trouble [sic] – but perhaps a week or two you might manage to spend not unpleasantly in London. Will you come? I think we could get you a cheap room. You know that by Dieppe there are return tickets available for one month for £2-10-0 – Now then for my news – though I take it, you have heard it already through Fantin – *The White Girl* was refused at the Academy, where they only hung the Brittany sea-piece and the Thames Ice Sketch! both of which they have stuck in as bad a place as possible. Nothing daunted I am now exhibiting *The White Child* at another exposition, where she shows herself proudly to all London – that is all London who goes to see her. She looks grandly in her frame and creates an excitement in the artistic world here which the Academy did not prevent or foresee – after turning it out, I mean.

In the catalogue of this exhibition it is marked

"Rejected at the Academy"

Whistler's friend, the art collector and collector's agent George Aloysius Lucas (1824–1900) after graduating from West Point Military Academy in 1848, worked with Whistler's stepbrother George as a railroad engineer. He lived in Paris from 1857 and in 1861 was joined by the art collector William T. Walters of Baltimore. His friendship with Whistler terminated in about 1886 because of what he considered to be the latter's ill-treatment of Maud Franklin, Whistler's mistress (see page 250).

Us: Whistler is referring to Joanna Hiffernan, his Irish mistress and model for The White Girl *(Colourplate 9) and* The Little White Girl *(Colourplate 17). Whistler's half-brother George William Whistler (1822–69).*

The French artist Henri Fantin-Latour (see page 82); The Coast of Brittany *YMSM 37 (page 64) and* The Thames in Ice *YMSM 36 (Colourplate 10). Thomas de Kay Winans [overleaf] (1820–78), inventor and engineer, son of Ross Winans; related to Whistler through his sister Julia's marriage to Whistler's half-brother George. Henri Oulevey [overleaf], a close friend of Fantin and Whistler in Paris, was probably the Oulevay [sic] who exhibited at the Salon between 1865 and 1880.*

What do you say to that? Isn't that the way to fight 'em! Besides which it is affichéd all over the town as

> Whistler's
> Extraordinary
> picture
> The
> Woman in
> White

That is done of course by the directors but certainly it is waging an open war with the Academy. Eh?

Adieu mon cher! George comes from St Petersburg this September. Tom Winans is in England and will be in London in a day or two if he has not already arrived. One thing more – you are altogether mistaken if you class Fantin with loafers of the type of Oulevey. Fantin is, in every sense of the word, a thorough gentleman and I remember he said to you, apropos of the commission you were giving him, that he was very much engaged with some paintings he had then in hand. The more you know Fantin the greater will be your esteem for him and you can never think too highly of him both as an artist and a gentleman.

BELOW *The Coast of Brittany*. 1861. 34⅜ × 45½″ (87.3 × 115.8 cm). Wadsworth Athenaeum, Hartford, Connecticut (in memory of William Arnold Healy, given by his daughter Susie Healy Camp).

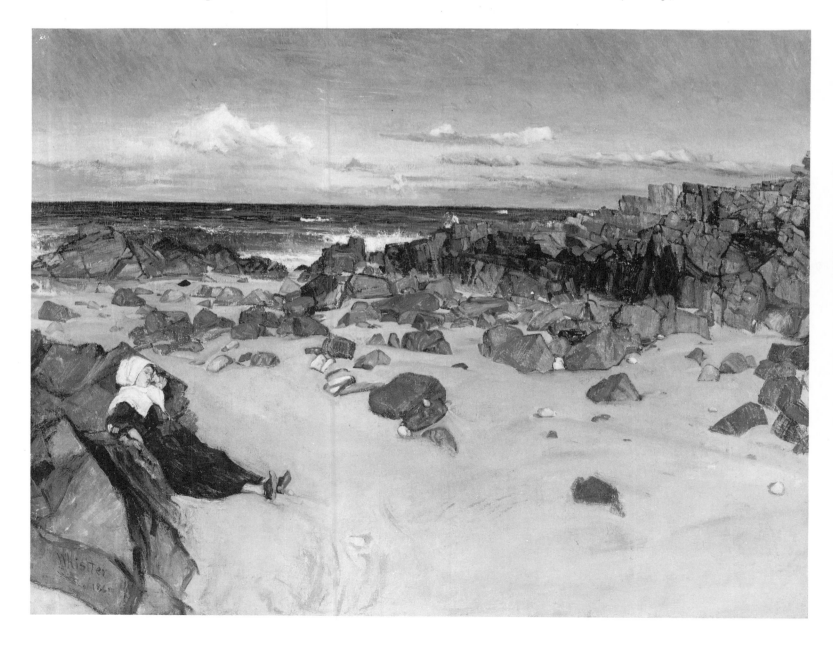

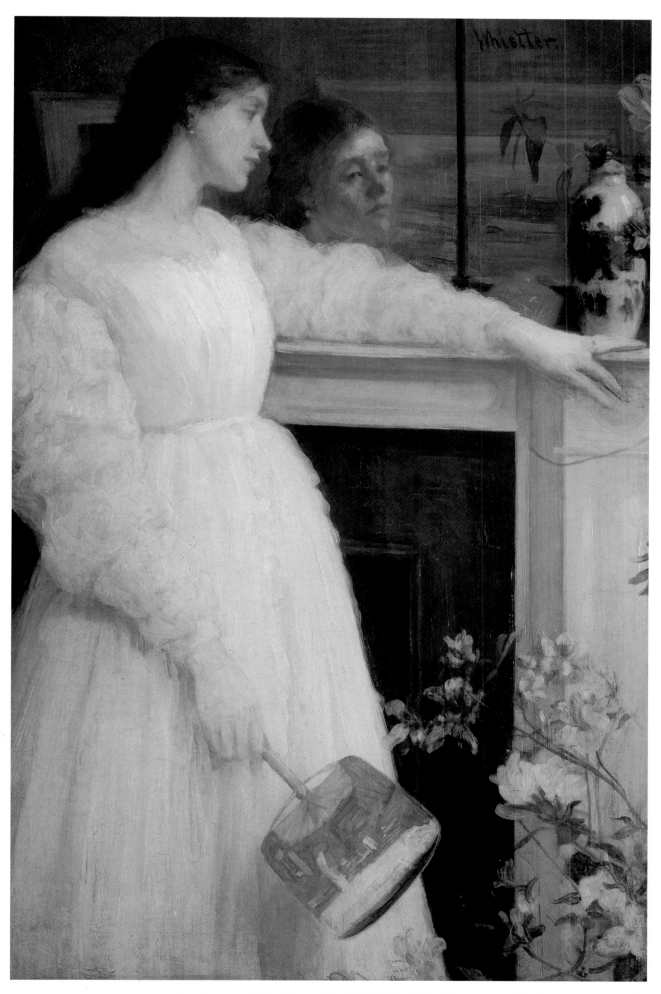

COLOURPLATE 17. *Symphony in White, No. 2: The Little White Girl.* 1864. 30 × 20″ (76 × 51 cm).
Tate Gallery, London.

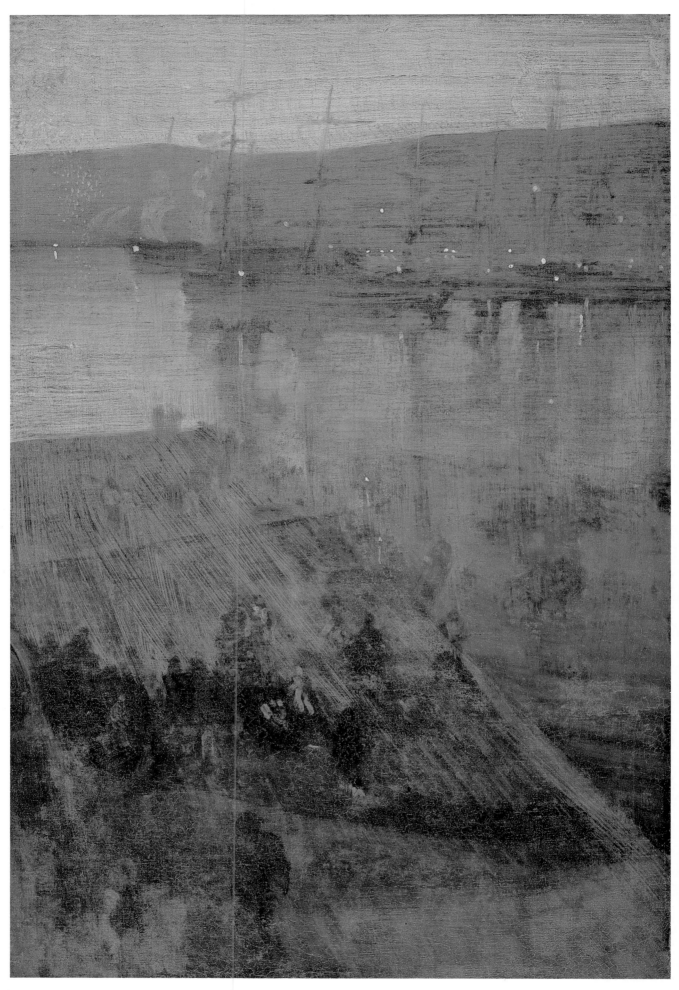

COLOURPLATE 18. *Nocturne in Blue and Gold: Valparaiso Bay.* 1866. 29¾ × 19¾″ (75.6 × 50.1 cm).
Freer Gallery of Art, Smithsonian Institution, Washington, D.C.

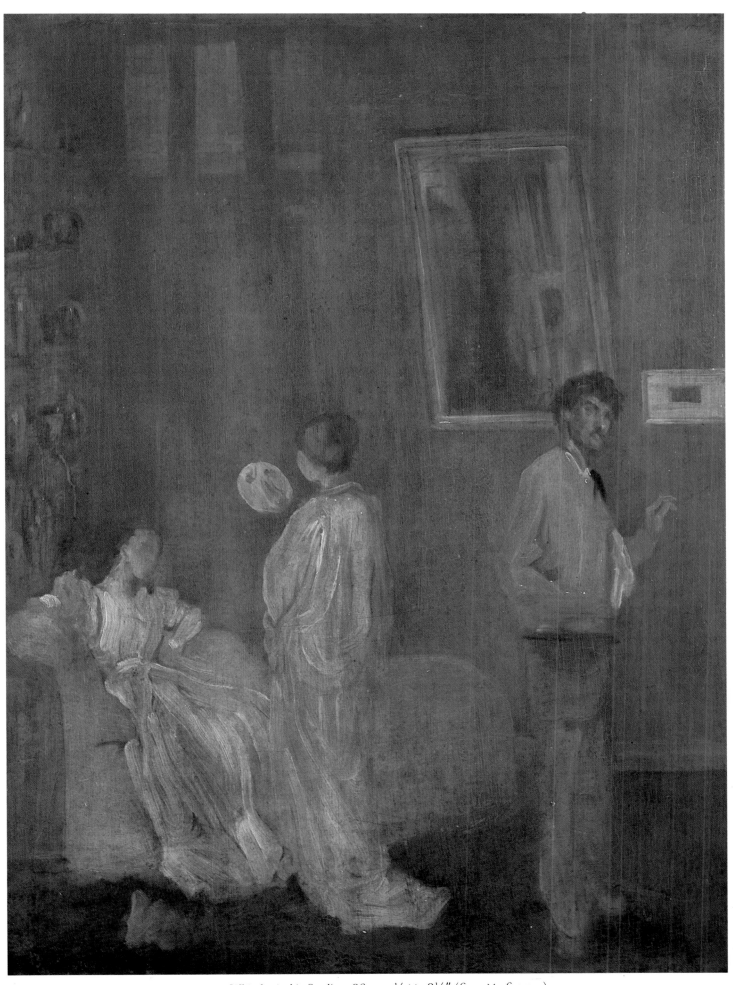

COLOURPLATE 20. *Whistler in his Studio*. 1865. 24½ × 18¼″ (62.2 × 46.3 cm).
Hugh Lane Municipal Gallery of Modern Art, Dublin.

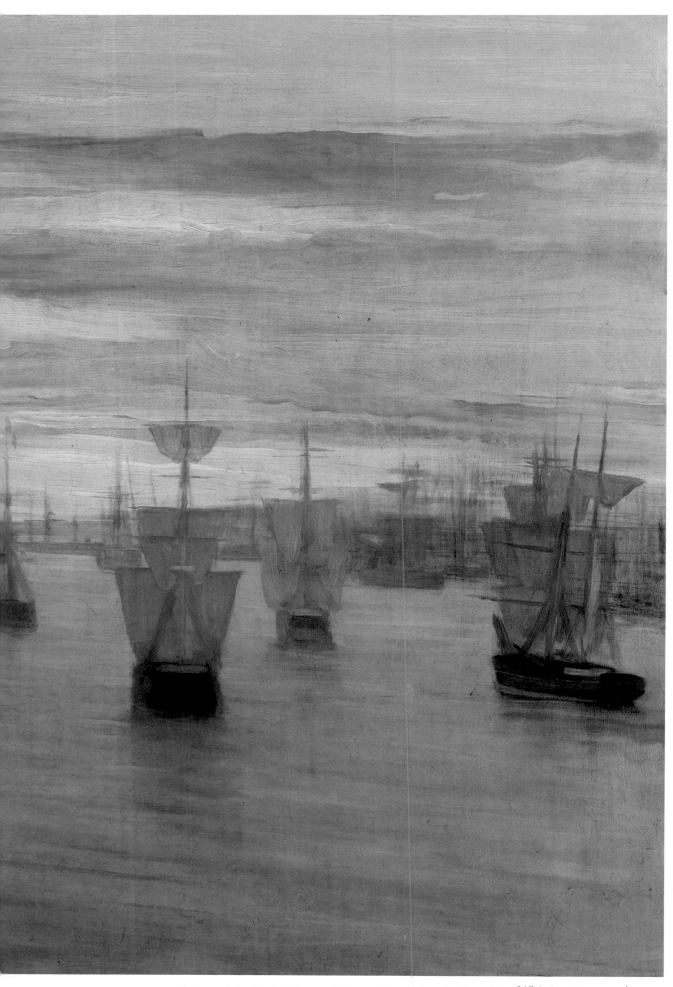

COLOURPLATE 19. *Crepuscule in Flesh Colour and Green: Valparaiso*. 1866. 23 × 29¾″ (58.4 × 75.5 cm).
Tate Gallery, London.

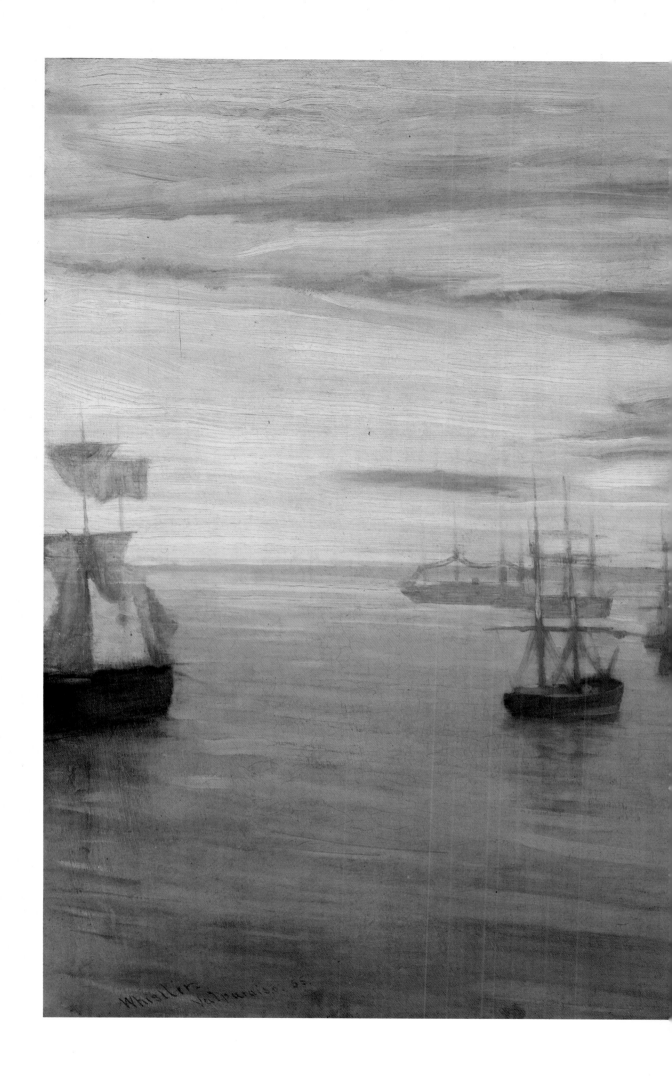

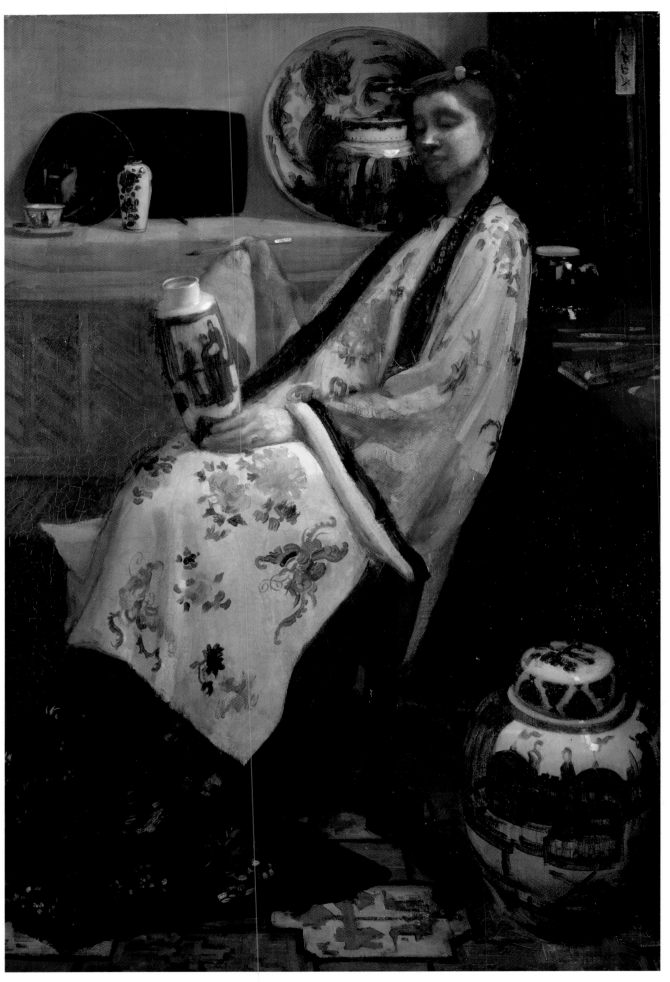

COLOURPLATE 21. *Purple and Rose: The Lange Leizen of the Six Marks.* 1864. 36 × 24½″ (91.5 × 61.5 cm).
Philadelphia Museum of Art (John G. Johnson Collection).

I am about entering into some agreement with Colnaghi, the publisher, concerning ten of my etchings, which if satisfied, will bring me in a pot of gold. Will it bother you too much to inquire into the etchings that I left for exhibition on the Boulevards? And tell Mon. Martinet that I would like to know when he intends hanging them again, if he has taken them down for the moment. There are fifteen of them. Will you see that they are not lost or injured?

Jo sends her love to you and to Madame, to whom present my compliments. Tout à vous.

Jemmie Whistler

PAUL MANTZ

GAZETTE DES BEAUX-ARTS
"Salon of 1863"
July 1863

The Woman in White by Mr James Whistler is a work full of taste, and this figure is at once much relished and much discussed by the group, less numerous than is believed, of lovers of painting. Mr Whistler, as is known, is an excellent etcher; collectors wrangle over his landscapes of the Thames and his seascapes. At the last exhibition at the Royal Academy in London, we saw some very interesting examples of his work as a painter, in which charm and singularity are brought together in such a way that one would find it hard to say where one began and the other ended.

The Woman in White also has something singular about it; but one would have to be ignorant of the history of painting to dare claim that Mr Whistler is an eccentric when, on the contrary, he has precedents and a tradition which should not be disregarded, particularly in France. What is this painting about? A young woman who, dressed in white from head to toe, stands out against a white curtain; I do not know if Mr Whistler has read the life of Oudry as told by the Abbé Gougenot but, had he done so, he would have learned that this skilful master frequently practised grouping "objects of different whites" together, and that, in the Salon of 1753, he exhibited among others a fairly large picture "representing various white objects on a white background, namely: a white duck, a damask table napkin, some porcelain, a cream pudding, a candle, a silver candlestick and some paper." These associations of similar shades were understood by everyone a hundred years ago, and the difficulty of painting them, which today would nonplus more than one master, passed for child's-play at that time: in seeking such an effect, Mr Whistler is thus continuing the French tradition, and that was no reason for rejecting his picture. But the American artist may have been wrong to scatter blue tones upon the carpet on which his charming phantom is walking; there he is straying beyond his principle, and almost beyond his subject, which is none other than a symphony in white. Let us add that the head of the young woman is painted with too rough a brush, and that it is not pretty; but the work has great individuality. Mr Whistler's picture does not contain merely an association of tones which possibly will seduce only sophisticates; it also has a poetry of its own. Whence comes this white apparition? What does she want from us with her dishevelled hair, her great eyes swimming in ecstasy, her languid pose and that petalless flower in the fingers of her trailing hand? No one can say: the truth is that Mr Whistler's work works a strange charm: in our view, the *Woman in White* is the principal piece in the heretics' Salon.

Paul Mantz (1821–95), critic and administrator, regularly wrote for the Gazette des Beaux Arts *and became director-general of fine arts in France (1881–82).*

Whistler had planned that if his picture was rejected by the Salon it should be shown at La Société Nationale des Beaux Arts, *run by Louis Martinet. On hearing from Fantin of the* Salon des Refusés *he authorized its exhibition there.*

In 1854 Mantz had edited a history of Academy artists, first published in 1761 by the Abbé Louis Gougenot; it included Jean-Baptiste Oudry (1686–1755).

COLOURPLATE 9.

Weary, K.92. 1863. Drypoint, 7¾ × 5⅛″ (19.5 × 13.2 cm). British Museum, London (Department of Prints and Drawings).

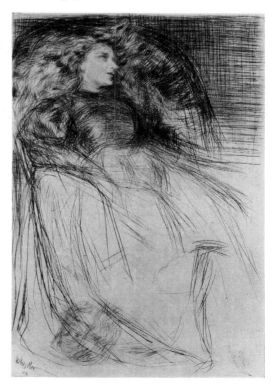

ANNA M. WHISTLER

Letter to Mr Gamble

10 February 1864

Whistler's mother appears to have met James Gamble and his family soon after moving to Scarsdale, New York, in 1853. When she moved away and finally settled in London in 1863 they became regular correspondents.

7 LINDSAY ROW [SIC], OLD BATTERSEA BRIDGE, CHELSEA, LONDON, 10 FEB. 1864

. . . Are you an admirer of old China? this Artistic abode of my Son is ornamented by a very rare collection of Japanese & Chinese, he considers the paintings upon them the finest specimens of Art & his companions (Artists) who resort here for an evening relaxation occasionally get enthusiastic as the[y] handle and examine the curious subjects pourtrayed [sic], some of the pieces more than two centuries old. he has also a Japanese book of painting unique in their estimation. You will not wonder that Jemies inspiration should be (under such influences), of the same cast he is finishing at his Studio (for when he paints from life, his models generally are hired & he has for the last fortnight had a fair damsel sitting as a Japanese study) a very beautiful picture for which he is to be pd one hundred guineas without the frame that is always separate. I'll try to describe this inspiration to you. A girl seated as if intent upon painting a beautiful Jar which she rests on her lap, a quiet & easy attitude, she sits beside a shelf which is covered with Chinese matting a buff colour, upon which several pieces of China & a pretty fan are arranged as if for purchasers. a Scind Rug carpets the floor (Jemie has several in his rooms & *none others.*) upon it by her side is a large Jar & all those are fac-similes of those around me in this room – which is more than half Studio for here he has an Easel & paints generally – tho he dignifies it as our withdrawing room – for here is our bright fire and my post. so finish now my poor attempt at describing the Chinese picture which I hope may come home *finished* this week – there is a table cov^d with a crimson cloth, on which there is a cup (Japanese) scarlet in hue, a sofa cov^d with buff matting, too, but each so distinctly separate, even the shadow of the handle of the fan,

Probably colour woodcuts by the Japanese print-maker Ando Hiroshige (1797–1858) which can be seen in Caprice in Purple and Gold: The Golden Screen *YMSM 60. (Colourplate 12).*
Purple and Rose: The Lange Leizen of the Six Marks *YMSM 47 (Colourplate 21) was bought by the London print-seller and art-dealer Ernest Gambart who sold it to the Newcastle collector James Leathart (see page 73). Lange Leizen is Dutch for "long Elizas" and was the Delft name for the blue and white Chinese porcelain decorated with figures of "long ladies." The "Six Marks" were the potter's marks, giving the signature and date on the base of the vases. One of Whistler's own "lange leizen" jars of the K'ang and Hs'I Dynasty (1662–1722) appears in the picture and the "Six Marks" decorate the roundels of the frame he designed for it.*

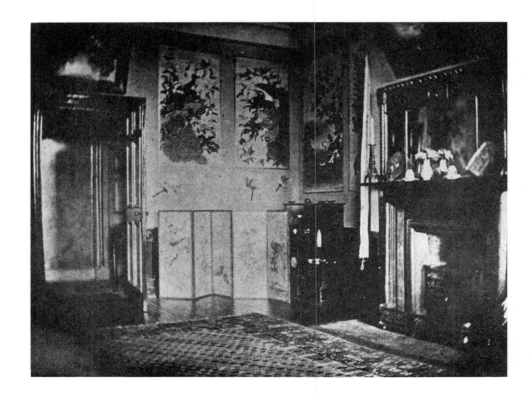

Whistler's drawing-room at 7 Lindsey Row. *c.* 1863. Photograph from the Whistler Collections, Glasgow University Library.

no wonder Jemie is not a rapid painter, for his conceptions are so nice, he takes out & puts in over & oft until his genius is satisfied. And yet during a very sharp frost of only a few days I think for two days ice was passing as we look out upon the Thames, he could not resist painting while I was shivering – at the open window two sketches & all say are most effective, one takes in the bridge of course they are not finished, he could not leave his oriental paintings which are ordered & he has several in progress: One pourtrays [sic] a group in Oriental costume on a balcony. a tea equipage of the old China, they look out upon a river, with a town in the distance. I think the finest painting he has yet done is one hanging now in this room, which three years ago took him so much away from me. It is called Wapping. The Thames and so much of its life, shipping, buildings, steamers, coal heavers, passengers going ashore, all so true to the peculiar tone of London & its river scenes it is so improved by his perseverance to perfect it. a group on the Inn balcony has yet to have the finishing touches. he intends exhibiting it at Paris in May, with some of those Etchings which won him the gold Medal in Holland last year. while his genius soars upon the Wings of ambition the every day realities are being regulated by his mother, for with all the bright hopes he is ever buoyed up by, as yet his income is very precarious. I am thankful to observe I can & do influence him. The Artistic circle in which he is only too popular, is visionary & unreal tho so fascinating.

Chelsea in Ice YMSM 53.

Variations in Flesh Colour and Green: The Balcony YMSM 56 (Colourplate 22).

Wapping YMSM 35 (Colourplate 11) had been begun in 1860 and was finally shown at the Royal Academy in 1864.

In 1863 Whistler had been awarded a gold medal for his etchings exhibited at The Hague.

WILLIAM BELL SCOTT

Letter to James Leathart

25 February 1864

The painter William Bell Scott (1811–90) was a friend and follower of D. G. Rossetti; he occasionally acted as agent for James Leathart of Newcastle, the prosperous owner of a lead-mining works, who collected modern pictures.

My dear Leathart,

I have seen Whistler's picture this forenoon. You know it and therefore it is not necessary to say it is a very fine thing. The figures in the foreground are just rubbed in, one of them merely in a tentative way, but the general painting is so rough it is difficult to say how far he means them for finished. The questions you require answered, I think, are, whether it is worth £250 compared to Jones' Merciful Knight at £180 and whether I think it would be the right picture for over your sideboard. I answer the first question, NO: of the two pictures by far the most valuable, intellectually and according to amount of work (I am inclined to say also in market value) is the Merciful Knight. The second question I answer, Yes: the Whistler picture has extraordinary power and distinctness at a distance, and would be so distinct among all the pictures you have in that room, that all would be benefited.

As I cannot answer both questions with either a negative or positive, your election as to purchase will not be made much easier by my opinion, I am afraid. But I can say in conclusion Whistler's picture is entirely too dear.

Brown did not know Whistler's address. I went to Rossetti's today, he was not in, so I asked Swinburne to go with me & had to tell him I wanted to see a picture. Whistler was not in, and I had again to ask to see the pictures. Any inspection of that kind shd. be done incidentally, but time would not permit on this occasion.

Ever yours

W. B. Scott

Edward Burne-Jones, The Merciful Knight. 1863. Gouache, 39½ × 27¼" (100.3 × 69.2 cm). City Museum and Art Gallery, Birmingham.

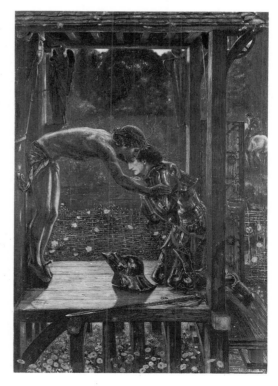

JEAN ROUSSEAU

LE FIGARO

"The Salon of 1864"

May 1864

Jean Rousseau (1829–91), Belgian critic and painter, and a regular contributor to Le Figaro *in Paris (1854–64). After returning to Belgium he became an art historian and fine arts administrator.*

This *Homage to Delacroix* consists of a bouquet of flowers about to be presented in front of his portrait by a young man who is completely unknown. A good-looking, well-dressed chap, nevertheless. Only he is wrong to turn his back on Delacroix to look at us. The rest of them are as completely unknown as the young man – except for Messieurs Champfleury, Baudelaire and Fantin himself who is sitting in the foreground. I suppose that the homage rendered to Delacroix is serious; but the most illustrious representatives of art and literature should have been convened for a ceremony of this sort. There is M Fantin representing 1830 romanticism, M Champfleury representing the realism of recent years, that's alright; but shouldn't we be told the names of the other celebrities who figure in this reunion, beginning with the one who has the most important role to perform, the young man holding the bouquet of flowers? Delacroix himself, with his head raised, has an air of surprise and seems to be asking – who do these backs belong to?

Henri Fantin-Latour's Homage to Delacroix *was shown at the Salon of 1864 as a tribute to the great Romantic artist who had died the previous year.*

Henri Fantin-Latour, *Homage to Delacroix*. 1864. Musée d'Orsay, Paris. (Back, l. to r., Louis Cordier, Alphonse Legros, Whistler, Édouard Manet, Félix Bracquemond, Albert de Balleroy; front, l. to r., Édmond Duranty, Henri Fantin-Latour, Jules Champfleury, Charles Baudelaire.)

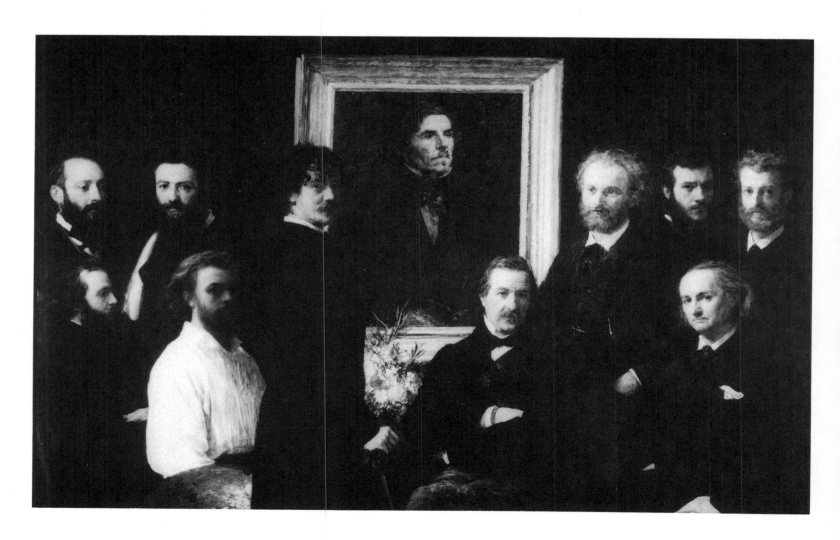

HENRI FANTIN-LATOUR

Draft Letter to Jean Rousseau

25 May 1864

Monsieur,

The observations you did me the honour of making in the *Figaro* on my picture have so impressed me that I would beg your permission for a few words in reply.

As a painter I willingly give myself up to your criticisms. I find them so singularly direct that I know of no salon review which demonstrates as much precise knowledge of painting as yours does.

Consequently please allow me to reply seriously to what you say concerning the people who appear in my picture, as well as the Art principle which joins me to them – namely realism.

In no way do I represent painting today. I represent it much less well than does Whistler, the author of the *White Girl* which received so much attention at the *Salon des Refusés* in 1863; or M Manet, a man of unquestionable talent with a gift for upsetting the feeble followers of convention; or M Legros, the painter of the vigorous and sincere *Ex-Voto* of 1861. These are the three *unknowns*, who along with M Bracquemond, one of the rarest draughtsmen of our time, and M Duranty, the writer a few may overlook before he gains worldwide recognition, make up the group I have painted. But with no intention other than to bring them together. What seems to have caused such excitement has only served to confuse some people.

As painters we spring from the movement M Courbet started, and in acknowledging it we don't in the least think our personal originality has been destroyed. A mighty artist has shown us the way. We acclaim it for his honour as well as our own, and we get pleasure in seeing our work greeted with disdain, jokes or injustice. It's sufficient confirmation for us that the road of realism we follow is the way to develop our personal styles; out of which great talent is formed. We are not at all concerned that some people want to make life hard for us, nor are we at all worried by having to wait.

Finally Monsieur, may I bring to your expert critical attention a picture by M Victor Muller (of Frankfort) of a *Nymphe des Bois*. I'm surprised you haven't seen it, for if you had you would have spoken of M Muller just as you did of M Ribot, because they both show figures as unidentifiable as the ones in the picture I exhibited this year. Please forgive Monsieur so long a reply and accept my sincerest wishes.

To the editor – Monsieur, the *Figaro's* spirit of traditional impartiality encourages me in the hope that you will be able to publish the letter I have taken the liberty of addressing to M Jean Rousseau in connection with an article he published on a picture which I am exhibiting this year.

Please accept in advance Monsieur editor my thanks and greatest respect.

H. Fantin-Latour,

rue St Lazare 79.

With Whistler's The White Girl *(Colourplate 9), Manet's* Luncheon on the Grass *(Musée d'Orsay, Paris) then called* Bathing, *attracted considerable attention when it was exhibited at the* Salon des Refusés *in 1863.*
Alphonse Legros's The Ex-Voto *(Musée des Beaux Arts, Dijon) shows a group of peasants praying by a roadside crucifix. It earned Legros critical success when shown in the Salon of 1861. Félix Bracquemond (1833–1914), best known for his etchings, is also credited with being the first French artist to acquire Japanese woodcut prints. Édmond Duranty (1833–80), Realist critic and novelist edited the periodical* Le Realisme *(1856–57) and was a close associate of Realist and Impressionist artists, particularly Degas.*

Victor Müller (1829–71), German painter of history and genre subjects, had been a pupil of Thomas Couture in Paris.
Théodule Augustin Ribot (1823–91), Realist painter of domestic subjects, particularly cooks, was much influenced by Spanish art of the seventeenth century, particularly that of Ribera.

ALGERNON CHARLES SWINBURNE

Letter to Whistler: "Before the Mirror"

2 April 1865

Algernon Charles Swinburne (1837–1909) poet and critic, close associate of Rossetti and friend of Whistler until he published a critical review of Whistler's Ten O'Clock *lecture in 1888 (see page 252).*

Cher père

I write a word to leave in case I find you gone out. Here are the verses, written the first thing after breakfast and brought off at once.

I could not do anything prettier, but if you don't find any serviceable as an Academy-Catalogue motto and don't care to get all this printed under the picture, tell me *at once* that I may try my hand at it tomorrow again.

Gabriel praises them highly, and I think myself the idea is pretty: I know it was entirely and only suggested to me by the picture, where I found at once the metaphor of the rose and the notion of sad and glad mystery in the face languidly contemplative of its own phantom and all other things seen by their phantoms. I wanted to work this out more fully and clearly, and insert the reflection of the picture and the room; but Gabriel says it is full long for its purpose already, and there is nothing I can supplant.

The Pre-Raphaelite painter Dante Gabriel Rossetti (1828-82), like Swinburne, first met Whistler in the Summer of 1862.

Tout à toi,
A. C. Swinburne

VERSES FROM "BEFORE THE MIRROR"

> "Come snow, come wind or thunder
> High up in air,
> I watch my face, and wonder
> At my bright hair;
> Nought else exalts or grieves
> The rose at heart, that heaves
> With love of her own leaves and lips that pair.
>
> "She knows not loves that kissed her
> She knows not where.
> Art thou the ghost, my sister,
> White sister there,
> Am I the ghost, who knows?
> My hand, a fallen rose,
> Lies snow-white on white snows, and takes no care.
>
> "I cannot see what pleasures
> Or what pains were;
> What pale new loves and treasures
> New years will bear;
> What beam will fall, what shower,
> What grief or joy for dower;
> But one thing knows the flower; the flower is fair."
>
> Glad, but not flushed with gladness,
> Since joys go by;
> Sad, but not bent with sadness,
> Since sorrows die;
> Deep in the gleaming glass
> She sees all past things pass,
> And all sweet life that was lie down and lie.

Before the Mirror, published in Poems and Ballads *(1866), was written for Whistler's picture* Symphony in White no. 2 *then called* The Little White Girl YMSM 52 (Colourplate 17), *first shown at the Royal Academy of 1865 with Swinburne's verses printed on gold paper attached to the frame. Two holographs of the poem, with variant readings, are in the Whistler Collections, Glasgow University Library. Ultimately forgiving Swinburne's critical slight of him, Whistler wrote in 1902 that the poem was "a rare and graceful tribute from the poet to the painter – a noble recognition of work by the production of a nobler one."*

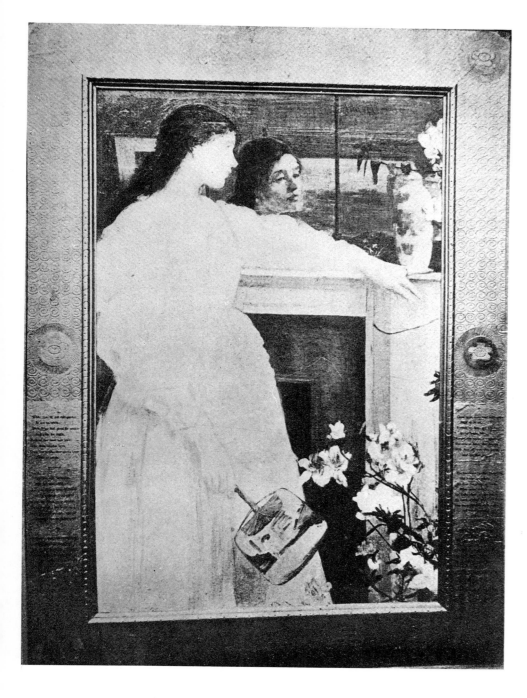

Photograph of *The Little White Girl* in its original frame, with Swinburne's verses. 1864. From Pennell, 1911, f.p. 124.

WILLIAM MICHAEL ROSSETTI

FRASER'S MAGAZINE

"The Royal Academy Exhibition"

June 1865

Of Mr Whistler's four contributions this year, two are perhaps the very best things he has yet exhibited; for charm, *The Little White Girl* (a title which seems to refer back to his earlier picture of *The Woman in White*); and, for perfection according to his individual scheme of execution, the *Old Battersea Bridge*. The exquisiteness of the *Little White Girl* is crucially tested by its proximity to the flashing white in Mr Millais's *Esther*: it stands the test, retorting delicious harmony for daring force, and would shame any other contrast. The loveliness of the delicate carnations, especially of the hand which lies along the white dress, cannot be overpraised. The

William Michael Rossetti (1829–1919), brother of Dante Gabriel Rossetti, critic and chronicler of Pre-Raphaelitism, also drew a regular salary as an Excise Secretary at Somerset House; he was a witness for Whistler in his libel suit against the critic John Ruskin in 1878 (see page 128).

COLOURPLATE 17.
Brown and Silver: Old Battersea Bridge *YMSM 33 (Colourplate 4) had been commissioned by Alexander C. Ionides, the father of Whistler's friends Luke and Aleco Ionides (see also page 84).*
Sir John Everett Millais' Esther was remarkable for the brilliant colour of a robe which adorned the subject of the picture.

flame-yellow of the hair, the black of the fireplace, the crimson-pink of the azaleas, contribute to a consummate whole. We say consummate, without any misgiving on the score of the peculiarities, at once slight and forcible, which Mr Whistler shows forth in this as in all his pictures. To advocate a style of execution as a model for general adoption is one thing: to recognize its absolute success in hands exceptionally gifted is another. No one who knows what he is about would ask Van Eyck to paint with the brokenness of Rembrandt, nor Tintoret with the precison of Leonardo. Mr Whistler seems to have a veritable intuition for a certain system of colour and handling which, with him, produces the exact result he aims at, and it is a peculiarly artistic and felicitous result; it is not less organized in *ensemble* than arbitrary in seeming by the square inch. That other painters encounter and conquer difficulties which Mr Whistler eludes is true, and their credit mounts up accordingly; but we cannot exact, in one true artist, conformity to the ways and means of another, while a contrary method is exuding, as it were, by instinct, from his very finger-ends. Let the alchemist turn dross into gold, and the painter turn canvas into fine art, by his own process. The *Old Battersea Bridge*, with a mud shore and a riverside group, boats ready for launching, a grey sky and greyer river, the sidelong bridge crossed by carts and passengers, shows one way of treating these simple materials to perfection, whether composition, tone, truth or originality, is in demand. We shall not ask for a different way, nor could two men in a thousand produce by *any* way so precious a picture. The two remaining contributions of Mr Whistler are Japanese subjects, unsurpassed in delicate aberrances and intricate haphazards of colour – but these hazards only happen to masters in their art. One of them, *The Golden Screen*, is fully up to their author's standard of completion; the second, *The Scarf*, might probably have been held over with advantage till next year. A Japanese would applaud them, we think: and no nation knows better than the Japanese what to be at in invention, colour and execution, or the concrete of all, fine art – if once we admit their national point of view, or even, to a great extent, without any such line drawn of concession and demarcation.

A picture in this exhibition by another artist, Mr Pettie, may here be glanced at, for the purpose of contrasting the peculiarities of slight execution which he displays with those of Mr Whistler. The former able artist appears to work on the assumption that a sketchy though not loose style of painting is preferable to the mature and deliberate style of a thorough picture. A dangerous assumption this, and sure, sooner or later, to lower the whole range of an artist's development. With Mr Whistler, on the contrary, the question is one of executive substance, moulding the work of art with a view to its artistic result – not, as with Mr Pettie, a question of mere propriety of representation. The difference is something like that between quality and quantity, or between breeding and etiquette.

Caprice in Purple and Gold: The Golden Screen *YMSM 60 (Colourplate 12). YMSM 59 (whereabouts unknown) depicted a girl in a Japanese dress.*

John Pettie RA (1839–93), Scots painter of history and genre subjects, resident in London, exhibited A Drum-head Court Martial *(192) in the 1865 Royal Academy exhibition (Mappin Art Gallery, Sheffield).*

WILLIAM MICHAEL ROSSETTI

ROSSETTI PAPERS 1862-70
Diary
1867

Tuesday, 5 February – Accompanied G[abriel] to Marks's; to look at the Chinese furniture he has bought there. . . . Met here Birket Foster, who commissioned G[abriel] for two pictures. Went on to dine with Whistler, for his house-warming at his new house in Lindsey Row. There are some

[. . .] here indicates omissions made by Rossetti in the published version of his diary. The dealer Murray Marks specialized in furniture and the decorative arts, especially blue and white china, and supplied it to Rossetti as well as to Whistler (see page 151). See George C. Williamson, Murray Marks and his Friends *(1919). Myles Birket Foster (1825–99), watercolourist, landscape painter and illustrator.*

fine old fixtures, as doors, fireplace, etc.; and W[histler] has got up the rooms with many delightful Japanesisms etc. Saw for the first time his pagoda cabinet. He has two or three sea-pieces new to me: one on which he particularly lays stress, larger than the others, a very grey unbroken sea: also a clever vivacious portrait of himself begun. Light not sufficient for judging any of these adequately. . . .

* * *

Friday, 29 March. . . . Whistler looked in. He says that he never from first to last received any invitation to contribute to the British Section of the Paris Exhibition. This might seem invidious: but the result is that he gets in the American Section much more space than could have been allotted him in the British. He will have pictures in this Exhibition, in the ordinary French Salon, and in the R.A., this year. The Salon people, or some of them, have shown a high estimate of him. . . .

Sunday, 31 March – Called to see Whistler's pictures for the R.A. etc. To the R.A. he means to send *Symphony in White No. 3* (heretofore named *The Two Little White Girls*) and a Thames picture; possibly also one of his four sea-pictures; and I rather recommended him to select the largest of these, which he regards with predilection, of a grey sea and very grey sky. His picture of four Japanese women looking out on a water-background (Thames) is as good as done, and in many respects very excellent. I think the unmitigated tint of the flooring should be gradated, but he does not seem to see it. . . .

* * *

Wednesday, 29 May – Gabriel has begun a portrait of Mrs Leyland. Miller, Whistler and other friends, at Chelsea. Much discussion about Turner – W[histler] being against him as not meeting either the simply natural or the decorative requirements of landscape-art, which he regards as the only alternative. . . .

* * *

Thursday, 13 June – Whistler, with whom we dined, has been written to by the Burlington Club that, if he does not resign on account of the Haden row, they would have to consider of his expulsion: if he resigns, his money would be returned. Gabriel and I agree in considering this very improper, as it amounts to condemning one member, unheard, on the *ipse dixit* of another. . . . Gabriel prepared a letter to Wornum expressing this view: and I have made up my mind to resign if W[histler] is expelled. . . . Mrs W[histler] is shortly about to return for a while to America, partly out of sympathy to many of her friends, now reduced from affluence to penury. W[illiam] W[histler], who saw much of the Southern prisons, denies that the Northern prisoners were ill-treated there, though straitened (as were the Southerners themselves) in some cases: he has no knowledge however of Andersonville. . . .

Saturday, 15 June – Meeting Wornum, I talked over the Whistler affair with him. It seems that Haden said it would be impossible for him to remain in the Club if W[histler] did so. . . . The Committee . . . thought they might themselves not be safe with W[histler], and they therefore suggested to him to resign. I pointed out to Wornum that it was not fair to ask him to resign without first asking him to explain; also assured him that there was no practical ground for alarm on the part of the Committee, or even of Haden while within the Club. Wornum informed me that, after their first letter and Whistler's reply thereto, the Committee have now invited an explanation from him; and, after a good deal of talk, I got him to admit that the right time for doing this would have been *before* asking him to resign. I told Wornum that, if Whistler is expelled, I shall resign; but shall not do anything in the way of agitation or caballing meanwhile. . . .

* * *

Two designs for a stair and wall decoration for Lindsey Row. Pen and ink, 8⅞ × 7⅛″ (22.6 × 18 cm). Hunterian Art Gallery, Glasgow University (Birnie Philip Bequest).

Mrs Frances Leyland (1834–1910), wife of Frederick Leyland, the Liverpool shipping owner and collector in whose London house Whistler painted Harmony in Blue and Gold: The Peacock Room *(Colourplates 63–65), (see pages 120–121).*

For the quarrel with Haden, see the Chronology.

Ralph Nicholson Wornum (1812–77), art historian and critic was appointed Keeper of the National Gallery in 1854.

Thursday, 12 December – A dinner at Whistler's (his Brother, Tebbs and Jeckyll, with myself), and grand discussion as to the campaign of tomorrow, when the motion for his expulsion from the Burlington is to come off. . . .

Friday, 13 December – Whistler's expulsion was voted by nineteen against eight. . . . W[histler] spoke some home truths. . . . Tebbs moved . . . my written proposal to take no action at this late end of the year. Scott seconded, and this had a good chance of passing if Whistler would have intimated that he would not renew his subscription: but he declined, and then the main vote passed against him. . . . I handed in my resignation to Wornum. . . .

* * *

Tuesday, 17 December – . . . Gabriel has now sent in his resignation to the Burlington Club. . . .

F. G. STEPHENS

THE ATHENAEUM

"Fine Arts. Royal Academy"

18 May 1867

Mr Whistler appears as eccentrically as ever, but with not less certainty than before of a glad artistic welcome, and its converse, stupidly blundering abuse from those who regard pictures as representations of something after their own minds. By way, as we suppose, of introducing a gleam of light to the minds of the latter, and giving a glimpse of his purpose, which may grow to better knowledge, and even to recognition of a purpose which seems not yet suspected, this artist calls his beautiful study in grades of white, pale rose tints and grey, *Symphony in White, No. 3*, and, by borrowing a musical phrase, doubtless casts reflected light upon former studies or "symphonies" of the same kind. It is clearly the duty of a painter to get himself understood, and not intemperately to dash back their ignorance into the faces of those who, although slow, may be willing to understand him. Art is not served by freaks of resentment, and, as the "British" notion of design is, although narrow, thoroughly honest, there can be nothing but thanks due to a painter who endeavours by any means to show what he really aims at, and to get observers to understand that he produces pictures for the sake of ineffable Art itself, not as mere illustrations of "subjects," or the previous conceptions of other minds. We cannot define the hues of Mr Whistler's "symphony," and so must limit our notice here to thanks for their beauty, wealth and melodious combining. As to what are the vehicles for these thoughts of beauty in chromatics, it is patent to eyesight that two women are seated at a couch, one upon, the other near it. Mr Whistler has a good deal of feeling for beauty in line, and, if he will, can draw; therefore we hold him deeply to blame that these figures are badly drawn, and are bound to say that, unlike Mr E. B. Jones, with whom his name has been frequently coupled, he has not the excuse of even temporary incapacity to deal with form. Such neglect as that which left the seated woman's arms in the state before us, is an impertinence of which the artist ought to be as much ashamed as we hope he would be if found in a drawing room with a dirty face.

Besides this exquisite chromatic study, Mr Whistler sends two examples of his craft in tone and colour, which take the landscape form. One is *Battersea*, barges going up the Thames, a rich and vigorous picture, – and a

Henry Virtue Tebbs was Dante Gabriel Rossetti's solicitor. Henry Jeckyll (1827–81), architect and designer of The Peacock Room *(Colourplates 63–65 – see page 122).*

Probably the artist William Bell Scott.

COLOURPLATE 28

In the 1860s Whistler occasionally aspired in his art to Edward Burne-Jones's (1833–98) classicizing ideals, but in the following decade they came to represent two distinct and divergent tendencies in modern English art. (See page 73.)

Grey and Silver: Old Battersea Reach YMSM 46 (Colourplate 15).

shore piece, *Sea and Rain*, which we commend to the wise, and leave a cruelly hard nut to be cracked by those who "can't bear Mr Whistler's pictures." – With the works of Messrs Mason and Whistler may be classed *The Musicians*, the contribution of Mr A. Moore, painter of the charming *Pomegranates* and *Apricots* of last year. This assimilates with Mr Whistler's *Symphony* in being a study in white, and combines with that the tints of yellow and pink. Two damsels are seated on a bench; to them a youth plays on a lyre. Mr Moore has a rarer feeling for the harmonies of lines and subtleties of contour than Mr Whistler; his idea of composition is of the highest: see the way in which the damsels' heads and limbs combine in curves and unisons of exquisite grace and proportion; his feeling for beauty is far higher in its tone than that of ninety-nine painters in a hundred here; thus his mind – or, as we are accustomed to say, his "taste," which is mind working in Art – would, even if it could at all conceive them, utterly reject the vulgarities of Mr Whistler with regard to form, and never be content with what suffices to the other in composition. The damsels of Mr Moore listen to the music of the lyre, and with limbs and heads at ease, meditate its beauty.

YMSM 65.

George Heming Mason ARA (1818–72), whose name was often linked with those of Whistler, Moore and Burne-Jones, specialized in subjects of myth and pastoral idyll. Whistler met Albert Moore (1841–93) in 1865 and until 1870 they shared an interest in similar subject-matter (see page 85). Moore, who lived without recognition from the Academy, was the only contemporary artist in England Whistler admired unreservedly, and on his death said of him "The greatest artist that, in the century, England might have cared for and called her own. . . ." Moore testified for Whistler at the Ruskin libel trial in 1878 and Whistler dedicated his pamphlet Art and Art Critics: Whistler versus Ruskin *to Moore. (See also page 128).*

PHILIP GILBERT HAMERTON
THE SATURDAY REVIEW
"Pictures of the Year. IX"
1 June 1867

Philip Gilbert Hamerton (1834–94), editor, art critic for the Saturday Review *(1865–68) and other periodicals, wrote several books on art, particularly etching, which brought him into further conflict with Whistler (see page 95).*

The exact opposite of Mr Brett is Mr Whistler. Mr Whistler is anything but a robust and balanced genius. No mental force was ever more curiously irregular and capricious in its application than his, but the gifts that he has are truly artistic gifts, and even in his weaknesses and defects there is the charm of a strange and delightful interest. Many an artist, having dead-coloured his picture, has regretted the necessity for finishing, and thereby destroying the harmony he had reached, but when Mr Whistler has reached a harmony in dead-colour he leaves it. It is probable that no picture ever exhibited in the Royal Academy contained so little manual labour as Mr Whistler's *Sea and Rain*. If the tints have been reached at once, as they seem to have been, the picture does not contain an hour's work. It is the extremest excess of tone-painting, the kind of painting in which tone is made the first aim, and detail considered altogether subordinate. If any one cares to note two representative instances of opposite tendencies in modern art, here they are in the same room – Mr Brett's sea-piece and Mr Whistler's *Sea and Rain*. We wish to describe Mr Whistler's picture, but the difficulty is that there is so little to describe. Grey sky, grey sea, grey wet sand. Some touches of white to indicate breakers, some birds, a figure lightly indicated. Materially there is nothing in it, mentally there is an impression of infinite dreariness, precisely the impression that we should feel before such a scene as this in nature. If the object of art is beauty, this cannot be art; but if we grant to painting the wider function of awakening or reviving impressions of any kind, and by any means in its power, then such work as this is not only art, but art entirely fulfilling its duties to the world. About the *Battersea* by the same painter there will be less variety of opinion. Few who can see colour will fail to enjoy the luminous grey sky, the purple and brown sails of the barges, the blue sprit, the delicate indications of colour in the fish hanging about the barge. So in the *Symphony in White, No. III*. there are many dainty varieties of tint, but it is not precisely a symphony in white. One lady has a

John Brett A.R.A. (1830–1902), sea and landscape painter exhibited Lat. 53° 15″ N., long. 5, 10W. *(614) in the 1867 Academy exhibition.*

YMSM 65.

Grey and Silver: Old Battersea Reach
YMSM 46 (Colourplate 15).

COLOURPLATE 28

yellowish dress and brown hair and a bit of blue ribbon, the other has a red fan, and there are flowers and green leaves. There is a girl in white on a white sofa, but even this girl has reddish hair; and of course there is the flesh colour of the complexions. Let us observe, with reference to Mr Whistler's painting, that it is pure brushwork, and conceived as such from the first, not careful drawing painted over. This is especially creditable to Mr Whistler because he is remarkable for minute precision in his etchings, and might be tempted to give painted drawings instead of pictures, but he understands the use of the brush far too well for that. Mr Whistler should be careful in the choice of his canvases when he uses thin opaque colour. His *Sunset on the Pacific*, now in the Paris Exhibition, has deteriorated considerably since we first saw it in England; and however much we might feel tempted to purchase a work of that kind, we should wait to see the effects of a few months upon it.

JAMES MCNEILL WHISTLER
Letter to Henri Fantin-Latour
[September?] 1867

2 LINDSEY ROW, OLD BATTERSEA BRIDGE, CHELSEA, LONDON

Dear Fantin – I've far too many things to tell you to write them all down this morning – because I'm weighed down with the most impossible work! – it's the pain of giving birth! you knew that – I've several pictures in my head and they only come out with some difficulty – for I must tell you that I am now experiencing demands and difficulties way beyond the time when I was able to throw everything down on the canvas pell mell – in the knowledge that instinct and fine colour would always bring me through in the end! – Ah my dear Fantin what a frightful education I've given myself – or rather what a terrible lack of education I feel I have had! – With the fine gifts I naturally possess what a fine painter I should be by now! If, vain and satisfied with those gifts only, I hadn't shunned everything else! No! You see the time was not good for me! Courbet and his influence was disgusting! The regret I feel and the rage, hate, even, I have for that now but perhaps there's an explanation. It's not poor Courbet whom I find repugnant, any more than his work – As always I recognize its qualities – I'm not at all complaining about the influence of his painting on mine – there is none, and you will not find it in my canvases – it couldn't be; because I'm too personal and know I've always been rich in qualities he doesn't have but which suit me well – But there's perhaps a reason why all this has been pernicious for me. It's that damned Realism which made an *immediate* appeal to my vanity as a painter! and mocking tradition cried out loud, with all the confidence of ignorance, "Long live Nature!!" Nature! My dear chap that cry has been a big mistake for me! – Where could you find an apostle more ready to accept so appealing an idea! that panacea for all ills – What? All he had to do was open his eyes and paint what he found in front of him! Beautiful nature and the whole caboodle! That was all there was to it! well you went to see! And what did you see – the Piano, the White Girl, the Thames pictures – the seascapes – canvases produced by a nobody puffed up with pride at showing off his splendid gifts to other painters – qualities which only required strict education to make their owner the master he really is – not a degenerate student. Ah my friend! our little group has been a vicious society! Ah! how I wish I had been a pupil of Ingres! I don't go into raptures in front of his pictures – I only have a moderate liking for them – I find several of his canvases we've seen together to be in a very questionable style – not at all Greek in the way you

Whistler's first response to Hamerton's observations was made, probably in 1878, in the margin of a volume of press cuttings (now in Glasgow University Library); and later published in The Gentle Art of Making Enemies (1892): "How pleasing that such profound prattle should inevitably find its place in print! 'Not precisely a symphony in white . . . for there is a yellowish dress . . . brown hair, etc . . . another with reddish hair . . . and of course there is the flesh colour of the complexions.' Bon Dieu! did this wise person expect white hair and chalked faces? And does he then . . . believe that a symphony in F contains no other note, but shall be a continued repetition of F, F, F? . . . Fool!"

The French artist Ignace-Henri-Théodore Fantin-Latour (1836–1904) first met Whistler in 1858 and with Alphonse Legros, who settled in London in 1863, made up "la société de Trois," formed in order to further the three artists' careers in London and Paris. This lasted until 1867 by which time Whistler had quarrelled with Legros; but not long after this letter was written Fantin began to feel out of sympathy with Whistler's art (see page 108) and their correspondence became less frequent. The original letter was first published in part, along with excerpts from Whistler's correspondence with Fantin, by the French art historian Léonce Bénédite in the Gazette des Beaux Arts in 1905.

At the Piano YMSM 24 (Colourplate 13); Symphony in White No. 1: The White Girl YMSM 38 (Colourplate 9); Wapping YMSM 35 (Colourplate 11).
"la société de Trois."
The French neo-classical painter Jean Auguste Dominique Ingres (1780–1867), whose work Whistler had copied in 1857 (see Colourplate 7).

would think – but they're really aggressively French! You feel there's much further to go! much more beautiful things to do – But I repeat would I had been his pupil! What a master he would have been – How *sound* a leader he would have been – drawing! My God! Colour – it's truly a vice! Certainly it's probably got the right to be one of the most beautiful of virtues – if directed by a strong hand – well guided by its master drawing – colour is then a splendid bride with a spouse worthy of her – her lover but also her master, – the most magnificent mistress possible! – and the result can be seen in all the beautiful things produced by their union! But coupled with uncertainty – drawing – feeble – timid – defective and easily satisfied – colour becomes a cocky bastard! making spiteful fun of "her little fellow", it's true! and abusing him as she pleases – treating things lightly so long as it pleases her! treating her unfortunate companion like a duffer who bores her! the rest is also true! and the result manifests itself in a chaos of intoxication, of trickery, of regrets – incomplete things! Well, enough of this! [One and a half lines illegible] In the end this explains the enormous amount of work that I am now making myself do – well old chap I've been undergoing this education for more than a year now – for a *long time*, and I'm sure I will make up the time I've wasted – but what a punishment! I'm sending you a photograph of the little sketch of the "balcony" – I am going to make it lifesize for the Salon – Tell me what you think of the composition, for line etc., the colour is very brilliant – Also there is a rough

Whistler probably derived the metaphor for the relationship between colour and drawing from the French art historian and theorist Charles Blanc, whose Grammaire des Arts du Dessin, Architecture, Sculpture, Peinture, *first serialized in the* Gazette des Beaux Arts, *was published in 1867.*

The composition which became Variations in Flesh Colour and Green: The Balcony *when it was finally exhibited in London in 1870 (YMSM 56, Colourplate 22); the "little sketch" may have been the oil sketch now in Glasgow University (YMSM 57); the "pen drawing" that is in the Avery Collection, New York Public Library.*

The Last of Old Westminster. 1862. 24 × 30½" (61 × 77.5 cm). Courtesy Museum of Fine Arts, Boston (Abraham Shuman Fund).

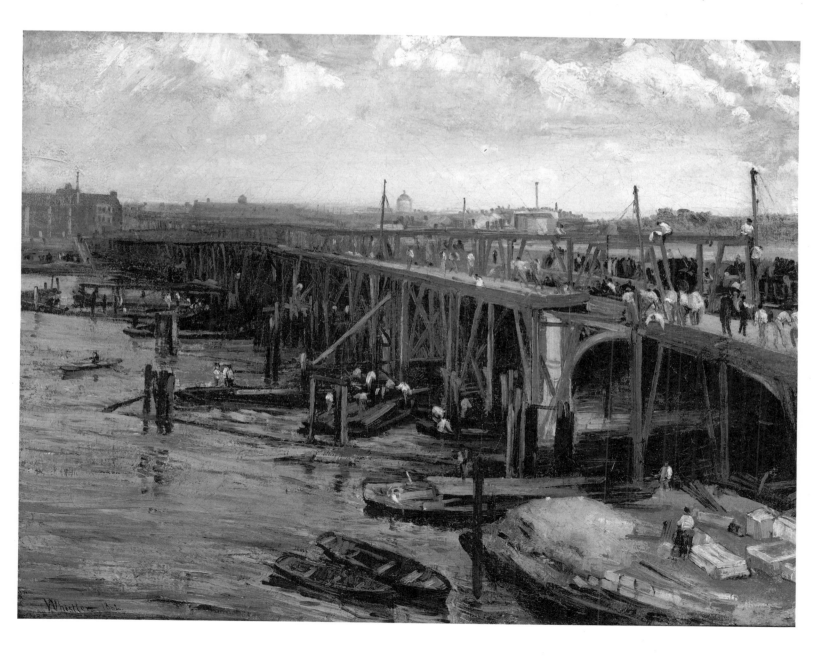

pen drawing of the composition occupying my time now – I'm also working at an arrangement of the *Bridge* – I believe it will result in a very important composition – I spend the whole day drawing from models!! – This is just between us – the others are useless to talk to about it – My dear Fantin I'm very sorry that you can't come and visit me – only I congratulate you on the reason why you can't. There you are, now really launched in high society! Bravo old chap – I'm very happy for you – and I'm sure that the picture you are going to do which you tell me about will be a fine thing.

Send me a rough pen sketch when you get it organized.

As far as the rest is concerned there's a bit – but nothing great. Legros had a picture at the Salon here, the *Psyche* – very bad in composition and everything – a little church scene perhaps not bad, but so badly hung you couldn't see it very well – He's no longer welcome at the Ionides' – I'm not going to attack him any more for gossiping about me in Paris because he's so pathetic – no wonder that after having been beaten he should be on the look-out! while for my part it's only natural that I should have nothing more to do with him! The renowned Favard would do well to distrust him, it could well happen to him too! – As to Burty, Haden's little dog – his yapping is no longer heard – when little dogs keep on irritating and getting under your feet they get a kick up the backside! Haden has had the stupidity to complain about the beating up he got from me – to the club where we are both members – threatening to have me expelled – that's blown up in his face but I'll tell you about it another day – it's even very funny – all in all I'm on the winning side so far – what you call my impudent good luck is long-lasting! Write me my dear Fantin – give my best wishes to Manet and the others. Tell Manet that on receiving his letter with Burger's note I straightaway wrote a long letter to Burger, to which I never had a reply – say hello to Émile and Ernest – I am sending you the receipts for the etchings – the others Haden has had for a long time! Now could you pack for me the picture of Westminster Bridge and send it by slow goods service? yourself. The packing case for it is with the concierge downstairs –

As always – Whistler

ALGERNON CHARLES SWINBURNE

ESSAYS AND STUDIES

"Notes on The Royal Academy Exhibition, 1868"

1875

The present year has other pictures to be proud of, not submitted to the loose and slippery judgement of an academy. Of one or two such I am here permitted to make mention. The great picture which Mr Whistler has now in hand is not yet finished enough for any critical detail to be possible; it shows already promise of a more majestic and excellent beauty of form than his earlier studies, and of the old delicacy and melody of ineffable colour. Of three slighter works lately painted, I may set down a few rapid notes; but no task is harder than this of translation from colour into speech, when the speech must be so hoarse and feeble, when the colour is so subtle and sublime. Music or verse might strike some string accordant in sound to such painting, but a mere version such as this is as a psalm of

Whistler may have been working on the "arrangement" that became Nocturne: Blue and Gold: Old Battersea Bridge *in 1872 YMSM 139, 140 (Colourplates 40, 42).*

Fantin had made his third, and final, visit to stay with Whistler in London in 1864; in 1867 he had enjoyed critical acclaim for his portrait of Edouard Manet exhibited at the Salon. Fantin was probably working on a composition inspired by Schumann's six impromptus for piano, Reflets d'Orient, *a charcoal drawing of which he sent Whistler at this time.*

Since 1865 Whistler had been quarrelling with Legros, who now became embroiled in Haden's feud with Whistler (see page 79). Legros subsequently attempted to sow enmity between Whistler and Fantin, and between Manet and Fantin.

Since 1863 the critic Philippe Burty had favoured Haden's etchings above Whistler's, finding in the latter's what he described as a false "theory of foregrounds" and evidence of what he claimed was a "photographic appearance." (See Katherine A. Lochnan, The Etchings of James McNeill Whistler, *New Haven and London, 1984.)*

Manet had forwarded to Whistler a letter from the French critic Théophile Thoré (1807–69, who wrote under the name of W. Bürger) in which he asked if he could buy At the Piano.

Whistler did not exhibit at the Royal Academy in 1868 so Swinburne's discussion of his art centred on the so-called Six Projects *(now in the Freer Gallery, Washington DC) then just completed, and which were probably intended for enlargement as a decorative scheme for F. R. Leyland for whom Whistler painted* Harmony in Blue and Gold: The Peacock Room *in 1876–77 (Colourplates 63–65). Swinburne's language, infused with romantic synaesthesia, parallels the musical analogy Whistler had announced with the painting he exhibited at the Academy the previous year.*
The White Symphony: Three Girls *YMSM 87 (Colourplate 26) from which at least two enlargements by Whistler were made (YMSM 89, 90).*

Tate's to a psalm of David's. In all of these the main strings touched are certain varying chords of blue and white, not without interludes of the bright and tender tones of floral purple or red. In two of the studies the keynote is an effect of sea; in one, a sketch for the great picture, the soft brilliant floor-work and wall-work of a garden balcony serve in its stead to set forth the flowers and figures of flower-like women. In a second, we have again a gathering of women in a balcony; from the unseen flower-land below tall almond trees shoot up their topmost crowns of tender blossom; beyond and far out to west and south the warm and solemn sea spreads wide and soft without wrinkle of wind. The dim grey floor-work in front, delicate as a summer cloud in colour, is antiphonal to the bluer wealth of water beyond: and between these the fair clusters of almond blossom make divine division. Again the symphony or (if you will) the antiphony is sustained by the fervid or the fainter colours of the women's raiment as they lean out one against another, looking far oversea in that quiet depth of pleasure without words when spirit and sense are filled full of beautiful things, till it seems that at a mere breath the charmed vessels of pleasure would break or overflow, the brimming chalices of the senses would spill this wine of their delight. In the third of these studies the sea is fresher, lightly kindling under a low clear wind; at the end of a pier a boat is moored, and women in the delicate bright robes of eastern fashion and colour so dear to the painter are about to enter it; one is already midway the steps of the pier; she pauses, half unsure of her balance, with an exquisite fluttered grace of action. Her comrades above are also somewhat troubled, their robes lightly blown about by the sea wind, but not too much for light laughter and a quivering pleasure. Between the dark wet stair-steps and piles of the pier the sweet bright sea shows foamless here and blue. This study has more of the delight of life than the others; which among three such may be most beautiful I neither care to guess nor can. They all have the immediate beauty, they all give the direct delight of natural things; they seem to have grown as a flower grows, not in any forcing-house of ingenious and laborious cunning. This indeed is in my eyes a special quality of Mr Whistler's genius; a freshness and fullness of the loveliest life of things, with a high clear power upon them which seems to educe a picture as the sun does a blossom or a fruit.

Variations in Blue and Green *YMSM 84 (Colourplate 23)*.

Symphony in White and Red *YMSM 85 (Colourplate 24)*.

JAMES MCNEILL WHISTLER

Draft Letter to Albert Moore

1870

My dear Moore – I have something to say to you which in itself difficult enough to say, is doubly so to write – Indeed for the last few days I have several times sat down to the matter and losing courage given it up – however it must be done at once or set aside forever as your precious time may not be lost – This is an awful opening rather and the affair is scarcely worthy of such solemnity. The way of it is this – First tho' I (must [word deleted] sic) would like you to feel thoroughly that my esteem for you and admiration for your work are such that nothing could alter my regard and in return I would beg that if I am making an egregious mistake you will be indulgent (enough [word deleted] sic) and forgive – believe that I do so with great timidity wishing for nothing more than to be put right – and would rather anything than that a strangeness should come about in our friendship through any stupid blundering letter I might write. – Well then your two beautiful sketches were shown to me by Leyland, – and while admiring them as you know I must do everything of yours – more than the production of any living man – it struck me – dimly – perhaps and with

Albert Moore was much influenced by Whistler's neo-classical style of decorative art at a time when he was beginning to reject the influence of Courbet's Realism. In 1865 Moore replaced Alphonse Legros as a member of "la société des Trois." In his turn Moore felt the influence of Whistler's tonal painting, but unlike Whistler, Moore continued to paint lightly draped female figures for the rest of his career. It was not until the later 1880s that Whistler returned to such subjects, then treating them in pastel, lithography and watercolour (see pages 305, 315, and Colourplate 113).

Symphony in Blue and Pink YMSM 86 (Colourplate 25), one of the "Six Projects." Nesfield [overleaf]: the architect William Eden Nesfield (1835–88).

great hesitation that one of my sketches of girls on the sea shore, was in motive not unlike your yellow one – of course I don't mean in scheme of color but in general sentiment of movement and in the place of the sea – sky and shore &c – Now I would stop here and tear this letter up as I have done others if I were not sure that you could not impute to me self sufficiency enough to suppose that I could suggest for a moment that any incomplete little note of mine could even unconsciously have remained upon the impression of a man of such boundless imagination and endless power of arrangement as yourself – Also I am encouraged a little to go on and send this to you by my remembering that one day you came to me and told me that it was you[r] intention to paint a certain bathing subject and that you were uncertain whether a former cketch [sic] of mine did not treat of the same subject – and thereupon told me that it would annoy you greatly to find yourself at work upon anything that might be in the same strain as that of another – Now what I would propose is that you should go with Billy Nesfield down to my place and together look at the sketch in question (it is hanging up on the wall in the studio) where you will be at once admitted without the necessity of mentioning your purpose) – The one I mean is one in blue green and flesh color of four girls careering along the sea shore, one with a parasol the whole very unfinished and incomplete – But I want you two to see [sic] is whether it may be judged (that we may each [words deleted]) by any suggestion of yours that we may each paint our picture without harming each other in the opinion of those who do not understand us and might be our natural ennemies – Or more clearly if after you have painted yours I may still paint mine without suffering from any of the arrangement either of the sea and shore or the mouvement of the figures [sic]. –

(Will you do this like a good friend and if I have made an ass of myself in this rashness [sentence deleted].)

If however Nesfield and you find that I am unnecessarily [sic] anxious and that I am altogether mistaken I will be more than satisfied and acknowledging my error still hope that you will consider all that I have written unsaid –

Again in every case begging you to excuse anything that may appear to you "inconvenant" in this letter believe me my dear Moore ever yours affectionately – JMW.

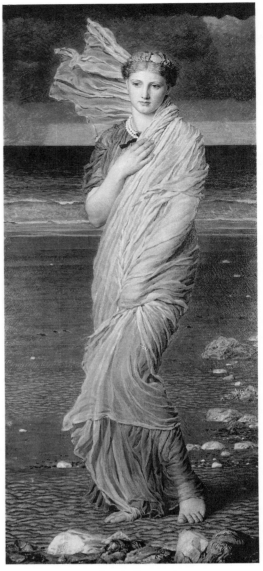

Albert Moore, *Seashells. c.* 1874. 61½ × 27″ (156.2 × 68.6 cm). Walker Art Gallery, Liverpool.

THE SATURDAY REVIEW

"Mr Whistler's Etchings"

12 August 1871

The general public has at length the opportunity of judging of Mr Whistler's merits as an etcher, and we can scarcely doubt that the sixteen plates now before us, several of which are already familiar to connoisseurs, will serve to enhance the artist's reputation. The subjects, chiefly on the Thames, are eminently English; the art treatment, on the contrary, is somewhat French. Mr Whistler, by extraction an American, is by education allied to the Continent of Europe; he studied painting in a somewhat desultory fashion in France; he entered, however, the Parisian studio of M Gleyre, an artist long known in the Gallery of the Luxembourg by *Les Illusions perdues* [Lost Illusions]. Thus the young painter, who at long intervals has presented himself fitfully in our Royal Academy, became allied to a school of silvery tone, tertiary colour, hazy outline, vague shadowy form. Occasionally, as in a picture not to be forgotten, *a symphony in white*, the harmonies evoked have been delicious, though the

Whistler's "Sixteen Etchings of Scenes on the Thames" or the "Thames Set" had been recently published by Ellis and Green, 33 King Street, Covent Garden.

Gleyre's Les Illusions perdues *["Lost Illusions"] (Louvre, Paris), proved a universal success at the Salon of 1843.*

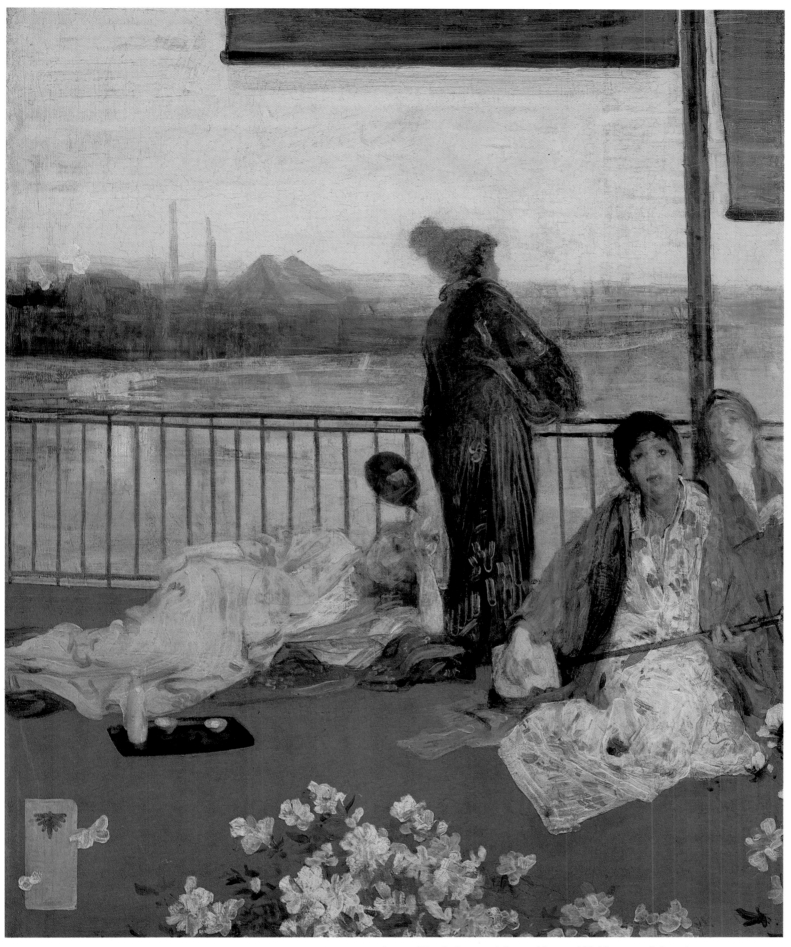

COLOURPLATE 22. *Variations in Flesh Colour and Green: The Balcony.* 1865. 24¼ × 19¼″ (61.4 × 48.8 cm).
Freer Gallery of Art, Smithsonian Institution, Washington, D.C.

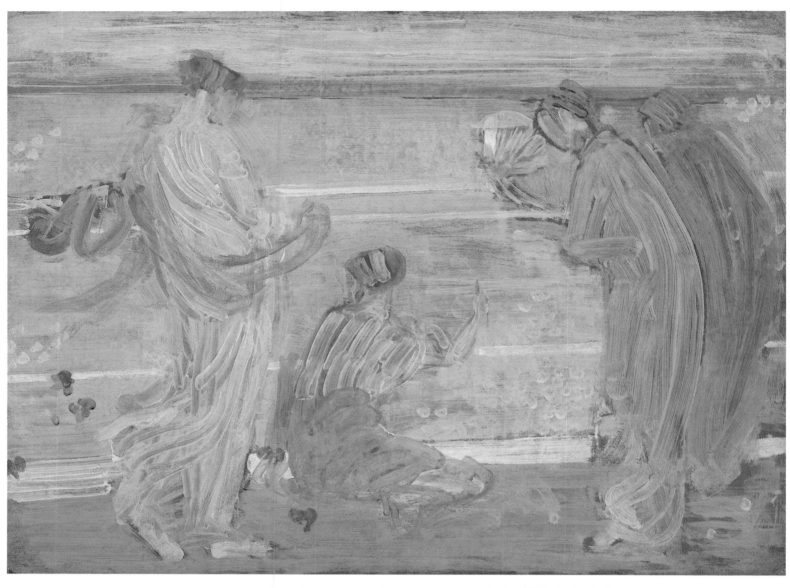

COLOURPLATE 23. *Variations in Blue and Green. c.* 1868. 18½ × 24⅜″ (46.9 × 61.8 cm).
Freer Gallery of Art, Smithsonian Institution, Washington, D.C.

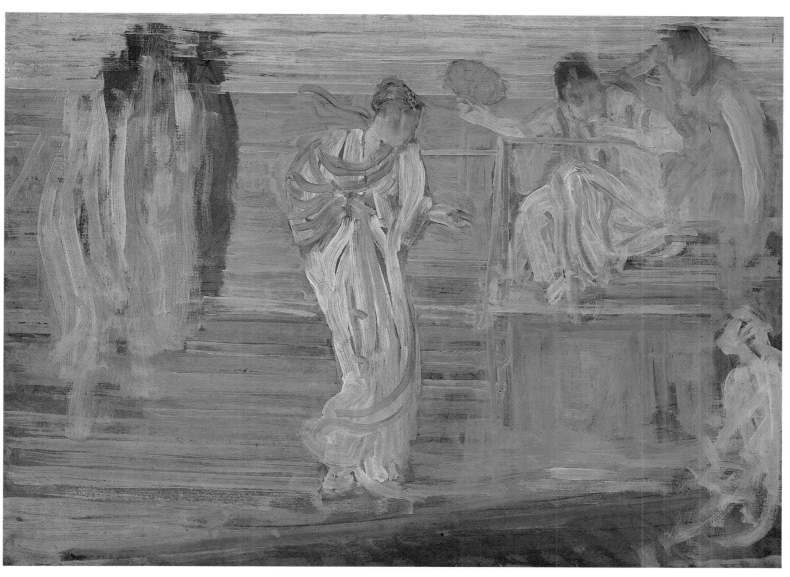

COLOURPLATE 24. *Symphony in White and Red. c.* 1868. 18⅜ × 24⅜″ (46.8 × 61.9 cm).
Freer Gallery of Art, Smithsonian Institution, Washington, D.C.

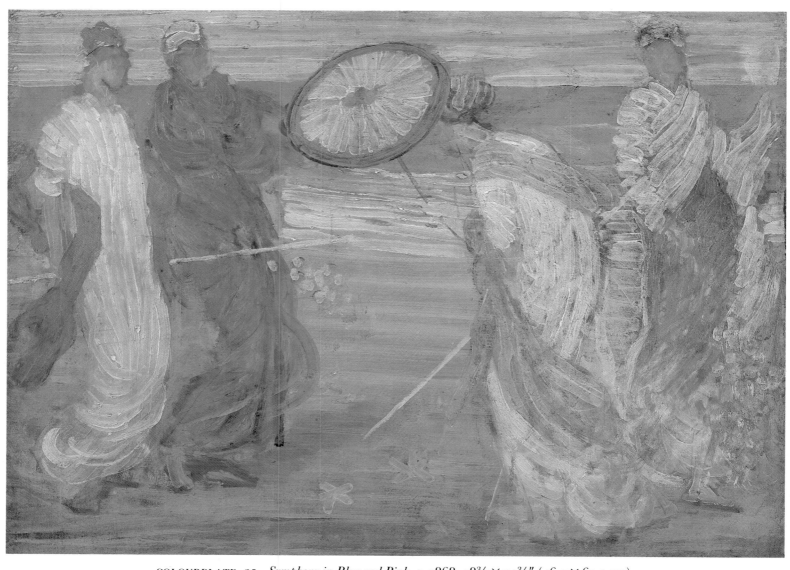

COLOURPLATE 25. *Symphony in Blue and Pink. c.* 1868. 18⅜ × 24⅜″ (46.7 × 61.9 cm).
Freer Gallery of Art, Smithsonian Institution, Washington, D.C.

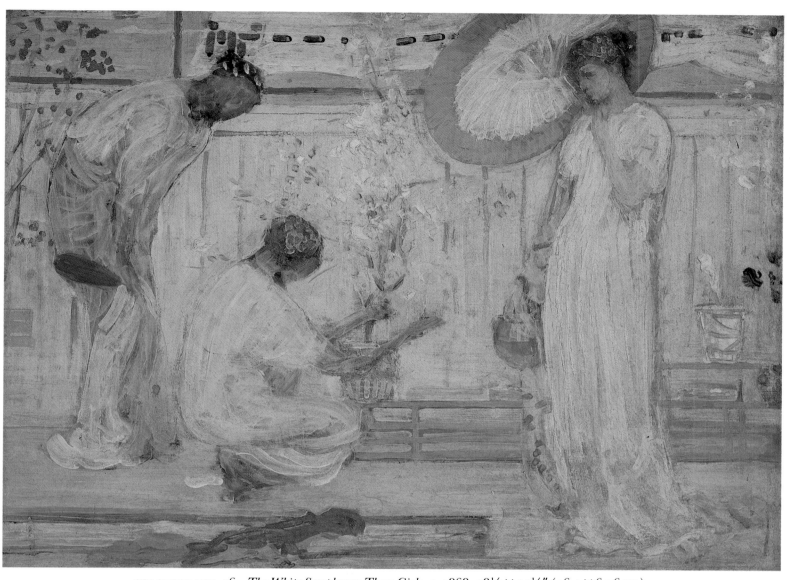

COLOURPLATE 26. *The White Symphony: Three Girls. c.* 1868. 18¼ × 24¼″ (46.4 × 61.6 cm).
Freer Gallery of Art, Smithsonian Institution, Washington, D.C.

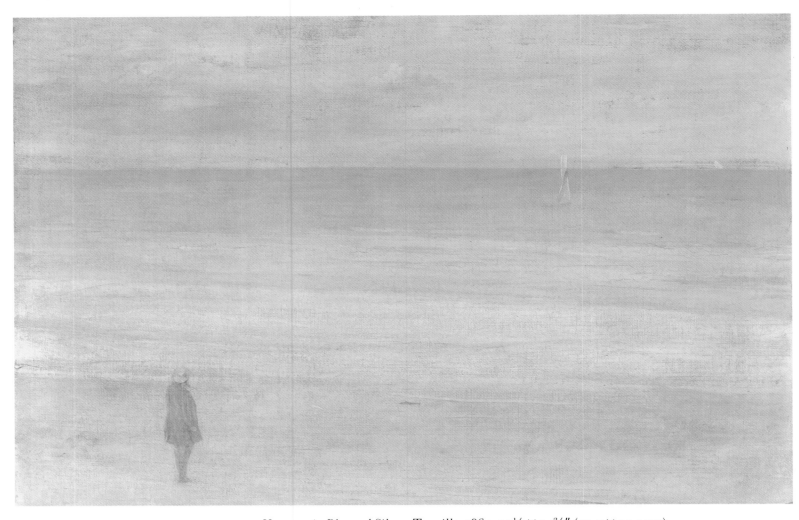

COLOURPLATE 27. *Harmony in Blue and Silver: Trouville.* 1865. 19½ × 24¾″ (49.5 × 75.5 cm).
Isabella Stewart Gardner Museum, Boston (photo Art Resource, New York).

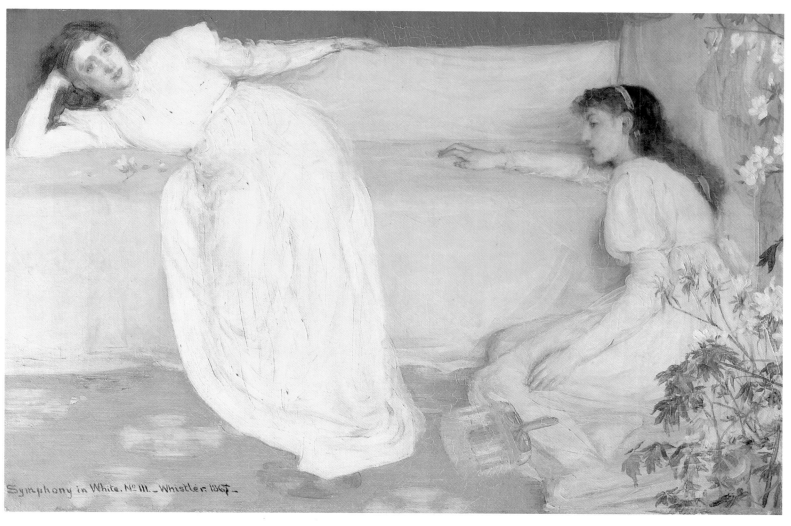

COLOURPLATE 28. *Symphony in White, No. 3.* 1865-67. 20½ × 30⅛″ (52 × 76.5 cm).
The Barber Institute of Fine Arts, The University of Birmingham.

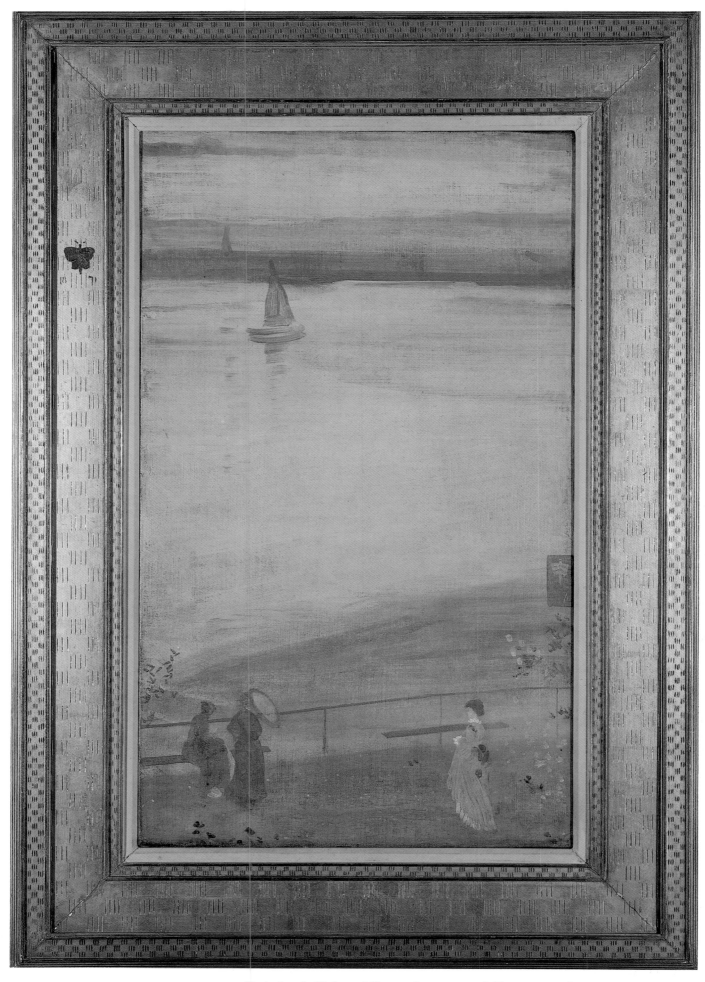

COLOURPLATE 29. *Variations in Violet and Green.* 1871. 24 × 14″ (61 × 35.5 cm).
Private Collection, New York.

style generally is foreign to our English tastes. Yet by degrees the British public has been indoctrinated with certain foreign ideas, as we took occasion to show in speaking of the Capri school in the Royal Academy of the present year. This school is "vaporoso" as a Scotch mist lighted up by a Southern sun; it has a harmony that is but a mild variation on monotone; it is as a tune played on a single string. M Hamon, who has been identified with Capri, and M Gleyre, who, as we have seen, was the master of Mr Whistler, appear to us in great measure responsible for works which by turns have been welcomed for genius and denounced for eccentricity and audacity. Without committing ourselves to either of these extreme judgements, we may say that a chief ingredient in these anomalous products has seemed to be nothing more alarming or incomprehensible than indolence and indifference. Even in the etchings now published we find, to say the least, a studious economy of labour; the work is thrown aside at the earliest possible moment, elaboration seems irksome, high finish might abate from the dash and the flourish which now pass as the sign-manual of genius. But we have to remember that between oil pictures and etchings there is a wide interval. A picture is not fit for exhibition when it is little more than an indication or a first rubbing-in; an etching, on the other hand, is often brilliant just as it is slight; it is frequently prized because it retains unspoilt the traits of a rapid, masterly sketch. The plates now collected, in spite of their shortcomings, will place Mr Whistler among the great masters of the art.

These plates, as before indicated, are like and yet unlike the artist's pictures. They show that he has been accustomed to think out his subjects in monotone; they are studious in the construction of light and shade, and prove that the grammar of chiaroscuro has been rightly understood. On the other hand, they have more decision in line, greater emphasis in touch, than we have been led to look for in the products of Mr Whistler's studio. The portfolio opens with a characteristic specimen, *Black Lion Wharf* – a work decisive and precise in execution, emphatic where emphasis is needed, brilliant in contrast of dark and light, delicate in the handling of unobtrusive passages, slight and sketchy in the treatment of episode. Mr Hamerton quotes this etching "as a representative example of Mr Whistler's peculiar qualities and faults; the faults being, as so often happens in art, inseparable from the qualities." The defects seem chiefly to be that "the foreground is slight in the extreme, and is altogether out of relation to the rest of the subject. The artist has exhausted all his darks in the details of the shore; the blacks in a single bow-window beyond the schooner have got down already to the very bottom of the scale; and as nothing in an etching can be made blacker than pure printer's ink, the artist has no resource left for his foreground, and so sketches it without attempting any statement of its relation to that bow-window." Mr Hamerton, in his volume on *Etching and Etchers*, devotes a whole chapter to Mr Whistler. In the artist's style merits and defects are indissolubly bound together; some passages are off-hand and careless, others minute even to excess; the lettering on signboards invites the scrutiny of a microscope; the smallest facts are observed with shrewdness, and handled with vivacity; and when the plate is finished, out of apparent disorder is educed a consummate composition. The manner is certainly anomalous; it is beset with contradictions, it deviates from ordinary routine, it is removed from commonplace. The artist comes upon his subjects at odd corners; he steals upon his incidents unawares; as a crafty sportsman, he seizes the prey before it can escape. The past he takes is sometimes direct, often zigzag; he views his subject askance, his eye traverses diagonals; hence his materials arrange themselves on paper in strange and unaccustomed fashion. And thus perhaps it also happens that what threatened, as we have said, to be most admired disorder, is in the end singularly picturesque. Bargemen and boats, bridges and churches, landing-stages, cranes, warehouses, signboards and tall chimneys, jostling together with as little mutual

Jean-Louis Hamon (1821–74), French painter of genre subjects.

K. 42.

With Frederick Wedmore (see page 143), Hamerton became the most influential spokesman for modern etching in England in the nineteenth century. His handbook Etching and Etchers, *first published in 1868 (revised and reprinted 1876, 1880), with a dedication to Whistler's brother-in-law Haden, treated Whistler's etchings with tolerant condescension, after Whistler had neglected to reply to a letter from Hamerton requesting the loan of his etchings. In future matters pertaining to etching, Whistler forever kept Hamerton in his sights (see* The Gentle Art of Making Enemies*).*

consideration as passengers disgorged from a Thames steamer, are made to marshal themselves pictorially, so that at length order conquers disorder. Only a most adroit artist could steer a clear course through such complexities. The navigation of a crowded river is not more intricate than the pictorial management of these strangely consorted materials. It is needful that the eye should be keen, the nerve unflinching, the hand swift and resolute. For clear perception, for clever sleight of hand, some of these etchings are unsurpassed.

We have said that Mr Whistler's style is Continental, consequently not English. Mr Hamerton, in treating of the present state of art of etching in England, says, "The English do not as etchers belong to the European community," "English etching, like English painting, is a product of the English soil, intensely and exclusively insular, and a result of many complex conditions." The author of *Etching and Etchers*, after deploring the want of patronage, proceeds to stigmatize the state of the art in England in the following terms:—

"But if etching in England is in a low condition, the fault is not entirely in the apathy of collectors, or the timidity of publishers; the etchers themselves are to blame. The English school, with a few notable exceptions, has sought to make the art pretty and popular rather than great; our etchers have not been faithful to the spirit of etching; they have condescended too much to the level of the common public. Let it be understood, once and for all, that this great art, if followed in the true spirit, must for ever be as far above the vision and criticism of the vulgar as an eagle's flight above the cackling of fowls in a farmyard. And between these two a choice has to be made – between greatness and nobleness on the one hand,

Black Lion Wharf, K.42. 1859. Etching, 5⅞ × 8⅞″ (15 × 22.2 cm). Tate Gallery, London.

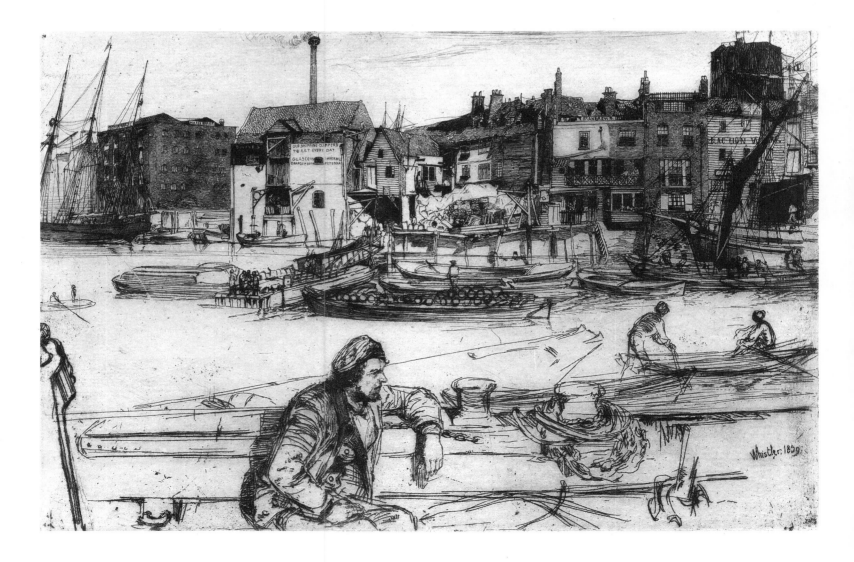

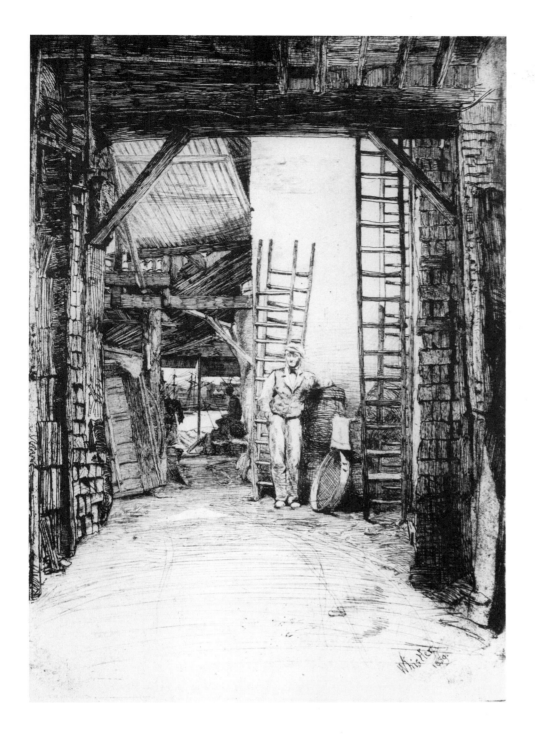

The Lime-Burner, K.46(ii). 1859.
Etching, 9⅞ × 6⅞″
(25.3 × 17.8 cm). Hunterian Art
Gallery, Glasgow University
(J. W. Revillon Bequest).

or prettiness and some slight chance of popularity on the other. The
English school has not aimed at greatness, except in one or two notable
instances; it has aimed at popularity, and it is not even popular."

The French fail in a direction opposite to the English; they are apt to
be capricious, pretentious, outrageous; their art is a wild vagary, and
liberty degenerates into licence. Hence it becomes a question whether the
timidity of the English school be not preferable to the audacity of the
French. Certainly it were an injustice to Mr Whistler to identify him with
either extreme; he seldom fails on the side of timidity, and though
occasionally he may scrawl at random, he never breaks loose wholly from
the laws of pictorial composition. Among these etchings there are several
which recall the style of M Corot and other French landscape painters.
Chelsea Bridge and Church, for instance, is slight and tender, silvery and
grey; also *Battersea, Early Morning*, a plate which preserves the quality of a
sketch, is tranquil, delicate and lovely. *Milbank* [sic] likewise may be
named as attaining force and yet preserving form; the lines are few, the
labour is slight, but the touches fall into the right places. This economy of

Camille-Jean-Baptiste Corot (1796–1875)

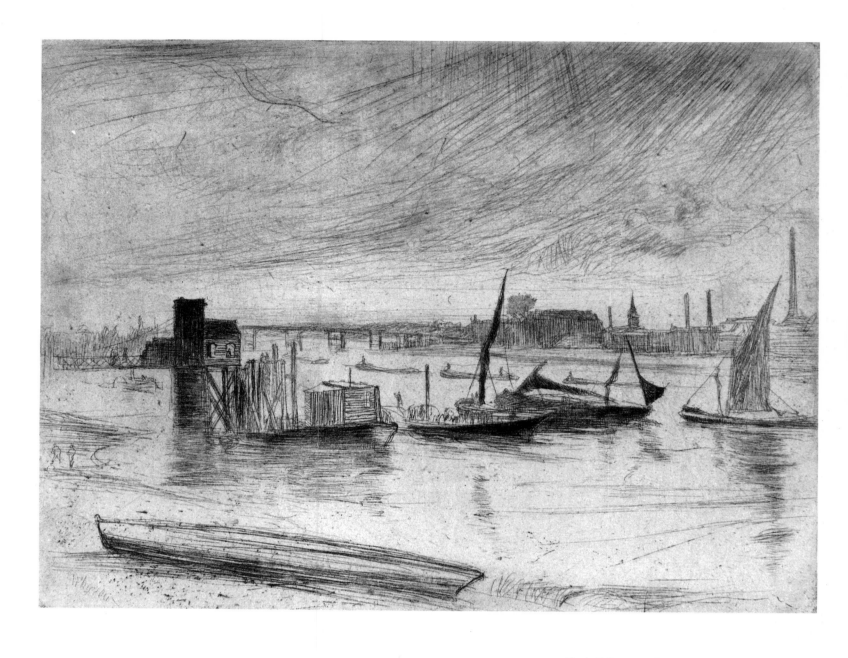

Early Morning, Battersea, K.75.
1861. Drypoint, 4⅜ × 6″
(11.3 × 15.2 cm). Hunterian Art
Gallery, Glasgow University (J.
A. McCallum Collection).

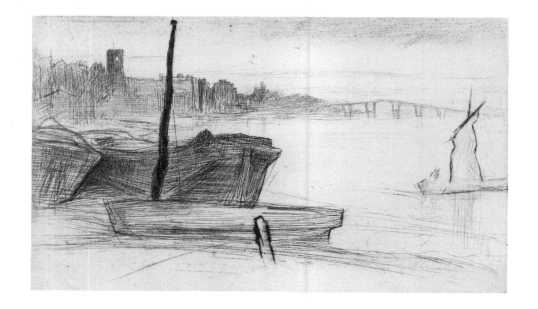

LEFT *Chelsea Bridge and Church*,
K.95(vi). 1870–71. Drypoint,
4 × 6½″ (10.2 × 16.7 cm).
Hunterian Art Gallery, Glasgow
University.

OPPOSITE *Eagle Wharf*, K.41. 1859.
Etching, 5⅜ × 8⅜″ (13.8 × 21.4 cm).
Hunterian Art Gallery, Glasgow
University (J. A. McCallum
Collection).

time and wise direction of energy, this defined purpose and subordination of means to ends, may be taken as characteristic of the French school. Art, as art, is supreme among the master-etchers of Paris.

Mr Whistler, trained in the atelier of M Gleyre, has probably more knowledge of the figure than he obtains credit for. *The Lime Burners* are not unworthy of Ostade. *Wapping*, sailors smoking, is capital for delineation of character. *The Pool* makes known to us a boat-boy who might be the companion of rustics sketched by William Hunt. But once at any rate the artist breaks down. *The Forge* involves difficulties which are not surmounted; the treatment is perplexed and purposeless, the handling uncertain and weak. In looking at this plate we miss the force of shade, the surprise of light, the strength of contrast which Rembrandt would have thrown into such a subject. Yet *The Fiddler* will scarcely suffer by comparison with the most famous of extant etchings, ancient or modern. This figure is magnificent in force of modelling, in its breadth and in its detail. The hand never loses itself, brilliance does not break into tone, force is focussed on the face. The subordinate parts are indicated by the sweep of the etching-needle, sharp, swift, and suggestive as the silver point of the old masters. A skilful etcher plays with his tool as a musician with his instrument.

Picturesque is the term which best designates the materials with which Mr Whistler deals. The classicism of Claude is wholly foreign to his style. There is little beauty or grace, little balanced symmetry in the compositions before us. But picturesque they eminently are. *Limehouse*, for example, assumes a Prout-like character in the crumbling old tenements that crowd the shore; and in *Eagle Wharf* we have one of the rustic figures which recall the manner of William Hunt. Indeed, in these plates the

K. 46.
The Dutch artist Adrian van Ostade (1610–85).
PAGE 61 *(K. 66)*
William Henry Hunt (1790–1864), painter and watercolourist of still-life and rustic genre who had an individually detailed style of stippling and hatching.

PAGE 145 *(K. 52)*

Claude Lorrain (1600–82)

Samuel Prout (1783–1852), watercolourist and painter of architectural subjects in the picturesque style.

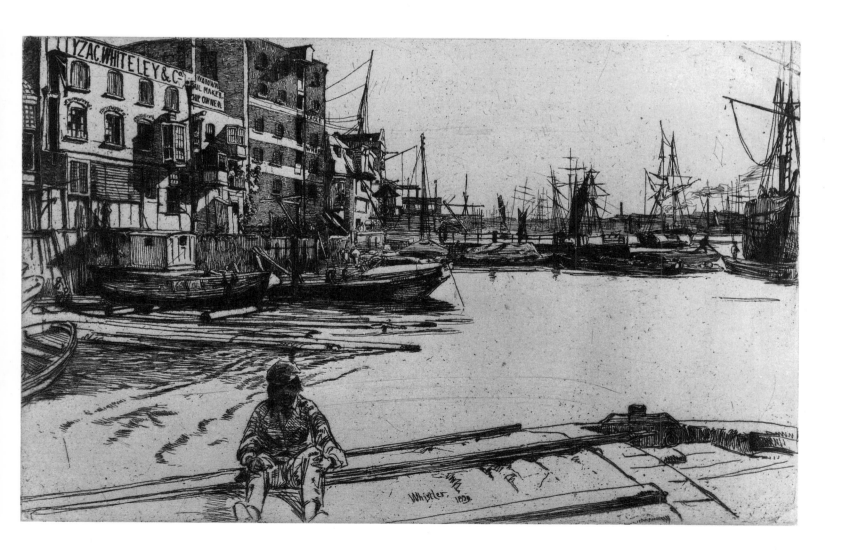

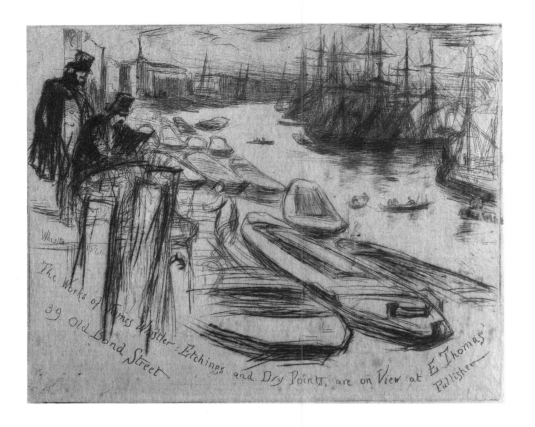

figures are usually just as picturesque as the weatherbeaten barges and the broken-down houses; they are, moreover, animated, as in the compositions of Callot and Canaletti, with purpose and movement; even when the etching is slight, as in *The Little Pool*, the rough tars are not wanting in force or character. Each style has necessarily its limitations; and in looking at these remarkable works we see how hard it is to be at once picturesque and imaginative, literal and ideal, matter-of-fact and creative. Thus the contrast is great between Mr Whistler and Turner; the one exhausts his force at a single throw, states facts concisely and emphatically, works out some obvious problem in light, shade and composition by a few simple means; the other holds back his resources till he can reach a grand climax, economizes his powers through subordinate passages until he comes to the stronghold of his composition, and so at length, by subtle elaboration, attains complex and imaginative pictorial effects. All artists suffer by comparison with Turner, just as all men must appear circumscribed when measured by the infinity of nature. But, failing of universality, it is well when a painter or draughtsman can become, like Mr Whistler, identified with a style strongly marked in its individuality. The Thames affords for this artist congenial sketching ground; what Canaletti did for Venice, Mr Whistler has been doing among the wharves, quays, bridges and river craft of London. Mr Hemy proved in the last Academy Exhibition, in *The Shore at Limehouse*, that in London there are still left scenes as paintable as any of the old cities of the Continent; and the late David Roberts showed in panoramas that the mists and smoke which gather on the Thames are, when illumined by sunshine, scarcely less dazzling than the sky of Italy or the waves of the Adriatic. In like manner Mr Whistler has, simply by means of the etching-needle, brought to the eye a vivid sense of light, heat and colour. Lastly, his labours are not without a topographic value. *Old Hungerford* and *Old Westminster Bridge* serve, like the plates by Callot of old Paris, to perpetuate the memory of works which now belong only to the past. The etcher has a gift and a privilege which not even the photographer can annul or take away; he makes himself the trusty ally of the antiquary and the historian; he is faithful as a chronicler, while fascinating as an artist.

EDWARD J. POYNTER

Letter to Whistler

10 October 1871

BEAUMONT LODGE, WOOD LANE, SHEPHERD'S BUSH, TUES. OCT. 10. 1871

My dear Jimmy,

I was sorry again not to be able to go to see you on Sunday – but I am *so* busy just now. – I went to the Dudley at the end of last week, but too late alas! to be of any use, for the pictures were most of them hung. One of yours is properly placed, but the other *the moonlight* seems to have riled the hangers for they have placed it badly. Had it been possible for me to be present at the hanging I would have gone, but my time is completely taken up – If you think my opinion worth anything, perhaps you will allow me to say how very much I admire both the paintings, but especially the moonlight, which renders the poetical side of the scene better than any moonlight picture I ever saw. I wish I had been there to see justice done to it.

Very truly yours

Edward J. Poynter

TOM TAYLOR

THE TIMES

"Dudley Gallery – Cabinet Pictures In Oil"

14 November 1871

There are here two much criticized examples of a different kind, in which the incompleteness is of the most studied and deliberate kind – where, in fact, the painter's work, however void and formless it may seem to common apprehension, is the result of a theory of art, and the expression of an artistic faculty not the less real and rare because it is exclusive in its self-assertion, and not the less interesting because it is so narrowly self-limiting. We refer to Mr J. A. M. Whistler's pictures, characteristically christened *Variations in Violet and Green*, and *Harmony in Blue and Green – Moonlight*. They are illustrative of the theory, not confined to this painter, but most conspicuously and ably worked out by him, that painting is so closely akin to music that the colours of the one may and should be used, like the ordered sounds of the other, as means and influences of vague emotion; that painting should not aim at expressing dramatic emotions, depicting incidents of history, or recording facts of nature, but should be content with moulding our moods and stirring our imaginations, by subtle combinations of colour through which all that painting has to say to us can be said, and beyond which painting has no valuable or true speech whatever. These pictures are illustrations of this theory. They contain the least possible amount of objects, nothing, in fact, beyond the faintest indications of river surface under moonlight, a dim mass of faintly lighted building closing the high horizon, and reflected in the water, and, for foreground objects, in the one case a scarcely intelligible barge and faint

The artist Edward Poynter first met Whistler in Paris (see page 55).

Whistler exhibited Harmony in Blue-Green-Moonlight, YMSM 103 *(Colourplate 34), later called* Nocturne: Blue and Silver – Chelsea, *in the 5th Winter Exhibition of Cabinet Pictures in Oil at the Dudley Gallery, Egyptian hall, Piccadilly; it was bought for £210 by the London banker W. C. Alexander (see also page 103).*

Tom Taylor (see page 59) here writes with sympathy of Whistler's first "moonlight" (see also above). It is probable Taylor gained his understanding direct from the artist, with whom he was then on cordial terms. As the decade progressed Taylor grew increasingly weary of the nocturnes – as they became known in 1872 – which he adversely regarded as merely decorative. He reiterated this negative view in support of Ruskin at the libel trial in 1878 (see page 128). Taylor then became a secondary target in Whistler's pamphlet Art and Art Critics: Whistler versus Ruskin *(1878), and their rebarbative public exchange concerning it was later reproduced in* The Gentle Art of Making Enemies *(1892).*

COLOURPLATES 29 and 34

figure of a mudlark, in the other some slightly indicated female personages on a shadowy balcony. The only way to explain the perspective of the pictures is to suppose them painted from a high window. The colour, consistently with the theory of the painter, is carried out into the frames by means of delicate diaperings and ripplings of faint greens and moony blues on their gold, and the Japanese influence in which the painter delights is carried even to the introduction of the coloured cartouche, which on the Japanese screen bears the address of the painter or seller.

Mr Whistler has introduced his own monogram or symbol in this way, carefully attuning the colour of the cartouche to the dominant harmony of his picture. With all the apparent slightness of the work, the management of colour all through is governed by the subtlest calculation, and the gradation and juxtaposition of delicate tones appeal to the finest chromatic susceptibles. Many who entirely dissent from the painter's theory, as excluding from the domain of art most that they are wont to think its noblest and highest elements, and who may be disposed to view it rather as the audacious invention of a prejudiced and limited mind, of rare powers in certain directions and as strange deficiencies in others, than as a conception of pictorial art to be gravely dealt with, will feel the beauty and charm *sui generis* of these pictures. They are, at least, the result of a very peculiar faculty, and are marked with an individual stamp, and this is the rarest thing in pictures at present. Mr Whistler's portfolio of etchings . . . which takes rank with the best modern work of the kind . . . shows that his avoidance of precise delineation in these pictures is calculated, and not the result of any want of drawing power.

JAMES MCNEILL WHISTLER
Letter to F. R. Leyland
November 1872

Dear Leyland,

I know you don't see the Athenaeum and so send the enclosed. The Princess is at Queens Gate and hanging in the "Velazquez Room" by the fireplace opposite the door so that you can see her from the hall as you go in. She looks charming – you will I hope be pleased to hear that among other things – am well at work at your large picture of the three girls and that it is going on with ease and pleasure to myself.

I want much to borrow Mrs Leyland's little *Nocturne*. She says that she has no objection, so if you would kindly let John pack it in the case I took it to Speke in and send it to me I should be very much obliged – with apologies for the trouble.

I say I can't thank you too much for the name *Nocturne* as a title for my moonlights! You have no idea what an irritation it proves to the critics and consequent pleasure to me – besides it is really so charming and does so poetically say all I want to say and *no more* than I wish. The pictures at the Dudley are a great success – The *Nocturne in Blue and Silver* is one you don't know at all. Tell Tom that two of his works are on exhibition in London and catalogued and priced – and there he is lancé! – We all went in triumph to see them, and Mrs Tom carries back the catalogue. I have had the Princess photographed, but have not yet seen the proofs. When they come I shall, of course, send one down. I do not think I shall come myself to Speke until about Christmas.

Yours ever,

James McN. Whistler

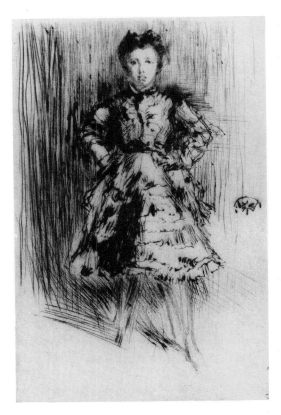

Elinor Leyland, K.109(iii). 1873. Drypoint, 7¾ × 5¼" (19.6 × 13.2 cm). Hunterian Art Gallery, Glasgow University.

Frederick Richard Leyland (1831–92), the Liverpool shipowner who founded the Leyland shipping line in 1873.

A review of the 6th Winter Exhibition of the Dudley Gallery where Whistler showed Nocturne in Grey and Gold *(probably YMSM 117) and* Nocturne in Blue and Silver *(YMSM 118) appeared in* The Athenaeum *on 2 November 1872. Leyland bought 49 Princes Gate [sic] in 1869;* The Princess from the Land of Porcelain, *YMSM 50 (Colourplate 16). Leyland had recently purchased a picture attributed to Velazquez. The "three girls" is a reference to* The White Symphony: Three Girls *YMSM 87 (Colourplate 26) or an enlargement of it Whistler was then working on. Whistler had recently given Mr Leyland* Nocturne in Blue and Silver *YMSM 113 (Colourplate 34); Leyland bought Speke Hall, the Tudor mansion outside Liverpool, in 1867. Leyland's fondness for playing Chopin may have suggested the name "nocturne" for Whistler's "moonlights." "Tom" is unidentified.*

E. F. S. PATTISON

THE ACADEMY

"The Exhibition of the Royal Academy of Arts"

15 May 1872

Emilia Francis Strong Pattison (1840–1904), art critic and historian of French art, and reformer of women's industrial status, married Sir Charles Wentworth Dilke MP, in 1885. In the Royal Academy of 1872 John Everett Millais was well represented by three portraits, two landscapes and a figure subject.

As a painter Mr Whistler cannot compete with the splendid realism of Millais. But Mr Whistler takes a foremost place in virtue of the intellectual power which he has shown in his forcible *Arrangement in Grey and Black: Portrait of the Painter's Mother*. The treatment of the subject is stiff, and harsh even to painfulness. At first sight in its voluntary renunciation of any attempt to rouse pleasurable sensations by line, or form, or colour, it brings up a vision of the typical Huguenot interior – protestantism in a Catholic country. Then, the longer we dwell on it, the more cruelly vivid becomes the presentment to us of life with its sources of joy sealed or exhausted. Mr Millais, as we have noticed above, starts directly from his sense impressions unmodified by any mental operation; Mr Whistler starts from a precisely opposite point of view. The attitude of mind in his sitter being conceived, he has worked it out, selecting the key of colour and the lines of composition so as to enforce, as it were, rather the mental attitude than the material facts. In Mr Watts we have an artist who is without the physical force of Millais, and (looking at Mr Whistler's work of this year) without the intellectual vigour of Whistler. But Mr Watts has a vein of poetic sensibility, and a refined taste, which make his work always interesting however unequal.

COLOURPLATE 30

ANNA M. AND JAMES MCNEILL WHISTLER

Letter to Mrs W. C. Alexander

26 August 1872

The London banker W. C. Alexander (1841–1916) purchased Whistler's first exhibited "nocturne" (see page 101, Colourplate 34) and subsequently commissioned portraits of three of his six daughters (YMSM 127, 129, 130). This letter, begun by Whistler's mother to Rachel Agnes Alexander, concerns the first portrait of the second daughter Cicely Henrietta which became Harmony in Grey and Green: Miss Cicely Alexander *YMSM 129 (Colourplate 46), although the dress differs from that designed here by Whistler.*
COLOURPLATE 17

2 LINDSEY HOUSES, CHELSEA, TUESDAY AFTERNOON, 26 AUGUST 1872

[Mrs Whistler] My dear Mrs Alexander

You are quite right to make me of any use in the studio. The Artist is very sorry to put you to any additional trouble, but his fancy is for a rather clearer muslin than the pattern enclosed in your note. I think Lins's Book muslin will be right, that the arms may be seen thru it as in the *Little White Girl* you may remember. It should be without blue, as purely White as it can be. He likes the narrow frilling such as is upon the upper skirt of the dress Sicily [sic] has worn. and I suppose the new one can be made in the same fashion exactly.

[J. McNeill Whistler] If possible it would be better to get fine Indian muslin – which is beautiful in color – It would be well to try at a sort of second-hand shop called Aked's in a little street running out of Leicester Square on the right hand corner of the Alhambra as you face it and on the same side of the square – like this: [drawing] or perhaps Farmer and Roger may have it they often keep it – But try Aked first –

Messrs. Farmer and Roger's Great Cloak and Shawl Emporium, where Arthur Lasenby Liberty was then Oriental Manager.

The dress might have frills on the skirts and about it – and a fine little ruffle for the neck – or else lace – also it might be looped up from time to time with bows of pale yellow ribbon – [drawing].

In case the Indian muslin is not to be had – then the usual fine muslin of which ladies evening dresses are made will do – the blue well taken out – and the little dress afterwards done up by the laundress with a little starch to make the frills and skirts etc stand out – of course not an atom of blue! –

[Mrs Whistler] As I handed as far as I had written to my son for his approval, he went on with it himself but that you need not feel nervous about the time alotted [sic], I have taken the freedom to put the dress left in my keeping, into the hands of my Laundress merely to extract the slight hue of sky blue, which is the sole objection, and so, it will be ready for Friday if this one ordered cannot be finished by then.

I must now express my grateful sense of your kindness, in your invitation for next Sunday. The Old Chelsea Church being closed and my Pastor absent I am like a stray sheep & shall I am sure be benefitted [sic] by attending your place of public worship, and I am as fond of children as of [indecipherable], I shall be delighted to see the originals of the pretty Photos shewn me yesterday, as, without having seen and heard Sici's [sic] little brothers and sisters, she has introduced them to me, in her natural loving talk of them – as she has won a place in my heart so will they.

Believe me dear Mrs Alexander

Very truly yours with esteem

Anna M. Whistler

E. R. AND J. PENNELL

THE LIFE OF JAMES McNEILL WHISTLER

The Nocturnes

1908

The brothers Greaves bought his materials and prepared his canvas and colours. "I know all these things because I passed days and weeks in the place standing with and beside him," Walter Greaves has said to us. And so it happens that, of the methods and materials of few other modern painters, is there so accurate a record as of Whistler's when he painted the *Nocturnes.* He reshaped his brushes usually, heating them over a candle, melting the glue and pushing the hairs into the form he wanted. Walter Greaves remembers that the colours were mixed with linseed oil and turpentine. Whistler told us that he used a medium composed of copal, mastic and turpentine. The colours were arranged upon a palette, a large oblong board some two feet by three, with the Butterfly inlaid in one corner and, round the edges, sunken boxes for brushes and tubes. The palette was laid upon a table. He had at various periods two or three of these, and at least one stand, with many tiny drawers, upon which it fitted. At times it was slightly tilted. At the top of the palette the pure colours were placed, though, more frequently, there were no pure colours at all. Large quantities of different tones of the prevailing colour in the picture to be painted were mixed, and so much medium was used that he called it "sauce." Mr Greaves says that the *Nocturnes* were mostly painted on a very

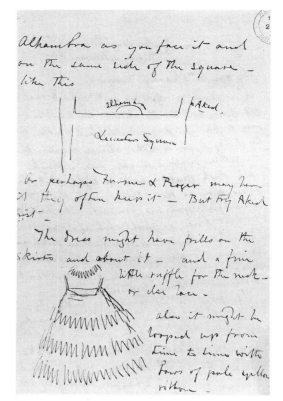

Drawing of design for a dress, in a letter from Mrs Anna M. Whistler and Whistler to Mrs W. C. Alexander, 26 August 1872. British Museum, London (Ashley MS AP24).

Joseph Pennell (1860–1926), the Philadelphia-born print-maker, and his wife Elizabeth Robins, first met Whistler in 1884 and were commissioned by the publisher William Heinemann in 1900 to write his biography.

Walter Greaves (1846–1930) and his brother Henry (1850–1900), boatmen of Lindsey Row, became Whistler's studio assistants and pupils. Otherwise untrained, Walter made Whistler's methods his own, closely emulating the style of the Nocturnes. *His work remained obscure until 1911 when it was "discovered" by a London art dealer whose exhibition of it sparked a furious public controversy concerning the artistic relationship of master and pupil, about which Whistler's biographer, Joseph Pennell, had much to say.*

OPPOSITE TOP *Nocturne: The River at Battersea*, W.5. 1878. Lithotint, 6¾ × 10⅛″ (17 × 25.7 cm). Hunterian Art Gallery, Glasgow University (Birnie Philip Bequest).

OPPOSITE BOTTOM *Early Morning*, W.7. 1878. Lithotint, 7 × 10½″ (18.2 × 26.9 cm). Hunterian Art Gallery, Glasgow University (J. A. McCallum Collection).

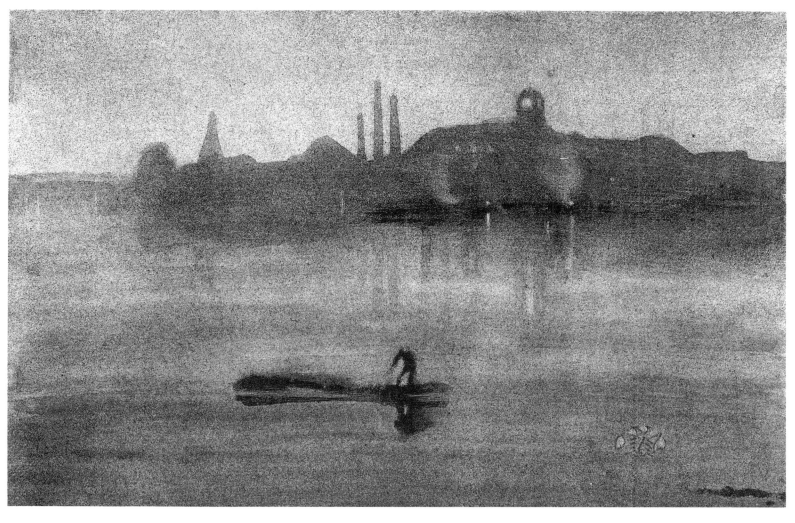

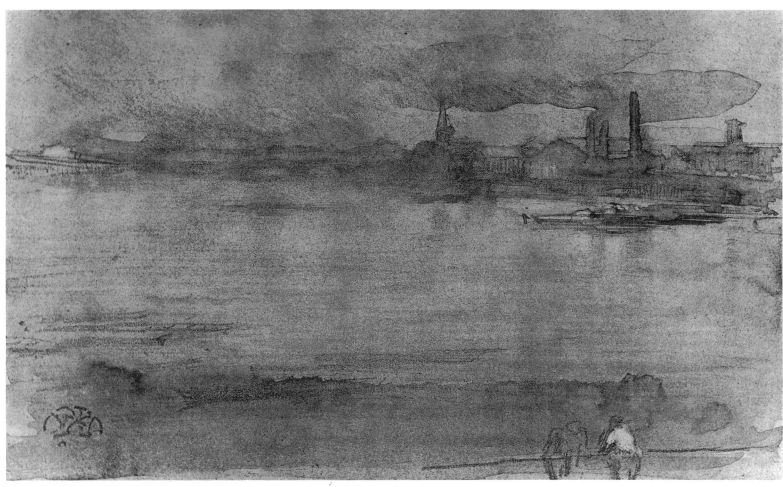

absorbent canvas, sometimes on panels, sometimes on bare brown holland, sized. For the blue *Nocturnes*, the canvas was covered with a red ground, or the panel was of mahogany, which the pupils got from their own boat-building yard, the red forcing up the blues laid on it. Others were done on "practically a warm black," and for the fireworks there was a lead ground. Or, if the night was grey, then, Whistler said, the sky is grey, and the water is grey, and therefore the canvas must be grey. Only once, within Mr Greaves' memory, was the ground white. The ground, for his *Nocturnes*, like the paper for his pastels, was chosen of the prevailing tone of the picture he wanted to paint or of a colour which would give him that tone, not to save work, but to save disturbing, "embarrassing," his canvas.

When Whistler had arranged his colour scheme on the palette, the canvas, which the pupils prepared, may have been stood on an easel, but so much "sauce" was used that, frequently, it had to be thrown flat on the floor to keep the whole thing from running off. He washed the liquid colours on to the canvas, lightening and darkening the tone as he worked. In many *Nocturnes*, the entire sky and water are rendered with great sweeps of the brush of exactly the right tone. How many times he made and wiped out that sweeping tone is another matter. When it was right, there it stayed. With his life's knowledge of both the effects he wanted to paint and the way to paint them, at times, as he admits himself, he completed a *Nocturne* in a day. In some he got his effect at once, in others it came only after innumerable failures. If the tones were right, he took them off his palette and kept them until the next day, in saucers or dishes under water, so that he might carry on his work in the same way with the same tones. Mrs Anna Lea Merritt tells us that when she lived in Cheyne Walk she remembers "seeing the *Nocturnes* set out along the garden wall to bake in the sun." Some were laid aside to dry slowly in the studio, some were put in the garden or on the roof to dry quickly. Sometimes they dried out like body-colour in the most unexpected fashion. He had no recipe, no system. The period was one of tireless research. He had to "invent" everything, though he profited by the technical training he had gained in painting the *Six Projects*.

T. R. WAY

MEMORIES OF JAMES McNEILL WHISTLER
Memory Training
1912

I shall never forget a lesson which he gave me one evening. We had left the studio when it was quite dusk, and were walking along the road by the gardens of Chelsea Hospital, when he suddenly stopped, and pointing to a group of buildings in the distance, an old public house at the corner of a road, with windows and shops showing golden lights through the gathering mist of twilight, said, "Look!" As he did not seem to have anything to sketch or make notes on, I offered him my notebook; "No, no, be quiet," was the answer; and after a long pause he turned and walked back a few yards; then, with his back to the scene at which I was looking, he said, "Now, see if I have learned it," and repeated a full description of the scene, even as one might repeat a poem one had learned by heart. Then we went on, and soon there came another picture which appealed to me even more than the former. I tried to call his attention to it, but he would not look at it, saying, "No, no, one thing at a time." In a few days I was at the studio again, and there on the easel was the realization of the picture.

In The Whistler Journal *(1921) Pennell describes the medium as Mcgilp [sic] – Mcgilp being a solution of mastic resin in turpentine with linseed oil, added to oil to improve its working qualities. Whistler's method of underpainting was probably derived from Liberat Hundertpfund's* Art of Painting Restored to its Simplest and Surest Principles *(1849).*

As testified under cross-examination in the Whistler-Ruskin trial in 1878 (see page 128).

Mrs Anna Lea Merritt (1844–1930), American artist, and painter of Love Locked Out *(Tate Gallery, London). Whistler's practice of placing the nocturnes outside to dry was seized upon and deliberately given a satirical edge by Ruskin's Counsel at the trial in 1878 (see page 129).*
COLOURPLATES 23–26

Thomas Robert Way's (1862?–1913) father Thomas Way owned a lithographic firm and with his encouragement Whistler took up lithography in 1878. Until Whistler moved to Paris in the 1890s, the Ways printed all of Whistler's lithographs. Way's Memoirs *(see page 304) and Whistler's correspondence with him are an important technical source for Whistler's lithographic practice.*

Note for a Nocturne. Pen and ink, 3¾ × 4¾" (9.5 × 12 cm). Hunterian Art Gallery, Glasgow University (Birnie Philip Bequest).

This incident, which illustrates his capacity for rapidly taking in a subject as a whole, and retaining the impression until he could realize it in painting, seems to me to throw a considerable light on the aim of much of his work, and to reveal, in no small measure, the secret of its charm. I think he was sleeping at his brother's house at that time, but whether so or not I was very greatly interested when, amongst some little pen-sketches which Mrs W. Whistler lately showed me, I recognized one of the subject here described. I think he must have made it as soon as he got indoors, and as I had made a memory-sketch of his painting I was able to compare them and identify it. I have never seen the picture since. Mr Luard wrote to me some time ago, suggesting that he probably learned this system of grasping his subjects from the French Professor, De Boisbaudran, who was teaching such a method at the time he was studying in Paris.

Horace Lecoq De Boisbaudran (1802–97) developed a method of teaching drawing based on memory training. Among his pupils were Fantin and Legros. L. D. Luard, The Training of the Memory in Art and the Education of the Artist (1911) incorporates translations of Boisbaudran's principal works.

JAMES MCNEILL WHISTLER

Letter to George Lucas

18 January 1873

Dear Lucas,

I have heard of you from time to time through Avery and listened with great pleasure to his description of your new house you have lately built. The Studio in it naturally interested me immensely. He tells me that you invite me to come and paint in it. This is a princely offer which I hope to remind you of and thank you for one of these days when I also intend to accept it. Meanwhile I write to tell you of an exhibition of several works of mine now to be opened by Mons Durand Ruel – Rue Lafitte. Go and see them and do like a good fellow write me a letter and tell me how you like them. They are not merely canvases having interest in themselves alone, but are intended to indicate slightly to "those whom it may concern" something of my theory in art. The science of colour and "*picture pattern*" as I have worked it out for myself during these years.

There – I will not bore you with an article. Go and see and also fight any battles for me about them with the painter fellows you may find opposed to them – of whom by the way there will doubtless be many. Write me what you may hear and in short as I am not there to see, tell me what effect my work produces, if any.

You will notice and perhaps meet with opposition that my frames I have designed as carefully as my pictures – and thus they form as important a part as any of the rest of the work – carrying on the particular harmony throughout. This is of course entirely original with me and has never been done. Though many have painted on their frames but never with real purpose or knowledge – in short never in this way or anything at all like it. This I have so thoroughly established there that no one would have to put any colour whatever (excepting the old black and white and that quite out of place probably) on their frames without feeling that they would at once be pointed out as forgers or imitators; and I wish this to be also clearly stated in Paris that I am the inventor of all this kind of decoration in colour in the frames; and I may not have a lot of clever little Frenchmen trespassing on my ground.

By the names of the pictures also I point out something of what I mean in my theory of painting.

I hope my dear Lucas you are quite well – and that you may perhaps run over this summer and give me a look up.

With best wishes for the New Year, believe me,

The American engraver and art dealer (1822–1904) who gifted his collection of etchings to New York Public Library in 1900.

Whistler exhibited Arrangement in Grey: Portrait of the Painter *YMSM 122 (Colourplate 44) and other works, including some of the nocturnes, at Durand-Ruel's Paris gallery in January 1873. They seem to have produced little response in the press and no sales are recorded, but see the next entry for the reaction of Whistler's artist friends in London and Paris.*

Whistler first began to decorate his frames of the nocturnes with a fish-scale or wave-pattern of blue on gold in 1871; he probably derived it from Japanese prints and from Anglo-Japanese pattern books. (See Colourplates 29, 41, 42.)

Ever yours affectionately

JA MC N. WHISTLER

You will see my mark on pictures and frames. It is a butterfly and does as a monogram for J.W.

Characteristic, I can say, you will sing in more ways than one. This exhibition of mine you will see clearly is especially intended to assert myself to the painters in short in a manner to register among them in Paris as I have done here, my work. Therefore I have not waited for the Salon – when I could only send two things. This is an "overture!"

HENRI FANTIN-LATOUR
AND OTTO SCHOLDERER
Correspondence
1872-73

Otto Scholderer (1834–1902), Realist painter, German follower of Courbet, and friend of Whistler and Fantin in Paris, had moved to London in 1872.

SCHOLDERER TO FANTIN, 26 NOVEMBER 1872

I like Whistler's landscapes more than before, also his portrait he calls *harmony in black and grey* – it's very fine, with a magnificent background, and it's true he has more nicety than Manet, but I still like the latter much more, I don't know where Whistler's painting will end up.

Arrangement in Grey: Portrait of the Painter YMSM 122 (Colourplate 44) was exhibited, together with a nocturne, in the fifth winter exhibition of the Society of French Artists, Durand-Ruel's London gallery, in 1872; Manet exhibited Woman with a Parrot *(Metropolitan Museum, New York).*

FANTIN TO SCHOLDERER, 23 JANUARY 1873

I've seen the pictures he has just sent at Durand-Ruel's. It was a big surprise for me, I don't understand anything there; it's bizarre how one changes. I don't recognize him any more. I'd like to see him to hear him explain what he's trying to do, but I need to see it again and then I will write frankly to him the effect it has on me.

SCHOLDERER TO FANTIN, 25 JANUARY 1873

As for Whistler's picture, I'm astonished to hear your judgement, because I hoped you could give the key to this painting better than I; still, I admit I'm beginning to understand them better now that I've seen several. I'm not yet at the stage Edwards is, who tells me he believes everyone ought to understand it. Do you talk about the landscapes? I've seen a dozen and I find them better each day. The finesse of his colour, above all, his touch charms me; it's as fresh as Manet's and finer, more *gourmand*, I can say. Still, Manet has a freshness in his subjects that Whistler doesn't know.

The etcher and landscapist Edwin Edwards (1823–79).

FANTIN TO SCHOLDERER, 10 MARCH 1873

I am left with my first impression, and to understand me you would have to have seen Whistler's first pictures, but the reason is everyone follows his own path; one no longer understands another, it's a law of Art. Every day I'm troubled by that; I no longer understand, I almost no longer like what I see by my old comrades, for which I reproach myself, I can't do otherwise. However I make a big effort. Everyone follows his own nature. . . . Manet is going to exhibit a man drinking beer, which I've already told you about, and Mlle Morisot in white, seated on a sofa, which you must have seen at Deschamps'. . . . If you see Whistler tell him from me that I do not know how to explain my impressions on seeing his pictures, that he must explain to me what he's up to.

Le Bon Bock *["A Good Glass of Beer"] (Philadelphia Museum of Art) earned Manet his first popular success when it was shown in the Salon of 1873. Manet's portrait of Berthe Morisot known as* Le Repos *["Rest"] (Museum of Art, Rhode Island School of Design, Providence) had been shown in the fourth summer exhibition of 1872 at the Society of French Artists, which was managed by Charles Deschamps.*

I've seen Whistler here, and I felt on seeing him how much less interested I am in all these things today; we discussed amicably what I didn't understand about what he wanted to do in his canvases. I think that he has too much feeling to be vexed with me, but in spite of all there was a coolness between us; what would you think? Each goes his own way, he appeared enchanted with himself, persuaded that he is moving forward while we others stick with the old painting. I feebly explained what I like and what I would like to do but without warmth; I'm no longer in a mood to discuss it.

For Whistler's relationship with Manet and French Impressionism see R. Spencer, "Whistler, Manet and the Tradition of the Avant-Garde," James McNeill Whistler, A Re-examination, Studies in the History of Art, vol. 19, National Gallery, Washington DC 1987.

HENRY BLACKBURN

THE PICTORIAL WORLD
"'A Symphony' in Pall Mall"
13 June 1874

Henry Blackburn, critic and editor of Academy Notes *and* Grosvenor Notes.

In a newly opened gallery at 48, Pall Mall, opposite to Marlborough House, there is an exhibition of excellence. 1. A *portrait of a gentleman* (Mr Leyland), which more nearly approaches the style of Velazquez than that of any living painter. 2. Examples of etchings and dry point engravings, many of them fifteen or twenty years old, which exhibit the consummation of skill and feeling in this branch of art. 3. Some delicate effects of colours, and studies in monochrome, that exceed in subtlety and refinement anything that modern art – fighting uphill against discordant, distracting and discouraging elements – has yet achieved.

Mr Whistler's works – for the exhibition consists of paintings, sketches and etchings, entirely by this artist – are exhibited in a congenial home. The visitor is struck, on entering the gallery, with a curious sense of harmony and fitness pervading it, and is more interested perhaps, in the general effect than in any one work. The gallery and its contents are altogether in harmony – a *symphony in colour*, carried out in every detail, even in the colour of the matted floor, the blue pots and flowering plants, the delicate tints of the walls, and, above all, in the juxtaposition of the pictures. When in America, I remember that Mr Whistler's name was a household word in art circles, but Mr Whistler's works seemed a household puzzle. "We are proud of our countryman, but we do not understand him," was a remark I heard more than once on the other side of the Atlantic; and it was curious to note the greatness of admiration and the smallness of result artistically. In America there are still only ten men who can draw in line, and of that little band there is not one who approaches Whistler, either in feeling or execution.

It will be interesting to see what amount of attention the present exhibition will attract in London, comprising as it does work of rare, if eccentric genius. There are seven full-length portraits, of which those of Mr Leyland, of the artist's mother and of Thomas Carlyle, are the most striking. The two latter are seated figures, nearly life-size. A line of etchings is ranged round the room; there are also some drawings in chalk, and numerous studies in colour, which, in the absence of a catalogue, we are unable to mention in detail.

But we should like to give the reader – as we may do in a future number – an idea of the effect and arrangement, in a sketch of the little gallery, with its graceful lines and delicate tints. If anyone wishes to realize what is meant by true feeling for colour and harmony – born of the Japanese – let him sit down here some morning, within a few yards of, but in secure shelter from, the glare of the guardsman's scarlet tunic in the bay

Because he had no studio suitable for showing work to patrons Whistler leased premises in Pall Mall for a one-man exhibition. He decorated it in a currently fashionable style in order to give potential collectors an idea of how his art would look in their own homes. Thirteen oil paintings, fifty etchings and thirty-six drawings were included.

Sunflowers. Design for matting. *c.* 1874. Pastel on brown paper, 11¼ × 7½″ (28.6 × 18.5 cm). Fogg Art Museum, Harvard University, Cambridge, Mass. (Bequest of Grenville L. Winthrop).

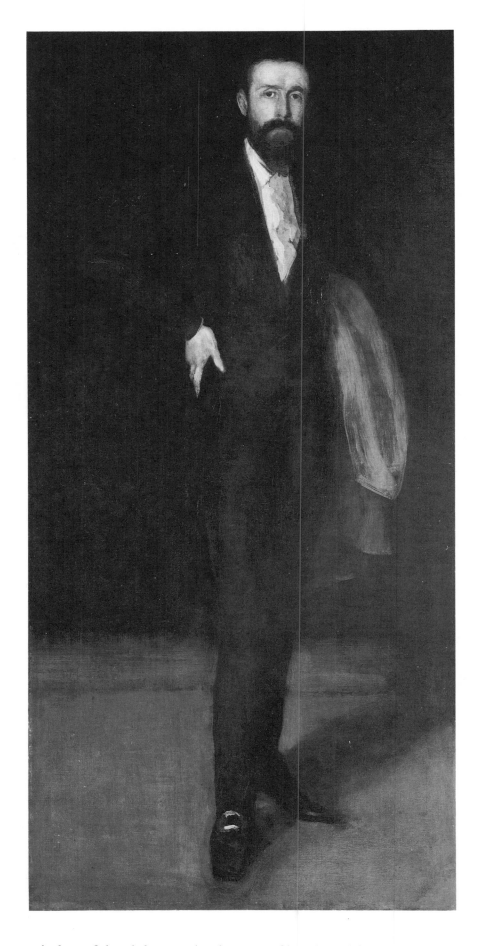

Arrangement in Black: Portrait of F. R. Leyland. 1870–73. 75⅞ × 36⅛" (192.8 × 91.9 cm). Freer Gallery of Art, Smithsonian Institution, Washington, D.C.

window of the club opposite, just out of hearing of Christie's hammer, and just out of sight of the conglomeration of a thousand pictures at the Royal Academy. A "symphony" is usually defined as "a harmony of sounds agreeable to the ear;" here, at 48, Pall Mall, is a harmony of colour agreeable to the eye.

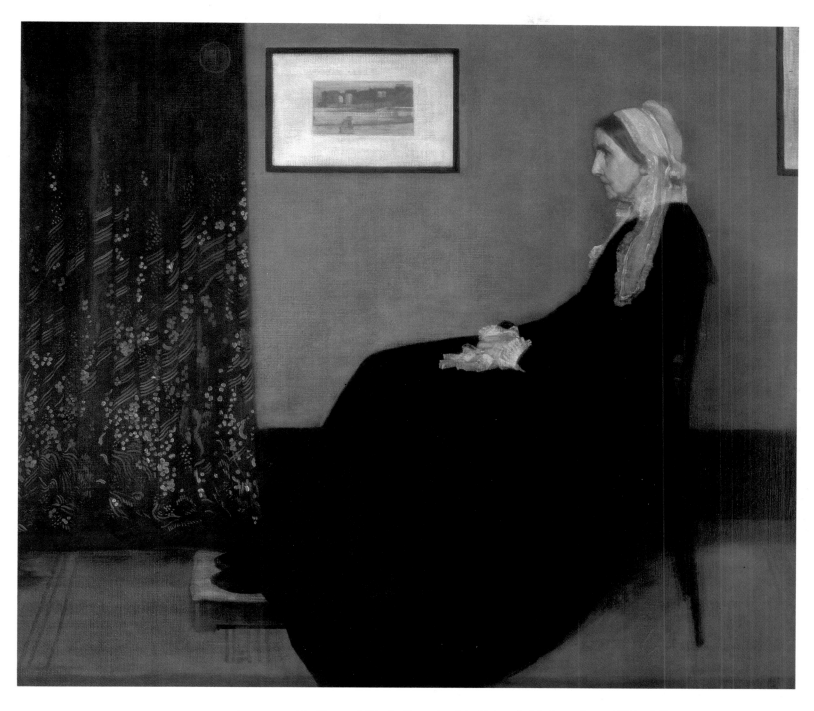

COLOURPLATE 30. *Arrangement in Grey and Black: Portrait of the Painter's Mother.* 1871. 56¾ × 64″
(144.3 × 165.2 cm).
Musée du Louvre, Paris (photo Bridgeman Art Library).

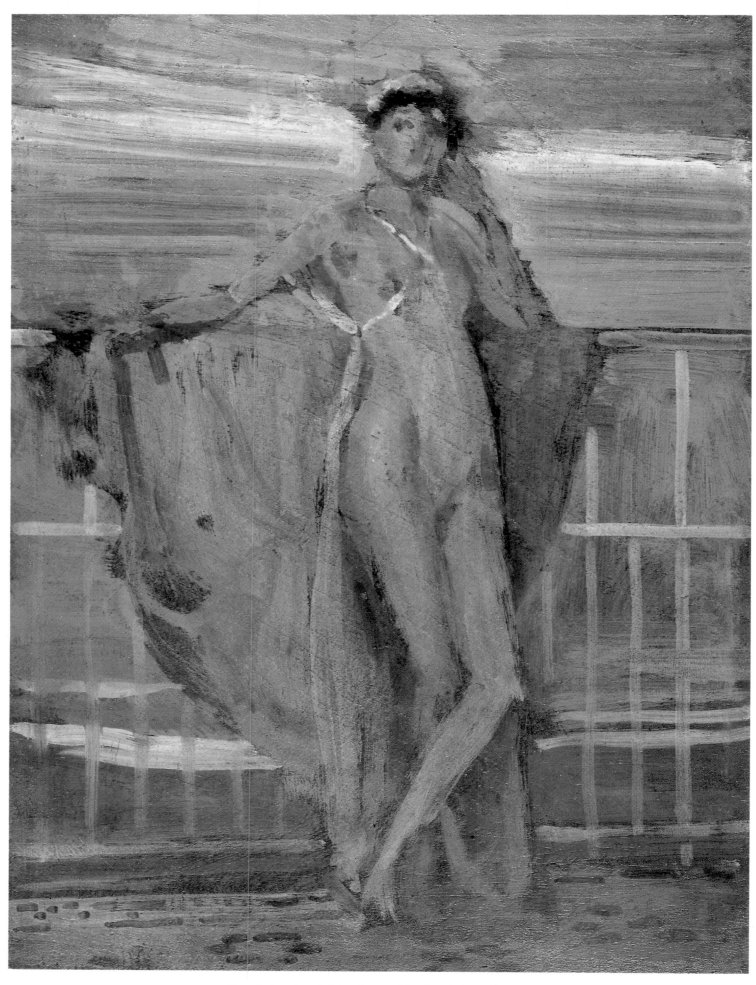

COLOURPLATE 31. Sketch for *Annabel Lee*. Late 1860s/*c*. 1896. 12⅛ × 8⅞″ (30.7 × 22.6 cm).
Hunterian Art Gallery, Glasgow University.

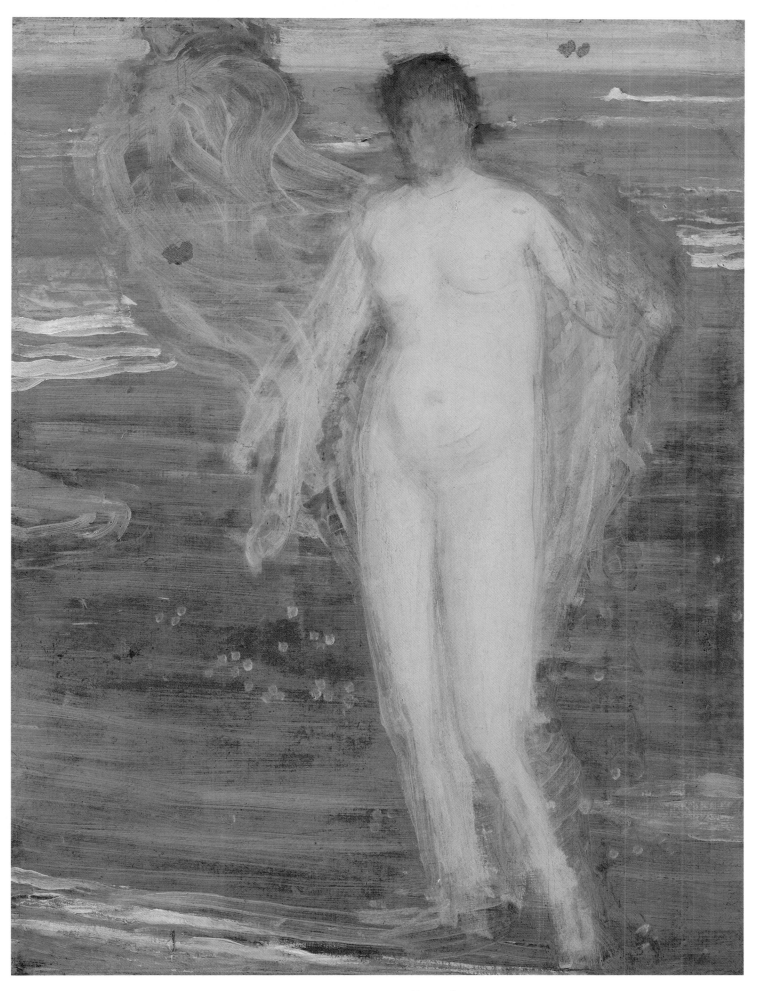

COLOURPLATE 32. *Venus. c.* 1868. 24⅜ × 18″ (61.9 × 45.6 cm).
Freer Gallery of Art, Smithsonian Institution, Washington, D.C.

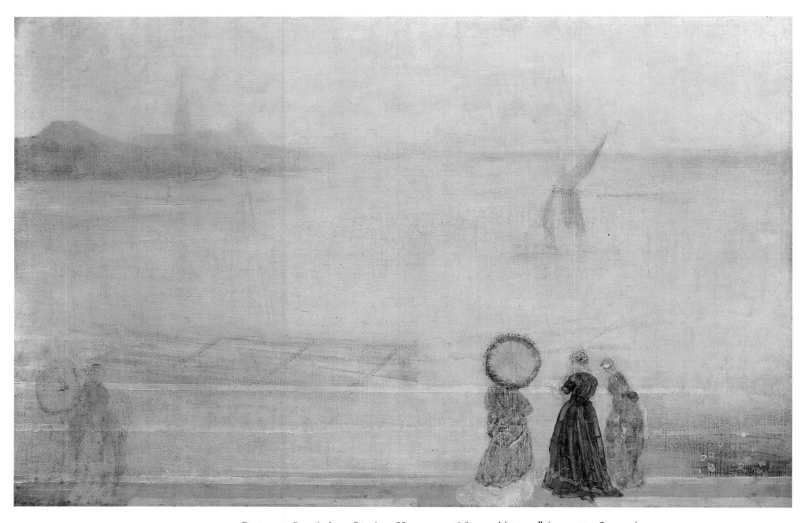

COLOURPLATE 33. *Battersea Reach from Lindsey Houses.* c. 1864. 20⅛ × 30″ (51.3 × 76.5 cm).
Hunterian Art Gallery, Glasgow University (Birnie Philip Bequest).

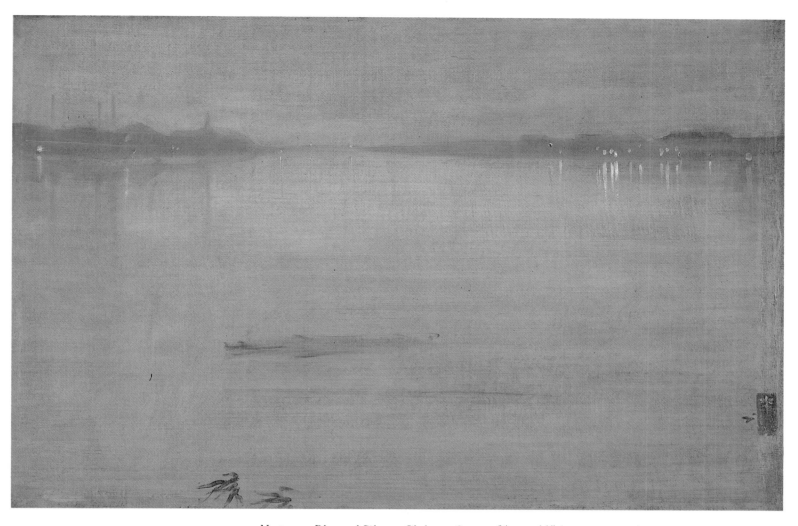

COLOURPLATE 34. *Nocturne: Blue and Silver – Chelsea*. 1871. 19¾ × 23½″ (50 × 59.3 cm).
Tate Gallery, London.

COLOURPLATE 35. *The Blue Dress. c.* 1871. Study for *Symphony in Flesh Colour and Pink: Portrait of Mrs Frances Leyland* (Colourplate 45). Pastel on brown paper, 11 × 7¼″ (28.1 × 18.5 cm). Freer Gallery of Art, Smithsonian Institution, Washington, D.C.

COLOURPLATE 36. *The Blue Girl*. 1872-74. Pastel on brown paper, $9\frac{7}{8} \times 5\frac{3}{4}''$ (25.2 × 14.5 cm).
Freer Gallery of Art, Smithsonian Institution, Washington, D.C.

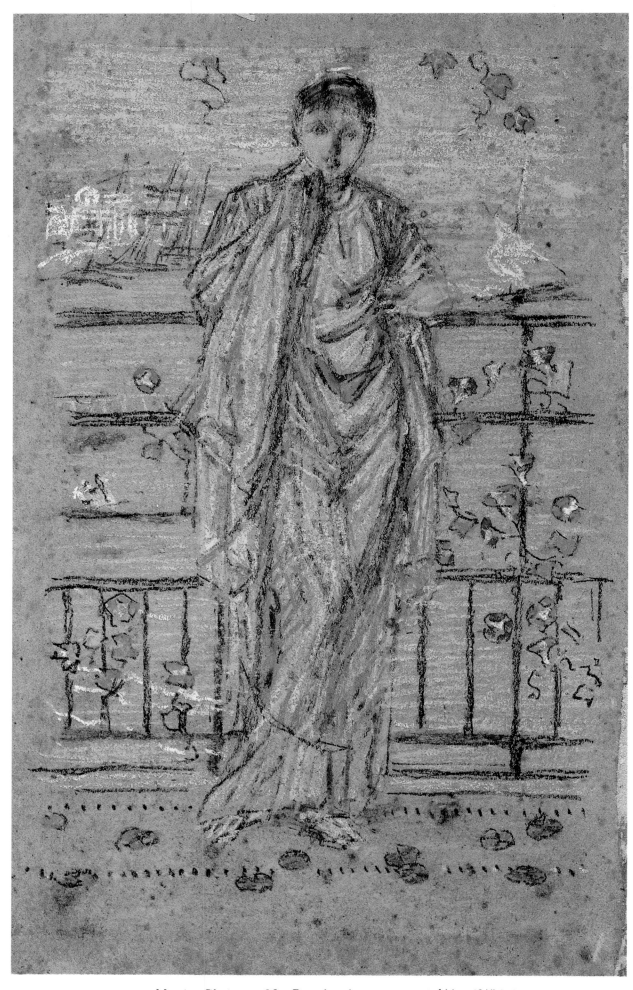

COLOURPLATE 37. *Morning Glories. c.* 1869. Pastel on brown paper, 10¼ × 6⅜″ (26.2 × 16.2 cm).
Freer Gallery of Art, Smithsonian Institution, Washington, D.C.

WILLIAM MICHAEL ROSSETTI

THE ACADEMY
"The Dudley Gallery"
30 October 1875

As usual, the Dudley Gallery alternates an oil-colour with a water-colour exhibition. It is now the turn of the oil-colours, and the result is a decidedly ordinary display – indeed, extremely commonplace to the eye which glances over the walls in a general way. Yet there are many clever and some superior works, to reward the endurance of those who will look for them.

The one picture which will be long remembered by visitors, and will always count as one of its author's chief masterpieces, and in its way never to be superseded and not often rivalled, is the *Nocturne in Blue and Gold, No. 3*, of Mr Whistler. This gives us a Thames view by night – night alloyed and enriched by the faintest twilight that is sufficient to clear and mellow the depths of darkness; it is rather, we think, the suggestion of dawn than the reluctant dying-out of sunset. The dark, grey-blue, smooth river, obscurely ridged but not perceptibly rippled, is nearly silent, hushing as if in murmurous talk; a few lights are reflected in it on the further side, supplying the "gold" of the painter's *Nocturne*; the sky, deep blue, but far less deep than the water, is full of colour which may be said to represent light absent now, but past and to be. A great dark angle of an edifice (the Houses of Parliament?) in the right-hand corner gives the needful recession to river and sky, making them yet more vast, and turning the emotional keynote of the whole work into a distinctly human one. The picture is a *chef-d'œuvre* of tone, tinting, solidity, and sentiment too. We know that many persons do not credit Mr Whistler with any serious command of such qualities – only with jumping at them, and falling on his feet now and again; they should look at the present picture before they quite settle their minds on the subject. Another contribution of the same painter is named *Nocturne in Black and Gold: the Falling Rocket*. This also is extremely good, and in some sense even a bolder attempt than the first-named work; it cannot be properly called *ad captandum*, but its artificial subject-matter places it at a less high level. The scene is probably Cremorne Gardens; the heavy rich darkness of the clump of trees to the left, contrasted with the opaque obscurity of the sky, itself enhanced by the falling shower of fire-flakes, is felt and realized with great truth. Straight across the trees, not high above the ground, shoots and fizzes the last and fiercest light of the expiring rocket.

In the ninth winter exhibition of the Dudley Gallery, 1875, Whistler exhibited Nocturne: Grey and Gold – Westminster Bridge *YMSM 145, which was then called* Nocturne in Blue and Gold, No. 3; *and* Nocturne in Black and Gold: The Falling Rocket *YMSM 170 (Colourplate 53) which was to become the main target of Ruskin's attack on Whistler two years later (see page 128). Although this remained unsold, Whistler's Westminster Nocturne was bought by the Hon. Percy Wyndham for £210. Whistler stated to a friend, "So you see this vicious art of butterfly flippancy is, in spite of the honest efforts of Tom Taylor, doing its poisonous work and even attacking the heart of the aristocracy as well as undermining the working classes."*

Cremorne Gardens, the pleasure gardens to the west of Chelsea, which finally closed in 1877. Whistler's Cremorne subjects (Colourplate 50) probably date from 1875.

ALAN S. COLE

Diary
1875-78

16 November 1875 – Dined with Jimmy; Tissot, A. Moore and Captain Crabb. Lovely blue and white china – and capital small dinner. General conversation and ideas on art unfettered by principles. Lovely Japanese lacquer.

7 December 1875 – Dined with Jimmy; Cyril Flower, Tissot, Storey. Talked Balzac – *Père Goriot* [Old Goriot] – *Cousine Bette* – *Cousin Pons* – *Jeune*

Alan Cole was the son of Sir Henry Cole (1808–82), who was largely responsible for the Department of Science and Art at the South Kensington Museum from 1857 to 1873.

James Tissot (1836–1902); Maud Franklin (see page 250); Mrs Frances Leyland; W. Eldon, possibly H. R. Eldon, whose portrait Whistler painted (YMSM 243–44), Bret Harte (1836–1902); Algernon Bertram Mitford (1837–1916), created Lord Redesdale 1902; Mark Twain (1835–1910).

Homme de Province à Paris [Young Man from the Country in Paris] – *Illusions perdues* [Lost Illusions].

6 January 1876 – With my father and mother to dine at Whistler's. Mrs Montiori, Mrs Stansfield and Gee there. My father on the innate desire or ambition of some men to be creators, either physical or mental. Whistler considered art had reached a climax with Japanese and Velazquez. He had to admit natural instinct and influence – and the ceaseless changing in all things.

12 March 1876 – Dined with Jimmy. Miss Franklin there. Great conversation on Spiritualism, in which J. believes. We tried to get raps – but were unsuccessful, except in getting noises from sticky fingers on the table.

25 March 1876 – Round to Whistler's to dine. Mrs Leyland and Mrs Galsworthy, and others.

16 September 1876 – Dined with W. Eldon there. Hot discussion about Napoleon (*Napoléon le petit*, by Hugo). The Commune, with which J. sympathized – Spiritualism.

29 December 1876 – To dine with J. – the Doctor. – Goldfish in bowl. Japanese trays. – Storks and birds. He read out two or three stories by Bret Harte – *Luck of Roaring Camp*, – *The Outcasts of Poker Flat* – *Tennessee's Partner*. Chatted as to doing illustration for a Catalogue for Mitford, and to his Japanese woman, and a decorated room for the Museum.

18 February 1878 – To Whistler's. – Mark Twain's haunting jingle in the tramcar: "Punch – punch – punch with *care* – punch in the presence of the passenger (jaire)."

27 March 1878 – Dined with Whistler, young Mills and Lang, who writes. He seemed shocked by much that was said by Jimmy and Eldon.

Menu written and illustrated by Whistler. *c.* 1875. Whistler Collections, Glasgow University Library.

F. R. LEYLAND
Letter to Whistler
21 October 1876

Dear Whistler,

I have just received your telegram; but I think it will be more satisfactory now that the work is finished if we settle the amount you are entitled to charge.

I can only repeat what I told you the other day that I cannot consent to the amount you spoke of – £2,000 – and I do not think you should have involved me in such a large expenditure without previously telling me of it. The peacocks you have put on the back of the shutters may possibly be worth (as pictures) the £1,200 you charge for them but that position is clearly a most inappropriate one for such an expensive piece of decoration; and you actually were not justified in placing them there without any order from me. I certainly do not require them and I can only suggest that you take them away and let new shutters be put up in their place.

As to the decorations to the ceiling and the flowers on the old leather, as well as the other work about the house; it seems to me the only way of arriving at a fair charge is to take the time occupied at your average rate of earnings as an artist.

I am sorry there should be such an unpleasant correspondence between us; but I do think you are to blame for not letting me know before developing into an elaborate scheme of decoration what was intended to be a very slight affair and the work of comparatively a few days.

Yours truly

F. R. Leyland

What began as a small commission to repaint the old Spanish leather on the walls of Leyland's dining-room, so that it did not clash with the carpet and the Princess from the Land of Porcelain *YMSM 50 (Colourplate 16), had, by the summer of 1876, resulted in Whistler's* Harmony in Blue and Gold: The Peacock Room *YMSM 178 (Colourplates 63–65). This exchange of three letters documents the only business arrangement which existed between patron and painter; thereafter their correspondence became acrimonious and their relationship was terminated the following year. What also irked Whistler was not only that Leyland refused to pay the full £2,000 but that the amount he chose eventually to pay was in pounds, as a tradesman would be paid, rather than in sovereigns, and calculated on the basis of the time it took Whistler to do the work – a central issue in the Ruskin trial in 1878 (see page 128). It was probably shortly after this exchange that Whistler painted the silver shillings at the feet of the "angry" peacock on the South wall, which together with the "proud" bird became an intentional symbol of Whistler's relationship with Leyland (see Colourplate 64). See D. P. Curry,* James McNeill Whistler, *New York and London, 1984.*

JAMES MCNEILL WHISTLER
Draft Letters to F. R. Leyland
October 1876

DRAFT NO. 4 [24-30 OCTOBER 1876]

Put not your trust in Princes . . . is not to the point, since your [sic] solemnly withdrew from that untenable position on Friday last in favour of the Marquis of Westminster – to my utter ruin and discomfiture! – But my dear Leyland I did still trust the "British Business Man", to which safer role you carefully returned on that occasion – was I wrong?

We agreed to bare [sic] alike the disaster of the decoration – I pay my 1,000 guineas as my share in the dining room, and you pay yours – bon! – but then mon cher you *don't* pay yours! – I learned my lesson of Friday and know that from a business point of view, money is all important and that Saturday should not have passed and Monday's post bring no cheque to

Your promising pupil in business wisdom

J. McN. Whistler

DRAFT NO. 6, 2 LINDSEY HOUSES, CHELSEA, 31 OCTOBER 1876

Dear Leyland – I have enfin received your cheque – for 600 pounds – [I perceive (words deleted)] shorn of my shillings I perceive! – another fifty pounds off – Well I suppose that will do – upon the principal [sic] that anything will do –

Bon Dieu! What does it matter! –

The work just created *alone remains* the fact – and that it happened in the house of this one or that one is merely the anecdote – so that in some future dull Vassari [sic] you also may go down to posterity, like the man who paid Corregio [sic] in pennies! –

Ever yours

J. McN. Whistler

Caricature of F. R. Leyland. 1879. Ink, 7 × 4¼" (17.7 × 11 cm). Ashmolean Museum, Oxford.

Leyland's contribution of £600 was calculated on the basis of his already having advanced Whistler £400; the case of Correggio's patron is told in Vasari's Lives of the Artists.

PALL MALL GAZETTE
"Mr Whistler's Decorative Paintings"
15 February 1877

We have lately had the opportunity of inspecting a very remarkable specimen of decorative painting executed by Mr Whistler for the dining-room of Mr Leyland's house in Prince's Gate. The artist has chosen different tints of blue and gold as the material of his work, and he has taken the plumage of the peacock as the foundation of his design. The walls of the room where any untouched space of wall is left are coloured with an even tint of deep blue, while the ceiling and the panelling around the walls are of pure gold. Beginning with the ceiling, Mr Whistler has devised two ornamental patterns, which he has wrought out in blue upon the gold ground. Radiating from pendent lamps we find the larger design suggested by the eye feather of the bird, and consisting of a series of segments of circles so treated as to give the impression of the low relief of overlapping feathers. Intervening between the circular spaces in which this ornament is disposed is the second pattern suggested by the softer plumage of the peacock's breast; and this double system of decoration,

Whistler held a press view in Leyland's house on 9 February (to which Leyland was not invited), at which he distributed his leaflet Harmony in Blue and Gold. The Peacock Room *(page 122). This, one of the many articles which resulted, may have been written by Sidney Colvin or Joseph Comyns Carr who both wrote for the* Pall Mall Gazette *in the 1870s.*

varied in treatment according to its position, forms the substance of all the purely ornamental work in the room. It is repeated along the double cove that serves as a finish to the walls, where, however, the smaller pattern takes the form of a delicate powdering of blue on gold; and it is used again, in reversed order of colouring upon the panels of the dado and upon the blue wall. The ingenuity employed to give to this simple scheme of ornamentation an impression of richness and variety is strikingly illustrated by the treatment of all this lower part of the room. It is at first sight difficult to believe that in the dado and the portion of the wall immediately above the dado the artist has only made use of the two patterns that cover the ceiling. The colouring is so frequently and so adroitly changed, and the arrangement as regards form and mass of ornament so cunningly alternated, that the simplicity of the means is forgotten in the sumptuous beauty of the result. But Mr Whistler has not been content with mere ornamentation, nor has he left us with only a suggestion of the grace of the bird whose plumage has served him as the material for ordered patterns of colour. Upon the insides of the gold shutters to the windows, and upon the large space of blue wall at the end of the room, he has given a living presentment of the peacock; and here, again, the colour is alternated from blue on gold to gold on blue. These pictorial designs gather up, and give new emphasis to, the beauty of the distributed ornament.

We have made some attempt to describe the plan of Mr Whistler's decoration, but it will be understood that the effect of this kind of work does not readily lend itself to description. It is not the matter, but the manner, of such a carefully balanced scheme of colour and design that constitutes its claim to attention. Peacocks have been painted before, and blue and gold is no new combination of colour; but it is nevertheless true that in Mr Whistler's hands these familiar materials take an entirely new form and become a thing of original and independent invention. The painter, as he here expresses himself, would seem to be very little indebted

BELOW "Harmony in Blue and Gold. The Peacock Room." Single-page leaflet printed by Thomas Way. London, 1877. Whistler Collections, Glasgow University Library.

LEFT *The Peacock Room.* 1892. Photograph by Bedford Lemere showing the room with blue and white china on the shelves. Royal Commission on the Historical Monuments of England, London.

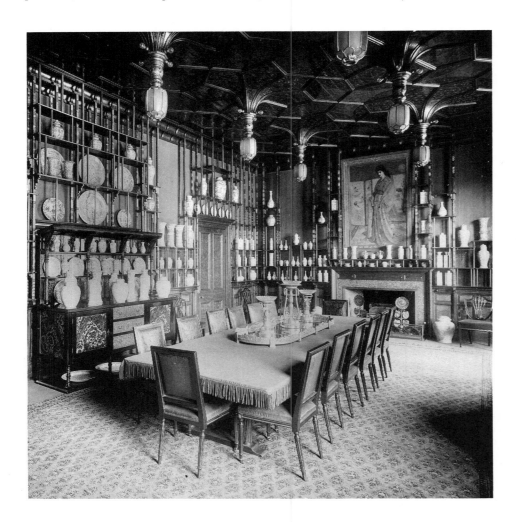

"HARMONY IN BLUE AND GOLD. THE PEACOCK ROOM."

The Peacock is taken as a means of carrying out this arrangement.

A pattern, invented from the Eye of the Peacock, is seen in the ceiling spreading from the lamps. Between them is a pattern devised from the breast-feathers.

These two patterns are repeated throughout the room.

In the cove, the Eye will be seen running along beneath the small breast-work or throat-feathers.

On the lowest shelf the Eye is again seen, and on the shelf above—these patterns are combined : the Eye, the Breast-feathers, and the Throat.

Beginning again from the blue floor, on the dado is the breast-work, BLUE ON GOLD, while above, on the Blue wall, the pattern is reversed, GOLD ON BLUE.

Above the breast-work on the dado the Eye is again found, also reversed, that is GOLD ON BLUE, as hitherto BLUE ON GOLD.

The arrangement is completed by the Blue Peacocks on the Gold shutters, and finally the Gold Peacocks on the Blue wall.

to the art of his own or of any other time, for, although it is possible to trace in his style of decoration an influence derived from the study of Oriental design, this is so entirely absorbed in the artist's own individuality as to be scarcely more than a reminiscence of general principles. The result so far resembles the best Oriental art as to possess an astonishing freedom of impression. The sense of law and government in the design is never allowed to injure the sense of life and liberty, and the system of control is so well concealed as to leave upon the work the stamp of a spontaneous and untutored growth. And it is again like Oriental art, and unlike the art of our own time and country, in being entirely independent of any intellectual problems. There is no human element in the design; and by avoiding this element, and thus frankly limiting the scope of his work, the artist has also avoided the difficulties that beset the rendering of human beauty. The result is elegant with the kind of elegance that makes mortals envious of birds and flowers, and, like the world which birds and flowers inhabit, it is gay without gaudiness, and has a splendour that does not sacrifice sobriety. The contrasted masses of blue and gold, that in less skilful hands could scarcely have escaped the impression of an overloaded magnificence, here assume a light and fairy-like character; and we feel no more disposed to reproach the artist for the brilliancy of his colouring or the fantastic freedom of his design than we should be to lecture the peacock itself upon its plumage, or to object to the pride of its movement.

REV H. R. HAWEIS

A SERMON PREACHED AT ST JAMES' HALL

"Money and Morals"

18 February 1877

Hugh Reginald Haweis (1838–1901), author and society preacher enjoyed popular appeal due to his attempt to "strike the keynotes of modern theology, religion and life." The text of this Sermon "Make to yourselves friends of the Mammon of Unrighteousness" (i.e. money) aimed to ease the aesthetic consciences of his essentially middle-class congregation.

I was looking the other day at a marvellous room painted all over with Peacocks' feathers by Mr Whistler, and although some people might say what a waste of time and money is here, I would have them reflect and mend their opinion. I went into that room again and again before the whole power of the conception and execution dawned upon me. Something akin to a religious awe, came over me as I began to understand the mystery and wealth of thought and beauty which lay hidden, nay, which lay like an open secret in a Peacock's plume. I said I never knew this before, but this man knew it, he has sat down before this great irridescent work of God – he has watched it, and questioned it, and to him it has yielded up its secret, and he has here told it out for the joy of the whole world. And so the spirit of this most subtle plume with its "multitudinous smile" has passed into his heart to come forth in this rich abundance of artistic creation – now one curve is seized and worked out in every variety – then the thought occurs inverted and contrasted with some other curve or flowery-eyed circle of the plume – then some lesser feather or portion is seized and thrown up into bold decorative relief, whilst to right and left the splendid creatures themselves live and move before the spectator until the walls and ceiling are aglow with the inexhaustible richness of the one Divine idea. Is there nothing in all this? I say there is a whole sermon, and a good one too in that room, the text of which was a peacock's feather, but it is preached by a living soul, and it will do good to every one who goes there and has ears to hear, or rather eyes to see.

Whistler's Statement of Claim for Libel against John Ruskin

28 July 1877

IN THE HIGH COURT OF JUSTICE, QUEEN'S BENCH DIVISION

Between JAMES ABBOTT McNEILL WHISTLER – Plaintiff
and
JOHN RUSKIN – Defendant

STATEMENT OF CLAIM

Delivered on the 21st day of November, 1877, by Mr JAMES ANDERSON ROSE, of No. 11 Salisbury Street, Strand, in the county of Middlesex, Plaintiff's Solicitor.

1. The Plaintiff is an artist and sells pictures painted by him.

2. Shortly before the publication by the Defendant of the libel hereinafter mentioned the Plaintiff had exhibited in a gallery called the Grosvenor Gallery opened to the public by Sir Coutts Lindsay on payment of an entrance fee certain pictures painted by the Plaintiff.

3. On or about the 2nd day of July 1877 the Defendant printed and published in a pamphlet called "Fors Clavigera" the words following that is to say –

"Lastly, the mannerisms and errors of these pictures," (meaning some pictures by Mr Burne Jones) "whatever may be their extent, are never affected or indolent. The work is natural to the painter, however strange to us; and it is wrought with utmost conscience of care, however far, to his own or our desire, the result may yet be incomplete. Scarcely so much can be said for any other pictures of the modern schools: their eccentricities are almost always in some degree forced; and their imperfections gratuitously, if not impertinently, indulged. For Mr Whistler's own sake, no less than for the protection of the purchaser, Sir Coutts Lindsay ought not to have admitted works into the gallery in which the ill-educated conceit of the artist so nearly approached the aspect of wilful imposture. I have seen, and heard, much of cockney impudence before now; but never expected to hear a coxcomb ask two hundred guineas for flinging a pot of paint in the public's face."

4. The expression Mr Whistler refers to the Plaintiff.

5. The said libel was falsely and maliciously printed and published by the Defendant of the Plaintiff. The Plaintiff's reputation as an artist has been much damaged by the said libel.

THE PLAINTIFF CLAIMS –
1. £1,000.
2. The costs of this Action.

The Plaintiff proposes that this Action be tried in the county of Middlesex.

In the summer of 1877 Whistler was invited to exhibit eight pictures, including Nocturne in Black and Gold: The Falling Rocket YMSM 170 (Colourplate 53), in Sir Coutts Lindsay's newly opened Grosvenor Gallery. There they were seen, together with works by Edward Burne-Jones, by John Ruskin (1819–1900), whose work extended beyond art criticism to encompass political and social issues of the day which since 1871 he had written about, in Fors Clavigera, a pamphlet addressed to the "Workmen and Labourers of Great Britain." Whistler immediately issued a libel action against Ruskin for the remarks he made about him, but the case did not come to court until November the following year, having been postponed on several occasions principally because of Ruskin's complete mental breakdown which occurred early in 1878.

E. W. GODWIN

THE BRITISH ARCHITECT

"Notes on Current Events"

18 April 1878

Who writes the "Various" in *The Examiner*? This is one of their "Variorum" in last Saturday's issue. "Mr Whistler's eccentric house at Chelsea, now in process of erection, is the despair of the Board of Works, which is said to have exhausted every form of entreaty in trying to induce the artist to modify the fantastic nature of his designs. Mr Whistler, however, holds to the belief that in a country where a man's house is his castle, the right to build that castle according to its owner's fancy should not be contested."

In a paragraph of only seven lines the *Examiner* has managed to get in about as many blunders as it well can. Mr Whistler's house is *not* "eccentric", neither is it "fantastic", and it certainly is *not* Mr Whistler's design. The building which is *not* "in process of erection", has been from first to last designed and superintended by Mr E. W. Godwin, and until the Board of Works compelled the addition of sundry mouldings and carved panels, might fairly have been described as an artist's house, having no vulgar pretension about it whatsoever. A farmhouse, or a bit of a monastery, or a wing of a Florentine Palace, it was not, and is not, sad to

The architect and Japonist designer Edward William Godwin (1833–86) had been a friend of Whistler's since the early 1860s. In 1888 Whistler married Godwin's widow Beatrice (see pages 250–252, 273). In September 1877 Godwin designed the White House for Whistler on a plot of land in Tite Street, leased from the Metropolitan Board of Works. The Board objected to the house's radical appearance. After Whistler's bankruptcy it became the property of Harry Quilter (see page 172) who carried out alterations (see The Gentle Art of Making Enemies *1892); it was subsequently demolished.*

E. W. Godwin, design for the interior of the White House. *British Architect*, 6 December 1878. Whistler Collections, Glasgow University Library.

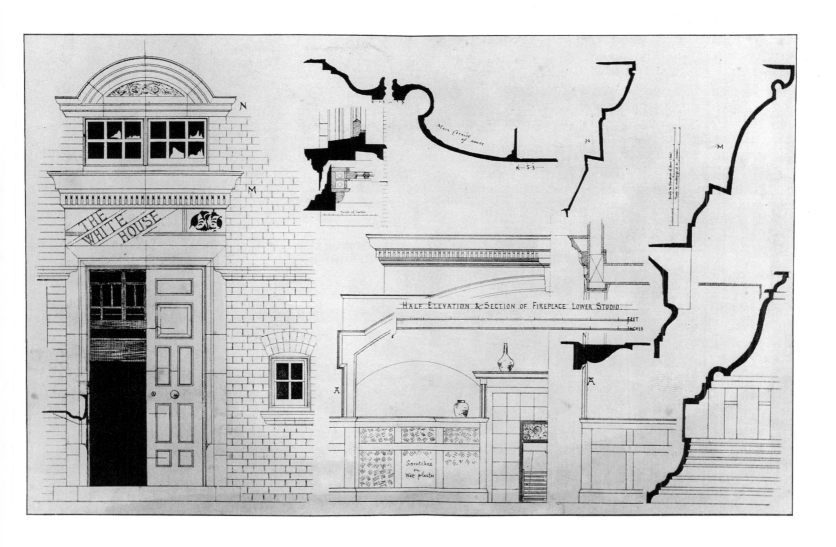

say. That it was not *Gothic*, nor *Queen Anne*, nor *Palladian*, was probably its crime before the Board of Works. It is unhappily of white brick and is covered with green slates – two heresies in the last modern faith, that believes only in red brick and red tile. Then again, the architect has placed his windows and doors where they were wanted, and not with Baker-street regularity; and he has kept his walls comparatively low and his roof comparatively high, for reasons of economy both of space and money. Building thus with common sense, attending to the proportions of those features which were necessary and content with one emphasis, a stone doorway of lofty dimensions and of delicate detail. Mr Whistler as owner, and Mr Godwin as author of the work must be prepared to be misunderstood in days devoid alike of simplicity and originality.

The Metropolitan Board of Works' objection was probably governed by a consideration that its design – unlike the red brick of "Queen Anne" houses then fashionable in Chelsea – would diminish the resale value of their lease.

THE WORLD

"Mr James Whistler at Cheyne-Walk"

22 May 1878

"Why not?" exclaims the artist, with true southern vivacity, his bright grey eyes sparkling with excitement; "why should not I call my works symphonies, arrangements, harmonies, nocturnes, and so forth? I know that many good people whose sense of humour is not very capacious think my nomenclature funny and myself eccentric. Yes, eccentric is the best adjective they find for me. I admit that it is easier to laugh at a man than to appreciate him. Perhaps in my case the latter operation is of unusual difficulty. But why do not they give me credit for meaning something, and knowing what I mean?" It is difficult to convey an idea of Mr Whistler's intense earnestness. Every hair curls with animation, and the slight active figure, clad in a blue-serge yachting-suit, almost realizes the exceptional existence of Sir Boyle Roche's bird. A genuine enthusiast and persistent seeker for perfection, he entertains a species of humorous resentment against the Philistines who will not understand his meaning – to him and his friends clear enough. Artist from the single grey lock of hair on his crest to the square toes of his natty shoes, he thinks it strange that the vast majority of English folk cannot and will not consider a picture as a picture, apart from any story which it may be supposed to tell.

"There is an illustration of my meaning," he continues, pointing to what he is pleased to call a *Harmony in Grey and Gold* – a snow scene with a single black figure making its way through the gloom to a brilliantly lighted tavern. "Now that to me is a harmony of colour only. I care nothing for the past, present or future of the black figure – placed there because the black was wanted at that spot – all that I know is that my combination of grey and gold satisfies my artistic feeling. Now this is precisely what many of my friends will not grasp. They say, "Why not call it Trotty Veck, and sell it for a round harmony of golden guineas?" I reply simply that I will do nothing of the kind. Not even the genius of Dickens should be invoked to lend an adventitious aid to art of another kind from his. Speaking under correction, I should hold it a vulgar and meretricious trick to excite people about Trotty Veck when, if they really care for pictorial art at all, they would know that the picture should have its own merit, and never depend upon dramatic or legendary or local interest." This is the corner-stone of Mr Whistler's art-philosophy. He insists that as music is the poetry of sound, so is painting the poetry of sight, and that the subject-matter has nothing to do with harmony of sound or of colour.

For The World's *"Celebrities at Home" in which Ruskin had featured in a previous issue, Whistler provided his interviewer with a prepared statement which became a manifesto of his artistic aims and practice. It was revised and reprinted in* The Gentle Art of Making Enemies *under the title "The Red Rag."*

"Spy" (Sir Leslie Ward), *A Symphony*. Caricature of Whistler. Lithograph. *Vanity Fair*, 12 January 1878. Whistler Collections, Glasgow University Library (J. W. Revillon Bequest).

"The great musicians knew this," he urges. "Beethoven and the rest wrote music – simply music: symphony in this key, concerto or sonata in that. On F or G they constructed celestial harmonies – as harmonies, as combinations, evolved from the chords of F or G and their minor correlatives. This is pure music as distinguished from airs – commonplace and vulgar in themselves, but interesting from their associations, as, for instance, 'Yankee Doodle' or 'Partant pour la Syrie.' Art should be independent of all claptrap – should stand alone, and appeal to the artistic sense of eye or ear, without confounding this with emotions entirely foreign to it, as devotion, pity, love, patriotism, and the like. All these have no kind of concern with art; and that is why I insist on calling my works arrangements and harmonies. There, hanging opposite my bed, is the picture of my mother, exhibited at the Royal Academy as an *Arrangement in Grey and Black*. Now that is what it is. To me it is interesting as a picture of my mother; but what can or ought the public to care about the identity of the portrait? It must stand or fall on its merits as an 'arrangement;' and it very nearly fell – that's a fact."

COLOURPLATE 30

Study: Seated Figure, W. 2.
1878. Lithotint, 10 × 9¼″
(25.5 × 24 cm). Hunterian Art
Gallery, Glasgow University
(Birnie Philip Bequest).

JAMES MCNEILL WHISTLER

THE GENTLE ART OF MAKING ENEMIES

Whistler versus Ruskin

1892

THE ACTION

In the Court of Exchequer Division on Monday, before Baron Huddleston and a special jury, the case of Whistler v. Ruskin came on for hearing. In this action the plaintiff claimed £1,000 damages.

Mr Serjeant Parry and Mr Petheram appeared for the plaintiff; and the Attorney-General and Mr Bowen represented the defendant.

Mr SERJEANT PARRY, in opening the case on behalf of the plaintiff, said that Mr Whistler had followed the profession of an artist for many years, both in this and other countries. Mr Ruskin, as would be probably known to the gentlemen of the jury, held perhaps the highest position in Europe and America as an art critic, and some of his works were, he might say, destined to immortality. He was, in fact, a gentleman of the highest reputation. In the July number of *Fors Clavigera* there appeared passages in which Mr Ruskin criticized what he called "the modern school," and then followed the paragraph of which Mr Whistler now complained, and which was "For Mr Whistler's own sake, no less than for the protection of the purchaser, Sir Coutts Lindsay ought not to have admitted works into the gallery in which the ill-educated conceit of the artist so nearly approached the aspect of wilful imposture. I have seen, and heard, much of cockney impudence before now; but never expected to hear a coxcomb ask 200 guineas for flinging a pot of paint in the public's face." That passage, no doubt, had been read by thousands, and so it had gone forth to the world that Mr Whistler was an ill-educated man, an imposter, a cockney pretender, and an impudent coxcomb.

Mr WHISTLER, cross-examined by the ATTORNEY-GENERAL, said: "I have sent pictures to the Academy which have not been received. I believe that is the experience of all artists. . . . The nocturne in black and gold is a night piece, and represents the fireworks at Cremorne."

"Not a view of Cremorne?"

"If it were called a view of Cremorne, it would certainly bring about nothing but disappointment on the part of the beholders. (*Laughter.*) It is an artistic arrangement. It was marked 200 guineas."

"Is not that what we, who are not artists, would call a stiffish price?"

"I think it very likely that that may be so."

"But artists always give good value for their money, don't they?"

"I am glad to hear that so well established. (*A laugh.*) I do not know Mr Ruskin, or that he holds the view that a picture should only be exhibited when it is finished, when nothing can be done to improve it, but that is a correct view; the arrangement in black and gold was a finished picture, I did not intend to do anything more to it."

"Now, Mr Whistler. Can you tell me how long it took you to knock off that nocturne?"

. . . "I beg your pardon?" (*Laughter.*)

"Oh! I am afraid that I am using a term that applies rather perhaps to my own work. I should have said, 'How long did you take to paint that picture?' "

"Oh, no! permit me, I am too greatly flattered to think that you apply, to work of mine, any term that you are in the habit of using with reference

Whistler's version of the two-day hearing of the libel action brought against Ruskin on 25 and 26 November 1878 forms the opening pages of The Gentle Art of Making Enemies. *It is reprinted here from the* Gentle Art, *but without Whistler's footnotes, which consist mostly of Ruskin's own words thrown back in the critic's face. In spirit and substance Whistler represents the case very much from his own viewpoint, delicately shading and refashioning the prosaic court-room language to suit his own end. He also omits the testimony of W. M. Rossetti, Albert Moore (see page 85) and W. G. Wills given on his own behalf, as well as the important contributions made by the judge and both Counsels in their opening and closing addresses to the jury.*

Sir John Walter Huddleston (1815–90), celebrated criminal lawyer, Conservative MP, judge and last baron of the exchequer after the passing of the Judicature Act of 1875. John Humffreys Parry (1816–80), criminal lawyer, appointed serjeant-at-law in 1856, was a highly successful advocate whose most celebrated indictment was of the Tichborne claimant. Sir John Holker (1828–82) was appointed Solicitor-general and knighted by Disraeli (1874), and appointed Attorney-general in 1875. Charles Synge Christopher Bowen (1835–94) a year after the trial was appointed judge of the Queen's bench division, knighted, and in 1888 made a judge of the court of appeal.

The Nocturne in Black and Gold: The Falling Rocket *YMSM 170 (Colourplate 53), first exhibited at the Dudley Gallery in 1875 (see page 119), was the only one of eight pictures by Whistler exhibited at the Grosvenor Gallery in the summer of 1877 which was offered for sale.*

to your own. Let us say then how long did I take to – 'knock off,' I think that is it – to knock off that nocturne; well, as well as I remember, about a day."

"Only a day?"

"Well, I won't be quite positive; I may have still put a few more touches to it the next day if the painting were not dry. I had better say then, that I was two days at work on it."

"Oh, two days! The labour of two days, then, is that for which you ask 200 guineas!"

"No – I ask it for the knowledge of a lifetime." (*Applause.*)

"You have been told that your pictures exhibit some eccentricities?"

"Yes; often." (*Laughter.*)

"You send them to the galleries to incite the admiration of the public?"

"That would be such vast absurdity on my part, that I don't think I could." (*Laughter.*)

"You know that many critics entirely disagree with your views as to these pictures?"

"It would be beyond me to agree with the critics."

"You don't approve of criticism then?"

"I should not disapprove in any way of technical criticism by a man whose whole life is passed in the practice of the science which he criticizes; but for the opinion of a man whose life is not so passed I would have as little regard as you would, if he expressed an opinion on law."

"You expect to be criticized?"

"Yes; certainly. And I do not expect to be affected by it, until it becomes a case of this kind. It is not only when criticism is inimical that I object to it, but also when it is incompetent. I hold that none but an artist can be a competent critic."

"You put your pictures upon the garden wall, Mr Whistler, or hang them on the clothes-line, don't you – to mellow?"

"I do not understand."

"Do you not put your pictures out into the garden?"

"Oh! I understand now. I thought, at first, that you were perhaps again using a term that you are accustomed to yourself. Yes; I certainly do put the canvasses into the garden that they may dry in the open air while I am painting, but I should be sorry to see them 'mellowed.'"

"Why do you call Mr Irving 'an arrangement in black'?" (*Laughter.*)

Mr BARON HUDDLESTON: "It is the picture, not Mr Irving, that is the arrangement."

A discussion ensued as to the inspection of the pictures, and incidentally Baron Huddleston remarked that a critic must be competent to form an opinion, and bold enough to express that opinion in strong terms if necessary.

The ATTORNEY-GENERAL complained that no answer was given to a written application by the defendant's solicitors for leave to inspect the pictures which the plaintiff had been called upon to produce at the trial. The WITNESS replied that Mr Arthur Severn had been to his studio to inspect the paintings, on behalf of the defendant, for the purpose of passing his final judgment upon them and settling that question for ever.

Cross-examination continued: "What was the subject of the nocturne in blue and silver belonging to Mr Grahame?"

"A moonlight effect on the river near old Battersea Bridge."

"What has become of the nocturne in black and gold?"

"I believe it is before you." (*Laughter.*)

The picture called the nocturne in blue and silver was now produced in Court.

"That is Mr Grahame's picture. It represents Battersea Bridge by moonlight."

BARON HUDDLESTON: "Which part of the picture is the bridge?" (*Laughter.*)

Arrangement in Black, No. 3: Sir Henry Irving as Philip II of Spain *YMSM 187 (Colourplate 57): the actor Henry Irving (1836–1905) in Tennyson's historical drama* Queen Mary, *staged at the Lyceum Theatre, London, 1876. Whistler and his solicitor had resisted giving Ruskin's solicitor unrestricted access to his work and instead arranged an exhibition of his pictures in the Westminster Palace Hotel, for the benefit of the jury, after Arthur Severn (see page 61) had inspected them on behalf of Ruskin. After lengthy discussion the judge obtained the consent of Ruskin's Counsel to agree to the jury adjourning to view them in the lunchtime recess.*
Nocturne: Blue and Gold – Old Battersea Bridge *YMSM 140 (Colourplate 42). In July 1877 Whistler had sent the picture to the Scottish collector William Graham [sic] MP, who had previously paid £100 for an imaginary subject* Annabel Lee *(YMSM 79) which Whistler had not completed (Colourplate 31).*

His Lordship earnestly rebuked those who laughed. And witness explained to his Lordship the composition of the picture.

"Do you say that this is a correct representation of Battersea Bridge?"

"I did not intend it to be a 'correct' portrait of the bridge. It is only a moonlight scene, and the pier in the centre of the picture may not be like the piers at Battersea Bridge as you know them in broad daylight. As to what the picture represents, that depends upon who looks at it. To some persons it may represent all that is intended; to others it may represent nothing."

"The prevailing colour is blue?"

"Perhaps."

"Are those figures on the top of the bridge intended for people?"

"They are just what you like."

"Is that a barge beneath?"

"Yes. I am very much encouraged by your perceiving that. My whole scheme was only to bring about a certain harmony of colour."

"What is that gold-coloured mark on the right of the picture like a cascade?"

"The 'cascade of gold' is a firework."

A second nocturne in blue and silver was then produced.

WITNESS: "That represents another moonlight scene on the Thames looking up Battersea Reach. I completed the mass of the picture in one day."

The Court then adjourned. During the interval the jury visited the Probate Court to view the pictures which had been collected in the Westminster Palace Hotel.

After the Court had re-assembled the *Nocturne in Black and Gold* was again produced, and Mr WHISTLER was further cross-examined by the ATTORNEY-GENERAL: "The picture represents a distant view of Cremorne with a falling rocket and other fireworks. It occupied two days, and is a finished picture. The black monogram on the frame was placed in its position with reference to the proper decorative balance of the whole."

"You have made the study of Art your study of a lifetime. Now, do you think that anybody looking at that picture might fairly come to the conclusion that it had no peculiar beauty?"

"I have strong evidence that Mr Ruskin did come to that conclusion."

"Do you think it fair that Mr Ruskin should come to that conclusion?"

"What might be fair to Mr Ruskin I cannot answer."

"Then you mean, Mr Whistler, that the initiated in technical matters might have no difficulty in understanding your work. But do you think now that you could make *me* see the beauty of that picture?"

The witness then paused, and examined attentively the Attorney-General's face and looking at the picture alternately, said, after apparently giving the subject much thought, while the Court waited in silence for his answer:

"No! Do you know I fear it would be as hopeless as for the musician to pour his notes into the ear of a deaf man. (*Laughter.*)

"I offer the picture, which I have conscientiously painted, as being worth 200 guineas. I have known unbiased people express the opinion that it represents fireworks in a night-scene. I would not complain of any person who might simply take a different view."

The Court then adjourned.

The ATTORNEY-GENERAL, in resuming his address on behalf of the defendant on Tuesday, said he hoped to convince the jury, before his case closed, that Mr Ruskin's criticism upon the plaintiff's pictures was perfectly fair and *bonâ fide*; and that, however severe it might be, there was nothing that could reasonably be complained of. . . . Let them examine the nocturne in blue and silver, said to represent Battersea Bridge. What was the structure in the middle? Was it a telescope or a fire-escape? Was it like Battersea Bridge? What were the figures at the top of the bridge? And

Here Whistler voices what was to become a primary incantation of modernism in twentieth-century art.

Nocturne in Blue and Silver *YMSM 113* (Colourplate 41) which had been presented by Whistler to Mrs Frances Leyland.

The frame of Nocturne: Blue and Gold – Old Battersea Bridge *is signed and decorated with a Japanese wave-pattern (Colourplate 42).*

if they were horses and carts, how in the name of fortune were they to get off? Now, about these pictures, if the plaintiff's argument was to avail, they must not venture publicly to express an opinion, or they would have brought against them an action for damages.

After all, Critics had their uses. He should like to know what would become of Poetry, of Politics, of Painting, if Critics were to be extinguished? Every Painter struggled to obtain fame.

No artist could obtain fame, except through criticism.

.... As to these pictures, they could only come to the conclusion that they were strange fantastical conceits not worthy to be called works of Art.

... Coming to the libel, the Attorney-General said it had been contended that Mr Ruskin was not justified in interfering with a man's livelihood. But why not? Then it was said, "Oh! you have ridiculed Mr Whistler's pictures." If Mr Whistler disliked ridicule, he should not have subjected himself to it by exhibiting publicly such productions. If a man thought a picture was a daub he had a right to say so, without subjecting himself to a risk of an action.

He would not be able to call Mr Ruskin, as he was far too ill to attend; but, if he had been able to appear, he would have given his opinion of Mr Whistler's work in the witness-box.

In fact Ruskin had more or less fully recovered from his mental breakdown by the time the case came to court.

He had the highest appreciation for *completed pictures*; and he required from an artist that he should possess something more than a few flashes of genius!

Mr Ruskin entertaining those views, it was not wonderful that his attention should be attracted to Mr Whistler's pictures. He subjected the pictures, if they chose, to ridicule and contempt. Then Mr Ruskin spoke of "the ill-educated conceit of the artist, so nearly appoaching the action of imposture." If his pictures were mere extravagances, how could it redound to the credit of Mr Whistler to send them to the Grosvenor Gallery to be exhibited? Some artistic gentleman from Manchester, Leeds or Sheffield might perhaps be induced to buy one of the pictures because it was a Whistler, and what Mr Ruskin meant was that he might better have remained in Manchester, Sheffield or Leeds, with his money in his pocket. It was said that the term "ill-educated conceit" ought never have been applied to Mr Whistler, who had devoted the whole of his life to educating himself in Art; but Mr Ruskin's views as to his success did not accord with those of Mr Whistler. The libel complained of said also, "I never expected to hear a coxcomb ask 200 guineas for flinging a pot of paint in the public's face." What was a coxcomb? He had looked the word up, and found that it came from the old idea of the licensed jester who wore a cap and bells with a cock's comb in it, who went about making jests for the amusement of his master and family. If that were the true definition, then Mr Whistler should not complain, because his pictures had afforded a most amusing jest! *He did not know when so much amusement had been afforded to the British Public as by Mr Whistler's pictures.* He had now finished. Mr Ruskin had lived a long life without being attacked, and no one had attempted to control his pen through the medium of a jury. Mr Ruskin said, through him, as his counsel, that he did not retract one syllable of his criticism, believing it was right. Of course, if they found a verdict against Mr Ruskin, he would have to cease writing but it would be an evil day for Art, in this country, when Mr Ruskin would be prevented from indulging in legitimate and proper criticism, by pointing out what was beautiful and what was not.

Evidence was then called on behalf of the defendant. Witnesses for the defendant, Messrs Edward Burne-Jones, Frith and Tom Taylor.

Mr EDWARD BURNE-JONES called.

Mr BOWEN, by way of presenting him properly to the consideration of the Court, proceeded to read extracts of eulogistic appreciation of this artist from the defendant's own writings.

There is no contemporary record of Bowen doing this; it would appear that Whistler was here trying to show that Burne-Jones had previously profited from Ruskin's influential public opinion of him.

131

The examination of witness then commenced; and in answer to Mr BOWEN, Mr JONES said: "I am a painter, and have devoted about twenty years to the study. I have painted various works, including the *Days of Creation* and *Venus's Mirror*, both of which were exhibited at the Grosvenor Gallery in 1877. I have also exhibited *Deferentia, Fides, St George* and *Sybil*. I have one work, *Merlin and Vivian*, now being exhibited in Paris. In my opinion complete finish ought to be the object of all artists. A picture ought not to fall short of what has been for ages considered complete finish.

Mr BOWEN: "Do you see any art quality in that nocturne, Mr Jones?"

Mr JONES: "Yes . . . I must speak the truth, you know". . . . (*Emotion.*)

Mr BOWEN: . . . "Yes. Well, Mr Jones, what quality do you see in it?"

Mr JONES: "Colour. It has fine colour, and atmosphere."

Mr BOWEN: "Ah. Well, do you consider detail and composition essential to a work of Art?"

Mr JONES: "Most certainly I do."

Mr BOWEN: "Then what detail and composition do you find in this nocturne?"

Mr JONES: "Absolutely none."

Mr BOWEN: "Do you think 200 guineas a large price for that picture?"

Mr JONES: "Yes. When you think of the amount of earnest work done for a smaller sum."

Examination continued: "Does it show the finish of a complete work of art?"

"Not in any sense whatever. The picture representing a night scene on Battersea Bridge is good in colour, but bewildering in form; and it has no composition and detail. A day or a day and a half seems a reasonable time within which to paint it. It shows no finish – it is simply a sketch. The nocturne in black and gold has not the merit of the other two pictures, and it would be impossible to call it a serious work of art. Mr Whistler's picture is only one of the thousand failures to paint night. The picture is not worth 200 guineas."

Mr BOWEN here proposed to ask the witness to look at a picture of Titian, in order to show what finish was.

Mr SERJEANT PARRY objected.

Mr BARON HUDDLESTON: "You will have to prove that it is a Titian."

Mr BOWEN: "I shall be able to do that."

Mr BARON HUDDLESTON: "That can only be by repute. I do not want to raise a laugh, but there is a well-known case of 'an undoubted' Titian being purchased with a view to enabling students and others to find out how to produce his wonderful colours. With that object the picture was rubbed down, and they found a red surface, beneath which they thought was the secret, but on continuing the rubbing they discovered a full-length portrait of George III in uniform!"

The witness was then asked to look at the picture, and he said: "It is a portrait of Doge Andrea Gritti, and I believe it is a real Titian. It shows finish. It is a very perfect sample of the highest finish of ancient art. The flesh is perfect, the modelling of the face is round and good. That is an 'arrangement in flesh and blood!'"

The witness having pointed out the excellences of that portrait, said: "I think Mr Whistler had great powers at first, which he has not since justified. He has evaded the difficulties of his art, because the difficulty of an artist increases every day of his professional life."

Cross-examined: "What is the value of this picture of Titian?" – "That is a mere accident of the sale-room."

"Is it worth 1,000 guineas?" – "It would be worth many thousands to me."

Mr FRITH was then examined: "I am an R.A.; and have devoted my life to painting. I am a member of the Academies of various countries. I am the author of the *Railway Station, Derby Day*, and *Rake's Progress*. I have

In the Grosvenor Gallery exhibition of 1877, Burne-Jones showed The Beguiling of Merlin *(59) and* Venus Mirror *(61), both then belonging to F. R. Leyland; six panels of* The Days of Creation *(60) lent by W. Graham;* Temperantia *(62),* Fides *(63) and* Spes *(65), all watercolours belonging to F. S. Ellis; a* St. George *(64) described in the catalogue as an "unfinished" oil and offered for sale at 300 guineas; as well as a 59 × 23½" watercolour* A Sibyl *"unfinished" also for sale for 300 guineas. Burne-Jones exhibited* The Beguiling of Merlin *(Lever Collection, Port Sunlight) at the Paris Universal Exhibition in 1878.*

The Portrait of the Doge Andrea Gritti, *then attributed to Titian and owned by Ruskin (National Gallery, London), is now thought to be by Vincenzo Catena (1470– 1531). After the trial Albert Moore wrote to* The Echo *pointing out that the portrait was "an early specimen of that master" (Titian) "and does not represent adequately the style and qualities which have obtained for him his great reputation;" a letter Whistler reproduced in his footnote to this passage in* The Gentle Art of Making Enemies. *William Powell Frith R.A. In his footnote to Frith's testimony Whistler quotes "'It was just a toss up whether I became an Artist or an Auctioneer' – W. P. Frith R.A.: REFLECTION: He must have tossed up."*

seen Mr Whistler's pictures, and in my opinion they are not serious works of art. The nocturne in black and gold is not a serious work to me. I cannot see anything of the true representation of water and atmosphere in the painting of *Battersea Bridge*. There is a pretty colour which pleases the eye, but there is nothing more. To my thinking, the description of moonlight is not true. The picture is not worth 200 guineas. Composition and detail are most important matters in a picture. In our profession men of equal merit differ as to the character of a picture. One may blame, while another praises, a work. I have not exhibited at the Grosvenor Gallery. I have read Mr Ruskin's works."

Mr Frith here got down.

Mr TOM TAYLOR – Poor Law Commissioner, Editor of *Punch*, and so forth – and so forth: "I am an art critic of long standing. I have been engaged in this capacity by the *Times*, and other journals, for the last twenty years. I edited the *Life of Reynolds*, and *Haydon*. I have *always* studied art. I have seen these pictures of Mr Whistler's when they were exhibited at the Dudley and the Grosvenor Galleries. The *Nocturne* in black and gold I do not think a serious work of art." The witness here took from the pockets of his overcoat copies of the *Times*, and, with the permission of the Court, read again with unction his own criticism, to every word of which he still adhered. "All Mr Whistler's work is unfinished. It is sketchy. He, no doubt, possesses artistic qualities, and he has got appreciation of qualities to tone, but he is not complete, and all his works are in the nature of sketching. I have expressed, and still adhere to the opinion, that these pictures only come 'one step nearer pictures than a delicately tinted wallpaper.'"

This ended the case for the defendant.

<div style="text-align:center">

Verdict for plaintiff. Damages one farthing.

</div>

Tom Taylor published his Life of Sir Joshua Reynolds *(1865) and a three-volume biography of Benjamin Robert Haydon (1853). In court he read his criticism published in* The Times *on 16 November 1878.*

HENRY JAMES

THE NATION

"On Art-Criticism and Whistler"

13 February 1879

Resident in London, and a contributor to the Nation *and other American papers, the novelist Henry James (1843–1916) had already made a conventional response to Whistler's nocturnes, exhibited in the first Grosvenor Gallery exhibition of 1877. They frequently met after Whistler moved to Paris in the early 1890s.*

I may mention as a sequel to the brief account of the suit Whistler v Ruskin, which I sent you a short time since, that the plaintiff has lately published a little pamphlet in which he delivers himself on the subject of art-criticism. This little pamphlet, issued by Chatto & Windus, is an affair of seventeen very prettily printed small pages; it is now in its sixth edition, it sells for a shilling, and is to be seen in most of the shop-windows. It is very characteristic of the painter, and highly entertaining; but I am not sure that it will have rendered appreciable service to the cause which he has at heart. The cause that Mr Whistler has at heart is the absolute suppression and extinction of the art-critic and his function. According to Mr Whistler the art-critic is an impertinence, a nuisance, a monstrosity – and usually, into the bargain, an arrant fool. Mr Whistler writes in an off-hand, colloquial style, much besprinkled with French – a style which might be called familiar if one often encountered anything like it. He writes by no means as well as he paints; but his little diatribe against the critics is suggestive, apart from the force of anything that he specifically urges. The painter's irritated feeling is interesting, for it suggests the state

The brown-paper-covered pamphlet Art and Art Critics: Whistler versus Ruskin, The White House, Chelsea, 24 December 1878, *printed by T. R. Way (see page 106), with a dedication to Albert Moore (see page 85).*

of mind of his brothers of the brush in the presence of the bungling and incompetent disquisitions of certain members of the fraternity who sit in judgement upon their works. "Let work be received in silence," says Mr Whistler, "as it was in the days to which the penman still points as an era when art was at its apogee." He is very scornful of the "penman," and it is on the general ground of his being a penman that he deprecates the existence of his late adversary, Mr Ruskin. He does not attempt to make out a case in detail against the great commentator of pictures; it is enough for Mr Whistler that he is a "*littérateur*," and that a *littérateur* should concern himself with his own business. The author also falls foul of Mr Tom Taylor, who does the reports of the exhibitions in *The Times*, and who had the misfortune, fifteen years ago, to express himself rather unintelligently about Velazquez. "The Observatory at Greenwich under the direction of an apothecary!," says Mr Whistler, "the College of Physicians with Tennyson as president! and we know that madness is about. But a school of art with an accomplished *littérateur* at its head disturbs no one, and is actually what the world receives as rational, while Ruskin writes for pupils and Colvin holds forth at Cambridge. Still, quite alone stands Ruskin, whose writing is art, and whose art is unworthy his writing. To him and his example do we owe the outrage of proffered assistance from the unscientific – the meddling of the immodest – the intrusion of the garrulous. Art, that for ages has hewn its own history in marble, and written its own comments on canvas, shall it suddenly stand still, and stammer, and wait for wisdom from the passer-by? – for guidance from the hand that holds neither brush nor chisel? Out upon the shallow conceit! What greater sarcasm can Mr Ruskin pass upon himself than that he preaches to young men what he cannot perform! Why, unsatisfied with his own conscious power, should he choose to become the type of incompetence by talking for forty years of what he has never done!" And Mr Whistler winds up by pronouncing Mr Ruskin, of whose writings he has perused, I suspect, an infinitesimally small number of pages, "the Peter Parley of Painting." This is very far, as I say, from exhausting the question; but it is easy to understand the state of mind of a London artist (to go no further) who skims through the critiques in the local journals. There is no scurrility in saying that these are for the most part almost incredibly weak and unskilled; to turn from one of them to a critical feuilleton in one of the Parisian journals is like passing from a primitive to a very high civilization. Even, however, if the reviews of pictures were very much better, the protest of the producer as against the critic would still have a considerable validity. Few people will deny that the development of criticism in our day has become inordinate, disproportionate, and that much of what is written under that exalted name is very idle and superficial. Mr Whistler's complaint belongs to the general question, and I am afraid it will never obtain a serious hearing, on special and exceptional grounds. The whole artistic fraternity is in the same boat – the painters, the architects, the poets, the novelists, the dramatists, the actors, the musicians, the singers. They have a standing, and in many ways a very just, quarrel with criticism; but perhaps many of them would admit that, on the whole, so long as they appeal to a public laden with many cares and a great variety of interests, it gratifies as much as it displeases them. Art is one of the necessities of life; but even the critics themselves would probably not assert that criticism is anything more than an agreeable luxury – something like printed talk. If it be said that they claim too much in calling it "agreeable" to the criticized, it may be added on their behalf that they probably mean agreeable in the long run.

For which Whistler took him to task in The World; *the correspondence is reproduced in the* Gentle Art. *(See page 133.)*
Alfred Lord Tennyson (1809–92), poet and dramatist, succeeded Wordsworth as poet laureate.
Sydney Colvin (1845–1927), Keeper of the Print Room at the British Museum 1884– 1914.

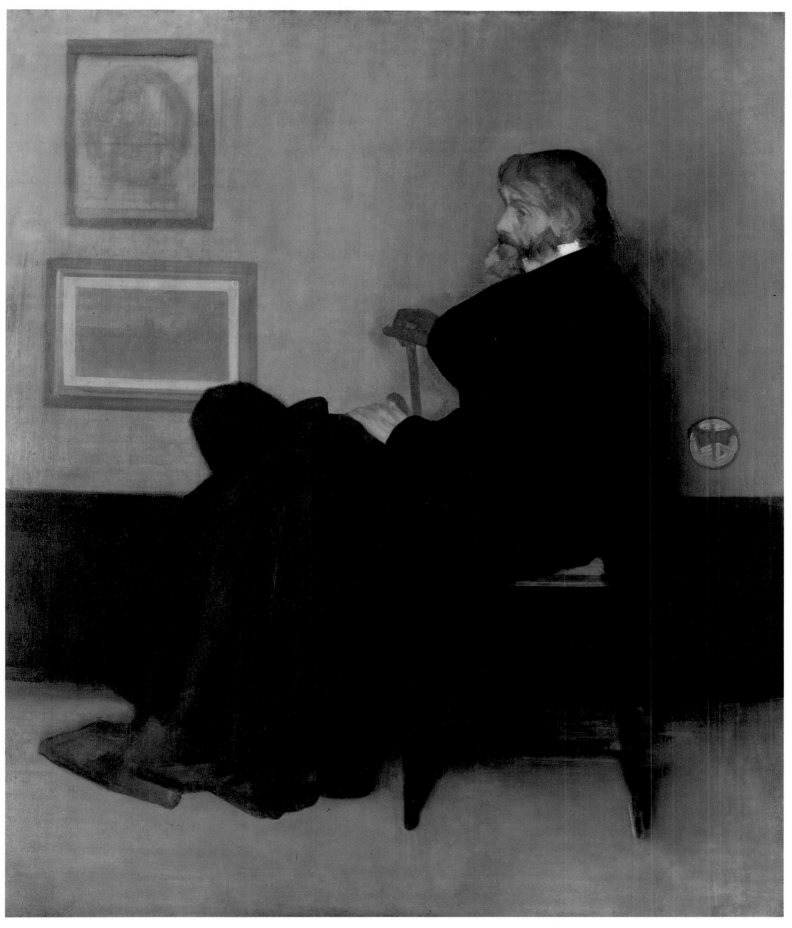

COLOURPLATE 38. *Arrangement in Grey and Black, No. 2: Portrait of Thomas Carlyle.* 1872-73.
67⅜ × 56½″ (171 × 143.5 cm).
Glasgow Art Gallery and Museum.

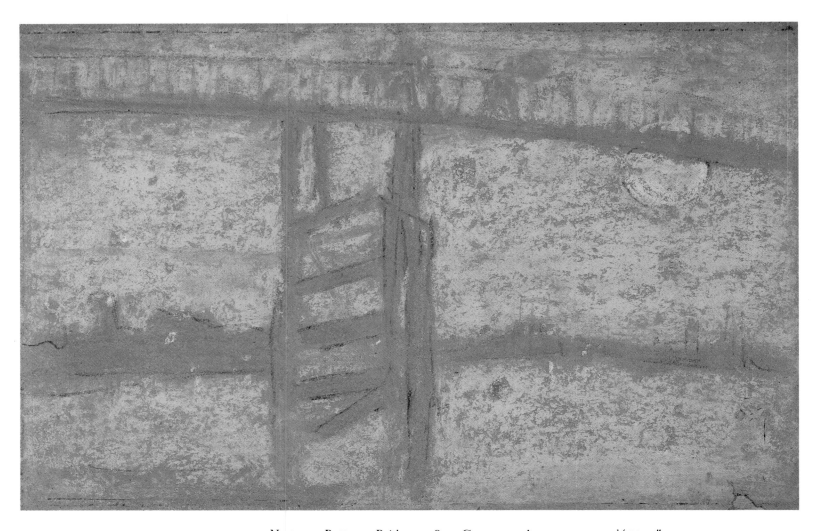

COLOURPLATE 39. *Nocturne: Battersea Bridge. c.* 1872. Crayon on brown paper, 7⅛ × 11″
(18.2 × 27.9 cm).
Freer Gallery of Art, Smithsonian Institution, Washington, D.C.

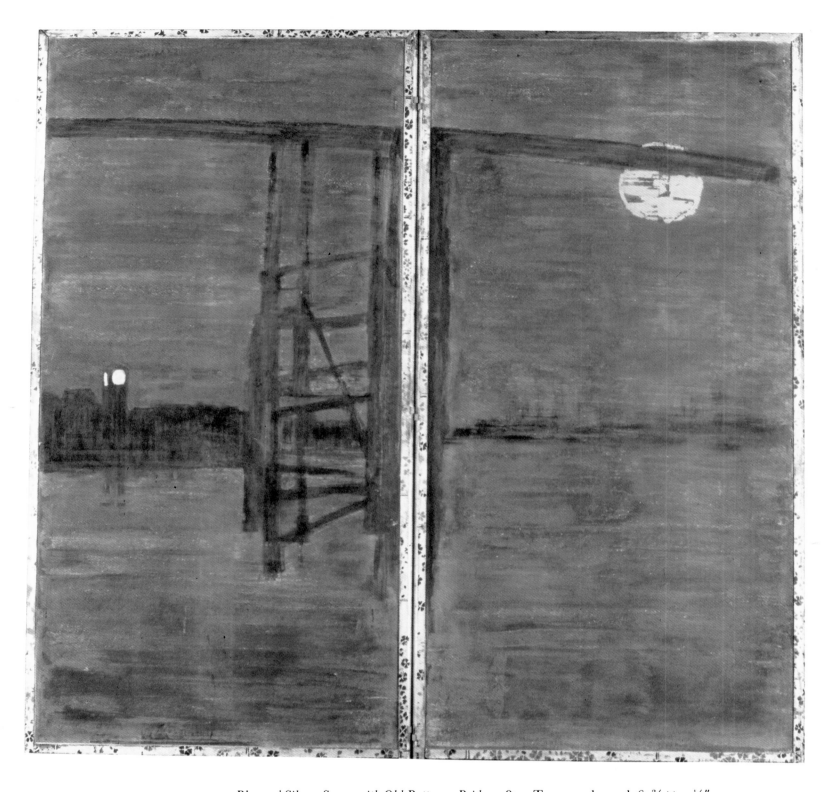

COLOURPLATE 40. *Blue and Silver: Screen with Old Battersea Bridge.* 1872. Two panels, each 67¾ × 33⅛″
(172 × 84 cm).
Hunterian Art Gallery, Glasgow University.

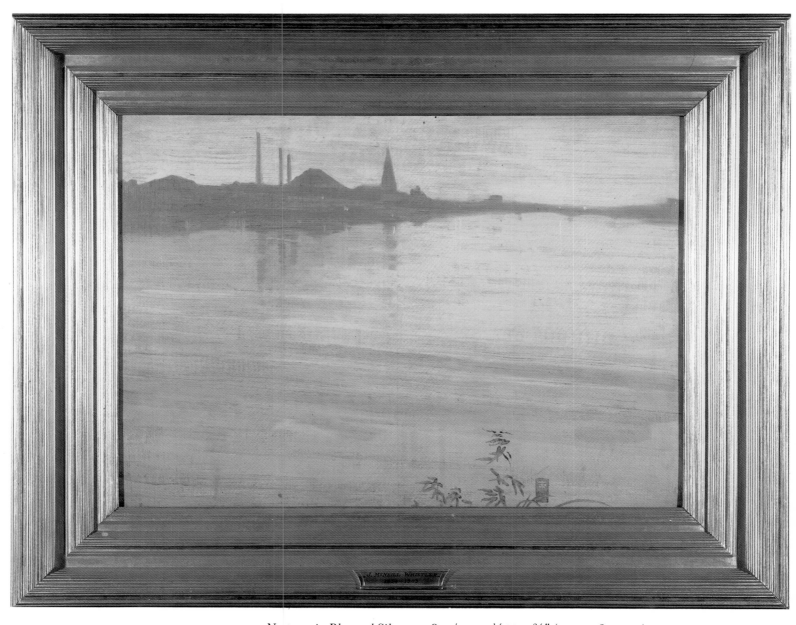

COLOURPLATE 41. *Nocturne in Blue and Silver. c.* 1871/72. 17½ × 23¾″ (44.5 × 60.3 cm).
Fogg Art Museum, Harvard University, Cambridge, Massachusetts
(Bequest of Grenville L. Winthrop).

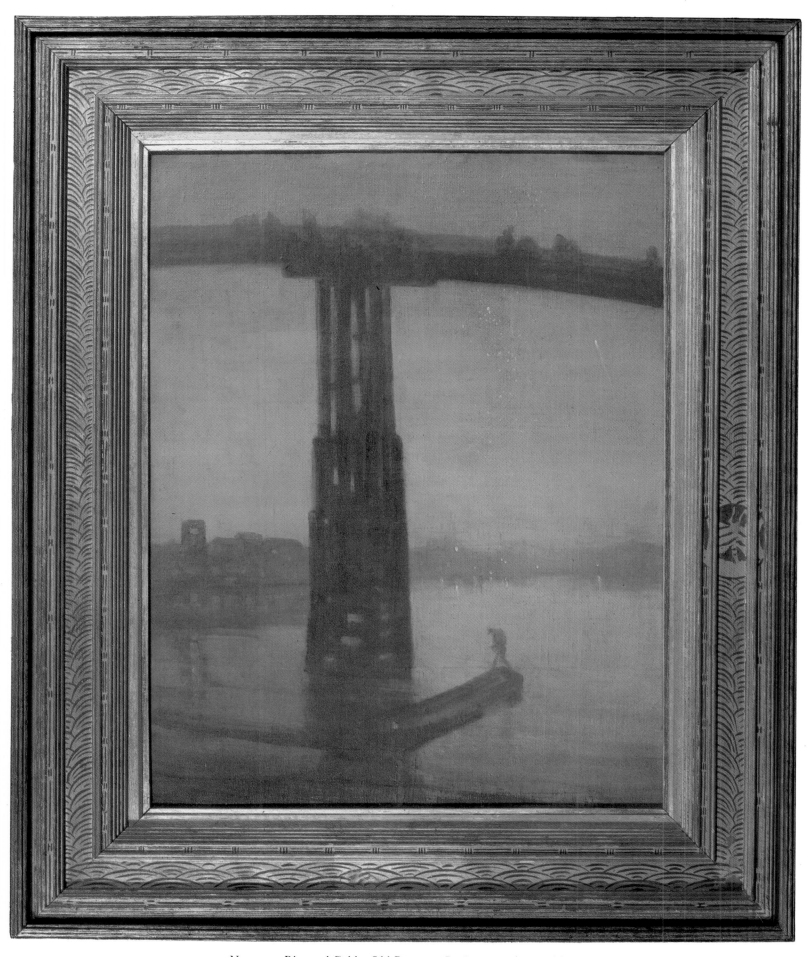

COLOURPLATE 42. *Nocturne: Blue and Gold – Old Battersea Bridge.* 1872/73. 26¼ × 19¾″ (66.6 × 50.2 cm).
Tate Gallery, London.

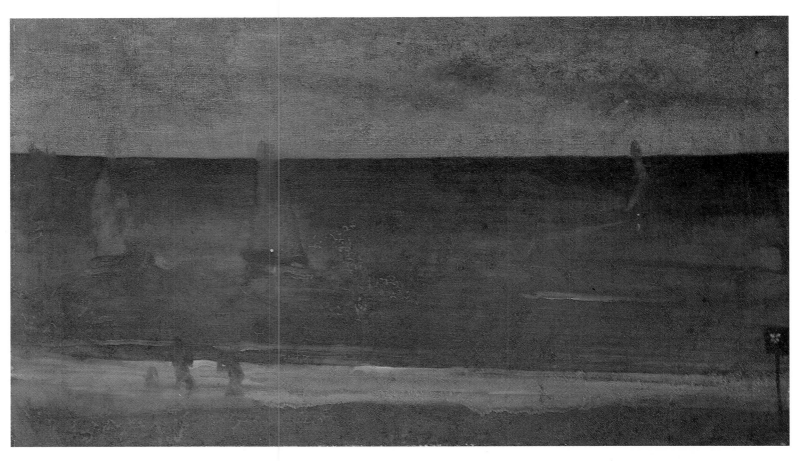

COLOURPLATE 43. *Nocturne: Blue and Silver – Bognor.* 1872/76. 19¾ × 33⅞″ (50.3 × 86.2 cm).
Freer Gallery of Art, Smithsonian Institution, Washington, D.C.

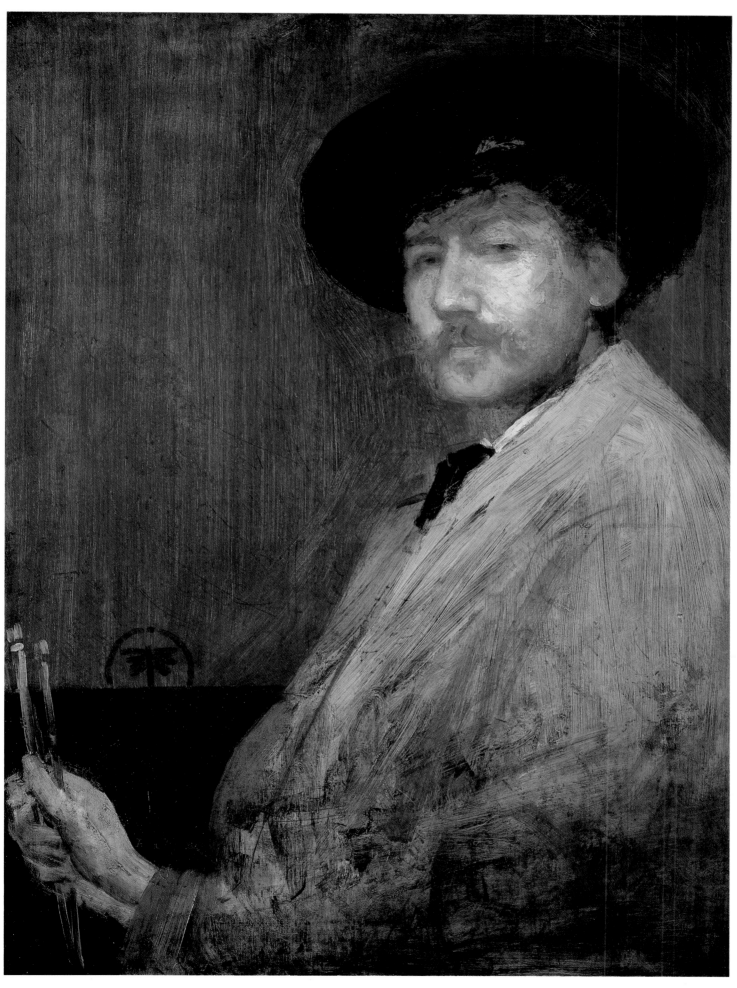

COLOURPLATE 44. *Arrangement in Grey: Portrait of the Painter.* 1872. 29½ × 21″ (74.9 × 53.3 cm).
© Detroit Institute of Arts (Bequest of Henry Glover Stevens in memory of Ellen P. Stevens and Mary M. Stevens).

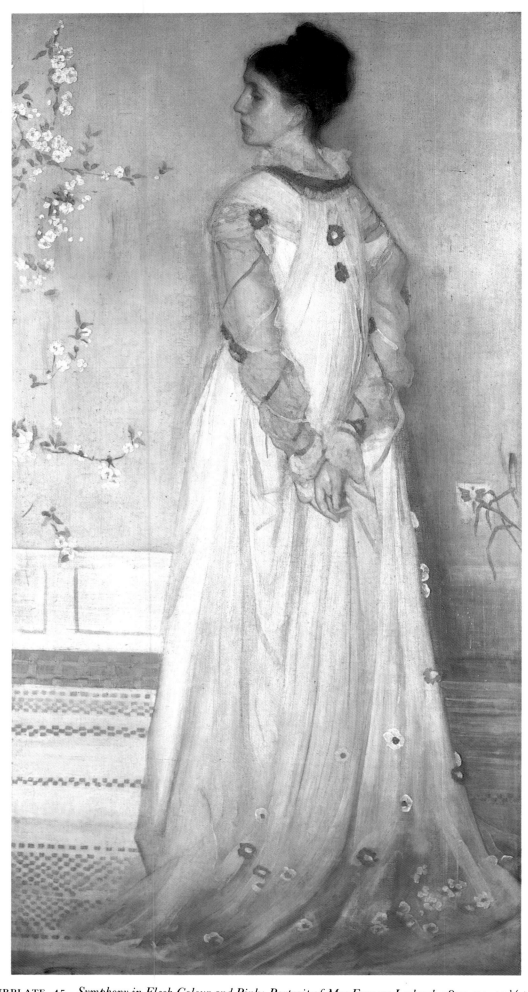

COLOURPLATE 45. *Symphony in Flesh Colour and Pink: Portrait of Mrs Frances Leyland*. 1871-74. 77⅛ × 40¼″
(195.9 × 102.2 cm).
© The Frick Collection, New York.

FREDERICK WEDMORE

THE NINETEENTH CENTURY

"Mr Whistler's Theories and Mr Whistler's Art"

August 1879

Frederick Wedmore (1844–1921) author, art critic and compiler of the second catalogue raisonné of Whistler's etchings (1886). Although Wedmore was to modify his opinion of Whistler's art before the end of the century – in etching placing him next to Rembrandt and recognizing him as a master of lithography – Whistler never forgave him the condescending and patronizing tone, exemplified throughout this review. Whistler took every opportunity of heaping ridicule on his critical pretensions, even to the extent of deliberately misquoting him in his exhibition catalogue (see page 200).

Some men are better than their creeds – some artists better than their theories. And though in Mr Whistler's trivial pamphlet there is little that one can seriously discuss, much of his Art has the interest of originality, and some of it the charm of beauty. It is true that the originality of his painted work is somewhat apt to be dependent on the innocent error that confuses the beginning with the end, accepts the intention for the execution, and exalts an adroit sketch into the rank of a permanent picture. *Mr Irving, as Philip of Spain*, was a murky caricature of Velazquez – an effort in which the sketchiness of the master remained, but the decisiveness of the master was wanting. I am told that at a yet earlier stage than the stage at which it was exhibited, the portrait promised well; but it is not to *portraits manqués* that we can look to sustain a theory or establish a reputation. With the *Nocturnes* the utter absence not only of definition but, as far as my eye may be trusted, of gradation, leads to the conclusion that these also are but encouraging sketches, whatever may be the theory on which they have been painted. We wait in them, and wait in vain, for the gradations of light and colour which the scene depicted presents. In them there is an effect of harmonious decoration, so that a dozen or so of them on the upper panels of a lofty chamber would afford even to the wall-papers of William Morris a welcome and justifiable alternative; but, especially on the scale on which they are painted, it is in vain that we endeavour to receive them as cabinet pictures. They suffer cruelly when placed against work, not of course of petty and mechanical finish, but of patient achievement. But they have a merit of their own, and I do not wish to understate it. So short a way have they proceeded into the complications of colour that they avoid the incompatible – they say very little to the mind, but they are restful to the eye, in their agreeable simplicity and emptiness. And, moreover, there is evidence that Mr Whistler, confined to colour alone, can produce harmonies more various and intricate. A great apartment in the house of Mr Leyland has shown to those who have seen it that a long and concentrated effort at the solution of the problems of colour is not beyond the scope of an artist who has never mastered the subtleties of accurate form. As a decorative painter Mr Whistler has few superiors. It is a department of Art in which his skill is wont to border upon genius. The large public, in its tour of the Grosvenor Gallery, has had a chance of knowing this. It has seen a quite delightful picture, suggested, indeed, by Japanese art, but itself not less subtle than the art which prompted it – a *Variation in Flesh Colour and Green*; bare-armed damsels of the furthest East lounging in one knows not what attitudes of nonchalant abandonment in some balcony or court open to the sunlight and the soft air. The picture had a quality of cool refreshment, such as the gentle colour and clean shining material of Luca della Robbia has afforded to the beholder of Tuscan Art. But the Tuscan had not risen to the conception that an art of lovely decoration may forswear intention, association and sentiment.

The interest of life – the interest of humanity – has but little occupied Mr Whistler; yet, in spite of his devotion to the art qualities of the peacock, it has not been given to him to be quite indifferent to the race to which he

Colourplate 57 (YMSM 187); at the Ruskin trial Whistler had described it as "a large impression – a sketch; but it was not intended as a finished picture. It was not exhibited as for sale" (Daily News).

*In his 1883 exhibition of Venice Etchings and Dry-points ("Mr Whistler and His Critics, A Catalogue") Whistler placed an asterisk after the word "eye" and *? in the margin, together with a dancing butterfly.*

The Arts and Craft firm of Morris and Co. then had a showroom in Oxford Street.

For Whistler's misuse of this quotation see "Taking the Bait," page 200.

i.e. Harmony in Blue and Gold: The Peacock Room *(Colourplates 63–65).*

Variation in Flesh Colour and Green: The Balcony *YMSM 56 (Colourplate 22) was shown in the 1878 Grosvenor Gallery exhibition.*
Luca della Robbia (1440–82), the Florentine designer of Madonna and Child subjects usually made in glazed terracotta.

belongs. His portraits, sometimes, have not been very obviously considered as arrangements of colour. He has painted with admirable expressiveness a portrait of his mother, and has recorded on a doleful canvas the head and figure of Mr Carlyle. In both the simplicity and veracity of effect are things to be noted. Not indeed that the pictures are without mannerism – the straight and stiffish disposition of the lines in the first and the resolute abstinence from colour in both are in themselves not so much merits as peculiarities. But the sense of dignified rest and a certain sense of reticent pathos are apparent in the portrait of the lady – whether or not they were intended. And the rugged simplicity of Mr Carlyle is suggested not only with skill of hand, but with mental skill that was not slow to perceive the best elements of high success with the subject. To have painted these things alone – however strange their mannerism or incomplete their technique – would have been enough to establish a hope that the career so begun, or so continued, might not close in work too obstinately faithful to eccentric error.

But I take it to be admitted by those who do not conclude that the art is necessarily great which has the misfortune to be unacceptable, that it is not by his paintings so much as by his etchings that Mr Whistler's name may aspire to live. Paintings like some of the *Nocturnes* and some of the *Arrangements* are defended only by a generous self-deception when it is urged for them that they will be famous tomorrow because they are not famous today. Alas! how much of the Art around us has that credential to immortality! The great have been neglected sometimes in their own time, but so alas! have the little, and their numbers preponderate. Strewing the floor of the Dudley Gallery and climbing to the darkest recesses of the Albert Hall, there are paintings of which the painters would very gladly find encouragement in the suggestion that the contemporary verdict is certain to be reversed. Futile consolation – there are failures that are complete and failures that are partial, and for both there remains, not fame, but oblivion.

In his etchings – at least in many of them – Mr Whistler makes good a claim to live by the side of the fine artists of the etching-needle. Even a familiarity with the noble work of Méryon allows us to retain much interest in his own. But for his fame Mr Whistler has etched too much, or at least has published too much. No one who can look at work of Art fairly, demands that it shall be faultless; least of all can that be demanded of work of which the very virtue lies sometimes in its spontaneousness; but we have good reason to demand that the faults shall not outweigh the merits. Now in some of Mr Whistler's figure-pieces, executed with the etching-needle, the commonness and vulgarity of the person portrayed find no apology in the perfection of her portrayal – the design uncouth, the drawing intolerable, the light and shade an affair of a moment's impressiveness, with no subtlety of truth to hold the interest that is at first aroused. See, as one instance, the etching numbered 3 in the published catalogue – notice the size of the hands. And see again No. 56, in which the figure is one vast black triangle in which there is apparent not a single quality which a work of Art should have. The portraits of Becquet, the violoncello player, of one Mann, and of one Davis, have character, with no disreputable mannerism, but with a good simplicity of treatment. But neither face nor art is of a kind to command a prolonged enjoyment. In some of his etchings or dry points not, it seems, included in the catalogue, there is apparent some feeling for grace of contour – for the undulations of the figure and its softness of modelling. But these are but the briefest sketches, and Mr Whistler has lacked the art, the patience or the will to continue them.

Many have been the themes which in the art of etching Mr Whistler has essayed. He has essayed landscape; he has drawn a tree in "Kensington Gardens," and a tree in the foreground of the "Isle St. Louis, Paris;" but the tree here seems drawn without any known form of vegetable

Arrangement in Grey and Black No. 2: Portrait of Thomas Carlyle YMSM 137 and Arrangement in Grey and Black: Portrait of the Painter's Mother YMSM 101 (Colourplates 38 and 30).

The French etcher Charles Méryon on whom Wedmore had written.

The references are to the first published catalogue of Whistler's etchings by Ralph Thomas, A Catalogue of the Etchings and Drypoints of James McNeill Whistler, *London, 1874. "No. 3" is* La Retameuse *(K. 14), one of the "French Set;" "No. 56" is* Finette *(K. 58); Becquet (K. 52); Mr Mann is also known as Mr Davis (K. 63).*

Greenwich Park (K. 35) known as Kensington Gardens in Thomas's catalogue; and Ile de la Cité, Paris (K. 60), but Wedmore is here mistaken: there is no tree visible in Whistler's view from the windows of the Louvre.

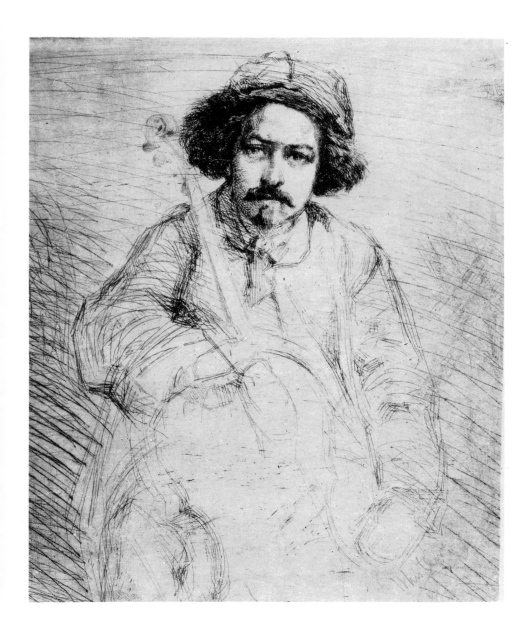

Becquet, K.52(i). 1859. Drypoint, 10 × 7½″ (25.4 × 19.1 cm). Hunterian Art Gallery, Glasgow University.

growth – it has the air of a shell that is exploding. Here and there – occupied with those juxtapositions of light and shade which fascinated the masters of Holland – Mr Whistler has drawn interiors, and in one of his interiors we note a success second only to the highest. This is the interior described as *The Kitchen*. Only the finest, the most carefully printed K. 24. impressions possess the full charm; but when such an impression presents itself to the eye, the Dutch masters who have followed most keenly the glow and the gradation of light on the walls of a chamber are seen to be almost rivalled. The kitchen is a long and narrow room, at the far end of which, away from the window and the keen light, stand artist and spectator. Furthest of all from them the light vine leaves are touched in with a grace that Adrian van Ostade would not have excelled. By the embrasure of the window – just before the great thickness of the wall – stands a woman, angular, uncomely, of homely build, busied with household cares. In front of her comes the sharp sunlight, striking the thick wall side, and lessening as it advances into the shadow and gloom of the humble room: wavering timidly on the plates of the dresser, in creeping half gleams which reveal and yet conceal the objects they fall upon. The meaningless scratch and scrawl of the bare floor in the foreground is the only fault that at all seriously tells against the charm of work otherwise beautiful and of keen sensitiveness; and the case is one in which the merit is so much greater that the fault may well be ignored or its presence allowed. Again, *La Vieille aux loques* [The old Rag-Lady] – a K. 21.

weary woman of humblest fortunes and difficult life – shows, I think, that Mr Whistler has sometimes been inspired by the pathetic masters of Dutch Art.

We have seen already that two things have much occupied Mr Whistler as an artist – the arrangement of colours in their due proportions: the arrangement of light and shade. And the best results of the life-long study which by his own account he has given to the arrangement of colour are seen in the work that is purely or the work that is practically decorative: the work that escapes the responsibility of a subject. And the best results of the study of the arrangements of light and shade are seen in half a dozen etchings, all of which, except *The Kitchen* and the *Vieille aux loques*, belong to that series in which the artist has recorded for our curious pleasure the common features of the shores of the Thames. Here also there is evident his feeling, not exactly for beauty, but at all events for quaintness of form. It had occurred to no one else to draw with realistic fidelity the lines of wharf and warehouse along the banks of the river; to note down the pleasant oddities of outline presented by roof and window and crane: to catch the changes of the grey light as it passes over the front of Wapping. Mr Whistler's figure-drawing, generally defective and always incomplete, has prevented him from seizing every characteristic of the sailor figures that people the port. The absence, seemingly, of any power such as the great marine painters had, of drawing the forms of water, whether in a broad and wind-swept tidal river or on the high seas, has narrowed and limited again the means by which Mr Whistler has depicted the scenes "below Bridge." But his treatment of the scenes is none the less original and interesting. By wise omission, he has managed often to retain the sense of the flow of water or its comparative stillness. Its gentle lapping lifts the keels of the now emptied boats of his *Billingsgate*. It lies lazy under the dark warehouses of his little *Limehouse*.

The artist's finest etchings of the Thames are six in number – we need not include such pretty dreams as his *Cadogan Pier* and the like: faint and agreeable sketches like his painted *Nocturnes*; they belong to that order of his work. Of these six finest – these six by which his etching takes serious permanent rank – two have been done somewhat lately. The *London Bridge* and the little *Limehouse* (Free Trade Wharf, I think) – not the larger *Limehouse* of the Catalogue – are among the happiest examples of the art that is swift and brief to record an impression. The spring of the great arch in *London Bridge*, as seen from below from the waterside, is rendered, it seems, with a sense of power in great constructive work such as is little visible in the tender handling of so many of the Thames-side etchings. The little *Limehouse*, published by the Fine Art Society in Bond Street, is, in its best impressions, a very exquisite little study of gradations of tone and of the receding line of murky buildings that follows the bend of the river. It is a thing of faultless delicacy. A third, not lately done, has been lately retouched: the *Billingsgate: boats at a mooring*. In the retouch is an instance of the successful treatment of a second "state," or even a later "state" of the plate, and such as should be a warning to the collector who buys first states of everything – the "Liber Studiorum" included – and first states alone, with dull determination. Of course the true collector knows better: he knows that the impression and not the "state" is all, and he must gradually acquire the eye to judge of the impression. A year or so ago Mr Whistler retouched the *Billingsgate* for the proprietors of the *Portfolio*, and the proof impressions of the state issued by them reach the highest excellence of which the plate has been capable. Not aiming at the extreme simplicity and extreme unity so happily kept in the *London Bridge* and the little *Limehouse*, it has faults which these have not. The ghostliness of the foreground figures demands an ingenious theory for their justification, and this theory no one has advanced. But the solidity of the buildings here introduced – the clock-tower and houses that edge the quay – is of rare achievement in etching. For once the houses are not drawn, but built like

Page 61 (K. 66).

K. 47; K. 40.

K. 75.

K. 153; Free Trade Wharf *(K. 163) which Wedmore also calls the "little 'Limehouse'" had just then been published by the Fine Art Society.*

Billingsgate *(K. 47) had been published in the* Portfolio, *January 1878.*

J. M. W. Turner's Liber Studiorum, *published after his own paintings.*

the houses and churches and bridges of Méryon. The strength of their realization lends delicacy to the thin-masted fishing boats with their thinner lines of cordage, and to the distant bridge in the grey mist of London, and to the faint clouds of the sky. Perhaps yet more delicate than *Billingsgate* is the *Hungerford Bridge*, so small, yet so spacious and airy.

Finally, there are the *Thames Police* and *Black Lion Wharf*. These are among the most varied studies of quaint places now disappearing – nay, many of them already disappeared – places with no beauty that is very old or graceful, but with interest to the Londoner and interest too to the artist – small warehouses falling to pieces or poorly propped when they were sketched, and vanished now to make room for a duller and vaster uniformity of storehouse front; narrow dwelling-houses of our Georgian days, with here a timber facing, and here a quaint bow window, many-paned – narrow houses of sea-captains or the riverside tradesfolk, or of custom-house officials, the upper classes of the Docks and the East-End; these too have been pressed out of the way by the aggressions of great commerce, and the varied line that they presented has ceased to be. Of all these riverside features, *Thames Police* is an illustration interesting today and valuable tomorrow. And *Black Lion Wharf* is yet fuller of happy accident of outline and happy gradation of tone, studied amongst common things which escape the common eye. It is a pleasure to possess these so faithful and so spirited records of a departing quaintness, and it is an achievement to have made them. It would be a pity to remove the grace from the achievement by insisting that here too, as in *Nocturne* and *Arrangement*, the art was burdened by the theory; that the study of the "arrangement of line and form" was all, and the interest of the association nothing. When Dickens was tracing the fortunes of Quilp on Tower Hill, and Quilp on that dreary night when the little monster fell from the wharf into the river, he did not think only of the cadence of his sentences, or his work would never have lived, or lived only with the levers of curious patchwork of mere words. Perhaps without his knowing it, some slight imaginative interest in the lives of Londoners prompted Mr Whistler, or strengthened his hand, as he recorded the shabbiness that has a history, the slums of the Eastern suburb, and the prosaic work of our Thames. Here at all events his art, if it has shown faults to be forgiven, has shown, in high excellence, qualities that fascinate. The Future will forget his disastrous failures, to which in the Present has somehow been accorded, through the activity of friendship or the activity of enmity, a publicity rarely bestowed upon failures at all; but it may remember the success of work peculiar and personal.

WILLIAM C. BROWNELL

SCRIBNER'S MONTHLY

"Whistler in Painting and Etching"

August 1879

Two things only need concern him [the lay critic] – the value of a painter's conceptions and the adequacy of his expression of them. He may leave it to Mr Burne-Jones to require that Mr Whistler's expression should be more than relatively adequate, and to lay down absolute rules about "finish." He will be the less hampered in trying to get some idea of Mr Whistler's genius, and the value of it. And, as it is a genius of very striking qualities, no one proceeding in this way and not smothered in

Old Hungerford Bridge *(K. 76)*. *K. 44* and *K. 42*.

Daniel Quilp, a character in Dickens's The Old Curiosity Shop (1841), *is drowned on the point of being arrested for felony.*

William Crary Brownell (1851–1928), art and literary critic, was the literary adviser to Scribners for thirty-nine years. Although Whistler and his art were known in America where he exhibited on several occasions in the 1860s and 1870s, this was undoubtedly the most substantial and considered article in an American publication to date.

The reference is to Burne-Jones's evidence in the Whistler–Ruskin trial (see pages 131–132).

considerations of technique can fail to get some idea of it. The qualities of few painters are so distinct, and indeed one is tempted to say aggressive. Every one will perceive in his slightest etching an effectiveness, an impressiveness, a force which may or may not justly be called eccentric, but which it is impossible not to recognize as original. More than almost any other contemporary painter that occurs to one, he seems to have been impressed by something, to have been harder hit than most. Less than any other, perhaps, is he concerned about the environment of an effect. His impression is manifestly always distinct, single and pictorial. It is so far from sophistication that it seems almost unreflective. It is indeed absolutely spontaneous, but it has the air of spontaneity unrevised by any afterthought, as so much of even what is justly to be called spontaneous does not. It is with aspect always and never with meaning that Mr Whistler is concerned. Nothing can be less exact than to speak of his work as affected. It would be difficult to find a better example of a pure painter, a painter to whom art is so distinct a thing in itself, and so unrelated to anything else. His attitude toward it is as simple as that of the Renaissance painters, and indeed it is method and expression that chiefly distinguish him from these. It is not rare to find a painter who admires this attitude and endeavours his utmost to assume it, whose pictures somehow look like a protest against the encroachment of literature upon the domain of painting, and a vindication of the unliterary character of pictorial art. But nothing could be further from Mr Whistler than protests or vindications. Nothing can be more foreign to his art than set purposes; the song of a bird is not more absolutely unconscious. Anything like philosophy, anything like introspection, it does not touch; there is far less of the nineteenth century about it than of the sixteenth. And it naturally follows from this that with those subtleties of dialects such as Couture delighted in – whether art is superior to nature, for example – he does not concern himself at all. Not a few painters, to be sure, easily shun these and devote themselves to what they reverently and unaffectedly believe to be the imitation of nature, with the result that their work is often more pleasing because of their own unconsciousness of its generalization, its selection, its modification, in a word, of its art. Mr Winslow Homer is an excellent instance of this. And it is always dangerous for a painter consciously to attempt to meddle with the model with which nature furnishes him. But Mr Whistler goes a step beyond this, and with ease and safety. His unconsciousness is so pure, and sophistication is so opposite to his genius, that he is somehow relieved of the necessity of imagining that he is reproducing a scene. There is nothing perilous for him in the immediate attempt to convey an impression, without referring the observer to any analogue in nature for the grounds of it. This is because – and of how many painters can the same thing be said? – this is because Whistler is not so much enamoured of his material as possessed by his ideal. That is at bottom, perhaps, his distinguishing trait. "Are those figures at the top of the bridge intended for people?" asked his cross-examiner in the Ruskin trial with the familiar irony. "They are just what you like," was his reply. In other words his art is self-dependent, and is not to be referred to nature for its excuse or its justification. His *Nocturne in Blue and Silver* represents indeed Battersea bridge by moonlight, and the testimony of the humorous British court-room audience that its merits as a portrait were not prominent is not perhaps satisfactory. Whether Battersea bridge by moonlight really looked to Mr Whistler as he represented it is of course as impossible as it is unimportant to determine. And it is the same impossibility in all cases in which nature is interpreted instead of copied that makes it impossible to settle the vexed, but, upon the whole rather idle, matter of idealization. One need not be so uncompromising a nominalist as Bishop Berkeley to believe that the beauty which the greatest artists find in nature exists only in the eye that beholds, or, better, divines it. And it is very certain that, but for the *Nocturne in Blue and Silver*,

the thing of which it is in any strict sense a portrait would never have been visible, whether one chooses to fancy that it exists or not. But what is important in all art of any high order is that there should be a complete harmony between its own elements. Then it may resemble Battersea bridge by moonlight, or "what you like;" there can no fault be found with it provided it be beautiful. Perhaps the least unsatisfactory definition of art that has been given is that it is "the interpenetration of an object with its ideal." It does not go so far as that of M Taine, who, untouched by the philosophical lunacy of the pre-Raphaelites, boldly maintains that it is the representation of a character or object more completely than it is found in nature; but it has the exactness of a definition, if not the fullness of a description. And, measured by it, Mr Whistler's pictures are in kind the perfection of art. It is his ideal always with which his work is interpenetrated; it is his ideal that interests one in his expression, and not at all his success in rendering either the superficies or the essence of natural objects. He allowed nothing to stand in the way of this. Considerations hostile to this, the neglect of which has earned him his reputation for extravagance and fantasticality, he never in the least heeds. "My whole scheme was only to bring out a certain harmony of colour," he explains of the *Nocturne in Blue and Silver*. "The black monogram on the frame was placed in its position so as not to put the balance of colour out," he says of the *Nocturne in Black and Gold*." Of course, it is inexact to speak of this as absolutely unconscious; but, as it has been said, it is natural and spontaneous; it results from the painter's perceptions and intuitions, and there is nothing argued or logical about it. An accomplished artist knows very well wherein and how essentially he differs from the painters around him; and of course no one better than Mr Whistler knows wherein and how vitally his art differs from that of Mr Burne-Jones or Mr Alma-Tadema, say. What it is here meant to indicate is only that Mr Whistler is, perhaps, the very last person to whom one would look for any philosophical exposition of a theory of art or of painting, and that this is evident from all his pictures, spite of the superficial and seeming eccentricity of some of them. Evidently his intelligence is employed solely in expressing, not in creating, his ideal.

And the nature of his ideal is singularly pure and high. It is this which, after all, finally measures an artist – the character of his ideal, his attitude toward absolute beauty, his conception of what is best in the visible world and the world that is to be divined. What impresses Mr Whistler most in nature, that is, in the material out of which every artist is to create his picture, is what one may call beautiful picturesqueness. What his imagination creates out of this material at any rate shows an intimate union of both character and poetry that it is rare to find. One of these two elements generally preponderates in the work of most painters. The painter inclines insensibly either toward power or toward charm, or, at least, betrays an endeavour to avoid either what is vapid or what is ugly. That does not, of course, imply that a picture must be either wholly vapid or wholly ugly; but, to take extreme instances, characterlessness is the conspicuous trait of M Bouguereau's Madonna-like peasants, and beauty is conspicuous by its absence from the pictures of M Gérôme. But in the work of Mr Whistler it would be difficult to discover a specific leaning in either direction. At first thought, and seeing that his work is never without the presence of character as a distinct force, one is tempted to say of it that it is strong, or, at least, picturesque rather than beautiful. He probably sets Mr Browning very far above Mr Tennyson. At the same time, its character is not character simply, but always character that has a distinct charm. And this is the ideal attitude for a painter to take; to Mr Whistler's essential attitude, at all events, it is impossible to object. No better illustration of this could be found than *The White Girl*, though, indeed, there is not an etching of Mr Whistler's that does not more or less pointedly illustrate it. *The White Girl* is certainly a lovely picture, but its loveliness has a marked individuality. Nothing could be more delightful than the simplicity and

delicacy of line and hue of this figure, nothing more graceful than her attitude, or more subtly charming than the broad harmonies worked out by the dark hair and the lily, the white drapery, and the soft fur upon which she stands. On the other hand, no one can fail to note the sense of character which pervades its loveliness, and to observe how its individuality is quite as strong as its beauty is charming. Indeed, one feels that it is an idealized portrait, quite as much as that it is ideal at all.

<center>* * *</center>

If there is one rule, however, which is without exceptions, it is that one has always the defects of one's qualities. Mr Whistler certainly has the limitations which the traits heretofore enumerated suggest. His manner and method are not commonplace; his artistic spirit is not unlike the true pagan spirit – not unlike the spirit of antique art before the Middle Age extinguished it, and of early modern art, after the monks had done with it; and his ideal is an ideal which includes both poetry and picturesqueness. But a painter of whom one's first thought is that he is not commonplace, is almost sure to seem at least tinctured with evident protestantism against conventionality; no one can utterly get rid of his environment, and be quick with the inspiration of other times and conditions; and the more comprehensive one's ideal, the greater danger there is that his art will not touch the highest point in any one direction. Mr Whistler does sometimes seem to shun commonplace with violence. And, though nothing that Mr Ruskin says or does is by this time surprising, it would be surprising if there were absolutely no grounds for the substantial agreement with Mr Ruskin's criticism, in this instance, of so many persons of cultivation and refinement. A recent review of the present Grosvenor Gallery exhibition, evidently written by some one whom the mention of "impressionism" does not inflame, notes the beauty of one of Mr Whistler's early works there displayed, in contrast to the lack of measure and propriety in the others, which are his latest. And, however far from the main point about Mr Whistler emphasis of what are termed his technical vagaries may be, vagaries, nevertheless, are blemishes, however unimportant they are in a large estimate. It is possible – time develops tendencies so much more than it modifies them, – that this lack of *bienséance*, this impetuous rejection of everything academic, which his later work evinces, is due to a natural pugnacity – which his pamphlet betrays – intensified, by popular misappreciation and ignorance, into an intemperate exaggeration of what was admirable originality into positive eccentricity. And positive eccentricity is always unsatisfactory. Possibly personal influences of this sort are the very last that would in any way affect Mr Whistler's art, and it may be that the increasing vigour of his unconventionality is to be attributed to a growing impatience with the ordinary methods of expression, and an inclination to substitute suggestion for depiction. The further we can get away from pigment and from all the manifestations of pigment, the better, perhaps; and perhaps in the painter's paradise one will only need a look, or even an "energizing," with which to convey his impressions. This side of that happy country, however, one has some title to ask that a picture should be not merely an intimation or a suggestion, but a complete expression, an adequate depiction of the idea or image it contains. And in his later works – idle as Mr Burne-Jones's and Mr Frith's censure of their lack of "finish," lack of "form," lack of what-not, seems – Mr Whistler does display a tendency to dispute any such title. One cannot state this without overstating it, to be sure, and it should be repeated that it does not touch the main point about Mr Whistler. But unless a man can free himself entirely from any disposition to exaggerate his traits into peculiarities, because of stupid objections to them; and if he feels the emptiness of the commonplace around him so keenly as to betray his hatred of it in his own work, he will not wholly avoid the manifestation of qualities rather opposed to than harmonious with the simple following of an ideal.

<center>* * *</center>

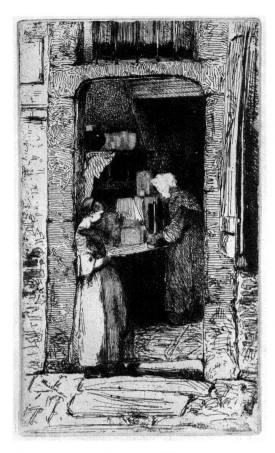

The Mustard-Seller, K.22(iii). 1858. Etching, 6⅛ × 3½″ (15.7 × 9 cm). Hunterian Art Gallery, Glasgow University (J. W. Revillon Bequest).

i.e. their evidence in the Whistler–Ruskin trial, see pages 131–133.

For with Mr Whistler's equipment and energy, and genius, the surprising thing about him is that there should be any discussion concerning his position as a painter – that he should not have vindicated his ability by something of unmistakably large importance. And what has contributed to prevent this more, possibly, than the conflict between his genius and his century is the faultlessness of his ideal heretofore alluded to. In the very perfection of this, there is a drawback to the highest accomplishment open to genius. Of all the great painters some distinctive leaning is characteristic, generally either toward charm or toward power, though the prominence of neither implies the absence of the other. And indeed, in Mr Whistler, one occasionally notices, spite of the distinct charm which his picturesqueness always possesses, a tendency toward picturesqueness that is rather more imperious than his sweetness; and the judgement may be hazarded that he is in so little danger from over-sweetness, that his sense of character might sometimes be even less strenuous than it is with advantage. But in the main the balance between these elements of beauty which he maintains is so just that it may have operated to prevent his accomplishment of anything absolutely great, anything of obviously large importance in the direction of either of them. One can scarcely be as admirable in all ways as Mr Whistler is, and still touch the highest point in any one way. Delacroix, for example possessed a genius of less rounded completeness, perhaps, but at the same time, Mr Whistler will never occupy as exalted a place in the estimation of men as Delacroix. And on the other hand, any one who turns from such a work as even the *Symphony in White*, to the best work of Mr Moore – very little known in this country, and less known anywhere than it deserves to be – must be impressed with the superior greatness of the latter. Mr Whistler no more has the perfect grace, the subtle compromise between blitheness and melancholy, the chaste sweetness, the *spirituelle* quality, of Mr Moore, than he has the sweep and vigour of Delacroix. But how delightful it is to reflect, that though he is not something other than he is – something which, with his traits, he could never become – nevertheless he is precisely what he is: perhaps the most typical *painter* and the most absolute artist of the time. That positive as is his delight in colour, and great as is his success with it – even according to Mr Frith and Mr Burne-Jones, – admirable as is his sense of form, as all his etchings show, skilful as is his composition, it is after none of these things, nor the sum of them, that he especially seeks, but after something of which they are merely the phenomena and attributes, something for which we have no other word than the Ideal.

Ferdinand-Victor-Eugène Delacroix (1798–1863).

COLOURPLATE 28 *(YMSM 61).*

THE ACADEMY

"Art Sales"

21 February 1880

In May 1879 Whistler was declared bankrupt and bailiffs took possession of the White House which was sold in September shortly after Whistler left for Venice (see page 153). This auction sale of his possessions held on 12 February 1880 was the second, the first had been held in the White House on 7 May 1879.

Last week Messrs Sotheby, Wilkinson and Hodge sold a collection of china – blue and white and other Oriental china – Oriental objects of *virtù*, original etchings, and one or two paintings, all from the estate of Mr James Abbot McNeill Whistler. We note the prices of the objects of chief interest: – a pair of bronze candlesticks, chased with scrolls, and on high rosewood stands, realized £9 (Howell); a handsome Japanese screen of several folds, with panels of silk, £13; a pair of dwarf screens, painted with landscapes and figures on gold grounds, £4 4s.; a pair of remarkable Japanese bronze candlesticks, pierced stems, and a stork with enamelled

Charles Augustus Howell, one-time secretary to Ruskin, entrepreneur art dealer, who while helping Whistler avoid bankruptcy helped himself.

wings, £4 15s. (these were very bold and free); eighteen Japanese picture-books, sketches of landscape and figures and loose drawings, £3 7s. 6d.; a large brown earthenware cistern or bath, somewhat ornamented with birds and flowers, £5 5s.; a Japanese china cabinet, fitted with ebony drawers and lac panels, painted with figures, and on a stand, £10 10s. After these there followed Mr Whistler's own productions. About a hundred copper-plates of etchings, mostly erased, sold for £6 15s. (Fine Art Society); one little plate, in perfect condition apparently, was sold separately for £5 10s.; about forty slight crayon sketches, chiefly of the figure, some black and white, and others variously coloured, went for £19 10s.; two framed etchings, being a river view and a sketch of a girl, realized £7 10s.; three etchings, framed – *A Forge, Battersea Bridge*, and a *Lady and Dog*, exhibited at the Grosvenor Galley – fetched £20 10s. (Flower); a framed crayon sketch, said to be Mdlle Sarah Bernhardt, perhaps erroneously, went for £5 5s.; another crayon sketch of a lady seated, exhibited at the Grosvenor, fetched £3 7s. 6d., while yet another crayon sketch of a nude female figure with drapery behind the shoulders fetched £4 (James). Lastly, there came two pictures which have been the subject of much remark. One of these was the large oil portrait of Miss Connie Gilchrist, of the Gaiety Theatre – an immature figure, fragile and light, with legs tripping forward in a skipping-rope dance. Though apparently slight in execution, the work may be considered both a good likeness and attractive as a work of art. It has certainly pleasant qualities of colour and expression, and the gesture of the model is adroitly caught. This large example of Mr Whistler's art sold for £50. It was followed by a less pleasing instance of his skill – a satirical painting of a gentleman, styled *The Creditor*. This extensive, but extremely sketchy, work sold for £12 12s. With this lot there came to a conclusion a sale which had excited some curiosity.

Probably The Little Forge *(K. 147), and* Under Old Battersea Bridge *(K. 176) exhibited in the 1879 Grosvenor Gallery exhibition (269 and 272); no etching of "a Lady and Dog" is recorded; they were probably bought by Cyril Flower (Lord Battersea).*

The sketch said to represent Sarah Bernhardt, which is probably of Maud Franklin (see page 250), was bought by Oscar Wilde; Whistler bought it back from the Fine Art Society in 1895.

[James]: Possibly Henry James.

Harmony in Yellow and Gold: The Gold Girl – Connie Gilchrist *YMSM 190 (Metropolitan Museum of Art, New York) was exhibited at the Grosvenor Gallery in 1879 (55); it was bought by Wilkinson, probably a dealer.*

[The Creditor]: *Otherwise known as* The Gold Scab *(YMSM 208), a satirical portrait of F. R. Leyland (see page 102), which shows him caricatured as a hideous peacock seated at the piano on a model of The White House, and in which Leyland's money and addiction to frilled shirts are the subjects of especial derision. It was bought by the dealer Dowdeswell and is now in the Palace of the Legion of Honor, San Francisco.*

Blue and white china collected by Whistler. From the collection of memorabilia in the Hunterian Art Gallery, Glasgow University.

OTTO BACHER

WITH WHISTLER IN VENICE
The Making of the Etchings
1908

Oils were a secondary medium with Whistler while in Venice, his main object being to complete his etchings and to get subjects and results as quickly as possible for his exhibition on his return to London. He would load his gondola, which was virtually his studio, with materials, and the old gondolier would take him to his various sketching points. It is noticeable in Venice that many subjects were pastel motives, and Whistler was very clever in deciding which these were. He generally selected bits of strange architecture, windows, piles, balconies, queer water effects, canal views with boats – very rarely figure subjects – always little artistic views that would not be complete in any other medium. He always carried two boxes of pastels, an older one for instant use, filled with little bits of strange, broken colours of which he was very fond, and a newer box with which he did his principal work. He had quantities of vari-coloured papers, browns, reds, greys, uniform in size.

In beginning a pastel he drew his subject crisply and carefully in outline with black crayon upon one of these sheets of tinted paper which fitted the general colour of the motive. A few touches with sky-tinted pastels, corresponding to nature, produced a remarkable effect, with touches of reds, greys and yellows for the buildings here and there. The reflections of the sky and houses upon the water finished the work. At all times he placed the pastels between leaves of silver-coated paper. Even his slightest notes and sketches were treated with the greatest care and respect.

He was never in a hurry in his work, always careful, and accomplished much. Some motives were finished at one sitting, but more often he made only the crayon outline, charming in its effect, leaving the unfinished sketch for days at its most fascinating point, to be filled in later with the pastels. Many times these outlines needed very little colour to complete them. At other times, he would take an old pastel which had been cast aside, and, by adding some new strokes, bring it into a beautiful creation. Skies with atmospheric effects beside the hard architectural lines were very charming, the reflections in water always delightful. They reminded you of colour but not paint. Taken as a whole, the pastels are as complete a collection of pictures of Venice and its life as can be found.

Whistler produced about one hundred pastels while in Venice, never had any framed, and very rarely showed them to strangers for fear of the rubbing which this would entail. He sold very few while there – then, only to patrons and well-known families. The majority were carried to London where they at once became popular.

Whistler lifted pastels from the commonplace to a very artistic medium. Before his work, pastels were not looked upon as a factor in art, with the notable exception of the *Chocolate Girl* and a few charming portraits done by Frenchmen. It was really left to Whistler to inspire future artists to use this medium as a rapid record of facts. Whistler retained his interest in pastels, carrying on the work in London where he executed many classical figures. . . .

In the late '70's, he was commissioned by the Fine Arts Society of London to execute a set of twelve etchings of Venice, and it was there that I became intimately associated with him and his work in etching. My keen interest was due to the fact that I had made many etchings myself.

The Cleveland-born painter and etcher Otto Henry Bacher (1856–1909), along with other American painters, met Whistler in Venice in the summer of 1880. Then began a period of close association after Whistler moved in to the Casa Jankovitz and began proofing the etchings of Venice he had been commissioned to make by the Fine Art Society, on a press Bacher had brought with him from Munich. Bacher saw Whistler in London in 1882 and again in 1885.

Only 12 oils are recorded (YMSM 211–22).

See pages 176–178 and Colourplates 55, 56, 58, 60.

153

Whistler seemed to be interested in them, especially so when I told him that some were done in one sitting while others were accomplished in eight, using the acid while I worked. Perhaps another bond of interest was the fact that I had studied his works and enthusiastically searched for the subjects depicted in his etchings on the Thames. London had furnished tall towers and old chimneys, tattered, broken-down houses, long distances, picturesque wharves, and generally etchable subjects. In contrast to this, Venice had a wealth of colour and the finished beauty of Byzantine architecture, none of which seemed to me appropriate for the needle. Venice had never before been etched, and I was more than anxious to see how he would treat it in lines.

There was a simple artisan in Venice whose work upon copper was most beautiful. He could hammer out and grind down a plate to just the thinness which Whistler desired. When not at work on his plates, he devoted his time to pots, kettles, and the usual things to be found in a

i.e. The Thames Set *(see pages 86–100)*.

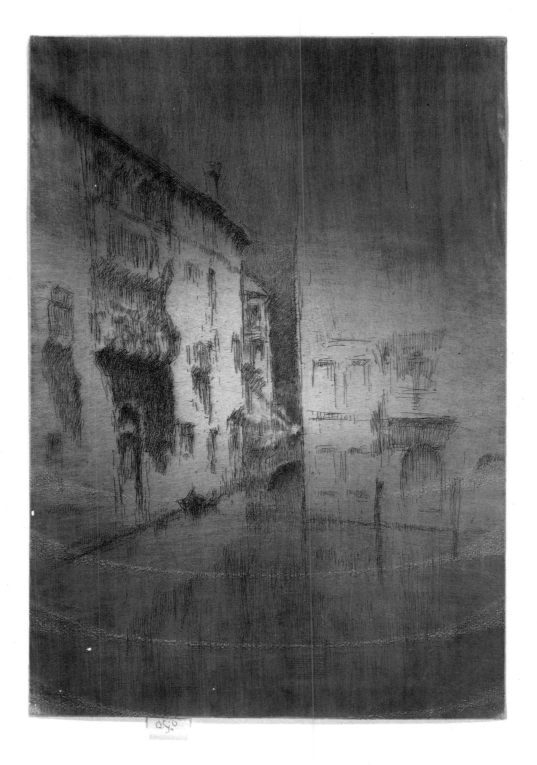

Nocturne: Palaces, K.202(iv). 1880.
Etching and drypoint,
11⅝ × 7⅞″ (29.6 × 20.1 cm).
Hunterian Art Gallery, Glasgow
University (Birnie Philip
Bequest).

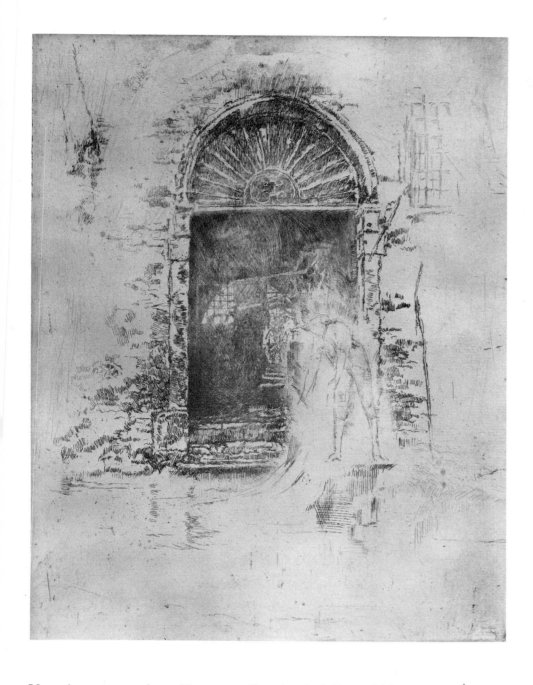

The Dyer, K.219(ii). 1880.
Etching, 11⅞ × 9⅜″
(28 × 22.9 cm). Hunterian Art
Gallery, Glasgow University
(Birnie Philip Bequest).

Venetian copper shop. He was well trained, delivered his own goods, was reasonable in his prices – hence all of our plates were made by him. In grounding these plates, Whistler always used the old-fashioned ground composed of white wax, bitumen pitch and resin. He heated the plate with an ordinary alcohol flame, holding the copper in a small hand-vice brought with him from England. The silk-covered dabber that spreads the ground over the plate was fascinatingly managed by Whistler, who seemed to love every phase of etching. When he came to smoking the plate, he preferred the old wax taper made for that purpose. He did not like to use the large torchlight wick and coal-oil lamp which I had, although it was surer and better. Later I generally grounded his plates because he learned to like my wax better than his own. It was the ground that bears Rembrandt's name, and is composed of thirty grains of white wax, fifteen grains of gum mastic and fifteen grains of asphaltum or amber. The mastic and asphaltum were pounded separately in a mortar; the wax was melted in an earthen pot, and the other ingredients were added little by little, the operator stirring all the time.

These grounded plates he would put between the leaves of a book to prevent them from being scratched, and leave them in the bottom of the boat. If he did much walking he took but a single plate wrapped in paper to preserve the etching ground surface, putting it in his pocket with one or

two etching-needles that were always punched into a cork to secure their very fine, sharp points; and they were very sharp – every one of them. These etching-needles were ordinary dentist's tools that he had procured before coming to Venice. If a point was not as sharp as he desired, he whetted it on a small oilstone which he always carried with him – point forward, pushing forward and backward the length of the small stone until it was of a desired sharpness. The sharpening of an etching-needle is quite a knack. He could keep a point for a long time. Occasionally he took only a clean copper-plate, expecting to do a dry-point.

His gondolier, Cavaldoro, a very handsome type of man, was hired by Whistler by the month, and came to know with his Italian intuition just where Whistler most desired to go. If he did not ride, he would follow his master, carrying the paraphernalia under his arm. All of Whistler's etchings of Venice were drawn right from the subject, and all the figures in these etchings were drawn from life, although some of them did not pose in the same spot in nature as they are represented as posing in the etchings; these figures were always done from life and out of doors, and often near his house. Groups of bead-stringers and lace-makers could be found almost every day in any of the "calles" of Venice. Whistler often worked from these groups of women as they worked daily at their vocation.

I have known him to begin an etching as early as seven o'clock in the morning, and continue until nine, then put that plate aside, and take up another until twelve – noon – get a bite of lunch, and commence on a third, sometimes an etching or perhaps a pastel – then take a fourth – his final subject for the day, and continue upon it until dusk, the subjects being wholly different. Whistler always had a half dozen under way, more or less complete.

I have heard it said that he surrounded his etching expeditions with a great deal of mystery, and was rarely prevailed upon to allow any one to accompany him, doing so, only under the strictest pledge of secrecy. This statement is absolutely incorrect, the reverse being the actual truth.

My early etchings of Venice, taken from the window in the Casa Jankovitz, were etched from nature in the acid bath, this method being known to the etching world as *Hamerton's Positive Process*. I had used this in Germany, but in Venice I found it impracticable because of the many details in the buildings, some of which would be over-bitten at one side and under-bitten on the other. Whistler seemed to be very little interested in this method, and I soon came to use his method – the old process, drawing the subject leisurely in one to a dozen sittings and biting the plate indoors, away from the subject.

In etching he would get the essential lines, holding the copperplate in one hand, generally the left, and with the other "he spun web-like lines of exquisite beauty – fascinating to see in the beginning as in the end." Where it required accuracy he was minute. He used the needle with the ease of the draughtsman with a pen. He grouped his lines in an easy, playful way that was fascinating: they would often group themselves as tones, a difficult thing to get in an etching. He used the line and dot in all its phases with ease and certainty. Sometimes the lines formed a dark shadow of a passage through a house with figures in the darkness so beautifully drawn that they looked far away from the spectator. These shadows which so beautifully defined darkness were made only by many lines carefully welded together and made vague as the shadow became faint in the distance or was contrasted with some light object.

He made his etched lines feel like air against solids; that is the impression some of his rich doorways of Venice gave me. He was the first to show me how to etch a deep, variegated door with a deeper figure somewhere in that darkness, all contrasted against something in the near opening that was much darker and which made the doorway effective. If he etched a doorway, he played with the lines and allowed them to jumble themselves into beautiful forms and contrasts, but was always very careful

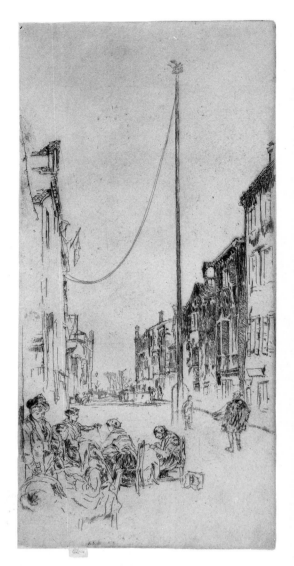

The Mast, K.195(v). 1880. Etching, 13⅜ × 6⅜″ (34 × 16.2 cm). Hunterian Art Gallery, Glasgow University (Birnie Philip Bequest).

Casa Jankovitz overlooked San Giorgio and the Salute.

of the general direction they should run as a whole. In the partial darkness he could put in a hazy figure, the values being adjusted by the biting. He worked for hours on figures, and at times became quite excited over some success attained after much painstaking labour.

"Look at this figure!" he excitedly yelled to me one day on the Riva. "See how well he stands!"

Whistler never cared to draw an old gondola as Ziem and others had done. He preferred to depict the beautiful new ones, the lines of which he considered "very swell." He would often remark while drawing one, "Doesn't this gondola sit in the water like a swan?"

Félix Ziem (1821–1911).

Whistler had no doctrine about lines, although Haden had, and expressed them in his published work on etching. All the theory Whistler hinted at was delicacy of biting, of printing, and of dry-point. Delicacy seemed to him the keynote of everything, carrying more fully than anything else his use of the suggestion of tenderness, neatness and nicety.

Whistler's brother-in-law, Francis Seymour Haden (see page 37). See his "Mr Seymour Haden on Etching", The Magazine of Art *(1879), pages 188–91, 221–24, 262–64.*

I have been asked by several collectors if it were not true that Whistler worked all his Venetian plates through a mirror, thereby avoiding the usual reversing of the subject. My answer was always an emphatic "No." All of Whistler's etchings of Venice are reversed, although that fact never offended one's appreciation of them. To see the prints as the subjects are in nature they must be seen through a mirror.

A traditional saying among etchers is that "one day's stopping-out is worth five with the needle." Whistler always had his stopping-out varnish with him in a small bottle, applying it with a brush in the most delicate manner. Whistler had brought some from England which was soon exhausted, and, as the proper kind could not be obtained in Venice it

The Riva, No. 2, K.206. 1880. Etching, 9¼ × 12″ (20.8 × 30.3 cm). Hunterian Art Gallery, Glasgow University.

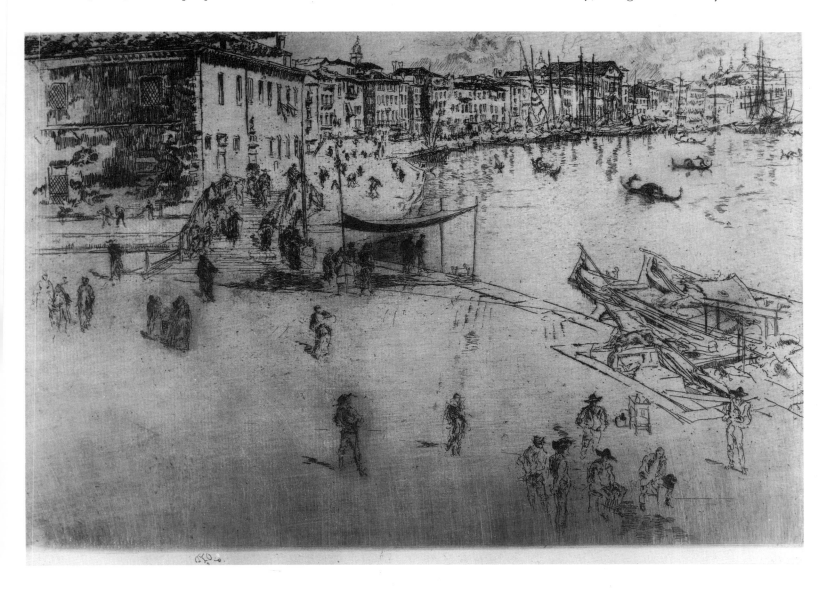

became necessary for me to make some for the use of both of us. This was done by mixing asphaltum varnish, a piece of old etching ground, white wax and ether. While he was working, although he avoided the use of the varnish as much as possible, if it became necessary for him to stop out part of the work, he would paint out any lines or figures, replacing the old forms with better lines.

In the *Etcher's Handbook* by Hamerton, which I had with me in Venice for reference, there are described several processes for biting, but Whistler, although he read many of them, had no use for them, preferring the old process, or, as Hamerton calls it, the old negative process.

Published in 1871.

A well-known dealer in etchings and a writer on the subject, once asked me if it was not true that Whistler allowed anybody to bite his plates. My answer was, "No – never! any more than Whistler would allow anybody to write his letters or sign his butterfly. Aside from the horror of such a thing the pleasure would be gone." When he bit a plate he put it on the corner of a kitchen table with his retouching varnish, etching-needle, feathers and bottle of nitric acid at hand ready for use. Taking a feather he would place it at the mouth of the bottle of nitric acid, tipping the bottle and allowing the acid to run down the feather and drop upon the plate. He moved the bottle and feather always in the same position around the edge until the plate was covered. He would use the feather continuously to swash the acid backward and forward upon the plate, keeping all parts equally well covered, now and then blowing upon some place where an air bubble had formed. If he desired to make any change on some particular spot, he would blow away the acid, make the desired change, and re-cover with the feather. When the plate was properly bitten in this particular state, he would pull it to the edge of the table and drain the acid into the bottle again by placing the feather at the edge, holding it there until every drop had disappeared. Whistler never banked his plate, and he could bite it to the very edge without spilling a drop of the fluid. This method in the use of the acid was peculiar to Whistler; the skill which he displayed was astonishing.

When the plate was dry and clear, he looked sharply over it with a magnifying glass for accidental scratches that would expose the surface of the plate in any future work upon it. He was most careful in detecting these as well as small bits of false biting or pits, which, on rare occasions, despite all his care, he found on the surface of the plate. I once remembered telling Whistler that the use of Seymour Haden's acid, sometimes called Dutch Mordant, had a tendency to obviate these defects because of the small bit of potash in its composition, but Whistler would not use this acid, preferring to stick to the nitric diluted with water. In his biting, Whistler carried lines into intricate deeper bitings that could be carefully followed with the eye – into complexities of a shadow or the depths of a doorway.

The most interesting part of his etching was the printing. If he wanted a proof from a plate in a certain state, his method of work was a revelation in the art, particularly the care with which he used the "dabber." When squashing the ink into the shallow lines and moving the hot plate over the surface of the plate-heater, he surely but gently forced in the ink from every side, rough-wiping neatly with muslin. When the plate was sufficiently chilled for manipulating, he used that remarkable hand of his to wipe the ink away in the daintiest manner imaginable. His hand would glide over the smudgy copper surface in light, quick strokes – *pit-pat-pat* – that fairly cut away the stiff ink that stuck fast in the palm. Buttoned close around his neck he wore a blouse that had seen service before. There was one large smudge on the right side that had layer upon layer of dry ink. In the same *pit-pat* regularity he wiped the ink from his hand on the same old smudge until the plate was ready for the press.

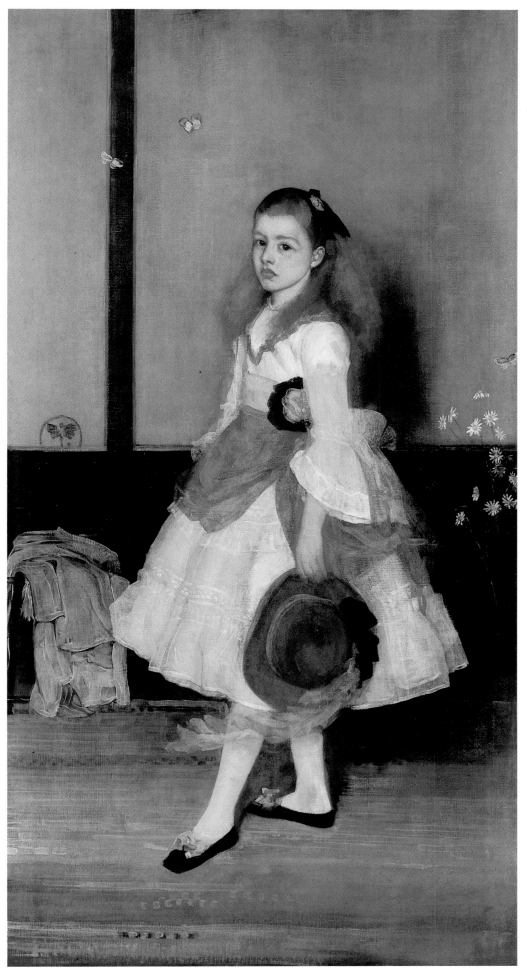

COLOURPLATE 46. *Harmony in Grey and Green: Miss Cicely Alexander.* 1872-73. 74¾ × 38½″ (190 × 98 cm).
Tate Gallery, London.

COLOURPLATE 47. Colour Scheme for the Dining-Room of Aubrey House. *c.* 1873. Body-colour on
brown paper, 7¼ × 5″ (18.3 × 12.6 cm).
Hunterian Art Gallery, Glasgow University (Birnie Philip Bequest).

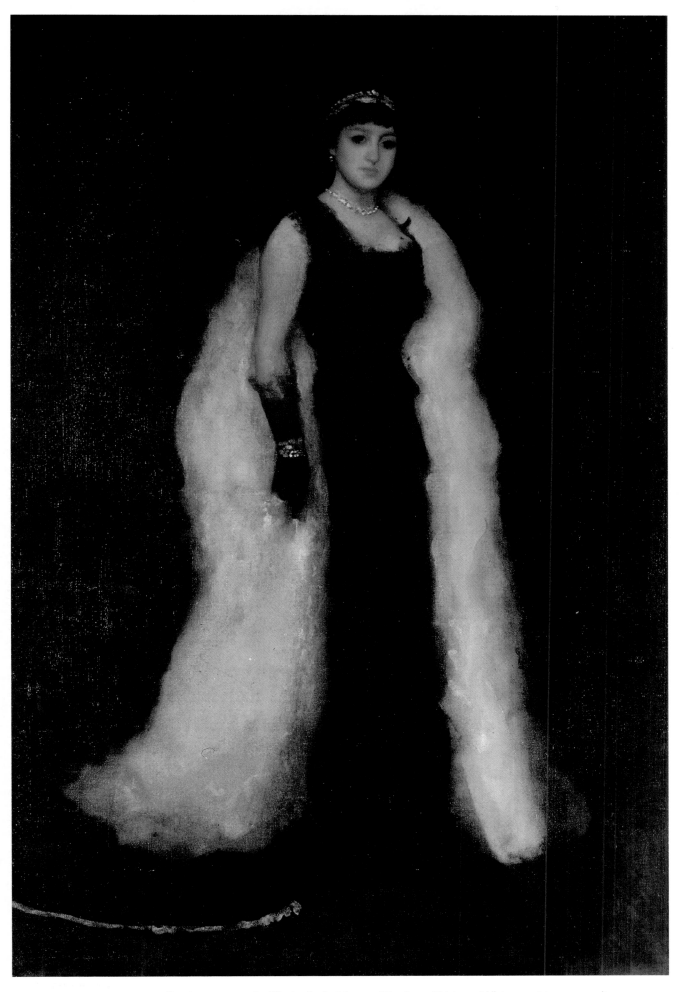

COLOURPLATE 48. *Arrangement in Black: Lady Meux.* 1881-82. 76½ × 51¼″ (194.2 × 130.2 cm).
Honolulu Academy of Arts, Hawaii.

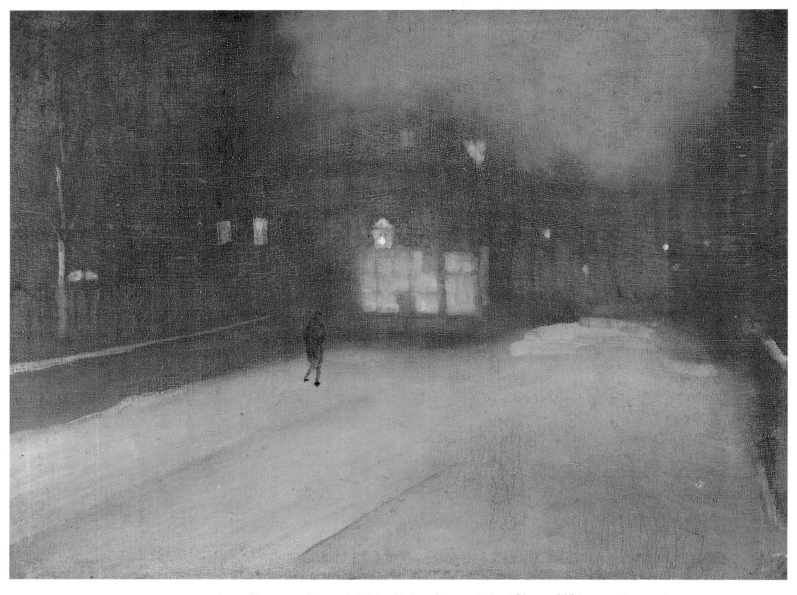

COLOURPLATE 49. *Nocturne: Grey and Gold – Chelsea Snow*. 1876. 18⅝ × 24⅝″ (47.2 × 62.5 cm).
Fogg Art Museum, Harvard University, Cambridge, Massachusetts
(Bequest of Grenville L. Winthrop).

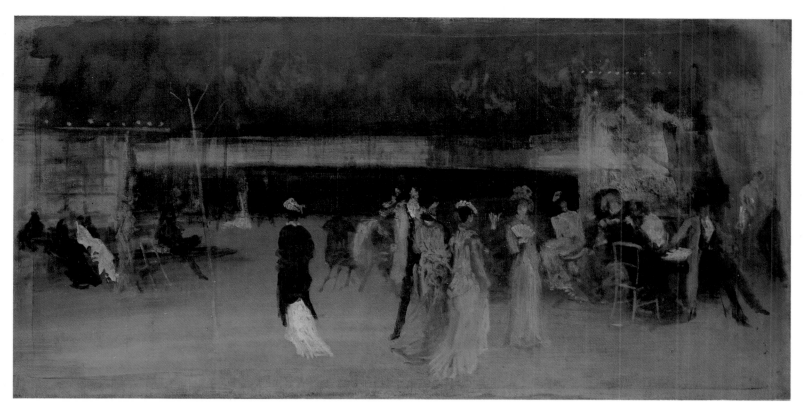

COLOURPLATE 50. *Cremorne Gardens, No. 2.* 1872/77. 27 × 53⅛″ (68.5 × 134.9 cm).
Metropolitan Museum of Art, New York (John Stewart Kennedy Fund, 1912).

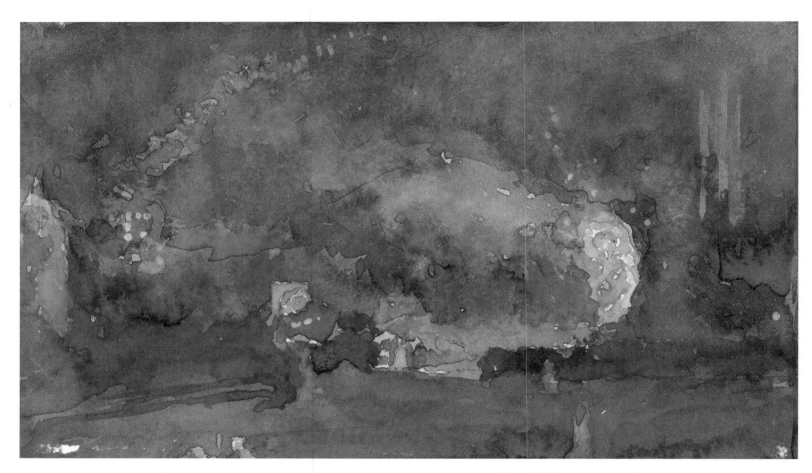

COLOURPLATE 51. *The Fire Wheel*. 1893. Watercolour, 3¾ × 6⅛″ (9.5 × 15.5 cm).
Hunterian Art Gallery, Glasgow University.

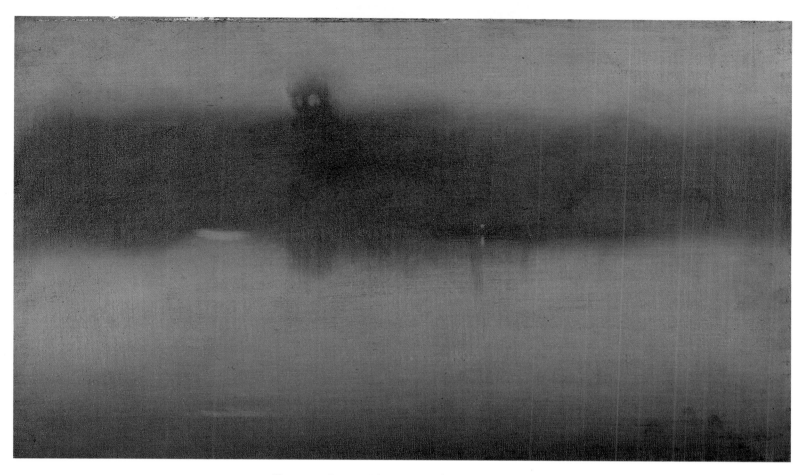

COLOURPLATE 52. *Nocturne: Grey and Silver.* 1873/75. 12¼ × 20¼″ (31.1 × 51.4 cm).
Philadelphia Museum of Art (John G. Johnson Collection).

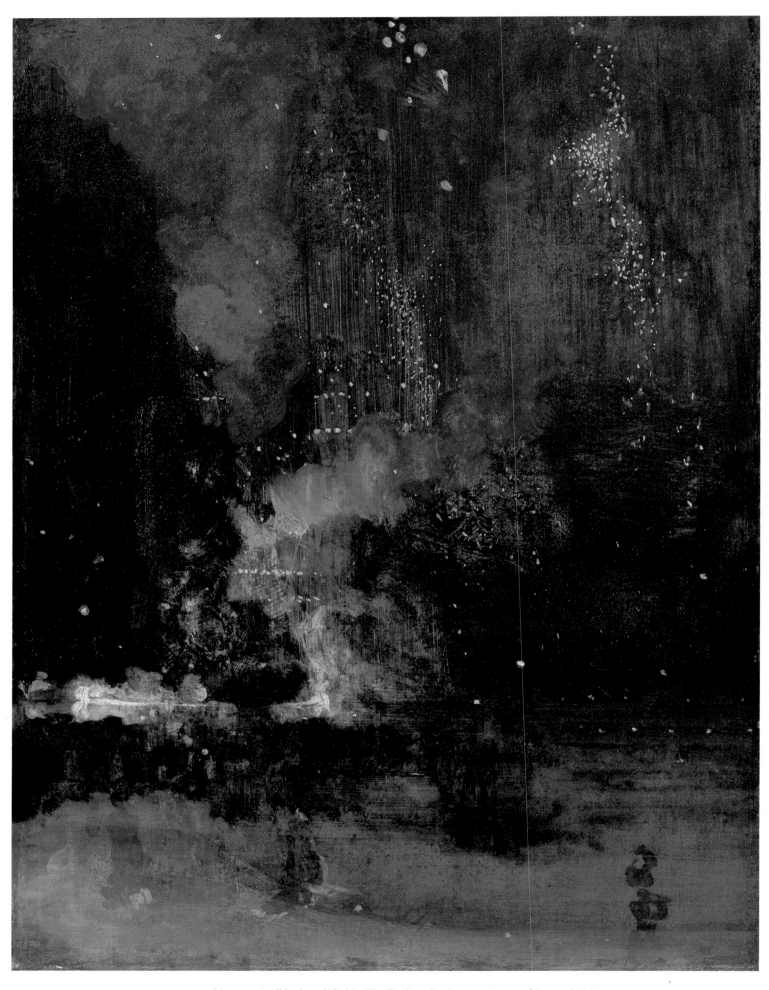

COLOURPLATE 53. *Nocturne in Black and Gold: The Falling Rocket. c.* 1874. 23¾ × 18⅜″ (60.3 × 46.6 cm).
© The Detroit Institute of Arts (Gift of Dexter M. Ferry Jr.).

One of the many charms of his etchings is the delicacy of "biting." In some of his plates the lines are bitten so shallow that only with the greatest care and knowledge is it possible to retain the ink in them.

The method of printing his own plates was as much a part of his art as was the needle or the acid. From these delicate plates he could "pull" a proof so rich and full that it would surprise most etchers to see how much ink he got from those tiny, web-like scratches, some of them so faint that they could barely be seen when the polished surface was held to the light. These plates would baffle an ordinary printer, who would probably cast them aside as unprintable and worthless.

All of Whistler's proofs were printed on my press, some plates being so large that the paper had to be folded in order to get it through. If he wished to make a large edition without the folding of the paper, he carried his plates to the old Venetian printer who had two wooden presses well equipped for this purpose. This old man kept his shop in one of the back streets of Venice, where he and his sister, a very old lady, did small Madonnas for the churches and told agreeable stories of the occupation of Venice by Napoleon, the facts of which they remembered well. He had inks for engraving, but I supplied him with etching inks brought from Germany.

In this shop Whistler became the workman, the old man, with his slow and hobbling walk, helping him by preparing the press and adjusting the blankets. After the windlass had pulled the big bed through, Whistler would carefully pull the proof from the plate, place it upon a cardboard, and examine every detail, comparing every line with the corresponding line upon the plate.

He often took a proof and went back to the subject to make corrections upon it with water-colours that matched the ink. Then he carried home the corrected print, recoated his plate, and worked it up to the recent proof. Sometimes he corrected a proof in water-colour without going to nature to verify his results.

During the first of his printing, Whistler did not trim down the print to the plate mark; later, and in his London printing from the Venetian plates, he did this, leaving his butterfly in one corner in a little square of its own. He held the remarque in contempt – never placing it on any of his work.

The early prints from some of Whistler's Venetian plates have none of the suggestions of the plate printer's art of retroussage. Two proofs printed from the same copper, one with his earlier, the other with his later method, would appear at first glance as two distinct subjects. Closer inspection would bring out the fact that he had resorted to two different kinds of printing, the later one involving the retroussage, which consisted in making the ink rise out of the lines and spread itself upon the plate. The plate with such treatment yields a rich, soft tone. Whistler went beyond this method, leaving much ink on the surface of the plate which gave an added depth of tone to the water or other parts.

As I never noticed this effect in any of his plates previous to his Venetian, and as it was not used in the first of these, I have often thought that the monotype or Bachertype, as they were locally known, may have influenced him to adopt this means of embellishing his prints.

Bachertype is a meaningless term in itself, and requires an explanation. While in Florence, Mr Duveneck and his class, of which I was a member, used to spend some of their evenings in a social way in the homes of the American and English colony in that city. As a means of amusement, we often painted a face or landscape upon a plate with some pointed instrument or thumb, using burnt sienna or ivory black and a medium. This would be run through my press – hence the term Bachertype. One print only could be made from one plate because the squashing through the press absorbed all of the colour. These would be numbered and raffled for by those present. Some wonderful impressions were made, and many are still in existence.

The remarque was the currently fashionable practice of embellishing the margins beyond the plate mark, as in the etchings of Félix Buhot (1847–98).

The French printer Auguste Delâtre (1822–1907), who printed Whistler's French Set was the greatest exponent of retroussage, and the most virtuosic etcher using this method was Lodovic Lepic (1839–89). The practice of retroussage divided the etching community (see the response to Whistler's etchings, page 86).
A variation on the principle of the monotype being used at this time by Degas.

Notably a vivid portrait of Whistler by Charles Corwin now in the Metropolitan Museum of Art, New York (repr. Lochnan, pl. 245).

Whistler knew of this Bachertyping and had seen many of the results. When he arrived in England, he met one of the women who had some of the best of them. I believe Whistler saw in their beauty the possibilities of their further use as a tonal form in the printing of etchings, for the Venetian etchings which were printed at this time reveal a more definite use of this form of printing. Some writers have recognized his adoption of tonal form at this time, and have called it a new scientific truth in the Whistler art of printing. This can hardly be true, for I am sure similar effects will be found in the works of any good etcher, these effects being a result of working with the press.

In *The Garden*, *The Balcony*, *Two Doorways*, *Door and Vine*, *The Beggars*, *The Doorway* and *Furnace Nocturne*, it was necessary to rebite certain passages. In order to do this, a new surface was required; and to get it, the copper was bulged out from the back by the aid of a hammer and anvil. On these plates they were used only to punch out a small part of the copper-plate from the back, which was done by placing the plate face downward on the anvil and then striking with the small part of the

K. 210, 207, 193, 196, 194, 213.

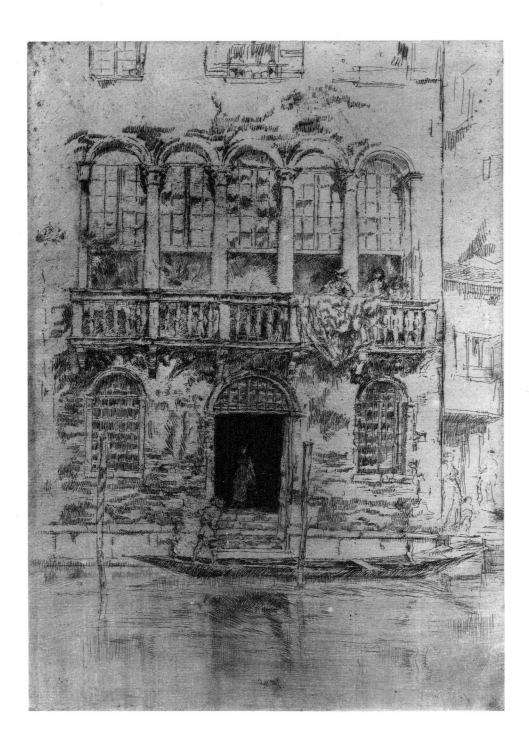

The Balcony, K.207(xii). 1880. Etching, 11⅝ × 7⅞″ (29.6 × 20.1 cm). Hunterian Art Gallery, Glasgow University (Birnie Philip Bequest).

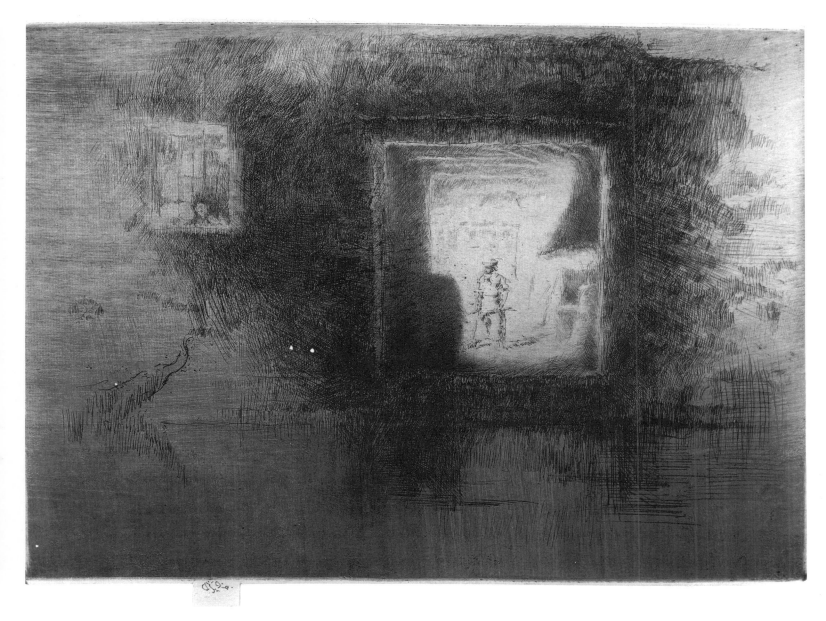

Nocturne: Furnace, K.213(vi).
1880. Etching, 6⅝ × 9⅛″
(16.8 × 23.2 cm). Hunterian Art
Gallery, Glasgow University.

hammer the spot to be erased. The stroke bulged out, face downward, the spot to be ground down; after which it was necessary to cut away old lines, reburnish the surface, recoat the plate, etch and rebite until complete.

Whistler promised to leave the anvil and hammer for me at the Café Florian, where I could call for it when I should come back to Venice the next spring. On my return, I found it there wrapped in a chamois bag to keep it from rusting.

While in Venice, Whistler printed many of his etchings on old Venetian paper which took the ink remarkably well because of its matured, glue sizing. In order to procure this particular kind, he wandered among the old, musty, second-hand book-shops, buying all the old books that had a few blank pages which he cut out for his printing.

One day after he had gathered a dozen sheets or more in this manner, he pointed them out to me saying, "Now, Bacher, if you are a good boy, Whistler may give you a few sheets upon which to print your etchings."

"I should be very glad to get them if you care to part with them," I replied.

"You know, Bacher, that they are very rare, and I gather them all over the continent. In London, you would have to pay a shilling a sheet for paper of this kind."

"Why, Jimmie," I replied, "I could go out any time around Venice and bring home a bundle of paper as good as that."

"Where would you go?" he asked. "You cannot find any as fine as this, for I have tried in every old book-store in Venice."

"Never mind. I will find some," I avowed, and at the same time made up my mind that if there was one sheet left in Venice I would find it.

A few days after this incident, on passing an old junk-shop, I noticed a bundle of old paper outside. On examining it, I found that it contained old Venetian paper. Besides having worm-holes as evidence of age, the dealer said, in reply to my question concerning its age: "The man who made this paper has no nose." This form of Italian humour was new to me and he saw at once that I did not understand, so he added, "That means that he has been dead many, many years. The paper is very old."

* * *

During my first visit to Whistler, when he was living near the Frari, it was my good fortune to see all of his works. Some were in oil, many were pastels, and all of his copperplates and proofs were there. Among the latter was the first proof of *The Traghetto*, the most remarkable of all. I was lavish in my praise. At length my exhausted vocabulary left me nothing but that good, homely expression, "Oh, what a bully etching that is! But why, Mr Whistler, do you keep that beautiful print pinned to the wall? It should be mounted and put away in a portfolio."

"Yes, yes," he answered, "I know; but Whistler wishes to keep it always before him to compare it with other proofs. As you seem so much

The Traghetto, No. 1 *(K. 190).*

The Traghetto, No. 2, K.191(iii). 1880. Etching, 9 × 12″ (22.9 × 30.5 cm). Hunterian Art Gallery, Glasgow University (Birnie Philip Bequest).

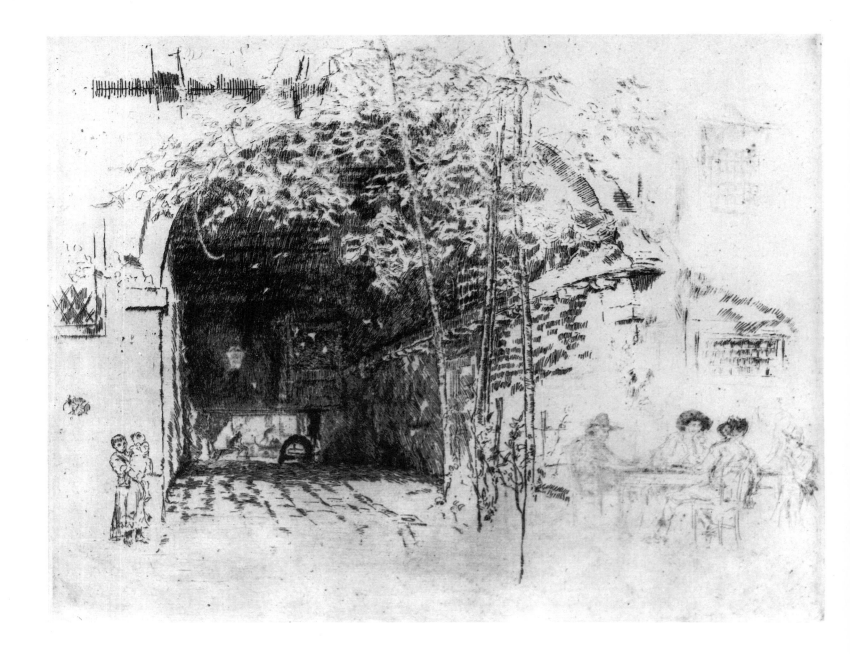

pleased with the first proof, Whistler will let you have a look at a better proof, drawn from the same plate in a later state." As he placed the new print before me he remarked: "I daresay you will notice the vast improvement. This is the second state of the plate."

At the first glance I noticed that he had added many new lines, thereby losing much of the life and charm of the first beautiful proof. By comparing the two prints, it seemed that he was losing his grip on that plate. Divining that I perceived this, a shadow of disappointment crossed his face as he brought me the third proof of the same plate. This last one represented the actual, sad condition of the copperplate as it was then. Horrors! What a shock ran through me! The plate was ruined, irrevocably ruined! I was stunned for a moment, and falteringly questioned him for the reasons that had influenced him to dare to add another line to the finished state of the copperplate which had yielded such a glorious proof as I had before me on the wall.

"I changed it because a duffer – a – duffer – a painter – thought it was incomplete." This was all he said, but he seemed very bitter.

On several occasions, after he had moved to the Casa Jankovitz, he mentioned *The Traghetto* plate. It troubled him very much. He would say: "I wonder how Whistler can get the plate back again like the first proof. Whistler must find some way to do it."

One morning he surprised me by saying: "Whistler has decided to do *The Traghetto* all over again. Now sit down, and he will tell you just how he is going about it. Whistler will take this first copperplate to his Italian coppersmith and have him make a duplicate in size and thickness. You know what beautiful thin plates he makes. Well, this will take a week. When Whistler gets the new one, he will prepare it with his swellest ground, as you know only Whistler can do. Now, listen! This is the interesting part. Whistler will use your press, of course, and will ink the first plate, – not with black printing ink, mind you, – but with white paint from a tube just the same as that with which you paint pictures. Now what do you think of that?"

"Well, I don't know what to think just yet," I said; "but tell me more about it."

"Well, then, when the plate is inked with white tube paint, cleaned and wiped as for ordinary printing, he will run it through the press and pull a proof on Dutch paper. Whistler will take the new plate, already prepared with a fresh black etching ground. Placing the fresh white proof upon this, he will run it through the press under light pressure, otherwise the white paint pressed on a non-absorbent surface will squash out and blur. You must help me, and, if we are successful, the result ought to be a perfect impression, a replica in white upon a black etching ground."

The result was most gratifying. Every detail worked out exactly as planned. The shining, black surface looked fascinating with its myriads of crisp, white lines. The task now was to find and etch only the lines in the original *Traghetto*. Whistler worked for days and days, always with the first beautiful proof before him. Days grew into weeks before he was ready for his favourite nitric acid.

Biting a plate was a serious affair even to Whistler. He usually set aside a day for this trying task, and, as it neared, his gaiety was noticeably affected. During this time was he thinking of his pet theory that "art is the science of the beautiful, and to the master as certain as one and one to the mathematician make two, and two and two make four – and like him the master can add or subtract combinations at will?"

When the day arrived, I found him bending over the copper, which was laid flat on the corner of a common kitchen table. There was no bordering wax around the plate, as books say etchers must have; yet Whistler kept the nitric acid swashing to and fro with a feather, which he handled with exceeding nicety. Much of this time his silence was oppressive, and his face wore a troubled look his "dearest enemies," as he

called them, never saw. He knew acids played rude tricks, in spite of his magic manipulation.

Arriving at the end of this tedious process of biting and of stopping out, he cleaned the etching ground from the plate with turpentine and examined the lines near the light, testing their depth with the long, shapely nail of his forefinger, which seemed made for this purpose. The lines of the new *Traghetto* plate were pleasant to look upon, and the result seemed to satisfy the great modern master of etching. Still, he had not reached the end of his journey; the final proof was yet to be made.

The launching of this great plate was an exciting moment. As the gentle old printer of Venice pulled the plate through the massive wooden rollers, heavily padded with felt blankets, nothing was heard but the squeaking of the old wooden press. It was the supreme moment of joy or of keen disappointment – it was the end of the journey and, fortunately the new proof was exquisite. It was another *Traghetto*, the one we now know; but it was not a duplicate of that marvellous first proof.

Whistler placed the two proofs side by side, and minutely compared them. When he came to a variation, he broke the silence, saying, "This bit came nicely, didn't it?" or "I wonder why the acid did not take hold here. See how well it is bitten over there. Whistler may have to do some dry-point work on this place, and possibly a little biting here, and there." Altogether, he seemed pleased, and I was certain of it when I heard his unmistakable and positive sign of satisfaction – the half-humming of his one and only song, his jubilant

> "We don't want to fight,
> But, by jingo! if we do,
> We've got the ships,
> We've got the men,
> And got the money too! oo-oo!"

HARRY QUILTER

THE TIMES

"Mr Whistler's Etchings of Venice"

25 December 1880

The art critic and painter Harry Quilter (1851–1907) first earned Whistler's enduring scorn for an article, supportive of Ruskin, which he wrote for the Spectator; *this was compounded by his purchase of, and alterations to, The White House (see page 125). After briefly succeeding Tom Taylor (see page 59) as* Times *art critic in 1880 Whistler relentlessly pursued "'Arry," as he called him, particularly in* The World, *where he published, with appropriately scathing commentary, Quilter's unsuccessful letter of application to become Slade Professor of Fine Art at Cambridge (see* The Gentle Art of Making Enemies *1892). This review of Whistler's exhibition at the Fine Art Society is of particular interest because Quilter met Whistler in Venice.*

In no department of art so much as in that of etching do we instantaneously recognize the difference between work which, however perfect in its technical portion, is in the main mechanical and uninteresting and that which seizes firmly, though it may be imperfectly, a true artistic idea. Indeed, in etching the idea is the real reason for the work existing; it is because of the capabilities of the etching-needle and the copperplate for translating with a rough fidelity an artist's momentary impression that the value of etchings is so great. And it is in this respect that the art differs so much from that of engraving. What may be fairly demanded from any painter who attempts to etch is that his work should contain a definite artistic impression, that the scene or incident which his plate records should have, besides its own intrinsic beauty of detail, the trace of the worker's own personality. It might almost be said that, whereas the chief merit of painting is to record things as they are in their most beautiful form, so the function of etching is to record things as they are not, save for some fleeting moment in the mind of the artist – that under a certain phase of mind and character any given object, landscape or action looked thus and thus only; that, for instance, one who went to Rome saw little in the

Colosseum, but much in the group of children which happened to be playing under the shadow of one of its ruined archways; that a traveller in Venice was impressed by its poverty, though he scarcely felt its beauty; any evidence, in fact, which can be gained from the proof of its having been executed under the pressure of one dominant thought, no matter how partial and even defective that thought may have been – this it is which identifies the work as true etching. Mr Whistler's present works do not represent the Venice of the poets and novelists, still less the Venice that most of us have learnt to love and look for through Mr Ruskin's teaching, but they are essentially Mr Whistler's Venice – an Italian city, that is, viewed by a modern American, whose charm consists in the continual opportunities which canal, lagoon and palace afford for presenting in the most forcible manner the contrasts of past greatness and present degradation. There has not been in our recollection any series of works published illustrative of Venice which gives the main features of the locality and its life so truly as do these twelve etchings. Still more certain is it that the artistic value of this series is a very high one. The plates may perhaps be divided into two classes – those in which the main effect is dependent upon the pure etched line, and those where it is chiefly produced by the somewhat less legitimate and certain method of printing from an imperfectly cleaned plate, the former of these approximating to the appearance of a woodcut, the latter to that of a mezzotint. As an example of the former, the one entitled *The Little Venice* leaves scarcely anything to be desired, its very simplicity being delightful. Something of the large grasp with which Turner used to treat the slow flow of a still current is visible in the expanses of placid water which Mr Whistler shows us in this etching and in that of the Riva degli Schiavoni, the latter of which, with its huddled gondolas and fishing boats, its irregular line of houses and its scores of figures, is probably the most genuine and satisfactory piece of pure etching in the exhibition. As might be expected, Mr Whistler's talent, great as it is, occasionally fails him where he takes a subject whose beauty is alien to his sympathies – as, for instance, in the etching entitled *The*

Arrangement for Exhibition of Whistler's first Venice Set of Etchings. c. 1880. Pencil, 4½ × 7″ (11.3 × 17.7 cm). Davison Art Center, Wesleyan University, Middletown, Connecticut (given by George W. Davison).

K. 183.

K. 192. The distinction Quilter makes between "pure line" and "artistic printing" was part of an ongoing debate about the nature of etching; significantly Quilter chose to favour "pure line" etching.

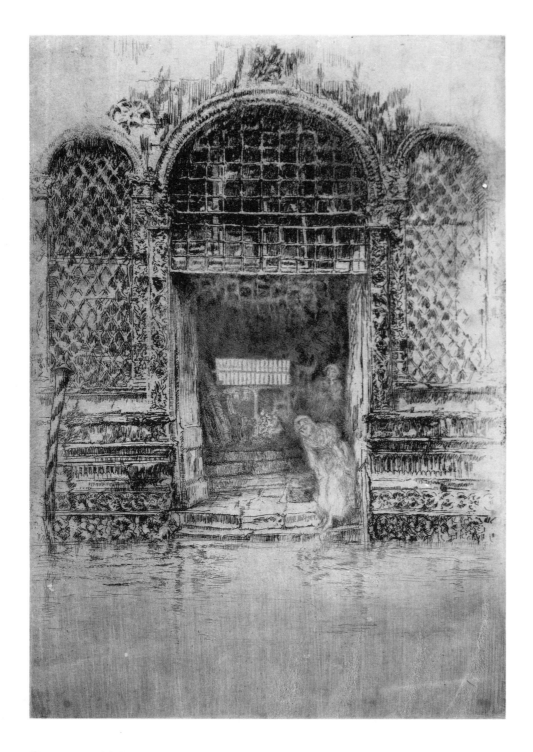

The Doorway, K.188(vi). 1880.
Etching, 11½ × 8″ (29.1 × 20 cm).
Hunterian Art Gallery, Glasgow
University (Birnie Philip
Bequest).

Doorway, which is a rather elaborate study of the ground, or rather water floor of one of the most beautiful palaces to be found in the back canal of Venice. This palace, which is now turned into a sort of Venetian Pantechnicon, is noticeable for having the lower courses of its architecture very boldly and beautifully carved in Byzantine work, and, immediately above these, having round its door and long windows pilasters of the Renaissance period, very delicately and richly carved in low relief. In no other building at Venice with which we are acquainted are the two styles brought into such clear contrast, and it is wonderful to see how, so far from destroying one another's beauty, the result is rather of the reverse kind. This at least in the original; in the etching we doubt whether many people would notice the contrast or realize the extreme beauty of the sculpture. The perfectly accurate curvature and elegant fancy of the Renaissance work is lost in the somewhat unsympathetic scratches with which Mr Whistler has delineated the carving, and in like manner the solidity and richness of light and shade in the lower panels have also disappeared. The result is a very picturesque doorway, set in a rich frame and delightful as a

K. 188. Quilter relates in his autobiography Opinions *(1909) how he and Whistler shared a gondola so that each could draw and etch the doorway. At the private view Quilter described Whistler's etching to him as "all wrong," defending his own Ruskinian method of study, at the same time privately believing it to be "a little masterpiece."*

picture; but what we admire in the etching is not what we should admire in the original, and one feels a little vexed at being taken to such a splendid piece of architecture and then being practically told only to look at how nicely the light and shade fall upon the chairs and tables and lounging girl which we see through the open door.

Perhaps the finest of all these works is the one entitled *The Two Doorways*, which represents a corner in one of the small canals. In this Mr Whistler has given us a perfectly intelligible and, as far as it goes, perfectly accurate account of the street architecture of Venice; he has given also an etching of singular purity, the effect scarcely at all dependent upon anything but actual work executed with the etching-needle, and portions of which are as fine in light and shade as could be desired – witness, as an example of this, the doorway on the left, in which is the hanging-lamp. The quality of these etchings taken as a whole, which will most surprise the outside public, who are accustomed to think of Mr Whistler chiefly through the somewhat indefinite pictures in oil which he has exhibited of late years, will be the excessive skill of the drawing, even where it is most free. Look, for instance of this, at the windows and the moored gondolas in the etching entitled *The Palaces* and at the drawing of the details of grated windows and shattered masonry which occur over and over again in this series. The quality which attracts us the most, and which is the one that in our opinion separates the series from others of like kind, is the thorough vivacity and individuality of the work. It does not feel much, but it sees everything, and what it does not feel to that it does not pretend. Such as it is, the work, besides being skilful, is undoubtedly genuine and original, and this sufficiently accounts for its charm as well as expresses its merit.

K. 193.

K. 187.

San Biagio, K.197. 1880. Etching, 8¼ × 12″ (21.6 × 30.5 cm). Hunterian Art Gallery, Glasgow University.

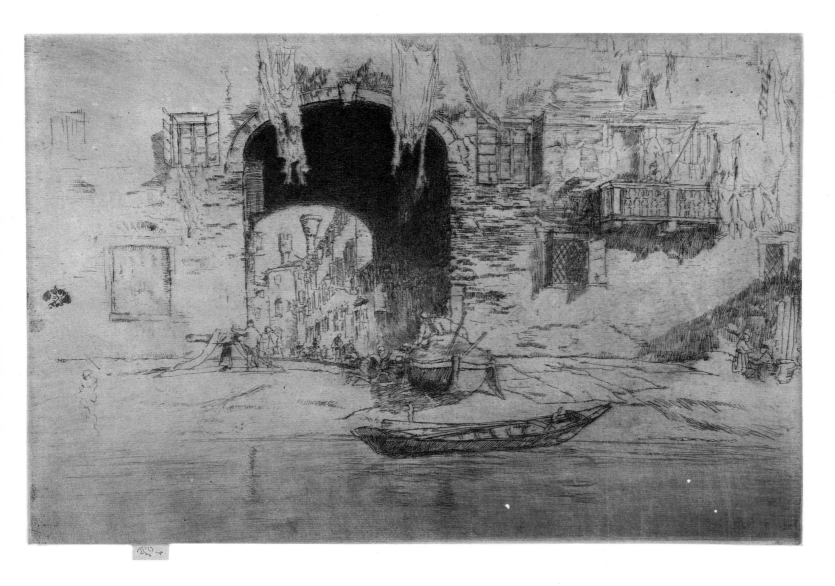

THE OBSERVER

"Venice Pastels"

6 February 1881

Mr Whistler is an artist of great talent and of still greater eccentricity. If not the inventor, he has, at least, been the popularizer of those ingenious though tricky effects of colour in which suggestiveness is made to do duty for representation, and to which musical names, such as symphony and nocturne, have been somewhat affectedly allotted. This nomenclature, specially dear to the school in which vague analogical sentimentalities are substituted for intelligent analysis, is to us universally distasteful; but the paintings with which it has been chiefly associated have not unfrequently been delightful and accurate memoranda, although sometimes, it must be admitted, they have been quite astonishing in their attainment of unreality. Mr Whistler has, however, been altogether too hardly dealt with for his aberrations, and cannot but have suffered much both from the preposterous admiration of his friends, and from the outrageous hostility of his detractors. We are glad, therefore, to welcome his reappearance as an exhibitor of an interesting set of pastels, the fruit, apparently, of a winter and autumn spent in the capital of the Doges. We confess to no special liking for the medium he has adopted. Great as is the dexterity with which he manipulates the pastel, the surfaces of the dry colour seem to us almost invariably too rough for effects of transparent light, while the heavy crayon line has a knack of forcing attention to the method when it ought to be wholly devoted to the production. Venice in her beauty never has been, and probably never will be, adequately painted, but there is a sombre and almost prosaic side of her – the rare wintry effects, the gloom of deepening nights and shortening days which Mr Whistler seems to have found congenial. Working in pastel mostly on brown or reddish paper, he has obtained a prevalent tone that is never thin but not unfrequently depressing. It is, moreover, mostly purchased by the loss of light and transparency. In colour of a different kind he has, however, some remarkable successes, amongst which we should be tempted to give the prize to *The Riva*. It is a somewhat lurid but magnificent sunset, and the little waves of the lagoon are glowing, though somewhat sullenly, with red and blue and orange fires. Nothing can be more dexterous than the way in which the dimpled sea is rendered by a few broad lines. Another scene similar in character is *The Storm-Sunset*. Here the clouds are even more striking in colour, and a certain luminousness missing in *The Riva* is attained, though not without some sacrifice of truthfulness. More pleasing, if less striking as a picture of declining day is *Sunset – the Gondolier*, a view taken from the Eastern end of the Riva dei Schiavoni. This is worth looking at, although the gondolier is strangely like a Neapolitan. The later evening pictures are not so satisfactory, Venetian mist and English fog being in several instances insufficiently differentiated. There are, however, some excellent scraps of architectural drawing, in some of which are charming glimpses of distant streets and *campi*, while the splashes of colour made by the gaudy garments which commonly hang from the windows of the Venetian poor are generally turned to admirable account. Of these *The Bridge*, and *Bead Stringers* are good examples. Near the latter is a drawing of a market boat, in which, despite the characteristic ugliness of the black and yellow sails, Mr Whistler is very happy, particularly in the colour of the water, while a few interiors, such as *The Red Doorway*, serve as good specimens of the artist's deft draughtsmanship. The salient defect in these very clever pictures is the excess of brown and sombre tones, so that a stranger to Venice, taking Mr Whistler as his guide, might well suppose

Whistler's second exhibition at the Fine Art Society opened on 29 January 1881 and consisted of 53 Venice pastels and the twelve etchings of Venice previously shown. Whistler designed a catalogue with brown paper covers as well as the colour scheme of the gallery, in an arrangement of brown, gold and Venetian red.

COLOURPLATE 58

COLOURPLATE 60

that brown skies, occasionally patched with blue, were normal in the home of Titian and Giorgione. Of real Venetian splendour, its golden hazes and dappled flashing peacock-hued seas, and its intensely luminous sky, seen between quaint Gentile Bellini chimney-pots, there is little or no trace in these pastels. The best of the attempts to depict this aerial beauty is, perhaps, to be found in *The Little Riva*, which has the true opaline colour and the true luminous delicacy, and this the artist has endeavoured to accentuate by placing his anagram, a spot of flat red colour, in a prominent and aggressive position. There is also a sketch on grey paper, a very truthful, though not characteristic, picture of the Giudecca; in the foreground the blurred outline of a gondola and its reflection, with the shadowy Redentore in the distance. Perhaps the most agreeable pastel for a permanent possession would be *The Cemetery*. The idea of the scene, the island loved of poets and painters, the cool white walls and green foliage, is admirably caught, although here, too, justice is not done to sky and sea. Clever as the colouring in these pictures often is and invariably excellent as is the drawing, we cannot but wish that Mr Whistler would devote himself more to those labours of the etcher in which he first gained a high place in art. His sense of colour never, indeed, wholly fails him, but his

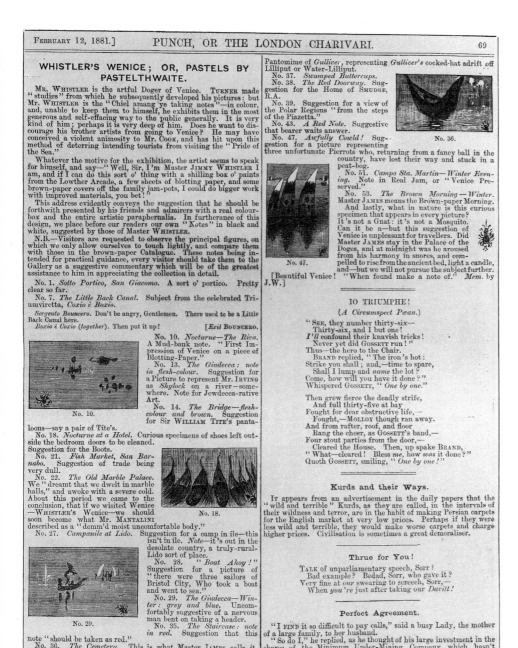

Harry Furniss, "Whistler's Wenice; or, Pastels by Pastelthwaite." *Punch*, 12 February 1881, p. 69. Framed and hung by Whistler in his 1883 Exhibition of Venice Etchings.

feeling for black and white never fails him at all. One has but to turn to the few examples (not catalogued) which adorn the east end of the room to see how really admirable is the latest work of his needle. Nothing can be more agreeable, for instance, than his etching of a view of the lagoon to the left of the door; the labour is quite trifling, but every line and every untouched surface tells of complete mastery of the method and complete appreciation of the end to be attained. Another fine plate, in a somewhat different style, is called, we believe, *The Two Doorways*, a view in one of the larger side canals. The works we have described are seen under most favourable conditions in the room of the Fine Art Society, which has been decorated for the present exhibition under the artist's personal supervision, an olive-coloured baize being carried high above the pictures, while the upper walls are toned to a dull Venetian red. It is the same room where that famous collection of Turner's water-colours were displayed to which Mr Ruskin furnished a characteristic and pungent commentary. The association of ideas is curious.

The exhibition Mr Ruskin's Drawings by the late J. M. W. Turner, R.A., and His Own Handiwork illustrative of Turner, with his Notes *had been held at the Fine Art Society in spring 1878.*

MRS JULIAN HAWTHORNE

HARPER'S BAZAAR

"Mr Whistler's New Portraits"

15 October 1881

Mrs Julian Hawthorne, first wife of the American novelist Julian Hawthorne (1846–1934).

Mr Whistler has lately been at work on two portraits, both of them female subjects, and treated with more than his usual subtlety and skill. We found the artist in his studio – a lofty room nearly bare of furniture, but looking like a place meant to work in. The canvases were set up at the further end of the apartment, the spectators – upward of twenty were present – being collected at the other end; for Mr Whistler's portraits require distance in order to their proper appreciation. On the left was a small four-legged table made of polished mahogany, finely wrought, and fitted on the top with a sloping desk-like surface between two narrow compartments. This is the artist's palette; he mixes his tints on the sloping surface, and keeps the tubes of colours in the compartments. The brushes he uses are for the most part larger than are generally employed by artists, and his method of work is in many respects original, as are the results he produces by it. The artist himself was on this occasion attired in his working costume, which consists in the removal of coat and waistcoat, and the revelation of a fine white shirt. With his swarthy brilliant face and jetty curling hair contrasting with his spotless cambric, Mr Whistler might be considered a masterly arrangement in black and white in his own person. And this may have been a bit of artistic harmony on his part, the principal one of the portraits on exhibition, or that one of them which alone he wished to be considered finished, being also a study in black and white of the purest kind. You see the full-length life-size figure of a beautiful woman, who stands nearly facing you, in a pose which is wonderful for ease and character. She is dressed in a flowing black robe, broadly trimmed with soft white fur or swan's down. The arms and neck are bare; the features, though only indicated, are full of individuality and expression. The background is wholly black, yet it appears not as a black surface, but as a mellow depth of darkness. How Mr Whistler contrives to give an effect of softness and harmony to a subject which in any other hands would appear hard and crude is a mystery known only to himself. He may be criticized for not working on a different principle, for not finishing his work

On his return from Venice, Whistler leased a studio and flat at 13 Tite Street opposite the house occupied by Oscar Wilde with whom he then became friendly (see page 228). He had been commissioned to paint three portraits of Lady Meux (1856–1910), the wife of the London brewer Sir Henry B. Meux. Two of them are described here: Arrangement in Black: Lady Meux *YMSM 228, which was shown at the Paris* Salon *of 1882 (see Colourplate 48); and the* Portrait of Lady Meux in Furs *(YMSM 230) which Whistler probably destroyed. Charles Brookfield, who first suggested to Whistler that he should paint Lady Meux, later drew a caricature of Whistler painting the three portraits at once (see opposite).*

in the manner of other artists, but from the point of view of his own artistic conception he is above criticism. What he does, no other man can do. In delicacy and truth of tone he has probably never been equalled. He apprehends colour in all its shades and relations with a kind of inevitable instinct; and though he is never neglectful of form, and can draw the human figure with a liveliness and accuracy that leave little to be desired, he appears to care for that department of art only in so far as it may conduce to the most effective presentation of colour. His portraits, and his work generally, suggest objects as they would appear to a near-sighted man with an unerring perception of colour. There is a mistiness about them, a vagueness, a mystery, but the longer you look at them, the stronger is the charm they reveal to you. You feel that the reality in all its details is there, though, as it were, behind a veil. It is, however, almost impossible to express in words the peculiar quality of Mr Whistler's pictures. Like all works of genius, their language is their own, and untranslatable. They remain in the memory as few other pictures do; they are the lyrics of pictorial art.

The other portrait, apparently of the same subject, was treated in a subdued tone of brown and brownish-red. The pose is somewhat as before, but the figure is enveloped in a long brown fur cloak reaching nearly to the feet. In its present unfinished state the artist deprecated criticism; but though the scheme of colour is less striking than in the former work, the management is quite as masterly. In both portraits you get a strong impression that a real human being stands before you – not a type nor a generalization, but a particular and distinct human person. That this impression should be wrought by work so defiantly unelaborate in detail and broad in treatment is another indication of the workman's curious genius. But nobody is more human than Mr Whistler.

The walls of the studio were coloured a sort of grey flesh-tint – a singularly cold and unsympathetic hue, but, according to Mr Whistler's idea, all the better adapted on that account for a studio, which, as he remarked, should not be itself a picture, but a place to make and exhibit pictures in. "Now my other rooms, they are pictures in themselves," added the artist, and we were allowed to inspect two or three of them. Pictures they were indeed, and exquisitely delicate and effective ones. Shades of yellow were present in all of them; in one room there was no other colour besides yellow. But it would be impossible to describe the subtle variations which had been played upon it; how the mouldings, the ceiling, the mantelpiece, the curtains, and the matting on the floor enhanced and

Whistler's approach to home decoration became especially influential, particularly after Oscar Wilde described Whistler's decorative schemes in lectures both in Britain and America in 1882.

Charles Brookfield, *Lady Meux Triplex*. Caricature of Whistler painting the three portraits of Lady Meux at once. *The Graphic*, 25 March 1911, p. 426.

beautified the general harmony. In the dining-room the mass of colour was a strangely vigorous blue-green, the precise counterpart of which we do not remember to have met with. This was picked out with yellow in the mouldings, cornice, etc., with a result extremely satisfactory and charming. All the decoration was entirely free from anything in the way of pattern or diaper; the colour was laid smoothly and broadly on the hard-finished plaster, and the effect depended solely upon the contrast and disposition of the tints. Such a method would fail in ninety-nine cases out of a hundred, for the least mistake in the selection or placing of a colour would spoil all; but Mr Whistler has done his work for himself, and it is faultlessly done. We venture to say that the exhibition of this house of his in some generally accessible centre of civilization would do more to refine the public conception of decoration than all the examples, lectures and books of which the modern decorative clique is just now so prolific.

THÉODORE DURET

GAZETTE DES BEAUX-ARTS

"English Artists – James Whistler"

March 1881

Théodore Duret (1838–1927), art critic and friend of the Impressionists, was introduced to Whistler by Manet in 1880. He owned paintings by Whistler and published a monograph (1904) and several influential articles on him, of which this, the first, marked Whistler's re-emergence as a major figure on the Parisian art scene.

Mr James Whistler is classed among English artists although, born in Baltimore, he is American in origin. Having come with his family to Europe at a young age, he did his artistic studies in Paris. In 1856 he was attending Gleyre's studio. Leaving the master's studio and given over to his own devices, he sent canvases, which were rejected by the jury, to the Salons of 1859 and 1860. In 1863 the jury rejected him once more, this time with an important work, the *Woman in White* which, exhibited at the Salon des Refusés, caused a sensation among the artists. In the interim Mr Whistler had left Paris to settle in London. The pictures he sent to English exhibitions made his name known, and when in 1865 he once again sent an important work to the Parisian Salon, *La Princesse des Pays de la Porcelaine* [The Princess from the Land of Porcelain], it was accepted without any hesitation, and hung on the line. In 1867 he exhibited one of his finest works at the Salon, a family scene, *At the Piano*.

Indifferent to his natal city Whistler alternatively cited, not Lowell, Massachusetts, but Boston, St. Petersburg or Baltimore as the place of his birth.

COLOURPLATE 9 *(YMSM 38)*.

COLOURPLATE 16 *(YMSM 50)*.

COLOURPLATE 13 *(YMSM 24)*.

Mr Whistler had devoted himself to etching at the same time as to painting, and he never ceased cultivating the two arts simultaneously. His first etchings date from 1858. They are French subjects printed in Paris, by Delâtre, including a series of views and figure studies. When he went to England, he began a series of English subjects, mainly views of the Thames. Intermingled with the views and landscapes were a large number of portraits, both English and French, etchings and dry-points.

Auguste Delâtre (see page 167).

In 1874, in London, Mr Whistler exhibited two canvases which occupy a considerable place in his *oeuvre*, *The Artist's Mother* and *Thomas Carlyle*. One might imagine that it is very difficult, in portraits, to find poses, and an arrangement, which have anything new about them; yet this is what Mr Whistler has achieved. He has painted his models life-size, in profile and seated. His mother has her feet resting on a stool, her hands crossed on her knee; on the canvas, she looks intensely life-like. Carlyle is seen in an almost identical pose, except that his face is slightly turned towards the viewer while a coat, casually thrown over his knees, drapes the lower part of his body.

COLOURPLATES 30 and 38 *(YMSM 101 and 137)*.

Now we must consider the particular features which distinguish the painting of Mr Whistler and which constitute its great originality.

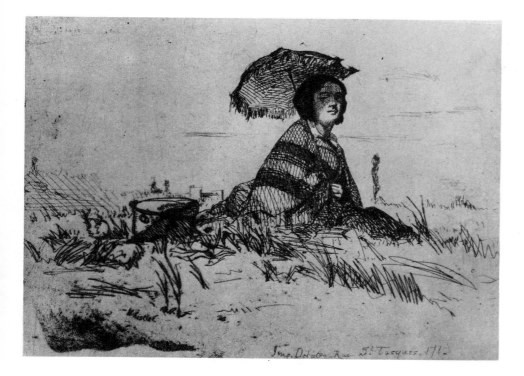

In the Sunshine, K.15(ii). 1858.
Etching, 3⅞ × 5¼″
(10.1 × 13.3 cm). Hunterian Art
Gallery, Glasgow University.

When, in 1863, the painting called *The Woman in White* was exhibited at the Refusés, artists had been struck by its range of colouring; the full-length figure of the woman stood out against a white curtain covering the whole background of the canvas. This was the work of a born painter, gifted with a vision absolutely his own. The picture thus had a figure as its subject and, at the same time, a combination of white tones that one might call an arrangement in white. There was no statement to this effect, as yet no subtitle or special designation drawing attention to the colour combination. But, as the artist proceeds to paint, reflection and judgement on his work develop too, and as combinations of tones similar to those found in the *Woman in White* recur in his other paintings, he was to add a subtitle serving to draw attention to them. Thus he says: *Portrait of the Artist's Mother: Arrangement in grey and black. Portrait of Carlyle: Arrangement in grey and black.* And indeed, in these two paintings, figures and background are painted in a combined range made up of greys and blacks.

As long as Mr Whistler paints large figures, it is unlikely for these figures to fade away into the colour combination and for the titles of the works not to derive from them. But here he is painting a decorative scheme where there are no longer human figures, where the only motif is the rainbow-coloured plumage of a bird, the peacock; so the combination of tones gives the work its title, moving into the forefront and putting the actual motif into second place. Mr Whistler designates his work:

<div style="text-align:center">

"HARMONY IN BLUE AND GOLD.

THE PEACOCK ROOM."

</div>

Then he adds in explanation: "The peacock is used to effect the desired arrangement of colours."

This peacock room is in London, in Prince's Gate. It is the dining-room of a town house occupied by Mr Leyland. The decoration on the ceiling and walls of the apartment is made up of two motifs, one borrowed from the tail feathers of the peacock, the other from its breast feathers, finer and differently iridescent. The two motifs are combined and alternated to give the design variety. At the same time, to give the colours the variety inherent in the design, the motifs are painted sometimes in gold on a blue background, sometimes in blue on gold. At one of the ends of the room, on the blue end wall, the artist has painted two large gold peacocks

In 1863 Fantin-Latour had written to Whistler describing the admiration of Manet, Bracquemond and Courbet, for The White Girl.

COLOURPLATES 63–65 *(YMSM 178). See pages 120–121.*

which seem to be challenging one another and urging each other to a fight; on the woodwork of the closed shutters, as a balance and contrast, he has painted a series in blue on a gold background. This decoration, entirely in blue and gold, is a feast for the eyes.

Thus, through the importance he attaches to colour combinations, Mr Whistler has come to give the particular colour arrangement as the main title to certain of his works, with the subject as a subtitle. He has gone further. He has actually gone as far as doing away with any kind of title at all other than that taken from the arrangement of the colours. In 1874 in Pall Mall, in London, he had an exhibition of a selection of his paintings and engraved works. In the catalogue certain pictures are referred to simply as *Harmony in grey and peach. – Symphony in blue and rose. – Variations in blue and green.* Nevertheless, these pictures still include figures, or are seascapes, and landscapes lit by the light of day, and the eye comes to rest on perceptible forms and easily perceives things other than an arrangement of tones. So that, in order to experience Mr Whistler's work at its extreme and most recent, one must take what he calls his "nocturnes". He has done many such: *Nocturne in black and gold. – Nocturne in blue and gold. – Nocturne in silver and blue.* Repeating the same effects with variations, he has happened to paint several nocturnes in an identical combination of colours and, to distinguish them, he has referred to them simply by numbers, calling them: *Nocturne in blue and gold, no. 1 – Nocturne in blue and gold no. 2.*

Mr Whistler's *Nocturnes*, as their name implies, depict the effects of night. Let us take the lightest one, the one in blue and silver. Let us place ourselves ten steps away from it and look at it carefully. The impression that the artist wants to set down on the canvas is that of moonlight on a fine night. As his subject he has chosen a river and its banks, because after all he does need a subject to carry his colour; but the subject is not there for itself, it has no importance in itself, so that the banks of the river can barely be distinguished, enveloped as they are in the nocturnal effect which is the real subject of the painting. And what is called upon to inform the eye of the effect that the painting wishes to render, is neither lines nor contours, but the general range of silvery-blue tones which, with reflections of light and shade, cover the entire canvas. In a word, in this nocturne, there are only two things without contours and without finished forms, yet utterly distinguishable, and which even succeed in producing a powerful impression, of air and a range of delicate and vibrant tones. In his nocturnes, by drawing the extreme consequences from the harmonic combinations of colours which had appeared instinctively in his first works, Mr Whistler has thus arrived at the outermost margins of formalized painting. One step more and there would be nothing on the canvas except a formless blob, incapable of imparting anything to the eye and mind. Mr Whistler's nocturnes put one in mind of those snatches of Wagnerian music where the harmonic sound, isolated from all melodic design and marked cadence, remains as a sort of abstraction and gives only an indefinite musical impression.

In 1878 Mr Whistler sent a series of nocturnes to the exhibition at the Grosvenor Gallery, referred to simply by their colour combinations. One may imagine the bewilderment of the public who, accustomed to turning to the catalogue for explanations of scenes at which they peered closely, found themselves faced with ranges of colour, crying out to be looked at from a distance and aiming to give only a general impression of the transparency and poetry of night. The critics let fly. Mr Ruskin led the pack. He did not restrict himself to ridiculing the paintings, he unleashed a volley of insults upon the painter. Mr Whistler thought they amounted to what English law describes as "libel" and he took Mr Ruskin to court. The case of Whistler versus Ruskin became a *cause célèbre* and all London followed it. The hearing included some richly comic incidents. The judge, lawyers and witnesses, transformed into aestheticians, expounded blindly on art and painting. The jury, who had probably never seen a painting in

Although little reliance can be placed on Whistler's numbering.

It is difficult to identify with certainty which Nocturne in blue and silver Duret is describing; but see Colourplate 41.

In 1893 George Moore was to write of Nocturne: Grey and Silver YMSM 156 *(Colourplate 52), then owned by Duret, "– purple above and below, a shadow in the middle of the picture – a little less and there would be nothing" (see page 292). It was of course 1877, not 1878, when Whistler's nocturnes were first exhibited at the Grosvenor Gallery (see page 132).*

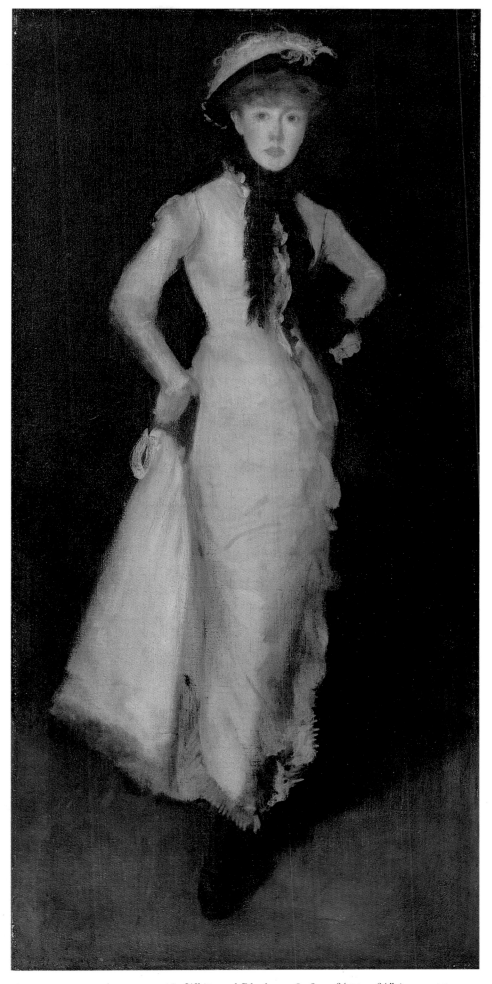

COLOURPLATE 54. *Arrangement in White and Black. c.* 1876. 75⅜ × 35¾″ (191.4 × 90.9 cm).
Freer Gallery of Art, Smithsonian Institution, Washington, D.C.

COLOURPLATE 55. *Nocturne: San Giorgio*. 1880. Chalks on grey-brown paper, 7⅞ × 11¾″
(20.2 × 29.8 cm).
Freer Gallery of Art, Smithsonian Institution, Washington, D.C.

COLOURPLATE 56. *The Steps*. 1880. Chalks on grey-brown paper, 7⅝ × 11¾″ (19.4 × 30.1 cm).
Freer Gallery of Art, Smithsonian Institution, Washington, D.C.

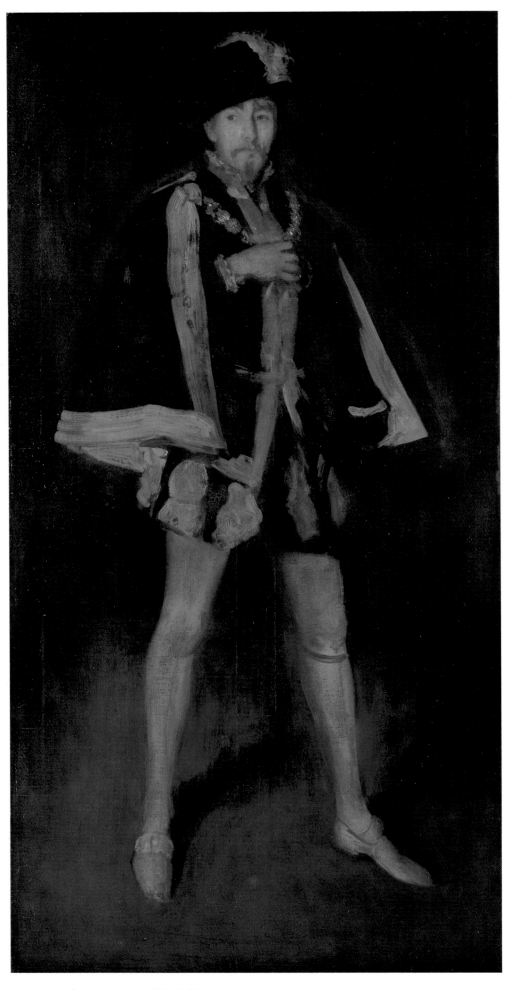

COLOURPLATE 57. *Arrangement in Black, No. 3: Sir Henry Irving as Philip II of Spain.* 1876-85. 84¾ × 42¾″
(215.3 × 108.6 cm).
Metropolitan Museum of Art (Rogers Fund, 1910).

COLOURPLATE 58. *Red and Gold: Salute, Sunset*. 1880. Pastel on brown paper, 8 × 11⅞″ (20.3 × 30.2 cm).
Hunterian Art Gallery, Glasgow University (Birnie Philip Bequest).

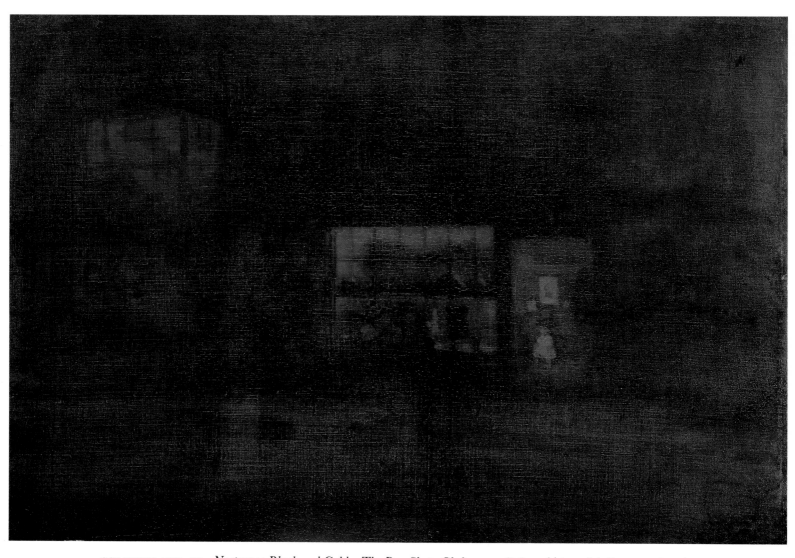

COLOURPLATE 59. *Nocturne: Black and Gold – The Rag Shop, Chelsea. c.* 1878. 14¼ × 20″ (36.2 × 50.8 cm).
Fogg Art Museum, Harvard University, Cambridge, Massachusetts
(Bequest of Grenville L. Winthrop).

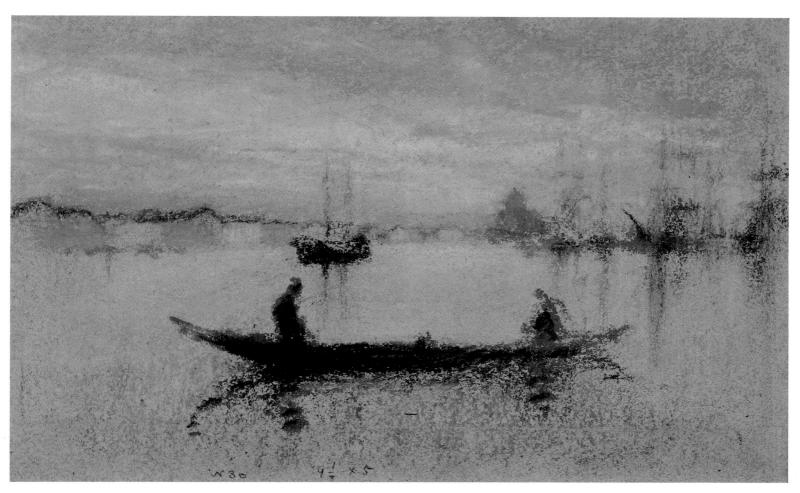

COLOURPLATE 60. *Note in Flesh Colour: The Giudecca.* 1880. Pastel on brown paper, 5 × 9″ (12.7 × 23 cm).
Mead Art Museum, Amherst College, Massachusetts (Gift of George D. Pratt).

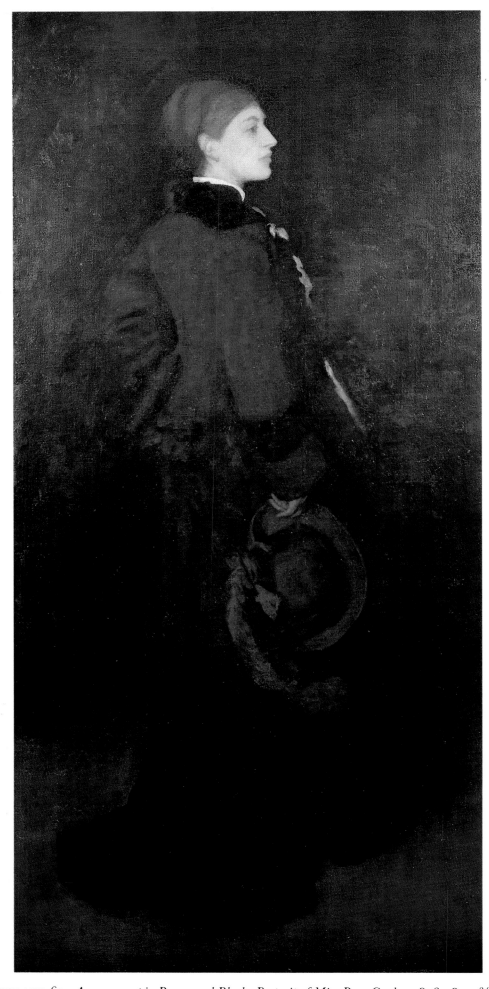

COLOURPLATE 61. *Arrangement in Brown and Black: Portrait of Miss Rosa Corder*. 1876-78. 75¾ × 36⅜″
(192.4 × 92.4 cm).
© The Frick Collection, New York.

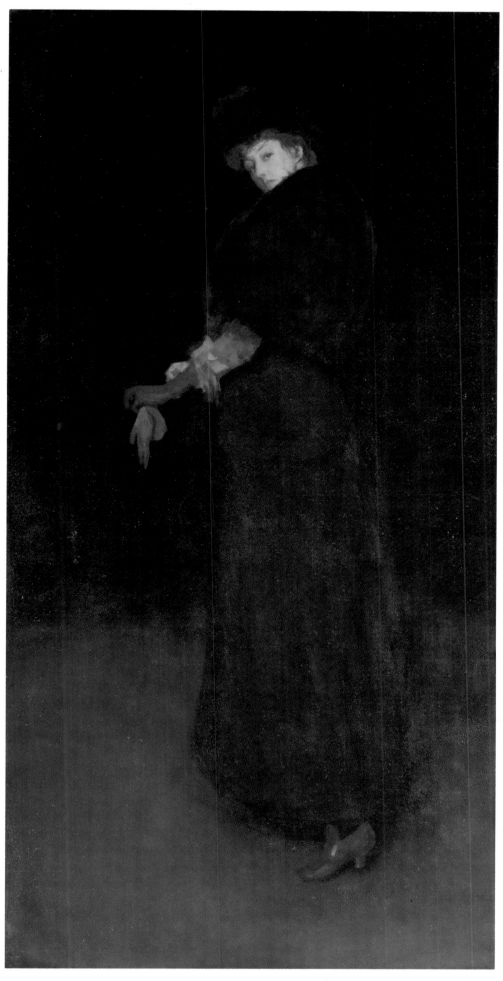

COLOURPLATE 62. *Arrangement in Black: The Lady in the Yellow Buskin – Portrait of Lady Archibald Campbell.*
1882-84. 86 × 43½″ (213.3 × 109.2 cm).
Philadelphia Museum of Art (W.P. Wilstach Collection).

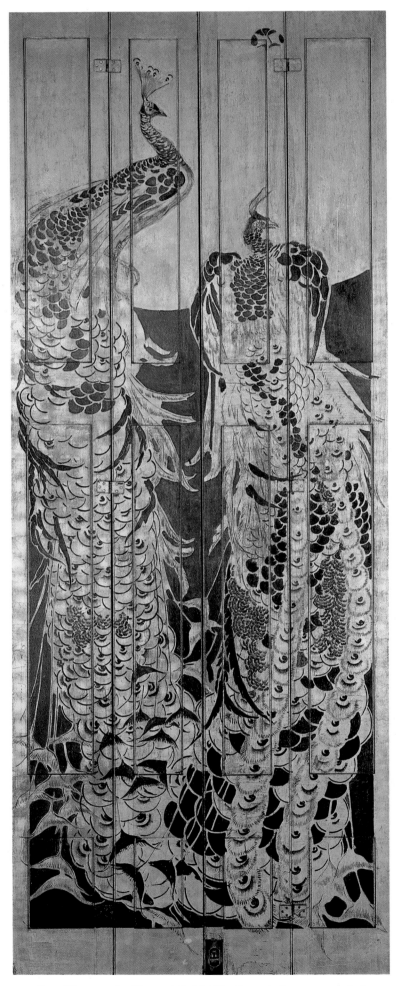

COLOURPLATE 63. *Harmony in Blue and Gold: The Peacock Room*, central shutter. 1876-77.
Freer Gallery of Art, Smithsonian Institution, Washington, D.C.

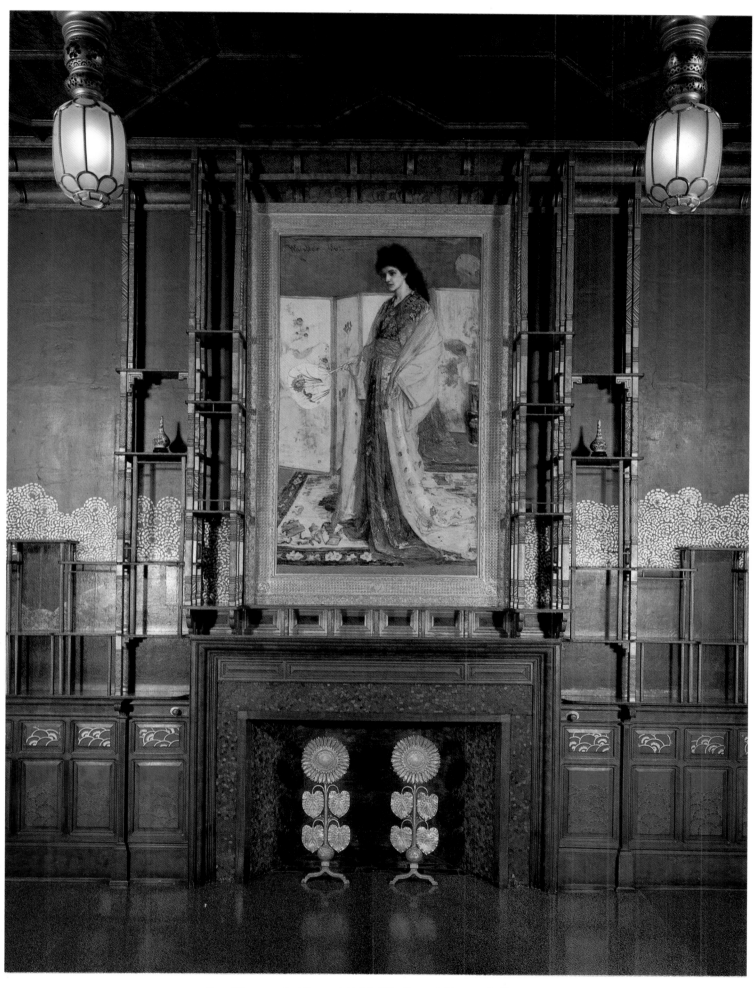

COLOURPLATE 65. *Harmony in Blue and Gold: The Peacock Room.* 1876-77.
Freer Gallery of Art, Smithsonian Institution, Washington, D.C.

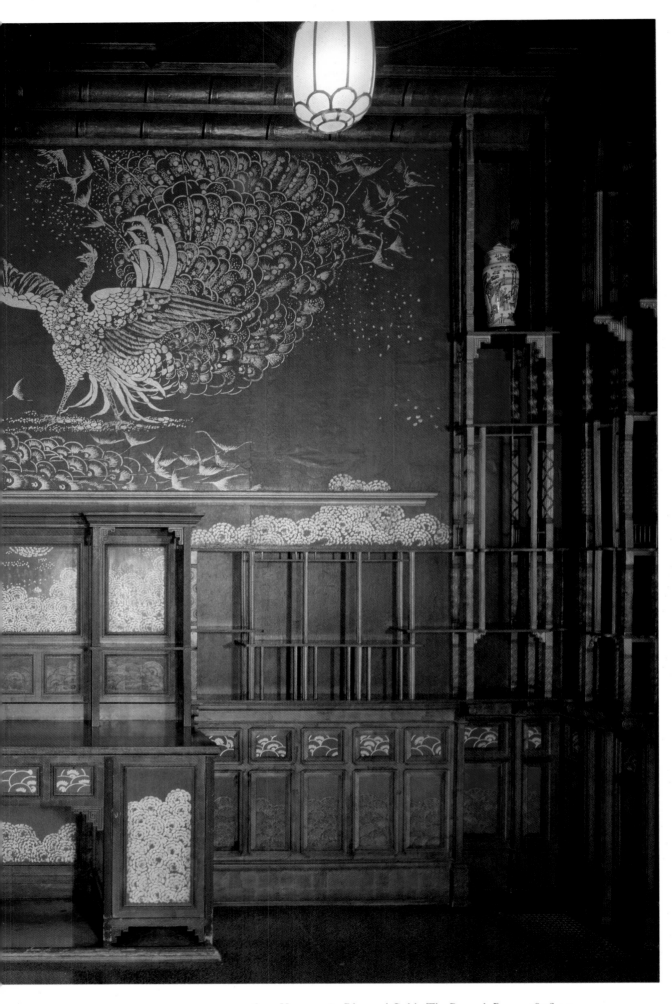

COLOURPLATE 64. *Harmony in Blue and Gold: The Peacock Room.* 1876-77.
Freer Gallery of Art, Smithsonian Institution, Washington, D.C.

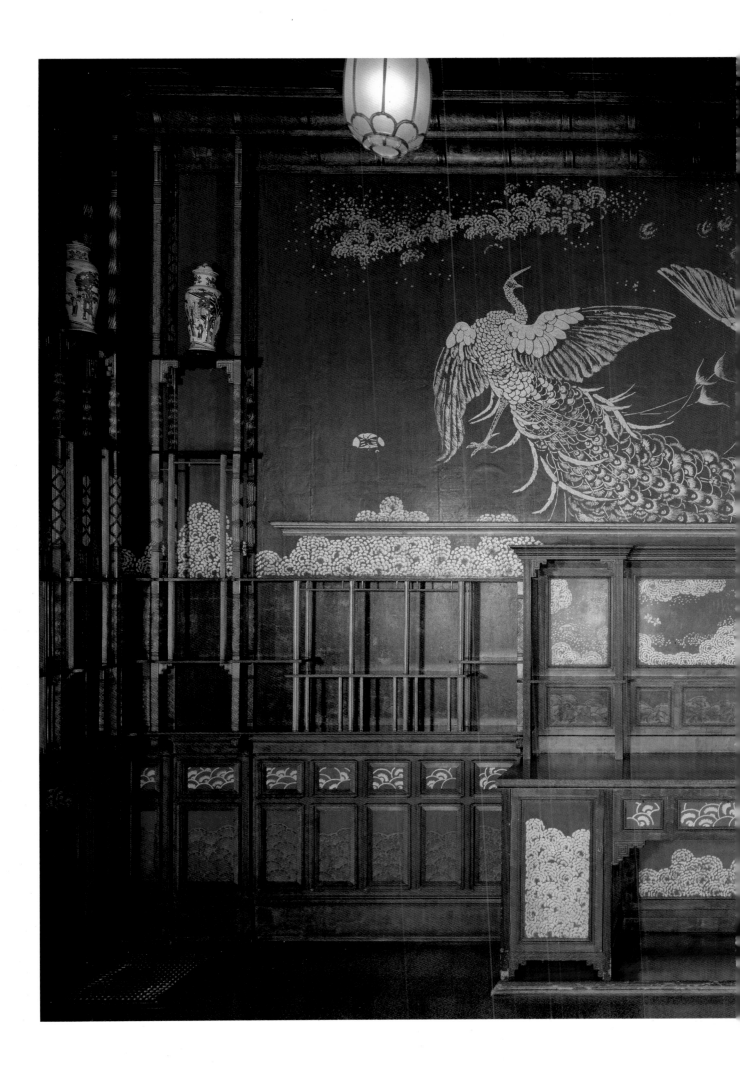

COLOURPLATE 66. *Harmony in Yellow and Gold: The Butterfly Cabinet.* 1877-78. 119¼ × 75″ (303 × 190 cm).
Hunterian Art Gallery, Glasgow University.

their lives, were taken before a Titian and were supposedly given a lightning education in matters of art, so as to be able to pronounce knowledgeably on the nocturnes of Mr Whistler. Furthermore, they acquitted themselves as men of spirit. They recognized Mr Ruskin as guilty of libel, but ordered him to pay one farthing's damages, a clear message to painters and critics to wash their dirty linen in private.

After his trial, Mr Whistler set to work again. He has just brought back to London a series of etchings and pastels of Venice, exhibited at the Fine Art Society in Bond Street. Mr Whistler's etchings are essentially those of a painter. They have that freedom of manner, that unexpected touch that one finds only in the work of artists who wield the point and the paintbrush with equal ease, using all processes indiscriminately to render their vision. In the engraved works of Mr Whistler, the line is supple and light, the figures are alive and striking, the landscape is full of air and depth.

The views Mr Whistler brought back from Venice may even surpass his earlier works in their suppleness of touch and their intimate feeling for nature. I shall choose one that gives us a general view of Venice. A small number of horizontal strokes represent water, and serve to banish the shore, the city and its monuments – simply rendered in the middle of the paper, by a few jagged lines – into an immense distance. Never has anyone attempted to render so much with so little apparent work and such simple means. Yet how this etching captures the impression we recall having had ourselves at the sight of Venice! How well he has caught a water-washed city which, from a distance, looks like an apparition about to sink beneath the waves! The pastels which accompany the etchings offer the eye a range of colours which the engraved work lacks; here the tone and colouring are as delicate and true as the stroke was in the etchings.

JAMES MCNEILL WHISTLER

Letter to Théodore Duret

May 1882

In the original letter the passages printed here in italics are written in French.

See page 180.

My "Arrangement in Black No. 5" has at last gone – and should arrive tomorrow or after tomorrow at Goupils – Goupils you know having representatives here, have taken all the trouble off my hands –
Go my dear Duret rightaway to see in what condition the picture is – I fear all that isn't quite right – for a start I have made the mistake of badly varnishing it the day before it left – and the varnish may have "bloomed" – you understand – so that the picture may have become covered with a sort of nasty thick blue veil – in which case it will want gently rubbing with a soft silk handkerchief – and afterwards when it is hung at the Salon, just before the opening it will want to be well varnished again –

Do ask Goupil to see to all this –
Meanwhile I have written also to Éphrussi, and hope they will both go with you, and that they will like the picture –
The Meux has not paid me yet!! –
I hope to run over to Paris some day soon –
Do like a good fellow write me a long letter and tell me if you are still pleased with your god child – for after all you know it is you who have "fathered" this black "harmony"!

Always devotedly and gratefully yours

[Butterfly signature]

Whistler had dispatched his portrait of Lady Meux, Arrangement in Black YMSM 228 (Colourplate 48), through the firm of Goupils, art dealers, for exhibition in the Paris Salon of 1882.

Charles Éphrussi, French art historian, author of Albert Dürer et ses Dessins *(1882). Whistler originally contracted to paint the three portraits of Lady Meux for 1,500 guineas, but in 1889 agreed to accept 1,200 guineas.*
Whistler's reference to Duret's part in the conception of the portrait is unclear.

13 Tite Street – Chelsea, London

I see there is to be an Exhibition in the Rue de Sèze with Alfred Stevens and De Nittis at the head – Do you think that I might send as representing America? I should very much like to let them have the other picture that you were so well pleased with – I mean the one of Madame in black – with the black hat and red feather – In a certain way you know as execution we were both of opinion that it was a progress and I think the one would appeal to the artists and explain or help the other – Will you ask about all this and let me know?

Of course I hope Manet will go with you and like the picture –

Exposition Internationale de Peinture, Première année, Galerie Georges Petit, 8 rue de Sèze, 1882.

Alfred Stevens (1823–1906), the Belgian portraitist and genre painter, friend of Whistler's; he exhibited with the Society of British Artists (see page 243); Giuseppe de Nittis (1846–84), Italian-born painter of Impressionist subjects; Harmony in Black and Red, YMSM 236 (present whereabouts unknown), a portrait of Maud Franklin, had been shown at the Grosvenor Gallery in 1882. Whistler did not exhibit at the Galerie Georges Petit until the following year (see page 258).

CAMILLE PISSARRO

Letter to his Son Lucien

28 February 1883

Camille Pissarro (1830–1903), Impressionist painter whose eldest son, the artist Lucien Pissarro (1863–1944), worked in England 1883–84, and moved to London in 1890, remained an admirer and perceptive critic of Whistler and his art.

OSNY

My dear son,

So now you are going to wear tails for the first time. It is a good thing you have the clothes. You will have embarrassments enough in an entirely new milieu, with strange customs and ways of behaviour. What wonderful things to observe!

How I regret not to have seen the Whistler show; I would have liked to have been there as much for the fine dry-points as for the setting, which for Whistler has so much importance; he is even a bit too *pretentious* for me, aside from this I should say that for the room white and yellow is a charming combination. The fact is that we ourselves made the first experiments with colours: the room in which I showed was lilac, bordered with canary yellow. But we poor little rejected painters lack the means to carry out our concepts of decoration. As for urging Durand-Ruel to hold an exhibition in a hall decorated by us, it would, I think, be wasted breath. You saw how I fought with him for white frames, and finally I had to abandon the idea. No! I do not think that Durand can be won over. –

Whistler makes dry-points mostly, and sometimes regular etchings, but the suppleness you find in them, the pithiness and delicacy which charm you derive from the inking which is done by Whistler himself; no professional printer could substitute for him, for inking is an art in itself and completes the etched line. Now we would like to achieve suppleness *before* the printing. I saw two prints exhibited in Paris a year or two ago; they were rather delicate, meagre and thin-looking, one would have to see a whole collection in order to judge them, for doubtless he has done some that are first rate.

I reread your postscript on aesthetics. I wouldn't want to be an aesthete, at least like those across the Channel. *Aestheticism* is a kind of romanticism more or less combined with trickery, it means breaking for oneself a crooked road. They would have liked to make something like that out of impressionism, which really should be nothing more than a theory of observation, without entailing the loss of fantasy, freedom, grandeur, all that makes for great art. But not *eccentricity* to make sensitive people swoon.

Venice, Etchings and Drypoints, Whistler's third exhibition at the Fine Art Society, February 1883; Whistler designed a yellow colour scheme for it (see opposite). It is generally believed that the walls of the rooms in which Pissarro and his Impressionist colleagues held their first exhibition in 1874 were hung with a reddish-brown material; here Pissarro may be referring to the fifth Impressionist exhibition of 1880 in which he showed several prints mounted on yellow paper and framed in lilac or purple.

Paul Durand-Ruel, the French dealer, framed Pissarro's work in white for the exhibition of Impressionist paintings shown at Dowdeswell's London gallery in May 1883. Whistler exhibited three Venetian etchings at the Salon of 1882, but Pissarro approved of the etchings Whistler sent in 1883, which he found "splendid, correctly drawn, strong." "Aestheticism" or "Art for Art's Sake" had been satirized in Gilbert and Sullivan's Patience (1881); it was associated with the art of Rossetti, Burne-Jones, William Morris, as well as Whistler who in the "Ten O'Clock" lecture in 1885 denounced Ruskin and Wilde (see page 228).

LADY'S PICTORIAL

"Art Gossip"

24 February 1883

The private view of Mr Whistler's etching of Venice took place last Saturday in the rooms of the Fine Art Gallery, Bond-street. Everything Mr Whistler does is original, even to audacity. One fault his critics cannot lay at his door – he is never dull. It is his whim just now to *posé* as a broken butterfly. A maimed butterfly has become his device. "Who breaks a butterfly upon a wheel" is the motto that figures on the catalogue of these etchings. The catalogue is a surprise; it is entitled, "Mr Whistler and his critics." Under the name of each work appears a selected specimen of the adverse opinions passed by the press upon the eccentric genius "Another crop of Mr Whistler's little jokes," remarks *Truth*. "Amateur prodige," sarcastically writes the *Saturday Review*. "The work does not feel," thunders the *Times*. "It is not the Venice of a maiden's fancies," sighs the "*Arry*." "Arry," as Mr Whistler calls him, is Mr Harry Quilten [sic], the tenant of the White House, who succeeded the maimed butterfly when he fluttered away from it. Mr Oscar Wilde is the only one who speaks up for his friend, averring in a characteristic epigram that "Popularity is the only insult that has not yet been offered to Mr Whistler." According to their various idiosyncrasies, the guests invited to the private view were enraged, amused and interested by the show and its various incidents. The announcement that from three to half-past four the rooms would be cleared and the doors closed, as the Prince and Princess of Wales had signified their intention of then visiting the etchings, was not cordially received. To be turned out in the cold on a chill February afternoon is trying to the temper of the most loyal subject and of the most admiring disciple of an eccentric master. There was a goodly mustering of ticket-holders about the doors and wandering about Bond-street, catalogue in hand, when the Prince and Princess of Wales drove up, and Mr Whistler went forth to meet them. The Prince shook hands with him, the Princess smiled upon him; it was evident that if critics growled at him Mr Whistler basked in royal favour. It was difficult to while away the hour; every moment the throng of guests grew thicker. The temper of not a few appeared ruffled. Fair ladies who wore Mr Whistler's colours and device in the form of a big yellow butterfly seemed inclined to pluck it off; others took the matter more good-humouredly – it was so very like Whistler! "Audacious as one of his nocturnes, or arrangements in black and white." The time of waiting came at last to an end, and the Prince and Princess, conducted back by Mr Whistler, reappeared. The Prince carried one of the catalogues, over which report said he laughed heartily; the Princess carried a yellow butterfly Mr Whistler had presented to her. She looked charming in a dress of silver grey plush and bonnet to match, trimmed with a large pink feather laid across the brim; a seal-skin jacket completed her *toilette*. When royalty departed, the crowd pushed its way in. The quiet rooms of the Fine Art Society were seen transfigured. They appeared a symphony in yellow and white. The walls yellow and white, the doors curtained with yellow; stands of yellow flowers, in yellow pots, in the corners; a footman, in splendid livery of yellow plush, handed catalogues. It was impossible to see the master's works for the numerous waiting admirers congregated around them. Many social, artistic, critical notabilities were present. Lady Archibald Campbell bravely sported the colours of the artist who has lately decorated her beautiful house. A yellow butterfly was in her hat of Canadian fur; another was pinned in her fur cloak. She

Whistler's third, and the most elaborate exhibition he designed for fifty-one of his etchings, mostly of Venice, was launched with a strategically planned private view at the Fine Art Society on 17 February 1883. As well as the Arrangement in White and Yellow, *Whistler designed the catalogue* Mr Whistler and his Critics *described here, and which, among others, ensnared his old adversary Frederick Wedmore (see page 143). The one-shilling admission fee to the exhibition was collected by the Fine Art Society, the one-shilling charged for the catalogue, by Whistler.*

Harry Quilter (see page 172).

Oscar Wilde (see pages 228–229).

Lady Archibald Campbell (d. 1923) whose portrait Whistler had painted in 1882 (see page 267), Colourplate 62; Mrs Louise Jopling-Rowe (1843–1933), artist and writer whose portrait Whistler had painted in 1877 (YMSM 191); her second husband was best man at Whistler's wedding in 1888. Mrs Yates, wife of Edmund Yates, editor of The World; *Miss Marion Terry (1856–1930), actress and younger sister of Ellen Terry; William Gorman Wills (1828–91), the dramatist and portrait painter, testified for Whistler in the Ruskin trial (pages 128–133); George Henry Boughton R.A. (1833–1905), American artist resident in London;*

carried some yellow flowers in her hand. Mrs Jopling, Mrs Yates and Miss Marion Terry were among the ladies who appeared thus decked. Among the literary and artistic notabilities we noticed Mr Wills (the dramatist), Mr Boughton, R.A, Mr Yates, Mr Comyns Carr, Mr Malcolm Lawson, Mr Watts, Mr Forbes Robertson and his son, the well-known actor.

Joseph Comyns Carr (1849–1916), art critic and editor, then a manager of the Grosvenor Gallery; Johnson Forbes-Robertson (1822–1903), artist, critic, and father of the actor Sir John Forbes-Robertson (1853–1937).

JAMES MCNEILL WHISTLER

THE GENTLE ART OF MAKING ENEMIES

Apology for Error

1890

TAKING THE BAIT

By the simple process of applying snippets of published sentences to works of art to which the original comments were never meant to have reference, and sometimes, too, by lively misquotation – as when a writer who "did not wish to understate" Mr Whistler's merit is made to say he "did not wish to understand" it, Mr Whistler has counted on good-humouredly confounding criticism. He has entertained but not persuaded; and if his literary efforts with the scissors and the paste-pot might be taken with any seriousness we should have to rebuke him for his feat. But we are far from doing so. He desired, it seems, to say that he and Velazquez were both above criticism. An artist in literature would have said it in fewer words; but indulgence may fairly be granted to the less assured methods of an amateur in authorship.

F. WEDMORE

In Mr Whistler and His Critics, *the catalogue to his 1883 exhibition of Venice etchings at the Fine Art Society, Whistler misquoted Frederick Wedmore (see page 143) on his works in 1879: "They have a merit of their own, and I do not wish to understand it." Wedmore complained in his review of the exhibition published in* The Academy *on 24 February 1883, but Whistler deftly reeled in his catch for* The World.

AN APOLOGY

ATLAS, – There are those, they tell me, who have the approval of the people – and live! For them the *succès d'estime*; for me, O Atlas, the *succès d'exécration* – the only tribute possible from the Mob to the Master! This I have now nobly achieved. *Glissons!* In the hour of my triumph let me not neglect my ambulance.

Mr Frederick Wedmore – a critic – one of the wounded – complains that by dexterously substituting "understand" for "understate," I have dealt unfairly by him, and wrongly rendered his writing. Let me hasten to acknowledge the error, and apologize. My carelessness is culpable, and the misprint without excuse; for naturally I have all along known, and the typographer should have been duly warned, that with Mr Wedmore, as with his brethren, it is always a matter of understating, and not at all one of understanding.

Quant aux autres – well, with the exception of "'Arry," who really is dead, they will recover. Scalped and disfigured, they are not mortally hurt; and – would you believe it? – possessed with an infinite capacity for continuing, they have already returned, nothing doubting, to their limited literature, of which I have exhausted the stock. – Yours, *en passant.*

The World, *28 February 1883.*

Harry Quilter (see page 172).

LE JOUR

The Portrait of Whistler's Mother

5 May 1883

The same could be said of a portrait Mr Whistler has done of his mother. It proceeds, indeed, from the same concerns, and it would seem imposs- ible, with such intentionally circumscribed means, to give this impression of calm and serenity. This appraisement may perhaps seem strange to some of our readers. But we have taken care to specify that for M Puvis de Chavannes, as for Mr Whistler, we were disregarding the colour to consider only the attitude, the gesture, the general arrangement and that indefinable something which the artist puts into his work and which bears his mark.

Like M Puvis de Chavannes, Mr Whistler uses an extremely sober palette. White, black, some yellows, some reds and that is all. But what poetry in the play of those four tones, where the first two dominate with such a strange savour! Last year Mr Whistler had a portrait of a woman with a fur, in black and white; she looked like a vision and she does not seem in general to have been understood in her utter simplicity. Yet one must become accustomed to these concerns when one wishes to appreciate all individual revelations in the form in which they are produced.

Reviews of Arrangement in Grey and Black. Portrait of the Painter's Mother *YMSM 101 (Colourplate 30) were not generally complimentary when it was shown at the Paris Salon of 1883 and awarded a third-class medal.*

Puvis de Chavannes (1824–98), the artist friend of Whistler, whose flat Italianate- inspired wall paintings shared similarities with his own work; latterly their art was often compared.

Arrangement in Black: Lady Meux YMSM 228 (Colourplate 48).

E. W. GODWIN

THE BRITISH ARCHITECT

"To Art Students, Letter No. 9"

11 July 1884

I hope those of my readers who have had the opportunity have not failed to possess the enjoyment offered by Mr J. McN. Whistler, at the galleries of Messrs Dowdeswell, Bond-street. The collection consists of sixty-six small paintings, drawings, pastels – stars of different magnitudes, grouped around a blue moon – a life-size full-length portrait, called by the artist *Scherzo in blue – the Blue Girl*. When, however, Mr Whistler's "notes, harmonies, nocturnes" – his moon and his stars – have departed to their several purchasers, there will remain to Messrs Dowdeswell a gallery specially prepared for this collection in grey, white and flesh colour, which might be in itself an exhibition if the people could enjoy colour. On a July afternoon, when the blind is drawn across the skylight, there is no place I know of more grateful, more satisfying to the eye. The restlessness of modern fashion, for ever changing, that cannot allow the best of things to last beyond a season, will, perchance, sweep away this decoration, and it will be counted with the other delightful harmonies Mr Whistler has produced in Piccadilly and Bond-street, and, indeed, whenever his works have been exhibited. That these exquisitely lovely arrangements of colour should live as memories only, gives to the very nomenclature our painter has adopted a touch of pathos. The room in Piccadilly and the rooms at the Fine Arts Society have gone, as Whistlerian compositions, quite as

Using the architectural journals for which he wrote regularly, E. W. Godwin (see page 125) was particularly supportive of Whistler's art in the 1880s. Unable to negotiate a mutually agreeable contract with the Fine Art Society for a fourth exhibition, Whistler turned instead to Walter Dowdeswell, who had previously worked for the Fine Art Society, and who in his gallery in 1883 held the first major exhibition of Impressionist paintings in London. The centrepiece of the exhibition Scherzo in blue – the Blue Girl *(YMSM 226) was probably effaced by Whistler later in the 1880s.*

effectually as the vibrations of the last quartet; and thus it comes about that a special and very significant value attaches to the little catalogues, with their brown paper covers, and to the messages the artist sends us wrapped up in them. A few see the pictures and drawings; fewer have the pleasure – the consummate joy – of seeing the room with its pictures; but all can see the catalogue, and keep it to read and re-read the forewords, or "*L'Envoie,*" as Whistler calls it in this his last message. To give a bit of this message would be as absurd as to give a bit of any other perfect work; so as the catalogue is not as plentiful as I should like to see it, I give you the message here, adding only that among the works catalogued there are two – *Grey and Silver: Pier, Southend* (water-colour) and *Caprice in Red* – which strike two notes with a precision and dexterity no painter has ever surpassed:–

"A picture is finished when all trace of the means used to bring about the end has disappeared.

"To say of a picture, as is often said in its praise, that it shows great and earnest labour, is to say that it is incomplete and unfit for view.

"Industry in art is a necessity – not a virtue; and any evidence of the same in the production is a blemish, not a quality – a proof not of achievement, but of absolutely insufficient work, for work alone will efface the footsteps of work.

"The work of the master reeks not of the sweat of the brow – suggests no effort, and is finished from the beginning.

"The completed task of perseverance only has never been begun, and will remain unfinished to eternity – a monument of goodwill and foolishness.

"There is one that laboureth, and taketh pains, and maketh haste, and is so much the more behind.

"The masterpiece should appear as the flower to the painter – perfect in its bud as in its bloom; with no reason to explain its presence; no mission to fulfil a joy to the artist, a delusion to the philanthropist, a puzzle to the botanist, an accident of sentiment and alliteration to the literary man."

Freer Gallery of Art, Washington D.C.; (oil) whereabouts unknown (YMSM 257).

The second of Whistler's Propositions*; the first, concerning the aesthetics of size, and a denouncement of the fashionable praise given to large etching plates, is also to be found in* The Gentle Art of Making Enemies *(1892).*

MORTIMER MENPES

WHISTLER AS I KNEW HIM

"The One-man Show"

1904

One of the most interesting periods of my friendship with Whistler was at a time when I had the privilege of being of some small assistance to him during three of his exhibitions. In the arrangement of his work Whistler showed himself to be more than ever a purist. It was a revelation to me. I had never imagined that one human being could be so completely a master in minute details. He missed nothing, absolutely nothing, and he dominated to an extraordinary extent.

First of all there were the choosing of the pictures and the framing of them. Whistler's frame maker, when he first employed him, was an ordinary workman; but very soon, under the influence of the Master, he became an Impressionist. (He felt that he must spread himself somewhere, and his impressionism took the form of music – in short, he learnt to play the violin.) The next work was to cut the pictures to fit their frames. This was invariably a terribly trying time both to Whistler and to the people by

The Australian-born artist Mortimer Menpes (1855–1938), settled in London in 1875 and became a member of the Society of Painter-Etchers in 1881, when he met Whistler who had recently returned from Venice. He left the South Kensington Schools to become a follower and pupil of Whistler, but their companionship foundered in 1887 when Menpes visited Japan, and in the following year he provoked Whistler's wrath by widely publicizing a colour scheme he designed for his own home without due acknowledgement to his Master (see The Gentle Art of Making Enemies*). Menpes later exhibited with the New English Art Club, and wrote a series of travel books which were illustrated with his own bright watercolours.*

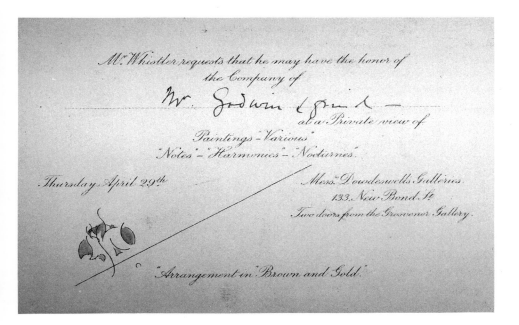

Private View card to Whistler's exhibition *Arrangement in Brown and Gold* at Dowdeswells, London, 1886. Whistler Collections, Glasgow University Library.

whom he was surrounded. Often he was in such frantic excitement that he has said to me: "Look here, Menpes: you take the pictures and cut them in the way you think best. I leave it to you; but, for heaven's sake, don't let me see them before they are framed."

When the pictures had been framed and sent round to the gallery, Whistler, with much care, would arrange them on the ground so as to form a decorative bit of placing. And thus they would be hung. Whistler, himself, always superintended the smallest detail in his exhibition. The colouring of the room was arranged in accordance with the pictures; so also were the hangings, which were festooned in beautiful lines around the gallery. The Private View card was the object of much care and consideration. Such details as the cut of the lettering and the placing of the type were all-important. Whistler would actually go to the length of training a member of the printing firm especially to put a touch of colour on the butterfly by hand. At one of the exhibitions there was a picture called *The Blue Girl*, which occupied a central position on one of the walls. At the last moment, early on the morning of the Press Day, Whistler came to the conclusion that he was not pleased with the painting of the mouth. Immediately he mounted upon a ladder and began to retouch it. It was terrible to watch him. He kept on painting the mouth, rubbing it out and repainting it; still it mocked and defied him. It seemed like a living thing. It changed continually. Sometimes it would simper, and sometimes the lips would curl in a sneer. After a time the picture lost its freshness. Whistler would now and then deceive himself into thinking he was satisfied. He would climb down from his ladder, and say to me: "Isn't that fine now? Much better than it was. I am not going to touch it again." No sooner had I turned my back than up he would climb and set to work to rub out the mouth and paint it in as though for dear life. By and by he became nervous and sensitive. The whole exhibition seemed to centre on that one mouth. It developed into a nightmare. At length, in despair, he dashed it out with turpentine, and fled from the gallery just as the first critic was entering.

There was an exhibition called *Flesh Colour and Grey*. Whistler decided that the decorations for this exhibition should be of flesh colour and grey alone. He insisted upon the colour scheme overflowing a little into Bond Street and oozing out *via* the "chucker-out," whose uniform was to be grey with flesh-colour facings. After a month of standing outside Whistler's show, the man was touched with the Master's enthusiasm. Eventually he became one of his most earnest students. He was constantly to be heard

YMSM 226. The centrepiece of Whistler's one-man exhibition Notes – Harmonies – Nocturnes *held at Dowdeswells' in 1884.*

The colour scheme for the 1884 exhibition described above.

expounding Whistlerian theories to his open-mouthed cronies round the corner. I overhead him one day asking a superior if he should clean the "toney" from off the windows, – "dirt" being absent from Whistler's vocabulary, – a word which was always translated into "tone." The poor fellow was completely demoralized when the exhibition was over. Feeling that he was quite unfitted for his career as "chucker-out," he drifted off into a new life, never to return to his old haunts.

When all the pictures had been hung to Whistler's satisfaction, he gave us a little dinner at the Arts Club – Walter Dowdeswell, who was a most sincere and enthusiastic admirer of the Master, myself and another. We were gathered for the purpose of pricing the pictures, and we drank a wine of which I have never known the name. All I remember is that it was cheap, sparkling and not champagne; it was, I think, what is commonly known as "artists' wine." Ill-natured people who were not of the party whispered "gooseberry;" but that suggestion, I feel sure, was due to the promptings of envy. At any rate, its stimulating effect upon us was great. After dinner the pictures were priced, and with each additional bottle that was placed upon the table the prices mounted higher and higher. A picture of a shop painted in St. Ives, called *The Blue Band*, was held out for our inspection. We gazed at it for some time in silence. Dowdeswell said boldly, "£40," and then looked uncertainly round the table with a scared expression as if to say, "What have I said?" Whistler put on his eyeglass, and surveyed him critically. After more sipping I suggested £50. The Master received the remark quite calmly. He seemed now to be indifferent, and left all discussion to his followers. But the colder he grew, the more enthusiastic we waxed, until at last Dowdeswell said, in a burst of enthusiasm, "Well, if the public doesn't care to give £60 for the picture, far better would it be to live with it." – "Quite right, Walter," said Whistler, approvingly, "quite right. I see you have appreciation. It is, as you say, a supremely fine work." Then I became excited. "I should make it £80," I cried in a nervous, spasmodic way, as though I were taking a header into a cold pool. Whistler looked at me benignly. "I like these bush instincts, Menpes," he said. "Yes: I distinctly like them." He himself did not drink much; and never was he calmer, cooler, more collected. Somehow his coolness spurred us on to fresh efforts. Our enthusiasm mounted to fever heat. In the end *The Blue Band* was priced at £120.

So we continued throughout the evening. The pictures were priced at what seemed to be fabulous sums. None of us, of course, realized that under the influence of drink we had really become prophetic: that we were placing Whistler on a plane where he should be. To outsiders the prices seemed ridiculously extravagant. We ourselves had misgivings next morning when the catalogue was printed, and the east wind was blowing, and we were away from the wine. It was Press Day. I arrived on the scenes very early – at half-past nine, when the gallery was scarcely open. Dowdeswell joined me, and together we paced before the pictures on the wall. We looked at each other, and at the exhibition, critically, but in dead silence. Neither of us uttered a word. We would not have admitted it for the world; but there was no doubt about it – in the cold daylight we were thoughtful and depressed. Brilliant and sparkling, the Master entered, and, with a few words, picked us up again. He knew the value of his own work, and he soon impressed us with his views, – dealers and all. He hypnotized the dealers, as he did everyone else; and they worked for him loyally. They showed the right spirit. It mattered little to them whether they sold the Master's work or not. They felt that it was sufficient privilege merely to exhibit them. Whistler literally bubbled over with joy. "Now," he said, "I can't have this. You must smile. Be merry, laugh, all of you!" Dealers and pupils mechanically worked up smiles to please the Master. It was splendid. The Master swept one rapid glance round the gallery. "There is," he said, "only one thing lacking, gentlemen, to complete the picture which this gallery should create. And that is the butterfly – a large

Probably Blue and Orange: The Sweet Shop, *painted when Menpes was with Whistler in St. Ives early in 1884, but exhibited in Whistler's second exhibition at Dowdeswells' in 1886 and actually priced by Whistler at £100 (YMSM 263, Colourplate 73).*

painted butterfly on the wall." There and then a ladder was brought. Whistler wished the butterfly to be almost on the ceiling. It was an anxious moment, – the Master aloft on a tall ladder, breathless disciples below. The ladder jolted, and Whistler bobbed as he aimed at the wall with his long brush; but each bob caused a stroke in the right direction, and in shorter time than it takes to tell the butterfly was caught, as it were, on the wing. It was obvious to everyone that the Whistler butterfly had pulled the exhibition together.

It was amusing to watch Whistler when the journalists began to arrive. Unless a critic was sympathetic, the Master treated him with scorn. An antagonistic man was torn to ribbons before he left the gallery; scarcely a shred of him was left to show to the world that he had once been a writer with views. Whistler had held the poor fellow up to ridicule before everyone, and the Dowdeswell gallery had rung again to many a roar of laughter. To be sure, Whistler was irresistibly funny. He would take a reporter by the arm, and lead him up to a very small and dainty picture of a shop in a fantastic Whistlerian frame. Then, anticipating all criticisms and complaints, he would din them into the man's ears, repeating them one by one, until the wretch had not a leg to stand upon. He would examine the reporter's face, and looking at the picture alternately, would say, after having apparently given the subject much thought: "It is very small, – isn't it? Very small, indeed. And if you come quite close, you can smell the varnish. That is a point, distinctly a point. It will enable you to discover that the picture is an oil colour. Don't you make any mistakes and call it a water-colour. Now, this pastel, – it's very slight – isn't it? If you were only to touch it with your finger, the colour would come off." No matter how clever the reporter might be, he never got a word in edgeways.

The first Press man, a very insignificant-looking person, arrived at about helf-past ten or eleven. Whistler was standing in the middle of the room surrounded by his marvellous exhibition of flesh colour and grey. The little man drifted into the gallery, and, taking Whistler for one of the attendants, asked him if he would kindly show him the way to Mr Whistler's exhibition of pictures. He evidently imagined himself to be in the entrance to the gallery. Coming up hastily at that moment, Mr Dowdeswell drew the little man on one side, and explained to him that this was the Master with whom he had been talking. Whistler was furious, and screamed. The critic looked as though he wished the earth might swallow him. Whistler mercilessly shouted to the attendant, "Who is this man?" with emphasis on the last word. "Mr ——, representative of *Funny Folks*, sir," answered the commissionaire. "O, it's *Funny Folks*, – is it?" Whistler began; but I fled from the battlefield in dismay, Whistler's eldritch laughter ringing in my ears.

If by chance a Press man were sympathetic, Whistler altered his tactics. He would say: "My dear fellow, in pointing out to these poor dear people, the public, how hopelessly wrong they are, you have a battle to fight, and a severe one. Now, I will tell exactly what you are to say in this article that you propose writing." He would then proceed to give the man word for word the whole gist of his article.

When the criticisms appeared in the papers next day, Whistler read them with relish, never missing one. It was the attacks that interested him. The praise, as Whistler himself said, was obvious: he knew it all beforehand. The reading of notices involved a series of long letters to be written, and a rush on my part to the various newspaper offices.

On his Private-view Day, Whistler was in his element. It was always more like a reception than a private view of pictures. People came there as to a drawing-room. And Whistler was admirable in the way he received his guests. Never was there a more perfect host. He seemed to be everywhere, talking to everyone at the same moment. The whole afternoon was a continuous joy. When everyone had gone, Walter Dowdeswell, Whistler and myself, with one or two others, went to the Arts Club to dine

and talk over the events of the day. Only a few pictures had been sold; but that did not depress us in the least. We were just as buoyant, just as hopeful, as ever. And here I must mention the splendid way in which the Messrs Dowdeswell and Mr Ernest Brown of the Fine Arts Society fought for Whistler in those early days, when his work was misunderstood and undervalued. They believed in him always, and were ever ready to help him and save him pain. For example, over twenty sets of Whistler's etchings printed by a professional printer were brought round to the Dowdeswell galleries for him to look over. He was not satisfied with them, and had not decided whether they should be passed. I begged him to destroy the proofs and print the plates himself, and Dowdeswell without a moment's hesitation seconded my petition. And, mind you, these proofs were printed ready for publication; whereas under the Master's hands it was uncertain when they might be finished; it might be in a month's time, it might be in a year. I never forgot Dowdeswell's generosity. The Master was extraordinarily fortunate in having such men as Dowdeswell and Brown to fight his battles. They did much to help him in the earlier days of his career.

Seats, Gray's Inn, K.299. 1888. Etching, $3\frac{1}{4} \times 7''$ (8.3 × 17.7 cm). Hunterian Art Gallery, Glasgow University (Birnie Philip Bequest).

Both art dealers Walter Dowdeswell and Ernest Brown began their professional careers with the Fine Art Society.
In April 1886 Dowdeswells' issued the Set of Twenty-Six Etchings *of Venice, in an edition limited to thirty sets.*

OCTAVE MAUS

THE STUDIO

"Whistler in Belgium"

June 1904

The art critic and musical impresario Octave Maus was the secretary – and driving force – behind the international exhibiting society Les XX, founded in Brussels in 1883, and a member of the editorial board of L'Art Moderne, *in which he wrote an article on Whistler (September 1885).*

When, early in 1884, a group of Belgian artists, bent on emancipating themselves and defying routine, founded the "Society of the XX," the first foreign painter to be invited to join their ranks in the club's opening exhibition was James McNeill Whistler. And among the ardent spirits

who were united by a common ideal of freedom, what man could more emphatically than Whistler personify the love of independence, the combativeness, the scorn of conventionality, the fervid glow of artistic feeling that fired these youthful souls? Only by name was he as yet known in Belgium. His dreams of mystery and harmony had not yet been revealed to us; but his subtle and indefatigable vitality was already recognized, the lofty pride of his uncompromising temper, his unyielding faith and aspiring ideas.

Would this man consent to place his conquering sword at the service of the young combatants now preparing to give battle? I, being desired to lay the matter before him, explained the motives which had led to the declaration of war – namely the hostility of official artists and public authorities towards the innovators, the systematic rejections of which they were the victims, and the ironical criticisms of the ignorant crowd. The first exhibition of the "XX" Club was to herald an era of conflict – to rouse the most obstinate resistance, and start a real revolution in aesthetics. The enterprise was glorious, no doubt, but full of perils.

The response came at once; Whistler wrote to me in substance to this effect: "I am with you and your friends, heart and soul. I like and admire your rebellious spirit; without it progress is impossible. We will fight together for the victory of our ideal." And not long after, among the works of young painters who have most of them become famous, four fine paintings and a series of his Venetian etchings, so delicate and yet so powerful, represented the artist, on the line, in the first exhibition of the "XX."

These were the *Arrangement in Black: a Portrait of Miss C., A Nocturne in Blue and Silver, A Symphony in White* and *An Arrangement in Grey and Green: Portrait of Miss Alexander*, chosen by the painter as among his best works.

COLOURPLATE 61 *(YMSM 203)*;
COLOURPLATE 34 *(YMSM 103)*;
COLOURPLATE 28 *(YMSM 61)*;
COLOURPLATE 46 *(YMSM 129)*.

Though these compositions and their whimsical titles puzzled some spectators, in the eyes of those who could see they added enormously to the interest of the exhibition. Critics who were but ill-disposed to the young society, were fain to proclaim their beauty in terms which consoled the painter for the prejudiced attacks of which he was the object at that time in London. "Adverse criticism must be silent in the presence of these powerfully original works," says the *Echo de Bruxelles* (11 February 1884). Another paper which was conspicuous for the violence of its enmity to the liberal enterprise of the "XX" – *L'Étoile Belge* – published this laudatory comment, written by its regular art critic, M Max Sulzberger: "These portaits by Mr Whistler are splendid in their deliberately chosen 'symphonic' arrangement – one in black and one in green and grey. The first, that of a young woman, has the grand style of a Tintoret; the second, of a girl, shows her standing squarely, like one of the Infantas Velazquez painted. Both have the artist's sign-manual" (3 February 1884). Finally, M Jules Destrée, in the *Journal de Charleroi*, wrote under the pseudonym of "Jeanne": "Whistler is prodigious. He exhibits two portraits, of which one, bearing the title *Arrangement in Grey and Green*, is a masterly piece of painting. His *Nocturne*, deep and calm, and his charming *Symphony in White*, reveal the painter as a powerful and singularly original colourist. Some of his etchings of Venice are masterpieces, and the draughtsmanship is amazing" (18 February 1884).

On two subsequent occasions the "XX," who every year renewed the list of invited exhibitors, besought Whistler to contribute to their show, and in 1886 he sent them his portrait of Sarasate.

PAGE 244 *(YMSM 315)*.
YMSM 181; YMSM 169.

In 1888 the painter exhibited *An Arrangement in Black*; *A Nocturne in Black and Gold*; two pastels: *Rose and Silver* and *Harmony in Rose and Violet*; and a selection of views in London, etchings. Thenceforward he was definitely connected with Belgian art circles, and ranked by them as one of the very first of contemporary painters. Indeed, the evolution to which he had so efficiently contributed was gradually making its triumphant way, though the battle was still fierce. This will be understood from the

following extract from *La Réforme* (15 March 1886): "Yesterday afternoon the Society of the 'XX' closed the doors of its exhibition in the face of the public. The torrent of strong language, not loud, but deep, and of witticisms – sometimes really witty – at the expense of the impressionist painters, is not to be imagined. For good or for ill, no exhibition of paintings in Belgium ever roused so many people to vehement comment. It attracted to the Palais des Beaux Arts many who had never till then suspected what the building was used for. Many unwilling admirers have begun their artistic education under the 'XX,' and ere long may cease to be unwilling. Where there is life there is progress, and the young men have every advantage on their side in this struggle. The elders must look out for themselves!"

The force in the field was not, indeed, contemptible. Besides Félicien Rops, Fernand Khnopff, van Rysselberghe, Ensor, Toorop, Henry de Groux – to name only the best known of the "XX" – Whistler found himself in company, among other invited exhibitors, with Claude Monet, Renoir, Guillaumin, Besnard, Rodin, Meunier, Anquetin, Forain, Redon, J. E. Blanche, H. de Toulouse-Lautrec, Sargent, William Chase, Liebermann, Israëls and Jakob Maris, who were all, with Whistler, eager to support the disinterested efforts of the young Belgian school – a glorious list of an aristocracy of art; to which may be added the names of Puvis de Chavannes, Eugène Carrière, Camille Pissarro, Alfred Sisley, J. F. Raffaëlli, Fantin-Latour, Bracquemond, F. Thaulow, Albert Bartholomé, George Frampton, J. M. Swan, Max Klinger and many more. These names of themselves indicate what was the company in which Whistler found himself in Belgium, and how close was their elective affinity.

In the course of these years I had been to London and had the honour of being admitted to the painter's intimacy: I remember with gratitude the friendship he kindly showed me. The distinction of his individuality, of his manner and his mind, his love of solitude and meditation, the absorbing charm of his talk, interrupted by frequent and almost jarring outbursts; the irony of his tone, of his smile, of his hard, short, nervous laugh, his weary indifference to all the material elements of life, taught me, in the well-lighted studio in Chelsea, where I spent many never-to-be-forgotten days, to understand his art – an art of dreams, sensations and mystery, illuminated by fugitive flashes – and at the same time the singular refinement of his eye. There was, indeed, a sort of intellectual relationship between himself and the painted figures wrought by his hands, who, in their narrow frames of dull gold, hung about his room. I felt that they, like him, were of the quintessence of humanity. Whistler infused into their features and attitudes something of his own superfine nature; his psychology shone through on his sitters, transfiguring and elevating them – though he gave full value to their individuality – by the extreme distinction which was his gift. The atmosphere he wrapped them in was that of his own mind. If it be true, as Camille Mauclair has asserted in his luminous study of Whistler, that the artist had the singular faculty of showing us the psychical glow of a human soul shining through, so that we seemed to see his spirit between ourselves and his body, it was undoubtedly the spiritual reflection of his own soul that was reflected in those twilight mirrors. The superiority of his genius set an indelible stamp on every one of his works; at the first glance we should know them among thousands.

Whistler was in Belgium in September 1887. He was enchanted at Brussels with the picturesque and disreputable quarter of les Marolles, in the old town. He was frequently to be met in the alleys which pour a squalid populace into the old High Street, engaged in scratching on the copper his impressions of the swarming life around him. When the inquisitive throng pressed him too hard the artist merely pointed his graver at the arm or neck or cheek of one of the intruders. The threatening weapon, with his sharp, spiteful laugh, put them at once to flight. These

Félicien Rops (1833–98); Fernand Khnopff (1858–1921); Théodore van Rysselberghe (1862–1926); James Ensor (1860–1949); Johannes Theodoor Toorop (1858–1928); Henry de Groux (1867–1930); Claude Monet (1840–1926); Pierre Auguste Renoir (1841–1919); Jean-Baptiste Guillaumin (1841–1927); Paul Albert Besnard (1849–1934); Auguste Rodin (1840–1917); Constantin Meunier (1831–1905); Louis Anquetin (1861–1932); Jean-Louis Forain (1852–1931); Odilon Redon (1853–1921); J. E. Blanche (1861–1942); H. de Toulouse-Lautrec (1864–1901); William Merrit Chase (1849–1916); Max Liebermann (1847–1935); Josef Israels (1824–1911); Jakob Maris (1837–99); Eugène Carrière (1849–1906); Alfred Sisley (1839–99); J. F. Raffaelli (1850–1924); Felix Bracquemond (1833–1914); F. Thaulow (1847–1906); Albert Bartholomé (1848–1928); George Frampton (1860–1928); J. M. Swan (1847–1910); Max Klinger (1857–1920).

Maus's immediate impressions of Whistler's art, including the Peacock Room, seen on a visit to London, are given in his article "James M.Neill Whistler," L'Art Moderne, 13 September 1885, pages 294–96.

Camille Mauclair (pseudonym of the critic Camille L. C. Fausti) "James Whistler et le Mystère dans la Peinture," Revue Politique et Littéraire: Revue Bleue, vol. 20, 3 October 1903, pages 440–44. Mauclair's rhapsodic praise of Whistler compares him to Mallarmé; there are also three chapters devoted to Whistler in the same author's De Watteau à Whistler (Paris, 1905).

Palaces, Brussels, K.361(i). 1887.
Etching, $8\frac{5}{8} \times 5\frac{1}{2}$"
(20.3 × 12.7 cm). Hunterian Art
Gallery, Glasgow University.

*The etchings Whistler made on this visit are
among his finest (see K. 349–69 inclusive and
also pages 153–172); unlike the Venice
etchings they were never published as a set.
By 1888, when the American journalist and
author of* Art: A Commodity, *Sheridan
Ford first wrote about him, Whistler – and
anything to do with him – had become
international "copy." Initially agreeing to
Ford's proposals to publish a version of* The
Gentle Art of Making Enemies *Whistler
quickly rescinded, deciding to re-edit and
design the book himself. It was first published
by William Heinemann in June 1890, on the
heels of Ford's unauthorized version, which,
in spite of Whistler's strenuous efforts to
suppress it, exists in two separate editions
published in France and America.*

etchings were intended to form as important a series in the artist's
collected works as those he carried away from Venice. But the scheme was
not completely carried out.

An unforeseen event brought Whistler again to Belgium several years
later. Unknown to him an American journalist had placed in the hands of
a printer at Antwerp the manuscript copy of a pamphlet called *The Gentle
Art of Making Enemies*, desiring him to print 2,000 copies. This was a
compilation of various documents collected by the painter in the course of
his chronic battles with his critics: the narrative of his action against John
Ruskin, the reports of his lectures on art, of his polemical correspondence
with the recognized judges of painting and etching – all the despatches, in
short, of the merciless war waged by one of the most original artists of the
age against those who had withstood innovations in art.

The journalist was authorized by Whistler to arrange these papers. Foreseeing the excitement they would cause as a contribution to the history of art, he had projected an edition of them on his own account. Twice already, in England and in America, Whistler had forefended this manoeuvre. It was on the point of success at Antwerp when the painter, informed of this new attempt, suddenly made his appearance in Belgium and took counsel with the famous lawyer, Edmond Picard, who advised him to have the whole of the papers and stock seized, and recommended him to his colleague, Albert Maeterlinck, one of the leaders of the Bar at Antwerp.

Albert Maeterlinck, cousin of the Symbolist poet Maurice Maeterlinck.

The case was tried at Antwerp in October 1891, and Whistler, who never drew back from any contest once begun, sat by the side of his counsel to defend his rights in person.

The *Indépendance Belge* reported this sensational trial as follows:–

By the journalist Gérard Harry.

"In the absence of the accused, who now resides in Paris and had prudently refrained from answering to the summons, the arguing of the case presented only half the interest expected of it. But, at any rate, those members of the legal profession in Antwerp who were at the Palais de Justice on Monday last had the rare treat of seeing the great artist Whistler, and of noting the Mephistophelian sparkle of his eye, which flashes with youthful fun from under the thick iron-grey eyebrows, behind the glass of his monocle. Mr Whistler, who had come to Antwerp on purpose, was, besides M Köhler, the printer for the journalist, the only witness examined, and he gave in French with amusing coolness and fluency his account of the matter. There was an amusing dialogue before the administration of the customary oaths.

"What religion do you profess, Mr Whistler?" asked the presiding judge.

Mr Whistler was silent, and seemed to hesitate. He did not expect this question, any more than the indiscreet inquiry as to his age – a question he always refused to answer.

"You are, perhaps, a Protestant?" pursued the judge, to relieve the situation.

Mr Whistler's answer was a shrug – a delightful shrug – which plainly said, "Well, yes, if you choose. I do not care, you know! It is for you to say."

After the printer's deposition, which confirmed Mr Whistler's story in every particular, Mr Maeterlinck had only to apply for a decision in accordance with the law for the protection of literary property. But, as an advocate of talent and taste, he would not restrict himself to so easy a task. In an interesting speech he dwelt on Mr Whistler's position as an artist, and compared his warfare against the critics with a famous polemical battle waged, in his day, by Paul Louis Courrier; and he pointed out the importance of this trial, and the service done by the magistracy of Antwerp to the cause of literature and art by aiding in the repression of an act of piracy committed within the limits of its jurisdiction.

Paul-Louis Courrier (1772–1825), polemicist and scholar.

The judgment pronounced, 26 October 1891 – M Charles Moureau presiding – condemned the journalist to a fine of 500 francs (£20), and an indemnity of 3,000 (£120) to be paid to Mr Whistler with costs, or three years' imprisonment in default of payment.

Mr Whistler had, at any rate, the satisfaction of printing in the original edition of his book (published by Heinemann) the ironical reflection: that it was some comfort to know that the illicit work of a pirate was left to rot in the cellars of a foreign law court.

SOCIETY IN LONDON

"Actors, Actresses, Etc. in Society"

1885

This view, by an anonymous author, of Whistler's social position was commonplace in English society papers of the mid 1880s.

There is one artist whose name may be mentioned as furnishing a crucial instance of the service which social and, above all, feminine assistance may render in the establishment of a professional reputation. Mr Whistler is, for all I know to the contrary, an artist who has the suffrages of his brother artists, a great painter in the judgement of those who live by painting, but if he had not followed the example of Mr Oscar Wilde his name would be comparatively unknown. He had the wit to see that genius must in these days wear the crown of eccentricity, even as it is the fool's cap which frequently conceals the fool, or rather invests him with the mantle of the wise man. The opportunity came and he took advantage of it. He developed a little group of characteristics which pleased the fancy and impressed themselves on the memory of society. First he cultivated a lock of hair sprouting from amidst his tresses and fashioned after the model of a feather. Next he substituted for a walking-stick a staff. Having thus appealed to the vision, he proceeded to appeal to society's sense of hearing and, exaggerating his American twang, invented a species of Yankee dialect hitherto unknown. In this he made it his business to utter grotesque antithetical incoherences, and to ramble on in a maundering monotone from theme to theme. Some clever things he contrived to say, for he is undoubtedly an exceedingly clever man. Concurrently with this he imported a novel mode of painting.

The critics were divided in their opinion. Some said it was genius, others said he was a daub. Society, being already prejudiced in favour of the man, now welcomed the artist, and saw in everything which came at long intervals from his studio the transcendent gifts of a great original. "Our James" became the rage, because, in fact, society's own James. From the artist he rose to the oracle. Having induced many gay and lively persons in London society to believe that he was the sole painter of the period who had the slightest notion of the rudiments of art, it occurred to him that he might as well explain from a public platform what these were. So he hired a room in Piccadilly, and announced a discourse to be delivered at the unusual hour of ten o'clock. The bait took. It was whispered about in society that it would be the right thing to hear "our James." He must be so entertaining.

When the eventful evening arrived there was not a seat to be had for love or money. All the smart people were there. Some of them could not hear, others could not understand. Some appreciated, others were simply perplexed; but they all resolved to say that it was exceeding clever; and so, whether he did or did not laugh at them in his sleeve, our James had his victory. If society had been ill-natured it might, I am disposed to think, have resented the whole business as an imposture, have exclaimed indignantly that it had been the victim of a practical joke, and have demanded that its money should be returned to it at the doors. But it never entered into its head to do any one of these things.

JAMES MCNEILL WHISTLER

The "Ten O'Clock" Lecture

1885

The lecture was first delivered at the Princes Hall at 10 pm on 20 February 1885; then on 24 March in Cambridge and on 30 April in Oxford. It was first published in brown paper covers in 1885 and then reprinted in its definitive form with changes to both text, punctuation and layout, in 1888. A French translation by Stéphane Mallarmé (see pages 302, 303) was made for Revue Indépendante, *May 1888. An American lecture tour – like Oscar Wilde's of 1882 – was considered by Whistler and much discussed in the press, but never took place.*

LADIES AND GENTLEMEN:

It is with great hesitation and much misgiving that I appear before you, in the character of The Preacher.

If timidity be at all allied to the virtue modesty, and can find favour in your eyes, I pray you, for the sake of that virtue, accord me your utmost indulgence.

I would plead for my want of habit, did it not seem preposterous, judging from precedent, that aught save the most efficient effrontery could be ever expected in connection with my subject – for I will not conceal from you that I mean to talk about Art. Yes, Art – that has of late become, as far as much discussion and writing can make it, a sort of common topic for the tea-table.

Art is upon the Town! – to be chucked under the chin by the passing gallant – to be enticed within the gates of the householder – to be coaxed into company, as a proof of culture and refinement.

If familiarity can breed contempt, certainly Art – or what is currently taken for it – has been brought to its lowest stage of intimacy.

The people have been harassed with Art in every guise, and vexed with many methods as to its endurance. They have been told how they shall love Art, and live with it. Their homes have been invaded, their walls covered with paper, their very dress taken to task – until, roused at last, bewildered and filled with the doubts and discomforts of senseless suggestion, they resent such intrusion, and cast forth the false prophets, who have brought the very name of the beautiful into disrepute, and derision upon themselves.

Alas, ladies and gentlemen, Art has been maligned. She has naught in common with such practices. She is a goddess of dainty thought – reticent of habit, abjuring all obtrusiveness, purposing in no way to better others.

She is, withal, selfishly occupied with her own perfection only – having no desire to teach – seeking and finding the beautiful in all conditions and in all times, as did her high priest, Rembrandt, when he saw picturesque grandeur and noble dignity in the Jew's quarter of Amsterdam, and lamented not that its inhabitants were not Greeks.

As did Tintoret and Paul Veronese, among the Venetians, while not halting to change the brocaded silks for the classic draperies of Athens.

As did, at the Court of Philip, Velazquez, whose Infantas, clad in inaesthetic hoops, are, as works of Art, of the same quality as the Elgin marbles.

No reformers were these great men – no improvers of the way of others! Their productions alone were their occupation, and, filled with the poetry of their science, they required not to alter their surroundings – for, as the laws of their Art were revealed to them they saw, in the development of their work, that real beauty which, to them, was as much a matter of certainty and triumph as is to the astronomer the verification of the result, foreseen with the light given to him alone. In all this, their world was completely severed from that of their fellow-creatures with whom sentiment is mistaken for poetry; and for whom there is no perfect work that shall not be explained by the benefit conferred upon themselves.

Humanity takes the place of Art, and God's creations are excused by their usefulness. Beauty is confounded with virtue, and, before a work of Art, it is asked: "What good shall it do?"

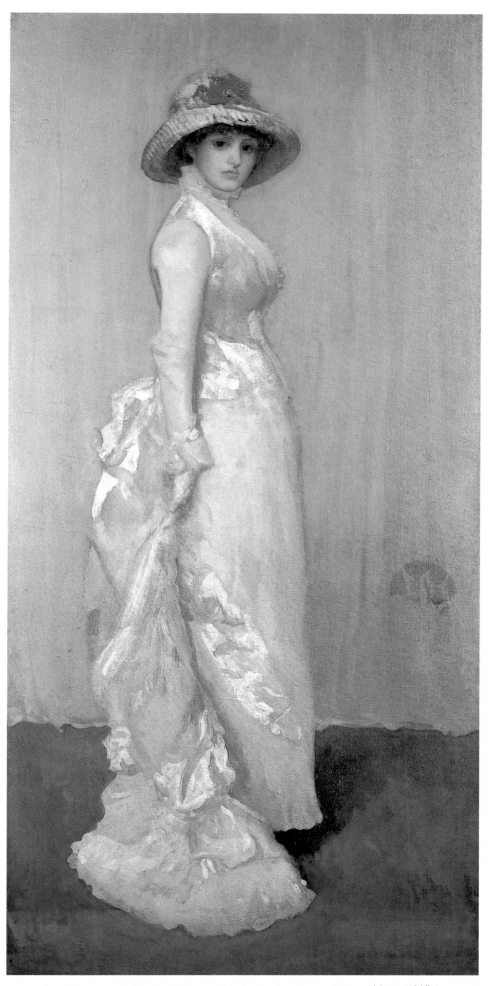

COLOURPLATE 67. *Harmony in Pink and Grey: Valerie, Lady Meux*. 1881. 76¼ × 36⅝″ (193.7 × 93.5 cm).
© The Frick Collection, New York.

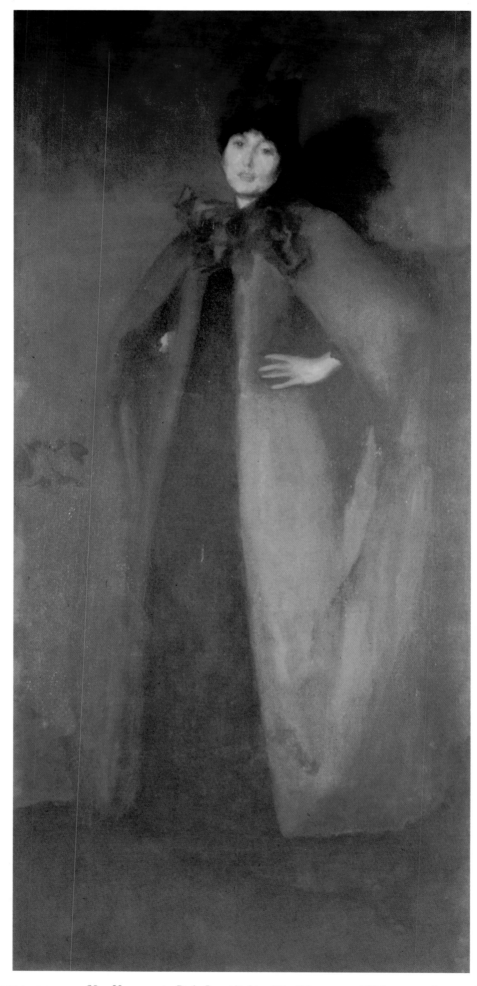

COLOURPLATE 68. *Harmony in Red: Lamplight.* 1884-86. 75 × 35¼″ (190.5 × 89.7 cm).
Hunterian Art Gallery, Glasgow University.

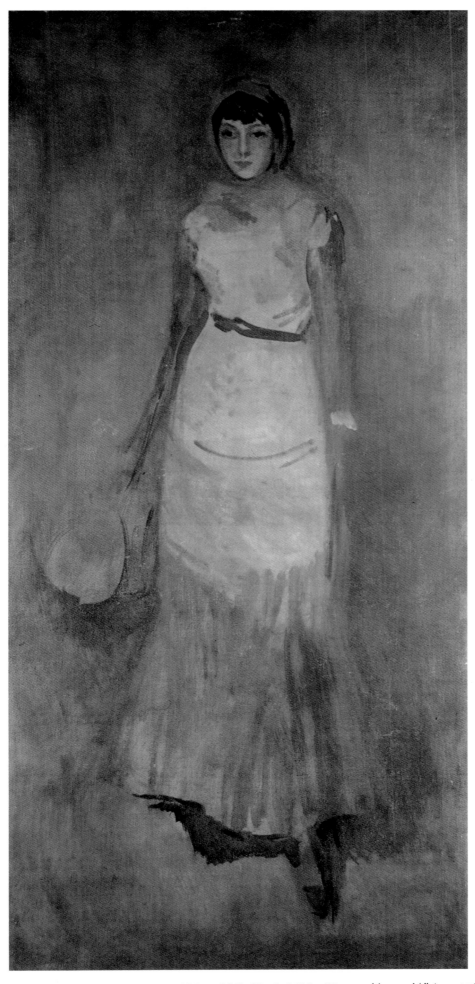

COLOURPLATE 69. *Harmony in Coral and Blue: Milly Finch.* Mid-1880s. 75¼ × 35¼″ (191 × 89.5 cm).
Hunterian Art Gallery, Glasgow University.

COLOURPLATE 70. Design for a Parasol for Lady Archibald Campbell. *c.* 1884. Pencil and watercolour, 11½ × 9⅛" (29.2 × 23.3 cm).
Hunterian Art Gallery, Glasgow University.

The trellis work must in this arrang. must be pale *primrose* color — anything at all of an orange tendency would make the whole *hot* — The doors and roofing will give the orange —

COLOURPLATE 71. Design for a Garden Trellis for Coombe Hill Farm, the Home of Lady Archibald Campbell. *c.* 1881. Ink, pencil and watercolour, 7 × 10″ (17.7 × 25.3 cm).
Hunterian Art Gallery, Glasgow University.

COLOURPLATE 72. *Resting in Bed. c.* 1884. Watercolour, 6¾ × 9⅜″ (17 × 24 cm).
Freer Gallery of Art, Smithsonian Institution, Washington, D.C.

COLOURPLATE 73. *Blue and Orange: The Sweet Shop.* 1884. 4⅜ × 8¼″ (12 × 21 cm).
Isabella Stewart Gardner Museum, Boston (photo Art Resource, New York).

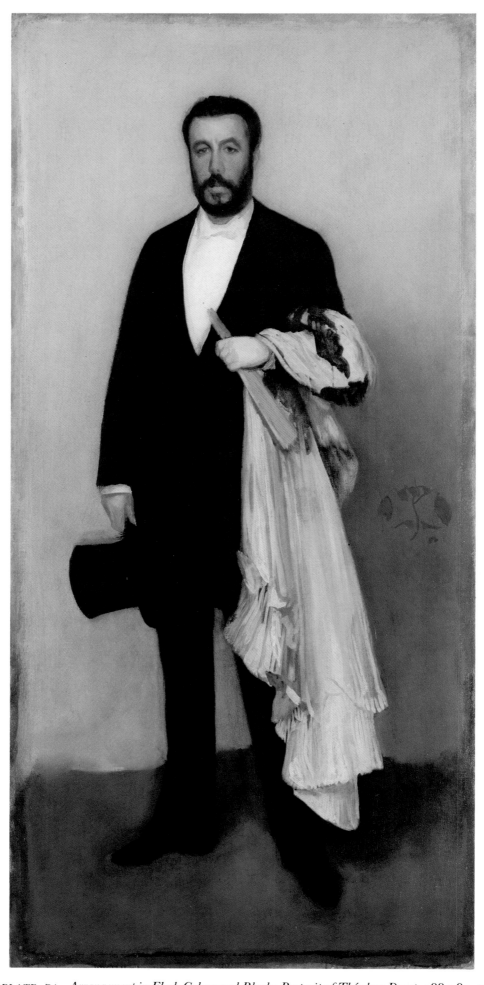

COLOURPLATE 74. *Arrangement in Flesh Colour and Black: Portrait of Théodore Duret.* 1883-84. 76⅛ × 35¾″
(193.4 × 90.8 cm).
Metropolitan Museum of Art, New York.

Hence it is that nobility of action, in this life, is hopelessly linked with the merit of the work that portrays it; and thus the people have acquired the habit of looking, as who should say, not *at* a picture, but *through* it, at some human fact, that shall, or shall not, from a social point of view, better their mental or moral state. So we have come to hear of the painting that elevates, and of the duty of the painter – of the picture that is full of thought, and of the panel that merely decorates.

A favourite faith, dear to those who teach, is that certain periods were especially artistic, and that nations, readily named, were notably lovers of Art.

So we are told that the Greeks were, as a people, worshippers of the beautiful, and that in the fifteenth century Art was engrained in the multitude.

That the great masters lived in common understanding with their patrons – that the early Italians were artists – all – and that the demand for the lovely thing produced it.

That we, of today, in gross contrast to this Arcadian purity, call for the ungainly, and obtain the ugly.

That, could we but change our habits and climate – were we willing to wander in groves – could we be roasted out of broadcloth – were we to do without haste, and journey without speed, we should again *require* the spoon of Queen Anne, and pick at our peas with the fork of two prongs. And so, for the flock, little hamlets grow near Hammersmith, and the steam horse is scorned.

Useless! quite hopeless and false is the effort! – built upon fable, and all because "a wise man has uttered a vain thing and filled his belly with the East wind."

Listen! There never was an artistic period.

There never was an Art-loving nation.

In the beginning, man went forth each day – some to do battle, some to the chase; others, again, to dig and to delve in the field – all that they might gain and live, or lose and die. Until there was found among them one, differing from the rest, whose pursuits attracted him not, and so he stayed by the tents with the women, and traced strange devices with a burnt stick upon a gourd.

This man, who took no joy in the ways of his brethren – who cared not for conquest, and fretted in the field – this designer of quaint patterns – this deviser of the beautiful – who perceived in Nature about him curious curvings, as faces are seen in the fire – this dreamer apart, was the first artist.

And when, from the field and from afar, there came back the people, they took the gourd – and drank from out of it.

And presently there came to this man another – and, in time, others – of like nature, chosen by the Gods – and so they worked together: and soon they fashioned, from the moistened earth, forms resembling the gourd. And with the power of creation, the heirloom of the artist, presently they went beyond the slovenly suggestions of Nature, and the first vase was born, in beautiful proportion.

And the toilers tilled, and were athirst; and the heroes returned from fresh victories, to rejoice and to feast; and all drank alike from the artists' goblets, fashioned cunningly, taking no note the while of the craftsman's pride, and understanding not his glory in his work; drinking at the cup, not from choice, not from a consciousness that it was beautiful, but because, forsooth, there was none other!

And time, with more state, brought more capacity for luxury, and it became well that men should dwell in large houses, and rest upon couches, and eat at tables; whereupon the artist, with his artificers, built palaces, and filled them with furniture, beautiful in proportion and lovely to look upon.

Here Whistler seeks to undermine the teachings of Ruskin and one of his principal followers, William Morris (1834–96) who had set up a colony of his Arts and Crafts followers at Kelmscott Manor, Hammersmith.

Whistler may have had in mind the "Aesthetic" suburb, Bedford Park, where to the west of Hammersmith between 1876 and 1881, both Godwin and Norman Shaw designed red-brick houses in the currently fashionable "Queen Anne" style.

And the people lived in marvels of art – and ate and drank out of masterpieces – for there was nothing else to eat and to drink out of, and no bad building to live in; no article of daily life, of luxury, or of necessity, that had not been handed down from the design of the master, and made by his workmen.

And the people questioned not, *and had nothing to say in the matter.*

So Greece was in its splendour, and Art reigned supreme – by force of fact, not by election – and there was no meddling from the outsider. The mighty warrior would no more have ventured to offer a design for the temple of Pallas Athene than would the sacred poet have proffered a plan for constructing the catapult.

And the Amateur was unknown – and the Dilettante undreamed of!

And history wrote on, and conquest accompanied civilization, and Art spread, or rather its products were carried by the victors among the vanquished from one country to another. And the customs of cultivation covered the face of the earth, so that all peoples continued to use what *the artist alone produced.*

And centuries passed in this using, and the world was flooded with all that was beautiful, until there arose a new class, who discovered the cheap, and foresaw fortune in the facture of the sham.

Then sprang into existence the tawdry, the common, the gewgaw.

The taste of the tradesman supplanted the science of the artist, and what was born of the million went back to them, and charmed them, for it was after their own heart; and the great and the small, the statesman and the slave, took to themselves the abomination that was tendered, and preferred it – and have lived with it ever since!

And the artist's occupation was gone, and the manufacturer and the huckster took his place.

And now the heroes filled from the jugs and drank from the bowls – with understanding – noting the glare of their new bravery, and taking pride in its worth.

And the people – this time – had much to say in the matter – and all were satisfied. And Birmingham and Manchester arose in their might – and Art was relegated to the curiosity shop.

Nature contains the elements, in colour and form, of all pictures, as the keyboard contains the notes of all music.

But the artist is born to pick, and choose, and group with science, these elements, that the result may be beautiful – as the musician gathers his notes, and forms his chords, until he bring forth from chaos glorious harmony.

To say to the painter, that Nature is to be taken as she is, is to say to the player, that he may sit on the piano.

That Nature is always right, is an assertion, artistically, as untrue, as it is one whose truth is universally taken for granted. Nature is very rarely right, to such an extent even, that it might almost be said that Nature is usually wrong: that is to say, the condition of things that shall bring about the perfection of harmony worthy a picture is rare, and not common at all.

This would seem, to even the most intelligent, a doctrine almost blasphemous. So incorporated with our education has the supposed aphorism become, that its belief is held to be part of our moral being, and the words themselves have, in our ear, the ring of religion. Still, seldom does Nature succeed in producing a picture.

The sun blares, the wind blows from the east, the sky is bereft of cloud, and without, all is of iron. The windows of the Crystal Palace are seen from all points of London. The holiday-maker rejoices in the glorious day, and the painter turns aside to shut his eyes.

How little this is understood, and how dutifully the casual in Nature is accepted as sublime, may be gathered from the unlimited admiration daily produced by a very foolish sunset.

The Crystal Palace, constructed for the 1851 Great Exhibition, had been moved to Sydenham in 1852–54.

The dignity of the snow-capped mountain is lost in distinctness, but the joy of the tourist is to recognize the traveller on the top. The desire to see, for the sake of seeing it, is, with the mass, alone the one to be gratified, hence the delight in detail.

And when the evening mist clothes the riverside with poetry, as with a veil, and the poor buildings lose themselves in the dim sky, and the tall chimneys become campanili, and the warehouses are palaces in the night, and the whole city hangs in the heavens, and fairyland is before us – then the wayfarer hastens home; the working man and the cultured one, the wise man and the one of pleasure, cease to understand, as they have ceased to see, and Nature, who, for once, has sung in tune, sings her exquisite song to the artist alone, her son and her master – her son in that he loves her, her master in that he knows her.

To him her secrets are unfolded, to him her lessons have become gradually clear. He looks at her flower, not with the enlarging lens, that he may gather facts for the botanist, but with the light of the one who sees in her choice selection of brilliant tones and delicate tints, suggestions of future harmonies.

He does not confine himself to purposeless copying, without thought, each blade of grass, as commended by the inconsequent, but, in the long curve of the narrow leaf, corrected by the straight tall stem, he learns how grace is wedded to dignity, how strength enhances sweetness, that elegance shall be the result.

In the citron wing of the pale butterfly, with its dainty spots of orange, he sees before him the stately halls of fair gold, with their slender saffron pillars, and is taught how the delicate drawing high upon the walls shall be traced in tender tones of orpiment, and repeated by the base in notes of graver hue.

In all that is dainty and lovable he finds hints for his own combinations, and *thus* is Nature ever his resource and always at his service, and to him is naught refused.

Through his brain, as through the last alembic, is distilled the refined essence of that thought which began with the Gods, and which they left him to carry out.

Set apart by them to complete their works, he produces that wondrous thing called the masterpiece, which surpasses in perfection all that they have contrived in what is called Nature; and the Gods stand by and marvel, and perceive how far away more beautiful is the Venus of Melos than was their own Eve.

For some time past, the unattached writer has become the middleman in this matter of Art, and his influence, while it has widened the gulf between the people and the painter, has brought about the most complete misunderstanding as to the aim of the picture.

For him a picture is more or less a hieroglyph or symbol of story. Apart from a few technical terms, for the display of which he finds an occasion, the work is considered absolutely from a literary point of view; indeed, from what other can he consider it? And in his essays he deals with it as with a novel – a history – or an anecdote. He fails entirely and most naturally to see its excellences, or demerits – artistic – and so degrades Art, by supposing it a method of bringing about a literary climax.

It thus, in his hands, becomes merely a means of perpetrating something further, and its mission is made a secondary one, even as a means is second to an end.

The thoughts emphasized, noble or other, are inevitably attached to the incident, and become more or less noble, according to the eloquence or mental quality of the writer, who looks the while, with disdain, upon what he holds as "mere execution" – a matter belonging, he believes, to the training of the schools, and the reward of assiduity. So that, as he goes on with his translation from canvas to paper, the work becomes his own. He

finds poetry where he would feel it were he himself transcribing the event, invention in the intricacy of the *mise en scène*, and noble philosophy in some detail of philanthropy, courage, modesty or virtue, suggested to him by the occurrence.

All this might be brought before him, and his imagination be appealed to, by a very poor picture – indeed, I might safely say that it generally is.

Meanwhile, the *painter's* poetry is quite lost to him – the amazing invention that shall have put form and colour into such perfect harmony, that exquisiteness is the result, he is without understanding – the nobility of thought, that shall have given the artist's dignity to the whole, says to him absolutely nothing.

So that his praises are published, for virtues we would blush to possess – while the great qualities, that distinguish the one work from the thousand, that make of the masterpiece the thing of beauty that it is – have never been seen at all.

That this is so, we can make sure of, by looking back at old reviews upon past exhibitions, and reading the flatteries lavished upon men who have since been forgotten altogether – but, upon whose works, the language has been exhausted, in rhapsodies – that left nothing for the National Gallery.

A curious matter, in its effect upon the judgement of these gentlemen, is the accepted vocabulary of poetic symbolism, that helps them, by habit, in dealing with Nature: a mountain, to them, is synonymous with height – a lake, with depth – the ocean, with vastness – the sun, with glory.

So that a picture with a mountain, a lake, and an ocean – however poor in paint – is inevitably "lofty," "vast," "infinite" and "glorious" – on paper.

There are those also, sombre of mien, and wise with the wisdom of books, who frequent museums and burrow in crypts; collecting – comparing – compiling – classifying – contradicting.

Experts these – for whom a date is an accomplishment – a hallmark, success!

Careful in scrutiny are they, and conscientious of judgement – establishing, with due weight, unimportant reputations – discovering the picture, by the stain on the back – testing the torso, by the leg that is missing – filling folios with doubts on the way of that limb – disputations and dictatorial, concerning the birthplace of inferior persons – speculating, in much writing, upon the great worth of bad work.

True clerks of the collection, they mix memoranda with ambition, and, reducing Art to statistics, they "file" the fifteenth century, and "pigeon-hole" the antique!

Then the Preacher "appointed!"

He stands in high places – harangues and holds forth.

Sage of the Universities – learned in many matters, and of much experience in all, save his subject.

Exhorting – denouncing – directing.

Filled with wrath and earnestness.

Bringing powers of persuasion, and polish of language, to prove – nothing.

Torn with much teaching – having naught to impart.

Impressive – important – shallow.

Defiant – distressed – desperate.

Crying out, and cutting himself – while the gods hear not.

Gentle priest of the Philistine withal, again he ambles pleasantly from all point, and through many volumes, escaping scientific assertion – "babbles of green fields."

Here Whistler particularizes Ruskin – who resigned his Slade Professorship of Fine Art at Oxford following his defeat in the libel trial (see pages 128–133).

So art has become foolishly confounded with education – that all should be equally qualified.

Whereas, while polish, refinement, culture and breeding, are in no way arguments for artistic result, it is also no reproach to the most finished scholar or greatest gentleman in the land that he be absolutely without eye for painting or ear for music – that in his heart he prefers the popular print to the scratch of Rembrandt's needle, or the songs of the hall to Beethoven's "C minor Symphony."

Let him have but the wit to say so, and not feel the admission a proof of inferiority.

Art happens – no hovel is safe from it, no Prince may depend upon it, the vastest intelligence cannot bring it about, and puny efforts to make it universal end in quaint comedy, and coarse farce.

This is as it should be – and all attempts to make it otherwise are due to the eloquence of the ignorant, the zeal of the conceited.

The boundary-line is clear. Far from me to propose to bridge it over – that the pestered people be pushed across. No! I would save them from further fatigue. I would come to their relief, and would lift from their shoulders this incubus of Art.

Why, after centuries of freedom from it, and indifference to it, should it now be thrust upon them by the blind – until wearied and puzzled, they know no longer how they shall eat or drink – how they shall sit or stand – or wherewithal they shall clothe themselves – without afflicting Art.

But, lo! there is much talk without!

Triumphantly they cry, "Beware! This matter does indeed concern us. We also have our part in all true Art! – for, remember the 'one touch of Nature' that 'makes the whole world kin.'"

Shakespeare: Troilus and Cressida, *Act III, Scene iii, l. 175.*

True, indeed. But let not the unwary jauntily suppose that Shakespeare herewith hands him his passport to Paradise, and thus permits him speech among the chosen. Rather, learn that, in this very sentence, he is condemned to remain without – to continue with the common.

This one chord that vibrates with all – this "one touch of Nature" that calls aloud to the response of each – that explains the popularity of the *Bull* of Paul Potter – that excuses the price of Murillo's *Conception* – this one unspoken sympathy that pervades humanity, is – Vulgarity!

The Dutch animal painter Paulus Potter (1625–54) whose most famous picture is the life-size Bull *of 1647 (The Hague); The Spanish artist Bartolomé Esteban Murillo (1617–82), whose* Immaculate Conception *was acquired by the Louvre at the sale of Marshal General Soult on 19 May 1852 for the then record price of £24,600.*

Vulgarity – under whose fascinating influence "the many" have elbowed "the few," and the gentle circle of Art swarms with the intoxicated mob of mediocrity, whose leaders prate and counsel, and call aloud, where the Gods once spoke in whisper!

And now from their midst the Dilettante stalks abroad. The amateur is loosed. The voice of the aesthete is heard in the land, and catastrophe is upon us.

The meddler beckons the vengeance of the Gods, and ridicule threatens the fair daughters of the land.

And there are curious converts to a weird *culte*, in which all instinct for attractiveness – all freshness and sparkle – all woman's winsomeness – is to give way to a strange vocation for the unlovely – and this desecration in the name of the Graces!

Shall this gaunt, ill-at-ease, distressed, abashed mixture of *mauvaise honte* and desperate assertion call itself artistic, and claim cousinship with the artist – who delights in the dainty, the sharp, bright gaiety of beauty?

No! – a thousand times no! Here are no connections of ours.

We will have nothing to do with them.

Forced to seriousness, that emptiness may be hidden, they dare not smile –

While the artist, in fullness of heart and head, is glad, and laughs

aloud, and is happy in his strength, and is merry at the pompous pretension – the solemn silliness that surrounds him.

For Art and Joy go together, with bold openness, and high head, and ready hand – fearing naught, and dreading no exposure.

Know, then, all beautiful women, that we are with you. Pay no heed, we pray you, to this outcry of the unbecoming – this last plea for the plain.

It concerns you not.

Your own instinct is near the truth – your own wit far surer guide than the untaught ventures of thick-heeled Apollos.

What! ill [sic] you up and follow the first piper that leads you down Petticoat Lane, there, on a Sabbath, to gather, for the week, from the dull rags of ages wherewith to bedeck yourselves? that, beneath your travestied awkwardness, we have trouble to find your own dainty selves? Oh, fie! Is the world, then, exhausted? and must we go back because the thumb of the mountebank jerks the other way?

Costume is not dress.

And the wearers of wardrobes may not be doctors of taste!

For by what authority shall these be pretty masters? Look well, and nothing have they invented – nothing put together for comeliness' sake.

Haphazard from their shoulders hang the garments of the hawker – combining in their person the motley of many manners with the medley of the mummers' closet.

Set up as a warning, and a finger-post of danger, they point to the disastrous effect of Art upon the middle classes.

Why this lifting of the brow in deprecation of the present – this pathos in reference to the past?

If Art be rare today, it was seldom heretofore.

It is false, this teaching of decay.

The master stands in no relation to the moment at which he occurs – a monument of isolation – hinting at sadness – having no part in the progress of his fellow-men.

He is also no more the product of civilization than is the scientific truth asserted dependent upon the wisdom of a period. The assertion itself requires the *man* to make it. The truth was from the beginning.

So Art is limited to the infinite, and beginning there cannot progress.

A silent indication of its wayward independence from all extraneous advance, is in the absolutely unchanged condition and form of implement since the beginning of things.

The painter has but the same pencil – the sculptor the chisel of centuries.

Colours are not more since the heavy hangings of night were first drawn aside, and the loveliness of light revealed.

Neither chemist nor engineer can offer new elements of the masterpiece.

False again, the fabled link between the grandeur of Art and the glories and virtues of the State, for Art feeds not upon nations, and peoples may be wiped from the face of the earth, but Art *is*.

It is indeed high time that we cast aside the weary weight of responsibility and co-partnership, and know that, in no way, do our virtues minister to its worth, in no way, do our vices impede its triumph!

How irksome! how hopeless! how superhuman the self-imposed task of the nation! How sublimely vain the belief that it shall live nobly or art perish.

Let us reassure ourselves, at our own option is our virtue. Art we in no way affect.

A whimsical goddess, and a capricious, her strong sense of joy tolerates no dullness, and, live we never so spotlessly, still may she turn her back upon us.

The rag market.

Here Whistler indicts Oscar Wilde's association with the movement for dress reform in which Wilde recognized himself when he came to review the lecture (see pages 228–229).

As, from time immemorial, she has done upon the Swiss in their mountains.

What more worthy people! Whose every Alpine gap yawns with tradition, and is stocked with noble story; yet, the perverse and scornful one will none of it, and the sons of patriots are left with the clock that turns the mill, and the sudden cuckoo, with difficulty restrained in its box.

For this was Tell a hero! For this did Gessler die!

William Tell and Gessler, legendary adversaries of Swiss lore.

Art, the cruel jade, cares not, and hardens her heart, and hies her off to the East, to find, among the opium-eaters of Nankin, a favourite with whom she lingers fondly – caressing his blue porcelain, and painting his coy maidens, and marking his plates with her six marks of choice – indifferent in her companionship with him, to all save the virtue of his refinement!

He it is who calls her – he who holds her!

And again to the West, that her next lover may bring together the Gallery at Madrid, and show to the world how the Master towers above all; and in their intimacy they revel, he and she, in this knowledge; and he knows the happiness untasted by other mortal.

i.e. Velazquez.

She is proud of her comrade, and promises that in after-years, others shall pass that way, and understand.

So in all time does this superb one cast about for the man worthy her love – and Art seeks the Artist alone.

Where he is, there she appears, and remains with him – loving and fruitful – turning never aside in moments of hope deferred – of insult – and of ribald misunderstanding; and when he dies she sadly takes her flight, though loitering yet in the land, from fond association, but refusing to be consoled.

With the man, then, and not with the multitude, are her intimacies; and in the book of her life the names inscribed are few – scant, indeed, the list of those who have helped to write her story of love and beauty.

"And so have we the ephemeral influence of the Master's memory – the afterglow, in which are warmed, for a while, the worker and disciple." (Whistler's footnote. In the 1885 edition this forms part of the text.)

From the sunny morning, when, with her glorious Greek relenting, she yielded up the secret of repeated line, as, with his hand in hers, together they marked in marble, the measured rhyme of lovely limb and draperies flowing in unison, to the day when she dipped the Spaniard's brush in light and air, and made his people live within their frames, and *stand upon their legs*, that all nobility and sweetness, and tenderness, and magnificence should be theirs by right, ages had gone by, and few had been her choice.

Countless, indeed, the horde of pretenders! But she knew them not.

A teeming, seething, busy mass, whose virtue was industry, and whose industry was vice!

Their names go to fill the catalogue of the collection at home, of the gallery abroad, for the delectation of the bagman and the critic.

Therefore have we cause to be merry! – and to cast away all care – resolved that all is well – as it ever was – and that it is not meet that we should be cried at, and urged to take measures!

Enough have we endured of dullness! Surely are we weary of weeping, and our tears have been cozened from us falsely, for they have called out woe! when there was no grief – and alas! where all is fair!

We have then but to wait – until, with the mark of the Gods upon him – there come among us again the chosen – who shall continue what has gone before. Satisfied that, even were he never to appear, the story of the beautiful is already complete – hewn in the marbles of the Parthenon – and broidered, with the birds, upon the fan of Hokusai – at the foot of Fusiyama.

The Japanese artist Hokusai (1760–1849).

OSCAR WILDE

THE PALL MALL GAZETTE
"Mr Whistler's Ten O'Clock"
21 February 1885

Last night, at Prince's Hall, Mr Whistler made his first public appearance as a lecturer on art, and spoke for more than an hour with really marvellous eloquence on the absolute uselessness of all lectures of the kind. Mr Whistler began his lecture with a very pretty *aria* on pre-historic history, describing how in earlier times hunter and warrior would go forth to chase and foray, while the artist sat at home making cup and bowl for their service. Rude imitations of nature they were first, like the gourd bottle, till the sense of beauty and form developed, and, in all its exquisite proportions, the first vase was fashioned. Then came a higher civilization of architecture and arm chairs, and with exquisite design, and dainty diaper, the useful things of life were made lovely; and the hunter and the warrior lay on the couch when they were tired, and, when they were thirsty, drank from the bowl, and never cared to lose the exquisite proportions of the one, or the delightful ornament of the other; and this attitude of the primitive anthropophagous Philistine formed the text of the lecture, and was the attitude which Mr Whistler entreated his audience to adopt towards art. Remembering, no doubt, many charming invitations to wonderful private views, this fashionable assemblage seemed somewhat aghast, and not a little amused, at being told that the slightest appearance among a civilized people of any joy in beautiful things is a grave impertinence to all painters; but Mr Whistler was relentless, and with charming ease, and much grace of manner, explained to the public that the only thing they should cultivate was ugliness, and that on their permanent stupidity rested all the hopes of art in the future.

The scene was in every way delightful; he stood there, a miniature Mephistopheles mocking the majority! he was like a brilliant surgeon lecturing to a class composed of subjects destined ultimately for dissection, and solemnly assured them how valuable to science their maladies were, and how absolutely uninteresting the slightest symptoms of health on their part would be. In fairness to the audience, however, I must say that they seemed extremely gratified at being rid of the dreadful responsibility of admiring anything, and nothing could have exceeded their enthusiasm when they were told by Mr Whistler that no matter how vulgar their dresses were, or how hideous their surroundings at home, still it was possible that a great painter, if there was such a thing, could, by contemplating them in the twilight, and half closing his eyes, see them under really picturesque conditions, and produce a picture which they were not to attempt to understand, much less dare to enjoy. Then there were some arrows, barbed and brilliant, shot off, with all the speed and splendour of fireworks, at the archaeologists, who spend their lives in verifying the birthplaces of nobodies, and estimate the value of a work of art by its date or its decay, at the art critics who always treat a picture as if it were a novel, and try and find out the plot; at dilettanti in general, and amateurs in particular, and (*O mea culpa!*) at dress reformers most of all. "Did not Velazquez paint crinolines? what more do you want?"

Having thus made a holocaust of humanity, Mr Whistler turned to Nature, and in a few moments convicted her of the Crystal Palace, Bank holidays, and a general overcrowding of detail, both in omnibuses and in landscapes; and then, in a passage of singular beauty, not unlike one that occurs in Carot's [Corot's] letters, spoke of the artistic value of dim dawns and dusks, when the mean facts of life are lost in exquisite and evanescent

Oscar Wilde (1854–1900), dramatist, wit and spokesperson for the Aesthetic Movement, became acquainted with Whistler soon after the latter returned from Venice; in 1882 they began a campaign of mutual admiration conducted in satirical repartee, in the pages of Edmund Yates's The World (*see* The Gentle Art). *This began to sour as Wilde grew in artistic stature, somewhat at Whistler's expense, and began to advocate the primacy of poetry over painting, as he does here. Soon after, their exchanges became acrimonious, plagiarism being the gravest charge Whistler levelled at Wilde, who finally responded, Wilde's biographer Richard Ellman convincingly argues (Oscar Wilde, 1987), by staging Whistler's literary death – murdered by his own creation – in the person of the painter Basil Hallward in* The Portrait of Dorian Gray (1890). *In any case Whistler had withdrawn his public association with the great writer before the time of his public humiliation in 1895.*

[Attributed to] Beatrice Whistler, *Two Caricatures of Oscar Wilde.* 9 × 7⅛" (22.9 × 18 cm). Hunterian Art Gallery, Glasgow University (Birnie Philip Bequest).

In 1882 Whistler had chided Wilde for his adoption of knee breeches; Wilde developed his argument about dress in a further review of the "Ten O'Clock," "The Relation of Dress to Art. A note in Black and White on Mr Whistler's Lecture," Pall Mall Gazette, *XLI, 28 February 1885, page 4.*

effects, when common things are touched with mystery and transfigured with beauty; when the warehouses become as palaces, and the tall chimneys of the factory seem like campaniles in the silver air.

Finally, after making a strong protest against anybody but a painter judging of painting, and a pathetic appeal to the audience not to be lured by the aesthetic movement into having beautiful things about them, Mr Whistler concluded his lecture with a pretty passage about Fusiyama on a fan, and made his bow to an audience which he had succeeded in completely fascinating by his wit, his brilliant paradoxes, and, at times, his real eloquence. Of course, with regard to the value of beautiful surroundings I differ entirely from Mr Whistler. An artist is not an isolated fact, he is the resultant of a certain millieu [sic] and a certain entourage, and can no more be born of a nation that is devoid of any sense of beauty than a fig can grow from a thorn or a rose blossom from a thistle. That an artist will find beauty in ugliness, *le beau dans l'horrible*, is now a commonplace of the schools, the argot of the atelier, but I strongly deny that charming people should be condemned to live with magenta ottomans and Albert blue curtains in their rooms in order that some painter may observe the side lights on the one and the values of the other. Nor do I accept the dictum that only a painter is a judge of painting. I say that only an artist is a judge of art; there is a wide difference. As long as a painter is a painter merely, he should not be allowed to talk of anything but mediums and megilp, and on those subjects should be compelled to hold his tongue; it is only when he becomes an artist that the secret laws of artistic creation are revealed to him. For there are not many arts, but one art merely; poem, picture, and Parthenon, sonnet and statue – all are in their essence the same, and he who knows one, knows all. But the poet is the supreme artist, for he is the master of colour and of form, and the real musician besides, and is lord over all life and all arts; and so to the poet beyond all others are these mysteries known; to Edgar Allan Poe and to Baudelaire, not to Benjamin West and Paul Delaroche. However, I would not enjoy anybody else's lectures unless in a few points I disagreed with them, and Mr Whistler's lecture last night was, like everything that he does, a masterpiece. Not merely for its clever satire and amusing jests will it be remembered, but for the pure and perfect beauty of many of its passages – passages delivered with an earnestness which seemed to amaze those who had looked on Mr Whistler as a master of persiflage merely, and had not known him, as we do, as a master of painting also. For that he is indeed one of the very greatest masters of painting, is my opinion. And I may add that in this opinion Mr Whistler himself entirely concurs.

THE MAGAZINE OF ART

"The American Salon"

1885

America, though recruited rather from Teuton than from Latin races, has chosen France to be her foster parent in the arts. We know that "the good American goes to Paris when he dies;" and he seems to appear there in the guise of an art student. The number of these Transatlantic learners, and the excellence of the work that they produce, have grown year by year more notable. It is not so long ago since the native American school first appeared in Paris, and met, in the persons of Messrs Church and Bierstadt, with a measure of recognition; and already the contribution of America to the annual display in Paris is signed by such names as Sargent

Here Wilde seems to widen his horizon to embrace the kind of criticism then often levelled at modern French painting.

For Whistler's use of megilp, see page 106.

In a much quoted exchange over this passage Whistler accused Wilde of naïvety as a poet in his choice of the history painter Sir Benjamin West PRA (1738–1820) and the French neo-classicist Paul Delaroche (1797–1856), both of whom, Wilde replied "rashly lectured upon Art;" warning Whistler to remain, as Wilde did "incomprehensible. To be great is to be misunderstood." (See The Gentle Art of Making Enemies, *1892.)*

This article is in fact by Robert Alan Mowbray Stevenson (1847–1900), cousin of R. L. Stevenson; art critic of the Pall Mall Gazette *(1893–1900); he published books on Rubens (1898) and* The Art of Velazquez *(1895).*

Oscar Wilde, A Woman of No Importance *(1893) Act I.*
Frederic S. Church (1842–1924); Albert Bierstadt (1830–1902), of the "Hudson River" school of American artists.
John Singer Sargent (1856–1925) settled in London in 1886, living in Whistler's old house at 33 Tite Street.

and Whistler: a change in the technical sense hardly to be exaggerated. Within our recollection Transatlantic students arrived in French studios trained according to the old South Kensington plan: wonderful stipplers, full of confidence, perhaps bearing prizes, but ignorant of any other material than chalk, and totally unaware of the real problems and difficulties that await the artist on the very threshold of art. And already these days are practically past; already the soundness of the *atelier* system, which we in England are still so slow to recognize, has become apparent to the brisker and clearer intellects of the United States. Such rapid growth is certain to be founded more or less on imitation, but the sweeping charge so often brought against American artists is only true of a limited number. It is true of such as but for the efficient training of the *atelier* system would never have attracted either praise or blame. Style has been given to those who in the English system would never have attained to a notion of what style is; and style in the hands of a man without originality is only a lamp to display emptiness. In other words, by its very excellence the French system of education strengthens the flight of those who are naturally imitative.

But it does not follow in the least that it clips the wings of those who are naturally original. The student may choose almost any known painter for his master, and may leave him for another when he likes. He is constantly thrown with the members of other studios, lives in a Babel of discussion with men of all countries and all kinds of previous training, and is thus in a position to compare the canons of different professors. A French artist does not keep an expensive academy for young gentlemen, nor pretend to regulate smoking and morals. He gives his advice for nothing, interferes very little with his pupils' sentiments, and for the most part confines himself to the practical and the technical. It is in France, surrounded by French plain speaking and bold painting, that the Americans have learned to make their great recent advance in art. Had they stayed in America, or had they come to study in England, that advance would in all probability never have been made, and at least it would have come much later. Our own English painters, brought up by English methods and living among the social humbug and suppressions of an Anglo-Saxon country, may do good work. The most workmanlike, however, is apt to look a little mild, a little weak, a little timid in style and a little doubtful in values, when hung upon the line and exposed to the competition of a Paris Salon. But the most advanced of the new school of Americans support this trial with no eclipse of brilliancy. And their work is not only sound and bold in treatment; it displays besides traces of the working of the Teutonic sap, a sympathy with the eccentric, a more fervid sentiment, and an original feeling for nature.

To take the case of Mr Whistler. Any one who has seen his portrait of Lady Archibald Campbell as it hung in the Salon will admit not only that it looked well, but that it looked better there than it did in London. Such work is out of place in our exhibitions. We prefer in England the pictures of gentlemen who paint as they would conduct a bank, only more imperfectly: as though we should prefer an inventory of the bar-room at the *Maypole* to the rapid and effective synthesis in *Barnaby Rudge*. Certainly the first is more accurate: a house-agent, an auctioneer or an intending purchaser will find in it more profit; and unfortunately it is with something of this mind, or at best with the scientific mind, that we in England approach the works of art in our galleries. This is not only true of laymen and outsiders, but of one half of the Academicians. And this point of view in the spectator intimidates and constrains the artist. Bold experiment is regarded as both ridiculous and rude. Men, as ignorant of painting as a Hottentot, see a touch which they do not understand, and think that in laughter they display the spirit of the connoisseur; and at the opposite pole, men enslaved to the routine of taste resent the freedom as the insolence of a charlatan. In truth, Mr Whistler is almost out of sight of the

The national form of art education systematized at the South Kensington Schools under Sir Henry Cole.

It was to be the French "atelier" method of art education, rather than the English system, which Whistler adopted when he opened the Académie Carmen in Paris in 1898 (see pages 329–330, 339–342).

Colourplate 62 (YMSM 242), exhibited in the 1885 Salon.

The Maypole Inn features in Dickens' historical novel Barnaby Rudge *(1841).*

common critic and gallery frequenter; he has advanced beyond them as much in the choice of what he tries to do as in the skill with which he does it; and the contempt which they sometimes profess is no more enlightened than that with which a schoolboy, well grounded up to quadratics, regards the apparently unfair juggling with π and θ of his elder brother from Cambridge.

To see everything painted with equal force and particularity is the vague, unconscious wish of the gallery frequenter; to seek to paint everything well and importantly is the first impulse of the inexperienced artist. The first is not often cured of this innocent taste; and the second only loses it through a course of dire exercises in the troubled questions of subordination to mass and focus. A dozen or a hundred times he may have begun to paint with some dim notion of dignity, of style, of sentiment; and under the pressure of incongruous facts which he does not know how to suppress, or of some inconsistent effect which he sees obtrusively in nature and has not the courage to banish from his canvas, he has seen with equal strides his picture advance towards a formal completion, and the informing spirit, "the glory and the dream" of his real subject, fade and disappear beneath his brush. But to recognize the necessity of choice and suppression is, in painting, to come only to the beginning of difficulties. The fact cannot be simply omitted as in literature. The canvas cannot stand empty; it must be filled from frame to frame. And here is required of the painter a special technical imagination, by which he shall devise means to slur elegantly what is unnecessary, and inexpressively, and yet still with decorative effect, to fill up the unimportant passage of the canvas. It is in this that Mr Whistler excels; and it is therefore no great wonder if the gallery frequenter, who does not even suspect the necessity of such a gift, should be slow to recognize his excellence. This is not in any way an invention of Mr Whistler's. The same quality, attained with less effort and bravado, may be admired in many Van Dycks, where corners of armour and sword-hilts gleam, and faces peep, out of the rich darkness. Indeed, it is Mr Whistler's fault to make artifice too obvious. The strong man rejoices, perhaps, too greatly in his strength. Marmont is said to have lost battles by yielding to the temptation of his singular skill in manoeuvering troops. This may be a parable to Mr Whistler; it can give no ground for the scoff of the incurably ignorant in art.

August Frederic Louis Viesse De Marmont, Duc de Raguse (1774–1852), Napoleonic marshal.

FRANK STEPHEN GRANGER

NOTES ON THE PSYCHOLOGICAL BASIS OF FINE ART

The Purpose of Art

1887

Frank Stephen Granger ARIBA, D.Litt., MA (1864–1936), pupil of E. W. Godwin (see page 125) from 1882 to 1885, was Professor of Classics and Philosophy at Nottingham University 1893–1935. His book is influenced by the ideas of the philosopher Herbert Spencer.

When Mr James Whistler invites the public to view his works, he sometimes provides the latter with a special setting: on one occasion a cheap and fitting background was formed of brown paper. Of course even this trivial circumstance gave a slight interest to the works exhibited quite apart from their proper purpose. It was an illustration of the many ways in which ordinary people are led astray from the right appreciation of paintings. The artist's processes, taken separately, are simple and easily understood. But when they are regarded as a whole, and in the light of their finished results, we tend to forget the many steps by which this perfection is attained, and to see mystery where there is none. A number of

For the exhibition Notes – Harmonies – Nocturnes *held at Dowdeswells' in 1886.*

unnecessary associations, as for instance with gossip about artists, the price of paintings and so forth, are added to the above, until the real aim of all is lost to view. And some painters have gone so far as to restrict their appeals to those who have peeped behind the scenes and seen them mixing their colours. They paint, not to give pleasant impressions nor to bring to life buried memories, but that they may perform little juggleries of effect, which only the initiated shall be able to detect. The name, which they give to this manner, is "art for art's sake." Such a spirit is quite removed from that of the great painters of this, or of any other age. Instead of consecrating his work to the gratification of his fellows, the artist turns it into an arena for the display of his own cleverness. When it is remembered that all arts, fine or not fine, are directed to some end, whence they derive their value, the meaning of this phrase is apparent. The artist who claims it for his watchword, announces in so many words that he mistakes the means of art for the end.

MORTIMER MENPES

WHISTLER AS I KNEW HIM

"Master and Followers"

1904

The Whistler Followers were privileged people; but among them there were only two genuine pupils. These were Walter Sickert and myself. The followers never met under the Master's eye; but they formed themselves into a society whose main object was to fight his battles. Individually we meant to fight for ourselves, too; but that was a bold idea, and we never let the Master know it. We were a little clique of the art world, attracted together in the first instance by artistic sympathies. At the most we never numbered a dozen. We were painters of the purely modern school – Impressionists, I suppose we might have been called – all young, all ardent, all poor. We had our ways to make in the world; we had ambition; we had intentions. Just then we had not much else. Severally and collectively we intended to be great. Of course, we intended to be rich; but that seemed an incidental consideration. We looked upon money merely as an ultimate result. Our immediate object was the work.

As soon as we found that we were in harmony as to our aims, we felt it desirable that we should meet frequently to assist one another in feeling our way to revelation. We resolved, therefore, to form ourselves into a club, and to hire a room where we might meet of an evening for the discussion of art. I remember well when the idea was first thought of. Gathered in my house in Fulham, we made red dots on the map of London to localize our homes. This was for the purpose of deciding on a central spot for the studio. Eventually we decided on Baker Street, and rented a little room there at six shillings a week. We had difficulty at first in collecting the shillings; but it was divided among seven of us, and when one didn't pay up the others did.

It was the hiring of the room that gave us an opportunity for putting into practice ideas on the subject of house decoration, which we felt to be of the utmost importance – in fact, a principal part of the mission. We were convinced that the prevailing system of house decoration was against the laws of art, and we were determined that our school should feel its way to a scheme that would revolutionize the system. "Be broad," was one of our favourite axioms; "Be simple," was another. We had a great many pet

Walter Richard Sickert (see page 256).

phrases: indeed, after a time we developed quite an art language of our own. "Nature never makes a mistake in matching her tones," we said; and we settled that we would go and match tones from nature for the decorative plan of our club room.

For personal as well as for artistic reasons, we wished to demonstrate that the highest decorative art is not necessarily expensive, and decided that our plan should be carried out in distemper. Distemper is cheap. Distemper is "broad and simple." Distemper is the best medium for putting on a wall; and in colour, we felt, lay our strength. Thereupon we proposed to take for our model the broad, simple, decorative scheme of the universe. Roughly speaking, our harmony should be that of sea and sky.

The club room was small, and we had realized that to cut it up in patches of decoration would be inartistic. We decided to distemper the walls blue, the colour of the sky, and the ceiling green, the colour of the sea. We did not at that time discover that the scheme was upside-down; but then we had a theory that nature was just as beautiful either way. What did it matter? Any woodwork about was painted the tone of the Dover cliffs, in sympathy with the sea-scape.

There was no fireplace in the room – if there had been we couldn't have afforded coal: – so we bought a paraffin stove, and in winter evenings we used to warm ourselves at its flame. Poor little stove! I always fancied there was something pathetic in the way we edged round it while we discussed art, and in the friendly surreptitious rivalry between boots and knees as to which should get nearest the flame.

We wrote on special notepaper, of a peculiar tint, sacred to the school; and, like the Master, had a special stamp. The design was, we thought, symbolic as well as decorative. It represented a steam-engine advancing, with a red light displayed, – a danger signal to the Philistines to warn them that reformers were on their track.

We were very enthusiastic at that period, and that, of course, led us into absurdities. Still, no doubt, enthusiasm did us a world of good; after all, it is a law of progress to march through mistakes to achievement. It was the peculiarity of the school that they were always on the verge of some great discovery in the matter of method, or of pigment, or of manipulation – touching, as it were, some hitherto unknown truth, which was to revolutionize all the old cannons of art. If you met one of us round a street corner, he would be excited and mysterious. "Ah, my dear fellow," he would exclaim, "I have something to tell you. I'm reducing nature to a system. I'm getting things to a state of absolute perfection. Just wait!"

We always waited; but nothing seemed to happen. That is, a great deal came, but nothing in the least approaching perfection. In fact, what generally did come was failure. We were not disheartened. We never lost our enthusiasm. Balked in one direction, we would bravely start off in another. If we hadn't been so earnest, there might have been something absurd in this blind chase after the ideal – a chase through poor, mean places where no ideal could possibly be found. To me the pathos of our misguided energy, the even tragedy of our hopelessly clogged aspirations, lifted our school far beyond the realms of the ludicrous.

At one time we were influenced by the work of another artist, Digars; but, of course, this was kept from the Master. It was Walter Sickert who first saw Digars's work. He brought enthusiastic descriptions of the ballet girls Digars was painting in Paris. We tried to combine the methods of Whistler and Digars, and the result was low-toned ballet girls.

There was another period when we used to travel all round London painting nature from the top of hansom cabs. It was lucky for us that Whistler never saw us. The ignominy of being sent home to bed would have been too terrible.

Once an interesting figure appeared on our horizon, – a French painter. He was Whistler's find, and was held up to us Followers as an example. "At last," Whistler said, "I have found a follower worthy of the

i.e. Degas
Sickert had escorted Arrangement in Grey and Black: Portrait of the Painter's Mother *(YMSM 101, Colourplate 30) to the Paris* Salon *in 1883 and taken with him an introduction to Degas from Whistler.*

Théodore Roussel (1847–1926) met Whistler in 1885 and was influenced by him, particularly in his graphic art. See Hilary Taylor, James McNeill Whistler, *London, 1978, page 163.*

233

Master." (I noticed with secret joy that he did not call him pupil.) This man went bareheaded always when in the presence of Whistler: whether out of doors or in, no one could persuade him to wear a hat.

He was a great example, for we were becoming a little careless – we sometimes forgot ourselves, and wore hats. The Frenchman was charming, and a brilliant mathematician. He it was who designed a series of mathematical instruments for matching the tones of nature. Also, he worked out a scheme for mixing perfectly pure pigment. It was by means of grinding crystals into a powder, which, he declared, used as a pigment, compared with the ordinary colours would appear just as brilliant as a patch of snow on a muddy road.

At one time the Followers became prismatic. This gave us a good deal of trouble. We began to paint in spots and dots; we painted also in stripes and bands. Form with us meant being perfect from the decorative point of view. That was all that mattered. Nature, we said, is for the painter a decorative patch; a portrait, a blot of colour, merely an object in relation to a background. We held it a fundamental error to introduce into pictorial art elements belonging strictly (we supposed) to the literary art. "Nature," we said, "for the painter should be divested of all human and spiritual attributes; sentiment, philosophy, poetry, romance – these things belong to the literary art, and are not in the painter's palette." For him, nature should be tilted forward and without distance – a Japanese screen, a broad mass of tones – a piece of technique. The face in a portrait should not be more important than the background. The moment you realized that it was a face, the literary art came in; and you had better give it a cup of tea, or pull its nose.

In the end we swept away all faces. Features, we felt, were unnecessary. A broad sweep of flesh tone sufficed for a portrait. We saw no difference between a face and a peach or a peach and a coal-scuttle.

Then we began to realize that nature was very fair, and that if you got into a coal-cellar and looked through the chink of a door you saw her much more truly than in any other way. For some time we painted nature only through the chinks of doors. Some of us became very exact. Others talked of the folly of painting pictures only at one hour of the day – midday. Therefore, we began to paint pictures at all times – morning, noon and night. We were continually asking one another to guess at what hour such-and-such a picture was painted. A Follower would suggest eleven-thirty. "Right you are – almost," the proud possessor would answer. Not eleven-thirty, but eleven-fifteen – because at that time the shadows were stealing round the haystack and forming that particular pattern. The school was becoming scientific. To be able to tell the time of day by a picture was astounding!

I must excuse myself for dwelling on the subject of the Followers. Our lives at that time were wrapped up in the one great and overpowering individuality of Whistler. It was he who stimulated us to do these extraordinary things. Our principles were his principles exaggerated. The Master was too great to be approached on the subject of art directly. We had never mentioned to him the school or its aims. We feared that he would perhaps regard it as insignificant, and us, its members, as unworthy exponents of aims so serious.

We seldom asked Whistler questions about his work, such as the way he mixed his pigment. If we had, he would have been sure to say, "Pshaw! you must be occupied with the Master, not with yourselves. There is plenty to be done." If there was not, Whistler would always make a task for you, – a picture to be taken in to the Dowdeswell's, or a copperplate to have a ground put on it.

Only once I remember him really teaching us anything. He told it to us two pupils; and Sickert, I remember, took down every word on his cuff. He described how in Venice once he was drawing a bridge, and suddenly, as though in a revelation, the secret of drawing came to him. He felt that he

wanted to keep it to himself, lest someone should use it – it was so sure, so marvellous. This is roughly how he described it: "I began first of all by seizing upon the chief point of interest. Perhaps it might have been the extreme distance – the little palaces and the shipping beneath the bridge. If so, I would begin drawing that distance in elaborately, and then would expand from it until I came to the bridge, which I would draw in one broad sweep. If by chance I did not see the whole of the bridge, I would not put it in. In this way the picture must necessarily be a perfect thing from start to finish. Even if one were to be arrested in the middle of it, it would still be a fine and complete picture."

That is the only instance that I can remember of Whistler sitting down and actually explaining anything to the pupils; but, of course, in a thousand subtle ways we benefited by his presence. In fact, as artists we owed our existence entirely to the Master. We were allowed the intimacy of his studio; we watched him paint day after day; we studied his methods, witnessed his failures and successes. He never placed us down as pupils and told us to paint such-and-such an object, nor did he ever see our work when it was finished; but we felt his influence, nevertheless, and strongly. We were true Followers; and in the first stage of our enthusiasm we had such a reverence for the Master that, highly as we esteemed Velazquez and Rembrandt, we still looked upon these persons as mere drivellers in art compared with him. Strange, eager amateurs we would recognize sometimes, but only because they painted on the Whistler lines. One lady, I remember, used to paint flowers. We thought her work very fine. She had no academic training; but we placed her high because she painted on grey panels and in sympathy with Whistler. He, of course, we placed far above Raphael. In fact, we couldn't stand Raphael because Whistler had said that he was the smart young man of his period.

One rainy day Whistler was sitting in my dining room poring over a large volume of Raphael's cartoons. After spending two hours with them, he came to the conclusion that Raphael did not count. But he was pleased, he said, to have had the opportunity of placing the smart young man of his day. Rembrandt we recognized to a certain extent because Whistler had been heard to say that he had had his good days. Also, however, he had remarked that Rembrandt revelled in gummy pigment and treacly tones: so Rembrandt, in our opinion, did not occupy much of a position. Canaletto and Velazquez we placed high, very high, but not, of course, on the same plane as Whistler. The only master with whom we could compare our own was Hokusai, the Japanese painter.

At that time we copied Whistler in every detail. If he painted from a table instead of using a palette, from that moment onward we discarded the use of palettes. Whistler talked of breadth and simplicity, and broader and emptier sketches than the Followers produced you could not possibly imagine. At that period I was painting little children on the sands – some clad only in sun-bonnets, and others without the bonnets. I began to paint so broadly and so simply that the flesh tone of the child and the sand were so much alike that the picture, when it was finished, resembled a clean sheet of paper.

Then, in company with the other Followers, I acquired the "grey-panel" craze. Personally, I have never seen nature in grey tones, but often in vivid, almost prismatic, colours; and the feeble little pictures I produced, stained grey panels in Whistlerian frames, were almost pathetic in their futility.

We Followers saw things from Whistler's standpoint. If we etched a plate, we had to etch it almost exactly on Whistlerian lines. If Whistler kept his plates fair, ours were so fair that they could scarcely be seen. If Whistler adopted economy of means, using the fewest possible lines, we became so nervous that we could scarcely touch the plate lest we should over-elaborate.

Of course, there were moments when we rebelled from the Master's

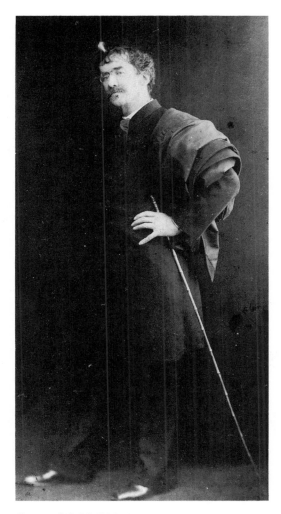

James McNeill Whistler. *c.* 1888. Photograph by Mendelsohn. Whistler Collections, Glasgow University Library.

See Whistler's "Ten O'Clock" lecture, page 227.

influence and tried to be bold. "The whole principle of art," we said, "is that you must be bold: you must be careless, indifferent, reckless." There was no such thing as technique. It did not matter what you used – brush, charcoal, dry-point, – you must be bold. We tore ourselves away from breadth and simplicity, staining panels and economizing means, and we tried to be bold.

It was then that the athletic period began, the period of over-eating. "Good work," we said, "is impossible without good food"; and thenceforward we spent our time in restaurants. One of the Followers etched a plate at luncheon with a fork. This did occur to me, even in my feverish condition, as being a trifle extravagant. Even the Master never followed more than one point – to use four seemed rather too bold – but the Follower was perfectly in earnest as to his "fork method," and etched a plate regularly every night at dinner. At my house he etched a plate of a celebrated lady artist. In the small hours of the morning I took it upstairs and printed a proof. I placed the proof in a frame, so that we might the better judge of its merit. It was framed in the usual way and, as I remembered afterwards, it had been etched upright; but one could not be too particular, and the Follower never even noticed the mistake. He looked at his work in a satisfied, admiring way, and said, "Amazing!" We all echoed him – feebly, I must admit. Then he turned to us, and said: "Friends, always remember this golden rule – in art nothing matters so long as you are bold. These swift lines of mine, put on with a fork, have great boldness and assurance. What does it matter whether it is a portrait of the lady artist or not?" To us it looked remarkably like a rainy day.

This may indicate the condition of Whistler's Followers; and, mind you, it is absolutely true – there is no exaggeration.

* * *

The Master sometimes encouraged us. Once he encouraged me very much indeed. Before I had met Whistler, I had been etching a series of plates in Brittany, and I showed him some of the proofs. They were the first I ever did. He told me to send them to the Crystal Palace exhibition, where he himself was one of the judges. I sent several of them in a frame, and received a gold medal. This mark of his favour naturally elated me tremendously. The master was with me! He had given me a gold medal! I felt that I had a future before me. He said, "You have the gold medal, Menpes, and Du Maurier the silver one; but don't forget that there is plenty of time – don't occupy yourself too much with your own affairs!"

It was pathetic sometimes – the way the Followers would attempt to copy Whistler's mannerisms. We tried to use stinging phrases and to say cutting things. Our mild expressions, I am afraid, did not carry them off to advantage.

Afterwards, when I had been thrust out of the school and looked back with clear, calm judgement at the Followers surrounding the Master, I coloured up and felt ashamed. I had been to Japan, had studied the methods of the Japanese, and had come back cleansed. I realized more than ever the greatness of the Master; but I also realized the absurdity of trying to copy him in any way. One saw these mild-faced Followers, nearly all new recruits, gathering a little reflected glory, using the Master's phrases and trying to say other caustic things. Of course, directly I returned from Japan and the Master left me, the Followers also left, in a body – I was an outcast. I took up my brush, began my solitary artistic life, and tried to make a success. I have tried ever since. I have never come in touch with Whistler or the Followers from that day to this. Where they are now I do not know; but I maintain that the period of enthusiasm did us all good. We worked well for the Master, and we loved him. I am quite convinced of one thing. No matter how seriously he may have attacked them, there is not one of those Followers but will remember the name of Whistler with gratitude, admiration and affection to the end.

e.g. Menpes' The Breton Peasant was published in The Etcher in 1882 (plate 21); his Breton Beggar in the Portfolio (XIV, 1883, f. p. 114).

It seems unlikely that Du Maurier is here intended.

In 1887.

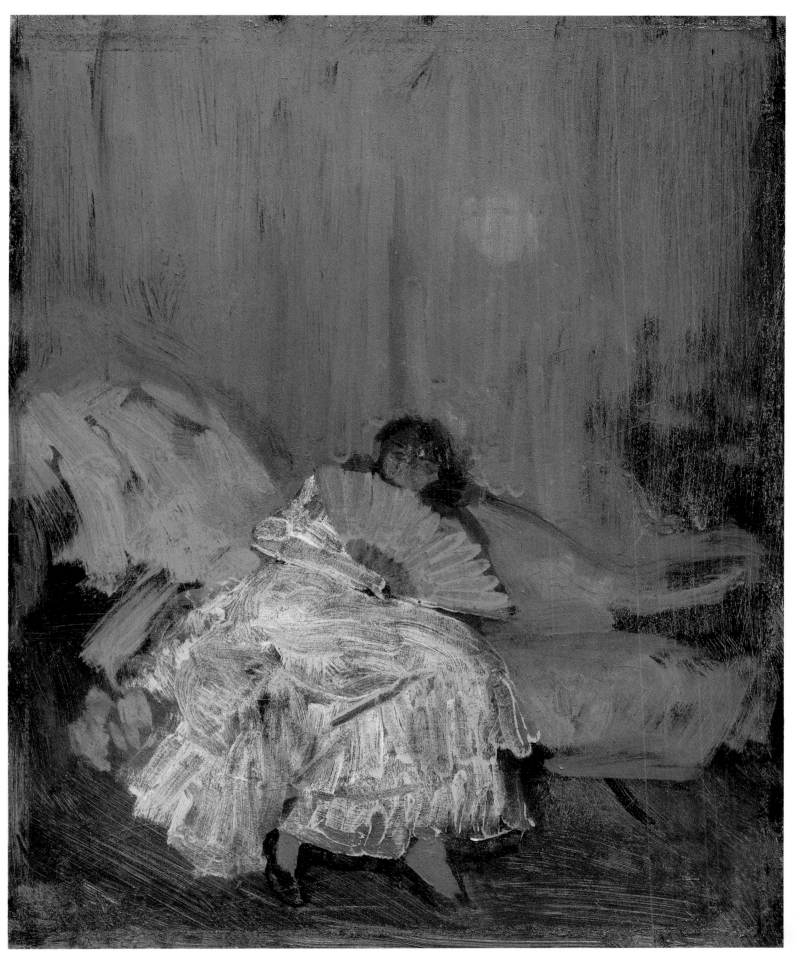

COLOURPLATE 75. *Red and Pink: The Little Mephisto. c.* 1884. 10 × 8″ (25.4 × 20.3 cm).
Freer Gallery of Art, Smithsonian Institution, Washington, D.C.

COLOURPLATE 76. *A Shop.* 1884/90. 5½ × 9⅛″ (13.9 × 23.3 cm).
Hunterian Art Gallery, Glasgow University.

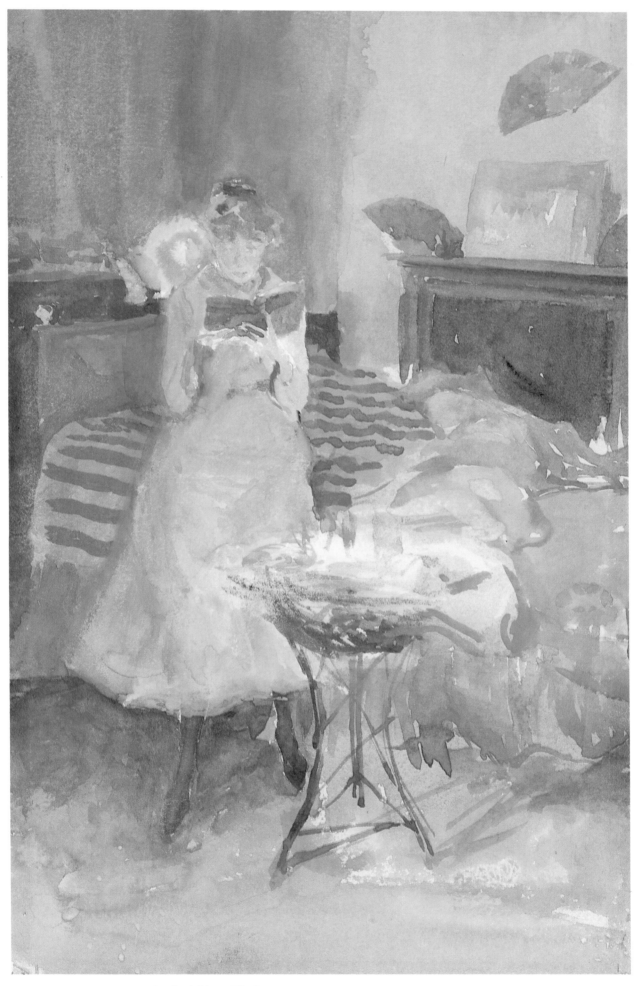

COLOURPLATE 78. *Pink Note: The Novelette. c.* 1884. Watercolour, 10 × 6⅛″ (25.3 × 15.5 cm).
Freer Gallery of Art, Smithsonian Institution, Washington, D.C.

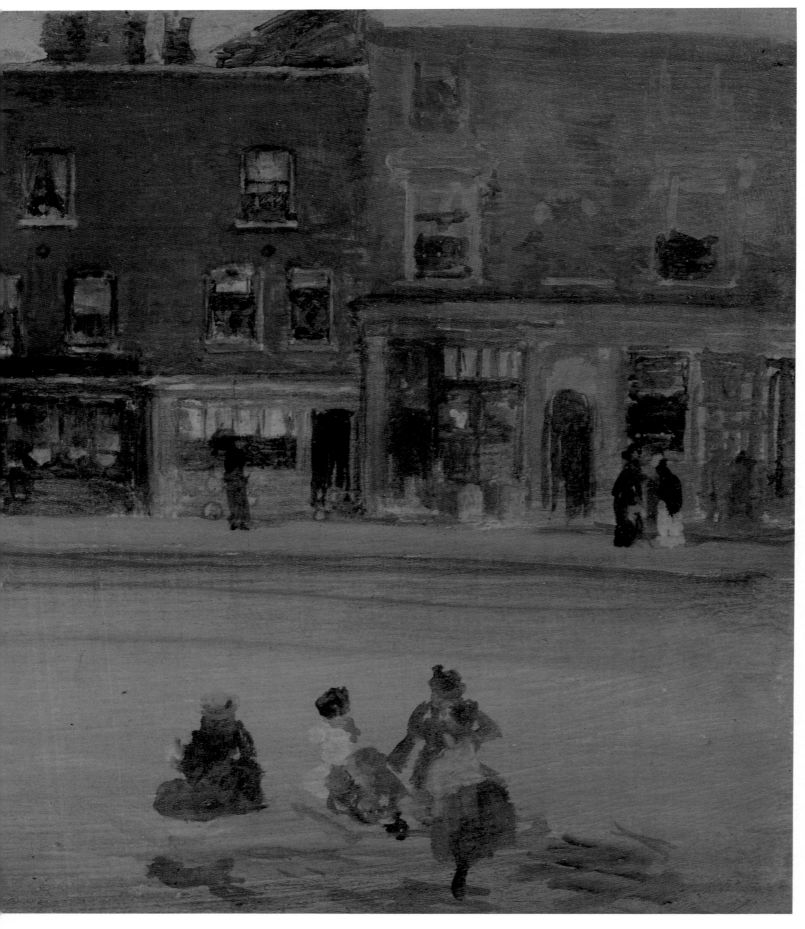

COLOURPLATE 77. *A Street in Old Chelsea*. 1880/85. 5¼ × 9⅛″ (14 × 22.9 cm).
Museum of Fine Arts, Boston (Gift of Denman Waldo Ross).

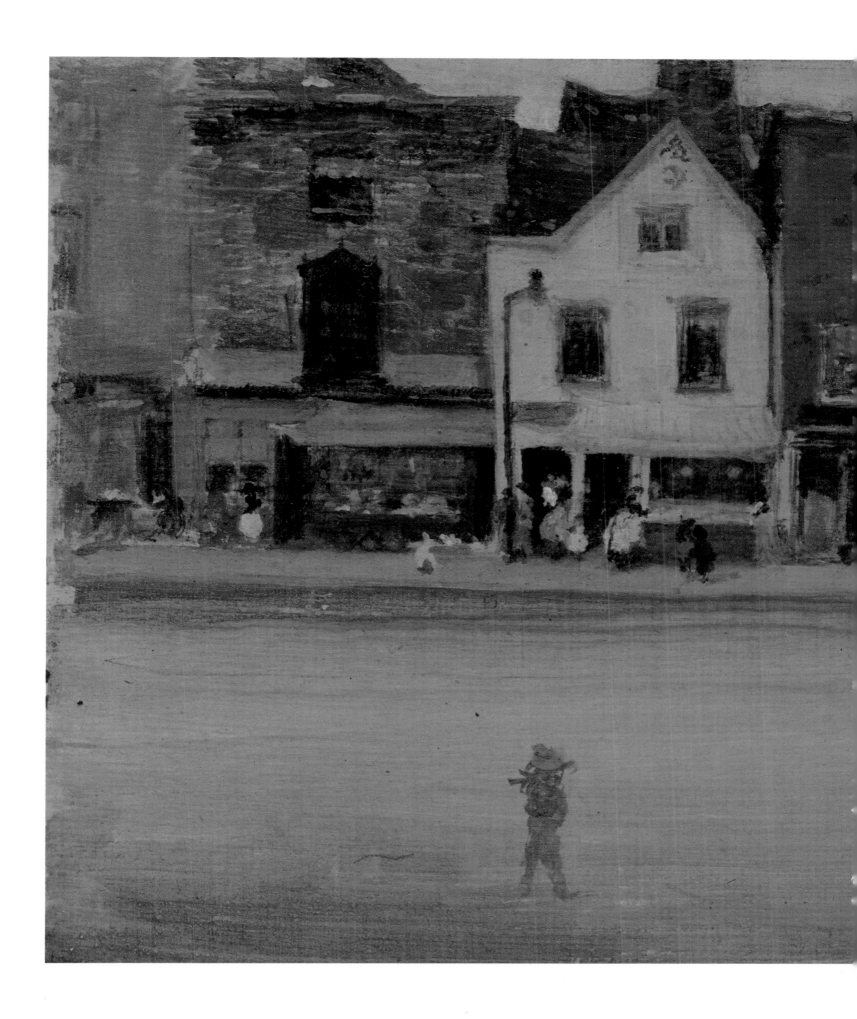

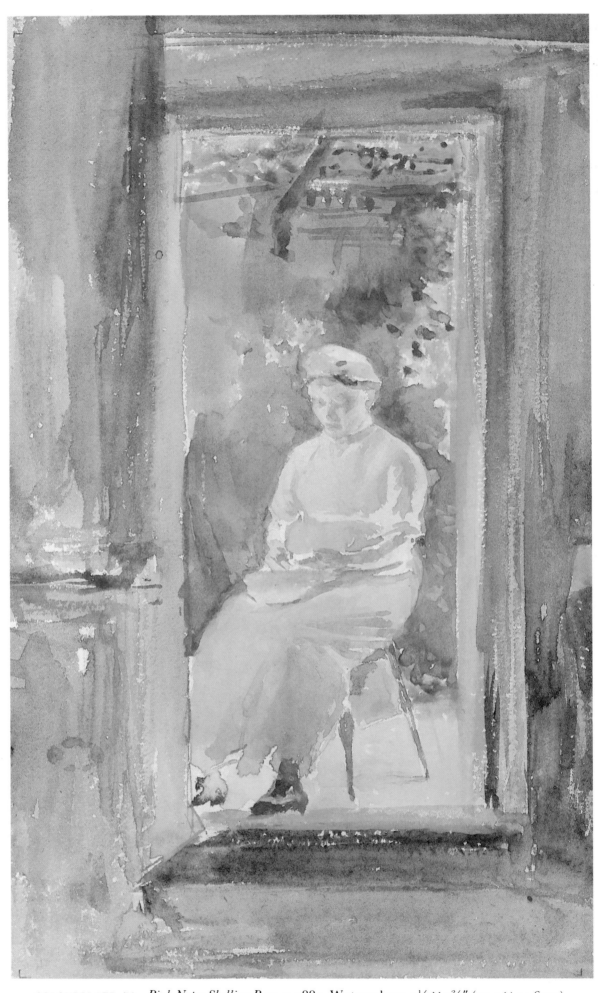

COLOURPLATE 79. *Pink Note: Shelling Peas. c.* 1884. Watercolour, 9½ × 5¾″ (24.3 × 14.6 cm).
Freer Gallery of Art, Smithsonian Institution, Washington, D.C.

ALBERT LUDOVICI

AN ARTIST'S LIFE IN LONDON AND PARIS 1870-1925

"The R.B.A. and Whistler"

1926

The Impressionist subjects of the artist Albert Ludovici Jnr. (1852–1932) were much influenced by Whistler. He exhibited with the Royal Society of British Artists and the International Society under Whistler's presidency (see pages 247–248), but, like his father (see below), lived mainly in Paris.

The following winter Sickert came to see me, and after telling me how Whistler had joined him at St Ives after I left, informed me that if the Society of British Artists chose to invite Whistler to become a member, he would be willing to join. This surprised me very much, and it was only after he assured me it was a fact that I could believe his statement. I saw at once what an advantage it would be to the Society, and, the next day being Sunday, I started calling on our President, John Burr, our Vice-President, Holyoake, and other officers of the Society. I had told the news to my father, who was Treasurer, the previous evening. It made him laugh, like all the other officers, who took it as a Whistler joke, and I had much difficulty in persuading them to take his offer seriously, at the same time pointing out what a splendid choice it was for the S.B.A. to have the works of such a renowned painter exhibited in the Gallery. I may here explain why all these men laughed at the idea of Whistler joining us.

During the famous Whistler *versus* Ruskin trial – the first case on record of an artist prosecuting an Art critic for libel – Whistler, in his replies to the Attorney-General, had displayed so much wit that the public was kept in fits of laughter. The Attorney-General actually declared that he did not know when so much amusement had been afforded the British public. After that the mere mention of Whistler's name made everyone laugh, and the general public could not believe that he was the great and serious artist which we who knew him were convinced he was. After the trial he took up the pen as a further means of expounding his views and of pursuing his campaign in favour of taste.

I had the honour and pleasure of making Whistler's acquaintance in 1884, soon after his return from Cornwall, when he asked Sickert to invite me to his studio in Chelsea. I had seen him at the Hogarth Club, but had not had the pleasure of speaking to him, and of course I had heard all the fantastic stories about him, as well as many of his witticisms, which had been passed round the studios to the delight of most of us. I was even influenced by the general opinion against him. But half an hour's conversation in his studio at our first meeting entirely dispelled these foolish prejudices, and I felt I was in the presence of a great artist, and for the first time since I had left Paris I enjoyed a conversation on Art unmixed with "shop" or "business."

With the enthusiasm of youth I became devoted to the much-misunderstood Whistler.

I have never forgotten that visit to the studio in Tite Street. On an easel was a portrait of Sarasate, the Spanish violinist, whose concerts at St James's Hall was attracting all London. No painter until then had dared to depict a man in conventional evening dress. Sarasate was small but well proportioned, and not unlike Whistler, with curly hair, less the white lock which was one of Whistler's distinctive features. The portrait was a subtle arrangement in black, full length, and well placed on the canvas, very low in tone, which made the critics say he had a dirty shirt-front, and that a shirt should be white – pure white. . . .

John Burr, the President, was the only member who was pleased to hear of Whistler's intention of joining our Society. Roberts, the Honorary

Walter Richard Sickert and Mortimer Menpes (see pages 256, 202) worked with Whistler in St. Ives, Cornwall, January–March 1884; The Society of British Artists had been founded in 1823 as an alternative to the Royal Academy, but by the 1880s its exhibitions were indiscriminatingly selected and overcrowded.
John Burr (1834–93), Scots artist elected President of the S.B.A. in 1881; William Holyoake (1839–94), Vice President 1881; Albert Ludovici Snr. (1820–94).

Page 244 (YMSM 315). Pablo de Sarasate y Navascues (1844–1908); Whistler's portrait was exhibited at the 62nd Annual exhibition of the Society of British Artists, 1885.

Thomas E. Roberts (1820–1901) had been elected Honorary Secretary in 1863.

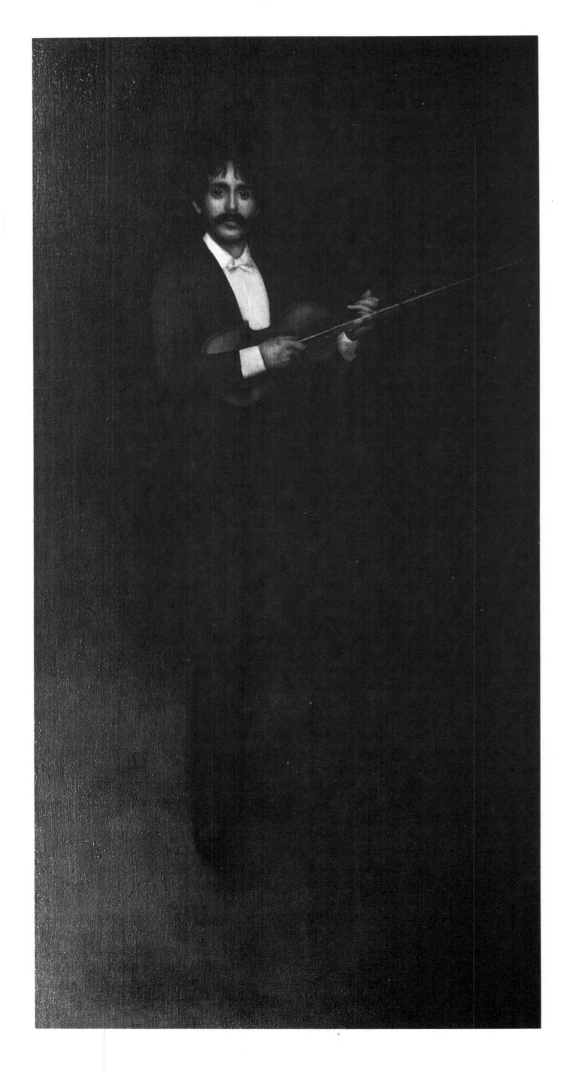

Arrangement in Black: Portrait of Señor
Pablo de Sarasate. 1884.
97¹³⁄₁₆ × 55⅜″ (248.4 × 140.7 cm).
Museum of Art, Carnegie Institute,
Pittsburgh, Pennsylvania
(Purchase, 1896).

Secretary, who was a sergeant in the Artists' Volunteers, of which Frederick Leighton was Colonel, appeared rather frightened of the idea, and especially afraid of being laughed at by that worthy corps for electing such an Art Buffoon into the nursery of the Royal Academy. Holyoake, the Vice-President, thought it would be a good thing for the Society, but did not believe Whistler would take sufficient interest in the working of the Society of British Artists or even exhibit more than once or twice. I pointed out to them what a splendid advertisement it would be for our winter show, which was coming on in a few weeks, if we could persuade Whistler to send some of his work, and asked them to call a special meeting at once so that we might elect him there and then. This they agreed to do, and that same week Whistler was elected. Very few of us could imagine him taking an interest in the working of the Society, and some even went so far as to warn us against the selfishness of the man, saying he would only make use of the Society for his personal advantage, and *Punch* had a small drawing of him as "King of the Frogs," gobbling them up. His supposed conceit was never forgotten, or his daring attack on their idolized critic, John Ruskin. Until then the public had only thought of artists as a body of men whose lives were spent in smoking and drinking, and many worthy people in this very commercial country still declare that Art and artists are not useful to a nation. Therefore the public were quite ready to agree with Ruskin when, in 1877, he wrote in *Fors Clavigera* the well-known words. . . .

In spite of all that had been said, Whistler took an immense interest in the Society, from the first meeting he attended down to the end of his one year's Presidency of the S.B.A. Young artists of the present day have much to thank Whistler for. They would be surprised to learn what a struggle it was to bring about any reform, or change, in the way of hanging a wall of works of art. Even a catalogue in those days looked more like a tradesman's book of advertisements than an artistic compilation of pictures. Whistler was an artist of great taste and refinement, which were shown in his work and interior decorations. He was the first to introduce white rooms and to do away with the elaborately patterned wallpapers so popular in those days, in favour of plain walls of different schemes of colour; this, with just sufficient furniture to make a room comfortable, was a great improvement to private houses, overcrowded, as was the fashion then, with unnecessary knick-knacks.

All the years I was friendly with Whistler I never heard him swear or use a vulgar word; neither did he care for coarse stories. He was always neatly dressed, in black in winter and white in summer, and his hair, with the white lock which grew near the centre of his forehead, carefully arranged. He always changed for dinner, and used to appear at the Suffolk Street meetings in evening dress, a habit which other members, who did not know him, considered rather snobbish. Whistler's hands were expressive and artistic, and his vitality enormous. He would stand day after day at his work for eight hours or more and then print his etchings until midnight without a rest. He often told me that his brain was so much at work he could only sleep a few hours at night. Towards the end of his life, and particularly after an illness he had, he would suddenly doze off for ten minutes when dessert was brought to the table. His wit and charming manners made him a great favourite with the ladies, and at a dinner party he would keep the company in fits of laughter with his amusing stories, told as only he knew how. His conversation was usually carried on more by suggestion, which made it sometimes puzzling to anyone who was not quite *au fait* with the details concerning the subject.

* * *

The small studies of old shops and back streets always reminded me of the days when, as a youth, I used to accompany my father to 62, Cheyne Walk, where the two old bachelors, E. and G. A. Holmes, members of the

Later Sir Frederic Leighton P.R.A. (1830–96).

On 21 November 1885.
Ludovici is here mistaken: the cartoon he refers to was published in Fun, *8 December 1886, page 241, after Whistler had assumed presidency of the R.B.A. on 1 June 1886.*

Savoy Scaffolding, K.267. 1887.
Etching, 7 × 3³⁄₁₆″
(17.8 × 8.1 cm). Hunterian Art Gallery, Glasgow University (Birnie Philip Bequest).

Edward (fl. 1841–91) and George Augustus Holmes (fl. 1852–1909).

Society of British Artists, used to live. I always felt I was going through some ancient village; their parlour overlooking the river was used as a painting room, and was quaint and old-fashioned, like their painting. One of them had painted a subject-picture which had a tremendous vogue when reproduced in colour; it was called *Can't You Talk?* and represented a child kneeling in front of a collie and looking up at him as if putting that question. Those were days when the copyright of a picture was worth money, and this one must have brought a small fortune to the publisher. Nearly every house in the British Isles had a copy hanging on the walls, for that was a sentimental age and subject was everything. I fear the artist did not derive much benefit from the sales; he tried to find another title as popular, but never succeeded.

Phil Morris, a painter and oarsman, used to live in Cheyne Walk, for, being an amateur of rowing he found Chelsea very convenient, and after work would take his boat up to Kew and back. That was years before he was elected A.R.A.

Another quiet but quaint spot in Chelsea off the King's Road was "The Vale," since pulled down and rebuilt. Here Stirling Lee, the sculptor, had his studio, and in a meadow alongside was an old cottage where Whistler had lived for a few years with Maud Franklin. I was always grateful to her for having, on varnishing day at the Society of British Artists, told me what he thought of a large canvas of a ballet-girl I had named *Terpsichore*, which hung in the principal gallery. Whilst painting it I had asked Whistler to come and see it at my studio before sending to the Gallery, but he was too busy to come. What Madame, as we used to call her, told me compensated for all the disappointment of not having shown it to the Master. She came up to me as soon as I entered the Gallery and said: "I must tell you what Jimmy said about your picture." He, as President of the Society, was on the Hanging Committee, and was present when the picture was put up. That evening he dined at the Beefsteak Club, and, getting home at two o'clock in the morning, awoke Maud, and talked to her of the picture, even making a sketch of it, which I believe she kept. I thought it very nice of her to tell me this in her simple manner. It not only gratified me, but encouraged me enormously.

On Private View day I was delighted to receive congratulations on my *Dancing Girl* from such eminent painters as M Claude Monet, who was in London for a few days, Mr Orchardson, R.A. and Mr Boughton, R.A.; but many, even some of the critics, thought I had degraded my Art by choosing such an immoral subject for my picture. In those days, let us remember, the Alhambra was noted for its ballets, and was considered a very naughty place to frequent. Ladies would only go out of curiosity, and would be disguised and hidden away in the boxes if they wished to see the performance. The *Daily Chronicle* of 3 December 1886, said:

By the by, there is a large full-length picture of a ballet-girl in the principal gallery called *Terpsichore* by A. Ludovici, jun., that we are sorry to see there. The art of painting is intended for something better than representations of ballet-girls, and whilst there may be grace in postures in a dance, we decline to think that time and skilled labour are well spent in such designs as the one we are referring to.

This is a specimen of the kind of criticism one got in the eighties. All the critics could talk of was the subject, with the exception of two or three, who grasped what an artist was aiming at. The following year I met an artist at the Royal Academy who, pointing to a big picture hanging on the line in the Central Gallery of King David stricken in years lying on a bed surrounded by maidens, said to me quite seriously that I never should paint such a subject as a ballet-girl; if I wanted to paint an indecent picture I ought to choose something out of the Bible, or give the picture a Biblical title, then the subject would not matter! The picture of David and the maidens had no title, but was simply called *The First Book of Kings, Chapter I*. This was typical of England in those days.

Can't You Talk *exhibited Royal Academy 1875 (577).*

Philip Richard Morris R.A. (1836–1902) was a friend of Whistler's in the 1870s.

Thomas Stirling Lee (1856–1916), associate of Whistler's and exhibitor at the International Society (see page 320); Whistler moved into The Vale with Maud Franklin (see page 250) in May 1885. Terpsichore *was exhibited in the 1886 winter exhibition of the Society of British Artists.*

Claude Monet (1840–1926) was invited by Whistler to exhibit in the 1887 winter exhibition of what had then become the Royal Society of British Artists (see next entry). Sir William Quiller Orchardson R.A. (1832–1910); George Henry Boughton R.A. (1833–1905).

Three designs for a lion for the Society of British Artists. 1887. Hunterian Art Gallery, Glasgow University.

Interior of the Society of British
Artists' Exhibition. c. 1887. Ink,
7⅞ × 6¼" (20.1 × 15.9 cm).
Ashmolean Museum, Oxford.

ILLUSTRATED LONDON NEWS

"The Royal Society of British Artists"

10 December 1887

A review of the 1887 winter exhibition of the
Royal Society of British Artists; 1887 was
Queen Victoria's Jubilee year. Whistler made
twelve etchings of the Naval Review at
Spithead (K. 316–327) and presented them to
the Queen who granted a Royal Charter to the
Society of British Artists under Whistler's
presidency.

Since the day when Mr Whistler became first a member and subsequently President of this society, a notable change has been apparent in its exhibitions. Previously they had marked the downward progress of conventional art, until at last the overcrowded walls showed more jejune and slipshod productions than a second-rate Art school. From this drowsy condition, the society has been suddenly – too suddenly, perhaps some will say – awakened; and some of its supporters seem, to judge from their efforts, to be still in a half-dazed state. Be that as it may, the "British Artists," and especially those of them who are foreigners, have raised aloft a standard of eclecticism, round which we find many young aspirants to notoriety eager to rally. It is, therefore, only fitting that we should devote ourselves to the study of these eclectics, leaving the few survivors of the old state of things to draw what comfort they can from the smiles – of contempt or admiration – which the works of their new colleagues excite.

* * *

Coming to those artists whom we still retain, but whose merits are only partially recognized, the place of honour is shared between Mr Whistler and M Monet, to whom the Impressionists of England and France respectively look up with reverence. The President himself is not seen this year at his best. His reminiscences of the Naval Review – if such they are intended to be – *Grey and Silver, Southampton* and *Blue and Silver, Portsmouth* are of the very slightest, and suggest that at the former spot he was but half awake and at the latter already half asleep on that eventful but tiring day. In like manner, his *Grey Note* is, to us, too low; but his *Red Note* – a fête on the sands at Ostend – is full of the vigour and subtlety which characterized so many of his earlier works. M Monet, the father of the French Impressionists, works with very different materials, and in a very different method. Whilst Mr Whistler's works require the closest study and will bear the most minute examination, it is scarcely possible to get far enough away from M Monet's *Coast of Belle Isle*, with its iridescent sea and many-coloured rocks glistening and glittering in the full blaze of the sun, or from the *Village of Bennecourt*, where the slender poplars cast their tall shadows across the field. If looked at from any nearer standpoint, these pictures are meaningless *macédoines* of colour – crude and shocking; it is only at a distance that the spectator is able to seize the painter's aim, and to realize that, having himself received an impression of the scene, he is anxious to translate it by the medium of his own personality.

Watercolours.

YMSM 286 and 366.

The presence of four works by Claude Monet did not please some members, and was a factor which contributed to Whistler's resignation as president the following year (see below).

ST JAMES'S GAZETTE

"The Rise and Fall of the Whistler Dynasty. An Interview with Ex-President Whistler"

16 June 1888

Whistler was forced to resign from the Royal Society of British Artists on 4 June. The exhibitors he had attracted as new members, either painting in his, or Impressionist styles, were not conducive to enough profitable sales, and his opponents claimed a decline in the Society's income which Whistler hotly disputed (see The Gentle Art of Making Enemies*). He was succeeded by Wyke Bayliss (1835–1906) who shortly afterwards was knighted.*

The adverse vote by which the Royal Society of British Artists transferred its oath of allegiance from Mr Whistler is for the time the chief topic of conversation in artistic circles. Whether the British Artists' taste has tired of light comedy and yearns for "the serious drama" once more, or whether, as the side that is "in" declared the other day, wounded pride and an empty exchequer are responsible for the phenomenal blizzard that has for some time been raging in Suffolk-street, we do not intend for the moment to inquire. But inasmuch as we have already laid before our readers a report emanating in the first instance from the "Conquering Hero" faction, we instructed our representative to visit Mr Whistler to obtain his explanation of the affair, and as far as possible to elicit an autobiographical account of his rise and fall:–

"The state of affairs?" said Mr Whistler, in his light and airy way, raising his eyebrows and twinkling his eyes, as if it were all the best possible fun in the world; "why, my dear sir, there's positively *no* state of affairs at all. Contrary to public declaration, there's actually nothing chaotic in the whole business; on the contrary, everything is in order, just as it should be, and as is always the case in the event of a downfall of any kind. The survival of the fittest as regards the presidency, don't you see, and, well – Suffolk-street is itself again! A new Government has come in, and, as I told the members the other night, I congratulate the society on the result of their vote, for no longer can it be said that the right man is in the wrong place. No doubt their pristine sense of undisturbed somnolence will

again settle upon them after the exasperated mental condition arising from the unnatural strain recently put upon the old ship. Eh? what? Ha! ha!"

"You do not then consider the society as out of date? You don't think, as is sometimes said, that the establishment of the Grosvenor took away the *raison d'être* and original intention of the society – that of being a foil to the Royal Academy?"

"I can hardly say what was originally intended, but I do know it was originally full of hope and determination and that is proved, don't you see, by getting a Royal Charter – the only art society in London I believe that has one. But by degrees it lapsed into a condition of incapacity – a sort of secondary state, do you see, till it acknowledged itself a species of crèche for the Royal Academy. Certain it is that when I came into it the prevalent feeling among all the men was that their best work should go to 'another place.' I felt that this sense of inferiority was fatal to the well-being of the place, don't you see – very well. And for that reason I attempted to bring about a sense of *esprit de corps* and ambition, which culminated in what might be called 'my first offence' – by my proposition that members belonging to other societies should hold no official position in ours. I wanted to make it an art centre," continued Mr Whistler, with a sudden vigour and an earnestness for which the public would hardly give credit to this Master of Badinage and Apostle of Persiflage; "they wanted it to remain a shop, although I said to them 'Gentlemen, don't you perceive that as shopmen you have already failed, don't you see, eh!' But they were under the impression that the sales decreased under my methods and my régime, and ignored the fact that sales had declined all over the country from all sorts of causes, commercial and so on, don't you know – very well. Their only chance lay in the art tone, for the old-fashioned pictures had ceased to become saleable wares – buyers simply wouldn't buy them. But members' work I *couldn't* by the rules eliminate – only the bad outsiders were choked off."

"Then how do you explain the bitterness of all the opposition?"

"A question of 'pull devil, pull baker,' don't you see – and the devil has gone, and the bakers remain in Suffolk-street. Ha! ha! Here is a list of the fiendish party, who protested against the thrusting forth of their president in such an unceremonious way – Alfred Stevens, Waldo Story, Nelson Maclean, Theodore Roussel, Macnab, Ludovici, jun., Starr, Francis James Rixon, Aubrey Hunt, Lindner, Girardot, Ludby, Arthur Hill, Llewellyn Symons, C. Wyllie, A. Grace, J. E. Grace, J. D. Watson, Mortimer Menpes, Jacomb Hood, Thornely, J. J. Shannon and Charles Keene. Why, the very flower of the society! And whom have they left – *bon Dieu!* whom have they left?"

"It was a hard fight, then?"

"My dear sir, they brought up the maimed, the halt, the lame and the blind – literally – like in Hogarth's *Election*; they brought up everything but corpses, don't you know – very well."

"But all this hardly explains the bitterness of the feud and personal enmity to you."

"What? Don't you see? My presidential career had in a manner been a busy one. When I took charge of the ship I found her more or less waterlogged. Well, I put the men to the pumps, don't you understand, and thoroughly shook up, you know, the old vessel; had her re-rigged, recleaned and painted, don't you see – and finally I was graciously permitted to run up the Royal Standard at the masthead, and brought her fully to the fore, ready for action –.as became a Royal flagship, don't you see. And as a natural result mutiny at once set in!

"Don't you see," he continued, with one of his strident laughs, "what might be considered, by the thoughtless, as benefits, were resented, by the older and wiser of the crew, as innovations and intrusions of an impertinent and offensive nature. But the immediate result was that interest in the society was undeniably developed, not only at home, but certainly

Since its opening in 1877 the Grosvenor Gallery was often regarded as being in open competition with the Royal Academy.

Thomas Waldo Story (1855–1915); Thomas Nelson Maclean (1845–94); Peter Macnab (fl. 1864 – d. 1900); Sidney Starr (1857–1925); E. Aubrey Hunt (1855–1922); M. P. Lindner (1854–1949); Ernest-Gustave Girardot (fl. 1860–93); Max Ludby (1858–1943); Arthur Hill (fl. 1858–93); William Christian Symons (1845–1911); Charles William Wyllie (1853–1923); Alfred Fitzwalter Grace (1844–1903); John Dawson Watson (1832–92); Percy Jacomb-Hood (1857–1929); Charles Thornely (fl. 1858–98); James Jesuba Shannon (1862–1923); Charles Keene (see page 59).
[Election]: William Hogarth's series of four pictures of 1754 in the Sir John Soane Museum.

abroad – don't you know. Notably in Paris all the art circle was keenly alive to what was taking place in Suffolk-street; and, although their interest in other institutions in this country had previously flagged, there was the strong willingness, you know, to take part in its exhibitions, do you see? For example, there was M Alfred Stevens, who showed his own sympathy with the progressive efforts by becoming a member. And look at the throngs of people that crowded our private views – eh? – ha! ha! – don't you see – what! But what will you! – the question is, after all, purely a parochial one – and here I would stop to wonder, if I do not seem pathetic and out of character, why the Artist is naturally an object of vituperation to the Vestryman? – Why am *I* – who, of course as you know, am charming, why am I the pariah of my parish? –

E. R. AND J. PENNELL

THE WHISTLER JOURNAL

Whistler, Maud and Beatrice Godwin

1921

These were the years when Whistler said he had no private life and Maud shared in the publicity. Back in London, they lived together. First in Alderney Street where, Miss Chambers told us, it was whispered at one moment that her figure looked rather queer and she went to Paris, or so she explained to friends, and stayed away two months. From others, we have heard of a daughter with her mother's wonderful hair. This daughter and John are Whistler's only children of whom we have a positive record, though from Mr Percy Thomas, during a visit he paid us on *4 October 1906*, we heard of four, a number unconfirmed by any one else. On her return, Whistler and Maud moved to the "Pink Palace" in Fulham, then to The Vale, Chelsea. Whistler, though he sold his etchings, could not sell his pictures, and was still miserably poor. Maud did everything for him, as in Venice, M Duret says and he never went to share with them the dinner Maud cooked without a bottle of wine and some fruit or pastry in his pockets. All this while Maud called herself Mrs Whistler, and was known as Mrs Whistler to Chelsea tradesmen and cabmen. Mrs Whistler was engraved on her cards, Maud Whistler was signed to her letters: two with this signature were published by Otto Bacher in his book about Whistler in 1908, the book suppressed by Whistler's executrix, though not because of Maud's letters. Some of Whistler's old friends say that he introduced her and spoke of her to them as Mrs Whistler; others, that *Madame* was his name for her, though he might occasionally refer to her as "my pupil." She was seen in many places with him, paid weekend visits with him, was prominent at British Artists' functions with him, where M Duret has told us that he, as foreigner and *garçon*, was ready to give her his arm if the respectable native hesitated. Always a few people accepted her, though the difficulty came after Whistler married. A friend was quoted to us as saying she could know one but not two Mrs Whistlers. The situation was of a kind not likely to be ignored by gossip, and gossip made the most of it, as of everything connected with Whistler. It was an impossible state of affairs for them both. If the few accepted Maud, the many did not. Whistler loved society, and to most houses to which he was invited, Maud did not go. On the other hand, in the houses to which she did go she was often an embarrassment. She would stay hours, Miss Chambers explained, and if people came in, there was no knowing by what name to introduce her.

Whistler first met the artist and model Maud Franklin (christened Mary, 1857–1941?) in about 1872 and she thereafter posed to Whistler for numerous figure studies in both painting and etching. She exhibited at the Grosvenor Gallery and at the Society of British Artists as a "pupil of Whistler" under the name "Clifton Lin."

i.e. after their return from Venice in November 1880.
The sister of Charles Augustus Howell.

Ione was born to Maud, probably in 1877; a second girl registered Maud McNeill Whistler Franklin was born on 13 February 1879; there was probably at least one pregnancy and/or a child who died in infancy; see Margaret MacDonald, "Maud Franklin," James McNeill Whistler, *a re-examination,* Studies in the History of Art, *vol. 19, N.G., Washington 1987.*

The Pennells mistake "John" for Charles James Whistler Hanson, born to Whistler and Louisa Hanson, parlourmaid, on 10 June 1870; they knew him as Whistler's secretary, but his true identity was not revealed during their association with Whistler.
Bacher's book was With Whistler in Venice, The Century Company, New York, *1908 (see page 153). Rosalind Birnie Philip (see page 52) was Whistler's executrix. After Whistler's death she retained copyright in his letters and prevented the Pennells from quoting them in their biography (1908).*

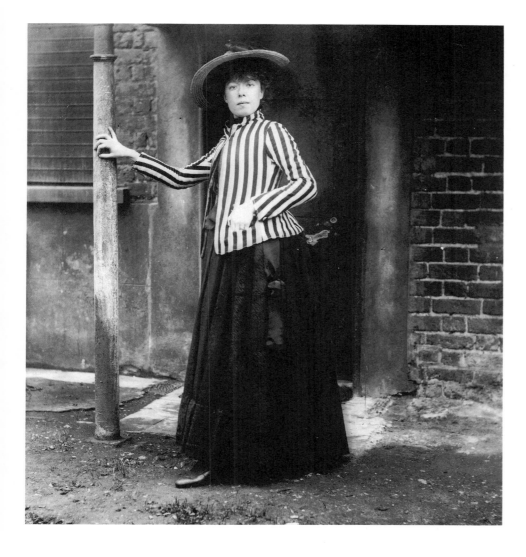

Photograph of Maud Franklin in a striped jacket. Pennell Collection (Prints and Photographs Division), Library of Congress, Washington, D.C.

Then Whistler would turn up and fetch her away and it was uncomfortable for everybody. Both had high tempers. Gossip rejoiced in tales of violent scenes in the "Pink Palace." Details are in Walter Greaves' talk with J. But it is useless to revive this unpleasantness of the past. All who knew them must have foreseen the end.

Whistler tired of so intolerable a life. Besides, his friendship with Mrs Godwin was strengthening. He had known her before he went to Venice. Godwin was his friend, the architect of the White House, the first to praise his Venetian work and his decorative scheme for its exhibition, which was a joke to the average critic. Godwin died in 1886. Mrs Dr Whistler told us (1 October 1906) that he was buried in a corner of a field somewhere down in the country and Mrs Godwin, Lady Archibald Campbell and Whistler had gone with the coffin, in some sort of an open cart, and they had covered up the coffin and made quite a picnic of it – perhaps what all funerals ought to be made if taken in the right way. Mrs Godwin lived in Chelsea after her husband's death, and gradually came more and more often to the studio. Lady Colin Campbell, then sitting – or rather standing – for her portrait, was inclined to resent the daily interruption, Mrs Godwin's arrival being the signal for work to stop. She chaffed Whistler about "the little widdie," but chaff could not reconcile her to the loss of her portrait which was never finished and disappeared after it was exhibited at the British Artists – destroyed by Whistler, Miss Philip informed her. Maud had not only a high temper, but the jealousy that goes with it. Her resentment had a more serious reason, than Lady Colin's, and the position grew strained beyond endurance. The crisis came with the exhibition of the British Artists in 1887. William Stott of Oldham showed a Venus with red hair which gossip declared was Maud's. Her portrait by Whistler – the

The conversation between Joseph Pennell and Whistler's pupil Walter Greaves (see page 104) took place in 1906; see The Whistler Journal.
Beatrice Godwin (see page 273).

Helen Whistler (née Ionides), the wife of Whistler's brother Dr William Whistler.

YMSM 354 exhibited in the 1885 winter exhibition of the Society of British Artists.

William Stott's (1857–1900) Venus Born of the Sea Foam *(Oldham Art Gallery); this brought Whistler into a violent, much*

portrait in bonnet and furs owned by Mrs Walter Sickert and by her returned to Whistler – was in another room: "the lady in her right clothing," the critics wrote. There was excitement, talk, and Whistler's indignation was natural, whether or no he believed the scandal. A little later Maud went to stay with the Stotts. While she was away, he left the house in The Vale, never to return. A tie so deliberately broken could not be mended. In 1888 Whistler married Mrs Godwin. Mrs Jopling-Rowe, who went with Mrs Godwin to the church, thought Whistler was uneasy during the ceremony, he looked from side to side as if in fear that Maud might be there.

Maud did not accept the inevitable by amiably effacing herself. When the Whistlers took their apartment in the Rue du Bac, she arrived in Paris and rented an apartment in the neighbourhood. She did not drop the Mrs Whistler from her cards. It was not pleasant for Whistler. But then, it was not pleasant for her. She was poor and alone. She returned to her profession, trying through M Duret, to pose, among others, to Miss Mary Cassatt. In the end, she married a rich South American.

publicized, physical conflict with Stott. Whistler's portrait of Maud was either Harmony in Black, No. 10, YMSM 367, or YMSM 186; in the same exhibition he also showed a portrait of Beatrice Godwin, Harmony in Red: Lamplight, YMSM 253 (Colourplate 68).

According to Margaret MacDonald (see page 250) Maud first lived with a New Yorker, John Abro Little, by whom she had a son, John. After Little's death she married an American, Richard H. S. Abbott, and lived at a villa near Cannes until her death, probably in 1941. She spurned all approaches for information from Whistler biographers. Mary Cassatt (1845–1926).

ALGERNON CHARLES SWINBURNE

FORTNIGHTLY REVIEW

"Mr Whistler's Lecture on Art"

June 1888

AN APOSTASY

To speak the truth, the whole truth, and nothing but the truth may justly be required of the average witness; it cannot be expected, it should not be exacted, of any critical writer or lecturer on any form of art. . . .

. . . And it appears to one at least of those unfortunate "outsiders" for whose judgement or whose "meddling" Mr Whistler has so imperial and Olympian a contempt. . . .

Let us begin at the end, as all reasonable people always do: we shall find that Mr Whistler concedes to Greek art a place beside Japanese. Now this, on his own showing, will never do; it crosses, it contravenes, it nullifies, it pulverizes his theory or his principle of artistic limitation. If Japanese art is right in confining itself to what can be "broidered upon the fan" – and the gist of the whole argument is in favour of this assumption – then the sculpture which appeals, indeed, first of all to our perception of beauty, to the delight of the eye, to the wonder and the worship of the instinct or the sense, but which in every possible instance appeals also to far other intuitions and far other sympathies than these, is as absolutely wrong, as demonstrably inferior, as any picture or as any carving which may be so degenerate and so debased as to concern itself with a story or a subject. Assuredly Phidias thought of other things than "arrangements" in marble – as certainly as Æschylus thought of other things than "arrangements" in metre. Nor, I am sorely afraid, can the adored Velazquez be promoted to a seat "at the foot of Fusi-yama." Japanese art is not merely the incomparable achievement of certain harmonies in colour; *it is the negation, the immolation, the annihilation of everything else.* By the code which accepts as the highest of models and of masterpieces the cups and fans and screens with which "the poor world" has been as grievously "pestered" of late years as ever it was in Shakespeare's time "with such waterflies – "diminutives of nature" – as excited the scorn of his moralizing cynic,

It appears that the poet Swinburne's companion, the writer and one-time friend of Whistler, Theodore Watts-Dunton, played no small a part in influencing this adverse review of the "Ten O'Clock" lecture which Whistler had originally requested, through Watts-Dunton, Swinburne should write. It was published in The Fortnightly Review, *June 1888, pages 745–51. When he came to edit it, (reprinted here from* The Gentle Art *without Whistler's marginal glosses but with passages italicized by Whistler) he omitted, in his pain, all of Swinburne's praise, some of which was fulsome.*

Velazquez is as unquestionably condemned as is Raphael or Titian. It is true that this miraculous power of hand (?) makes beautiful for us the deformity of dwarfs, and dignifies the degradation of princes; but that is not the question. It is true, again, that Mr Whistler's own merest "arrangements" in colour are lovely and effective; but his portraits, to speak of these alone, are liable to the damning and intolerable imputation of possessing not merely other qualities than these; but qualities which actually appeal – I blush to remember and I shudder to record it – which actually appeal to the intelligence and the emotions, to the mind and heart of the spectator. It would be quite useless for Mr Whistler to protest – if haply he should be so disposed – that he never meant to put study of character and revelation of intellect into his portrait of Mr Carlyle, or intense pathos of significance and tender depth of expression into the portrait of his own venerable mother. The scandalous fact remains, that he has done so; and in so doing has explicitly violated and implicitly abjured the creed and the canons, the counsels and the catechism of Japan. . . .

Query added by Whistler.

COLOURPLATES 38 *and* 30 *(YMSM 137 and 101).*

And when Mr Whistler informs us that "there never was an artistic period," we must reply that the statement, so far as it is true, is the flattest of all possible truisms; for no mortal ever maintained that there ever was a period in which all men were either good artists or good judges of art. But when we pass from the positive to the comparative degree of historic or retrospective criticism, we must ask whether the lecturer means to say that there have not been times when the general standard of taste and judgement, reason and perception, was so much higher than at other times and such periods may justly and accurately be defined as artistic. If he does mean to say this, he is beyond answer and beneath confutation; in other words, he is where an artist of Mr Whistler's genius and a writer of Mr Whistler's talents can by no possibility find himself. If he does not mean to say this, what he means to say is exactly as well worth saying, as valuable and as important a piece of information, as the news that Queen Anne is no more, or that two and two are not generally supposed to make five.

But if the light and glittering bark of this brilliant amateur in the art of letters is not invariably steered with equal dexterity of hand between the Scylla and Charybdis of paradox and platitude, it is impossible that in its course it should not once and again touch upon some point worth notice, if not exploration. Even that miserable animal the "unattached writer" may gratefully and respectfully recognize his accurate apprehension and his felicitous application of well-nigh the most hackneyed verse in all the range of Shakespeare's – which yet is almost invariably misconstrued and misapplied – "One touch of nature makes the whole world kin"; and this, as the poet goes on to explain, is that all, with one consent, prefer worthless but showy novelties to precious but familiar possessions. "This one chord that vibrates with all," says Mr Whistler, who proceeds to cite artistic examples of the lamentable fact, "this one unspoken sympathy that pervades humanity, is – Vulgarity." But the consequence which he proceeds to indicate and to deplore is calculated to strike his readers with a sense of mild if hilarious astonishment. It is that men of sound judgement and pure taste, quick feelings and clear perceptions, most unfortunately and most inexplicably begin to make their voices "heard in the land." Porson, as all the world knows, observed of the Germans of his day that "in Greek" they were "sadly to seek." It is no discredit to Mr Whistler if this is his case also; but then he would do well to eschew the use of a Greek term lying so far out of the common way as the word "æsthete." Not merely the only accurate meaning, but the only possible meaning, of that word is nothing more, but nothing less, than this – an intelligent, appreciative, quick-witted person; in a word, as the lexicon has it, "one who perceives." The man who is no æsthete stands confessed, by the logic of language and the necessity of the case, as a thick-witted, tasteless, senseless and impenetrable blockhead. I do not wish to insult Mr Whistler, but I feel bound to avow my impression that there is no man

Richard Porson (1759–1808), classical scholar and elucidator of Greek idioms.

now living who less deserves the honour of enrolment in such ranks as these – of a seat in the synagogue of the anæsthetic. . . .

. . . Such abuse of language is possible only to the drivelling desperation of venomous or fangless duncery: it is in higher and graver matters, of wider bearing and of deeper import, that we find it necessary to dispute the apparently serious propositions or assertions of Mr Whistler. *How far the witty tongue may be thrust into the smiling cheek* when the lecturer pauses to take breath between these remarkably brief paragraphs it would be certainly indecorous and possibly superfluous to inquire. But his theorem is unquestionably calculated to provoke the loudest and the heartiest mirth that ever acclaimed the advent of Momus or Erycina. For it is this – that "Art and Joy go together," *and that tragic art is not art at all.* . . .

Blame or Desire, Horace Odes, *Book 1. ii.*

. . . The laughing Muse of the lecturer, "quam Jocus circumvolat," must have glanced round in expectation of the general appeal, "After that let us take breath." And having done so, they must have remembered that they were not in a serious world; that they were in the fairyland of fans, in the paradise of pipkins, in the limbo of blue china, screens, pots, plates, jars, joss-houses, and all the fortuitous frippery of Fusi-yama.

"about whom hovers mirth", Horace Odes, *Book 1. ii.*

It is a cruel but an inevitable Nemesis which reduces even a man of real genius, keen-witted and sharp-sighted, to the level of the critic Jobson; to the level of the *dotard and the dunce*, when paradox is discoloured by personality and merriment is distorted by malevolence (!) No man who really knows the qualities of Mr Whistler's best work will imagine that he really believes the highest expression of his art to be realized in reproduction of the grin and glare, the smirk and leer, of Japanese womanhood as represented in its professional types of beauty; but to all appearance he would fain persuade us that he does.

Exclamation added by Whistler.

In the latter of the two portraits to which I have already referred there is an expression of living character. . . . This, however, is an exception to the general rule of Mr Whistler's way of work: an exception, it may be alleged, which proves the rule. A single infraction of the moral code, a single breach of artistic law, suffices to vitiate the position of the preacher. And this is no slight escapade, or casual aberration; it is a full and frank defiance, a deliberate and elaborate denial, hurled right in the face of Japanese jocosity, flung straight in the teeth of the theory which condemns high art, under penalty of being considered intelligent, to remain eternally on the grin.

If it be objected that to treat this theorem gravely is "to consider too curiously" the tropes and the phrases of a *jester* of genius, I have only to answer that it very probably may be so, but that the excuse for such error must be sought in the existence of the genius. A man of genius is scarcely at liberty to choose whether he shall or shall not be considered as a serious figure – one to be acknowledged and respected as an equal or a superior, not applauded and dismissed as *a tumbler or a clown*. And if the better part of Mr Whistler's work as an artist is to be accepted as the work of a serious and intelligent creature, it would seem incongruous and preposterous to dismiss the more characteristic points of his theory as a lecturer with the chuckle or the shrug of mere amusement or amazement. Moreover, if considered as a joke, a mere joke, and nothing but a joke, this gospel of the grin has hardly matter or meaning enough in it to support so elaborate a structure of paradoxical rhetoric. It must be taken, therefore, as something serious in the main; and if so taken, and read by the light reflected from Mr Whistler's more characteristically brilliant canvases, it may not improbably recall a certain phrase of Molière's which at once passed into a proverb – "Vous êtes orfèvre, M. Josse [You are a goldsmith, M. Josse]." That worthy tradesman, it will be remembered, was of opinion that nothing could be so well calculated to restore a drooping young lady to mental and physical health as the present of a handsome set of jewels. *Mr Whistler's opinion that there is nothing like leather – of a jovial and Japanese design – savours somewhat of the Oriental cordwainer.*

"You're a goldsmith, Mr Josse, and your advice betrays a man eager to sell his jewelry," Molière, L'Amour Médecin, *1665, I, i (Sganarelle).*

JAMES MCNEILL WHISTLER

THE WORLD

A Riposte to Swinburne

3 June 1888

Reprinted from The Gentle Art of Making Enemies *(1892)*.

"ET TU, BRUTE!"

Why, O brother! did you not consult with me before printing, in the face of a ribald world, *that you also misunderstand*, and are capable of saying so, with vehemence and repetition?

Have I then left no man on his legs? – and have I shot down the singer in the far off, when I thought him safe at my side?

Cannot the man who wrote *Atalanta* – and the *Ballads* beautiful, – can he not be content to spend his life with *his* work, which should be his love, – and has for him no misleading doubt and darkness – that he should so stray about blindly in his brother's flower-beds and bruise himself!

Atlanta in Calydon *(1865)*; Poems and Ballads *(1866)*.

Is life then so long with him, and *his* art so short, that he shall dawdle by the way and wander from his path, reducing his giant intellect – garrulous upon matters to him unknown, that the scoffer may rejoice and the Philistine be appeased while he takes up the parable of the mob and proclaims himself their spokesman and fellow-sufferer? O Brother! where is thy sting! O Poet! where is thy victory!

How have I offended! and how shall you in the midst of your poisoned page hurl with impunity the boomerang rebuke? "Paradox is discovered by personality, and merriment is distorted by malevolence."

Who are you, deserting your Muse, that you should insult my Goddess with familiarity, and the manners of approach common to the reasoners in the market-place. "Hearken to me," you cry "and I will point out how this man, who has passed his life in her worship, is a tumbler and a clown of the booths – how he who has produced that which I fain must acknowledge – is a jester in the ring!

Do we not speak the same language? Are we strangers, then, or, in our Father's house are there so many mansions that you lose your way, my brother, and cannot recognize your kin?

Shall I be brought to the bar by my own blood, and be borne false witness against before the plebeian people? Shall I be made to stultify myself by what I never said – and shall the strength of your testimony turn upon me? "If" – "If Japanese Art is right in confining itself to what can be broidered upon the fan" . . . and again . . . "that he really believes the highest expression of his art to be realized in reproduction of the grin and glare, the smirk and leer" . . . and further . . . "the theory which condemns high art, under the penalty of being considered intelligent, to remain eternally on the grin" . . . and much more!

"Amateur writer!" Well should I deserve the reproach, had I ventured ever beyond the precincts of my own science – and fatal would have been the exposure, as you, with heedless boldness, have unwittingly proven.

Art tainted with philanthropy – that better Art result! – Poet and Peabody!

You have been misled – you have mistaken the pale demeanour and joined hands for an outward and visible sign of an inward and spiritual earnestness. For you, these are the serious ones, and, for them, you others are the serious matter. Their joke is their work. For me – why should I refuse myself the grim joy of this grotesque tragedy – and, with them now, you all are my joke!

255

Bravo! Bard! and exquisitely written, I suppose, as becomes your state.

The scientific irrelevancies and solemn popularities, less elaborately embodied, I seem to have met with before – in papers signed by more than one serious and unqualified sage, whose mind also was not narrowed by knowledge.

I have been "personal," you say; and, faith! you prove it!

Thank you, my dear! I have lost a *confrère*; but, then, I have gained an acquaintance – one Algernon Swinburne – "outsider" – Putney.

Published in The World, *3 June 1888; reprinted from* The Gentle Art of Making Enemies *1892.*

WALTER RICHARD SICKERT

THE PALL MALL GAZETTE

"Impressionism – True and False"

2 February 1889

SIR, – "*Je suis luministe*," says the Impressionist artist in "*La Cigale*," the original of the Gaiety "*Grasshopper.*" "*Si je ferais votre portrait je vous ferais probablement violet* [I am a Luminist. If I did your portrait I would probably make you violet]." To paint in violet and green spots is popularly supposed to be the note of the French Impressionism, or as it is now the fashion to call its latest development in Paris, "le vibrisme." With us "Impressionism" probably conveys to most people the idea of very large crop of funny frames containing very small pictures which you can't make out. And just as the visitor to the Exhibition of the "Société des Impressionistes" in Paris may well be pardoned if he overlooks, in the crowd of prismatic mannerisms, the calm and unobtrusive presence of works by the greatest draughtsman since the time of Holbein, so do we here run a risk of losing sight of the master in the crowd of his noisy mimics. For to English ears the word "Impressionist" calls up associations of one name, and one name only, and, strangely enough, that of a painter who has always repudiated with emphasis its application to him or his work. And he has done wisely if he is to be made responsible for all the sorry brood of callow art-product that would take refuge under the "citron wing" of the butterfly. And yet this plague of "Whistler for the million" may have been sent to the master as a salutary chastening in some things. He has allowed his work, essentially and invariably serious, and with qualities inimitable, to be presented in certain quaint garbs, and accompanied by certain external flourishes that could easily be imitated, and he has invited rather than discouraged the familiarity with it of a joyous five o'clock tea throng, whom the carpet and the crush of the exhibition room "passioned," and who would hardly notice the substitution on the walls of something cheaper, in queerer frames, for his "Notes, Harmonies, Nocturnes." He has been too lavish of his good things, and while the student and the specialist basked gratefully in the generous rays, the public that he had called in with the big drum forgot before a "hint in apple-green," which merely puzzled them, the painter of Carlyle and Sarasate. They thought that perhaps the point of the show consisted in the number of works executed in a given time. They did not know that if speed, as such, were a quality in art, the picture factories that avail themselves of the judicious help of a detective camera can leave Velazquez miles behind. No, he has mistaken his audience. His audience is an entirely serious one.

Walter Richard Sickert (1860–1942), together with Mortimer Menpes (see page 202), became Whistler's closest follower and pupil. Introduced to Degas by Whistler he adopted the theatre subjects of the former and painted the shop fronts and tiny seascapes favoured by the latter in St. Ives early in 1884 where all three artists worked together. He later fell out with Whistler (see page 276); by the time of Whistler's death, he had begun to revise his assessment of Whistler's place in modern English art.

Meilhac and Halévy's La Cigale *("The Grasshopper") in which Impressionism – particularly the art of Degas in the person of Marignan – is satirized, was first produced in Paris in 1877. In its English adaptation, Marignan's counterpart, Pygmalion Flippit, was based on Whistler.*

[Vibrisme]: *the paintings of Seurat and his followers.*

i.e. Degas; Hans Holbein (1497/8–1543).

i.e. Whistler (for Whistler's own repudiation of French Impressionist developments see page 273).

COLOURPLATE 38 *and* PAGE 244 *(YMSM 137, 315).*

They know every stroke of his brush, and every scratch of his needle, and they neither need to be gathered in by any advertisement, nor will consent to be misled even by himself. And for a work like the portrait of the painter's mother, or a monument of colour decoration like the *Peacock room*, or, more wonderful perhaps than either, for such triumphs of selection and summary expression in pure line as his latest etchings, they will refuse to accept as any sort of substitute the burlesque of disciple or follower, authorized or unauthorized, whether he superfluously confess his obvious obligations or, droller still, gravely repudiate them. – I am &c.,

W. S.

30 January

HENRI DE RÉGNIER

MERCURE DE FRANCE

"Encounters"

1931

The Symbolist poet Henri de Régnier (1864–1936) was a friend of Stéphane Mallarmé who translated Whistler's "Ten O'Clock" lecture into French in 1888. His memoirs contain several telling observations concerning their friendship.

Mallarmé instantly succumbed to Whistler's magic and was touched, as though by a conjuror's wand, by the ebony cane which this great dandy of painting wielded so elegantly. Everything in Whistler justified the curiosity and affection Mallarmé felt for him: his mysterious and pondered art, full of subtle practices and complicated formulae, the singularity of his person, the intelligent tension in his face, the lock of white hair amid the black, the diabolical monocle restraining his frowning brows, his prompt wit in the face of the scathing retorts and cruel ripostes, that ready and incisive wit which was his weapon of defence and attack.

JORIS-KARL HUYSMANS

CERTAINS

"Wisthler"

1889

Joris-Karl Huysmans (1848–1907), novelist and author of À Rebours (Against Nature) *(1884), whose "decadent" hero Des Esseintes was based on Comte Robert de Montesquiou (see page 274), first wrote about Whistler, whom he persistently referred to as "Wisthler," in 1883. A copy of* À Rebours, *with the dedication "À M. James Wisthler, l'un de ses fervents, J. K. Huysmans" (To Mr James Wisthler, from one of his admirers, J. K. Huysmans) is in the Whistler Collections, Glasgow University Library.*

The observant and acute author of "avant-garde" criticism, M Théodore Duret, who was one of the first to defend Manet, the Impressionists and all the refugees from the successful world of art, informs us that Mr James Mc Neil Wisthler [sic] was born in Baltimore, the son of a major in the American army, and that like Edgard [sic] Poe he attended the courses at the West Point Military Academy and, also like the poet, hastened to escape a future of barracks and guard duty.

Coming to Paris in 1857, he enrolled in Gleyre's studio, sent canvases to the official salons of 1859 and 1860 which the jury rejected; in 1863 he was represented in the Salon des Refusés by a woman clothed in white standing out against a white background. Here is the description of the work, which I am copying from a now rare booklet by Fernand Desnoyers.

257

"The most singular painting, the most original, is that by Mr Wisthler. The title of his picture is *The White Girl*. It is the portrait of a spiritualist, of a medium. The figure, the attitude, the physiognomy, the colour, are all strange. It is both simple and fanciful; the face has a haunted and charming expression which rivets the attention. There is something shadowy and profound in the gaze of this young woman whose beauty is so particular that the public does not know whether to find her ugly or beautiful. This portrait is living, it is a remarkable and delicate painting, one of the most original to have come before the eyes of the jury."

In 1865, the customs officials of the Institut allowed in *La Princesse des Pays de la Porcelaine* [The Princess from the Land of Porcelain]. "A princess of a thousand and one days, as radiant as those forms which the imagination can conceive above the clouds, is standing, with hair ruffled and trailing her draperies over a sky-blue patterned carpet. I hope her costume sets a trend; this winter she may perhaps come to some court ball where the princess of the lands of porcelain will shine; in a pearl-grey dress with a floral pattern, a saffron-coloured cloak, and a bouquet of tropical flowers, a scarlet belt, and a fan of bird-of-paradise feathers in her right hand. The background is a pale screen and, above it, whiteish panelling. As a colourist's fantasy, this princess drives one wild" (William Bürger, Salon of 1865).

In 1867 Mr Wisthler exhibited a canvas, *At the piano*, and, having long since settled in England, he no longer aroused discussion, and no longer exhibited in France.

But in 1878 rumour of his court case against Mr Ruskin crossed the Channel. In the review *Fors Clavigera* Mr Ruskin, the defender of the Pre-Raphaelites, declared in connection with certain of the painter's pictures, including his *Harmonies* and *Nocturnes*, that he had "seen, and heard, much of Cockney impudence before now; but never expected a coxcomb to ask 200 guineas for flinging a pot of paint in the public's face." Mr Wisthler was indignant and, like a good American, took legal action against the critic before the Exchequer Division for disparaging his stock-in-trade; and Mr Ruskin was ordered to pay him a farthing's damages.

Then Mr Wisthler decided to exhibit again in France. He sent to the 1882 salon a portrait that was black, ghost-like, and above all bizarre. Basically, it was not until the following year that we were to be able to admire the extraordinary personality of this painter.

He sent the portrait of his mother to the official salon – an old woman standing out in profile, clothed in black, against a grey wall and a black curtain, speckled with white. It is disturbing, the colour is unlike anything we are accustomed to. Yet the canvas is lightly painted, its grain almost showing through.

The harmony of the grey and the Chinese ink black were a joy for the eye, surprised by those deep and exquisitely calculated harmonies; it was realist painting, utterly intimate, but already unfolding in the realm of a dream.

Almost at the same time, at the international exhibition in the rue de Sèze, he was exhibiting his paintings that were well-known in London, his dream landscapes, his delicious *Nocturne in silver and blue* where a city built on a river bank rises into the blue; his *Nocturne in black and gold*, where fireworks burst forth from bloody wands and bespangle the shadows of a dense night; lastly, his *Nocturne in blue and gold*, representing a view of the Thames above which, in a faery mist, the pale rays of a golden moon light up shadowy forms of vessels lying asleep at anchor.

Inevitably, our thoughts turn to de Quincey's visions, to those vistas of rivers, whose fluid dreams are produced by opium. In their pale gold frames, streaked with turquoise and spangled with silver, these evocative watery sites stretching to infinity hint at cloistered thoughts, and transport the observer on magic carpets into times that have never been, regions

COLOURPLATE 16 *(YMSM 50) exhibited in the 1865 Salon.*

The pseudonym of the critic Théophile Thoré (see page 84); reprinted in Salons de W. Burger, 1861 à 1868, *2 vols, Paris 1870.*
COLOURPLATE 13 *(YMSM 24).*

See pages 128–133.

Arrangement in Black: Lady Meux YMSM 228 (Colourplate 48).

COLOURPLATE 30 *(YMSM 101).*

Whistler exhibited eight oil paintings in the Exposition Internationale de Peinture *Deuxième année, Galerie Georges Petit, 11 May–10 June 1883.*
COLOURPLATE 41 *(YMSM 113).*
i.e. The Falling Rocket YMSM 170 *(Colourplate 53); probably* Nocturne: Blue and Gold – Southampton Water YMSM 117.

Thomas De Quincey (1785–1859), whose Confessions of an English Opium Eater *influenced French literature.*

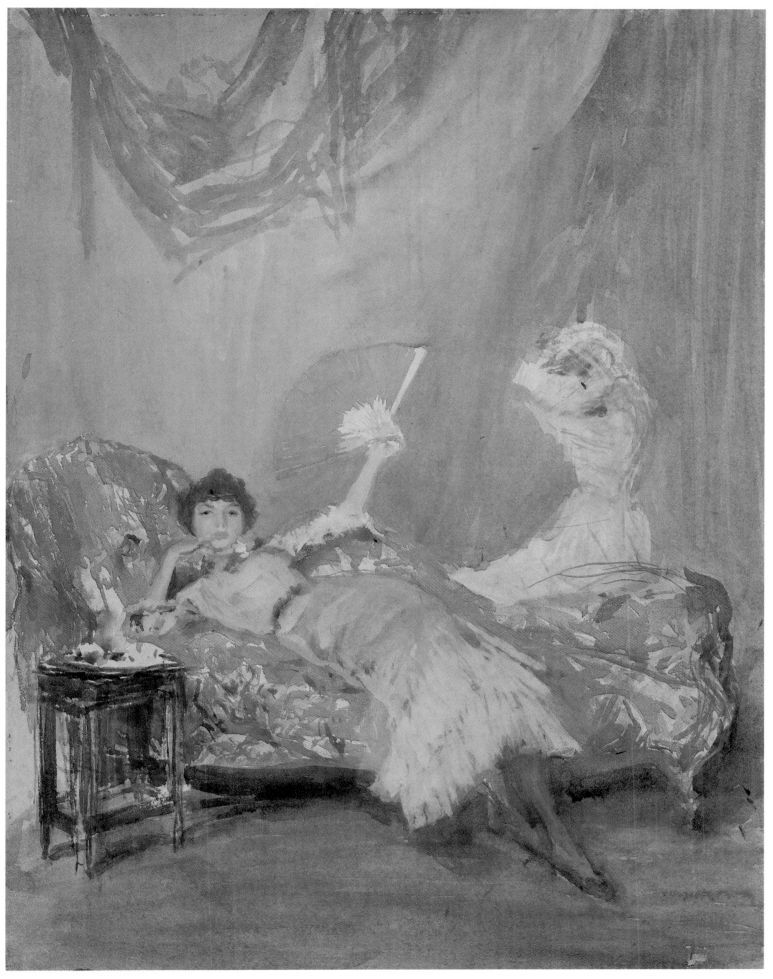

COLOURPLATE 80. *Milly Finch. c.* 1884. Watercolour, 11¾ × 8⅞″ (29.8 × 22.5 cm).
Freer Gallery of Art, Smithsonian Institution, Washington, D.C.

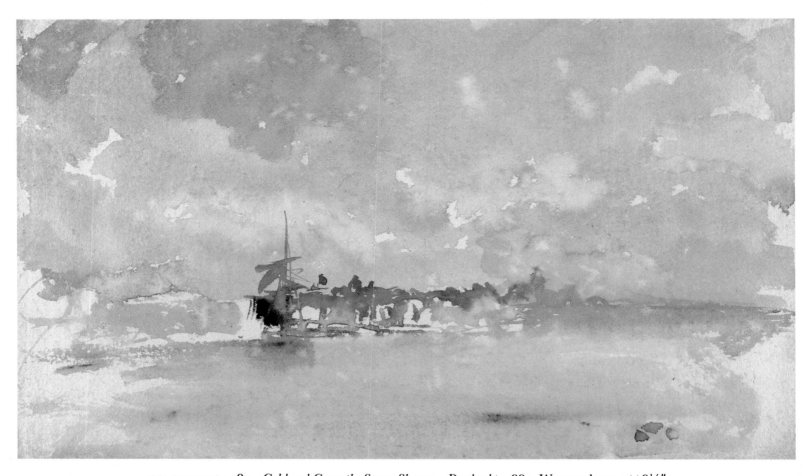

COLOURPLATE 81. *Gold and Grey: the Sunny Shower – Dordrecht.* 1884. Watercolour, 5 × 8½″
(12.7 × 21.6 cm).
Hunterian Art Gallery, Glasgow University.

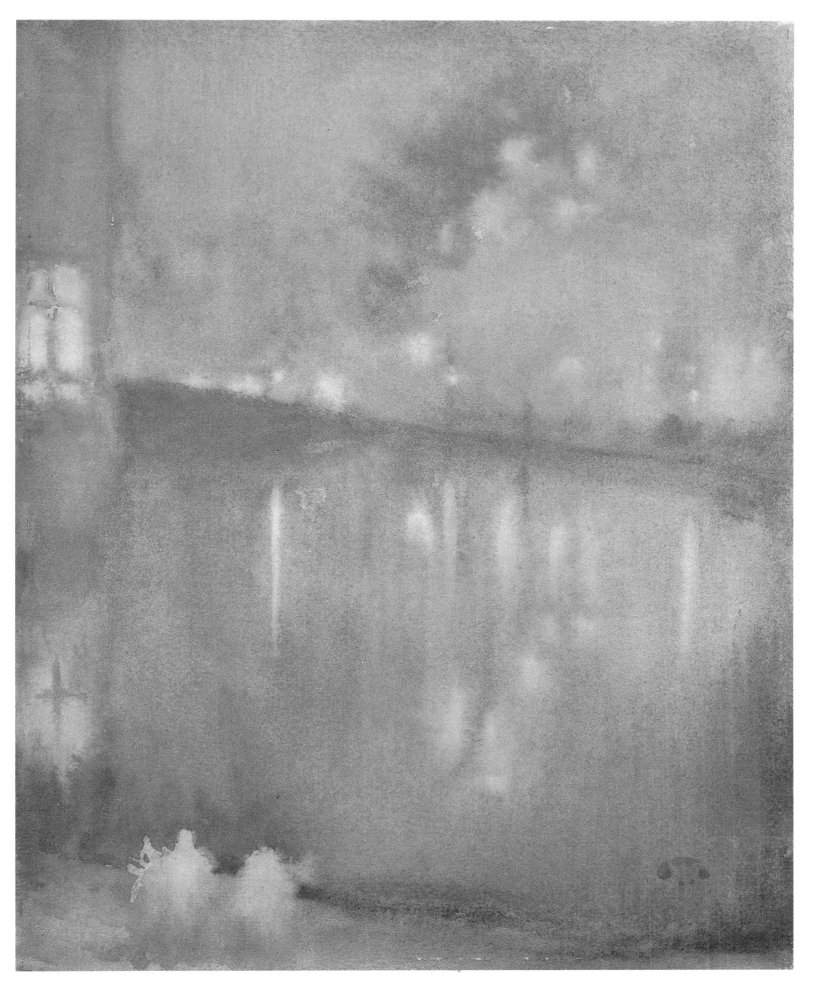

COLOURPLATE 82. *Nocturne: Grey and Gold – Canal, Holland.* 1883-84. Watercolour, 11½ × 9⅛″
(29.3 × 23.1 cm).
Freer Gallery of Art, Smithsonian Institution, Washington, D.C.

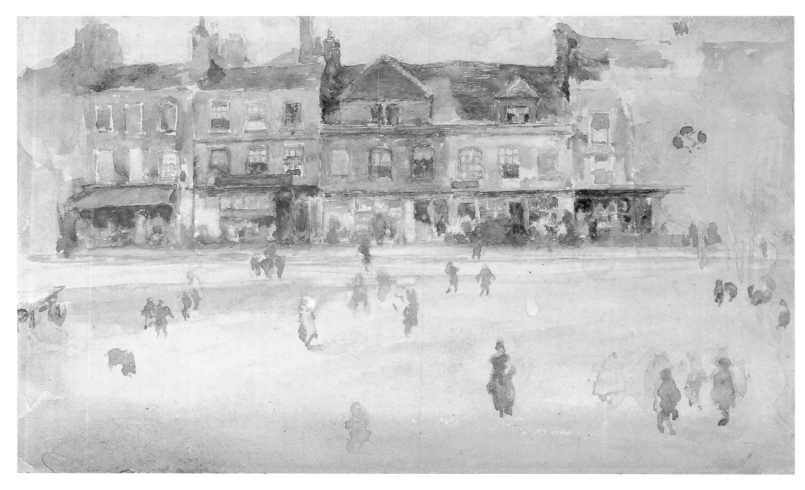

COLOURPLATE 83. *Chelsea Shops. c.* 1885. Watercolour, 4⅞ × 8¼″ (12.5 × 21 cm).
Freer Gallery of Art, Smithsonian Institution, Washington, D.C.

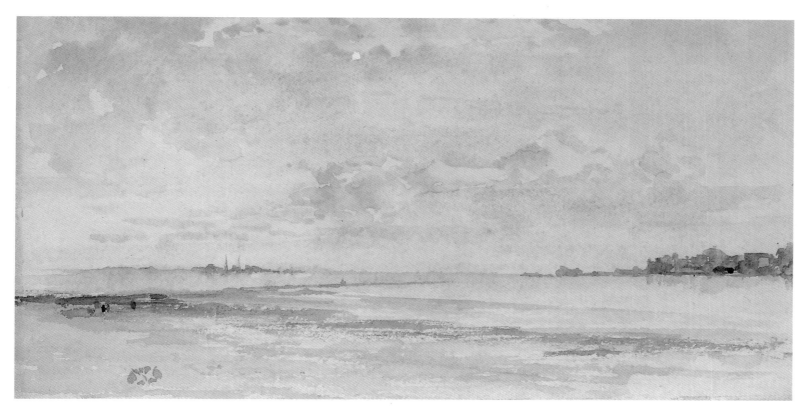

COLOURPLATE 84. *Note in Blue and Opal: The Sun Cloud.* 1884. 4⅞ × 8½″ (12.4 × 21.7 cm).
Freer Gallery of Art, Smithsonian Institution, Washington, D.C.

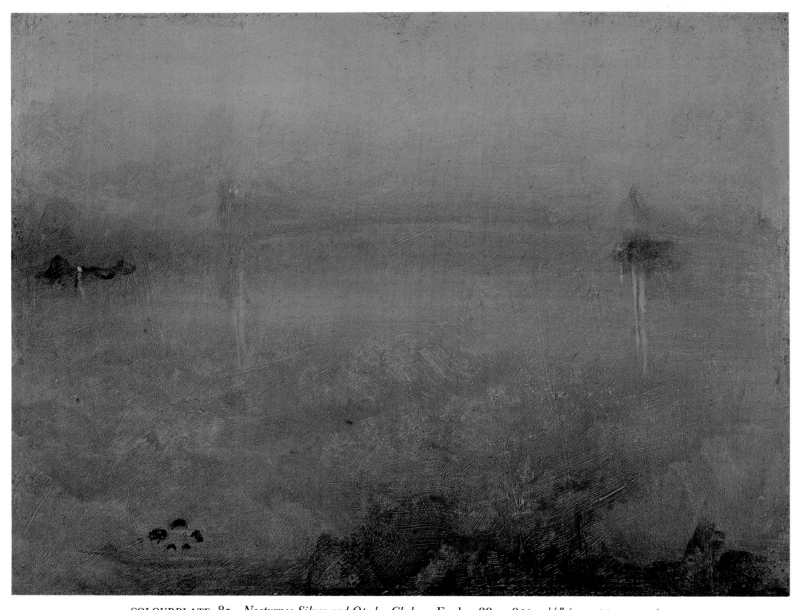

COLOURPLATE 85. *Nocturne: Silver and Opal – Chelsea*. Early 1880s. 8 × 10⅛″ (20.3 × 25.7 cm).
Freer Gallery of Art, Smithsonian Institution, Washington, D.C.

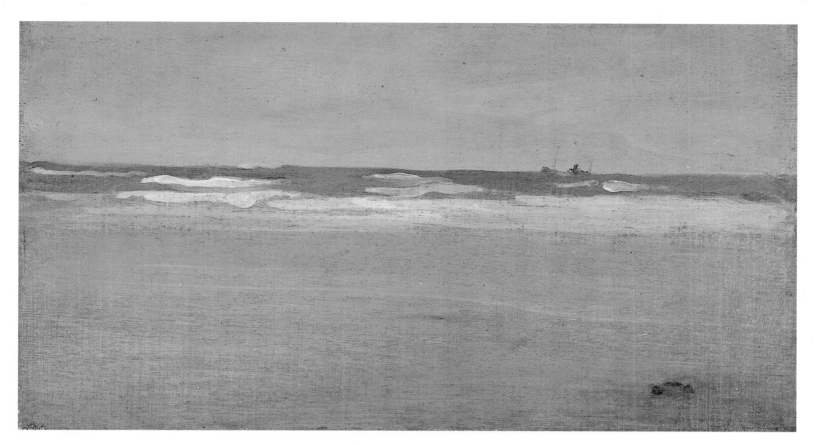

COLOURPLATE 86. *The Angry Sea.* 1884. 4⅞ × 8½″ (12.4 × 21.7 cm).
Freer Gallery of Art, Smithsonian Institution, Washington, D.C.

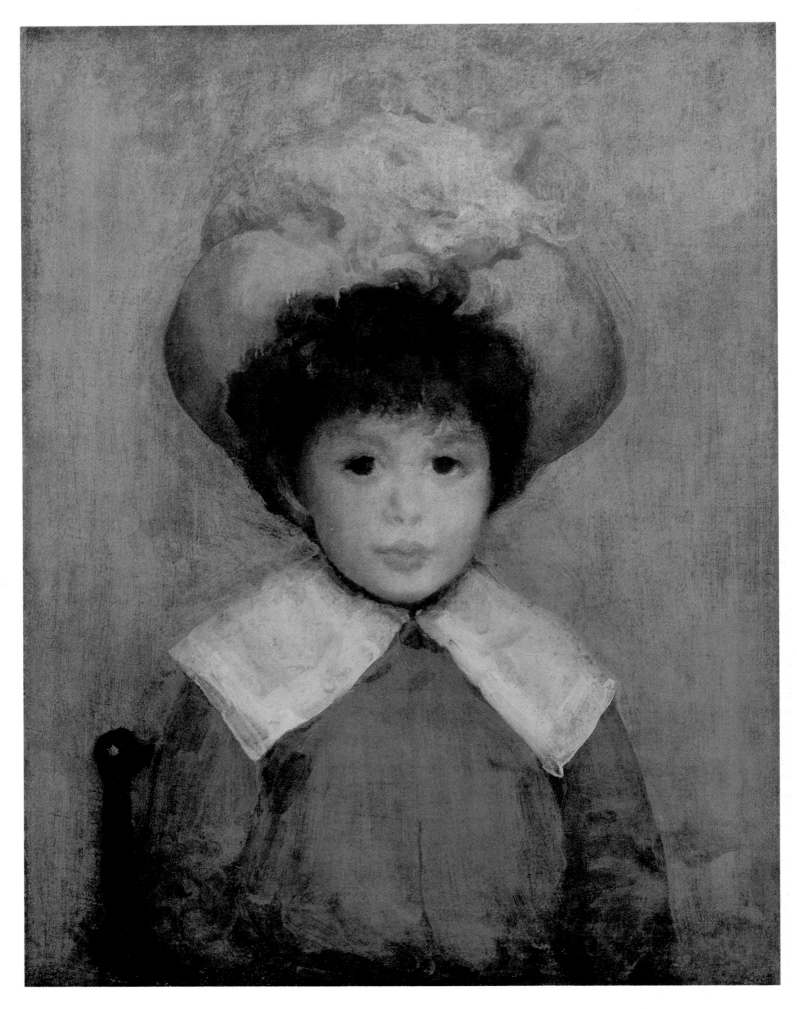

COLOURPLATE 87. *Arrangement in Grey: Portrait of Master Stephen Manuel. c.* 1885. 20 × 15″
(50.8 × 38.1 cm).
Freer Gallery of Art, Smithsonian Institution, Washington, D.C.

that never were, suspended worlds, far from modern life, far from everything, to the outermost margins of painting, and which seem to evaporate into invisible trails of colour on his airy canvases.

In 1884 the artist returned to public view with two portraits, those of *Miss Alexander* and of *Carlyle*. The historian who had the good faith to admit that basically there was no true history and who, somewhere, wrote this conclusive phrase: "Altars should be put up to solitude and silence," is seated in profile, in a full black frock-coat, with his hat on his knee. This sad, slightly surly figure, with his salt and pepper beard, breathes, meditates and slowly reflects; it is a portrait which gets under the skin, which projects a reflection of his innermost thoughts on to the sitter's features; it is a portrait of an open soul, but astonishing as it may seem, the one of *Miss Alexander* seems to me more admirable still.

Imagine a little girl, ash blonde, dressed in white, holding a grey felt hat with a feather and standing against a panel of amber-grey heightened by the pure black of a plinth; a little blonde girl, anaemic and aristocratic, offhand and mild, an English infanta moving in an atmosphere of grey, gilded from below by the unobtrusive gold of old silver-gilt. Also, its broad finish makes it appear barely painted, and it lives an intense life of its own, just like a Velazquez, painted boldly with such beautiful impasto in a range of silver greys.

As in the other works of Mr Wisthler, there is, in this canvas, a disconcerting unearthly touch. Admittedly, the figure bears the likeness of a real person, that is certain; admittedly, quite apart from physical appearance, there is a bit of her character in this painting, but there is also a supernatural side in this mysterious, slightly ghostly painter, which to some degree justifies the word "spiritualist" used by Desnoyers. One cannot indeed read the more or less truthful revelations of Dr Crookes concerning Katie, her female shadow embodying both tangible and fluid forms at the same time, without thinking of Wisthler's portraits of women, those ghost-portraits which seem to want to retreat, to sink into the wall, with their enigmatic eyes and glazed, ghoulish red mouths.

These reflections may perhaps be particularly applicable to the portrait of Sarasate which he lent in 1886, a portrait of a medium, tense and fleeting, and even to the splendid *Lady Archibald Campbell* who glorified the official Salon of 1885.

Portrayed from the side, almost from behind, with her face turned towards us, she retreats into black shadows which are both deep and warm; two strokes of tinder brown – her little shoes and the long gloves she is buttoning up – ring out through the darkness where the shadows lift a little towards the bottom of the canvas; but that is a mere accessory, a detail taking its place in the whole intended by the painter. Lady Campbell rises powerfully, with supreme elegance; from within her otterskin cape, and her dark dress, her tightly laced body quivers, her mysterious face is bent forward, her eyes haughty yet inviting, her mouth a dull repelling red. This time again the artist has drawn forth, from the flesh, an elusive expression of the soul, and he has also transmuted his model into a disquieting sphinx.

I shall not say anything for the moment of the portrait of M Duret who is portrayed in a black suit, holding a fan with red slats and a pink domino on his arm. It is a curious work, firm but with less of a thrust towards the beyond, and the colours are cheerless – almost those of a smooth, atonal Manet. Instead I come to the series of pictures – of landscapes, for the most part – which he exhibited in May 1887 in the gallery of Mr Georges Petit, and in May 1888 in the rooms of Mr Durand Ruel; a whole series of harmonies, of arrangements; a village entitled: green and opal; a view of Dieppe: silver and violet; a place in Holland: grey and yellow; a pastel: blue and mother of pearl; then duos in nasturtium red and pink, silver and mauve, lilac and gold; and lastly a solo sung by a sweet-shop, and entitled: an orange note sweet-shop.

YMSM 129, 137, both shown in the 1884 Salon. (Colourplates 46 and 38.)

Dr William Crookes, celebrated spiritualist of the 1880s.

YMSM 242, 315 shown in the Salons of 1885 and 1886 respectively. (Page 244 and Colourplate 62).

YMSM 252 also exhibited at the 1885 Salon. (Colourplate 74.)

Whistler exhibited 50 small oils, watercolours and pastels at the Galerie Georges Petit in May 1887; and Nocturnes as well as etchings and drawings at Durand-Ruel's in 1888.

An Orange Note: The Sweet Shop YMSM 264.

Unequal in value, these pictures – some of which seemed the merest sketches – confirmed our recognition of those landscapes exhibited in 1883 in the rue de Sèze: veiled horizons, glimpses of another world, twilights awash with warm rain, river mists, flights of blue haze, a whole range of fleeting nature, floating cities, languishing estuaries blurred in the confused light of dreams; in addition to being contemporary art, they were the painting of convalescence, utterly personal, utterly new, "the painting of the fluid" which this visionary has tried to render even in his more finished etchings, where he scatters monuments and cities with a few strokes, gives a sense of limitless space, and projects a quite unique sense of distance.

The work of an ultra-lucid artist, releasing the suprasensible from the real, these landscapes put me in mind of certain poems by Verlaine with their murmurous, cajoling sweetness, as though whispered in confession, barely brushed in. At times, like Verlaine, Mr Wisthler conjures up subtle suggestions, at others lulls us with a sort of incantation whose occult spell escapes us. Verlaine has clearly gone to the borders of poetry, to the point where it vanishes completely and the art of music begins. In his shaded harmonies, Mr Wisthler almost passes the frontiers of painting; he enters the realm of literature, and walks forwards along the melancholy banks where Verlaine's pale flowers grow.

In his *Ten o'clock* translated by Stéphane Mallarmé, Mr Wisthler defines art as he conceives it: "She is," he says, "a goddess of dainty thought – reticent of habit." And it will be to his honour, as to those few who will despise the public taste, to have practised this art aristocratically – this art which is resistant to common ideas, this art which shrinks from the crowd, this art which is resolutely solitary, haughtily secret.

Paul Verlaine (1844–96), whose verse was often compared to Whistler's painting by French critics in the 1880s.

PALL MALL BUDGET
"A Chat with Mr Whistler"
13 March 1890

Last November Mr Whistler looked about him for new worlds to conquer, and elected to visit Amsterdam, which he thinks one of the most picturesque cities in Europe. He packed up his copperplates, his wax candles, his acids, his etching-needles and the various tools of the etcher, and proceeded to the quaint old capital of the Low Countries. The result will be given to the world in a series of ten etchings, which are practically completed. Proofs of these, enclosed in their frames of white with black bars, reposed on the studio floor with their faces to the wall, and one after the other they were placed on the easel. Picture to yourself delightful representations of stagnant Dutch canals, reflecting on their surface every detail of the quaintly grotesque architecture.

The man who only knows Mr Whistler as the gay, versatile *farceur* thinks that he leads a butterfly existence. But – excepting the famous emblem – Mr Whistler is not one of the *Lepidoptera*. In Amsterdam he began early and worked into the night, defying the searching blasts and the withering weather. Here, for instance, is the *nocturne* of the series, a wonderful representation of night on one of the canals, the weird and ghostlike gloom being shown by a brilliant flash of light from a lantern placed in one of the mullioned windows above. Mr Whistler has often been joked about his *nocturnes*, in private and in a court of law. But his retort is true enough. Night has no form – gloom no length or breadth. This particular nocturne, however, is full of the most delicate and elaborate detail when your eyes have accustomed themselves to the lantern flash. You see the shadows of the people through the blinds and curtains, and the glow of the oil lamps softened by the gloom of night. Here, again, is a proof

Whistler's two-month visit to Amsterdam in the autumn of 1889 resulted in oils and watercolours (see Colourplate 94) as well as fourteen etchings (K. 403–416). Unable to interest the Fine Art Society in publishing the etchings, on his return to London he printed and sold them himself in comparatively small editions of about a dozen.

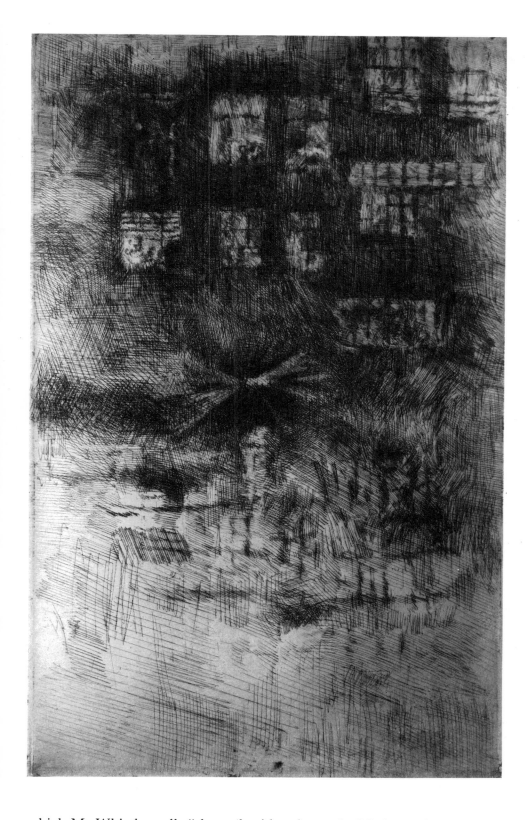

which Mr Whistler calls "the embroidered curtain." It hangs in a window overlooking one of the canals, and the delicate tracery of the pattern has been worked out to the minutest detail. But Mr Whistler did not spend all his time in these sombre and narrow water byways, in which the houses rise on either side like the precipitous and frowning walls of a Colorado cañon. We find him emerging now and then into the sun on expeditions which result in bits of real lowland scenery, dotted with windmills and alive with traffic. In this series of etchings the master has avowedly shown himself to the public in all his powers. "I divide myself into three periods," he says, being in his most serious and sensible mood. "First, you see me at work on the Thames," producing one of the famous series. "Now, there you have the crude and hard detail of the beginner. So far, so good. There, you see, all is sacrificed to exactitude of outline. Presently, and almost

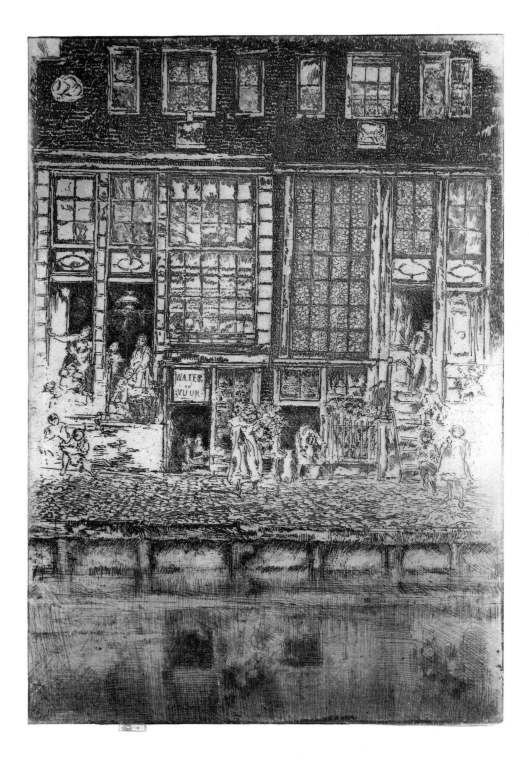

unconsciously, I begin to criticize myself, and to feel the craving of the artist for form and colour. The result was the second stage, which my enemies call The Inchoate, and I call Impressionism. The third stage I have shown you. In that I have endeavoured to combine stages one and two. You have the elaboration of the first stage and the quality of the second." For some reason or another, Mr Whistler has decided not to hold an exhibition, but his etchings will be on view at one or two of the galleries. The conversation then turned on the number of proofs which he prints from his plates. It is well known that Mr Whistler's early etchings are rare and extremely valuable. Instances can be given in which a half-guinea proof is now worth seventy guineas, or even more. The collector hates the common crowd, and will only have etchings that are scarce. It is easy to gratify him by keeping the supply down. From his early plates Mr Whistler told me he had taken about a hundred proofs, and then destroyed the plate. But the numbers vary according to his judgement. Sometimes there might be a hundred, but ofttimes a dozen or

By the "second stage," Whistler meant his etchings of Venice.

If Whistler is referring to the "Thames Set" plates, this is not entirely accurate. After printing from them himself he sold them in 1871 when an edition of 100 was published by Ellis and Green (see page 86); they were again sold and a further edition printed. After 1880 Whistler became much more selective in the editioning of his prints not contracted with galleries or publishers.

twenty proofs, each having the sign of the butterfly, and the little note which shows that he also printed the proof. Mr Whistler's studio is more like a workshop than a famous artist's retreat. Sumptuous draperies, luxurious couches, thick carpets and bric-à-brac are conspicuous by their absence; and in their place are the presses and inking rollers with which he now is at work.

See etchings on pages 154, 156, 157, 169, 175.

GUSTAVE GEFFROY

LA JUSTICE

"The Salon of 1891"

1 July 1891

Gustave Geffroy (1856–1926), journalist, novelist and art critic, had been introduced to Whistler by Théodore Duret in London in the winter of 1890.

Last November, going from Calais to Dover, I saw dusk fall upon the sea. The glassy blue-green water, with the long boat gliding smoothly through it, gradually merged with the sky, which was already so low, so near, at the last moments of the day, enfolding the landscape so hermetically in its circular grey embrace. Night released things, broke the rigid, inexorable line of demarcation. The fluidity of the shadow flooded the hostile atmosphere of the winter twilight, and brought the cold emerald sea and the ashen sky together in the darkened space. All there was now, around the navigation lamp sparkling in the bows, was an expanse of gloom.

Suddenly, to the right, a lighthouse sent out a ray, a yellow beam, round and glittering like a star. Then, a little further back, another sharper light, then another, then more still, appearing slowly or suddenly, at irregular points, in a broken line, in a vista which came and went. At last everything was revealed, circumscribed in deep blue. It was a fairy-tale garden hung in the night, between the water and the dimly imagined sky, a garden where living, moving flowers of gold, flowers of light, flowers of fire blossomed, sometimes apparently veiled, closing their calyxes, disappearing under gauze, foundering beneath the waves, then taking on new life and reappearing with renewed brightness. They rose up and sank according to the rhythmical movement of the boat, straining towards the clouds, hiding beneath the crest of the waves, burning like curious shining eyes on a dreamy horizon: tremulous flowers, eyes of flame, with their haloes of air, reflected in the water, lost in infinity, criss-crossing the distance with eerie trails of brilliant dots, gold and silver dust, and creating, over and beyond reality, the trappings of a strange non-existent city, where one sensed the approaching lines of a protruding jetty, the edge of a quay, the rise of a hill, a dark mass of houses, a flotilla rocked in the calm of a harbour. Inevitably, your thoughts turn to art: the name of the magician comes unbidden to your lips:

– A Whistler!

A Whistler, yes, it was indeed a Whistler that was being conjured up in this place, at this hour, by this Dover lit up above the waves, below the sky. The world of the painter's landscapes and *Nocturnes* was partly summed up here, by that sparkling curve, by those immense, deep, dark surroundings. As the ferry made the final move towards the coast, to the sound of the paddles' last grinding, as the view broadened out and the light became brighter, I recalled so many lucid and dreamy transformations, so many expressive representations of things sunk in shadow and in silence, so many poems of fading light signed by the prestigious artist James McNeill Whistler. In my mind's eye I saw nocturnes in blue and silver, black and gold, silver and black, one of them

in particular, seen at Théodore Duret's, the boldest and perhaps the most extraordinary. Water, sky and, between water and sky, an irregular black mass, broken up at its base by the jagged bank, indented at its summit by aerial darkness and light. That is all, sufficient for the eye's viewing and the spirit's contemplation. The spectacle unrolls in harmonious beauty, ceaselessly deepening before a questing rêverie. What have we before us? A city, trees? Do living beings dwell behind this silent scenery? At last one sees this mass gilded here and there by the odd imperceptible gleam, and, right at the top, in some faint church tower or belfry, a pale illuminated clock, a tremulous, blurred night-light, is telling the time uncertainly in the gloom; and, at the base of this mysterious town, in the deepest black, one can also make out a low flame hidden behind some invisible window pane! But all this is conjectured rather than seen, overrun by encroaching darkness. Baudelaire's line comes to mind: *"Entends, ma chère, entends la douce nuit qui marche!"* [Listen, my dear one, to sweet encroaching night!]. It is night walking on the water, swallowing the town, absorbing the air, it is night which dominates this landscape, which gives it that unclassified colour one sees with one's eyes closed, which renders it a Shadow made visible – a prodigious portrait of Darkness.

<p style="text-align:center">* * *</p>

There are other landscapes by Whistler, watercolours, paintings, etchings of the rarest craftsmanship, indicators of veracity, proofs of sensations felt with unquestionable authority. At the Salon in the Champ de Mars this year there is a *Seascape (harmony in green and opal)*, a harbour in Valparaiso where the water and sky are in delicious accord, where light craft are celebrating long voyages and the sweet return to port, and yearning to be off again. And this Salon seascape, exhibited beside a portrait, leads me to Whistler's great portraits, which were confirmed by my first walk through London, as the landscapes had been verified at the approach to Dover, at the hour when twilight was vanquished and overwhelmed by darkness.

That day, in London after a snowstorm, the misty atmosphere was particularly dense and sumptuous: the street, the ground, the houses, the monuments had been despotically seized by an all-engulfing fog, wide and high, enormous and rampant, which held the whole sky, embracing all the earth, rolling and settling in everywhere slowly and remorselessly. A greenish brightness was to be felt here and there in this heavy grey and white atmosphere, a dusting of silver-gilt, the much-prolonged emanation of an invisible pale sun withdrawing into infinity. Then unforgettable silhouettes loomed up in the middle of squares, at street corners, in the haloes of shop lights, under the smudged flames of the gas lights! It was an endless parade, where figures were visible only for a fleeting glance, when long black shapes appeared dimly, came into focus, vanished and were replaced by others, in the movement of a restless street, of silence, of snow, of tragic life.

A number of these figures live for ever on the canvases of Whistler, standing before dark backgrounds, in dense atmospheres. I saw some of these again at his house in Chelsea, after a welcome consisting of a cordial gesture and a well-chosen word. I saw them amidst the muddle of a working studio, in the light of a candle. The admirable portrait of the woman exhibited currently at the Champ de Mars, the Woman seen from behind, turning away in disdainful profile, belongs to the family of those slender, elegant, haughty creatures, silent beings with white hands and faces full of secrecy!

From now on this portrait of a woman will be engraved in the memory alongside the canvases we already know: the artist's mother, the portraits of Lady Archibald Campbell, of Théodore Duret, of Pablo de Sarasate, of the historian Carlyle, of Miss Alexander. The afore-mentioned are just some from among works of such subtle psychology, such proud truthfulness, and such haughty strangeness.

Nocturne: Grey and Silver, *YMSM 156 (Colourplate 52).*

Crepuscule in Flesh Colour and Green: Valparaiso *YMSM 73 (Colourplate 19) was shown in the exhibition of the* Société Nationale des Beaux-Arts *in May 1891, where it was titled* Marine (harmonie en vert et opale), *together with* Arrangement in Brown and Black: Portrait of Miss Rosa Corder *YMSM 203 (Colourplate 61) as* Arrangement en noir: no. 7.

JAMES MCNEILL WHISTLER

Letter to his Wife Beatrice

11 June 1891

PARIS

. . . On my way I could not resist walking through Durand Ruels' – and then I saw again that horrible "lampoon" of Chase's – Shocking – I told them so – The place for the first time seems to be full of people! – The young son tells me that all Americans go there – I shall see what I shall say to him about my possible exhibition, but I shall be careful – Oh!, but Renoir! – There is a little room full of Renoirs. You have no idea! – I *don't* know what has happened to the eyes of everybody – The things are simply *childish* – and a Degas absolutely shameful!! – If you were with me the two wams would hold each others hands as they thought of the beautiful Rosies and Nellies in the little drawer on the sofa!! – Take care of them Trixie – take the two drawers, just as they are, and carry them up stairs – don't let them be shaken, and cover them over with a little drapery and wait till I come back – We have no idea how precious they are! –

I don't seem to be in any hurry to bother about Montesquiou – but doubtless I shall go out to him tomorrow or the day after – I shan't stay many days – but I shall try and get at Mallarmé and settle about the Lemercier people for the lithograph business – William must send the framed etching all right to the Hotel du Helder – and by post parcel also

Beatrice Whistler (1855–96), the daughter of the sculptor John Birnie Philip, married E. W. Godwin (see page 125) in 1876. He died in 1886 and Whistler and Beatrice were married at St. Mary Abbott's, Kensington on 11 August 1888. As an illustrator and artist she painted in a Whistlerian manner and exhibited at the Royal Society of British Artists under the name Rix Birnie. Two years after the Whistlers moved to Paris in 1892 her health began to fail and she died of cancer in 1896.

The American artist William Merritt Chase (1849–1919) met Whistler in London in 1885 and each painted the portrait of the other; Chase's is in the Metropolitan Museum, New York, but Whistler probably destroyed his portrait of Chase (YMSM 322). Whistler's nickname for himself and his wife. Models, including Rose Pettigrew, who posed for pastels and drawings.

Whistler was painting the portrait of Comte Robert de Montesquiou, YMSM 398 (see Colourplate 91 and overleaf). Lithographic printers; "William" is probably Whistler's brother.

Photograph of Beatrice Whistler. Probably late 1880s. Whistler Collections, Glasgow University Library.

send me two small copies of the *Gentle Art* – and two large copies – probably making two parcels of them – The journey across was like a mill pond – and the steward furnished me with ruggs [sic] – The wicked Bunnie – to whom many amiable things – of course gave me no silk socks! – perhaps a pair might be put over the glass of the etching – Rosie had better be told to give *Monday* to some one else – after that I shall be back before *Wednesday*. Paris is lovely – !! – We must come here directly – and the wam shall get garments for the seaside – I am off now – the rest later – My dear Chinkie I have just come back from the Exhibition! – Oh! Chincks!!! – Well you cannot imagine it – Bad – so jolly bad! – it is really stupendous how everything is not only bad, but *going* on to the bad! baddest without stopping for breath – just *galloping* down – I don't believe that in London we would notice it so much, simply because there, nothing is of *any* quality whatever – there everything is absolutely beneath notice and cannot even excite your contempt – There is the quiet trade of painting Parishoners [sic], beadles and workers boys – and one year is what all years have been & will be – but here the painters you are forced to look at – and they seem to be gone stark staring mad after the Bad!! – The Impressionist analines (I can't even spell it) seem to have spilled over all the palettes – Even the man Dannat, who by the way is right *next* to the really *holy* Valparaiso has mauve and ultramarine running into the huge legs of his Spaniard – and, by the same token there is no B- to be found anywhere – They must have got through with her – But beyond this, the *drawing* is marvellous in its blatant badness! – The men seem to thrown [sic] all tradition and discipline to the winds, in the crazy hope that something else shall take its place – Sargent's *Boy* that was supposed to be a masterpiece is *horrible*! – Boldini has some bad paintings and some hysterically *clever* pastels – but wildly out of drawing – My imitator Gandarini [sic], of course I fancy I see something in – but I hope you wouldn't! – The Rosa Corder naturally is very austere and grand among these strange strugglings – but we have better – and Oh horrors it struck me suddenly that she looked short! I wonder? – Well well my dear luck more tomorrow –

I shan't stay long – I want to be at work with luck in my pocket again – We must never stop, for we have much farther to go – my own Trixie. . . .

Whistler's nickname for his wife's younger sister, Ethel Birnie Philip (1861–1920).

Whistler's nicknames for his wife.

William Turner Dannat (1853–1929), American artist, whose Manuela *was shown in the* Exposition Internationale des Beaux Arts *in 1891 (253).*

J. S. Sargent's Portrait de jeune garçon *(850).*
Jean Boldini (1842–1931), who showed three portraits in the 1891 exhibition (110–11), painted Whistler's portrait in 1897 (see page 349 for Helleu's drawing after Boldini).
Antonio de Gandara (1862–1917), French artist, much influenced by Whistler, exhibited a portrait and a landscape (386, 387).

EDMOND AND JULES DE GONCOURT

JOURNAL

Robert de Montesquiou

7 July 1891

The De Goncourt brothers, Edmond (1822–96) and Jules (1830–70), novelists and writers on eighteenth-century French art also known for their Journal, *here visit the Symbolist poet Comte Robert de Montesquiou-Fezensac. Montesquiou, a model for J. K. Huysmans'* À Rebours *(1884) and for Proust's Baron de Charlus (see page 364), included a chapter on Whistler in his posthumous memoirs (Les Pas effacés, Paris, 1923).*

VISIT TO MONTESQUIOU-FEZENSAC, THE DES ESSEINTES OF "À REBOURS"

A ground-floor apartment on the Rue Franklin, with high, small-paned seventeenth-century windows, giving the house an ancient feel. A house full of a jumble of disparate objects, old family portraits, frightful Empire furniture, Japanese *kakemonos*, Whistler etchings.

An original room: the dressing-room, with a tub made of an immense enamelled Persian tray, and beside it the most enormous Oriental kettle in beaten and *repoussé* copper, all closed in by doors of strips of coloured glass, a room where the hydrangea – probably a pious family memory of Queen Hortense – is represented in all materials and all manners of painting and drawing. And in the midst of this dressing-room, a little glass case

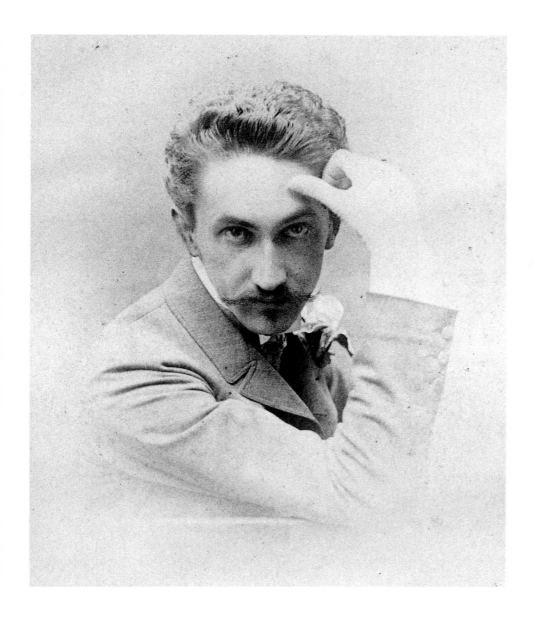

affording a glimpse of the tender hues of a hundred or so neckties, beneath a slightly pederastic photograph of Larochefoucauld, shown in a bathing-dress offsetting his charming androgynous body.

As I was pausing before a Whistler etching, Montesquiou told me that Whistler was currently doing two portraits of him: one, dressed in black with a fur under his arm, the other in a grey great coat, with the collar up and, at his neck, the faintest hint of a necktie of a shade . . . a shade . . . which he did not specify, but whose perfection was indicated by his expression.

And Montesquiou is interesting on the subject of Whistler's way of painting: he had given him seventeen sittings during a month's stay in London. For Whistler, the sketch is a positive onslaught on the canvas, one or two hours of fevered madness, from which the thing would emerge fully structured in its externals . . . and the sittings, long sittings where, most of the time, with his paintbrush held close to the canvas, the painter would not make the stroke he had at the tip of his brush, but would throw it aside and take another – and sometimes, in three hours, he would put only fifty or so strokes on to the canvas . . . each stroke, according to Whistler, lifting a veil from the glaze of the sketch. Oh! the sittings where it seemed to Montesquiou that Whistler was drawing his life from him with the fixity of his attention, was sucking something of his individuality from him; and finally he felt so drained that he felt a sort of contraction of his whole being, and luckily one evening he had discovered a wine made with coca, which helped him recover from these terrible sittings!

*The portrait with the grey great-coat –
Impressions du gris perle YMSM 397 –
was not continued; all future sittings were
devoted to the Arrangement in Black and
Gold YMSM 398 (Colourplate 91).
In June 1891.*

*According to Duret, Montesquiou posed over a
hundred times before the second portrait was
exhibited in 1894.*

WALTER RICHARD SICKERT

THE FORTNIGHTLY REVIEW

"Whistler To-day"

April 1892

"The other criticism is quite a science. It demands a complete understanding of the works, a clear view of a period's characteristics, the adoption of a system, a faith in certain principles; in other words, a law, a relationship, a judgement. This art of criticism thus becomes the judge of ideas, the censor of its time; it practises a priesthood: while the other is an acrobat who does turns to earn a living, as long as he has the legs to do it. The distance between Claude Vignon and Lousteau is that which separates technique from art."

Where, in the columns that have been supplied to their editors by the ladies and gentlemen of the critical press on the subject of Whistler, in 1892, is to be found the comprehension, the faith, the priesthood, of the exercise of which Balzac speaks? Grudgingly, and with a bad enough grace, acknowledgement of qualities that painters and connoisseurs have seen in the work of this master for over thirty years has been wrung out of them by sheer punishment and exposure.

There is a suggestive passage in one of Byron's letters to Moore which might have been written with admirable appropriateness to Whistler. He says – "You are, single-handed, a match for the world, which is saying a good deal, the world being like Briareus, a very many-handed gentleman; but to be so, you must stand alone." And Mr Whistler has stood alone, and, not only unaided, but opposed by that instinctive conspiracy which leads the second-rate, like the gods in Homer, even when they live in different suburbs, to know each other very well, has wrung from the nation and from the world an acknowledgement that his place in art is with the great of all time.

A critic in the sixties or seventies spoke of the colour in *The Little White Girl* as generally grimy grey. Thirty years have really made very little difference. Today the critic of the *Daily Chronicle*, with *La dame au brodequin jaune* [The Lady with the Yellow Buskin] staring him in the face, misses in the collection at Goupil's the portrait of Lady Archibald Campbell. The *St. James's Gazette* gravely fixes Whistler's best period – sixty to sixty-four. The art critic of the *Times* regrets that a man capable of painting the *Symphony in White, No. 3*, should waste his time on comparatively unimportant trifles like the *Nocturnes*. The *Daily News* writer mistakes a picture of a grey day for a nocturne, and speaks of conscientious labour as if it could only be manifested in the accumulation of detail. He is also apparently ignorant of the fact that the portrait of Mr Whistler's mother is unavailable for exhibition in London, not because it has been previously exhibited here, but because it hangs in the Luxembourg.

The *Pall Mall Gazette*, in an article which looks suspiciously as if it had come from the pen of the second best critic, cannot find the *Nocturnes* poetical without an apology for laying themselves under a suspicion of cant. An article in *Truth*, which is by way of being appreciative, still hints at the existence of pictures by Whistler which are "artistic jokes," and are not included in this exhibition. It would require Mr Whistler's own intolerable insistence and iron physique –

"One moment on the mightiest, and the next
On little objects with like firmness fixed" –

Sickert wrote regularly in support of Whistler and his principles until 1897 when their friendship suffered a breach (see page 256). Here Sickert reviews the retrospective exhibition of 43 Nocturnes, Marines and Chevalet Pieces *held at the Goupil Gallery in March 1892, which marked something of a turning-point for Whistler's reputation in England. The catalogue "The Voice of A People" (reprinted in* The Gentle Art*) reproduced adverse criticism of Whistler from the past, and provided Sickert with the theme for his review.*

The unscrupulous arriviste *man of letters, Lousteau was the antithesis of Vignon, the sincere Academician, in Balzac's* La Comédie Humaine.

Lord Byron to Thomas Moore; in Greek mythology Briareus was a 300-handed monster.

COLOURPLATE 17 (YMSM 52).

COLOURPLATE 62.

COLOURPLATE 28 (YMSM 61).

to travel, point by point, through all the irresponsible stuff that has been written in the last week on the subject of the little exhibition in Bond Street. I do not propose to do this, but to present a few main considerations which have been entirely lost sight of, so far as public utterance is concerned.

The fact that Mr Whistler's portrait of his mother has been bought by the Luxembourg has not in any way altered the canvas which was only saved from rejection at the hands of the hanging committee of the Royal Academy by the intervention of Sir William Boxall, and the accident of his personal friendship with the family of the painter. Purchase by the Corporation of Glasgow of the portrait of Carlyle has altered neither the drawing nor the colour of the work which Sir Coutts Lindsay, or his assistants, Messrs Carr and Hallé, considered proper decoration for a passage, while canvases by the latter gentleman basked complacently on the line in the Grosvenor galleries. Two proofs of etchings by Whistler, bought by an acquaintance of mine for £1, and sold for £71, are the same as they were on the day when they left the press of Delâtre or of the painter. The oil painting in the present exhibition, bought some thirty years ago for £80, for which the owner is asking, and will get, £800, is no better than it was when it left the studio in Lindsay Row.

Let us, then, frankly face the fact that as a nation it has required these and a hundred similar purely commercial indications to convince us of truths which our eyes have not been sufficiently educated to perceive for themselves.

Had we confined ourselves to a purely agnostic or indifferent attitude, our position would have been unattackable. We should in no way have stultified ourselves, and we should owe no apology; but we have done nothing of the kind. We, or what amounts to the same thing, our servants in the press – for they admittedly produce their matter in accordance with the laws of supply and demand – have, more perhaps in ignorance than malice, persistently interfered to hinder the artist to whom, with Charles Keene, England of the nineteenth century will owe whatever of enduring fame in painting is destined to be hers. Reflect upon it. As if the difficulties and disappointments of the work itself were not more than sufficient, our ignorance must needs vent itself in ribaldry, which would have extinguished a man who was merely mortal. Even his sitters – at a date, be it remembered, when the more exquisite achievements of the new journalism had not been dreamt of – were subjected through his work to personal impertinences, so that the *rôle* of a patron of Whistler's some fifteen years ago required not only discrimination but some personal courage.

Truly we owe him some amends, and they should be made honourably and ungrudgingly, with a sense of gratitude that he is still with us to receive them.

It was Gautier, I think, who said, "*Les journalistes aiment toujours mieux ce qu'on a fait que ce qu'on fait* [Journalists always prefer what you have done to what you are doing]." How often have I encountered the three fatuous platitudes which sum up the opinion of the well-bred indifferent on the subject of Whistler! The first step is, "Do you admire Whistler?" to which the answer is, "As an etcher." The next step invariably is the assertion of the superiority of his early Thames etchings over the later Venetian, Dutch, Belgian, Parisian and London ones, if indeed the speaker has ever heard of these latter. If the master be admitted at all as a painter the conversation takes this turn – "he gave great promise in the sixties" – in fact, the verdict somewhat tardily bottled by the *St. James's Gazette*, and referred to above.

These three propositions are no whit less ignorant and stupid than the dictum that we have on record, dated 16 November 1878, of the art critic of the *Times*, to the effect that the nocturne in black and gold is not a serious work of art. Even those who imagine themselves to have been at

In November 1891 Arrangement in Grey and Black: Portrait of the Painter's Mother *YMSM 101 (Colourplate 30) had been purchased by the French Government for the Luxembourg museum; in the 1892 exhibition it was represented by a photograph.*

Sir William Boxall R.A. who had painted Whistler's portrait in 1847 (see pages 37, 38). Purchased by the Corporation of Glasgow in April 1891 for 1,000 guineas, the first of Whistler's pictures to be bought for a public collection.
Lindsay was owner of the Grosvenor Gallery; Joseph Comyns Carr and Charles E. Hallé (1846–1914) (managers, the latter also a practising artist).

The resale prices for his pictures in 1892 angered Whistler, and he went to some length to control the market in his own work.

The Punch *illustrator much admired by Whistler and Sickert (see page 59).*

Théophile Gautier (1811–72).

i.e. Tom Taylor's testimony at the Ruskin trial, see page 133.

last properly drilled into orthodox appreciation, betray themselves in their estimate of the early work. Take, for instance, the *Lange Leizen*, perhaps the earliest painting, now in Bond Street. That picture, besides containing passages of astonishing excellence and refinement, is supremely interesting because it is by the painter of, say, *The Little Sweetstuff Shop*, in the possession of Mr Wickham Flower, or *The Angry Sea*. It is the work of a boy, a boy of genius undoubtedly, but to cite it as representative of Whistler's best period would be much as if we were to exalt the pothooks and hangers with which Shakespeare probably began his studies in literature to the disadvantage of *Hamlet*. In the same manner the early Thames etchings have a double value. They are intrinsically in the same category with the work of Rembrandt, but they are historically interesting as the stations by which the artist reached the consummate achievement of the *Rialto Steps*.

COLOURPLATE 21 *(YMSM 47)*.

An Orange Note: The Sweet Shop *(YMSM 264) had been bought by Flower, with another picture, from Whistler's first exhibition at Dowdeswells' in 1884 for £160; YMSM 282 (Colourplate 86)*.

K. 211.

Those who do not know Whistler's work must not imagine that these two rooms contain in any sense a summary of it. They contain rather extracts from some chapters; and, in view of the educational aim which Messrs Boussod, Valadon, & Co. have evidently set themselves, they have done wisely to prelude what I hope is destined to be something approaching to a complete unfolding before the eyes of London of the genius of its greatest painter, by a collection of some of the landmarks in his career, which have already obtained a measure of acknowledgement, and which, from the fact of their being earlier steps in his progression, are more likely to be appreciated by the few who are born with the eye to see and the brain to understand.

The earliest pictures furnish interesting evidence of the fact that the qualities which have made of the masterpieces of Whistler the wonder of the artistic world were asserted from the first stroke of his brush, and have been invariably present through all the different stages of his strange and versatile development. Note in *The Music-room* the unerring hand of the etcher in the drawing of the patterned curtains, the divine eye for colour in the difference between those curtains and their reflection, in the vase and its reflection, in the marble of the mantlepiece. Note, at a period when the painting world had a tendency to substitute on all shoulders the same tiresome conventional face of this or that sub-school for the infinite variety and unexpected charm of nature, the relentless grasp of personal character in the heads in this picture, in the *Little White Girl* and in *The Gold Screen*.

YMSM 34, painted in 1860 or 1861.

COLOURPLATES 17 and 12 *(YMSM 52 and 60)*.

One quality there is about fine painting – it leaves nothing to be said. It is just as stupid to try to describe a Whistler as to etch a Velazquez, or to copy in charcoal the fragments of the Parthenon. In the large gallery you are conscious at once that the works give to four bare walls an atmosphere of repose and grandeur, suggesting in no way a shop or an exhibition. The great tall, dark canvases make exquisite backgrounds for figures – no palace can command a finer *mise-en-scène*. To move in the atmosphere created by them is to catch involuntarily something of the grace and distinction, of the nobility and dignity which they exhale. In this they fulfil their first function of superbly decorating the house. Where else in modern work can we see as we see here that paint is itself a beautiful thing, with a loveliness and charm of infinite variety? Does that ever occur to us in any other modern exhibition? Are we not rather wearied into a loathing of the leathery matter with which the annual acres of canvas are loaded or smeared with mechanical regularity? Look at the revel of the brush on the coarse threads of the portrait of Lady Meux. Is it not beautiful and exhilarating in itself, and is it not a marvel how the living, breathing woman in that dainty gown is built up by passages of brushwork, which in no way copy the dress, but express it in a language of inspiration? Then the exquisite enamel of *The Falling Rocket* – perfect form, exquisite colour, and that peculiar triumph of execution which consists in the complete absence of all appearance of labour. It has no more technique than the night sky itself, or the scattering sparks, or the cold,

COLOURPLATE 48 *(YMSM 228)*.

COLOURPLATE 53 *(YMSM 170)*.

dark grass. How beautiful the very threads of the canvas are in the *Nocturne in Blue and Gold – Battersea Bridge*, drenched in the fair opaque blue – how charming the sweep of the brush horizontally across the whole picture in the *Blue and Silver – Chelsea*! Look at the flowers in the *Little White Girl* and the tray with the *sakè* cups in *The Balcony*! That is what it is to be a painter! To know and love your material, as a rider knows his horse or a violinist his fiddle.

Higher, perhaps, even than this quality is the grandeur of conception which has dictated such a composition as the *Nocturne in blue and gold – Old Battersea Bridge*. The great T formed by a segment of the bridge and its solitary support, the eternity of sky it encloses, the track of fire, Chelsea crowned by the old church tower, and, far away, the lights of Vauxhall nestling low down on the fairy river!

The *Nocturne in Blue and Silver – Bognor*, again, can never be surpassed. The blue of the summer sea, growing black with intensity at the horizon, the silent stars, the ghostly wreaths of cloud trailing in the watery sky. Four little boats hover like great moths and melt their phantom sails in a dusky sea. Three show lights that glimmer on the water. Though it is night, it is light enough to see the white foam turned over by the bows of the two nearer boats. That on the far right is going about under your very eyes, leaving a white track in the wondrous water. The waves creep in while they seem not to move, except where they curl and break and tumble at your feet on a dusky shore. You are conscious, at the water's edge, of shadowy figures going about their mysterious business with the night. All these things and a million-fold more are expressed in this immortal canvas, with a power and a tenderness that I have never seen elsewhere. The whole soul of the universe is in the picture, the whole spirit of beauty. It is an exemplar and a summary of all art. It is an act of divine creation. The man that has created it is thereby alone immortal a thousand times over. Who are we that we should scribble and nag at him?

JAMES MCNEILL WHISTLER

Letter to D. C. Thomson

2 May 1892

33, RUE DE TOURNON, PARIS

Dear Sir,

I have received your telegram – and hope the Fire wheel will be here all right by tomorrow night or Wednesday morning. Also doubtless Mr J. J. Shannon will kindly lend you his sea piece – which even if it leaves tomorrow would still be here to be hung before Friday.

Photographs. Arrived all right – My first impression of their appearance is upon the whole a good one – One or two however want slight retouching – and some are *much too dark* in printing –

I should think indeed that with more time and good light better proofs of many might be obtained. There is a *much finer* proof of Mr Potter's Little *White girl* at my brother's – Dr Whistler, 17 Wimpole St. Borrow it – and I have no doubt that Mr Potter will let you have the picture again so that you can at once take another photo of the *same size* as Dr Whistlers – for *that* negative is lost. Also you ought to get a better photo of Mr Potter's "Nocturne Cremorne lights" – The present one is entirely to [sic] murky and dark – It might be smaller – His Blue shore on the other hand is beautiful – *The Fur Jacket* – is much too dark – Mr Sickert has a proof of

COLOURPLATE 42 *(YMSM 140)*.

COLOURPLATE 34 *(YMSM 102)*.
COLOURPLATE 22 *(YMSM 56)*.

COLOURPLATE 43 *(YMSM 100)*.

David Croal Thomson (1855–1930), art critic, dealer and manager of the Goupil Gallery, master-minded, with Whistler, the 1892 exhibition (see page 276). Subsequently Whistler collaborated with him to publish an album of photographs of his work, Nocturnes – Marines – Chevalet Pieces, *progress on which is described here. (For further information see Nigel Thorp, "Studies in Black and White: Whistler's Photographs in Glasgow University Library,"* James McNeill Whistler, A Re-examination, Studies in the History of Art, *vol. 19, National Gallery of Art, Washington, 1987.)* The Fire Wheel *YMSM 169; the artist James J. Shannon owned* Harmony in Blue and Silver: Trouville *YMSM 66 (Colourplate 27).*

COLOURPLATE 17 *(YMSM 52)*.

YMSM 115.

YMSM 181.

the picture (in an earlier state – but that doesn't matter) showing how much finer it could be.

The Lady Meux ought to give a *sharper* result.

The Carlyle should be much fairer in the printing.

The Music room ought to be done *again* . . . *smaller*. It is an early work and comes out too hard – As you have the picture you can take it at leisure.

Mr Orchars Nocturne, has a blemish – white spot, by the boats – that ought to be got rid of in the negative – Mrs Leylands Nocturne – might be clearer. (Mr Alexander's is perfect!) perhaps you had better borrow the picture again – it is so very bright – the photograph gives no true rendering of it.

I am sure the Miss Corder ought to give a much finer and lighter result – see how well the portrait of my mother came out in the photograph done in Paris –

Indeed the portraits all are too hard and *purple* black – They ought to be *fairer* and more *golden* brown –

The two firework pictures are marvellous! – and are wonderful proof of the *completeness* of those works.

Album. Now what about the get up of all this? – Of course the mounts will be of much finer quality. They ought to look like hand-made mounts – the whole thing ought to be *luxurious* in its appointment – even if the price be higher – It should certainly not have a poor cheap appearance.

Graves. You are now in complete error as to the royalty you believe you are to pay him. I thought I had written to you telling you of Mr Algernon Graves' visit to me in Paris, and that he *entirely* withdraws all claims *whatsoever*. We are not to give him *one penny*.

I cannot at this moment enter into all the details of the conversation, but you may simply accept the fact. There is never to be a question about it again – for this I have his word.

I wish you would write me more in detail of all that you have thought about the form of publication – You ought to get an old portfolio from Huish or try Dowdeswells (on your own hook!) that I brought out with the Venice Etchings – that would give you a starting point. Of course I should improve upon the original –

This must go at once

Yours very truly

J. McN. Whistler

COLOURPLATE 48 (YMSM 228).
COLOURPLATE 38 (YMSM 137).
YMSM 34.

YMSM 205.
COLOURPLATE 41 (YMSM 113).
COLOURPLATE 34 (YMSM 103).

COLOURPLATE 61 (YMSM 203).
COLOURPLATE 30 (YMSM 101).

YMSM 169, 170.

The print-seller and art-dealing firm of Henry Graves had dealings with Whistler from about 1877 to 1891; Henry's son Algernon (1845–1922) worked for the firm and was the compiler of several important art reference books.

Marcus B. Huish, managing director of the Fine Art Society.

RICHARD MUTHER

Letter to Whistler

5 September 1892

MUNICH

Honoured Master – Just back from a journey I heard from my friend Paulus, the news that you may be presenting the Royal Printroom with your wonders from the International Art Exhibition. The Royal Printroom has for many years tried as far as its means allowed to acquire your impressions of genius, and welcomes as a great piece of luck your unheard of generosity. I will as soon as I have your confirmation at once inform the King's Minister of State of your gift for which my thanks to you, as well as the official thanks of the Head of the Royal Household.

The German art historian Richard Muther (1860–1909), Keeper of Prints at the Munich Pinakothek from 1886, became Professor of Art History at the University of Breslau in 1895. His influential History of Modern Painting was published in English in 1895. It was the first major study to set Whistler in a European context; his art received extensive coverage in the chapter "Whistler and the Scotch Artists."

At the sixth International Art Exhibition in Munich, 1892, Whistler was awarded a first-class gold medal. The committee of the Pinakothek, under the direction of Adolf Paulus, unsuccessfully tried to buy The Little White Girl (YMSM 52) (Colourplate 17).

Herewith I avail myself of this opportunity to make a private request. For years I have been one of the greatest admirers of your refined art, and have often had the opportunity in our Art press of speaking of your masterpieces. Last year I tried, unhappily unsuccessfully, to meet you in London. I would gladly have learnt about your latest work.

At the beginning of next year an illustrated *History of Modern Painting* will be brought out by me, in several volumes, in which is a separate chapter on you – As illustrations for it I have so far only been able to obtain the Portrait of your Mother, Carlyle's and that of Lady Colin Campbell, as for your *Harmonies* and *Nocturnes* all help has failed. If they were perhaps placed where they could be photographed by some good photographer and if you would allow your own photograph to be sent with them I would be overwhelmingly indebted to you. The photographs would be returned to you after the reproductions had been made, otherwise the Royal Printroom would keep them. . . .

COLOURPLATES 30, 38 (YMSM 101, 137, 240–1).

GEORGE MOORE

MODERN PAINTING

"Whistler"

1893

Still, for my own personal pleasure, to satisfy the innermost cravings of my own soul, I would choose to live with the portrait of Miss Alexander. Truly, this picture seems to me the most beautiful in the world. I know very well that it has not the profound beauty of the Infantes by Velazquez in the Louvre; but for pure magic of inspiration, is it not more delightful? Just as Shelley's *Sensitive Plant* thrills the innermost sense like no other poem in the language, the portrait of Miss Alexander enchants with the harmony of colour, with the melody of composition.

The Irish-born author, playright, poet and critic George Moore (1852–1933), lived in Paris from 1873. In the later 1880s he began to write criticism informed by a knowledge of French Impressionism, Symbolist literature and Whistler, on whose art he wrote for the Speaker *in 1891, incorporating this material for the first chapter of his book* Modern Painting *(1893). This also included chapters on aspects of modern English and French art, including "The New Art Criticism," of which Moore himself was an influential exponent.*

Colourplate 46 (YMSM 129); the portrait was shown in the first exhibition of the Society of Portrait Painters which Moore reviewed for the Speaker *in 1891.*

Strangely original, a rare and unique thing, is this picture, yet we know whence it came, and may easily appreciate the influences that brought it into being. Exquisite and happy combination of the art of an entire nation and the genius of one man – the soul of Japan incarnate in the body of the immortal Spaniard. It was Japan that counselled the strange grace of the silhouette, and it was that country, too, that inspired in a dim, far-off way those subtly sweet and magical passages from grey to green, from green again to changing evanescent grey. But a higher intelligence massed and impelled those chords of green and grey than ever manifested itself in Japanese fan or screen; the means are simpler, the effect is greater, and by the side of this picture the best Japanese work seems only facile superficial improvization. In the picture itself there is really little of Japan. The painter merely understood all that Japan might teach. He went to the very root, appropriating only the innermost essence of its art. We Westerns had thought it sufficient to copy Nature, but the Japanese knew it was better to observe Nature. The whole art of Japan is selection, and Japan taught Mr Whistler, or impressed upon Mr Whistler, the imperative necessity of selection. No Western artist of the present or of past time – no, not Velazquez himself – ever selected from the model so tenderly as Mr Whistler; Japan taught him to consider Nature as a storehouse whence the artist may pick and choose, combining the fragments of his choice into an exquisite whole. Sir John Millais' art is the opposite; there we find no selection; the model is copied – and sometimes only with sufficient technical skill.

But this picture is throughout a selection from the model; nowhere has anything been copied brutally, yet the reality of the girl is not sacrificed.

The picture represents a girl of ten or eleven. She is dressed according to the fashion of twenty years ago – a starched muslin frock, a small overskirt pale brown, white stockings, square-toed black shoes. She stands, her left foot advanced, holding in her left hand a grey felt hat adorned with a long plume reaching nearly to the ground. The wall behind her is grey with a black wainscot. On the left, far back in the picture, on a low stool, some grey-green drapery strikes the highest note of colour in the picture. On the right, in the foreground, some tall daisies come into the picture, and two butterflies flutter over the girls's blond head. This picture seems to exist principally in the seeing! I mean that the execution is so strangely simple that the thought, "If I could only see the model like that, I think I could do it myself," comes spontaneously into the mind. And this spontaneous thought is excellent criticism, for three-parts of Mr Whistler's art lies in the seeing; no one ever saw Nature so artistically. Notice on the left the sharp line of the white frock cutting against the black wainscoting. Were that line taken away, how much would the picture lose! Look at the leg that is advanced, and tell me if you can detect the modelling. There is modelling, I know, but there are no vulgar roundnesses. Apparently, only a flat tint; but there is on the bone a light, hardly discernible; and this light is sufficient. And the leg that is turned away, the thick, chubby ankle of the child, how admirable in drawing; and that touch of darker colour, how it tells the exact form of the bone! To indicate is the final accomplishment of the painter's art, and I know no indication like that ankle bone. And now passing from the feet to the face, notice, I beg of you to notice – it is one of the points in the picture – that jaw bone. The face is seen in three-quarter, and to focus the interest in the face the painter has slightly insisted on the line of the jaw bone, which, taken in conjunction with the line of the hair, brings into prominence the oval of the face. In Nature that charming oval only appeared at moments. The painter seized one of those moments, and called it into our consciousness as a musician with certain finger will choose to give prominence to a certain note in a chord.

There must have been a day in Mr Whistler's life when the artists of Japan convinced him once and for ever of the primary importance of

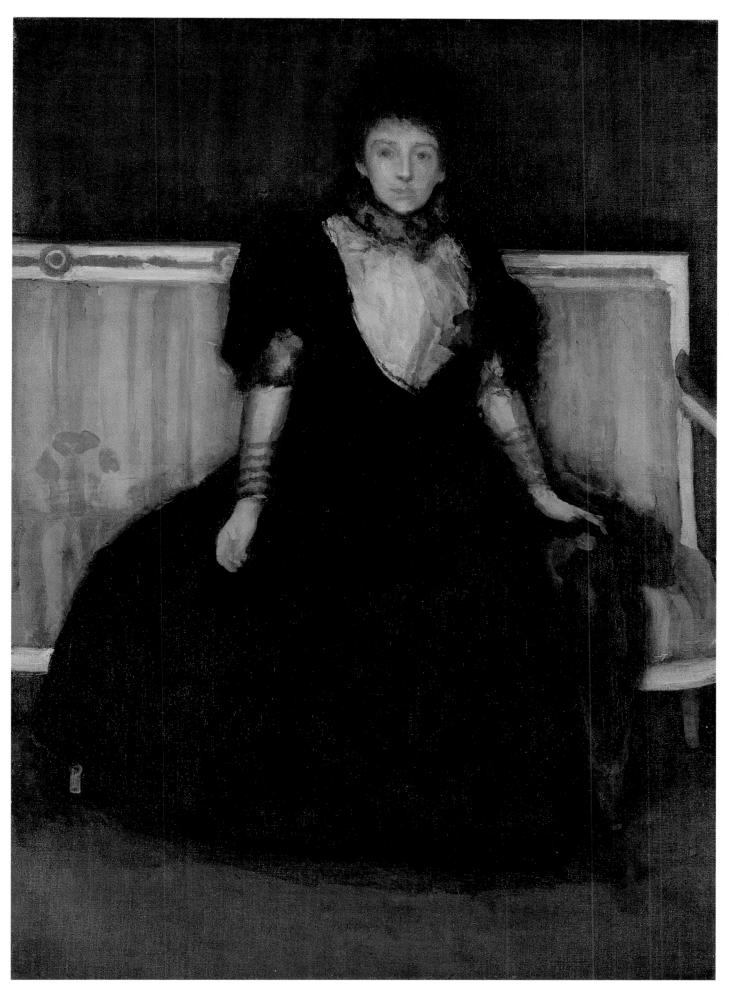

COLOURPLATE 88. *Green and Violet: Portrait of Mrs Walter Sickert.* 1885-86. 34 × 24″ (86.4 × 61 cm).
Fogg Art Museum, Harvard University, Cambridge, Massachusetts
(Bequest of Grenville L. Winthrop).

COLOURPLATE 89. *Off the Dutch Coast.* 1887. Watercolour, 9¾ × 5⅞″ (25 × 15 cm).
Hunterian Art Gallery, Glasgow University.

COLOURPLATE 90. *Flower Market: Dieppe.* 1885. Watercolour, 5 × 8¼″ (12.8 × 21 cm).
Freer Gallery of Art, Smithsonian Institution, Washington, D.C.

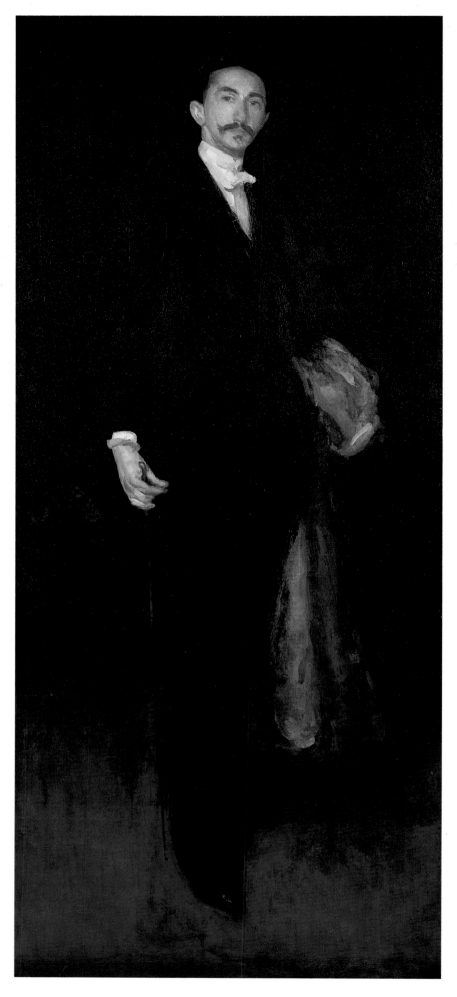

COLOURPLATE 91. *Arrangement in Black and Gold: Comte Robert de Montesquiou-Fézensac.* 1891-92.
82⅛ × 36⅛″ (208.6 × 91.8cm).
© The Frick Collection, New York.

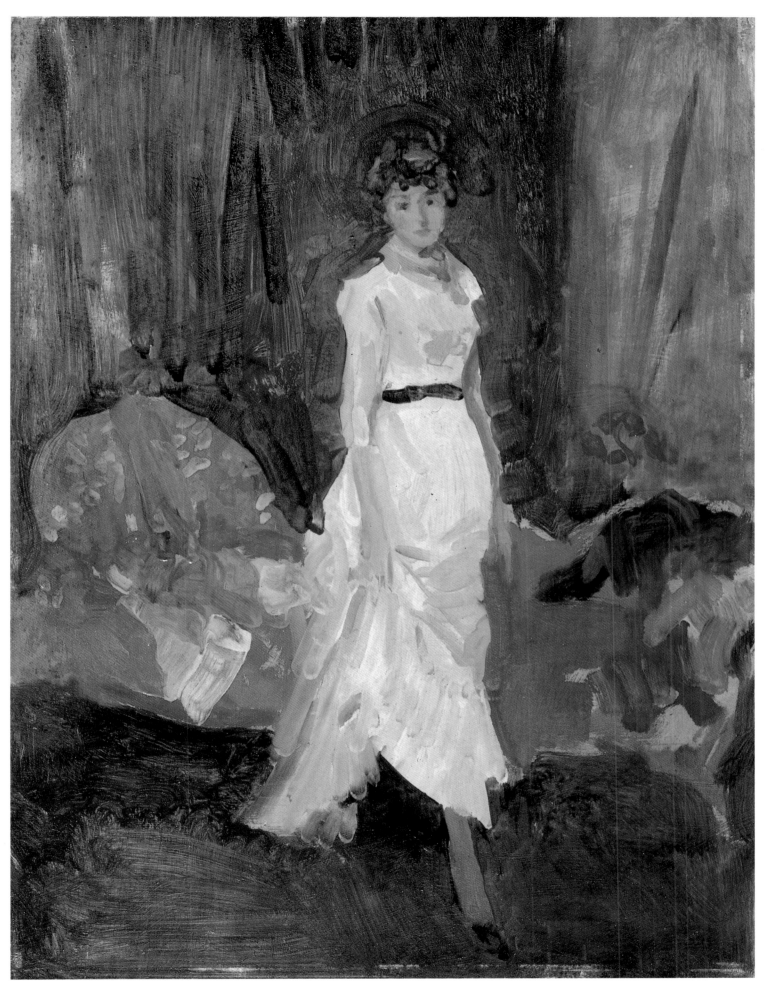

COLOURPLATE 92. *Arrangement in Pink, Red and Purple.* 1885. 12 × 9″ (30.5 × 22.8 cm).
Cincinnati Art Museum, Ohio.

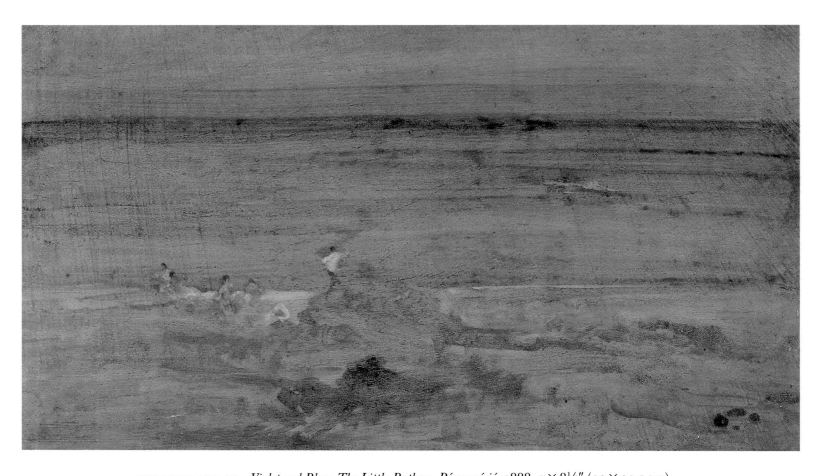

COLOURPLATE 93. *Violet and Blue: The Little Bathers, Pérosquérié.* 1888. 5 × 8½" (13 × 21.5 cm).
Fogg Art Museum, Harvard University, Cambridge, Massachusetts
(Bequest of Grenville L. Winthrop).

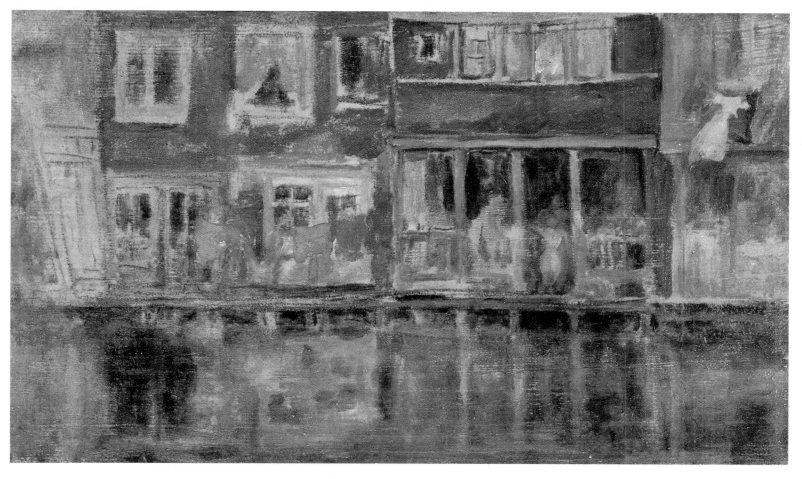

COLOURPLATE 94. *The Canal, Amsterdam.* 1889. 5⅜ × 9⅛″ (13.8 × 23.2 cm).
Hunterian Art Gallery, Glasgow University.

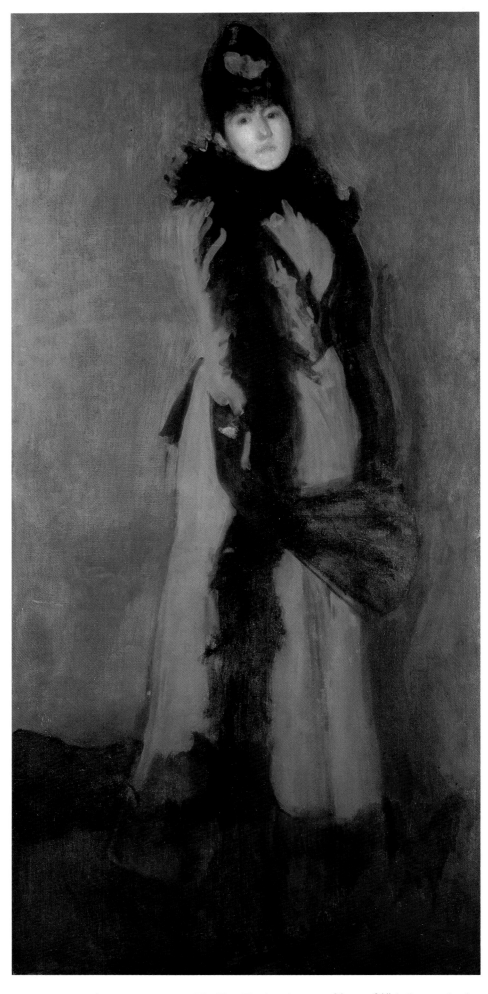

COLOURPLATE 95. *Red and Black: The Fan.* Early 1890s. 73¾ × 35⅜″ (187.4 × 89.8 cm).
Hunterian Art Gallery, Glasgow University.

selection. In Velazquez, too, there is selection, and very often it is in the same direction as Mr Whistler's, but the selection is never, I think, so much insisted upon; and sometimes in Velazquez there is, as in the portrait of the Admiral in the National Gallery, hardly any selection – I mean, of course, conscious selection. Velazquez sometimes brutally accepted Nature for what she was worth; this Mr Whistler never does. But it was Velazquez that gave consistency and strength to what in Mr Whistler might have run into an art of trivial but exquisite decoration. Velazquez, too, had a voice in the composition of the palette generally, so sober, so grave. The palette of Velazquez is the opposite of the palette of Rubens; the fantasy of Rubens' palette created the art of Watteau, Turner, Gainsborough; it obtained throughout the eighteenth century in England and in France. Chardin was the one exception. Alone amid the eighteenth century painters he chose the palette of Velazquez in preference to that of Rubens, and in the nineteenth century Whistler too has chosen it. It was Velazquez who taught Mr Whistler that flowing, limpid execution. In the painting of that blond hair there is something more than a souvenir of the blonde hair of the Infante in the *salle carrée* in the Louvre. There is also something of Velazquez in the black notes of the shoes. Those blacks – are they not perfectly observed? How light and dry the colour is! How heavy and shiny it would have become in other hands! Notice; too, that in the frock nowhere is there a single touch of pure white, and yet it is all white – a rich, luminous white that makes every other white in the gallery seem either chalky or dirty. What an enchantment and a delight the handling is! How flowing, how supple, infinitely and beautifully sure, the music of perfect accomplishment! In the portrait of the mother the execution seems slower, hardly so spontaneous. For this, no doubt, the subject is accountable. But this little girl is the very finest flower, and the culminating point of Mr Whistler's art. The eye travels over the canvas seeking a fault. In vain; nothing has been omitted that might have been included, nothing has been included that might have been omitted. There is much in Velazquez that is stronger, but nothing in this world ever seemed to me so perfect as this picture.

* * *

His hold on poetic form was surer than his hold on pictorial form, wherein his art is hardly more than poetic reminiscence of Italian missal and window pane. Yet even as a painter his attractiveness cannot be denied, nor yet the influence he has exercised on English art. Though he took nothing from his contemporaries, all took from him, poets and painters alike. Not even Mr Whistler could refrain, and in *La femme en blanc* [The woman in white] he took from Rossetti his manner of feeling and seeing. The type of woman is the same – beauty of dreaming eyes and abundant hair. And in this picture we find a poetic interest, a moral sense, if I may so phrase it, nowhere else to be detected, though you search Mr Whistler's work from end to end. The woman stands idly dreaming by her mirror. She is what is her image in the glass, an appearance that has come, and that will go leaving no more trace than her reflection on the glass when she herself has moved away. She sees in her dream the world like passing shadows thrown on an illuminated cloth. She thinks of her soft, white, and opulent beauty which fills her white dress; her chin is lifted, and above her face shines the golden tumult of her hair.

The picture is one of the most perfect that Mr Whistler has painted; it is as perfect as the mother or Miss Alexander, and though it has not the beautiful, flowing, supple execution of the "symphony in white," I prefer it for sake of its sheer perfection. It is more perfect than the symphony in white, though there is nothing in it quite so extraordinary as the loving gaiety of the young girl's face. The execution of that face is as flowing, as spontaneous, and as bright as the most beautiful day of May. The white drapery clings like haze about the edge of the woods, and the flesh tints are

The portrait of Don Adrian Pulido Pareja in the National Gallery, London, now ascribed to Del Mazo.

Symphony in White No. 2: The Little White Girl *YMSM 52 (Colourplate 17) is referred to.*

pearly and evanescent as dew, and soft as the colour of a flowering mead. But the kneeling figure is not so perfect, and that is why I reluctantly give my preference to the woman by the mirror. Turning again to this picture, I would fain call attention to the azaleas, which, in irresponsible decorative fashion, come into the right-hand corner. The delicate flowers show bright and clear on the black-leaded fire grate; and it is in the painting of such detail that Mr Whistler exceeds all painters. For purity of colour and the beauty of pattern, these flowers are surely as beautiful as anything that man's hand has ever accomplished.

Mr Whistler has never tried to be original. He has never attempted to reproduce on canvas the discordant and discrepant extravagancies of Nature as M Besnard and Mr John Sargent have done. His style has always been marked by such extreme reserve that the critical must have sometimes inclined to reproach him with want of daring, and ask themselves where was the innovator in this calculated reduction of tones, in these formal harmonies, in this constant synthesis, sought with far more disregard for superfluous detail than Hals, for instance, had ever dared to show. The still more critical, while admitting the beauty and the grace of this art, must have often asked themselves what, after all, has this painter invented, what new subject matter has he introduced into art?

Paul Albert Besnard (1849–1934).

Frans Hals (1580–1666); see pages 342-343.

It was with the night that Mr Whistler set his seal and sign-manual upon art; above all others he is surely the interpreter of the night. Until he came the night of the painter was as ugly and insignificant as any pitch barrel; it was he who first transferred to canvas the blue transparent darkness which folds the world from sunset to sunrise. The purple hollow, and all the illusive distances of the gas-lit river, are Mr Whistler's own. It was not the unhabited night of lonely plain and desolate tarn that he chose to interpret, but the difficult populous city night – the night of tall bridges and vast water rained through with light red and grey, the shores lined with the lamps of the watching city. Mr Whistler's night is the vast blue and golden caravanry, where the jaded and the hungry and the heavy-hearted lay down their burdens, and the contemplative freed from the deceptive reality of the day understand humbly and pathetically the casualness of our habitation, and the limitless reality of a plan, the intention of which we shall never know. Mr Whistler's nights are the blue transparent darknesses which are half of the world's life. Sometimes he foregoes even the aid of earthly light, and his picture is but luminous blue shadow, delicately graduated, as in the nocturne in M Duret's collection – purple above and below, a shadow in the middle of the picture – a little less and there would be nothing.

COLOURPLATE 52 *(YMSM 156).*

There is the celebrated nocturne in the shape of a T – one pier of the bridge and part of the arch, the mystery of the barge, and the figure guiding the barge in the current, the strange luminosity of the fleeting river! lines of lights, vague purple and illusive distance, and all is so obviously beautiful that one pauses to consider how there could have been stupidity enough to deny it. Of less dramatic significance, but of equal aesthetic value, is the nocturne known as *the Cremorne lights.* Here the night is strangely pale; one of those summer nights when a slight veil of darkness is drawn for an hour or more across the heavens. Another of quite extraordinarily beautiful things, is *Night on the Sea.* The waves curl white in the darkness, and figures are seen as in dreams; lights burn low, ships rock in the offing, and beyond them, lost in the night, a vague sense of illimitable sea.

COLOURPLATE 42 *(YMSM 140).*

YMSM 115.

Unidentified.

Out of the night Mr Whistler has gathered beauty as august as Phidias took from Greek youths. Nocturne 11 is the picture which Professor Ruskin declared to be equivalent to flinging a pot of paint in the face of the public. But that black night, filling the garden even to the sky's obliteration, is not black paint but darkness. The whirl of the St. Catherine wheel in the midst of this darkness amounts to a miracle, and the exquisite drawing of the shower of falling fire would arouse envy in

Nocturne: Black and Gold – The Firewheel *(YMSM 169) was not in fact the picture Ruskin attacked in 1877.*

Rembrandt, and prompt imitation. The line of the watching crowd is only just indicated, and yet the garden is crowded. There is another nocturne in which rockets are rising and falling, and the drawing of these two showers of fire is so perfect, that when you turn quickly towards the picture, the sparks really do ascend and descend.

More than any other painter, Mr Whistler's influence has made itself felt on English art. More than any other man, Mr Whistler has helped to purge art of the vice of subject and belief that the mission of the artist is to copy nature. Mr Whistler's method is more learned, more co-ordinate than that of any other painter of our time; all is preconceived from the first touch to the last, nor has there ever been much change in the method, the painting has grown looser, but the method was always the same; to have seen him paint at once is to have seen him paint at every moment of his life. Never did a man seem more admirably destined to found a school which should worthily carry on the tradition inherited from the old masters and represented only by him. All the younger generation has accepted him as master, and that my generation has not profited more than it has, leads me to think, however elegant, refined, emotional, educated it may be, and anxious to achieve, that it is lacking in creative force, that it is, in a word, slightly too slight.

W. GRAHAM ROBERTSON

TIME WAS

"Of James McNeill Whistler"

1931

The artist and collector W. Graham Robertson (1867–1948), once a pupil of Albert Moore, owned several important pictures by Whistler, of which the acquisition of two is here described in his memoirs.

Arrangement in black and brown, Miss Rosa Corder. I remember the picture in '79 at the Grosvenor Gallery and have always thought it by far the best of what Whistler called his "black portraits." More subtle in quality than the *Sarasate*, in every way superior to the overrated *Lady Meux* and *Comte Robert de Montesquiou*, more complete than the lovely *Fur Jacket*, it eclipsed its more serious rival, *Le Brodequin Jaune – Lady Archibald Campbell*, in its grave dignity and noble beauty.

A fair woman, in a black jacket and long black skirt, stands in profile against a black background holding in her right hand a plumed hat. Nothing could be more simple, yet it is one of the world's great pictures. When I first saw it in the Grosvenor Gallery I knew neither Miss Corder nor Whistler, but the portrait was one day to introduce me to both.

Its original owner was a certain C. A. Howell, a mysterious and fascinating Anglo-Portuguese, around and about whom has collected a perfect Arabian Nights' Entertainment of tales true and untrue; the hero himself being, I think, chiefly responsible for the untrue ones.

He had in his time been almost everybody's bosom friend and usually their private secretary. The secretaryships always came to an abrupt end owing to financial complications; the friendships often lingered surprisingly long. He always seemed to have been extraordinarily attractive to "portable property" such as pictures, furniture and bric-à-brac; they flew to him, and adhered, as the steel to the magnet.

No one knew what he possessed or did not possess, nobody could exactly remember when or why they had bestowed upon him various *objets d'art*, and he had several times excited curiosity by pseudo-posthumous

COLOURPLATE 61 *(YMSM 203).*

PAGE 244; COLOURPLATES 48, 91, 62 *(YMSM 315, 228, 398, 181, 242).*

Charles Augustus Howell (c. 1849–98), whose mistress was Rosa Corder (see page 151).

Including Ruskin's.

sales to which his bewildered friends had flocked in the faint hope that their long-lost and half-forgotten treasures might come to the surface – which they seldom, if ever, did.

One day I received a hurried scrawl from Ellen Terry – "Howell is *really* dead *this* time! Do go to Christie's and see what turns up."

The actress (1848–1928); Christie's, 13 November 1890.

I went; and apparently people had become weary or distrustful of Mr Howell's abortive demises, for the sale was poorly attended and a valuable though very miscellaneous collection fetched low prices.

Among the pictures two stood out as masterpieces and both were by Whistler, the *Rosa Corder* and the *Crepuscule in Flesh Colour and Green – Valparaiso*, that dream of opaline dusk falling on phantom ships becalmed in an enchanted sea. They were each equally beyond my reach, but, in a spirit of adventure, I recorded two absurd bids – bids so futile that I did not trouble to go to the sale. When I heard that both the wonderful things had been knocked down to me I was as much amazed as delighted.

COLOURPLATE 19 *(YMSM 73).*

A few days afterwards I received a letter from Whistler. "I am told," he wrote, "that you have acquired the two paintings of mine that were offered at the Howell sale the other day. This being the case, you will perhaps pardon my curiosity to see them hanging on your walls and my desire to know the collector who so far ventures to brave popular prejudice in this country."

Robertson paid £241-10-0 for the portrait and £126 for the seascape.

"The collector" – it sounded so important – and elderly. I had been brought up by Albert Moore in the knowledge and love of Whistler, but had never met him, and now I felt very young and uninteresting and quite sure of proving a disappointment.

However, I was in for it; Whistler was coming to luncheon, my mother had taken to her bed in a sudden attack of shyness which she called a slight chill, and I was left alone to face the Great Man in much perturbation and a thick yellow fog.

I had of course heard tales of his sarcasm, his pitiless wit, his freakish temper, and by the time he arrived was on the point of developing a slight chill myself.

But behold, instead of the Whistler of legend entered a wholly delightful personage, an *homme du monde* whose old-world courtesy smoothed away all awkwardness and who exercised an almost hypnotic fascination such as I have met with in no one else.

I knew him for Whistler by the restless vitality of the dark eyes; there was the dapper figure, the black curls, the far-famed white lock, but of the scoffer, the Papilio mordens, not a trace.

We seemed to slip into a sudden intimacy: it may have been partly owing to the fog which walled us round with thick darkness, swallowing up all sights and sounds from without and leaving us curiously alone in the lamp-lit room.

This first impression of a friendly Whistler was, I am glad to say, never effaced; I seldom came across the fretful satirist of *The Gentle Art of Making Enemies*. This work was certainly held by the author in high esteem; he once read nearly the whole of it aloud to me at a sitting with the greatest enjoyment, but his delight in it was mischievous rather than malicious, and the Enemies, having served their turn, seemed if not forgiven, at least forgotten. The man whom I knew was courteous, kindly and affectionate and showed a lovable side to his nature with which he is not often credited.

The meeting between the painter and his masterpiece, *Rosa Corder*, was quite touching. He hung over her, he breathed softly upon her surface and gently stroked her with his handkerchief, he dusted her delicately and lovingly.

"*Isn't* she beautiful," he said – and so she was.

"And what else was in the sale?" he asked, when he could tear himself away from Miss Corder.

"Well," I said, considering, "there was a most lovely lacquer bed – black lacquer with a curious canopy."

"Like this?" asked Whistler, sketching a great oval in the air.

"Just like that," said I.

"That's mine!" cried Whistler. "I never *could* remember where that bed was. He would never *let* you remember where your things were. What else?"

I went through a list of objects that had pleased me, Whistler thoughtfully docketing them – "That was Rossetti's – that's mine – that's Swinburne's" – and so on. He seemed not in the least put out at the loss of his property, all ill-feeling being merged in admiration.

"He was really wonderful, you know," he went on. "You couldn't keep anything from him and you always did exactly as he told you. That picture," pointing to *Rosa Corder*, "is, I firmly believe, the only thing he ever paid for in his life: I was amazed when I got the cheque, and I only remembered some months afterwards that he had paid me out of my own money which I had lent to him the week before."

The portrait, it appeared, had been a commission from Howell, and Whistler instanced his prompt acceptance of the same, with little or no hope of payment, as an example of the man's strange influence; but a still stronger influence must have been the pure and noble face of the sitter, her clear-cut profile and gentle dignity of bearing.

According to Howell in 1878 he paid Whistler 100 guineas for the portrait, but £70 of the money, according to Whistler, was paid from an advance made by the dealer Graves on a proposed portrait of Disraeli (see page 298).

* * *

The Master was so far satisfied with our tête-à-tête luncheon that we made a day of it. The fog still rendering most objects invisible, he suggested that such an opportunity of viewing the Academy should not be missed, so we repaired thither, the appearance of the Arch Enemy within their gates fluttering the dove-cotes of the Forty not a whit; thence we went to the New English Art Club, then the stronghold of what Whistler called the "Steer-y-Starr-y-Stott-y lot" in elegant allusion to the chief painters' names, and finally parted on the best of terms.

Philip Wilson Steer (1860–1942); Sidney Starr (1857–1925). Stott, see page 251.

I knew that his easy acceptance of me was due to friendship for Albert Moore, with whom he had discussed me; nevertheless, I felt not a little elated, and from that time we saw much of each other until, some years later, he deserted London for Paris.

He was then living in a little house in Cheyne Walk with a large garden behind it. He was perpetually changing houses and each house was to serve as a subject for new and charming schemes of decoration, but, as a matter of fact, these schemes were never carried out.

In 1892.
21 Cheyne Walk, to where the Whistlers moved in February 1890.

Once in the house, he distempered the dining-room walls lemon yellow, hung the Six Projects (lovely sketches for pictures that never materialized), laid a white cloth upon the table and placed thereon a centre-piece of *Old Blue* which was his most cherished possession – and then fell to work and forgot all about the rest of the house wherein one stumbled up uncarpeted stairs and sat upon unpacked crates. But the yellow dining-room was a dream. A little peat fire always burned on the blue-tiled hearth, the Projects sparkled on the walls, the room seemed full of warm spring sunshine.

COLOURPLATES 23–26 *(YMSM 82–7).*

The front and back drawing-rooms on the first floor were used as a studio and were all that a studio should be – very bare – very untidy – very dirty, yet made beautiful by the glimpse of the river from two tall windows.

Here I used often to come when light was fading and he could paint no more; we would sit in the blue twilight that he loved and he would talk, sometimes fantastically, capriciously, his thought alighting for a moment on a subject, like his sign-manual, the Butterfly, extracting a sip of what I am bound to confess was not always honey, and flitting gaily on to the

next. But on one subject, his Art, he never jested; when he spoke of that he was always in deadly earnest. He was usually a pitiless critic of his own output and would day after day wipe out work which to anyone else would have appeared perfect.

On one or two memorable occasions we turned out the studio together, going through the many canvases stacked against the walls, and I had brief glimpses of pictures almost complete, some of them, to my eyes, among his best work, which I have never seen or heard of again.

One in particular I remember: a girl in black, painted I think from his sister-in-law, Miss Philip, standing by a table covered with a white cloth on which were silver tea or breakfast things. It was a large canvas, about the size of the *Rosa Corder*, and at that moment most beautiful.

YMSM 480.

Another wonderful "rub in" on an even larger scale was a full-length figure of Venus, running with wide-flung arms and flying tresses up a beach of golden sand from a sea of pale turquoise. A small version of the design was among the cherished "Projects" but the large picture, as far as it went, was even finer: it was the most poetic treatment of the well-worn subject that I have ever seen. Here was no languid nymph posing in an unseaworthy shell, no conscious bather struggling with her back hair, but the incarnate Joy, born of the sunshine and the dancing foam.

YMSM 548.

Even as he showed it to me I realized that at no time in his life could he ever have carried that picture to a finish; to paint a life-size nude figure to satisfy himself would always have overtaxed his frail physique and powers of draughtsmanship – but I wonder what has become of that lovely, half-realized dream.

He frequently spoilt his work by trying to take it beyond a certain point and then, as a rule, destroyed it ruthlessly; though in his last two or three years this critical faculty deserted him to a certain extent, and I have seen adorers, during that late and brief day of popularity, bending in reverence before "little masterpieces" which formerly would never have survived their hour of birth. The delicate hand had grown weary, the drawing (never a strong point) had gone all to pieces, and the execution was weak.

But when I first came to his studio these days were still far off. He would often go on painting after I arrived, and I would watch breathlessly while the magician wove his spells. In his painting there was no mechanical process, no laying of an elaborate foundation, as with Albert Moore. He painted direct upon a dark ground – very slowly – each brushful of delicate colour laid on and left, the next very slightly overlapping but not mixing with it. The picture began to grow at once into the effect desired; it was, as he loved to say, "finished from the first," though over it, when perfectly dry, were painted many other pictures until he succeeded in pleasing himself.

Doubtless by this means he obtained freshness and spontaneity, but there was one drawback. Paint in course of time becomes transparent and the dark ground beneath must gradually appear through it, dulling the super-imposed hues. During the years that the *Rosa Corder* was in my possession I noticed a perceptible difference.

Whistler, when he met a picture again after a long separation, always saw the change, yet not even to himself would he acknowledge the cause. He would order varnishing and, in many cases, cleaning – cleaning as a picture dealer understands it – and under this treatment some of his best work has suffered severely.

He at once ordered *Rosa Corder* into dock for repairs, and with a sinking heart I saw her carted off to the "restorer." Two days later I visited her in hospital and the operator, showing me a small corner of the canvas, said triumphantly, "There! And the whole picture will 'come up' just like that."

"The whole picture will come home with me at once," said I, and *Rosa*, after a thorough dusting and under a light coat of varnish, returned home none the worse.

I do not think that other people's pictures interested Whistler much. Nothing would induce him to praise where he saw no merit, though when he could say an encouraging word to a friend it seemed to give him real pleasure. Once – only once – he really liked a painting of mine, a small portrait of Sarah Bernhardt, and I remember him carrying it about the room, putting it in various lights and ejaculating at intervals – "No, but I say – eh? – isn't it – eh? – isn't it – pretty?" – and the word 'pretty' was not used opprobriously. But such moods were unusual.

Albert Moore was about the only living painter for whose work he expressed unqualified admiration, but he had never cared to acquire an Albert Moore. Moore *did* possess a Whistler, but he kept it in a dusty corner with its face to the wall.

As a fact, I have never known a painter anywhere near the front rank who could see much merit in work upon other lines than his own. Whistler could find nothing to admire in a portrait by Sargent. "Is he still doing that brown stuff?" he would enquire if I came to him from Sargent's studio. The superb decorative quality of Burne-Jones's designs escaped him altogether; he could only see the mechanical painting and the early Italian *pastiche*. For Burne-Jones, Whistler's pictures might have been blank canvas – the lovely, limpid brushwork, the delicate mystery wrought their charm for him in vain. Sargent, always broad-minded and kindly, perforce admired the technical perfections of Whistler's best works, but I think they gave him little pleasure: the artistry, the creative touch that distinguishes a picture from a clever life study, weighed but lightly with him.

The truth is that no great painter cares much about pictures painted by other people: catholic appreciation would seem to be a second-rate quality.

I, always hopelessly second-rate, often found myself in difficulties with Whistler over this point. He would have his friends and disciples "leave all and follow him," and he knew me to be compassed about with guilty entanglements elsewhere; though I tried to keep them discreetly in the background they were always turning up. On the whole he bore with them wonderfully.

Once, I remember, we had taken Mrs Whistler to call on Albert Moore and were walking away from his house together when I prepared to say good-bye and turn Hammersmithwards.

"What are you going down there for?" asked Whistler, suspiciously.

I braced myself. "I'm going to see Burne-Jones."

"Who?"

"Burne-Jones."

"O – Mister Jones" (this curiously pointless gibe never palled upon Whistler). "But what on earth are you going to see him for?"

"I suppose, because I like him."

"*Like* him. But what on earth do you like him *for*? *Why* do you like him?"

He had now faced round barring the way, his little cane rapping angrily on the pavement. Why did I like Burne-Jones? There were so many reasons and I could not stand in the middle of the High Street giving them all to Whistler. I took the first that occurred.

"I suppose – because he amuses me," I said feebly.

"Amuses you? Good heavens – and you like him because he amuses you! I suppose" – with rapid deduction – "I suppose *I* amuse you!" Another rap of the cane and a fiery glance. Here was an impasse. If I said yes – yet on the other hand, if I said no –

"Don't tease him, Jimmy," said Mrs Whistler. "Surely he may choose his own friends."

Whistler suddenly and lightly touched my hand. "He doesn't mind, do you?" he said with one of his rare smiles. Though he laughed much he seldom smiled, the carefully studied sardonic grin being merely a stage

effect and counting for nothing. When he smiled he was irresistible: I felt that he had apologised and sworn undying friendship, though I am sure that nothing was further from his thoughts. The memory of Burne-Jones's evidence against him in the Ruskin trial always rankled. Truly this had been a great mistake, but the primary error was the calling of Burne-Jones on the case at all, a craftsman in an entirely different branch of Art. They might as well have called Grinling Gibbons or Benvenuto Cellini. Whistler himself as a critic of Burne-Jones's work would have been of equal value.

* * *

Another selected sitter who failed to appreciate the honour paid to him had been Disraeli. Whistler had long wished to paint that remarkable man, whose bizarre appearance appealed strongly to him as a subject, and he had tried through many channels to attain his desire, but in vain.

One day he had come upon the longed-for model sitting alone in St James's Park, apparently absorbed in thought. Even Whistler experienced an unusual sensation which he recognised as shyness in the strange and sinister presence, but plucking up his courage, he plunged boldly in, endeavouring to recall himself to the mystic Prime Minister and finally making his request. The Sphinx remained silent throughout; then, after an icy pause, gazed at him with lack-lustre eyes and murmured, "Go away, go away, little man."

Whistler went, and with him the Great Poseur's chance of immortality on canvas. He shortly afterwards graciously assented to sit to Millais, who produced – nothing in particular to everybody's entire satisfaction.

* * *

During his brief reign as President of the British Artists of Suffolk Street he devised for the Gallery a very quiet scheme of grey-brown with just a hint of gold here and there, but while it was being carried out he was perforce absent for a few days. On his return he found that gold was being used freely, to the complete undoing of his design, but the artist in charge, much disappointed at his President's disapproval, explained that there *was* the gold, and, in his opinion, it ought to be used.

"After all," continued the well-meaning man, "you're *using* gold in the decoration, so I don't see why –"

"Look here," said Whistler patiently, "suppose I'm making an omelette and you come along and drop in a seagull's egg. I'm *using* eggs, but – see?"

I hope that the British Artist saw, for Whistler was really an authority on omelettes and indeed on cookery in general, and perhaps I should quote one of his golden rules as a guide to housewives.

"I can't think why people make such a to-do about choosing a new cook," he would observe reflectively. "There is only one thing that is absolutely essential. I always ask at once, 'Do you drink?' and if she says, 'No,' I bow politely and say that I am very sorry but I fear that she will not suit. All *good* cooks drink."

* * *

On the sad return to England after the Paris years I do not like to dwell. Mrs Whistler had become alarmingly ill, and when she was brought home the end was already close at hand. Her husband, who was devoted to her, would not acknowledge the hopelessness of the case: he shut his eyes to it and would talk to me of schemes for the future, of houses to be taken, of studios to be looked at, all to be done "when Trixie was better." And yet he knew – and I knew – and he knew that I knew. He now looked old for the first time, and after the dreaded blow had fallen was never the same man again.

Benjamin Disraeli, Rt. Hon. Lord Beaconsfield (1805–81), declined an invitation to sit for Whistler in July 1878 when, according to Alan Cole (see page 119), Whistler visited him at Hughenden.

Millais' portrait of Lord Beaconsfield was shown in the Royal Academy of 1881 and is now in the National Portrait Gallery, London.

Robertson writes here of the period from late 1894 until the death of Whistler's wife in May 1896.

He wandered for a while to Lyme Regis and other places and I heard of him from time to time from a kind friend of his and old school-fellow of mine, Arthur Studd, who was much with him; but he finally drifted back to Chelsea and Cheyne Walk, to a house which never took on any Whistlerian atmosphere, a house that I hated at sight and whose hideous brass door I never passed without a sense of discomfort. Here I remember but few meetings and not one that did not leave me sad. Once he seemed almost himself; he had been writing one of his old, freakish letters and was chuckling over it as of old, yet a note was unfamiliar. He looked ill, but – there was something else. He read me the letter with glee, challenging approval. "Well? Eh? Well? How's that, d'you think?" I hesitated. It was too long, too laboured, all was said in the last sentence and the involved paragraphs leading up to it should have been cut out. "Eh?" still said Whistler, and I still hesitated.

Miss Philip, his sister-in-law, made some excuse to brush by my chair. "Don't tell him *now* if you don't like it," she whispered. "He has been over it all the morning and he's so tired."

So tired. Yes, that was it. He was tired – tired at last. Certainly the two most vital people that I have ever known were Whistler and Sarah Bernhardt. Life was to them an art and a cult, they lived each moment consciously, passionately. I had seen the painter after a day's struggle with a picture, the actress after a hard evening's work, come to a momentary halt from physical exhaustion, yet it was as the halt of an engine at a station – the imprisoned energy still throbbed and panted to be off again. This was different: Whistler was "so tired." I only saw him once again.

In September 1895.

Arthur Haythorne Studd (1864–1915), artist and collector, bought Symphony in White No. 2: The Little White Girl *YMSM 52 (Colourplate 17) in 1893, and also acquired YMSM 115, 169. In April 1902 Whistler leased 72 Cheyne Walk, designed by the architect C. R. Ashbee.*

Rosalind Birnie Philip (see page 52).

CLAUDE DEBUSSY

Letter to Eugène Ysaye

22 September 1894

My dear good friend,

I was so long in writing to you because I'm afraid my letter may find you on the . . . "great ships which sail upon the waters," taking good music to the straightforward Americans. So forgive me, but I'm so shattered by writing endless double crochets on paper unswervingly covered with 32 staves, that I don't even have the energy to write to those I'm fondest of, and you may boldly count yourself among their ranks.

I'm working on three nocturnes, for solo violin and orchestra; the orchestra in the first one is made up of strings; the second of flutes, four horns, three trumpets and two harps, the third bringing these two combinations together. In a word it is an investigation into the various arrangements a single colour can give, like a study in grey in painting, for example.

I hope it will interest you, and such pleasure as you may find in it is what concerns me most. But I'm not letting *Pelléas* drop on that account, and anyway, the further I get, the blacker my doubts become . . . and actually this pursuit of the dream-like expression, which a mere nothing dispels, and also the intentional suppression of all garrulous contingencies, are finally wearing me down like a stone under passing carriages. I wish you all the success you can rightly hope for and believe me your faithful and devoted friend,
Claude Debussy

The French composer Claude Debussy (1862–1918) first conceived the "Nocturnes" in 1890, based on poems by the Symbolist poet Henri de Régnier. In 1894 they were rearranged as a three-movement concerto for the Belgian violin virtuoso Eugène Ysaye and orchestrated in their definitive form in 1899. Debussy derived the title "Nocturnes" from Whistler who on 17 May 1893 attended the première of Maeterlinck's Pelléas and Mélisande *with Debussy, Mallarmé and de Régnier.*

WILLIAM ROTHENSTEIN

MEN AND MEMORIES

Homage to Whistler

1931

To the artist William Rothenstein (1872–1945), Whistler was "almost a legendary figure" when he met him in Paris in 1892 and became a regular guest at the Rue du Bac. Rothenstein's memoirs provide rich insights into the artistic personalities of the 1890s, in London and Paris, including Whistler, whose nickname for Rothenstein was "Parson" and with whom he remained on amicable terms until he testified for Sickert in the Pennell lithography case, and was seen in the company of Whistler's bête noire of 1895, Sir William Eden (see pages 325–326).

It is true that Whistler, while he had an inimitable sense of drawing, was not, in the full sense of the word, a good draughtsman. Yet so exquisite was his feeling for form, he succeeded where less sensitive draughtsmen failed. And so elusive was the mark at which he aimed, and so often, as he thought, he failed to achieve it, his fastidiousness cost him the destruction of a large part of his life's work.

There are two different approaches to painting: one is that of surrendering oneself to life in order to interpret its vivid, surprising, articulated forms, to get to grips with each aspect of nature, to ravish from each individual object or person something of life's vivacity and profundity, something that shall stand for life as a whole. This was the way of Velazquez and Hals and Chardin, which the Realists and Impressionists followed. But there is another aspect of life in painting: there is a finality of form, removed from momentary appearance. This aspect has been supremely expressed in certain Italian paintings, where form is seen as though carved from agate or ivory, hard, resisting, everlasting, so that the figures dealt with have something in common with images set in shrines, through their very remoteness from life, images which evoke, in those who worship before them, a comfort, a beauty, a truth of which all men get an inkling at rare moments.

Now this agate-like quality of design and form which so dignified painting, and which I missed in the Realists, has always moved me. Certain drawings have this quality; I was dimly aware of it in some of Rossetti's early drawings, especially his pen-drawing of Miss Siddall at the South Kensington Museum; later on I found it in other of his clear and close-knit designs. This was at least Rossetti's aim, if not the aim of the other Pre-Raphaelites, to achieve completeness of conception rather than finish. Whistler, too, aimed at something less accidental, something more foreseen, than his French contemporaries, and he laboured to achieve a quality of material and surface which should suggest both the mystery and the permanence of life.

Strangely enough Cézanne, whom Whistler so much disliked, was haunted by a similar desire. Manet, Degas, Renoir and Monet were less disturbed by such dreams. Only Millet achieved the perfect fusion between movement and form, between what was passing and what was permanent. Perhaps it was the inkling I had of his underlying desire for something other than casual appearance that drew me so strongly to Whistler's work. Of all his portraits, I most liked the *Rose Corder*, which was shown, with several other paintings by Whistler, at the first Salon du Champ de Mars.

Elizabeth Siddall (1834–62), Rossetti's muse and mistress who became his wife.

Paul Cézanne (1839–1906). His biography, by the dealer Ambroise Vollard, testifies to Whistler's dislike of Cézanne's art (1934). Jean-François Millet (1814–75).

YMSM 203, exhibited in 1891 (see Colourplate 61).

* * *

Whistler was still living in Paris, but he often came over to London, staying at Garland's Hotel. He went occasionally to the Chelsea Club. There, one evening, I found Whistler dining with Pennell. Whistler made me sit down next him, saying, "My dear Parson, I can't play second fiddle to anyone, so I could not reply to your amusing letters." He was very charming and lively, but Pennell was sulkily hostile. Talking of *Trilby*, which had lately been published, Whistler said that Du Maurier's manuscript had actually been sent to him, that he might delete anything

The Chelsea Arts Club founded in 1891. Joseph Pennell (see page 104). The incident described here must have occurred in 1894, the year Du Maurier's novel was published.

he considered offensive to himself. He was in London, he said, about lithographs and law.

Whistler had taken a great fancy to Macmonnies; and he talked much in praise of Forain. He was to paint Alphonse Daudet's little girl; and he spoke about one of the Boston decorations, which he had been asked to undertake, as he wished. Speaking of Edmond de Goncourt, he said: "The man who keeps a journal always ends in the dock."

When Whistler was talking of someone to whom he had given letters of introduction, Pennell said pointedly, "They all start that way, whether they have them or not." I was angry, and I assured Pennell I had been received in London with open arms, because people knew I was not one of his friends. Whistler laughed and calmed Pennell down.

I didn't really dislike Pennell; but he showed such hostility to me that I was forced into an aggressive attitude towards him. He was an uncritical worshipper of Whistler, resentful of sharing Whistler's friendship with people who showed independence. In his life of Whistler, a life which is full of interesting matter, and which gives a very vivid presentment of the man, he speaks with small respect of those whom he calls "the followers," yet what was he himself but one of the most sycophantic of these? He says truly that Whistler was not really so quarrelsome as people thought, or as Whistler himself would have them believe. It was people like Pennell who played on Whistler's vanity, and prejudiced him against certain people. Pennell, for instance, was interested in the International Exhibition; therefore the people connected with the International Exhibition must be shown in the most agreeable light.

No one adored Whistler more than myself, but the gross flattery offered him by men who could keep his friendship only by compromising their own dignity, revolted me. After the decline of the Grosvenor Gallery, the most important independent movement in England was obviously that of the New English Art Club. Pennell goes out of his way to speak maliciously of everyone connected with the Club. No artists were more stalwart supporters of Whistler than Walter Sickert, Wilson Steer, Henry Tonks, William Nicholson (who by the way was never a member of the New English Art Club) and Charles Conder. One of his strongest champions in the press was D. S. MacColl; yet Pennell suggests that MacColl was only a lukewarm supporter of Whistler, for no other reason than that Whistler had once or twice exhibited at the New English Art Club. This is a gross libel on MacColl's attitude to Whistler's art throughout his career as a critic. Sickert, during many years of his life, was Whistler's most intimate and ardent friend. Steer, whose nature was never demonstrative, had the highest opinion of Whistler's work. But Whistler required from his friends not only loyalty and admiration, but exclusive loyalty and admiration. This was asking too much of high-spirited youth, for the generosity of youth is unlimited. Whistler could absorb all the devotion and admiration, even flattery, which were given him; but like most people he would not look too closely into the work of his admirers. He was unlikely to be over critical so long as he had their homage; but the Pennells did scant justice to Whistler's fine critical acumen, in taking so seriously his pleasant ways with his worshippers; for Whistler knew perfectly well who were artists to be reckoned with, and who were not.

Max Beerbohm used to tease me about my admiration for Whistler.

* * *

My admiration for Whistler has never changed. He was without doubt one of the remarkable artists of the nineteenth century, and one of its great personalities. His faults were obvious; among them was his habit of judging people in relation to himself. But his character was a whole and rounded one, and one accepted it, and still accepts it, as unique and legitimate – legitimate for the reason that he made of his life an unity.

Frederick William MacMonnies (1863–1937), the American sculptor who later taught at Whistler's Académie Carmen (see page 329); Jean-Louis Forain (1852–1931). There is no further record of Whistler painting a portrait of the writer Alphonse Daudet's daughter and only a painted sketch survives of Whistler's 1891 commission to decorate Boston Public Library (YMSM 396).

The Life of James McNeill Whistler (2 vols, Lippincott, Philadelphia, and Heinemann, London 1908).

The International Society of Sculptors, Painters and Gravers, under Whistler's Presidency, held its first exhibition in London in April 1898 (see page 320).

Founded in 1886 the New English Art Club was the nursery of English Impressionism and, to some extent, rivalled the Royal Society of British Artists and the International Society which Whistler intended should outflank it.
Henry Tonks (1862–1937); William Nicholson (1872–1949); Charles Conder (1868–1909); the critic and artist D. S. MacColl (1859–1948). Whistler exhibited at the New English Art Club in 1888.

Max Beerbohm (see page 351).

When he attacked this man or that, it was largely because he stood in the way of his own reflection. His life was to be, as it were, a perfect self-portrait. The Pennells were blind to Whistler's human fallibility, blind to qualities outside Whistler's compass. One of the most touching letters Whistler wrote was a letter to Fantin-Latour in which he regrets that he couldn't draw with the precision of Ingres. Absurd modesty! say the Pennells, Whistler drew much better!

See page 82; and the Pennells' Life of Whistler, *I, page 146.*

JAMES MCNEILL WHISTLER

Letter to Mallarmé

1896

PARIS, OCTOBER(?) 1896

I come in, and I write you these few words, my dear Mallarmé, without further reflection upon those conventions which remind one of the bitter truth: always distrust the first thought that comes to mind – it is often the right one –

I cross Paris and return to London to find myself alone and timid before my work (which may feel resentful at my having left it) and having to present a smiling and brave front to my enemies.

And now I am always alone – alone as Edgar Poe must have been – you said you saw a certain resemblance. But in leaving you, I seemed to be saying Adieu to a second self! – alone in your Art as I am in mine – and in shaking your hand that evening, I felt the need to tell you how drawn I feel towards you – how touched I am by the closeness of spirit you showed me.

Between 1888, when he translated the "Ten O'Clock" lecture, and his death in 1899, the poet Stéphane Mallarmé (1842–99) was Whistler's most intimate friend and closest intellectual collaborator. Both aimed at suggestion rather than description in their respective art forms, recognizing in each other the seeker of ever higher forms of artistic expression, which is spontaneously expressed here in unqualified admiration for the poet in a letter originally written in French after the death of Whistler's wife.

Stéphane Mallarmé, *Récréations Postales.* Cover design (recto). Drawing. 1893. Whistler Collections, Glasgow University Library.

Stéphane Mallarmé, No. 1, W.66.
1894. Lithograph, 3¾ × 2¾"
(9.5 × 7 cm). Hunterian Art
Gallery, Glasgow University
(Birnie Philip Bequest).

STÉPHANE MALLARMÉ

DIVAGATIONS

On Whistler

1899

If, externally, he appears, on superficial examination, to be the man of his painting, it is to the contrary – first in the sense that work such as his, innate, eternal, gives up beauty's secret; acts the miracle and denies authorship.

A rare Gentleman, in some regard a prince, emphatically the artist, proclaims that this is him, Whistler, all of a piece, since he paints the person whole, the stature, lowly to those who wish to see it as such, lordly, matching the tormented, knowing, handsome head; and again returns to the obsession with his canvases.

Just enough to be provocative! the enchanter of a work of mystery as inaccessible as perfection itself, which the throng would pass by even without hostility, has understood the duty required of his presence – to challenge this situation by means of a few fits of bravura until the wholly admiring silence is defeated.

This discretion, refined into a softness of touch, leisurely, composing a presence, very easily, and without losing anything of its gracefulness, breaks out into the vital contempt which the black garments provoke against the radiance of the linen like the whistling of laughter and presents to contemporaries, faced with the exception of sovereign art, precisely what they need to know about the author, the shadowy though known guardian of a genius, nearby like a dragon, warring, exultant, precious, worldly.

This description of Whistler is Mallarmé's literary pendant to the poet's portrait Whistler made in lithography for the frontispiece of his Vers et Prose *published in 1893. Copies of Mallarmé's principal publications, inscribed to Whistler, are in Glasgow University Library. Some, however, are uncut, for Whistler too was mindful of the difficulty of some of the poet's more opaque writing, when he said in a letter to his half-sister Deborah, Lady Haden, written in 1896: "Yes, Mallarmé is curiously difficult – perhaps – but the most charming and* raffiné *of men – and the truest and fondest of friends."*

Letter from Whistler to Thomas R. Way jr. from the Royal Lion Hotel, Lyme Regis, Dorset. 25 October 1895. Freer Gallery of Art, Smithsonian Institution, Washington, D.C. Whistler's letter shows which drawings Way is to transfer to lithographic stones.

T. R. WAY

THE STUDIO

"Mr Whistler's Lithographs"

December 1895

The publication from time to time in THE STUDIO of separate lithographs by Mr Whistler, and rumours of other prints which have passed into the hands of collectors, have stimulated the interest of all art-lovers to see a really representative collection of these works, and the recent Exhibition at the Fine Art Society's Gallery showed, what everyone who has studied his works expected from Mr Whistler, that he has made the material his own, and proved it a worthy medium to express the extraordinary versatility of his art. The exhibition formed a worthy tribute to the memory of Senefelder, the inventor of lithography, on the completion of the centenary of his discovery, from the most distinguished artist who has yet used it. Mr Pennell, in his charming account of Senefelder which formed the introduction to the catalogue seems to hint at this idea; and as the exhibition was held here in London, it goes far to put us on an equal footing with Paris, where a general exhibition of lithography to celebrate the event was lately held. Only a short time ago a distinguished artist said that lithography has not had its Rembrandt as etching has, although the possibilities open to the artist by its varied processes were greater. True; but this collection showed that it can claim a master of the same rank, who has brought distinction to it, even as he did to the art of etching, although there Rembrandt had been before him.

It is now about twenty years since Mr Thomas Way, a lithographic printer, first brought to Mr Whistler's notice the possibilities of lithography, and he entered into the matter with his usual enthusiasm, producing during 1878-79 some very beautiful works. The four lithotints – *Nocturne, Early Morning, Limehouse* and *The Toilet* – were done during this period, and they are not only the most exquisite works of art in themselves, but they are technical masterpieces in the art of lithography, and it would be difficult to point to anything produced in any country up to that time to equal them as such. In the early part of the century Hulmandel, the prince

Thomas Robert Way in April 1893, with W. Rothenstein (see page 300), wrote for The Studio *a two-part article on Whistler's lithography, and in 1896 published the first catalogue raisonné of the lithographs (*Mr Whistler's Lithographs, *Geo. Bell & Sons, London, second edition 1905), which led to a quarrel between Whistler and the Ways. The exhibition of lithographs was held from December 1895 to January 1896. The catalogue has a prefatory note by Pennell, and is notably the only one for which Whistler asked someone else to write the introduction. Aloys Senefelder (1771–1834).*

i.e. Thomas Way (Sen.) (see page 106).

W. 5, 7, 4, 6, all made in 1878 (see page 105).

Charles-Joseph Hulmandel (1789–1850).

of English lithographic printers, had invented and perfected a process of wash drawing on stone which gave excellent results; it may be seen frequently in the drawings of Harding, Nash and Catermole; unfortunately with the death of Hulmandel the secret was lost. Mr Way had spent many years in trying to recover it, and had fortunately arrived at a sufficiently satisfactory result to be able to put this process before Mr Whistler, along with the others more generally in use. But in the hands of any one but a master the result is not often satisfactory, as from the beginning of a drawing he must know exactly at what he is aiming, and go right to his end in the most direct way. The *Nocturne* illustrated in this article shows this in a very perfect manner. A difficulty seems to have arisen in the minds of some people as to the locality of the *Nocturne* and *Early Morning*, but those who know the river as it runs past Chelsea will have no difficulty in finding the subjects, if they will remember that the prints are reversed. After these three years a long break took place in Mr Whistler's lithographic work, whilst he was making his wonderful series of Venice etchings and pastels; for, like most artists who work in a variety of mediums, each will monopolize his thought for a long period. But in his case, when next he turned to lithography, he entered on a completely new phase of the art, and has not again used the lithotint process at all. It is to be hoped, however, that in the future he will do so, and will bring the fruits of his later studies to bear on it. About 1885-86, when he began working afresh, the transfer papers and processes had been greatly developed and improved, and being desirous of working out of doors, the naturally great facilities of this method tempted him to use it in place of the stone. It is, perhaps, as well that it was so, as it would have been quite impossible to

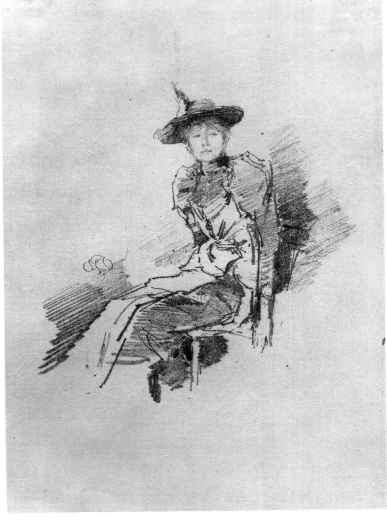

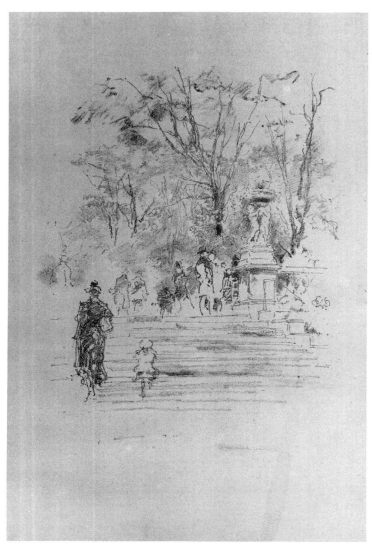

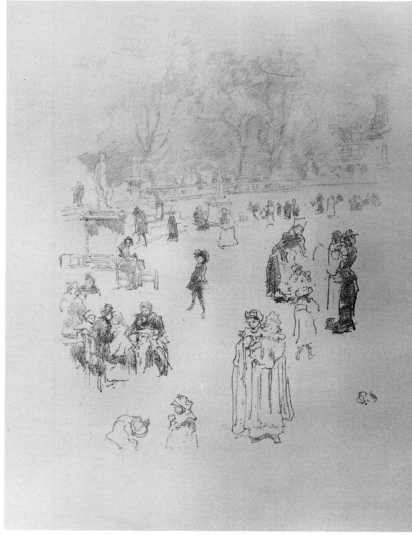

have had a stone out in the street to draw many of the delightful shops and groups of old buildings which were done about this time, and, indeed, extend right up to the present. The earliest were the *Entrance Gate, St Bartholomew's* and the *Little Court, Clothfair*; soon after came the *Ragshops, The Wheelwright* and *Maunders' Fish Shop*; whilst, at the same period, too, the delightful semi-classic studies of lightly draped girls, recalling to one's mind the loveliest Tanagra figures, *The Dancing Girl* and *Model Draping*, and *The Little Nude Model Reading*, which is one of the finest studies of the nude ever made in black and white. Whilst, in what may be classed as portraiture, the two very popular drawings of *The Winged Hat* and the *Gants de Suéde*, the latter issued as a supplement to THE STUDIO of April 1894 – drawings so full of colour and life, and so marvellously firm, as indeed may be said of every drawing recently exhibited. A little later came the drawings of the *Hôtel Colbert*, with the capital group of cock and hens done in the same manner as the preceding; but when we look at the next series, the drawings of Vitré, we see a distinct development. In *The Canal*, Mr Whistler uses the stump for the first time, and produces by its means the exquisite liquidity of the water and the delicate cloudy sky. "Stumping," as here used, and also in a great number of the following drawings, must not be confounded with a process of secondary printing lately described in THE STUDIO. On stone it has been in use nearly as long as lithography has been invented, being always a favourite process with French artists; but its application by Mr Whistler to his drawings is on quite individual and distinct lines, as will be seen when we study the Luxembourg series – *The Steps*, with its dainty figures ascending and groups at the top, or the dark

ABOVE LEFT *The Steps, Luxembourg Gardens*, W.43. 1893. Lithograph, 8¼ × 6¼" (21 × 15.8 cm). Hunterian Art Gallery, Glasgow University (J. A. McCallum Collection).

ABOVE *Nursemaids: "Les Bonnes du Luxembourg,"* W.48. 1894. Lithograph, 7⅞ × 6⅛" (19.8 × 15.5 cm). Hunterian Art Gallery, Glasgow University.

The lithographs referred to are, respectively: W. 16, 18 (1887); 21, 22 (1888); 27, 28 (1890); 30, 31, 29 (1890); 25, 26 (1890); 35, 36 (1891); 39 (1893).

W. 43, 45 (1893)

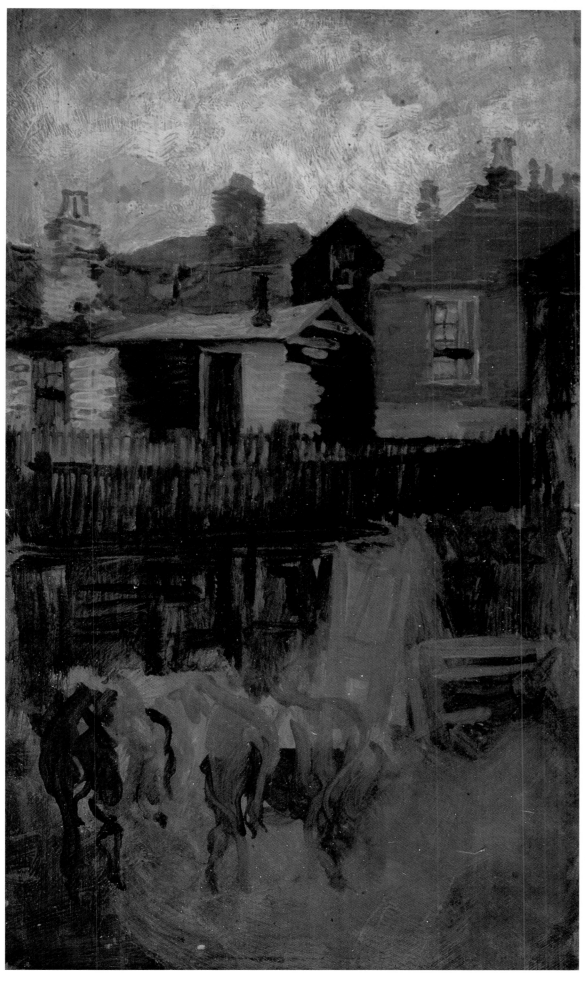

COLOURPLATE 96. *The Little Red House*. Early 1880s. 8½ × 4⅞″ (21.5 × 12.4 cm).
Hunterian Art Gallery, Glasgow University.

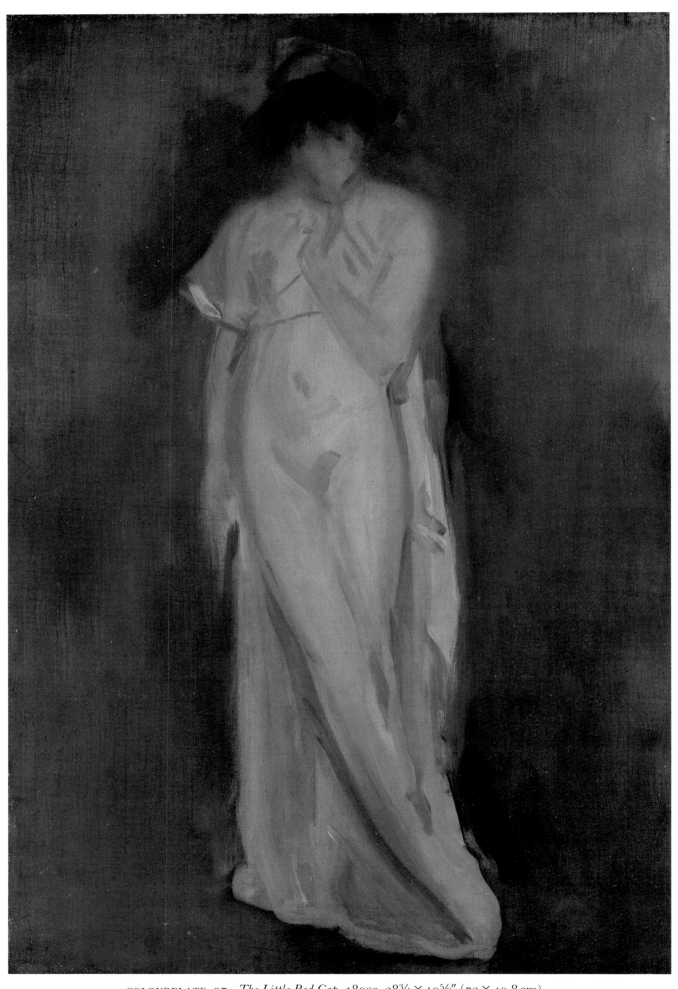

COLOURPLATE 97. *The Little Red Cap.* 1890s. 28¾ × 19⅝″ (73 × 49.8 cm).
Hunterian Art Gallery, Glasgow University.

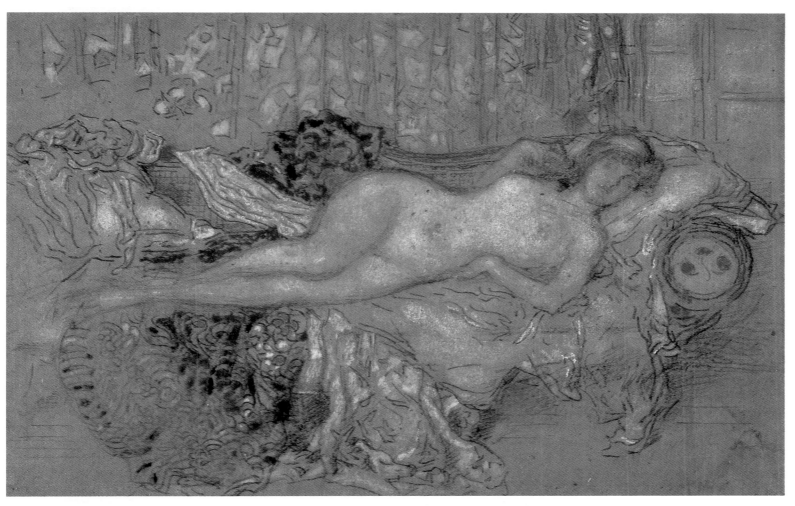

COLOURPLATE 98. *The Arabian. c.* 1892. Pastel on brown paper laid down on card, 7⅛ × 11″
(18.1 × 27.8 cm).
Hunterian Art Gallery, Glasgow University.

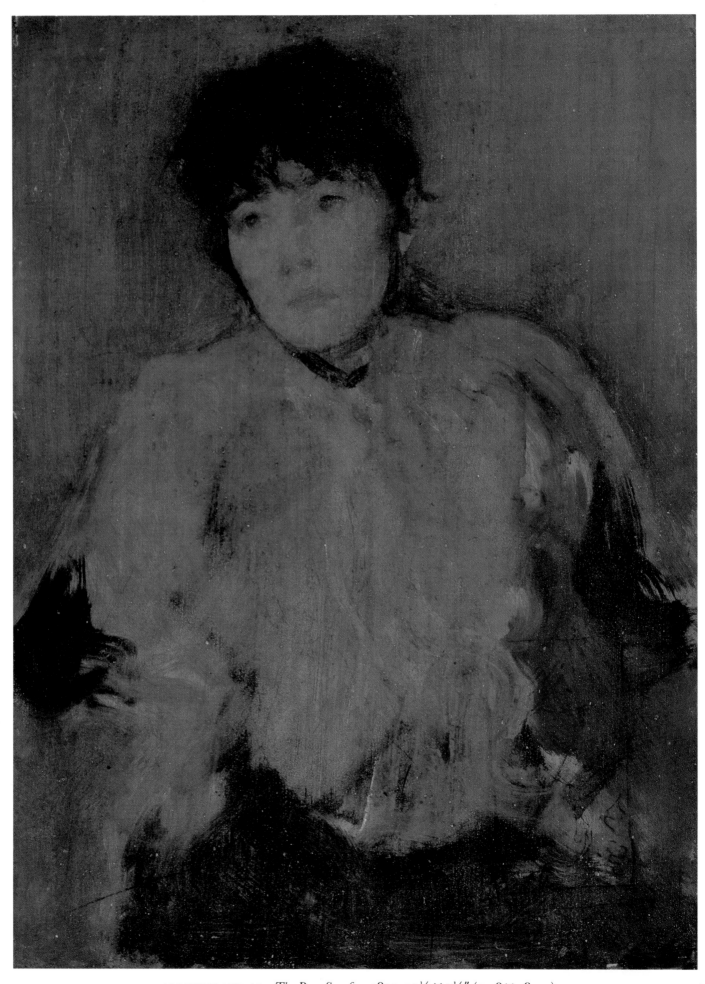

COLOURPLATE 99. *The Rose Scarf. c.* 1890. 10⅛ × 7⅛″ (25.8 × 18 cm).
Hunterian Art Gallery, Glasgow University.

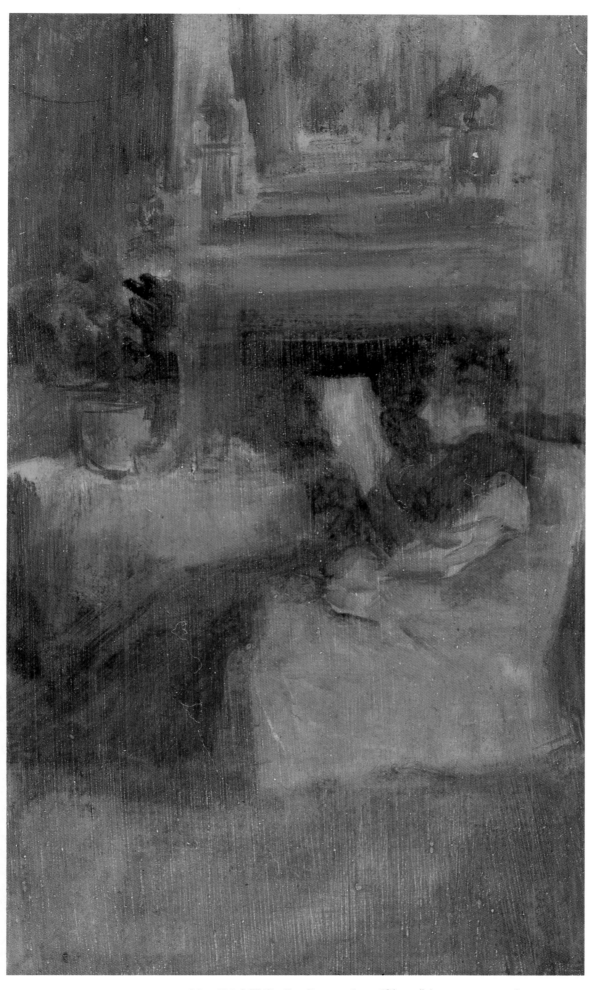

COLOURPLATE 100. *Miss Ethel Philip Reading. c.* 1894. 8⅜ × 5″ (21.2 × 12.7 cm).
Hunterian Art Gallery, Glasgow University.

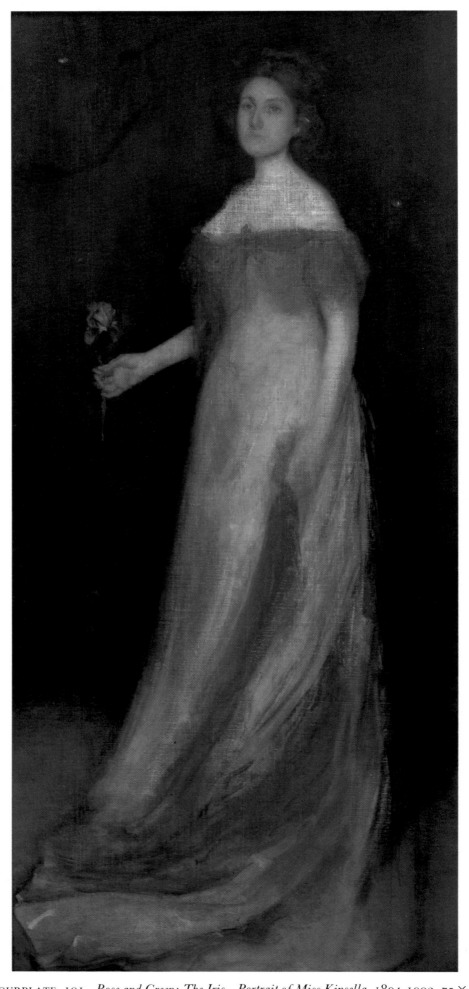

COLOURPLATE 101. *Rose and Green: The Iris – Portrait of Miss Kinsella.* 1894-1902. 75 × 35″
(190.5 × 88.9 cm).
The Terra Museum of American Art, Chicago.

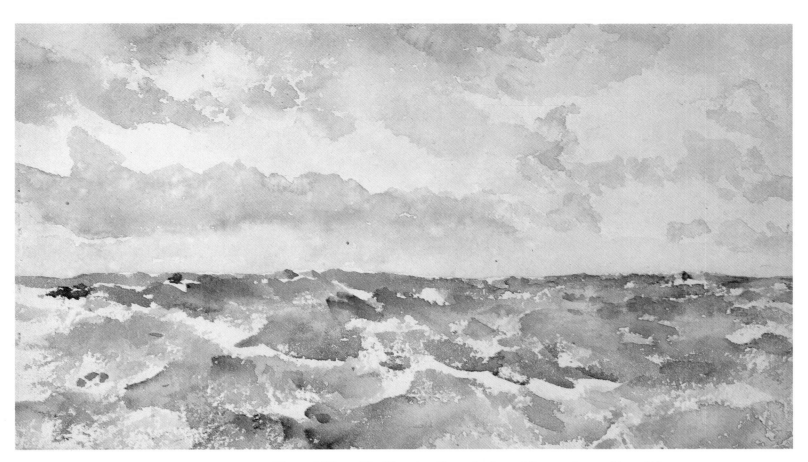

COLOURPLATE 102. *Blue and Silver: The Chopping Channel.* 1890s. Watercolour, $5\frac{1}{2} \times 9\frac{1}{2}''$
(14.1×24.2 cm).
Freer Gallery of Art, Smithsonian Institution, Washington, D.C.

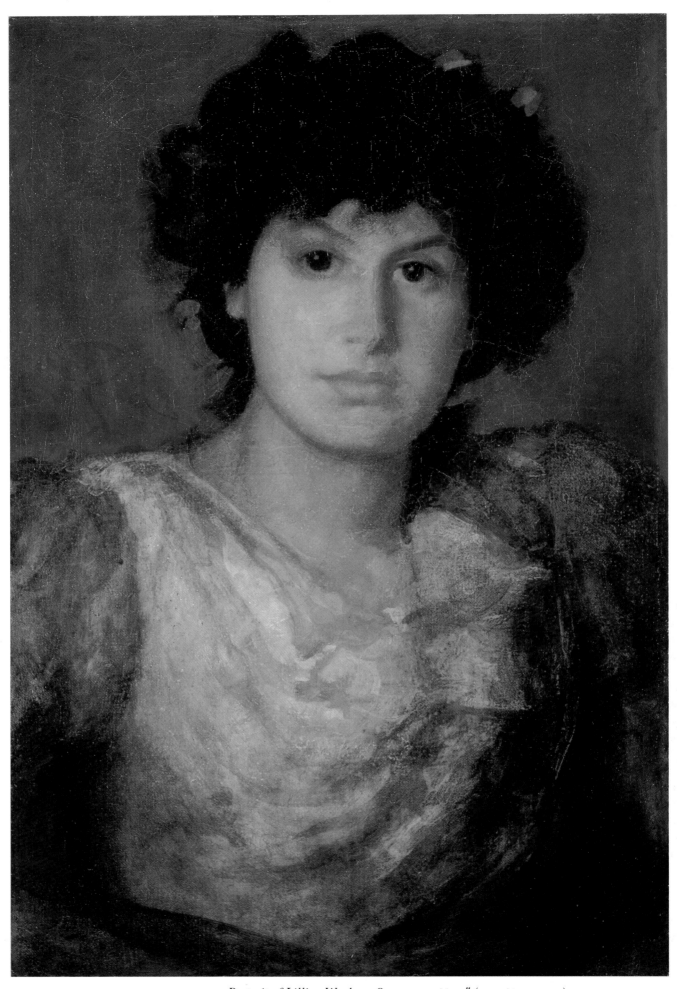

COLOURPLATE 103. *Portrait of Lillian Woakes*. 1890-92. 21 × 14″ (53.5 × 35.5 cm).
Phillips Collection, Washington, D.C.

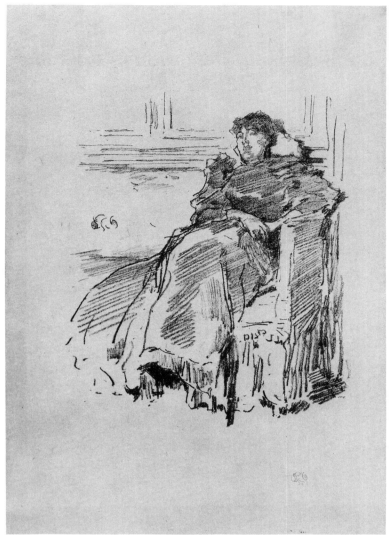

Dome of the Pantheon from the terrace on which are the familiar nursemaids and children; but the peculiar quality, the velvety softness of stumping, is seen in its most elaborate form, perhaps, in the *Nude Model Reclining* and the *Draped Model Seated*, which are almost entirely modelled by this process; such work, indeed shows the master!

The next few drawings return to the simple methods of the earlier ones, *The Nursemaids* and *The Balconies* being drawn with the point. The former is a very typical example of Mr Whistler's treatment of a number of little groups of figures; charmingly composed, treated in a manner that rivals Hiroshigé in his rendering of Japanese streets. The two drawings called *The Balcony* and *The Long Balcony*, in brilliant sunlight, are hardly suggestive of the sombre occasion which called them into being – the funeral of President Carnot. *The Long Gallery, Louvre*, one of the few interiors, will be well within the memory of the readers of THE STUDIO. With the *Rue Furstenburg* we come to a fresh development, the drawing being free from the mechanical texture to be found in those preceding it – although it must be allowed that the artist has used this grain in such a way that it in no sense interferes with the beauty of his drawings, and in fact, it is quite unnoticeable until we look for it; but this drawing shows a quite different treatment of a street scene, suggested no doubt by the subject, which is very typical of Paris in its older quarters. *La Belle Dame Paresseuse* [The Beautiful Lazy Lady] is more like a charcoal drawing than a lithograph, but the next two, *Confidences dans le jardin* [Secrets in the Garden] and *La Belle Jardinière* [The Beautiful Gardener], do not fail to impress themselves as lithographs of the most delightful description, and

ABOVE LEFT *The Draped Figure – Seated*, W.46. 1893. Lithograph, 11 × 8″ (27.8 × 20.2 cm). Hunterian Art Gallery, Glasgow University (J. A. McCallum Collection).

ABOVE *The Red Dress*, W.68. 1894. Lithograph, 13 × 8½″ (33.2 × 21.4 cm). Hunterian Art Gallery, Glasgow University (Birnie Philip Bequest).

Respectively: W. 47, 46 (1893); W. 48, 49, 50 (1894).
Marie-François Sadi Carnot, fourth President of the 3rd Republic, assassinated by Italian anarchist 24 June 1894.

W. 52, published in The Studio, *September 1894, f. p. 190; W. 59 (1894); W. 62 (1894), a portrait of Beatrice Whistler; W. 60, 63 (1894).*

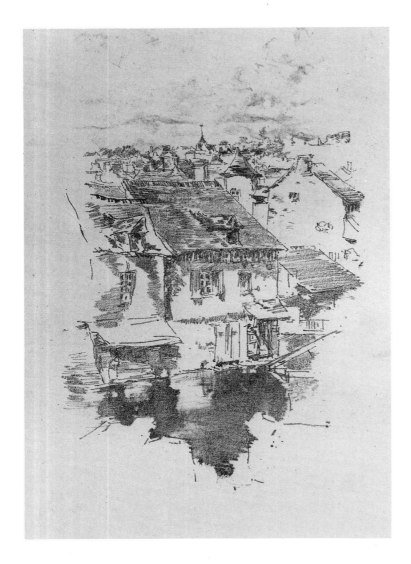

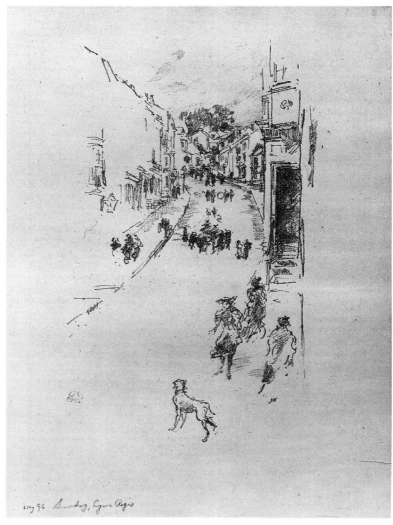

Hy 96 Sunday, Lyme Regis

show a new and unexpected side of the artist's art; surely they cannot fail to entirely satisfy the most utter Philistine, whilst they will give equal pleasure to his warmest admirers; and the same remark applies to the night interior *The Duet*; the arrangement of light and shade is worthy of Rembrandt in his own peculiar line. The two dark interiors, *The Smith* and *The Forge*, of the Place du Dragon, mark yet another change, and should be considered as drawings on stone, for, although drawn on paper from Nature and transferred to stone, the fine qualities of both were then added; and where is more exquisite finish to be found than will be seen in the little figures of these two drawings? In them, also, the peculiar qualities of stumping is observable.

Then we have the charming drawing, *La Robe Rouge* [The Red Dress], so lately printed in THE STUDIO, *La Belle Dame Endormie* [The Beautiful Sleeping Lady], and the beautiful group of the *Sisters*, graceful alike in action and composition, and the two splendid portraits, *Stéphane Mallarmé*, the great French poet, and *The Doctor*, the famous throat surgeon, and brother of the artist. Next we come to the latest series of drawings, made during the last few months at Lyme Regis, and showing yet another side to the artist's amazing versatility, for who would have imagined that he would now show himself as an accomplished animal draughtsman? And yet, are not *The Smith's Yard* and *The Good Shoe* worthy of any artist who might have spent his whole life in studying horses? And, moreover, as lithographs, this series is quite different from all that precede it. How slight a drawing is *The Strong Arm*, and yet how suggestive of the brilliant warm light of the furnace, and the *Father and Son*, of sunlight; whilst in the night scene, *The Fair*, full of busy little groups, the tall building in the distance is dimly seen lit with the flickering lights from the booths; then,

latest of all, *The Fifth of November*, with its bonfire, and the *Sunday, Lyme Regis*. This last is an exquisite drawing, which seems to have called forth a universal chorus of praise, such as the great brilliancy of the drawing well deserves, even amongst the others. The two colour prints hung at the end of the exhibition should in date be placed much earlier. They are full of promise, and it is to be hoped that Mr Whistler will in the future do many more. The *Yellow House*, with its green woodwork, is most exquisite in colour, and like one of his own Venice pastels. Few people will be able to understand the difficulties to be contended with in such a work. There are, however, in this drawing, practically speaking, five original drawings to be made, one for each of the five colours used, which must all fit in their proper places to produce the one complete proof. It may seem that this article has entered too fully into the details of the collection, but the writer has thought that it would be of interest to students to trace through, somewhat in their proper periods, the different groups of drawings.

One last word in conclusion. In making his lithographs Mr Whistler has always had in view the printed proof, and the drawing itself, whether on transfer paper or stone, has to him no real value except in its ultimate form of the print, which in many cases he alone could foresee – and which is certainly the true spirit in which artists ought to approach lithography.

W. 97, 96 (1895)

W. 101 (1893)

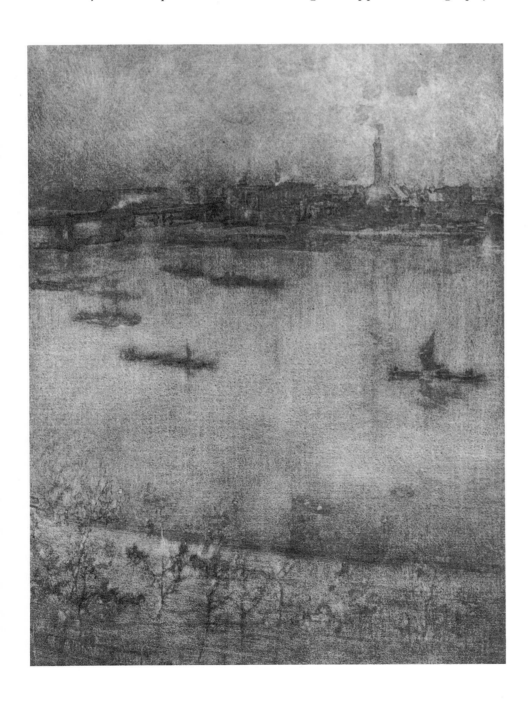

The Thames, W.125. 1896.
Lithotint, 10½ × 7⅜″
(26.5 × 18.7 cm). Hunterian Art
Gallery, Glasgow University
(Birnie Philip Bequest).

THE ST JAMES'S GAZETTE

"Artists and their Critics. An Action for Libel"

April 1897

In the Queen's Bench Division today, Mr Justice Mathew and a special jury commenced the hearing of the case of Pennell v. Harris and another. This was an action brought by Mr Joseph Pennell, the well-known artist, to recover damages for alleged libel from Mr Frank Harris and Mr Walter Sickert in respect of an article published in the *Saturday Review*. The defendants denied the libel, and Mr Sickert further said that the words were true. Sir E. Clarke, Q.C., and Mr J. E. Banks were for the plaintiff; and Mr Bigham, Q.C., Mr Macaskie and Mr Stevenson for the defendants.

Sir Edward Clarke, in opening the case, said the plaintiff brought his action against the proprietor of the *Saturday Review*, and the writer of the article. Mr Pennell was an artist and a literary man who was well known. An article had been written imputing to him no want of artistic capacity, but misdoings in the issue of a certain production and a desire to palm off upon the public works of art of one class which were really works of art of another and of an inferior description. There were present in court many distinguished persons in the art world who would, if necessary, be called on this question. It appeared that some years ago a book was published by Professor Herkomer, called *An Idyll*, containing sixteen illustrations. It was a costly production, and the illustrations were supposed to be etchings. The plaintiff and Mr Sickert doubted this, believing that some of the illustrations were not etchings in the true sense of the term. Professor Herkomer subsequently admitted that, out of the sixteen, nine had not been etched from one plate by his own hand. In this matter both Mr Pennell and Mr Sickert were agreed and wrote publicly about it. Now the defendants said of the plaintiff that he had issued as lithographs illustrations which could not be called lithographs, which the plaintiff knew were not lithographs and were of less commercial value. The article reflecting upon the plaintiff was published on the 26 December 1896. The plaintiff stated that a litho upon transfer-paper and then put upon the stone was a genuine litho, and therefore it was absolutely untrue to say that was an attempt to palm off on the public an inferior production.

Cross-examined by Mr Bigham, the witness stated that Mr Sickert said that he was a clever but a bad critic, and he presumed in the latter remark Mr Sickert referred to his criticism of one of Raphael's pictures – "Shoddy commercialism". (Laughter.)

Mr James McNeill Whistler said that he had produced many works in lithography. To an artist there was no distinction between the work, either on stone, zinc or paper so long as the result was his own work. The artist on paper was at no disadvantage with the artist on the stone. There was no limit to what could be done by the transfer process.

Cross-examined by Mr Bigham, Mr Whistler said that his grievance in the matter was this. In the attack upon Mr Pennell, as he understood, the most fraudulent practices were suggested, and at the end of the article it was said, "Mr Whistler pursues the same course."

So you are very angry with Mr Sickert? – Not in the smallest degree. (Loud laughter.) If any one could be vexed at all, it is that distinguished people like ourselves should be brought here by a gentleman absolutely unknown.

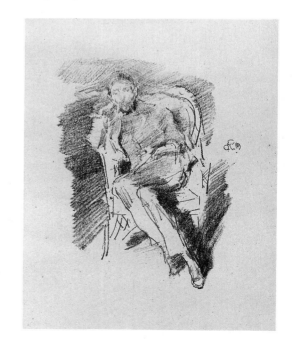

Then Mr Sickert is a very insignificant and irresponsible person who cannot do harm? – Oh I think that a fool may do harm. (Laughter.) Continuing the witness said he thought the article a most impudent piece of insolence. He was afraid, if Mr Pennell had not brought this action, he should have been obliged to take that course. (Laughter.)

Mr Whistler asked his Lordship if he might explain why they were all there. (Laughter.)

His Lordship declined to allow it. They were all there because they could not help it. (Laughter.)

Mr Alfred Gilbert, R.A., said he was acquainted with lithography and gave it as his opinion that there was a difference between lithography by direct drawing from the stone and that by drawing on the stone from paper. The advantage of the process of transfer was that there was a drawing direct. The artist's reproduction was his own work.

Mr Sydney Colvin, keeper of prints and drawings at the British Museum, said a difference was made in classification between the lithography direct from the stone and those transferred from paper.

Max Beerbohm, *Mr Whistler giving evidence in the case of Pennell v. The Saturday Review and Another.* City Museum and Art Gallery, Birmingham.

GUSTAV KLIMT AND W. SCHOLERMANN

Letter to Whistler

13 December 1897

Dear Sir,

The "Vereinigung Bildender Künstler Oesterreichs" [Society of Austrian Artists. *Secession*] has constituted itself this year in Vienna for the purpose of bringing the public of Austria into closer contact with the modern artistic productions of all nations, to stimulate and educate the latent interest of the people in the fine and applied arts, to encourage Austrian artists, and to gain a wider range for all that is true and noble in art. Our society will endeavour to further its aims in the first place by: *Select Exhibitions* which will distinguish themselves in a marked degree from the ordinary gigantic "art-warehouse" so refractory to good taste and art; secondly by: *the publication of a richly illustrated monthly periodical* to which leading modern artists and men of letters have promised to be our regular contributors. Prominent artists of all nations have readily assented to assist us by becoming honorary members of our society and co-operating with us in gaining the object in view.

The "Vereinigung Bildender Künstler Oesterreichs" trusts that you, dear Sir, will also lend us your co-operative assistance to the best of your power, accept our offer of honorary membership and thereby contribute to the attainment of our high aim by the weight of your name and influence.

W. Scholermann
General Secretary

Gustav Klimt
President

VIENNA

The Vienna Secession, under the presidency of the Austrian artist Gustav Klimt (1862–1918), held its first exhibition in March 1898 – without the participation of Whistler who was too busy preparing for the first large showing of international modern art in London under the auspices of the International Society of Sculptors, Painters and Gravers, of which he was president (see page 320). The circumstances of Whistler's failure to participate in the Vienna Secession are described by Joseph Engelhart, "Memories of Whistler," The Living Age, vol. 338, 15 May 1930, pages 369–74.

Ver Sacrum, *the Secession journal.*

THE PALL MALL GAZETTE

"The International Art Exhibition. Interview with Mr Whistler"

26 April 1898

[FROM OUR OWN CORRESPONDENT.]

Paris, Monday

In artistic circles great interest is taken in the International Art Exhibition that is to be opened shortly in London at the Prince's Club. We are now in the spring season of the art production of Paris. The leaves are coming out on the Boulevards, and the doors of the picture shows are about to be thrown open. In three days we shall have the salons upon us.

The prospect of eating salmon and green sauce at Ledoyen's on the day of the Vernissage has been wrecked by the demolition of the Palais de l'Industrie. The *monde* – the people who make taste – will have to find another rallying point for this annual occasion. But in spite of the changed condition of things, the yearning for new pictures has taken possession of the Paris public just as ever. It comes in with the new potatoes, the new peas, and the new toilettes.

Hitherto foreign art has not received a warm welcome in England, so far at least as the semi-official exhibitions such as that of the Royal Academy are concerned. Foreign artists have looked in vain for that return of hospitality on the part of the English which their own very great hospitality has given them every right to expect. The English are so insular; and insularity is another word for bad manners. In the Paris salons every good painter even if he is a German may be sure of being "hung." What does the annual exhibition of the Royal Academy tell us about the progress of art outside England? Evidently nothing; and the fact is an indication of *parti-pris*, a sign of poorness of spirit, of which we all ought to be thoroughly ashamed (and doubtless most of us are), and which procures us the dislike and the contempt of our neighbours. Poor Albion! Perfidious even in art! And the contempt which falls upon us in consequence has this result – that when invitations are extended by different art associations in England to foreign artists to exhibit in England the invitation is not, as a rule, taken seriously. England is spurned and despised. She is looked on askance. She is told to go and mind her own wretched little one-eyed business, and not to meddle in artistic movements of which she knows or cares nothing. Yet all this is not quite fair. Albion is not so black as she is painted. She is only very ill advised. She has good points. Even the French recognize this. And the other real artists in other parts of the world also, when they are approached in the right way; and that is why the International Art Exhibition has become a possibility, and will be in all probability a success.

I was told that Mr Whistler took a great interest in this International Art Exhibition, and I accordingly went to see him to ask him about it. I found him very busy at his studio in the Rue Notre Dame des Champs. He was painting the portrait of a lady, and he gave me an appointment at his house – that charming little green and white *pavillion* in the Rue du Bac – for the following morning. He was suffering, he told me, when I called the next day, from the effects of a severe *grippe*, which did not, however, prevent him from working, but obliged him to work more slowly.

"First of all," said Mr Whistler, "it must be thoroughly understood that the organizers of the International Exhibition are animated by the most serious artistic motives. I was approached, to begin with, by a number of young men – the vanguard of English art – who expressed the

The first exhibition of the International Society of Sculptors, Painters and Gravers, the aims of which included "the non-recognition of nationality in art," opened in May 1898 at the Prince's Skating Club, Knightsbridge, with over 600 works; as much space was given to graphic art as to oil painting. Whistler, who exhibited a representative collection of his own work (see page 16) was created President and John Lavery (1856–1941) Vice-President.

The fashionable Café-concert *on the Champs Élysées.*

desire to see a really international collection of pictures brought together in London. We wanted to break through the wearisome routine of the annual shows – to mention only the Royal Academy, the New Art Gallery, the Grosvenor, and so forth. Mere annual output we have nothing to do with. What we want is to show artists and the public, too (if the public likes), the present point to which art has reached, and no opportunity for this has yet occurred in England. The English, for instance, are very proud of their black and white artists. Well, we would like to show them that all they have done in black and white, in coloured lithography, and so forth, is the merest child's play as compared with what has been done on the Continent. The British public is kept completely in the dark as to the real nature of the Art movement throughout the world. It will be the task of the International Art Exhibition to enlighten that ignorance. Fortunately the position which I occupy here gives me the necessary authority to persuade the great continental painters to treat this scheme seriously. I have been able to point out the advantages of this exhibition to men of the highest eminence such as Puvis de Chavannes, Rodin, Forain and others, all of whom have consented to contribute, and are much interested in the success of the show. And, believe me, the lesson will be great, the revelation enormous. For instance, there will be a fine show of drawings by Milceandeau [sic] and quite a big collection of Foraines."

Mr Whistler then unhooked from the wall a framed drawing by Milceandeau, representing a medieval personage in knightly guise. "Who draws like that in England at the present day?" he said. "There's a quality about that which is perfectly extraordinary – the air of something that comes out of a museum. And so with coloured lithography: the exhibition will show the English artists and the English public the giant strides that have been made abroad in this department of Art."

"And you prophesy success for this exhibition, Mr Whistler?"

With the decline of the Grosvenor Gallery, its managers Comyns Carr and Charles Hallé resigned to start the New Gallery which opened in Regent Street in 1888.

The first exhibition included work by Von Uhde, Manet, Monet, Cézanne, Degas, Maris, Segantini, Thaulow, Zorn, Klinger, Thoma, Liebermann, Renoir; and from Great Britain a strong representation of Scottish painters.
Édmond Charles Théodore Milcendeau (1872–1919).

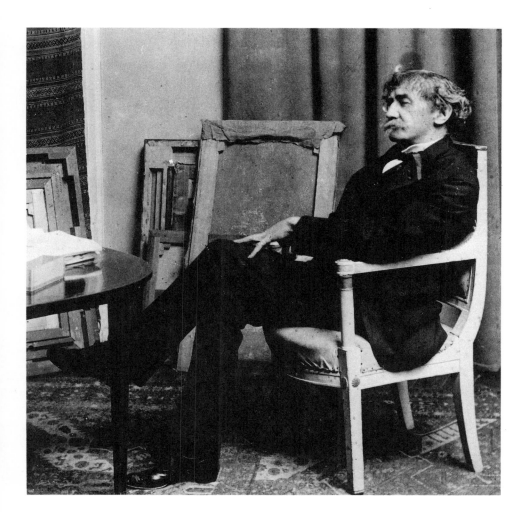

Whistler in his Paris studio.
c. 1892. Photograph by Dornac.
Whistler Collections, Glasgow University Library.

Studies of Loïe Fuller Dancing. 1895.
Ink, 8¼ × 12½″ (21 × 32 cm).
Hunterian Art Gallery, Glasgow
University (Birnie Philip
Bequest).

"It seems to me," he replied, "that the people who go down Bond street and Piccadilly would hardly fail to come to our show. But we do not address ourselves so much to the general public, to the paying public, as to that section of the public that is seriously interested in Art. The International Art Exhibition will be an artistic congress held in London – with or without the public – for the purpose of enabling artists and the public, if it likes, to study and comprehend the progress which Art is making.

"Of course," said Mr Whistler, in conclusion, "we shall meet with a certain amount of opposition. We shall be looked on with a very wooden eye by the working men of the trade. That doesn't matter. We shall have brought together the most representative collection of international art that has ever been exhibited in London, and thus supplied a want that has long been felt. We have the serious men with us, and they take us seriously. Naturally the larger proportion are foreigners. It just happened that the best men are abroad. We have had to seek them and find them where we could. That London should have been chosen as the centre where this artistic congress is to meet is a fact of which London may be proud."

JAMES MCNEILL WHISTLER

Letter to Charles Lang Freer

29 July 1899

PAVILLON MADELEINE, POURVILLE-SUR-MER, NEAR DIEPPE

I am delighted my dear Mr Freer that you like the pictures you speak of – and wish to keep them –

They are yours of course – and I will tell you when we meet how glad I am that they go to the group you have of distinguished work in your Gallery –

And now you must yield a point in proof of friendship and sympathy already proven!

Nothing is to be said about prices in this matter – until the Blue Girl takes her place to preside –

All this you will understand completely and feel with when we meet –

Charles Lang Freer (1854–1919), whose fortune was made in the manufacture of railroad rolling-stock, purchased the Venice Second Series of etchings in 1887. He first met Whistler in 1890; his life-long passion for Whistler's work led him to form the largest single collection anywhere. Whistler also directed Freer's interest in Oriental art. His collections were bequeathed to the Smithsonian Institution to form the Freer Gallery of Art, opened in Washington in 1923 (see page 365). Whistler here refers to the gallery in Freer's house in Ferry Avenue, Detroit.

Freer bought Harmony in Blue and Gold:
The Little Blue Girl *YMSM 421*

Meanwhile I think I may tell you without the least chance of being misunderstood, that I wish you to have a fine collection of Whistlers!! perhaps *the* collection –

You see the Englishmen *have all* sold – "for 'tis their nature to," as Dr Watts beautifully puts it – whatever paintings of mine they possessed! directly they were hall-marked by the French Government, and established as of value, turning over, under my very eyes, literally for thousands what they had gotten for odd pounds! So that with the few exceptions that prove the rule, there is scarcely a canvas of mine left in the land! While you will understand the mischievous pleasure I have in "constateing" this fact, & so placing the British Macænas where he ought to be, behind the counter, & in his shop – you will also appreciate the lack of all communion between the artist and those who hold his work! and the great pleasure it gives him to look forward to other relations! –

I am glad you have the little *Cigale* – she is one of my latest pets – and of a rare type of beauty – the child herself I mean – and the painting – well the painting you see what I have said of it!!

The little Lady of Soho! I am glad you have chosen her too – I think before she is packed, I know of a touch I must add – and then she can follow you in the next steamer – But this I shall see when I come over – for I am getting stronger and hope perhaps next week I may be able to cross – If the pictures have left the International, they will have gone to the "Company of the Butterfly" 2. Hinde Street, Manchester Square.

So I enclose the order.

I have written to Messrs Heinemann to send you my book! *The Baronet & the Butterfly*! You must tell me how you like my campagne [sic], if you think it worthy of West Point!

Always sincerely

(Sgd.) J. McNeill Whistler

(*Colourplate 107*), *with three drawings from Whistler, on 23 November 1894 for 1,300 guineas, but Whistler was unable to complete it, and Freer only received it after his death.*

i.e. the purchase of Arrangement in Grey and Black: Portrait of the Painter's Mother *YMSM 101 (Colourplate 30) by the French Government in 1891.*

Rose and Brown: La Cigale *YMSM 495 (Colourplate 114).*

Rose and Gold: The Little Lady Sophie of Soho *YMSM 504.*

i.e. the Channel.
i.e. the International Society of Sculptors, Painters and Gravers; "The Company of the Butterfly", intended to control the market in Whistler's work, was formed in April 1897. William Heinemann, publisher of The Gentle Art of Making Enemies *(1890).* The Baronet and the Butterfly *(1899) see page 325.*

P. H. EMERSON

NATURALISTIC PHOTOGRAPHY FOR STUDENTS OF THE ART

"American Art"

1899

Of American art there is but little to say. No name stands out worthy of record till J. M. Whistler appears, and he, though an American by birth, can hardly be called an American painter, for the life and landscape of his country he neglects, as also does Sargent, a strong painter, French by education. Whistler's name rises far above any artist living in England; his portrait of his mother and those of Carlyle and Sarasate are works good for all time. But his most original note has been struck in his delicate and subtle landscapes, chefs-d'oeuvre worthy to be ranked with the best. Mr Whistler's influence, too, has been great and good. As a pioneer he led the revolt against ignorant criticism by his attack on Ruskin. His life in England has been a long battle for art, and though many do not approve of all his methods, and still less of his brilliant but illogical *Ten O'Clock*, his work and influence have been for good.

Another great step in advance, introduced by Mr Whistler, has been the reform in hanging pictures; though he has not been allowed to carry out his plans thoroughly, yet he has managed his exhibitions much more artistically than any others in the country. In landscape his night scene at

Whistler's art and ideas about its relationship to nature played a crucial, if at times paradoxical, role in the work and aesthetic of the photographer Peter Henry Emerson (1856–1936). Bringing Whistlerian polemic to bear in his vehement attack on the stilted conventions of art photography, Emerson developed a unique style of naturalism, influenced by Whistler, but in 1890 briefly recanted his faith in the future of such photography as a fine art. While historians of photography differ as to the exact part Whistler may have played in this (Life and Landscape: P. H. Emerson Art and Photography in East Anglia 1885–1900, *ed. N. McWilliam and V. Sekules, Norwich 1986), there is no doubt that Emerson was the first great modern photographer to be deeply affected by Whistler's vision. In his turn, Whistler much admired the originality of Emerson's* Pictures of East Anglian Life *(1888).*

Valparaiso is marvellous, and we doubt whether paint ever more successfully expressed so difficult a subject. But even as Homer nods, so does, at times, Mr Whistler and sometimes "impressions" in oil, water-colour and etching appear with his name, an honour of which they are unworthy. Yet so long as art lives will Mr Whistler live in his Carlyle, his portrait of his mother, *The Balcony, Lady Campbell* and some smaller works.

COLOURPLATE 18 *(YMSM 76)*.

COLOURPLATES 22 and 62 (YMSM 56 and 242).

* * *

But still there is a link binding Nature, Art and Photography together – a touch of kinship – and that is *decoration*. The artist admires Nature when she "sings in harmony," *i.e.* is *decorative*; he admires the photograph when it "sings in harmony," *i.e.* is *decorative*, and he admires works of art when they "sing in harmony," *i.e.* are *decorative*.

Thus, photographs must be *decorative* to appeal to artists, but that does not make them *art* any more than Nature is art when she is decorative. In a word, art is the personal expression of a personal vision of Nature or ideal. A decorative photograph is a mechanical reflection of Nature *when* she "sings in tune," the good photographer requiring to know when Nature does "sing in tune." In a word, he must have true perception of the beautiful to succeed, after that he is merely the starter of a machine.

If you will allow me to digress for a moment let me here make a reservation. It is that it matters not, for *merely* decorative purposes, what lens be used or how it be used, what exposure be given or how it be given, what developer be used or how it be used, what printing method be adopted or how it be handled, *provided* always the result be *decorative*, for no photograph can be said to have any "art qualities" (this does not allow it can be art) without being first of all decorative – a harmonious whole. That is the first quality which differentiates the few photographs from the thousand. But there are higher qualities, degrees of interest and distinction, as it were, and to possess these it must be illusively true, and fine in its *natural* sentiment, as well as decorative; in a word "naturalistic." And even Mr Whistler (a far greater artist than philosopher) gives himself away upon this very point in what I years ago called his brilliant but illogical *Ten O'Clock*, though such an acute critic as Mr Henley has called this lecture the greatest art writing of the century, which I submit it is not. In this *Ten O'Clock* Mr Whistler advocates throughout his work art for art's sake (*i.e.* pure decoration) as the be-all and end-all of art. But I submit that he gives his case away when he writes:–

"*As did her high-priest Rembrandt, when he saw* NOBLE DIGNITY *in the Jew's quarter of Amsterdam.*"

Or –

"To the day when she dipped the Spaniard's brush in light and air, and made his people . . . STAND UPON THEIR LEGS, that all nobility and sweetness, *and tenderness and magnificence should be theirs by right.*"

"Noble dignity," "tenderness," &c., have *nothing* necessarily to do with decoration, but they are the ALL-ESSENTIAL qualities for fineness of sentiment in the pictures cited.

It was on this very point that our greatest poet, Mr Swinburne, fell foul of Mr Whistler and got worsted. I venture to think, had Mr Swinburne merely quoted these and similar passages his position would have been invulnerable, but he must argue. Indeed, truth of sentiment and fineness of sentiment are distinctly advocated as virtues in these passages and as I have always claimed them to be, and so what becomes of *l'art pour l'art* theory and the contention that "subject" has nothing to do with it. I have always maintained "subject" is as necessary as decoration for the perfect work, and I still maintain it: but "subject" is often confounded with "story-telling."

What is wanted in naturalism is a decorative illusion of Nature, a decoration embodying some fine and true *natural* sentiment, the decoration without the sentiment (not sentimentality) is a mere sensuous patchwork

In his 1889 edition of Naturalistic Photography*; in the* Scots Observer, *9 November 1889.*
See pages 212, 221–227.

of colour, the sentiment without the decoration is mere "literature in the flat," and the truthful illusion without either sentiment or decoration is a mere statement of fact, which explains why Mr Whistler's masterly *Carlyle* must always be of more *interest* than, say, a "still-life" picture by the same hand.

This may be a fitting place to insert a warning against an error born of misunderstanding. It has been said many times that by-and-by photographers will do works of art when they get "soul" into their photographs. The photograph that is fine in sentiment and decoration and true to illusion can never be *improved upon* any more than can the statue of the Venus of Melos. A perfect work is good for all time, as Mr Whistler has said. Means are now at the command of photographers to produce the perfect black and white photographic work, though in future increased *facilities* for producing such work may be found by inventors.

And now we will return to the main subject, which I shall lay before you in a series of *propositions only*, for psychology has not yet become a science in *the true sense*; psychological work is merely in the working hypothesis stage, though by no means at the worked out hypothesis end.

EDEN VERSUS WHISTLER. THE BARONET AND THE BUTTERFLY

Judgment

1899

THE COURT,

Having heard the counsels for plaintiff and defendant, and the summing up of the Avocat-Général, and being called upon to pronounce judgment in the appeal made by the defendant, Whistler, against the decision of the Civil Tribunal of the Seine, given 20 March 1895

Inasmuch as the agreement described in the judgment against which the defendant appeals consisted merely of a contract to execute, making the defendant liable, in case of non-execution, for damages

And inasmuch as William Eden *was never, at any moment, the owner of the picture for which his wife sat*, and merely asserts that the painter, actuated by caprice or *amour propre*, refused to give up the portrait in question as required

Inasmuch as Whistler, having failed to keep his engagement, as above stated, has to return the 2625 francs (100 guineas) he accepted from Eden, with five per cent interest thereupon from the day of payment; and inasmuch as he has further to pay damages to the amount of 1000 francs (£40); –

But inasmuch as the Judges of the lower Court wrongfully ordered that the portrait mischievously altered by Whistler should be handed over to Eden, on the grounds that the picture was the exclusive property of Eden, and ought to be given up to him; and inasmuch as the agreement between the parties *was in no sense a contract to sell*, but merely an *obligation to execute*, so that the portrait *has never ceased to be the artist's property, and cannot be taken from him without his consent*

Inasmuch, on the other hand, as this portrait, though altered in some essentials, still retains the general harmony given to his composition by the artist with the help of certain motives [motifs] furnished by Lady Eden, and that, under these conditions, it seems evident that the artist's

Proofs of the Preface and the Dedication of *The Baronet and the Butterfly*, altered and corrected by Whistler (details). 1899. Whistler Collections, Glasgow University Library.

right to the picture is not absolute, without limitation or restriction, and that, on the contrary, so long as the transformation of the little picture is not complete, Whistler may not make any use of it, public or private

HEREBY

confirms the judgment against which appeal is made in so far as it set forth the material facts,

And confirms it in ordering the appellant to refund the 2625 francs (100 guineas) paid him by William Eden, with five per cent interest thereon from 14 February 1894, and to pay 1000 francs (£40) damages, with interest

But rules that the judgment was at fault in declaring that William Eden became the owner of the picture as soon as the contracting parties had agreed as to the thing and the price

Amending this clause of the judgment, and pronouncing afresh, the Court declares the contract between the parties to have been merely an agreement to execute, resolving itself, in the event of non-execution, into a question of damages; it therefore *leaves the artist master and proprietor of his work till such time as it shall please him to deliver it, and give up the holding thereof*

It discharges Whistler from all obligation to give up the portrait to William Eden laid upon him by the lower Court, but declares, on the other hand, that so long as the work remains incomplete, and unfit to deliver, Whistler can make no sort of use of it, public or private.

It orders Whistler to pay the costs of the first suit, and William Eden to pay costs of appeal.

The fine to be refunded.

IGOR GRABAR'

NIVA (LITERARY SUPPLEMENT)

"Decline or Revival?"

January-April 1897

. . . There is one artist, however, whom Nature has endowed with even more talent, perhaps, than Zorn . . . His name is James McNeill Whistler and he is as great a master as Zorn. His work may not be as frenzied, energetic or marked by such an arduous temperament, but it is austere, calm, majestic and concientious. Nature has endowed him with a divine gift for seeing colour and for harmonizing and understanding both the beauty of form and line, and of the whole composition – a talent not seen since the art of Velazquez. . . .

Whistler was born in America in 1834, but spent his childhood in Russia, where his father was employed as an engineer. Whistler received his art education in France, where he painted his first large-scale compositions, and he now lives in London. He can be called neither an American, nor a Frenchman, nor an Englishman. He is simply Whistler – an artist who has created an entire school which is continuing the tasks first begun by Manet. Manet himself lacked the knowledge and talent needed and failed even to have the last word concerning the harmony and unity of impressions on the canvas, leaving it instead to someone who would come after him. That person was Whistler. In 1865 [sic] he was amongst those rejected by the very same Salon to which Manet had contributed. And, like Manet, he was heavily influenced by Japanese art, publicly admitting his indebtedness to the Japanese and to Velazquez on a

After suggesting 500 guineas for painting a portrait head of Sir William Eden's wife, Whistler in 1892 agreed to accept "one hundred to one hundred and fifty pounds." In 1894 Eden sent a cheque for 100 guineas which Whistler banked, but he refused a further offer of 150 guineas and retained the picture. Eden demanded delivery and instituted legal proceedings but Whistler returned £105, claiming to be "relieved from obligation." Whistler painted out the face and substituted another, but in 1895 the court ruled that he should hand over the portrait and pay damages of 1000 francs. In the Judgment of the Appeal, reprinted here, what had previously existed as a traditional agreement between artist and patron was codified in law for the first time, namely the right of the artist to retain his work until such time as it shall please him to deliver it. (See Albert Elsen, "The artist's oldest right," Art History XI, June 1988, pages 217–30.)
Whistler substituted for Lady Eden a portrait of an American, Mrs Herbert Dudley Hale, who in the original Tribunal in 1895 sat beside him in the same brown costume in which she had posed (YMSM 408, Colourplate 110).

Igor Emmanuilovich Grabar' (1871–1960), artist and art historian, studied at the St. Petersburg Academy of Arts (1894–96), then in Munich (1896–8); member of the "World of Art" group of artists and of the "Union of Russian Artists." In 1899 Whistler exhibited in St. Petersburg and his work was illustrated in the World of Art journal to which Grabar' also contributed.

Anders Zorn (1860–1920).

In fact, in the Salon des Refusés of 1863.

number of occasions. Japanese art taught Whistler how to see; Velazquez taught him how to understand and love form and colour, and how to unite and communicate the integrity of his impressions in a generalized form. With his knowledge of Japanese art, Whistler was also able to perceive the harmony in Velazquez' paintings. He has elevated this harmony to the level of a cult, giving his own paintings titles such as "harmonies", "nocturnes", "symphonies", "harmony of blue and gold", "harmony of grey and silver", "symphony in white", "arrangement of yellow with white". These number amongst his best works. The subjects of Whistler's paintings are usually portraits, and sometimes landscapes or twilit and nocturnal scenes. He rarely shows at exhibitions and his works are not to be found in any of the well-known galleries of Europe. Only the Luxembourg Museum in Paris has his famous portrait of his mother, *Arrangement in Black and Grey*. In 1895 I managed to see only two of his paintings, one at an exhibition in Venice, and another at the Secession. In 1894, some of the most outstanding works of this "magician" of harmony and artistic feeling were put on show at an exhibition in Antwerp. They are all in private collections. . . .

The Scottish artists are the direct pupils and successors to Whistler, only they lack his knowledge, talent and taste. To this day Whistler is without rivals. The most talented of the Scottish artists – Guthrie, Walton and Lavery – are elaborating the same problems of the harmony and unity of impressions in their works. Brangwyn, an artist of undoubted originality, is less of a direct imitator of Whistler than his colleagues, and he produces new gems every year, making him very popular amongst the younger generation of artists. . . . A man of only twenty-five, we can expect much from him in the future. His colleagues are all equally young – hence the name "Glasgow Boys" to designate their school. . . .

The paintings of a group of American artists such as Alexander, Harrison, Sargent, Dannat and Melchers, are quite similar to those of the "Glasgow Boys", as well as indicating the influence of Whistler. . . .

Our art has attained its highest apogee in the art of Zorn and Whistler. Whistler has published a number of brochures on art, but unfortunately none have been translated from the English. His book, *The Gentle Art of Making Enemies* (London, 1892), which contains various essays on art and narrates the story of his famous lawsuit against Ruskin, is an outstanding literary work, subtle, witty and thrilling to read. Indeed, the various views put forward by Whistler in his book can be seen as a vindication of contemporary art. Thus, there can be no more appropriate a conclusion to this essay than the extracts from Whistler's remarkable book cited below.

Above all else, Whistler is opposed to tendentiousness in art. Guided by the old masters, he sees art only as an expression of ideals of beauty. He is also opposed to realism, which likewise was not recognized by the old masters. This is what he says on the subject:

Nature contains the elements, in colour and form, of all pictures, as the keyboard contains the notes of all music.

To say to the painter, that Nature is to be taken as she is, is to say to the player, that he may sit on the piano.

That Nature is always right, is an assertion, artistically, as untrue, as it is one whose truth is universally taken for granted. Nature is very rarely right, to such an extent even, that it might almost be said that Nature is usually wrong: that is to say, the condition of things that shall bring about the perfection of harmony worthy a picture is rare, and not common at all. Still, seldom does Nature succeed in producing a picture.

It is the task of the *artist* to discover the painting in Nature:

To him her secrets are unfolded, to him her lessons have become gradually clear. He looks at her flower, not with the enlarging

COLOURPLATE 30 *(YMSM 101)*.

Symphony in White, No. 2: The Little White Girl *YMSM 52 (Colourplate 17) was shown at the first International Art Exhibition in Venice, 1895, and several works in the Universal Exposition, US Section, Antwerp, 1894. Sir James Guthrie P.R.S.A. (1859–1930); Edward Arthur Walton (1860–1922); Sir John Lavery R.A. (1856–1941); Sir Frank Brangwyn R.A. (1867–1956).*

John White Alexander (1856–1915); Thomas Alexander Harrison (1853–1930); John Singer Sargent (1856–1925) (see page 229); William Turner Dannat (1853–1929); Julius Gari Melchers (1860–1932).

lens, . . . but with the light of the one who sees in her choice selection of brilliant tones and delicate tints, suggestions of future harmonies.

In all that is dainty and lovable he finds hints for his own combinations, and *thus* is Nature ever his resource and always at his service, and to him is naught refused.

Through his brain, as through the last alembic, is distilled the refined essence of that thought which began with the Gods, and which they left him to carry out.

Whistler defines the difference between an artist's and a layman's view of Nature in the following way:

The sun blares, the wind blows from the east, the sky is bereft of cloud, and without, all is of iron. The windows of the Crystal Palace are seen from all points of London. The holiday-maker rejoices in the glorious day, and the painter turns aside to shut his eyes . . . and Nature, who, for once, has sung in tune, sings her exquisite song to the artist alone, her son and her master – her son in that he loves her, her master in that he knows her.

This and the preceding two quotes are from the "Ten O'Clock" lecture.

On the question of the significance of the subject in a work of art, Whistler states that, just as music is the poetry of sound, so painting is the poetry of vision, and the subject has nothing in common with the harmony of sounds and colours. All great musicians in the past knew and understood this fact; they simply wrote music and did not waste time telling stories. Beethoven wrote symphonies and harmonies. When Whistler started calling his paintings symphonies and harmonies, he was reproached with trying to appear original. As justification for his action he states:

Art should be independent of all clap-trap – should stand alone, and appeal to the artistic sense of eye or ear, without confounding this with emotions entirely foreign to it, as devotion, pity, love, patriotism, and the like. All these have no kind of concern with it, and that is why I insist on calling my works "arrangements" and "harmonies."

From "The Red Rag" (1878, see page 127), also published in The Gentle Art.

Generally speaking, the view of public opinion is often that a painting is only considered complete when the smallest of details has been meticulously noted – the more accurately the eyebrow, eyelashes or leaves on the tree are painted, the more complete is the painting. Whistler opposes such an opinion, which destroys all the meaning and significance of art and elevates a retoucher of photographs, endowed with infinite patience, to the most inaccessible of heights, while reducing Velazquez to the level of mediocrity. According to Whistler:

A picture is finished when all trace of the means used to bring about the end has disappeared.

"Proposition – No. 2."

Thus, Velazquez' greatest works are not his earliest paintings, which indicate painstaking study and torment, but those from his later period, when his paintbrush no longer knew how to heed him and his talent had gone beyond any troublesome question of technique, opening up an infinite scope for inspiration and creativity. What, then, is the meaning and purpose of a work of art, if it is so absorbed in its own tasks? Whistler writes:

The masterpiece should appear as the flower to the painter – perfect in its bud as in its bloom – with no reason to explain its presence – no mission to fulfil – a joy to the artist – a delusion to the philanthropist – a puzzle to the botanist – an accident of sentiment and alliteration to the literary man.

"Proposition – No. 2."

Whistler is the greatest of contemporary painters, a genuine artist from head to foot, whose works are marked with the imprint of genius. His wonderful compositions of beauty and harmony provide the final link in a chain, ripped apart by the centuries, which, henceforth, will join the time of Velazquez to our contemporary painting. Our time is not one of decline, not one of the petty passions of petty artists, but it is a time of hope and of splendid revival. Who needs these complaints, this perpetual whimpering? Behind the pettiness and insignificance which mark our age, as they did the age of Velazquez, Van Dyck, Rembrandt and Titian, one would have to be blind not to notice the great things which that time has brought down to us. Let us pause for a moment, throw off this melancholic air which is no good to anyone, and let us look more closely, look and reflect before pronouncing our final judgements. If not actually joined by blood, Whistler is Velazquez' kinsman – not his slave or imitator, but a brilliant successor in his own right.

E. R. AND J. PENNELL

THE LIFE OF JAMES MCNEILL WHISTLER

The Académie Carmen

1908

"The *ateliers*, under the direction of *Madame* Carmen Rossi, were thrown open and the *Académie* began its somewhat disturbed career in the fall of 1898. Students hastened from all parts, hearing the confirmation of Mr Whistler's rumoured intention to teach – a letter was received from him announcing that he would shortly appear – and, on the day appointed, the *Académie Carmen* had the honour of receiving him for the first time. He proceeded to look at the various studies, most carefully noting under whose teaching and in what school each student's former studies had been pursued.

"Most kindly something was said to each, and to one student who offered apology for his drawing, Mr Whistler said simply 'It is unnecessary – I really come to learn – feeling you are all much cleverer than I.'

"Mr Whistler, before he left, expressed to the *Patronne* his wish that there should be separate *ateliers* for the Ladies and Gentlemen, and that the present habit of both working together should be immediately discontinued.

"His second visit took place on the following Friday, and was spent in consideration of the more advanced students. One, whose study suffered from the introduction of an unbeautiful object in the background, because it happened to be there, was told that, 'One's study, even the most unpretentious, is always one's picture, and must be, in form and arrangement, a perfect harmony from the beginning.' With this unheard-of advice, Mr Whistler turned to the students, whose work he had been inspecting, and intimated that they might begin to paint, and so really learn to draw, telling them that the true understanding of drawing the figure comes by having learned to appreciate the subtle modellings by the use of the infinite gradation that paint makes possible.

"A third visit, and a memorable one, took place on the following Wednesday.

This account of the Académie Carmen, situated in the Passage Stainslas, a small street running off the Rue Notre-Dame-des-Champs, where Whistler had a studio, was written by Inez Bates, later Mrs Clifford Addams, at "his [Whistler's] request and [was] partially corrected by him." According to the sculptor Frederick MacMonnies, who also taught there, "all the schools in Paris were deserted immediately, and the funny little studios of Carmen's place were packed with all kinds of boys and girls, mostly Americans, who had tried all styles of teaching in every direction." While it was clearly Whistler's intention to reinstate the academic techniques he had experienced himself at Gleyre's forty years before, art school training had changed by the turn of the century, and many students were surprised to find that to achieve Whistler's results a disciplined method of study was required. Carmen Rossi was Neapolitan and posed for Whistler (YMSM 441, 505–7); she was later suspected of removing paintings from Whistler's studio and sold some at the Hôtel Drouot after his death.

"He turned to one student, and picked up her palette, pointing out that being the instrument on which the painter plays his harmony, it must be beautiful always, as the tenderly cared-for violin of the great musician is kept in condition worthy of his music.

"Before passing on, he suggested that it would be a pleasure to him to show them his way of painting, and if this student could, without too much difficulty, clean her palette, he would endeavour, before his present visit ended, to show them 'the easiest way of getting into difficulties!'

"And it was then that Mr Whistler's own palette was generously given, for upon the one presented to him he made careful preparation in his own manner, sending for simple colours and placing them in his scientific and harmonious arrangement.

"Mr Whistler's whole system lies in the complete mastery of the palette – that is to say, on the palette the work must be done and the truth obtained, before transferring one note on to the canvas.

"He usually recommended the small oval palettes as being easy to hold and place his arrangement of colour upon. White was then placed at the top edge in the centre, in generous quantity, and to the left came in succession: yellow ochre, raw Sienna, raw umber, cobalt and mineral blue, while to right: vermilion, Venetian red, Indian red and black. Sometimes the burnt Sienna would be placed between the Venetian and Indian red, if the harmony to be painted seemed to desire this arrangement, but generally the former placing of colours was insisted upon.

"A mass of colour, giving the fairest tone of the flesh, would then be mixed and laid in the centre of the palette near the top, and a broad band of black curving downward from this mass of light flesh note to the bottom, gave the greatest depth possible in any shadow; and so, between the prepared light and the black, the colour was spread, and mingled with any of the various pure colours necessary to obtain the desired changes of note, until there appeared on the palette a tone picture of the figure that was to be painted – and at the same time a preparation for the background was made on the left in equally careful manner.

"Many brushes were used, each one containing a full quantity of every dominant note, so that when the palette presented as near a reproduction of the model and background as the worker could obtain, the colour could be put down with a generous flowing brush.

"Mr Whistler also said, 'I do not interfere with your individuality – I place in your hands a sure means of expressing it, if you can learn to understand, and if you have your own sight of Nature still.' Each student prepared his or her palette to suit individual taste – in some the mass of light would exceed the dark; in others, the reverse would be the case. Mr Whistler made no comments on these conditions of the students' palettes:– 'I do not teach Art; with that I cannot interfere; but I teach the scientific application of paint and brushes.' His one insistence was, that no painting on the canvas should be begun until the student felt he could go no further on the palette; the various and harmonious collection of notes were to represent, as nearly as he could see, the model and background that he was to paint.

"Mr Whistler would often refrain from looking at the students' canvas at all, but would carefully examine the palette, saying that there he could see the progress being made, and that it was really much more important that it should present a beautiful appearance, than that the canvas should be fine and the palette inharmonious. He said, 'If you cannot manage your palette, how are you going to manage your canvas?'

"These statements sounded like a heresy to the majority of the students, and they refused to believe the reason and purpose of such teaching, and as they had never before even received a hint to consider the palette of primary importance, they insisted in believing that this was but a peculiarity of Mr Whistler's own manner of working, and that, to adopt it, would be with fatal results!

Whistler's painting and etching materials. From the collection of memorabilia in the Hunterian Art Gallery, Glasgow University.

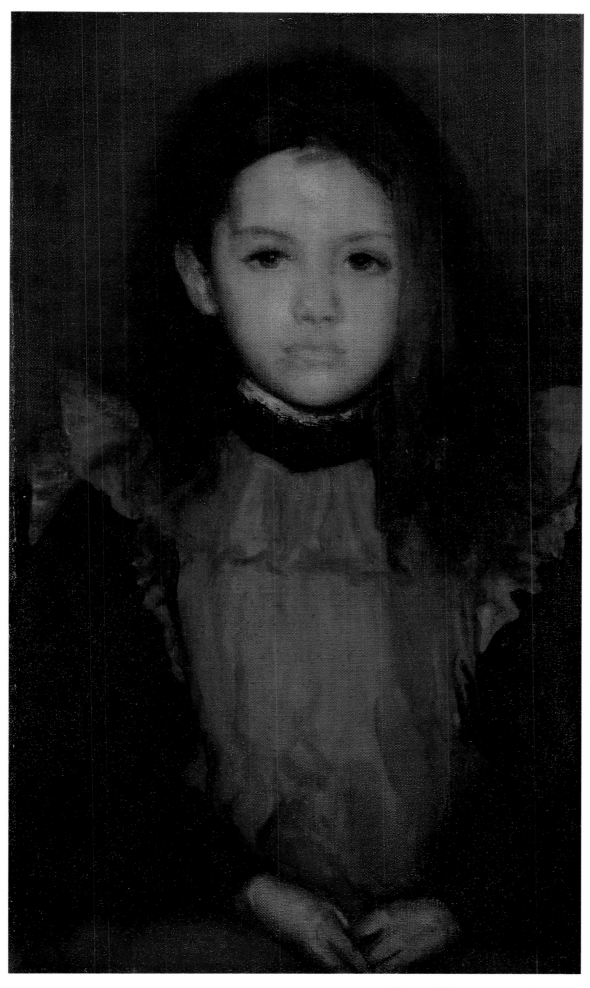

COLOURPLATE 104. *The Little Rose of Lyme Regis*. 1895. 20¼ × 12¼″ (51.5 × 31 cm).
Museum of Fine Arts, Boston (William Wilkins Warren Fund).

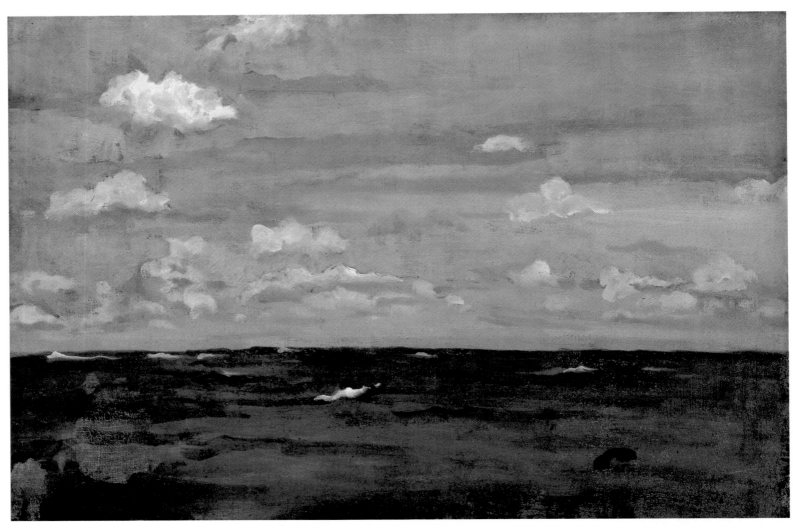

COLOURPLATE 105. *Violet and Silver: A Deep Sea*. 1893. 19¾ × 28⅞″ (49.7 × 73 cm).
© 1988 Art Institute of Chicago, All Rights Reserved (Gift of Clara Margaret Lynch in memory of
John A. Lynch, 1955).

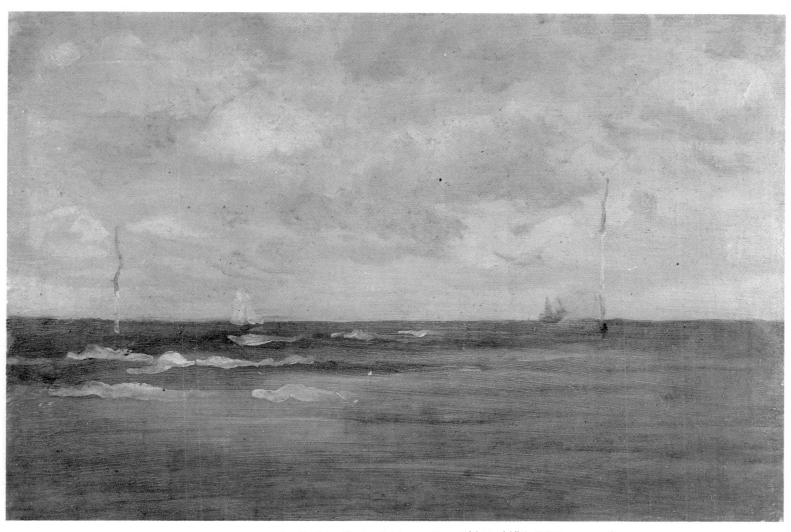

COLOURPLATE 106. *Bathing Posts, Brittany.* 1893. 6½ × 9½″ (16.6 × 24.3 cm).
Hunterian Art Gallery, Glasgow University.

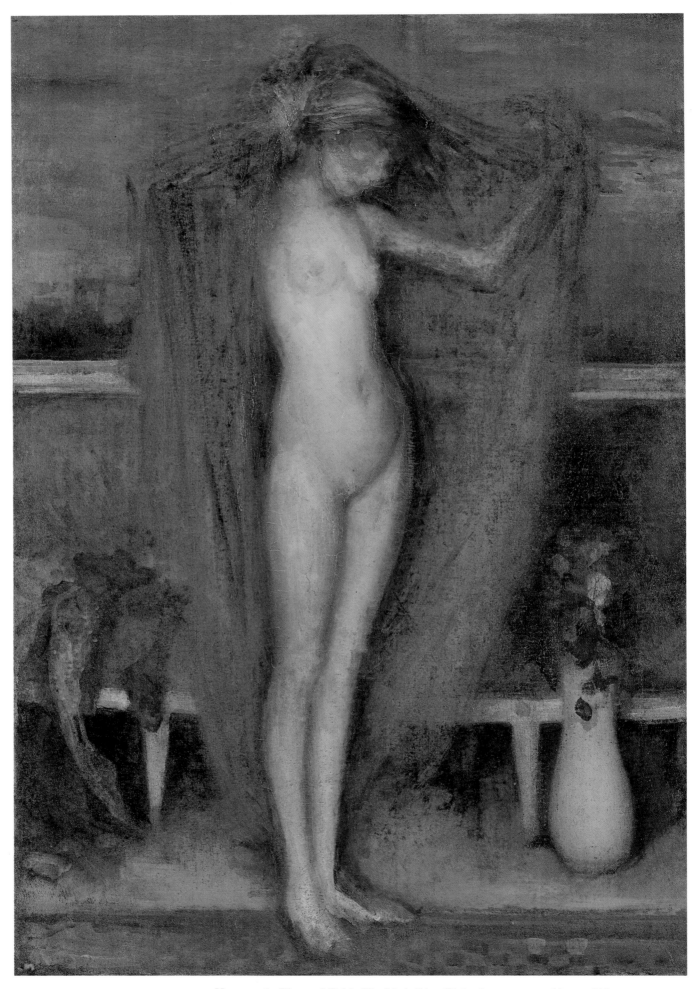

COLOURPLATE 107. *Harmony in Blue and Gold: The Little Blue Girl.* 1894-1901. 29⅜ × 19⅞″
(74.7 × 50.5 cm).
Freer Gallery of Art, Smithsonian Institution, Washington, D.C.

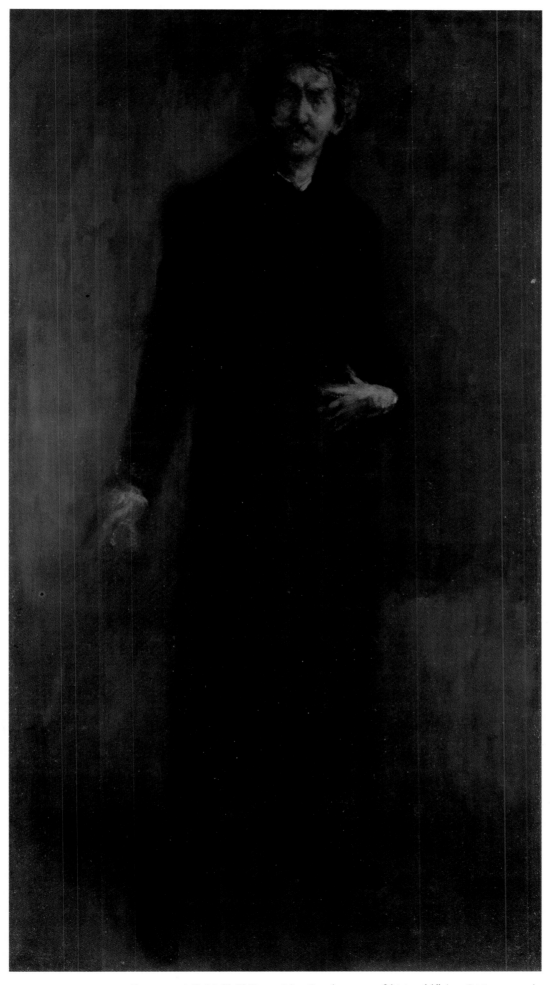

COLOURPLATE 108. *Brown and Gold (Self-Portrait)*. 1895/1900. 37¾ × 20¼″ (95.8 × 51.5 cm).
Hunterian Art Gallery, Glasgow University.

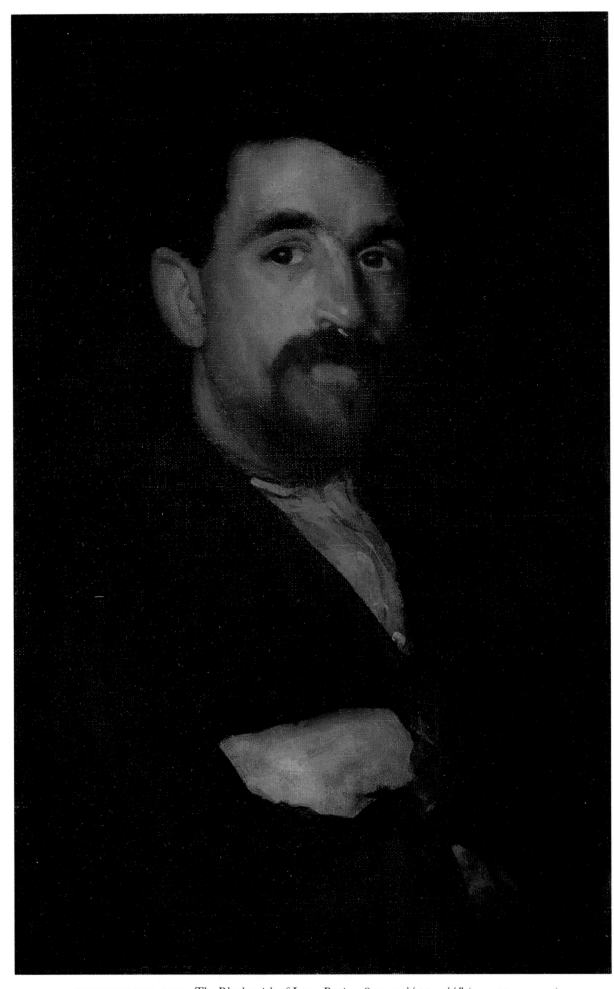

COLOURPLATE 109. *The Blacksmith of Lyme Regis*. 1895. 20¼ × 12¼″ (51.4 × 31.1 cm).
Museum of Fine Arts, Boston (William Wilkins Warren Fund).

COLOURPLATE 110. *Brown and Gold: Portrait of Lady Eden.* 1894. 18 × 12¾″ (20.4 × 32.4 cm).
Hunterian Art Gallery, Glasgow University.

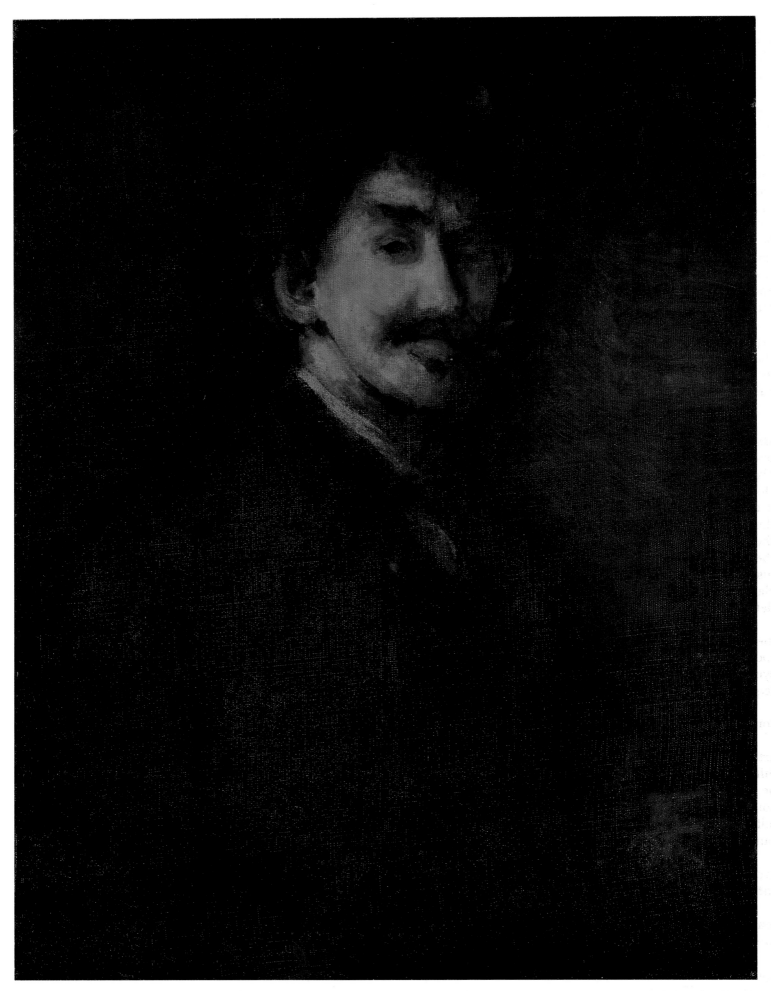

COLOURPLATE III. *Gold and Brown (Self-Portrait). c.* 1896. 24¼ × 18¼″ (62.4 × 46.5 cm).
National Gallery of Art, Washington, D.C. (Gift of Edith Stuyvesant Gerry).

"The careful attempt to follow the subtle modellings of flesh placed in a quiet, simple light, and therefore extremely grey and intricate in its change of form, brought about, necessarily, in the commencement of each student's endeavour, a rather low-toned result. One student said to Mr Whistler that she did not wish to paint in such low tones, but wanted to keep her colour pure and brilliant; he answered, 'then keep it in the tubes, it is your only chance, at first.'

"It was taught to look upon the model as a sculptor would, using the paint as a modeller does his clay; to create on the canvas a statue, using the brush as a sculptor his chisel, following carefully each change of note, which means 'form;' it being preferable that the figure should be presented in a simple manner, without an attempt to obtain the thousand changes of colour that are there in reality, and make it, first of all, *really and truly exist in its proper atmosphere*, than that it should present a brightly coloured image, pleasing to the eye, but without solidity and non-existent on any real plane. This it will be seen was the reason of Mr Whistler's repeated and insistent commands to give the background the most complete attention, believing that by it alone the figure had a reason to exist.

"In the same way, or rather in insistence of the same important principles, he pointed out the value of the absolutely true notes in the shadow, for they determine the amount of light in the figure, and therefore its correct drawing as perceived by the eye, and he said that 'in the painting of depth is really seen the painter's power.'

"Mr Whistler would often paint for the students.

"Once he modelled a figure, standing in the full, clear light of the *atelier*, against a dull, rose-coloured wall. After spending almost an hour upon the palette, he put down with swift, sure touches, the notes of which his brushes were already generously filled, so subtle that those standing close to the canvas saw apparently no difference in each successive note as it was put down, but those standing at the proper distance away noticed the general turn of the body appear, and the faint subtle modellings take their place, and finally, when the last delicate touch of light was laid on, the figure was seen to exist in its proper atmosphere and at its proper distance within the canvas, modelled, as Mr Whistler said, 'in painter's clay,' and ready to be taken up the next day and carried yet further in delicacy, and the next day further still, and so on until the end.

"And it was insisted upon that it was as important to train the eye as the hand, that long accustoming oneself to seeing crude notes in Nature, spots of red, blue and yellow in flesh where they are not, had harmed the eye, and the training to re-adjust the real, quiet, subtle note of Nature required long and patient study.

"'To find the true note is the difficulty,' was taught; 'it is comparatively easy to employ it when found.'

"He once said that if he had been given at the commencement of his artistic career what he was then offering, that his work would have been different. But that he found in his youth no absolute definite facts, and that he 'fell in a pit and floundered,' and from this he desired to save whom he could. 'All is so simple, he would say, 'it is based on proved scientific facts; follow this teaching and you *must* learn to paint; not necessarily learn art, but, at least, absolutely learn to paint what you see.'

"It will be readily understood that he had no desire to have the ordinary 'roller through Paris' in his *Académie*, and so came about the rather stringent rules which caused much discussion and dissension.

"He also demanded the student to abandon all former methods of teaching, unless in harmony with his own, and to approach the science as taught by himself in a simple and trustful manner.

"Mr Whistler once said to the students that 'there is one word that could never come to one's lips in the *Salon Carré* of the Louvre: How clever! – How magnificent! how beautiful! yes, but clever, never!' And the student used to having any little sketch praised, and finding such efforts remained

unnoticed by Mr Whistler, while an intelligent and careful, though to their eyes stupid, attempt to model in simple form and colour, would receive approbation, grew irritated, and the majority left for a more congenial atmosphere.

"It was pointed out that a child, in the simple innocence of infancy, painting the red coat of the toy soldier red indeed, is in reality nearer the great truth, than the most accomplished trickster with his clever brushwork and brilliant manipulation of many colours.

"'Distrust everything you have done without understanding it. I mean every effort you have obtained without knowing how. Remember I am speaking always to the student, and teaching you how to paint.

"'It is not sufficient to have achieved a fine piece of painting. You must know *how* you did it, that the next time you can do it again, and never have to suffer from that disastrous state of being of the clever and meretricious artist, whose friends say to him, What a charming piece of painting, do not touch it again – and, although he knows it is incomplete, yet he dare not but comply, *because he knows he might never get the same clever effect again.*

"'Find out and remember which of the colours you most employed, how you managed the turning of the shadow into the light, and, if you do not remember, scrape out your work and do it all over again, for you are here to learn, and one *fact* is worth a thousand misty imaginings. You must be able to do every part equally well, for the greatness of a work of Art lies in the perfect harmony of the whole, not in the fine painting of one or more details.'

"It was many months before, finally, a student produced a canvas which showed a grasp of the science he had so patiently been explaining. Mr Whistler delighted to show his pleasure in this, and had the canvas placed on an easel and in a frame that he might more clearly point out to the other students the reason of its merit; it showed primarily an understanding of the two great principles; first, it represented a figure *inside* the frame and surrounded by the proper atmosphere of the studio, and, secondly, it was created of one piece of flesh, simply but firmly painted and free from mark of brush. As the weeks went on, and the progress in this student's work continued, Mr Whistler finally handed over to her [Mrs Addams] the surveillance of the newcomers and the task of explaining to them the first principles of his manner.

"The *Académie* continued to receive much praise and much blame; at least, it had the distinction of causing the rumour that something was being taught there; something definite and absolute. But the inability to understand caused, in most cases, a bitter feeling of resentment and deep distrust, and there was a constant going and coming in the *Académie*.

"A large number of students who had been in the *Académie* for a short time and had left, again returned, dissatisfied with other schools (where ordinary weekly criticism of the usual kind was received). After the statements heard from Mr Whistler they seemed strangely alone and unguided, and so they returned that they might once more satisfy themselves that nothing was to be learned there after all.

"Mr Whistler allowed this to continue for some time. But, finally, the fatigue of such constant changes caused him to issue an order that the *Académie Carmen* should be tried but once.

"Most particularly were the students in the men's life class constantly changing. On Christmas Day, Mr Whistler invited them to visit him in his *atelier* and showed them many of his own beautiful canvases in various stages of completeness; explaining how certain results had been obtained, and how certain notes had been blended; and assuring them that he used *au fond* the science he was teaching them, only that each student would arrange it according to his own needs as time went on, and begging them not to hesitate to ask him any question that they wished or to point out anything they failed to understand. There was an increased enthusiasm for a few weeks, but gradually the old spirit of misunder-

standing and mistrust returned, and the men's class again contained but few students.

"Another disappointment to them was that Mr Whistler explained, when they showed him pictures they had painted with a hope to exploit as pupils of the Master in the yearly Salon, that this was impossible – that their complete understanding of the Great Principles and the fitting execution of their application could not be a matter of a few months' study, and he laughingly told them that he was like a chemist who put drugs into bottles, and he certainly should not send those bottles out in his name unless he was quite satisfied with, and sure of, the contents.

"In February 1899, Mr Whistler had copies made of *A Further Proposition* [from *The Gentle Art*, page 177], the opening paragraph slightly changed, and one was placed in English and one in French [the translation by M Duret] on the walls of the two *ateliers*.

"And a month later, copies of *Proposition No. 2* [*Gentle Art*, page 115] were hung beside it.

"The last week of the *Académie's* first year arrived – and Mr Whistler spent the whole of each and every morning there. The supervision of the students' work was so satisfactory to himself in one case that he communicated with the student, after the closing of the *Académie*, to announce to her that he desired to enter into an Apprenticeship with her, for a term of five years, as he considered it would take fully that time to teach her the whole of his Science and make of her a finished craftsman – with her artistic development he never for a moment pretended to interfere, or to have anything to do – 'that,' he said, 'is or is not superb – it was determined at birth, but I can teach you *how to paint*.'

"So, on the 20 July (1899), the Deed of Apprenticeship [with Mrs Addams] was signed and legally witnessed, and, in the following terms, she 'bound herself to her Master to learn the Art and Craft of a painter, faithfully to serve after the manner of an Apprentice for the full term of five years, his secrets keep and his lawful commands obey, she shall do no damage to his goods nor suffer it to be done by others, nor waste his goods, nor lend them unlawfully, nor do any act whereby he might sustain loss, nor sell to other painters nor exhibit during her apprenticeship nor absent herself from her said Master's service unlawfully, but in all things as a faithful Apprentice shall behave herself towards her said Master and others during the said term. . . . And the said Master, on his side, undertakes to teach and instruct her or cause her to be taught and instructed. But if she commit any breach of these covenants he may immediately discharge her.'

"Into the hands of his Apprentice – also now the *Massière* – Mr Whistler gave the opening of the school the second year, sending all instructions to her from Pourville where he was staying.

"Each new candidate for admission should submit an example of his or her work to the *Massière*, and so prevent the introduction into the *Académie* of, firstly, those who were at present incompetent to place a figure in fair drawing upon the canvas; and, secondly, those whose instruction in an adverse manner of painting had gone so far that their work would cause dissension and argument in the *Académie*. Unfortunately, this order was not well received by some, though the majority were only too willing to accede to any desire on the part of Mr Whistler.

"A number absolutely refused to suffer any rule, and preferred to distrust what they could not understand, and the talk among the students of the *Quartier* was now in disparagement of the *Académie*.

"Mr Whistler continued his weekly visits, as soon as he returned to Paris, although he did not always attend the afternoon classes as before, but when he was unable to do so he always criticized the work after he had been round the *atelier*, and seen the studies which were then being worked upon in the morning class.

"He gave always the same unfailing attention, though to those who

Head student in charge.

had just entered he would say little at first, leaving the *Massière* to explain the palette.

"Compositions were never done in the school. It was told that it was so much more important to learn to paint and draw Nature, for as Mr Whistler said, 'if ever you saw anything really perfectly beautiful, suppose you could not draw and paint it!' – 'The faculty for composition is part of the artist, he has it, or he has it not – he cannot acquire it by study – he will only learn to adjust the compositions of others, and, at the same time, he uses his faculty in every figure he draws, every line he makes, while in the large sense, composition may be dormant from childhood until maturity; and there it will be found in all its fresh vigour; waiting for the craftsman to use the mysterious quantity, in his adjustment of his perfect drawings to fit their spaces.'

"The third and last year (1900) of the *Académie Carmen* was marked at its commencement by the failure to open a men's life class. Mr Whistler had suffered so greatly during the preceding years from their apparent inability to comprehend his principles and also from the very short time the students remained in the school, that at the latter part of the season he often refused to criticize in the men's class at all. He would call at the Passage Stanislas sometimes on Sunday mornings and himself take out and place upon easels the various studies that had been done by the men the previous week, and often he would declare that nothing interested him among them, and that he should not criticize that week, that he could not face the fatigue of the 'blankness' of the *atelier*.

"The *Académie* was opened in October 1900, by a woman's life class alone, and it was well attended. The school had been moved to an old building in the Boulevard Montparnasse. But shortly after, Mr Whistler was taken very ill, and he was forced to leave England on a long voyage. He wrote a letter to the students, that never reached them; then, from Corsica, another, with his best wishes for the New Century, and his explanation of the Doctor's abrupt orders. The *Académie* was kept open by the Apprentice until the end of March, but the faith of the students seemed unable to bear further trials, and after great discontent at Mr Whistler's continued absence and a gradual dwindling away of the students until there were but one or two left, the Apprentice wrote of this to Mr Whistler who was still in Corsica (1901)."

E. R. AND J. PENNELL

THE LIFE OF JAMES MCNEILL WHISTLER

Whistler in Holland

1908

The account of Whistler's visit in early September 1902 to the Frans Hals Museum, Haarlem, which had opened in 1862, was written by the Bavarian-born artist George Sauter (1866–1937). Whistler would almost certainly have visited the museum on previous trips to Holland.

"We wandered along the line from the early *St George's Shooting Guild* of 1616 down to the old women of 1664.

"Certainly no collection would give stronger support to Whistler's theory that a master grows in his art, from picture to picture, till the end, than that at Haarlem.

"We went through the life with Hals the people portrayed on the canvases, his relations with, and attitude towards, his sitters; he entered in his mind into the studio to examine the canvas before the picture was started and the sitters arrived, how Hals placed the men in the canvas in

the positions appropriate to their ranks, how he divined the character, from the responsible colonel down to the youthful dandy lieutenant, and how he revelled in the colours of their garments!

"As time went on, Whistler's enthusiasm increased, and even the distance between the railing and the picture was too great for this intimate discourse. All of a sudden, he crept under the railing close up to the picture, but lo! this pleasure could not last for long.

"The attendant arrived and gave him in unmistakable words to understand that this was not the place from which to view the pictures.

"And Whistler crawled obediently back from his position, but not discouraged, saying 'Wait – we will stay after they are gone' – pointing to the other visitors.

"Matters were soon arranged with the courteous little chief attendant down in the hall, who, pointing to the signature in the visitor's book, asked, '*Is dat de groote Schilder*' (Is that the great painter?) and on my confirming it, pressed his hands together, bent a little on one side, opened his eyes and mouth wide, and exclaimed under his breath, 'Ach!' He was a rare little man.

"We were soon free from fellow visitors and watchful attendants, and no more restrictions were in the way for Whistler's outburst of enthusiasm.

"We were indeed alone with Frans Hals.

"Now nothing could keep him away from the canvases, particularly the groups of old men and women got their full share of appreciation.

"He went under the railing again turning round towards me, saying, 'Now, *do* get me a chair.' And after it was pushed under the railing, he went on, '*And now, do* help me on the top of it.' From that moment there was no holding him back – he went absolutely into raptures over the old women – admiring everything – his exclamation of joy came out now at the top of his voice, now in the most tender, almost caressing whisper – 'Look at it – just look – look at the beautiful colour – the flesh – look at the white – that black – look how those ribbons are put in. O what a swell he was – can you see it all – and the character – how he realized it' – moving with his hand so near the picture as if he wanted to caress it in every detail – he screamed with joy, 'Oh, I must touch it – just for the fun of it' – and he moved tenderly with his fingers, over the face of one of the old women.

"There was the real Whistler – the man, the artist, the painter – there was no 'why drag in Velazquez' spirit' – but the spirit of a youth, full of ardour, full of plans, on the threshold of his work oblivious of the achievements of a lifetime.

"He went on to analyze the picture in its detail.

"'You see, *she* is a grand person' – pointing to the centre figure – 'she wears a fine collar, and look at her two little black bows – she is the Treasurer – she is the Secretary – she keeps the records' – pointing at each in turn with his finger.

"With a fierce look in his eye, as though he would repulse an attack on Hals – and in contemptuous tone, he burst out, 'They say he was a drunkard, a coarse fellow, don't you believe it – they are the coarse fellows. Just imagine a drunkard doing these beautiful things!'

"'Just look how tenderly this mouth is put in – you must see the portrait of himself and his wife at the Rijks Museum. He was a swagger fellow. He was a Cavalier – see the fine clothes he wears. That is a fine portrait, and his Lady – she is charming, she is lovely.' In time, however, the excitement proved too much for him in his weak state, and it was high time to take him away into the fresh air. He appeared exhausted, and I feared a collapse after such emotions.

"During my absence in looking for a carriage, he went on talking to Mrs Sauter. 'This is what I would like to do – of course, you know, in my own way' – meaning the continual progress of his work to the last. 'O, I would have done anything for my Art.' It was a great relief to have him safely seated in the carriage with us."

Whistler had recently been in Amsterdam.

343

E. R. AND J. PENNELL

THE WHISTLER JOURNAL

Whistler's Funeral

1921

Whistler died on 17 July 1903. This account of the funeral in Chelsea Church, and interment at Chiswick Cemetery, was written by Elizabeth Robins Pennell.

Wednesday, 22 July. The funeral – J. went early with the International. I took Augustine. Later than I meant to be. It was five minutes to eleven when I reached the church and I expected to find it crowded, but it was perhaps not half full. Mrs Dr Whistler, with Mrs Thynne and Miss Thynne in deep mourning in a pew a little in front of me. Saw various people – little Brown; D. C. Thomson; a pew of Academicians, Alma-Tadema and East among them; Mrs Abbey; Charles Whibley, his brother-in-law, in a pew in the side aisle; Heinemann with Dr Chalmers Mitchell coming in later. Joseph saw Mrs Heinemann and Mortimer Menpes – but the names are all in the papers. At last the funeral procession. The coffin was carried the short distance from the house to the church. The men staggered under it as they walked up the aisle, the purple velvet pall any which way, owing no doubt to difficulty of passing the font at the entrance; then the pall-bearers; then the Philip family – the five sisters, the brother, young Godwin, young Lawson; then Webb, the Doctor and Studd, and immediately after, as if part of the procession, Brandon Thomas and his wife, who came in the pew with me. The clergyman has a dull, emotionless voice, and as he reads lessons and prayers, the beautiful burial service is not in the least impressive, neither so simple as to be solemn in its simplicity, nor so fine in its formality as to be dignified with the dignity Whistler loved. The procession re-forms, the Council of the International fall in behind and the people follow in carriages and hansoms provided by themselves, but not many. At Chiswick, J. says a crowd evidently is expected for numbers of policemen form round the funeral party as if to protect it, but there are few people. Miss Philip walks to the grave and looks in with calm, expressionless face. The International Council are given a place close to the grave. A man in blue monocle, red coat, blue shirt, orange flower in buttonhole, fur cap, long fur-edged gloves, comes leaping over the graves like some strange uncanny monster. The clergyman takes off his biretta, mumbles the prayers as if in haste to get through with them. Miss Kinsella crouches on the grass, crying audibly. And all is over. But the graveyard is calm and beautiful, the grave under a wall covered with clematis.

In the confusion of coming away, J. finds himself in a carriage with Studd, who explains how he happened to be with the family. They had asked him to be a pall-bearer, but, at the last moment, as a favour begged him to make way for Duret. It is to be noted that among the pall-bearers – George Vanderbilt, Freer, Abbey, Guthrie, Lavery and Duret – there are three Americans, one Scotchman, one Irishman, one Frenchman, and *no* Englishman. It is also to be noted that not an art critic is present in the church. A wreath of gold bay leaves, one of the only two wreathes on the coffin, was sent by the International. When J. reached the church, no arrangement had been made to reserve seats for anybody, and only by his instructions to the verger were pews reserved for the International Council and friends. He lunched at the Hyde Park Hotel with the others of the Council, to talk over a Whistler Memorial. Howard, in a moment of inspiration, suggested a gallery. Sauter was in a state of indignation because the funeral was so little impressive, anywhere else it would have been an official occasion, the chief authorities represented, the military out. Indeed, all the Societies and Academies to which Whistler belonged should have been represented and they probably would be very indignant because they had not been.

J – Joseph Pennell.
The Pennells' French maid.

Widow of Whistler's brother William; daughter and granddaughter of Whistler's half-sister Deborah, Lady Haden. Ernest Brown and David Croal Thomson, art dealers; Sir Lawrence Alma-Tadema (1836–1912); Sir Alfred East (1849–1913); wife of the artist Edwin Austin Abbey (1852–1911); Charles Whibley (1859–1930), journalist and writer, married Beatrice Whistler's sister Ethel Philip (see page 15); Dr Chalmers Mitchell, Secretary of the Zoological Society, was a friend of Whistler's and the Heinemanns'.
The Philip brother Ronald; Edward ("Teddie") Godwin (1876–?), the only son of E. W. Godwin and Beatrice Philip who became Whistler's stepson, trained as a sculptor and designed the grave in Chiswick for his mother and stepfather; "Young Lawson," probably the son of the artist Cecil Gordon Lawson (1851–82) who in 1879 married Constance, the eldest of the Philip daughters; William Webb, Whistler's solicitor; Arthur Studd, artist and Whistler collector; Brandon Thomas (1856–1914), actor and dramatist.

Louise Kinsella, daughter of the American newspaper editor Thomas Kinsella, posed for her portrait to Whistler, Rose and Green: The Iris between 1894 and 1902 (YMSM 420, Colourplate 101).

George Washington Vanderbilt (1862–1914) posed for Whistler (YMSM 481) and owned several paintings by him.

The Council of the International Society later commissioned a memorial from Rodin, who succeeded Whistler as President; it exists in several versions but was never publicly installed. Francis Howard, who also went under the names of Gassoway and O'Connor, was a Texan art dealer and critic, and Honorary Secretary of the International Society.

ROGER FRY
THE ATHENAEUM
"Mr Whistler"
25 July 1903

The Bloomsbury group member Roger Fry (1866–1934), aesthetician and painter, became art critic of The Athenaeum *in 1901; he became associated with the promotion of modern French painting in London, through the exhibitions of Post-Impressionism at the Grafton Gallery in 1910 and 1912.*

The penalty of perpetual youth is premature death, and Mr Whistler's death, whenever it had occurred, must have seemed premature, for to the generation of artists who came under this spell it was impossible to conceive of Mr Whistler as an elderly man. When, some years ago, Mr George Moore found him too old to fight a duel with, we started with amazement, for we had formed the habit of regarding him as young. His attitude of pugnacious antagonism to all that savoured of middle age caused the illusion. He seemed to be always inaugurating a revolution, leading intransigeant youth against the strongholds of tradition and academic complacence. And all the time, without our noticing it, he was becoming an old man, and now, too soon, he is an Old Master. For, whatever may be thought of his theories, his rankling and sometimes cruel witticisms, whatever may be thought of him as a friend and as an enemy, his work will remain even more interesting to posterity than his interesting and whimsical personality. His work is already seen to have scarcely a trace of that whimsicality and *gaminerie* with which his own writings invested it when it was new. Himself the most serious of artists, he injured himself by his Quixotic tilt against the dull-witted cunning of the "serious" charlatan. For of all the artists of our time he has stood out most emphatically for artistic probity.

There are certain things which are of the essence of the painter's craft, and whoever neglects these in order to point a moral, or to indulge a craving for cheap sentiment, or to satisfy an idle curiosity, is guilty, however unconsciously, of an imposture. It was these essential qualities of pictorial art that Mr Whistler insisted on to a generation that demanded bribes to the intelligence and the emotions before it could pocket the insult of pictorial beauty.

Whistler's argument, in 1890, was in fact with George Moore's brother Augustus Moore, editor of The Hawk, *over what Whistler considered to be offensive remarks he published concerning E. W. Godwin, the first husband of his wife Beatrice.*

This is not to say that other artists of the time have not practised this, the most difficult, as it is the cardinal virtue for a modern artist. But with some of them – Mr Watts, for instance – it has not been so critical a question, since they have ranged themselves more readily in line with contemporary ideas. But Mr Whistler's mordant humour turned for him the vague idealism and the sentimental romanticism of his day to utmost ridicule. He found himself singularly alone in his generation, and his pugnacity and his bitterly satiric vein increased his isolation and his consciousness of his own superiority. Irritated at the incapacity of the public to recognize certain truths that were self-evident to him, he refused to persuade them, and took a vicious pleasure in being misunderstood; so that, though severely critical of himself, he missed the boon of sympathetic criticism from outside – of adulation and contempt he had enough to spare. Thus it came about that, in his hatred of the accursed thing – of the trappings in which art seeks to recommend itself to an inartistic public – Mr Whistler threw over much that belongs to the scope of pictorial art, and narrowed unduly his view of its legitimate aims. Along with sentimentality, which he rightly saw was the bane of our age and country, he denounced all sentiment, all expression of mood in art, until he arrived at the astounding theory, enunciated in his *Ten o'Clock*, that pictorial art consists in the making of agreeable patterns, without taking account of the meaning for the imagination of the objects represented by them – that, indeed, the recognition of the objects was not part of the game. The forms presented were to have no meaning beyond their pure sensual quality, and each patch of colour was to be like a single musical note, by grouping which a symphony, as he himself called it, could be made. The fallacy of

See pages 212, 221–227.

the theory lay in its overlooking the vast difference in their effects on the imagination and feelings between groups of meaningless colour-patches and rhythmical groups of inarticulate sounds. As a protest it was, or might have been, valuable, since it emphasized that side of art which, when once realistic representation is attainable, tends to be lost sight of; but as a working theory for an artist of extraordinary gifts it was unfortunate, since it cut away at a blow all those methods of appeal which depend on our complex relations to human beings and nature; it destroyed the humanity of art. What Mr Whistler could not believe is yet a truth which the history of art impresses, namely, that sight is rendered keener and more discriminating by passionate feeling – that the coldly abstract sensual vision which he inculcated is, in the long run, damaging to the vision itself, while the poetical vision increases the mere power of sight.

Moreover, the painter himself could not act up to his own theories. As Mr Swinburne pointed out at the time, he infringed them flagrantly by expressing in his portrait of his mother a tenderly filial piety which transcends the facts of an arrangement in black and grey. Still, on the whole, his theory coloured his art, and led him to treat his sitters with an almost inhuman detachment. When he was engaged on the portraits of two sisters, in his communications with their parents he never got nearer to recognizing their personalities than was implied in calling one the arrangement in grey and the other the arrangement in white. There was something almost sublime in his inhuman devotion to the purely visible aspect of people, as of a great surgeon who will not allow human pity to obstruct the operations of his craft. To him people and things were but flitting, shadowy shapes in the shifting kaleidoscope of phenomena – shapes which served no other purpose than in happy moments to adjust themselves into a harmonious pattern which he was there to seize.

But, indeed, he reaped to the full the benefit of his detachment, for in an age when the works of man's hands were becoming daily uglier, less noble, and less dignified in themselves, he found a way to disregard the squalid utilitarianism which they expressed. If to him nothing was in itself noble or distinguished, neither was anything in itself common or unclean. Mean Chelsea slums, ignoble factories by the Thames, the scaffolding and *débris* of riverside activity, all might afford to his alert perception at a given moment the requisite felicitous concatenation of silhouettes and tones. This point of view he shared, of course, with other Impressionists, but what was singular to him, what he scarcely shared even with Manet, to whom he owed so much, was the exquisite tact, the impeccable taste of his selections. To the public at large he appeared at times as an impostor, who would make them accept meaningless scribbles as works of fine art, and from the point of view of mere representation there was much that served no purpose in his work; but from the other point of view no artist was ever more scrupulous in what he rejected, more economical or more certain of the means by which he attained his end. Every form, every tone, every note of colour in his pictures, had passed the severest critical test, it could only be there for its perfect and just relation with every other element in the scheme. Nothing was allowed on merely utilitarian or representative grounds. Critical taste rather than creative energy was his supreme gift, and his taste was that of a Greek vase painter or – and he was the first to seize the likeness – that of a Japanese worker in lacquer.

In all this he was the very antithesis of Rossetti, in whom a creative poetic energy controlled and harmonized every faculty; and yet in his early years in London even Whistler came under his spell. A few early drawings and etchings and one or two pictures, such as *At the Piano* and the *Girl in White*, betray something of the Pre-Raphaelite influence; but already they show a preoccupation with the surfaces of things rather than with their inner meaning – already they show that exquisite sense of the beautiful qualities of paint which dominated his art. Indeed, from some points of view these early pictures, with their rich but fluid impasto and vigorously

COLOURPLATE 30 *(YMSM 101)*.

COLOURPLATES 13 and 9 *(YMSM 24 and 38)*.

designed silhouettes, were never surpassed. But it was in Japan that Whistler soon learnt to find the most congenial expression of that purely pictorial, that non-plastic view of things which suited his temperament, and under this influence his technique changed so that he learnt to give to oil paint almost the freshness and delicacy of touch of the Japanese water-colour on silk. The problem which he set himself, and which he solved most completely in the portrait of Miss Alexander, was how to give the complete relief and the solidity of tone of an oil painting together with this flower-like fragility and spontaneity – to give the sense that this undeniable and complete reality was created, like the blossom on a fan, in a moment, almost at a single stroke. It was a feat of pure virtuosity which only an Oriental could have surpassed, and it meant not only amazing nervous control, but also an untiring analysis of the appearances, a slow and laborious reduction of forms and tones to the irreducible minimum which alone was capable of such expression. In such works he pushed the self-denying art of concealing artifice to its utmost limits, and few can guess at the strenuous labour which underlies these easy productions. They have, too, a flawless and lacquer-like perfection of surface which was an entirely new beauty in oil painting, and which none of his pupils or imitators have understood or approximated to in the least. But such an acrobatic feat required a perfect functioning of the whole man which could not long be maintained. In his later pictures he lost much of his sense of beautiful quality, and his work suffered the decay which was inevitable to one who was not upheld by any generous imaginative impulse. The negative and critical side of his art ended by killing the source of its own inspiration. It was too much a matter of nerves, too little sustained by spiritual energies from within, which in some men can, by their continued development, supply the place, and more than cover the defects, of failing physical powers.

Still in the achievements of his prime he will, we think, live as a great painter – above all, as a great protest and an amazing exception. A French American he may have been, but England was the home of his finest work, and it was to English seriousness that he preached his gospel of gaiety and indifference. It is for us, rather than for any other people, to do justice to a great man. As we pointed out lately, it is a monstrous injustice that none of his pictures was acquired for the Chantrey Bequest. It is to be hoped that, now that he is dead, even our officials may give to his works a tardy recognition. Merely from the point of view of worldly wisdom, Burlington House should this winter arrange for a representative collection of the works of Whistler the Old Master, to whom as a living man they grudged the barest recognition.

ARTHUR SYMONS

STUDIES IN SEVEN ARTS
"Whistler"
1906

Whistler is dead, and there goes with him one of the greatest painters and one of the most original personalities of our time. He was in his seventieth year, and until quite lately seemed the youngest man in London. Unlike most artists, he was to be seen everywhere, and he was heard wherever he was seen. He was incapable of rest, and incapable of existing without production. When he was not working at his own art, he was elaborating a fine art of conversation. In both he was profoundly serious, and in both he

COLOURPLATE 46 *(YMSM 129)*.

The purchasing fund named after the sculptor Francis Chantrey and administered by the Royal Academy. A memorial exhibition of Whistler's work was organized for London in 1905 by the Council of the International Society; memorial exhibitions were also held in Buffalo (1904) and Paris (1905).

The poet and critic Arthur Symons (1865–1945) did much to promote French Symbolism in England, through his editorship of The Savoy *and the critical studies he wrote on Baudelaire, Blake, Pater and Wilde.*

aimed at seeming to be the irresponsible butterfly of his famous signature. He deceived the public for many years; he probably deceived many of his acquaintances till the day of his death. Yet his whole life was a devotion to art, and everything that he said or wrote proclaimed that devotion, however fantastically. I wish I could remember half the things he said to me, at any one of those few long talks which I had with him in his quiet, serious moments. I remember the dinner party at which I first met him, not many years ago, and my first impression of his fierce and impertinent chivalry on behalf of art. Some person officially connected with art was there, an urbane sentimentalist; and after every official platitude there was a sharp crackle from Whistler's corner, and it was as if a rattlesnake had leapt suddenly out. The person did not know when he was dead, and Whistler transfixed him mortally. I know not how many times; and still he smiled and talked. I had said something that pleased Whistler, and he peered at me with his old bright eyes from far down the room; and after dinner he took me aside and talked to me for a full hour. He was not brilliant, or consciously clever, or one talking for effect; he talked of art, certainly for art's sake, with the passionate reverence of the lover, and with the joyous certainty of one who knows himself beloved. In what he said, of his own work and of others, there was neither vanity nor humility; he knew quite well what in his art he had mastered and what others had failed to master. But it was chiefly of art in the abstract that he talked, and of the artist's attitude towards nature and towards his materials. He only said to me, I suppose, what he had been saying and writing for fifty years; it was his gospel, which he had preached mockingly, that he might disconcert the mockers; but he said it all like one possessed of a conviction, and as if he were stating that conviction with his first ardour.

And the man, whom I had only before seen casually and at a distance, seemed to me almost preposterously the man of his work. At dinner he had been the controversialist, the acrobat of words; I understood how this little, spasmodically alert, irritably sensitive creature of brains and nerves could never have gone calmly through life, as Rodin, for instance, goes calmly through life, a solid labourer at his task, turning neither to the right nor to the left, attending only to his own business. He was a great wit, and his wit was a personal expression. Stupidity hurt him, and he avenged himself for the pain. All his laughter was a crackling of thorns under the pot, but of flaming thorns, setting the pot in a fury of boiling. I never saw any one so feverishly alive as this little, old man, with his bright, withered cheeks, over which the skin was drawn tightly, his darting eyes, under their prickly bushes of eyebrow, his fantastically creased black and white curls of hair, his bitter and subtle mouth, and, above all, his exquisite hands, never at rest. He had the most sensitive fingers I have ever seen, long, thin, bony, wrinkled, every finger alive to the tips, like the fingers of a mesmerist. He was proud of his hands, and they were never out of sight; they travelled to his moustache, crawled over the table, grimaced in little gestures. If ever a painter had painter's hands it was Whistler. And his voice, with its strange accent, part American, part deliberately French, part tuned to the key of his wit, was not less personal or significant. There was scarcely a mannerism which he did not at one time or another adopt, always at least half in caricature of itself. He had a whole language of pauses, in the middle of a word or of a sentence, with all sorts of whimsical quotation marks, setting a mocking emphasis on solemn follies. He had cultivated a manner of filling up gaps which did not exist; "and so forth and so on," thrown in purely for effect, and to prepare for what was coming. A laugh, deliberately artificial, came when it was wanted; it was meant to annoy, and annoyed, but needlessly.

He was a great wit, really spontaneous, so far as what is intellectual can ever be spontaneous. His wit was not, as with Oscar Wilde, a brilliant sudden gymnastic, with words in which the phrase itself was always worth more than what it said; it was a wit of ideas, in which the thing said was at

On 4 May 1900, at a dinner given by the Heinemanns', with Whistler, Mrs Chalmers Mitchell, Walter Armstrong and a "Marchesa something," according to the Pennells. The critic and writer on art Sir Walter Armstrong (1850–1918) was Director of the National Gallery of Ireland 1892–1914.

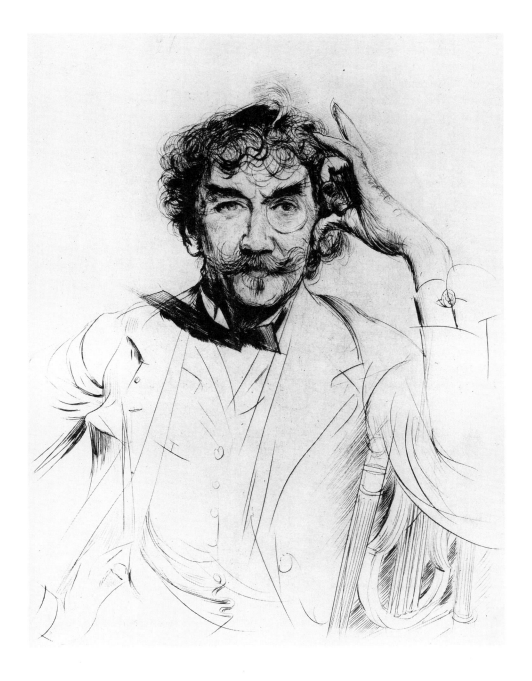

Paul Helleu, *Portrait Made while Whistler Posed to Boldini.* 1897. Drypoint, 13¾ × 10¼" (35 × 26.1 cm). Pennell Collection, Library of Congress, Washington, D.C.

least on the level of the way of saying it. And, with him, it was really a weapon, used as seriously as any rapier in an eternal duel with the eternal enemy. He fought for himself, but in fighting for himself he fought for every sincere artist. He spared no form of stupidity, neither the unintelligent stupidity of the general public, and of the critics who represent the public, nor the much more dangerous stupidity of intelligences misguided, as in the "leading case" of Ruskin. No man made more enemies, or deserved better friends. He never cared, or was able, to distinguish between them. They changed places at an opinion or for an idea.

He was a great master of the grotesque in conversation, and the portrait which he made of Mr Leyland as a many-tentacled devil at a piano, a thing of horror and beauty, is for once a verbal image put into paint, with that whole-hearted delight in exuberant extravagance which made his talk wildly heroic. That painting is his one joke in paint, his one expression of a personal feeling so violent that it overcame his scruples as an artist. And yet even that is not really an exception; for out of a malicious joke, begun, certainly, in anger, beauty exudes like the scent of a poisonous flower.

The Gold Scab (*YMSM 208*).

349

Many of his sayings are preserved, in which he seems to scoff at great artists and at great artistic qualities. They are to be interpreted, not swallowed. His irreverence, as it was called, was only one, not easily recognizable, sign of a delicate sensitiveness in choice. And it had come to be one of the parts that he played in public, one of the things expected of him, to which he lent himself, after all, satirically. And he could be silent on occasion, very effectively. I happened to meet him one day in front of the Chigi Botticelli, when it was on view at Colnaghi's. He walked to and fro, peered into the picture, turned his head sideways, studied it with the approved air of one studying it, and then said nothing. "Why drag in Botticelli?" was, I suppose, what he thought.

* * *

There is a lithograph of Mallarmé, reproduced in the *Vers et Prose*, which, to those who knew him, recalls the actual man as no other portrait does. It is faint, evasive, a mist of lines and spaces that seem like some result of happy accident: "subtiles, éveillées comme l'improvisation et l'inspiration," as Baudelaire said of the Thames etchings. Yet it cost Whistler forty sittings to get this last touch of improvisation into his portrait. He succeeded, but at the cost of what pains? "All trace of the means used to bring about the end has disappeared," after how formidable, how unrelaxing a labour!

See page 303.

In 1862, page 60.

It is the aim of Whistler, as of so much modern art, to be taken at a hint, divined at a gesture, or by telepathy. Mallarmé, suppressing syntax and punctuation, the essential links of things, sometimes fails in his incantation, and brings before us things homeless and unattached in middle air. Verlaine subtilizes words in a song to a mere breathing of music. And so in Whistler there are problems to be guessed, as well as things to be seen. But that is because these exceptional difficult moments of nature, these twilight aspects, these glimpses in which one sees hardly more than a colour, no shape at all, or shapes covered by mist or night, or confused by sunlight, have come to seem to him the only aspects worth caring about. Without "strangeness in its proportion," he can no longer see beauty, but it is the rarity of beauty, always, that he seeks, never a strange thing for the sake of strangeness; so that there is no eccentricity, as there is no display, in his just and reticent records. If he paints artificial light, it is to add a new, strange beauty to natural objects, as night and changing lights really add to them; and he finds astonishing beauties in the fireworks at Cremorne Gardens, in the rockets that fall into the blue waters under Battersea Bridge. They are things beautiful in themselves, or made beautiful by the companionship and co-operation of the night; in a picture they can certainly be as beautiful as stars and sunsets.

Or, take some tiny, scarcely visible sketch in water-colour on tinted paper: it is nothing, and it is enough, for it is a moment of faint colour as satisfying in itself as one of those moments of faint colour which we see come and go in the sky after sunset. No one but Whistler has ever done these things in painting; Verlaine has done the equivalent thing in poetry. They have their brief coloured life like butterflies, and with the same momentary perfection. No one had ever cared to preserve just these aspects, as no one before Verlaine had ever cared to sing certain bird notes. Each was satisfied when he had achieved the particular, delicate beauty at which he had aimed; neither cared or needed to go on, add the footnote to the text, enclose the commentary within the frame, as most poets and painters are considerate enough to do.

* * *

Look round a picture gallery, and you will recognize a Whistler at once, and for this reason first, that it does not come to meet you. Most of the other pictures seem to cry across the floor: "Come and look at us, see how like something we are!" Their voices cross and jangle like the voices of

rival sellers in a street fair. Each outbids his neighbour, promising you more than your money's worth. The Whistlers smile secretly in their corner, and say nothing. They are not really indifferent; they watch and wait, and when you come near them they seem to efface themselves, as if they would not have you even see them too closely. That is all part of the subtle malice with which they win you. They choose you, you do not choose them.

One of the first truths of art has needed to be rediscovered in these times, though it has been put into practice by every great artist, and has only been seriously denied by scientific persons and the inept. It has taken new names, and calls itself now "Symbolism," now "Impressionism"; but it has a single thing to say, under many forms: that art must never be a statement, always an evocation. In the art of Whistler there is not so much as a momentary forgetfulness of this truth, and that is why, among many works of greater or less relative merit, he has done nothing, however literally slight, which is not, so far as it goes, done rightly. No picture aims at anything else than being the evocation of a person, a landscape, some colour or contour divined in nature, and interpreted upon canvas or paper. And the real secret of Whistler, I think, is this: that he does not try to catch the accident when an aspect becomes effective, but the instant when it becomes characteristically beautiful.

It is significant of a certain simplicity in his attitude towards his own work, that Whistler, in all his fighting on behalf of principles, has never tried to do more than establish (shall I say?) the correctness of his grammar. He has never asked for more praise than should be the reward of every craftsman who is not a bungler. He has claimed that, setting out to do certain things, legitimate in themselves, he has done them in a way legitimate in itself. All the rest he is content to leave out of the question: that is to say, everything but a few primary qualities, without which no one can, properly speaking, be a painter at all. And, during much of his lifetime, not even this was conceded to him. He wasted a little of his leisure in drawing up a catalogue of some of the blunders of his critics, saying, "Out of their own mouths shall ye judge them." Being without mercy, he called it *The Voice of a People*.

The 1892 catalogue of the exhibition Nocturnes, Marines and Chevalet Pieces, *see pages 276–279*.

MAX BEERBOHM

THE METROPOLITAN MAGAZINE
"Whistler's Writing"
September 1904

Prompted by the second edition of The Gentle Art of Making Enemies, *Max Beerbohm (1872–1956), cartoonist and wit of the late Victorian and Edwardian age, wrote a critical essay in which he questioned why such a great artist should stoop to being a mere showman (*The Saturday Review, *vol. 84), 20 November 1897, pages 546–47); it did not please Whistler. Intervening years provided Beerbohm with the opportunity of delivering the more considered judgement published here.*

If I were reading a First Folio Shakespeare by my fireside, and if the match-box were ever so little beyond my reach, I vow I would light my cigarette with a squill made from the margin of whatever page I were reading. I am neat, scrupulously neat, in regard to the things I care about; but a book, as a book, is not one of these things. Of course, a book may happen to be in itself a beautiful object. Such a book I treat tenderly, as I would a flower. And such a book is, in its brown-papered boards, whereon gleam little gilt italics and a little gilt butterfly, Whistler's *Gentle Art of Making Enemies*. It happens to be also a book which I have read again and again – a book that has often travelled with me. Yet its cover is as fresh as when first, some twelve years since, it came into my possession. *On dirait* a flower freshly plucked – a brown and yellow flower, with a little gilt butterfly fluttering over it. And its inner petals, its delicately spaced pages, are as white and undishevelled as though they never had been opened.

The book lies open before me as I write. I must be careful of my pen's transit from ink-pot to MS.

Yet, I know, many worthy folk would like the book blotted out of existence. These are they who understand and love the art of painting, but neither love nor understand writing as an art. For them *The Gentle Art of Making Enemies* is but something unworthy of a great man. Certainly, it is a thing incongruous with a great hero. And for most people it is painful not to regard a great man as also a great hero. Hence all the efforts to explain away the moral characteristics deducible from *The Gentle Art of Making Enemies*. These efforts may be said to have culminated in that of a recent American biographer. Whistler, it seems, was for a short time at the military training college of West Point. Soldiers, it seems, are arbitrary, intolerant persons. Therefore, in his after-life, Whistler sometimes seemed to be an arbitrary, intolerant person, though inwardly (q.e.d.) he was saturated through and through with the quintessence of the Sermon on the Mount.

Well! Hero-worship is a very good thing. It is a wholesome exercise which we all ought to take, now and again. Only, let us not strain ourselves by overdoing it. Let us not indulge in it too constantly. Let hero-worship be reserved for heroes. And there was nothing heroic about Whistler, except his unfaltering devotion to his own ideals in art. No saint was he, and no one would have been more annoyed than he by canonization: would he were here to play, as he would have played incomparably, the Devil's advocate! So far as he possessed the Christian virtues, his faith was in himself, his hope was for the immortality of his own works, and his charity was for the defects in those works. He is known to have been an affectionate son, an affectionate husband; but, for the rest, all the tenderness in him seems to have been absorbed into his love for such things in Nature as were expressible through terms of his own art. As a man in relation to his fellowmen, he cannot, from any purely Christian standpoint, be applauded. He was inordinately vain and cantankerous. Enemies, as he has wittily implied, were a necessity to his nature; and he seems to have valued friendship (a thing never really valuable in itself, to a really vain man) as just the needful foundation for future enmity. Quarrelling and picking quarrels, he went his way through life, blithely. Most of these quarrels were quite trivial and tedious. In the ordinary way, they would have been forgotten long ago, as the trivial and tedious details in the lives of great men are often forgotten. But Whistler was great not merely in painting, nor merely as a wit and dandy in social life. He had, also, an extraordinary talent for writing. He was a born writer. He wrote, in his way, perfectly; and his way was his own, and the secret of it has died with him. Thus, conducting them through the post office, he has conducted his squabbles to immortality.

Immortality is a big word. I do not mean by it that so long as this globe endures, the majority of the crawlers round it will spend the greater part of their time in reading *The Gentle Art of Making Enemies*. Even the pre-eminently immortal works of Shakespeare are read very little. The average of time devoted to them by Englishmen cannot (even though one assess Mr Churton Collins at eight hours per diem, and Mr Sidney Lee at twenty-four), tot up to more than a small fraction of a second in a lifetime (reckoned by the Psalmist's limit). When I dub Whistler an immortal writer, I mean precisely that so long as there are people interested in the subtler ramifications of English prose as an art, so long will there be a few constantly recurring readers of *The Gentle Art*. There are in England, at this moment, a few people to whom prose appeals as an art. But none of them, I think, has yet done justice to Whistler's prose. None has taken it with the seriousness it deserves. I am not surprised. When a man can express himself through two media, people tend to take him lightly in his use of the medium to which he devotes the lesser time and energy, even though he use that medium not less admirably than the other, and even though they

Arthur Jerome Eddy, Recollections and Impressions of James A. McNeill Whistler, *J. B. Lippincott Company, Philadelphia and London, 1903.*

A sheet of *Butterfly Studies*. 1890. Pencil, $14\frac{1}{2} \times 9\frac{3}{4}''$ (36.8×23.8 cm). Hunterian Art Gallery, Glasgow University (Birnie Philip Bequest).

themselves care about it more than they care about the other. Perhaps this very preference in them creates a prejudice against the man who does not share it, and so makes them skeptical of his power. Anyhow, if Disraeli had been unable to express himself through the medium of political life, Disraeli's novels would long ago have had the due which the expert is just beginning to give him. Had Rossetti not been primarily a poet, the expert in painting would have acquired long ago his present penetration into the peculiar value of Rossetti's painting. Likewise, if Whistler had never painted a picture, and, even so, had written no more than he actually did write, this essay in appreciation would have been forstalled again and again. As it is, I am a sort of herald. And however loudly I shall blow my trumpet, not many people will believe my message. For many years to come, it will be the fashion among literary critics to pooh-pooh Whistler, the writer, as an amateur. For Whistler was primarily a painter, not less than was Rossetti primarily a poet, and Disraeli a statesman. And he will not live down quicker than they the taunt of amateurishness in his secondary art. Nevertheless, I will, for my own pleasure, blow the trumpet.

I grant you, Whistler was an amateur. But you do not dispose of a man by proving him to be an amateur. On the contrary, an artist with real innate talent may do, must do, more exquisite work than he could do if he were a professional. His very ignorance and tentativeness may be, must be, a means of special grace. Not knowing "how to do things," having no ready-made and ready-working apparatus, and being in constant fear of failure, he has to grope always in the recesses of his own soul for the best way to express his soul's meaning. He has to shift for himself, and to do his very best. Consequently, his work has a more personal and fresher quality, and a more exquisite "finish," than that of a professional, however finely endowed. All of the much that we admire in Walter Pater's prose comes of the lucky chance that he was an amateur, and never knew his business. Had Fate thrown him out of Oxford upon the world, the world would have been richer for the prose of another, John Addington Symonds, and would have forfeited Walter Pater's prose. In other words, we should have lost a dollar and found a cent. Had Fate withdrawn from Whistler his vision for form and colour, leaving him only his taste for words and phrases and cadences, Whistler would have settled solidly down to the art of writing, and would have mastered it, and, mastering it, have lost that especial quality which the Muse grants only to them who approach her timidly, bashfully, as suitors. . . . Perhaps I am wrong. Perhaps Whistler would never, in any case, have acquired the professional touch in writing. For we know that he never acquired it in the art to which he dedicated all but the surplus of his energy. Compare him with the other painters of his day. He was a child in comparison with them; they, with their sure science, solving so roughly and readily problems of modelling and drawing and what not that he never dared to meddle with.

It has often been said that Whistler's art was an art of evasion. But the reason of the evasion was reverence. He kept himself reverently at a distance. He knew how much he could not do; nor was he ever confident even of the things that he could do; and these things, therefore, he did superlatively well, having to grope for the means in the recesses of his soul. The particular quality of exquisiteness and freshness that gives to all his work, whether on canvas or on stone or on copper, a distinction from and above any contemporary work and makes it dearer to our eyes and hearts, is a quality that came to him because he was an amateur, and that abided with him because he never ceased to be an amateur. He was a master through his lack of mastery. In the art of writing he was a master through his lack of mastery. There is almost exact parallel between the two sides of his genius. Nothing could be more absurd than the general view of him as a masterly professional on the one side and a trifling amateur on the other. He was, certainly, a painter who wrote. But, by the slightest movement of

Walter Pater (1839–94), author of the celebrated work Studies in the History of the Renaissance *(1873).*

John Addington Symonds (1840–93), author of the seven-volume Renaissance in Italy, *which was often compared to Burckhardt's.*

Fate's little finger, he might have been a writer who painted, and this essay have been written not by me from any standpoint, but by some painter eager to suggest that Whistler's painting was a quite serious thing.

Yes, that painting and that writing are marvellously akin; and such differences as you will see in them are superficial merely. I spoke of Whistler's vanity in life, and I spoke of his timidity and reverence in art. That contradiction is itself merely superficial. Bob Acres was timid, but he was also vain. His swagger was not an empty assumption to cloak his fears: he really did regard himself as a masterful and dare-devil fellow, except when he was actually fighting. Similarly, except when he was at his work, Whistler, doubtless, really did think of himself as a brilliantly effortless butterfly. The pose was, doubtless, a quite sincere one, a necessary reaction of feeling. Well, in his writing he displays to us his vanity; whilst in his painting we discern only his reverence. In his writing, too, he displays his harshness – swoops hither and thither, a butterfly equipped with sharp little beak and talons; whereas in his painting we are conscious only of his caressing sense of beauty. But look from the writer, as shown by himself, to the means by which himself is shown. You will find that for words as for colour-tones he has the same reverent care, and for phrases as for forms the same caressing sense of beauty. Fastidiousness – "daintiness," as he would have said – dandyishness, as we might well say: by just that which marks him as a painter is he marked as a writer too. His meaning was ever ferocious; but his method, how delicate and tender! The portrait of his mother, whom he loved, was not wrought with a more loving hand than were his portraits of Mr Harry Quilter for the London *World*.

His style never falters. The silhouette of no sentence is ever blurred. Every sentence is ringing with a clear vocal cadence. There, after all, in that vocal quality, is the chief test of good writing. Writing, as a means of expression, has to compete with talking. The talker need not rely wholly on what he says. He has the help of his mobile face and hands, and of his voice, with its various inflections, and its variable pace, whereby he may insinuate fine shades of meaning, qualifying or strengthening at will, and clothing naked words with colour and making dead words live. But the writer? He can express a certain amount through his handwriting, if he write in a properly elastic way. But his writing is not printed in facsimile. It is printed in cold, mechanical, monotonous type. For his every effect he must rely wholly on the words that he chooses, and on the order in which he ranges them, and on his choice among the few hard-and-fast symbols of punctuation. He must so use these slender means that they shall express all that he himself can express through his voice and face and hands, or all that he *would* thus express if he were a good talker. Usually, the good talker is a dead failure when he tries to express himself in writing. For that matter, so is the bad talker. But the bad talker has the better chance of success, inasmuch as the impressiveness of his voice and face and hands will have sharpened his scent for words and phrases that shall in themselves convey such meanings as he has to express.

Whistler was that rare phenomenon, the good talker who could write as well as he talked. Read any page of *The Gentle Art of Making Enemies*, and you will hear a voice in it, and see a face in it, and see gestures in it. And none of these is quite like any other known to you. It matters not that you never knew Whistler, never even set eyes on him. You see him and know him here. The voice drawls slowly, quickening to a kind of snap at the end of every sentence, and sometimes rising to a sudden screech of laughter; and, all the while, the fine fierce eyes of the talker are flashing out at you, and his long, nervous fingers are tracing quick arabesques in the air. No! You need never have seen Whistler to know what he was like. He projected through printed words the clean-cut image and clear-ringing echo of himself. He was a born writer, achieving perfection through pains which must have been infinite for that we see the trace of them at all.

Bob Acres, a character in Sheridan's The Rivals.

The art critic, see page 172.

Max Beerbohm, *Whistler Transformed into a Candlestick*. Ink, 8 × 7¼″ (20.6 × 18.5 cm). Hunterian Art Gallery, Glasgow University.

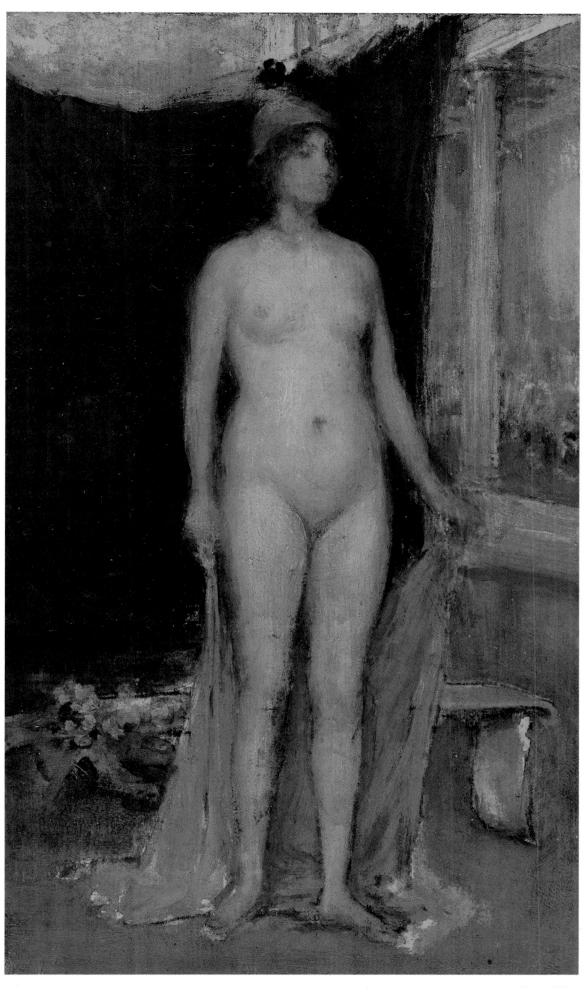

COLOURPLATE 112. *Purple and Gold: Phryne the Superb! – Builder of Temples.* 1898-1901. 9¼ × 5⅜″
(23.6 × 13.7 cm).
Freer Gallery of Art, Smithsonian Institution, Washington, D.C.

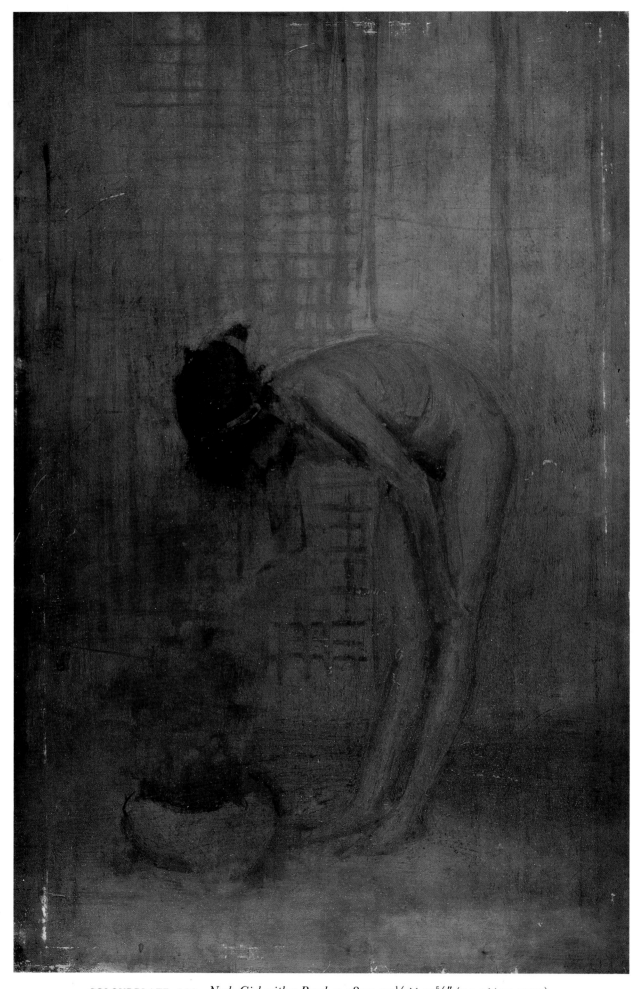

COLOURPLATE 113. *Nude Girl with a Bowl. c.* 1892. 20¼ × 12⅝″ (51.4 × 32.2 cm).
Hunterian Art Gallery, Glasgow University.

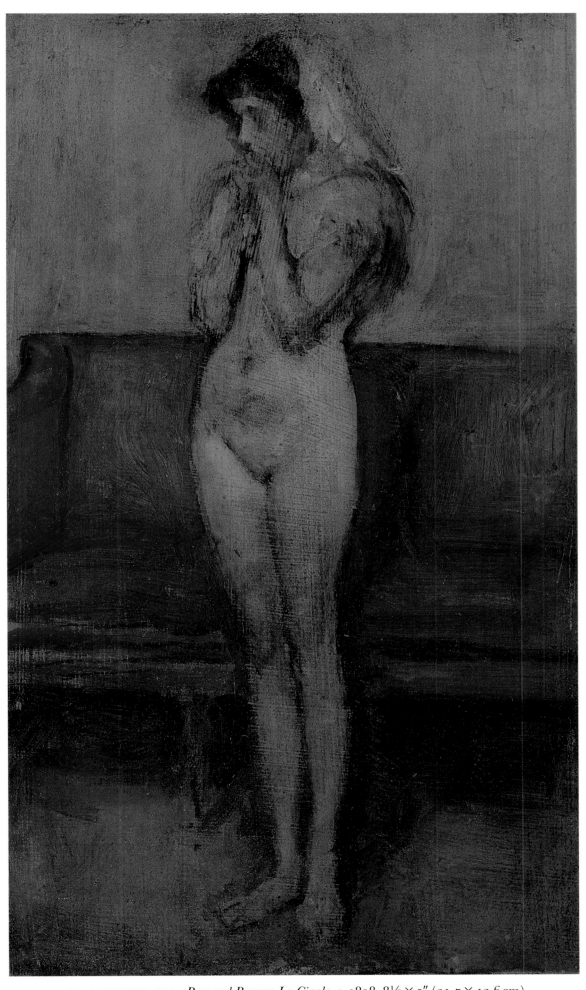

COLOURPLATE 114. *Rose and Brown: La Cigale. c.* 1898. 8½ × 5″ (21.7 × 12.6 cm).
Freer Gallery of Art, Smithsonian Institution, Washington, D.C.

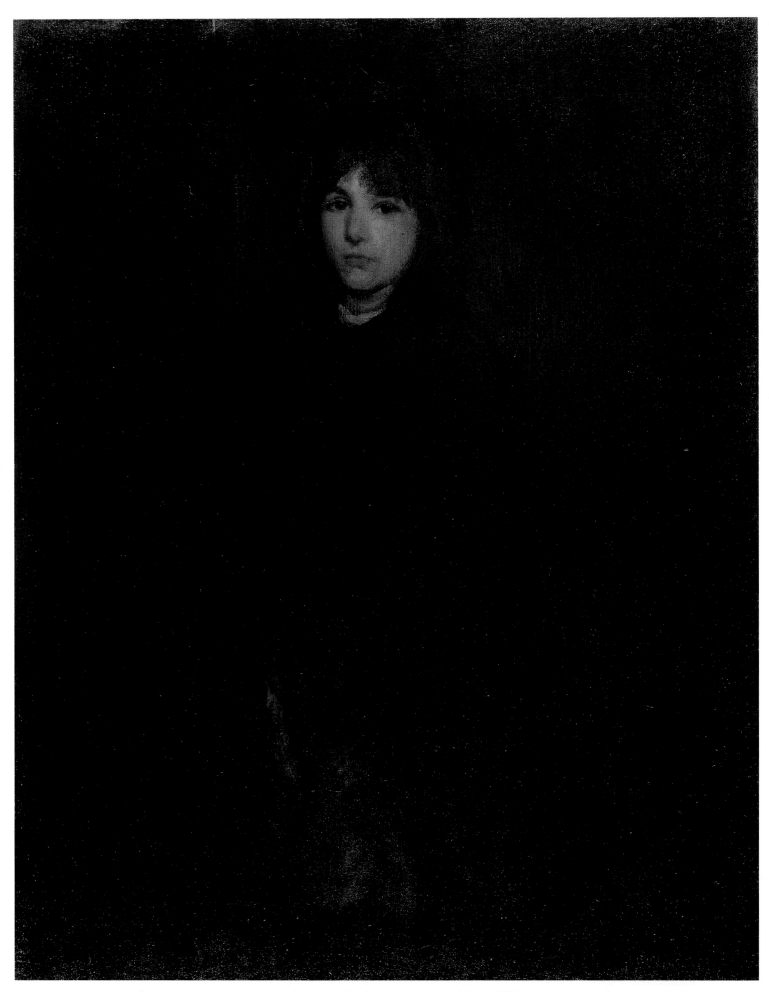

COLOURPLATE 115. *The Boy in a Cloak*. 1896/1900. 38⅛ × 28½″ (96.8 × 72.4 cm).
Hunterian Art Gallery, Glasgow University.

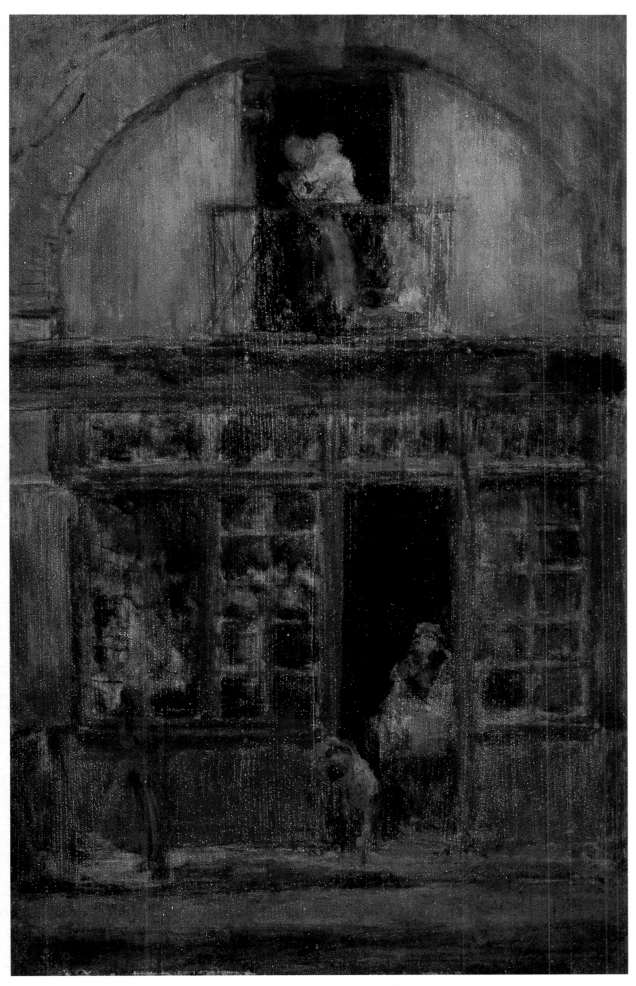

COLOURPLATE 116. *A Shop with a Balcony.* 1890s. 8¾ × 5⅜″ (22.3 × 13.7 cm).
Hunterian Art Gallery, Glasgow University.

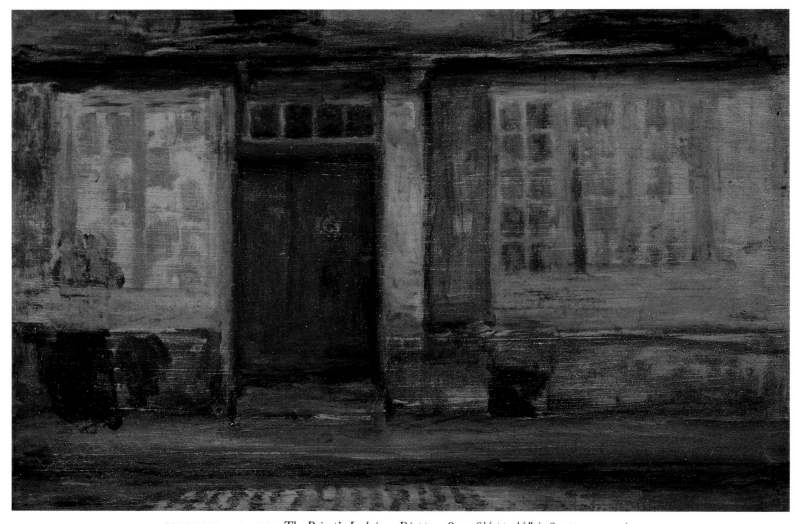

COLOURPLATE 117. *The Priest's Lodging, Dieppe.* 1897. 6½ × 9½″ (16.5 × 24.3 cm).
Hunterian Art Gallery, Glasgow University.

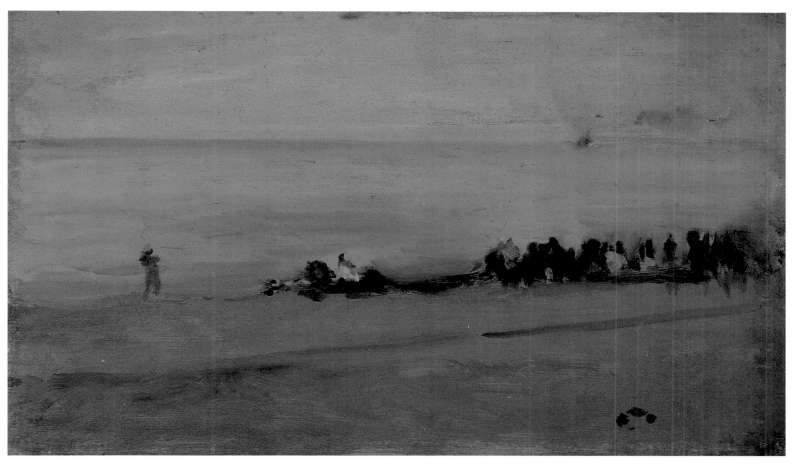

COLOURPLATE 118. *Blue and Silver: Boat Entering Pourville*. 1899. 5½ × 9¼″ (14.1 × 23.4 cm).
Freer Gallery of Art, Smithsonian Institution, Washington, D.C.

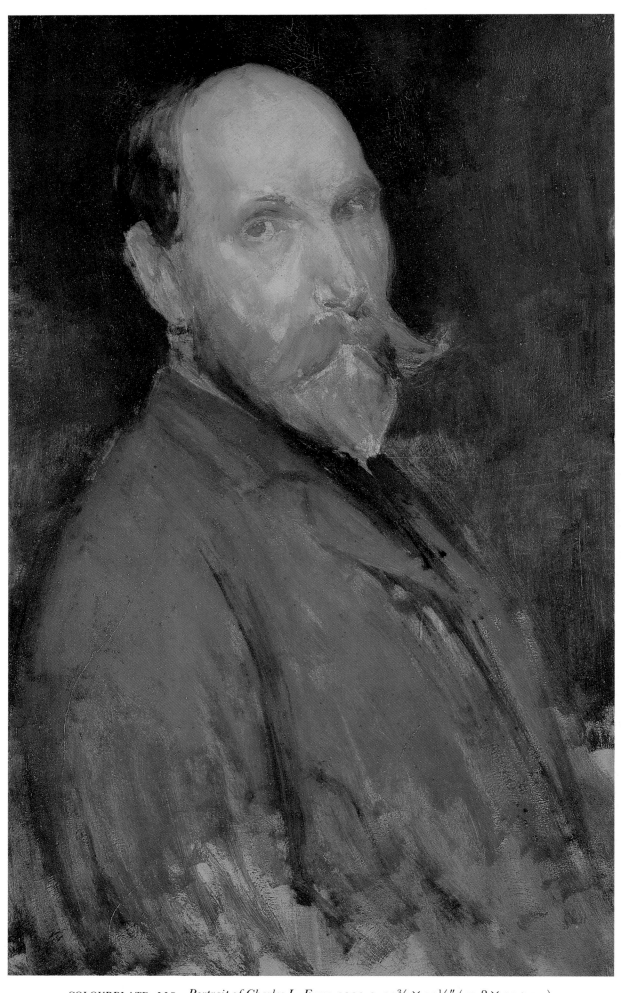

COLOURPLATE 119. *Portrait of Charles L. Freer.* 1902-3. 20⅜ × 12½″ (51.8 × 31.7 cm).
Freer Gallery of Art, Smithsonian Institution, Washington, D.C.

Like himself, necessarily, his style was cosmopolitan and eccentric. It comprised Cockneyisms and Boweryisms and Parisian *argot*, with constant reminiscences of the authorized version of the Old Testament, and with chips off Molière, and with shreds and tags of what-not snatched from a hundred and one queer corners. It was in fact an Autolycine style. It was a style of the maddest motley, but of motley so deftly cut and fitted to the figure, and worn with such an air, as to become a gracious harmony for all beholders. After all, what matters is not so much the vocabulary as the manner in which the vocabulary is used. Whistler never failed to find the right words and the right cadence for a dignified meaning, when dignity was his aim: "And when the evening mist clothes the riverside with poetry, as with a veil, and the poor buildings lose themselves in the dim sky, and the tall chimneys become Campanili, and the warehouses are palaces in the night, and the whole city hangs in the heavens, and fairyland is before us. . . ." That is as perfect in its dim and delicate beauty as any of his painted *Nocturnes*. But his aim was more often to pour ridicule and contempt. And herein the weirdness of his natural vocabulary, the patchiness of his reading, were of very real value to him.

Take the opening words of his letter to Tom Taylor: "Dead for a ducat, dead! My dear Tom: and the rattle has reached me by post. '*Sans rancune*' say you? Bah! you scream unkind threats and die badly. . . ." And another letter to the same unfortunate gentleman: "Why, my dear old Tom, I never *was* serious with you, even when you were among us. Indeed, I killed you quite, as who should say, without seriousness, 'A rat! A rat!' you know, rather cursorily. . . ." There the very lack of coherence in the style, as of a man gasping and choking with laughter, drives the insults home with a horrible precision. Notice the technical skill in the placing of "you know, rather cursorily," at the end of the sentence. Whistler was full of such tricks – tricks that could never have been played by him, could never have occurred to him, had he acquired the professional touch. Not a letter in the book but has some such little felicity of cadence or construction.

The letters, of course, are the best thing in the book, and the best of the letters are the briefest. An exquisite talent like Whistler's, whether in painting or in writing, is always at its best on a small scale. On a large scale it strays and is distressed. Thus the *Ten O'Clock*, from which I took that passage about the evening mist and the riverside, does not leave me with a sense of artistic satisfaction. It lacks structure. It is not a roundly conceived whole. It is but a row of fragments. Were it otherwise, Whistler could never have written so perfectly the little letters. For no man who can finely grasp a big theme can play exquisitely round a little one.

Nor can any man who excels in scoffing at his fellows excel also in taking abstract subjects seriously. Certainly the little letters are Whistler's passport among the elect of literature. Luckily, I can judge them without prejudice. Whether in this or that case Whistler was in the right or in the wrong, is not a question which troubles me at all. I read the letters simply from the literary standpoint. As controversial essays certainly, they were often in very bad taste. An urchin scribbling insults to some one on a street wall would not go further than Whistler often went. Whistler's mode of controversy reminds me, in another sense, of the writing on the wall. His opponents really did find their souls required of them. After an encounter with him, they never again were quite the same men in the eyes of their fellows. Whistler's insults always stuck, stuck and spread around the insulted, who found themselves at length encased in them, like flies in amber. You may shed a tear over the flies, if you will. For myself, I am content to laud the amber.

i.e. destructive of itself.

Whistler's correspondence of 1879 with Tom Taylor (see page 59) is reproduced in The Gentle Art; *it parodies Polonius's death at the hands of Hamlet (Act III, scene iv).*

MARCEL PROUST

Letter to Marie Nordlinger

8 or 9 February 1905

Dear friend,

. . . Happiness is something I have sometimes stopped hoping for for myself but never for others. And I bless the Wisthlerian [sic] magician who has brought you happiness. For I do not think that things alone have given it to you. And I sense that persons also contribute. Thank you infinitely for the delicious little book on Wisthler. I've looked everywhere for the article you asked for and haven't been able to find it. Tell me the name of the Review, I'll go there and have it sent to you. When I'm better I'll read the little booklet carefully and will talk to you about it in more detail. I'm sorry to think that your new friend, since you bethought yourself to talk to him about me, must, as a good Wisthlerian, feel considerable scorn for an admirer of Ruskin. But in reality I think that if their *theories*, which are the least intimate part of each one of us, were opposed, *at a certain depth* they had something in common more often than they believed. Thus Wisthler's best remark was uttered against Ruskin: "I did indeed take only a few moments to paint this picture," he replied to the judge, "but I painted it with the experience of a whole lifetime." Now I have read what Ruskin said to Rossetti: "Your only good works are the ones you paint quickly, the studied ones are bad. This is because in fact the studied ones, things which cause you trouble because you've never thought about them, take you two or three months to do. But the unpremeditated ones, the ones you do for pleasure, take but a moment to embody an obscure desire long cherished in your heart, so that in reality you paint them with several years' accumulated knowledge." Here Ruskin is abandoning theory and coming to meet Wisthler in a valuable moment of intimate experience.

Having had a little respite these days I have begun *Queens Gardens* which I have decided to add to *Sesame*. The old and charming English scholar I told you about will serve me as "Mary."

As a New Year's gift I received the splendid new edition of Ruskin. You will enjoy reading it when you come back. And you will see the magnificent new illustrations. I have a friend (M Lucien Daudet) who studied painting with Wisthler. If the information he could [perhaps (?)] provide our friend with might be such as would interest him, I should be delighted to question him. But I myself never knew Wisthler except for one evening, when I got him to say something positive about Ruskin! and after which I kept his lovely grey gloves, since lost. But I've heard a lot about him from Robert de Montesquiou and Boldini. Tell your friend that in my intentionally *bare* room there is only one single reproduction of a work of art: an admirable photograph of Wisthler's *Carlyle* with a serpentine coat like the dress of the *Artist's Mother*. The more I think of Ruskin's and Wisthler's theories, the more I feel they are not irreconcilable. Wisthler is right to say in *Ten o'clock* that Art is distinct from Morals. And yet Ruskin too is saying something true, on another level, when he states that all great art is moral. But now that's enough chatter, and I shall send you my respectful and grateful affection without further ado.

Marcel Proust

The author of À La Recherche du Temps Perdu, *Marcel Proust (1871–1922).*

An English edition of the "Ten O'Clock" lecture, 1888.

According to Kolb, the "new friend" was Charles Lang Freer (see pages 322, 365).

Proust cites from memory a letter of 1854 from Ruskin to Rossetti in William Michael Rossetti, ed., Ruskin, Rossetti, Preraphaelitism; Papers 1854 to 1862, *George Allen, London, 1899, pages 28–30. Proust translated Ruskin's* Sesame and lilies *(1906).*

Son of Alphonse, the writer.

Boldini painted Whistler's portrait in 1897.

COLOURPLATES 38 and 30 *(YMSM 137 and 101).*

ERNEST F. FENELLOSA

THE PACIFIC ERA

"The Collection of Mr Charles L. Freer"

2 November 1907

It may be premised that the Freer collection, with a very few exceptions, consists, as already hinted, of three great parts, apparently, at first sight, distinct from each other. These are, to state briefly – first, by far the largest and most representative series of all the pictorial work of James McNeill Whistler that now exists in any one group, or that it is physically possible shall ever exist: – second, the most comprehensive and aesthetically valuable collection anywhere known of all the ancient glazed pottery of the world. Egyptian, Babylonian, Persian, Indian, Chinese, Korean and Japanese: – and third, the finest and best unified group of masterpieces by the greatest Chinese and Japanese painters of all ages that exists outside of Japan, with the possible exception of that in the Boston Art Museum.

* * *

As a whole, this collection strikingly illustrates the most conspicuous fact in the history of art, that the two great streams of European and Asiatic practice, held apart for so many thousand years, have, at the close of the nineteenth century, been brought together in a fertile and final union. The future historian will look back to the year 1860 as a nodule, a starting-point of the whole subsequent course in the world's art. It was about then that Japanese art, recently revealed to the West, began its course of freeing our Western practice from a narrow realism of long tradition. But the service was already a much more positive one than mere freeing. It had creative qualities to suggest to any Western master of insight strong enough to avoid the mere copying of pungent externals. Millet, Carot [sic] and their *confrères* had already been influenced by Japanese prints, which they eagerly went up to Paris to buy. The general absence of shadow in the print encouraged their explorations of natural values. Manet and others had been helped by oriental example in their daring adoption of flat-tones, local darks and lights, new angular spacing, and more sympathetic brushwork. But among these groups of pioneers in France there was one young American student whose mind was led by Japanese work much further – not only through a strengthening to solve problems already conceived, but through a suggestion of new ranges of aesthetic quality, utterly strange species of beauty, that had never been suspected, or at least fully stated, in earlier Western art. It was to explore this rich world of combinations, in their own right, that now became for Whistler the steady aim of his life.

To those students of Whistler's art who are forbidden by temperament or education from grasping the power of oriental, it may seem as if this special claim for the former were beside the point. For them Whistler's strength is only a mastery of representative technique akin to what had already been developed in Europe, two centuries before by such men as Hals and Velazquez, and it is true that the fresh genius of these former masters, as of some still earlier Venetians, had penetrated to a new universal, a purely pictorial method, as distinct from the general overweighting of European painting with canons of sculpture. Their painting ceased to be an attempt to copy on a flat plane the effects of coloured statues set in an artificial studio light; and asserted itself as a strong suggestion of a more lyrical treatment of human relations, in terms of lovely firm spacing, and of rich surface-harmony. But the germ of their occasional example did not take root in the heart of an eighteenth century

Charles Lang Freer regarded the scholar Ernest Francisco Fenellosa (1853–1908), who became the first curator of Japanese art at the Boston Museum, as "the greatest of living critics of Japanese art," and as a collector of oriental art consulted him regularly, hoping that he would catalogue his collections. Receptive to Whistler's influence on Freer, Fenellosa realized Whistler's importance as a bridge between the visual arts of the East and the West.

i.e. Corot
Photograph of Charles Lang Freer comparing Whistler's *Venus Rising from the Sea* with a large Oriental jar. *c.* 1915. Freer Gallery Archives, Smithsonian Institution, Washington, D.C.

Europe proud of its classic renaissance; and even today the bulk of our modern critics are hampered by the old Western prejudice that art is properly a stiffer kind of expressive language.

* * *

Now it remained for Whistler, not quite to discover this important truth, but to suspect and sound the incredible *vastness* and *variety* implicit in this frankly accepted lyrical world of vision. This is the substance of his whole career, all too short to complete the survey, and never wasting time in repetitions. Now it was a trial of some new alignment, or tossing polygonal beauty in his spaces. Now it was a year's long search for an evanescent, Shelley-like note in colour. His "unfinished sketches" and most meagre etchings are not so much imperfect and transient studies as the striking of so many complete chords, which the addition of a single touch would shatter into noise. Nature became to him infinitely richer in pictorial suggestions, because a thousand settings of subjects, before tabooed, flashed upon his freed eye as beautiful, and for this insight, Japanese art, and especially the prints of Hiroshige, gave him positive suggestion. For the first time in them he saw a part of a horse, or a slice of a man, set prominently in the lateral frame of a composition; and a tree, or a hanging cloth, or a human head, obtruded into the foreground. Any group of spots making new harmonious cuttings of the primary canvas-rectangle became not only admissible, but urgent. It is this chiefly that sets Whistler apart from Western art, without making him a mere copier of Eastern. He is the first to grasp fully and creatively the oriental principle in order to express occidental feeling. Whistler thus stands forever at the meeting-point of the two great continental streams; he is the nodule, the universalizer, the interpreter of East to West, and of West to East.

The Six Projects are probably here referred to *(Colourplates 23–26)*.

The positivity of Whistler's work does not end in line; but pours over into breadth of dark-and-light massing. Here other Westerns had already started a revolution against the tyranny of shadow. The greater truth of local lights and of atmospheric planes was already acknowledged. Effect, removed as far as possible from the plaster-cast stage, no longer had to rely on an exaggerated "rounding-up." But Whistler, in going so much farther than a mere recognition of this truth, finds, in exploring for their own sake this new wealth of tonal beauties, a wealth of natural truth which no realist, however enlightened, could suspect. He is the first occidental to express firmly, and in almost flat planes, pearly films of greys so subtly differentiated that, without blending, each seems to vibrate and deliquesce into its neighbour. Here he becomes far less brutal, and limited to the range of harsh contrasts than Rembrandt and Manet. He models in middletones, like a modern amateur photographer. He makes us see infinite beauty, where men before saw nothing. He discovers for Western practice the affinities of synthetic dark-and-light, – much as Bach revealed for all time the possibilities of musical harmony.

In colour Whistler's explorations are even more positive and illuminating. Filling his strange angles [sic], warming his shifting values, endless new colour chords, quiet, flower-like, pungent, and with clinging affinities, leap into play. The heavy scarlet and crimsons of a Venetian robe, the deep ultramarines of an Italian sky, and the warm orange gliding of sunlight on flesh – no such limits of obvious progression will he allow. His flesh in twilight shadow may become a plum purple, contrasted with browns that seem to cool like drying earth. His scarlets are small tongues of flame, vibrating through ribbons and flower-petals. He, first of occidentals, has explored the infinite ranges of tones that lie wrapped about the central core of greys. His greys themselves pulsate with imprisoned colours. Years ago I had said of the old Chinese school of colouring, that it conceived of colour as a flower growing out of a soil of greys. But in European art I have seen this thought exemplified only in the work of Whistler.

But though Whistler's key to larger range be stolen from the East, it must not be supposed that he falls out of relation to past European achievement. If his work be of universal value, and not freakish, it must have points of contact with all old greatnesses. It is just because he is, first and last, a genuine creator, that his ideas in line, tone and colour – drawn up from objective affinities rather than personal whims – are charged with the widest range of analogy. In his lovely series of pastel studies of young girls, for instance, girls gauzily draped – we see an instantaneous flash of the supple line that early Greeks modelled into their clay figurines. In his grander figure work in oil – such as the eight supreme *Arrangements*, kept by him in his studio till his death, and now, as it were, bequeathed to the American people through Mr Freer – the long drapery lines rise to such a height of spontaneous splendour that they court comparison with Phidias on the one hand, and with the greatest Chinese painter, Ririomin, on the other. In his portraits Whistler uses for their own beauty ranges of tone that Velazquez unconsciously tried for realistic ends. His greatest landscapes recall the fifteenth century Japanese, Sesshu, whose work he never saw. It is, of course, not meant to declare here that Whistler is as great in their own line as all these masters; still less that he is the greatest artist of the world. But we do say that he is central in this sense, that, in the wide play of his experimenting with absolute beauty, he struck again and again, without consciousness of imitation, and often in complete ignorance, the characteristic beauties of the most remote masters, both Western and Eastern. And it is this modern centrality in which Mr Freer discerns his supreme importance.

On 27 December 1904 Freer had presented to President Theodore Roosevelt his proposal to gift his collections to the nation.

Sesshû Tôyô (1420–1506).

EZRA POUND

THE NEW AGE
"Patria Mia"
24 October 1912

The verse of the "Imagist" American poet Ezra Pound (1885–1972) was deeply informed by the impression Whistler's art made on him; and his influence sufficiently felt to warrant a photograph Pound had taken of himself dressed in the pose of Whistler's Carlyle.

America is the sort of country that loses Henry James and retains to its appreciative bosom a certain Harry Van Dyke.

This statement is a little drastic, but it has the facts behind it.

America's position in the world of art and letters is, relatively, about that which Spain held in the time of the Senecas. So far as civilization is concerned America is the great rich, Western province which has sent one or two notable artists to the Eastern capital. And that capital is, needless to say, not Rome, but the double city of London and Paris.

From our purely colonial conditions came Irving and Hawthorne. Their tradition was English unalloyed, and we had to ourselves Whitman, *The Reflex*, who left us a human document, for you cannot call a man an artist until he shows himself capable of reticence and of restraint, until he shows himself in some degree master of the forces which beat upon him.

And in our own time the country has given to the world two men, Whistler, of the school of masterwork, of the school of Durer, and of Hokusai, and of Velazquez, and Mr Henry James, a follower in the school of Flaubert and Tourgueneff.

* * *

I was about to say, that while I had taken deep delight in the novels of Mr Henry James, I have gathered from the loan exhibit of Whistler's paintings now at the Tate (September 1912), more courage for living than I have gathered from the Canal Bill or from any other manifestation of American energy whatsoever.

Henry Van Dyke (1852–1933), writer, preacher, diplomat.

Washington Irving (1783–1859); Nathaniel Hawthorne (1804–64); Walt Whitman (1819–92).

Gustave Flaubert (1821–80); Ivan Turgenev (1818–83).
Loan Collection of Works by James McNeill Whistler, *National Gallery of British Art*, Room V, July–October 1912; it consisted mainly of works owned by Rosalind Birnie Philip.

And thereanent I have written some bad poetry and burst into several incoherent conversations, endeavouring to explain what that exhibit means to the American artist.

Here in brief is the work of a man, born American, with all our forces of confusion within him, who has contrived to keep order in his work, who has attained the highest mastery, and this not by a natural facility, but by constant labour and searching.

For the benefit of the reader who has not seen this exhibition I may as well say that it contains not the expected array of *Nocturnes*, but work in many styles, pastels of Greek motif, one pre-Raphaelite picture and work after the Spanish, the northern and the Japanese models, and some earlier things under I know not what school.

The man's life struggle is set before one. He had tried all means, he had spared himself nothing, he had struggled in one direction until he had either achieved or found it inadequate for his expression. After he had achieved a thing, he never repeated. There were many struggles for the ultimate nocturnes.

I say all this badly. But here was a man come from us. Within him were drawbacks and hindrances at which no European can more than guess.

And Velazquez could not have painted little Miss Alexander's shoes, nor the scarf upon the chair. And Durer could not have outdone the two faces. *Grenat et Or* and *Brown and Gold – de Race*. The first is called also *Le Petit Cardinal*.

YMSM 469, 511

These two pictures have in them a whole Shakespearean drama, and Whistler's comprehension and reticence would never have permitted any but the most austere discussion of their technique, of their painting as painting. And this is the only field of the art critic. It is the only phase of a work of art about which there can be any discussion. The rest you see, or you do not see. It is the painter's own private affair which he shares with you, if you understand it. It has nothing in common with the picture which tells a story, against which sort he so valiantly inveighed.

But what Whistler has proved once and for all is that being born an American does not eternally damn a man or prevent him from the ultimate and highest achievement in the arts.

And no man before him had proved this. And he proved it over many a hindrance and over many baffled attempts. He is, with Abraham Lincoln, the beginning of our Great Tradition.

CLIVE BELL

ART

Whistler and the Critics

1914

That beauty is the one essential quality in a work of art is a doctrine that has been too insistently associated with the name of Whistler, who is neither its first nor its last, nor its most capable, exponent – but only of his age the most conspicuous. To read Whistler's *Ten o'Clock* will do no one any harm, or much good. It is neither very brilliant nor at all profound, but it is in the right direction. Whistler is not to be compared with the great controversialists any more than he is to be compared with the great artists. To set *The Gentle Art* beside *The Dissertation on the Letters of Phalaris*, Gibbon's *Vindication* or the polemics of Voltaire, would be as unjust as to

It was the Bloomsbury critic Clive Bell's (1881–1962) intention "to develop a complete theory of visual art" as applicable to a Persian carpet as to a fresco by Piero della Francesca or a portrait bust of Hadrian. While Bell's ambition owed something to Whistler's espousal of a universal vision in art, it was to examples of recent French painting that Bell turned, by Cézanne, Gauguin, Matisse and Picasso (who had been recently promoted in England by his friend Roger Fry), to find confirmation for his ideas. Here Bell criticizes what he feels to be the lack of distinction Whistler made between art and nature in order to highlight his theory of "significant form" which he demonstrates is present, above all, in the work of Cézanne. The letters of the tyrant of Arcagas (c. 570/65–554/49 BC), written by a sophist in

hang *Cremorne Gardens* in the Arena Chapel. Whistler was not even cock of the Late Victorian walk; both Oscar Wilde and Mr Bernard Shaw were his masters in the art of controversy. But amongst Londoners of the "eighties" he is a bright figure, as much alone almost in his knowledge of what art is, as in his power of creating it: and it is this that gives a peculiar point and poignance to all his quips and quarrels. There is dignity in his impudence. He is using his rather obvious cleverness to fight for something dearer than vanity. He is a lonely artist, standing up and hitting below the belt for art. To the critics, painters and substantial men of his age he was hateful because he was an artist; and because he knew that their idols were humbugs he was disquieting. Not only did he have to suffer the grossness and malice of the most insensitive pack of butchers that ever scrambled into the seat of authority; he had also to know that not one of them could by any means be made to understand one word that he spoke in seriousness. Overhaul the English art criticism of that time, from the cloudy rhetoric of Ruskin to the journalese of "'Arry," and you will hardly find a sentence that gives ground for supposing that the writer has so much as guessed what art is. "As we have hinted, the series does not represent any Venice that we much care to remember; for who wants to remember the degradation of what has been noble, the foulness of what has been fair?" – "'Arry" in the *Times*. No doubt it is becoming in an artist to leave all criticism unanswered; it would be foolishness in a schoolboy to resent stuff of this sort. Whistler replied; and in his replies to ignorance and insensibility, seasoned with malice, he is said to have been ill-mannered and caddish. He was; but in these respects he was by no means a match for his most reputable enemies. And ill-mannered, ill-tempered, and almost alone, he was defending art, while they were flattering all that was vilest in Victorianism.

As I have tried to show in another place, it is not very difficult to find a flaw in the theory that beauty is the essential quality in a work of art – that is, if the word "beauty" be used, as Whistler and his followers seem to have used it, to mean insignificant beauty. It seems that the beauty about which they were talking was the beauty of a flower or a butterfly; now I have very rarely met a person delicately sensitive to art who did not agree, in the end, that a work of art moved him in a manner altogether different from, and far more profound than, that in which a flower or a butterfly moved him. Therefore, if you wish to call the essential quality in a work of art "beauty" you must be careful to distinguish between the beauty of a work of art and the beauty of a flower, or, at any rate, between the beauty that those of us who are not great artists perceive in a work of art and that which the same people perceive in a flower. Is it not simpler to use different words? In any case, the distinction is a real one: compare your delight in a flower or a gem with what you feel before a great work of art, and you will find no difficulty, I think, in differing from Whistler.

JAMES LAVER

WHISTLER

Whistler in Retrospect

1930

The first frontal attack on Whistler's reputation came from the German critic, Julius Meier-Graefe, whose monumental work on Modern Art was translated into English in 1908. His opinion of English art altogether was

the 2nd century AD; Edward Gibbon's A Vindication of some Passages in the XVth and XVIth Chapters *(1779)*; George Bernard Shaw *(1856–1950)*.

Harry Quilter; Bell quotes his review of Whistler's Venice etchings published in The Spectator, *11 December 1880 which in his 1883 catalogue Whistler ascribes to* The Times.

i.e. in the present book Art.

The biography of Whistler by the cultural historian and authority on costume James Laver *(1899–1975) was written in a decade when Whistler's reputation was at a particularly low ebb. It nevertheless remains one of the best-judged accounts of Whistler's place in nineteenth-century art and is perceptive in considering the decline of Whistler's critical fortune after his death.*

Julius Meier-Graefe, Modern Art, Being a Contribution to a New System of Aesthetics, *translated by Florence*

extremely unflattering, and he insisted on regarding Whistler as primarily an English artist. He was "fundamentally an unfrocked Pre-Raphaelite," and Pre-Raphaelitism itself was a "criminal conspiracy" which tore up by the roots all the centenarian elements of a native art capable of development. "The hundred skins in which nature and his own dexterity in disguises enveloped him conceal a perfectly English core." Yet everything that happened in European art during the mid-nineteenth century was reflected in his own work. He was aware of developments in Paris, and it was this cosmopolitanism of his – in itself a weakness – which gave him his enormous reputation. To the English he stood against a background of European culture of which they were only dimly aware. To the French he was almost the only artist working in England, and was therefore magnified against a background of what they regarded as complete barbarism.

Even Meier-Graefe's praise of Whistler is a little back-handed. He speaks of the brilliant pattern of *At the Piano*, the *Carlyle* and the *Mother*, the dexterity with which the profile is set against the wall, the distinction of the pose, and goes on to say that these canvases have all the qualities of the true Salon picture. "Indulgent critics of the future will no doubt bracket Whistler with Fantin. They were both very similar powers of a totally different kind. Both stand aloof from the great artistic achievements of the nineteenth century, the one deliberately, the other involuntarily. Neither was a creator in the true sense, both transformed inherited materials, and the results of their activity were not indispensible to modern art-development."

The protest which can be entered here is that it is possible to be an important artist without necessarily diverting the stream of art. The professional art historian inevitably tends to think influences more important than achievements, or rather he falls into the habit of considering them to be almost the same thing.

With the literary appreciation of the late nineteenth century Frenchmen, Meier-Graefe will have nothing to do. Where, in the *White Girl* they saw the evocation of a spirit, he sees nothing but "glass eyes, false hair, clothes, carpet and curtains." In plain terms, "there are no spirits, and nothing happens of itself, least of all in art, which knows nothing of the arbitrary and accidental."

Even the *Nocturnes* fare hardly at the German critic's hands. They are not without charm, and many of them show a highly cultivated taste. No educated person can now walk along the bank of the Thames at nightfall without thinking of Whistler. Yet Whistler chose Nature in her weaker manifestations in order to conquer her more easily. "He chose her so small that nothing remains of her but a nebulous veil."

Yet even Meier-Graefe admits the beauty of the *Miss Alexander*, and of many of the water-colours, etchings and lithographs, and concludes that he was a "little master," an industrial artist of delicate taste, a stimulating influence which we may turn to good account. It would have been nothing less than miraculous if America, as yet without artistic traditions, had contrived to bring forth a great artist. Hence Whistler's insistence on the isolation of the artist, in order to justify his own existence.

The same point is made by the English critic, Charles Marriott. "Whistler stood for that impossible thing, a cosmopolitan art . . . it is art divorced from life and depending entirely upon culture. . . . Whistler was a fine artist, but his philosophy of art was not only unsound, but uneasy. Otherwise he would not have needed to talk and write so much about it. . . . The truth is, that with all its peculiar charm, the art of Whistler was based upon a series of compromises and evasions. The French Impressionists pursued the theory of Realism to its logical conclusion . . . (Whistler's) larger works, at any rate, are efforts to escape from the logic of Realism into a region of twilight and undertones. Lacking the imagination, or perhaps the courage, to translate the facts of nature

Simmonds and George W. Chrystal, 2 vols, William Heinemann, London, 1908. Meier-Graefe's difficulty in seeing Whistler whole (vol. II pages 198–225) is underscored by dividing his discussion into four separate chapters: "Whistler: The Englishman;" "Whistler: The Frenchman;" "Whistler: The Japanese;" and "Whistler: The Spaniard." Unable to measure up to his requirements in all of these categories, Whistler's art failed to meet Meier-Graefe's notion of international modernism.*

COLOURPLATES 13, 38, 30 *(YMSM 24, 137, 101).*

COLOURPLATE 9 *(YMSM 38).*

COLOURPLATE 46 *(YMSM 129).*

Charles Marriott, Modern Movements in Painting, *Chapman and Hall, Ltd., London, 1920.*

boldly into terms of his medium, he waited for or invented conditions in which the facts would not be too obvious, and made them 'decorative' by arrangements that were entirely lacking in the logic of design."

Certain modern American critics also, feeling, no doubt, that there was an element of Chauvinism in Pennell's exaggeration of the accomplishment of Whistler, have tended to be more severe in their estimate than their colleagues in England, although none of them has pushed denigration so far as Meier-Graefe.

One of the most recent, Frank Jewett Mather includes him among the "twilight" Impressionists like Carrière and Cazin, and concludes: "Whistler's fastidiously reticent art, a thing of whispers and raised eyelids, is charming just that and nothing more. . . . His lucidity and satire was useful in riddling a galvanized official art, but he had no better aesthetic than the faith that art will happen. . . . He did a rather small thing amazingly well, and in retrospect I fear his delightful art will diminish. It hung too much on his wit and personal legend. He had the magnificent background of Victorian London and the Royal Academy. His exotic brilliance too easily dominated such a scene."

Frank Jewett Mather Jr., Modern Painting, *Garden City Publishing Co. Inc., New York, 1927; Eugène Carrière (1849–1906); Jean Cazin (1841–1901).*

Whistler's reputation is suffering from an inevitable reaction, and perhaps will never stand quite as high as it did thirty years ago. He pays the penalty of impressing himself too vigorously on the world, for it is not those who inspire the most fanatical personal discipleship who always found a school to revere their names when they are dead, and carry their principles into practice. What Whistler said is even yet of interest to apprentice wits. But is what Whistler painted of interest to budding artists?

The dominant influences which still control painting in England derive, like Whistler's own art, from France; but they only flowed indirectly through him. The New English Art Club, which Whistler thought so wholly ridiculous, received and transmitted the lessons of Manet, Monet and Degas. The first exhibition was held at the Marlborough Gallery, Pall Mall, in 1886. Steer and Professor Brown were among the original members, and Sickert appeared in their midst two years later. Sickert, as we have seen, was at one time Whistler's most ardent disciple, and he retained a modified Whistlerianism for some years. It is therefore only in a minor degree and almost by accident that Whistler has part in the movement which was to revolutionize English painting. He was, indeed, patron of the school which Sickert and Alfred Thornton opened in De Morgan's old studio in the Vale (that same cul-de-sac which had witnessed the furious altercation between the not-yet-discarded Maud and the future Mrs Whistler), but the school was a failure, and in any case influence by teaching can only be gained by long devotion, such as that which Legros gave to the Slade. The part played by the Slade in the development of modern painting should not be forgotten, although it has been overlaid by more startling influences, but with that, too, Whistler had nothing to do.

Whistler is supposed to have compared The New English Art Club as "a raft" to the International Society as "a battleship." Professor Frederick Brown (1851–1941) of the Slade School of Art.

Alfred Thornton (1863–1939); William De Morgan (1839–1917).

Whistler was a superb decorator, and his influence on decoration continues. If we no longer load our rooms with knick-knacks, if we prefer our walls plainly distempered, if we hang few pictures instead of many, and prefer Chinese matting to rose-embroidered carpets, it is at least as much his doing as anyone else's. But in painting, it is another story. He was too personal and too sophisticated. The neo-primitives of the modern studios, the admirers of negro art, the "strong" painters of today can have little use for an artist whose canvases were the epitome of all that is refined, civilized and reticent. The later Impressionists with their "treble" palette are the complete antitheses of Whistlerian twilight, and it is from them that modern painting derives its colour. The disciples of Cézanne, the apostles of "construction in depth," attempt the very opposite of Whistler's careful flattering, his narrowing of planes, and it is from them and from the exponents of the geometrical, that modern painters derive their interest in form.

So far as modern easel-painting is concerned, Whistler is in complete eclipse, was so, indeed, before he died. Yet the elimination of the anecdote which has liberated painting from the trammels of literature and left it free to develop in accordance with the laws of its own nature was, partly at least, his work, and for that we may be grateful, and for that he may still be honoured. The name of "greatest painter of the nineteenth century," which his first biographers so rashly bestowed upon him, may be disputed by many artists – by Constable, by Ingres, by Manet, by Degas – but his own particular niche is secure. What he set out to do, he did with singular perfection, and that is all we have the right to demand of any artist.

i.e. the Pennells.

STEPHEN SPENDER

Sir Stephen Spender (b. 1909) the English poet and critic.

THE LISTENER

"A Painter Haunted by Greatness"

8 September 1960

The exhibition of paintings and other works by Whistler at the Arts Council Gallery in London, most imaginatively arranged, complete with blue-and-white porcelain lent by Messrs Spink, and, on the opening day, with a vase of white lilies in the first room so odiferous they nearly anaesthetized me, offers much more than nostalgic, period charm. There is a kind of excitement of the really new, a defiant heroism, which still has something to communicate to the spectator. It is a quality that one finds also in the early Blue Period Picassos from Russia, now hung in the Tate Gallery, and in certain cubist paintings. It is the excitement of a modern art determined to convert a modern world. This art, perhaps significantly, tends towards monochrome, pure colours, blue, grey or gold, to assert its single-minded values. What makes Whistler so different from his contemporaries like Rossetti or Beardsley is the idea of great and independent art that haunts even a sketch as slight as that of the head of Miss Cicely Alexander. And just because there is this ghost of a Great Painting beyond the actual painting, we are inclined perhaps to use the great idea suggested as a standard of measurement and to underestimate what we actually see.

YMSM 128.

We feel that a man with such a vision of art, so capable of giving us work which suggests the sublime, should somehow have been a greater painter with a greater productivity. There is always a sense in a Whistler painting or etching of there *being very little of this*, where in a painting of one of his contemporaries and friends – Courbet, Manet or Degas – there is the sense of there being many more where this one came from. Yet, looking at this exhibition, one is able to see how distinct, pure, accomplished and beautiful Whistler's achievement remains. In one respect at least he is among the great inventors. Certain of his images – whether the pose of the seated figure of Carlyle or of Whistler's mother, or the dark and golden hieroglyphic streakings in a Thameside nocturne, or even the little butterfly of his own signature – once seen become glued on one's mind. They belong among those postage stamps of art we carry round, together with Botticelli's figure of Venus on her scallop shell rising from the bird-winged waves, or the floating, shrieking, blown-up face of a woman in Picasso's *Guernica*.

of 1937.

Whistler is sometimes dismissed as a dilettante if not an amateur. But what non-professional was ever quite so accomplished a technician? His limitations are rather those of the aesthete, or the animator who uses his

art, however original it may be, to communicate influences and ideas – like those of the Japanese woodcuts, which he perceived so delicately. The technique of each painting is confined too exquisitely to its occasion. There is no carrying over of energy from painting to painting. If we were told that a single painting here (one of the best) was his only work, we would go away satisfied, thinking it the epitome of his talent.

When, as often happens, Whistler draws with the brush a line or lines right across the canvas one is conscious of the eye that sees the drawn line rather than of the separate animal energy of the hand that drew it. This precision is not deliberately impersonal and mechanical (as when Ben Nicholson or Mondrian simply rules a line) nor is it quite of joyous flesh and blood. The superiority of this art is that it is distinctively dictated by a highly critical eye; but it is only of the eye. The moment one thinks of a Romney, a Turner, a Goya, a Manet (all of them, after all, just as full of "aesthetic" qualities as Whistler) one feels the limitations of the "pure" aesthete.

Ben Nicholson (1894–1982); Piet Mondrian (1872–1944).

George Romney (1734–1802).

All the same, one can get the pleasure of an entirely fresh experience from some of the less-familiar pictures here – as though they were painted yesterday. I had never before seen *Nocturne: Snowstorm*, a picture almost entirely lacquer black, flaked with malacca-like chips of white. It looks today as original and exciting as the latest Max Ernst. And from the Municipal Gallery of Modern Art in Dublin comes the beautiful portrait of the young Walter Sickert, smudged in dark near-monochromes of brownish green, through the mask of which stare the brilliant white discs of the sitter's eyes.

In the National Museum of Wales, Cardiff, but not now thought to be by Whistler. Max Ernst (1891–1976).

YMSM 350.

INDEX

(Numbers in italics refer to the page numbers of the illustrations)